A history
of the
WORLD
in
100 objects

NEIL MacGREGOR

A history
of the
WORLD
in
100 objects

PENGUIN BOOKS

PENGUIN BOOKS

Published by the Penguin Group
Penguin Group (USA) LLC
375 Hudson Street,
New York, New York 10014

USA | Canada | UK | Ireland | Australia | New Zealand | India | South Africa | China
penguin.com
A Penguin Random House Company

First published in Great Britain by Allen Lane 2010
First published in the United States of America by Viking Penguin,
a member of Penguin Group (USA) Inc., 2011
First published in this format by Allen Lane 2011
Published by Penguin Books 2013

To all my colleagues at the British Museum

Contents

PART FOUR

The Beginnings of Science and Literature

2000–700 BC

PART FIVE

Old World, New Powers

1100–300 BC

PART SIX

The World in the Age of Confucius

500–300 BC

PART SEVEN

Empire Builders

300 BC–AD 10

PART TWELVE

Pilgrims, Raiders and Traders

AD 800–1300

PART THIRTEEN

Status Symbols

AD 1100–1500

PART FOURTEEN

Meeting the Gods

AD 1200–1500

PART FIFTEEN

The Threshold of the Modern World

AD 1375–1550

PART SIXTEEN

The First Global Economy

AD 1450–1650

PART SEVENTEEN

Tolerance and Intolerance

AD 1550–1700

PART EIGHTEEN

Exploration, Exploitation and Enlightenment

AD 1680–1820

PART NINETEEN

Mass Production, Mass Persuasion

AD 1780–1914

CONTENTS

Preface: Mission Impossible

Telling history through things is what museums are for. And because the British Museum has for over 250 years been collecting things from all round the globe, it is not a bad place to start if you want to use objects to tell a history of the world. Indeed you could say it is what the Museum has been attempting to do ever since Parliament set it up in 1753 and directed that it should be 'aimed at universality' and free to all. This book is the record of a series of programmes on BBC Radio 4, broadcast in 2010, but it is also in fact simply the latest iteration of what the Museum has been doing, or attempting to do, since its foundation.

The rules of the game for *A History of the World in 100 Objects* were set by Mark Damazer, Controller of Radio 4, and they were simple. Colleagues from the Museum and the BBC would choose from the collection of the British Museum 100 objects that had to range in date from the beginning of human history around two million years ago and come right up to the present day. The objects had to cover the whole world, as far as possible equally. They would try to address as many aspects of human experience as proved practicable, and to tell us about whole societies, not just the rich and powerful within them. The objects would therefore necessarily include the humble things of everyday life as well as great works of art. As five programmes would be broadcast each week, we would group the objects in clusters of five, spinning the globe at various points in time and looking at five snapshots of the world through objects at that particular date. And because the Museum's collection embraces the whole world and the BBC broadcasts to every part of it, we would invite experts and commentators from all over the world to join in. Of course it could only ever be

'a' history of the world, but it would still try to be a history to which the world had in some measure contributed. (Partly for reasons of copyright, the contributors' words have been left here essentially as they were spoken.)

The project was clearly in many respects impossible, but one particular aspect of it caused an especially lively debate. All these objects would be presented not on television but on radio. They would have to be imagined by the listener, not seen. At first I think the Museum team, used to the close examination of things, was daunted by this, but our BBC colleagues were confident. They knew that to imagine a thing is to appropriate it in a very particular way, that every listener would make the object under discussion their own and in consequence make their own history. For those who simply had to see them, and who couldn't visit the Museum in person, pictures of all the objects have been available on the 'A History of the World in 100 Objects' website throughout 2010, and are now reproduced in this beautifully illustrated book.

Neil MacGregor
September 2010

Introduction:
Signals from the Past

In this book we travel back in time and across the globe, to see how we humans have shaped our world and been shaped by it over the past two million years. The book tries to tell a history of the world in a way which has not been attempted before, by deciphering the messages which objects communicate across time – messages about peoples and places, environments and interactions, about different moments in history and about our own time as we reflect upon it. These signals from the past – some reliable, some conjectural, many still to be retrieved – are unlike other evidence we are likely to encounter. They speak of whole societies and complex processes rather than individual events, and tell of the world for which they were made, as well as of the later periods which reshaped or relocated them, sometimes having meanings far beyond the intention of their original makers. It is the things humanity has made, these meticulously shaped sources of history and their often curious journeys across centuries and millennia, which *A History of the World in 100 Objects* tries to bring to life. The book includes all sorts of objects, carefully designed and then either admired and preserved or used, broken and thrown away. They range from a cooking pot to a golden galleon, from a Stone Age tool to a credit card, and all of them come from the collection of the British Museum.

The history that emerges from these objects will seem unfamiliar to many. There are few well-known dates, famous battles or celebrated incidents. Canonical events – the making of the Roman Empire, the Mongol destruction of Baghdad, the European Renaissance, the Napoleonic wars, the bombing of Hiroshima – are not centre stage. They are, however, present, refracted through individual objects. The politics

of 1939, for example, determined both how Sutton Hoo was excavated and how it was understood (Chapter 47). The Rosetta Stone is (as well as everything else) a document of the struggle between Britain and Napoleonic France (Chapter 33). The American War of Independence is seen here from the unusual perspective of a native American buckskin map (Chapter 88). Throughout, I have chosen objects that tell many stories rather than bear witness to one single event.

The Necessary Poetry of Things

If you want to tell the history of the whole world, a history that does not unduly privilege one part of humanity, you cannot do it through texts alone, because only some of the world has ever had texts, while most of the world, for most of the time, has not. Writing is one of humanity's later achievements, and until fairly recently even many literate societies recorded their concerns and aspirations not only in writing but in things.

Ideally a history would bring together texts and objects, and some chapters of this book are able to do just that, but in many cases we simply can't. The clearest example of this asymmetry between literate and non-literate history is perhaps the first encounter, at Botany Bay, between Captain Cook's expedition and the Australian Aboriginals (Chapter 89). From the English side, we have scientific reports and the captain's log of that fateful day. From the Australian side, we have only a wooden shield dropped by a man in flight after his first experience of gunshot. If we want to reconstruct what was actually going on that day, the shield must be interrogated and interpreted as deeply and rigorously as the written reports.

In addition to the problem of mutual miscomprehension there are the accidental or deliberate distortions of victory. It is, as we know, the victors who write the history, especially when only the victors know how to write. Those who are on the losing side, those whose societies are conquered or destroyed, often have only their things to tell their stories. The Caribbean Taino, the Australian Aboriginals, the African people of Benin and the Incas, all of whom appear in this book, can speak to us now of their past achievements most powerfully through

the objects they made: a history told through things gives them back a voice. When we consider contact between literate and non-literate societies such as these, all our first-hand accounts are necessarily skewed, only one half of a dialogue. If we are to find the other half of that conversation, we have to read not just the texts, but the objects.

All so much easier said than done. Writing history from the study of texts is a familiar process, and we have centuries of critical apparatus to assist our assessment of written records. We have learnt how to judge their frankness, their distortions, their ploys. With objects, we do of course have structures of expertise – archaeological, scientific, anthropological – which allow us to ask critical questions. But we have to add to that a considerable leap of imagination, returning the artefact to its former life, engaging with it as generously, as poetically, as we can in the hope of winning the insights it may deliver.

For many cultures, if we are to know anything about them at all, this is the only way forward. The Moche culture of Peru, for example, now survives solely through the archaeological record. A Moche pot in the shape of a warrior (Chapter 48) is one of our few starting points for recovering who these people were and understanding how they lived, how they saw themselves and their world. It is a complex and uncertain process in which objects now reachable only through layers of cultural translation have to be rigorously scrutinized and then re-imagined. The Spanish conquest of the Aztecs, for instance, has masked for us the Aztec conquest of the Huastec people: because of these revolutions of history the voice of the Huastec is now recoverable only at two removes, through a Spanish version of what the Aztecs told them. What did the Huastec themselves think? They left no textual record to tell us, but the material culture of the Huastec does survive in figures such as a five-foot-high stone goddess (Chapter 69), whose identity was roughly equated first with the Aztec mother goddess Tlazolteotl and later with the Virgin Mary. These sculptures are the primary documents of Huastec religious thought, and while their precise meaning remains opaque, their numinous presence sends us back to the second-hand accounts of the Aztecs and Spaniards with new perceptions and sharper questions – but still ultimately reliant on our own intuitions about what is at issue in this dialogue with the gods.

Such acts of imaginative interpretation and appropriation are

essential in any history told through things. These were methods of understanding familiar to the founders of the British Museum, who saw the recuperation of past cultures as an essential foundation for understanding our common humanity. The collectors and scholars of the Enlightenment brought to the task both a scientific ordering of facts, and a rare capacity for poetic reconstruction. It was an enterprise being pursued simultaneously on the other side of the world. The Qianlong emperor in China, an almost exact contemporary of George III, in the middle of the eighteenth century was also engaged in gathering, collecting, classifying, categorizing, exploring the past, making dictionaries, compiling encyclopaedias and writing about what he had discovered, on the surface just like an eighteenth-century European gentleman scholar. One of the many things he collected was a jade ring or *bi* (Chapter 90), very like jade rings found in the tombs of the Zhang Dynasty about 1500 BC. Their use is still unknown today, but they are certainly objects of high status and very beautifully made. The Qianlong emperor admired the strange elegance of the jade *bi* he found and began to speculate what it was for. His approach was as much imaginative as scholarly: he could see it was very old, and he reviewed all the broadly comparable objects he knew about, but beyond that he was baffled. So, characteristically for him, he wrote a poem about his attempt to make sense of it. And then, perhaps rather shockingly to us, he had his poem inscribed on the prized object itself – a poem in which he concludes that the beautiful *bi* was meant to be a bowl stand, so he'll put a bowl on it.

Although the Qianlong emperor came to the wrong conclusion about the purpose of the *bi*, I confess I admire his method. Thinking about the past or about a distant world through things is always about poetic re-creation. We acknowledge the limits of what we can know with certainty, and must then try to find a different kind of knowing, aware that objects must have been made by people essentially like us – so we should be able to puzzle out why they might have made them and what they were for. It may sometimes be the best way to grasp what much of the world is about, not just in the past but in our own time. Can we ever really understand others? Perhaps, but only through feats of poetic imagination, combined with knowledge rigorously acquired and ordered.

The Qianlong emperor is not the only poet in this history. Shelley's response to Ramesses II – his Ozymandias - tells us nothing about the making of the statue in ancient Egypt, but a great deal about early nineteenth-century fascination with the transience of empire. In the great ship burial of Sutton Hoo (Chapter 47), two poets are at work: Beowulf's epic tale is recovered in historical reality, while Seamus Heaney's evocation of the warrior helmet gives an urgent topicality to this famous piece of Anglo-Saxon body-armour. A history through things is impossible without poets.

The Survival of Things

A history of the world told through objects should therefore, with sufficient imagination, be more equitable than one based solely on texts. It allows many different peoples to speak, especially our ancestors in the very distant past. The early part of human history – more than 95 per cent of humanity's story as a whole – can indeed be told only in stone, for besides human and animal remains, stone objects are all that survive.

A history through objects, however, can never itself be fully balanced because it depends entirely on what happens to survive. It is particularly harsh on cultures whose artefacts are made mostly of organic materials, and especially so where climate will cause such things to decay: for most of the tropical world, very little survives from the distant past. In many cases, the oldest organic artefacts we have are those collected by the first European visitors: two of the objects in this book, for example, were gathered by the expeditions of Captain Cook – the Australian aboriginal bark shield already mentioned (Chapter 89) and the Hawaiian feather helmet (Chapter 87) – in each case acquired at the very first moment of contact between these societies and Europeans. Of course both Hawaii and south-east Australia had complex societies, producing elaborate artefacts, long before then. But virtually none of these earlier artefacts made from wood, plants or feathers has survived, so the early stories of those cultures are now hard to tell. A rare exception is the 2500-year-old textile

fragment from mummies in Paracas (Chapter 24), preserved by the exceptionally dry conditions in the deserts of Peru.

Things do not, however, need to survive intact to yield enormous amounts of information. In 1948, dozens of small pottery fragments were found by an alert beach-comber at the bottom of a cliff at Kilwa in Tanzania (Chapter 60). They were, quite literally, rubbish: broken bits of crockery thrown away and of no use to anyone. But as he gathered them together he came to realise that in these pot sherds lay the story of East Africa a thousand years ago. Indeed, examination of their variety reveals a whole history of the Indian Ocean, because once we look at them closely, it is clear that these fragments come from widely different places. A green sherd and a blue-and-white one are clearly fragments of porcelain manufactured in huge quantities in China for export. Other pieces bear Islamic decoration and are from Persia and the Gulf. Still others derive from indigenous East African earthenware.

These ceramics – all used, we think, by the same people, all broken and thrown on the rubbish dump at roughly the same time – demonstrate what was for long beyond the view of Europe: that between AD 1000 and 1500, the East African coast was in contact with the whole of the Indian Ocean. There was regular trade between China, Indonesia, India, the Gulf and East Africa, and raw materials and finished commodities were circulating widely. This was possible because in contrast to the Atlantic, where the winds are very disobliging, the winds in the Indian Ocean blow kindly from the south-east for six months of the year and from the north-west for the other six, allowing sailors to set out over huge distances and be reasonably certain of getting home. The Kilwa fragments demonstrate that the Indian Ocean is in effect an enormous lake across which cultures have been communicating for millennia, where traders bring not only things but ideas, and the communities around whose shores are every bit as connected as those around the Mediterranean. One of the things this object history makes clear is that the very word 'Mediterranean' – 'the sea at the centre of the earth' – is misconceived. It is not at the centre of the Earth, and is just one among many marine cultures. We shan't of course find another word for it, but perhaps we should.

The Biographies of Things

This book might perhaps have been more accurately titled *A History of Objects Through Many Different Worlds*, for one of the characteristics of things is that they so often change – or are changed – long after they have been created, taking on meanings that could never have been imagined at the outset.

A startlingly large number of our objects bear on them the marks of later events. Sometimes this is merely the damage that comes with time, like the broken headdress on the Huastec goddess, or from clumsy excavation or forceful removal. But frequently, later interventions were designed deliberately to change meaning or to reflect the pride or pleasures of new ownership. The object becomes a document not just of the world for which it was made, but of the later periods which altered it. The Jomon pot (Chapter 10), for example, speaks of the precocious Japanese achievement in ceramics and the origins of stews and soups many thousands of years ago, but its gilded inside tells of a later, aestheticizing Japan, conscious now of its own particular traditions, revisiting and honouring its long history: the object has become a commentary on itself. The African wooden slit drum (Chapter 94) is an even more remarkable example of an object's many lives. Made in the shape of a calf for a ruler probably in the northern Congo, it was re-branded as an Islamic object in Khartoum, and then, captured by Lord Kitchener, carved with Queen Victoria's crown and sent to Windsor – a wooden narrative of conquests and empires. I do not think any text could combine so many histories of Africa and Europe, nor make them so powerfully immediate. This is a history only a thing can tell.

Two objects in the book are disconcertingly material tales of changed allegiances and of structures that failed, showing two different faces to two very different worlds. From the front, Hoa Hakananai'a (Chapter 70) proclaims with unshakable confidence the potency of ancestors who, properly venerated, will keep Easter Island safe. On his back, however, is sculpted the failure of that very cult and its later, anxious replacement by other rituals as the Easter Island ecosystem broke down and the birds essential to life on the island moved

away. The religious history of a community, lived out over centuries, is all legible in this one statue. The Russian Revolutionary plate (Chapter 96), by contrast, shows changes that were very much the consequence of human choice – and political calculation. The use of imperial porcelain to carry Bolshevik imagery has a beguiling irony about it; but that is rapidly overtaken by admiration for the unsentimental commercial brilliance which guessed correctly that capitalist collectors in the West would pay more for a plate if it combined the hammer and sickle of the Revolution with the imperial monogram of the Tsar. The plate shows the first steps in the complex historic compromise between the Soviets and the liberal democracies which would continue for the next seventy years.

These two reworkings both fascinate and instruct, but the refashioning which gives me the most pleasure is without doubt the Admonitions Scroll (Chapter 39). For hundreds of years, as it was slowly unrolled before them, owners and connoisseurs have taken delight in this celebrated masterpiece of Chinese painting, and have then recorded it by marking it with their seals. The result may alarm a western eye used to regarding the work of art as an almost sacred space, but there is I think something very moving about these acts of aesthetic witness which create a community of shared enjoyment spanning the centuries, and to which we in our turn may be admitted – even if we do not add our seals. There could be no clearer statement that this beautiful thing, which has charmed people in different ways over such a very long time, still has the power to delight and is now ours to enjoy.

There is another way in which the biographies of things change over time. One of the key tasks of museum scholarship, and above all of museum conservation science, is to keep returning to our objects, as new technologies allow us to ask new questions of them. The results, in recent years especially, have frequently been astonishing, opening up fresh lines of investigation and discovering unsuspected meanings in what we thought were familiar things. At the moment, objects are changing fast. The most striking instance in this book is surely the jade axe from Canterbury (Chapter 14), whose origin we can now trace to the very boulder from which it was originally chipped, high on a mountain in northern Italy. In consequence we have a new under-

standing of the trade routes of early Europe and a fresh set of hypotheses about the significance of the axe itself, especially valued, perhaps, because it came from above the clouds and far away. New methods of medical examination allow us intimate knowledge of the ailments of the ancient Egyptians (Chapter 1) and of the talismans they took with them into the afterlife. The medieval Hedwig beaker (Chapter 57), long famous for its ability to change water into wine, has also recently changed its own nature. Thanks to new analysis of the glass, it may now with some confidence be sourced to the eastern Mediterranean, and with less confidence (but great enjoyment) speculatively linked to a particular moment in medieval dynastic history and to a colourful character in the history of the Crusades. Science is rewriting these histories in totally unexpected ways.

Precise material science combines with powerful poetic imagining in the case of the Akan drum (Chapter 86), which was acquired for Sir Hans Sloane in Virginia around 1730. Wood and plant specialists have recently established that this drum was undoubtedly made in West Africa: it must have crossed the Atlantic on a slave ship. Now that we know its place of origin, it is impossible not to wonder what it may have witnessed, and not to accompany it, in imagination, on its journey from a West African royal court on the terrible Atlantic crossing to a North American plantation. We know that such drums were used to 'dance the slaves' on the ships to fight depression, and on the plantations sometimes rallied the slaves to revolt. If one of the purposes of an object history is to use things to give voice to the voiceless, then this slave drum has a special role – to speak for millions who were allowed to take nothing with them as they were enslaved and deported, and who were unable to write their own story.

Things across Time and Space

Spinning the globe, trying to look at the whole world at roughly the same moment as I described in the preface, is not the way history is usually told or taught: I suspect that few of us in our schooldays were ever asked to consider what was happening in Japan or in East Africa in 1066. But if we do look across the globe at particular times, the

result is often surprising and challenging. Around AD 300 (Chapters 41–45), for example, with what seems like bewildering synchronicity, Buddhism, Hinduism and Christianity all moved towards the conventions of representation which broadly they still use today, and all of them began to focus on images of the human body. It is an astonishing co-incidence. Why? Were all three influenced by the enduring tradition of Hellenistic sculpture? Was it because they were all products of rich and expanding empires, able to invest heavily in the new pictorial language? Was there a new, shared idea that the human and the divine were in some sense inseparable? It is impossible to propose a conclusive answer, but only this way of looking at the world could so sharply pose what should be a central historical question.

In some instances, our history returns to more or less the same spot several times, at intervals of thousands of years, and observes the same phenomenon. But in these cases the similarities and coincidences are easier to explain. The sphinx of Taharqo (Chapter 22), the head of Augustus from Meroë (Chapter 35) and the slit drum from Khartoum (Chapter 94) all speak of violent conflict between Egypt and what is now Sudan. In each case, the people from the south – Sudan – enjoyed a moment (or a century) of victory; in each case, the power ruling in Egypt finally reasserted itself and the frontier was re-established. Pharaonic Egypt, the Rome of Augustus and the Britain of Queen Victoria were all in turn forced to recognize that around the first cataracts of the Nile, where the world of the Mediterranean meets black Africa, there is a secular geo-political fault line. There the tectonic plates have always collided, resulting in endemic conflict, whoever is in control. This is history that explains much about the politics of today.

Spinning the globe also, I think, shows how different history looks depending on who you are and where you are looking from. So although all the objects in the book are now in one place, it deliberately includes many different voices and perspectives. It draws on the expertise of the British Museum's combined team of curators, conservators and scientists, but it also presents research and analysis by leading scholars from all over the world, and includes assessments by people who deal professionally with objects similar to those discussed historically: the Head of the British Civil Service rates one of the oldest surviving Mesopotamian administrative records (Chapter 15), a

contemporary satirist looks at Reformation propaganda (Chapter 85) and an Indonesian puppet-master describes what is involved in such performances today (Chapter 83). With extraordinary generosity, judges and artists, Nobel Prize-winners and religious leaders, potters, sculptors and musicians have brought to the objects the insights of their professional experience.

Happily the book also includes voices from the communities or countries where the objects were made. This is, I believe, indispensable. Only they can explain what meanings these things now carry in that context: only a Hawaiian can say what significance the feather helmet given to Captain Cook and his colleagues (Chapter 87) has for the islanders today, after two hundred and fifty years of European and American intrusion. Nobody can explain better than Wole Soyinka what it means to a Nigerian now to see the Benin bronzes (Chapter 77) in the British Museum. These are crucial questions in any consideration of objects in history. All round the world national and communal identities are increasingly being defined through new readings of their history, and that history is frequently anchored in things. The British Museum is not just a collection of objects: it is an arena where meaning and identity are being debated and contested on a global scale, at times with acrimony. These debates are an essential part of what the objects now mean, as are the arguments about where they should properly be exhibited or housed. These views should be articulated by those most intimately concerned.

The Limits of Things

All museums rest on the hope – the belief – that the study of things can lead to a truer understanding of the world. It is what the British Museum was set up to achieve. The idea was articulated powerfully by Sir Stamford Raffles, whose collection came to the British Museum as part of his campaign to persuade Europeans that Java had a culture which could proudly take its place beside the great civilizations of the Mediterranean. The head of the Buddha from Borobudur (Chapter 59) and the shadow-puppet of Bima (Chapter 83) show how eloquent objects can be in pleading such a cause, and I cannot be the only

person who looks at them and is totally persuaded by Raffles's argument. These two objects take us to very different moments of Java's history, demonstrating the culture's longevity and vitality, and they speak of two very different areas of human endeavour – a solitary spiritual quest for enlightenment, and riotous public fun. Through them, a whole culture can be glimpsed, apprehended and admired.

The object which perhaps best resumes the ambitions not just of this book but of the British Museum itself, the attempt to imagine and understand a world we have not experienced directly but know of only through the accounts and experiences of others, is Dürer's *Rhinoceros*, a beast which he drew but never saw. Confronted with reports of the Indian rhinoceros sent from Gujarat to the king of Portugal in 1515, Dürer informed himself as fully as he could from the written descriptions that had circulated around Europe and then tried to imagine what this extraordinary beast might look like. It is the same process that we all go through as we gather evidence, and then build our image of a world in the past or far away.

Dürer's animal, unforgettable in its pent-up monumentality and haunting in the rigid plates of its folding skin, is a magnificent achievement by a supreme artist. It is striking, evocative and so real you almost fear it is about to escape from the page. And it is, of course – exhilaratingly? distressingly? reassuringly? (I don't know which) – wrong. But in the end that is not the point. Durer's *Rhinoceros* stands as a monument to our endless curiosity about the world beyond our grasp, and to humanity's need to explore and try to understand it.

PART ONE
Making us Human

2,000,000 — 9000 BC

Human life began in Africa. Here our ancestors created the first stone tools to chop meat, bones and wood. It was this increasing dependency on the things we create that makes humans different from all other animals. Our ability to make objects allowed humans to adapt to a multitude of environments and spread from Africa into the Middle East, Europe and Asia. From about 40,000 years ago, during the last Ice Age, humans created the world's first representational art. This Ice Age caused the world's sea levels to fall, exposing a land bridge between Siberia and Alaska that allowed humans to reach the Americas for the first time and spread rapidly across the continent.

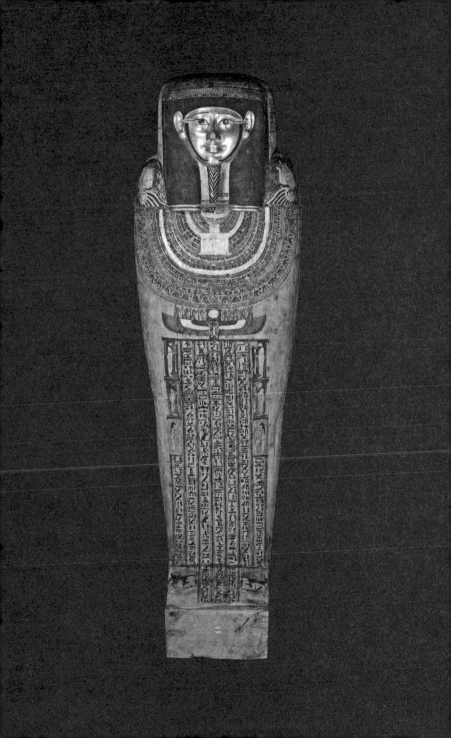

I

Mummy of Hornedjitef

Wooden mummy case, from Thebes (near Luxor), Egypt
ABOUT 240 BC

When I first came through the doors of the British Museum in 1954, at the age of eight, I began with the mummies, and I think that's still where most people begin when they first visit. What fascinated me then were the mummies themselves, the thrilling, gruesome thought of the dead bodies. Today, when I cross the Great Court or climb the front steps, I still see groups of excited children heading for the Egyptian galleries to brave the terror and the mystery of the mummies. Now I am much more interested in the mummy cases and, although this one is by no means the oldest object in the Museum, it seems a good place to begin this history through objects. Our chronological story begins in Chapter Two, with the earliest objects that we know were intentionally made by humans just under two million years ago, so it may seem slightly perverse to begin some way into the story. But I start here because mummies and their cases remain some of the Museum's most potent artefacts and demonstrate some of the ways in which this history will ask – and occasionally answer – different kinds of questions about objects. I've chosen this particular mummy case – made in around 240 BC for a high-ranking Egyptian priest called Hornedjitef, and one of the most impressive in the Museum – because it is still, remarkably, yielding new information and sending us messages through time.

If we come back to a museum that we visited as a child, most of us have the sense that we have changed enormously while the things have remained serenely the same. But they haven't: thanks to continuing research and new scientific techniques, what we know about them is constantly growing. The mummy of Hornedjitef is housed in a massive

black outer coffin in the shape of a human body, an elaborately decorated inner case, and then the mummy itself, carefully embalmed and wrapped up with amulets and talismans. Everything we know about Hornedjitef we know from this group of objects. In a sense, he is his own document, and one that continues to give up its secrets.

Hornedjitef arrived at the Museum in 1835, ten years or so after the mummy was excavated. Egyptian hieroglyphic script had just been deciphered, so the first step was to read all the inscriptions on his coffins, which told us who he was, what his job was, and something about his religious beliefs. We know Hornedjitef's name because it is written on his inner coffin, along with the fact that he was a priest in the Temple of Amun at Karnak during the reign of Ptolemy III – that is, between 246 and 222 BC.

The inner coffin has a fine gilded face – the gold indicates divine status, as Egyptian gods were said to have flesh of gold. Below the face is an image of the sun god as a winged scarab beetle, symbol of spontaneous life, flanked by baboons who worship the rising sun. Like all Egyptians, Hornedjitef believed that if his body was preserved he would live beyond death, but before reaching the afterlife he would have to undertake a hazardous journey for which he needed to prepare with the utmost care. So he took with him charms and spells for every eventuality. The underside of the lid of the coffin is decorated with inscriptions of spells, images showing gods, who act as protectors, and constellations of stars. Their position on the lid suggests the heavens stretched out above him, turning the whole coffin interior into a miniature cosmos: Hornedjitef has commissioned his own personal star map and time machine. Paradoxically, his meticulous preparation for the future now allows us to travel in the opposite direction, back to him and his world. And beside the numerous inscriptions, we can now begin to decipher the thing itself – the mummy, its case and the objects it contains.

Thanks to advances in scientific research, we can learn much more about Hornedjitef today than was possible in 1835. Especially in the last twenty years, there have been huge steps forward in ways of gathering information from objects without damaging them in the process. Scientific techniques allow us to fill in many gaps which the inscriptions don't touch on – the details of everyday life, how old people

Inside the lid of Hornedjitef's inner coffin

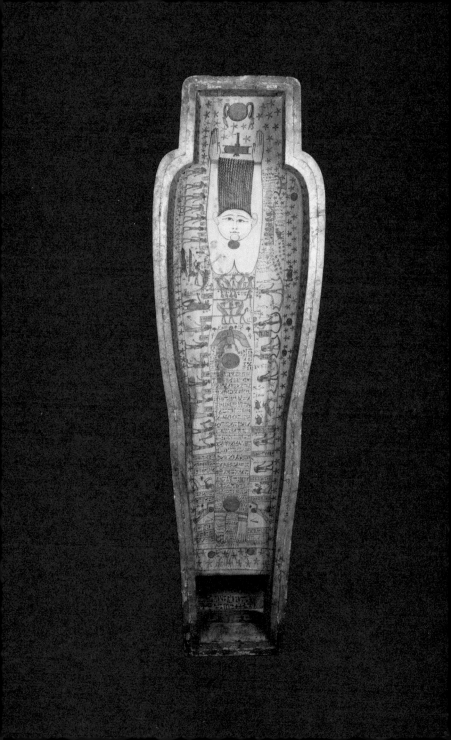

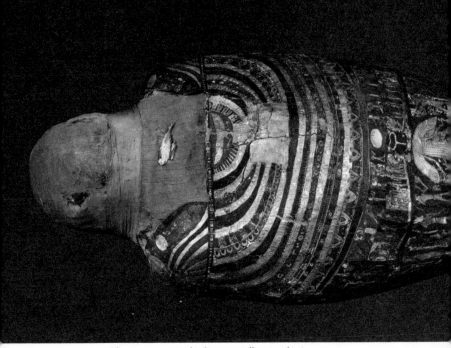

The mummy wrapped in linen, partially covered in its cartonnage

were, what kind of food they ate, the state of their health, how they died and also how they were mummified. For example, until recently we have never been able to investigate inside the linen wrappings of the mummy, because unwinding the wrappings risks damaging them and the body. But now, with CT scanning techniques that are used on living people, we are able to see beneath the surface of the linen to the objects wrapped inside the cloth and to the body beneath.

John Taylor, Curator of our Department of Ancient Egypt and Sudan, has been researching the mummies in the British Museum for more than two decades, and in recent years he has taken a few of them to London hospitals for special scans. These non-invasive, non-destructive examinations have yielded great insights:

> We can now say that Hornedjitef was middle aged to elderly when he died, and that he was mummified according to the best methods available at the time. We know that his internal organs were taken out, carefully packaged up and then put back inside him; we can see them there,

deep inside. We can see that they've poured resins – expensive oils – into his body to preserve him, and we can also detect amulets, rings and jewellery and little charms placed on him beneath the wrappings, to protect him on his journey to the afterlife. If you unwrap a mummy it's a very destructive process, and the amulets, which are very small, can move out of place; the positioning of them was absolutely crucial to their magical function, and by scanning the mummy we see them all exactly in position in the same relationships to each other that they had when they were placed there thousands of years ago, so that is a huge gain in knowledge. We can also examine the teeth in great detail, establishing the wear and the dental disease that they suffered from; we can look at the bones, and have seen that Hornedjitef had arthritis in his back, which must have been very painful.

Recent scientific advances have allowed us to find out about a great deal more than Hornedjitef's bad back. Being able to read the words on his coffin tells us about his place in society and what that society believed about life after death, but the new techniques enable us to analyse the materials with which mummies were prepared and coffins made, which helps us understand how Egypt was economically connected to the world round about it. Mummies may for us be quintessentially Egyptian, but it turns out that it took far more than the resources of Egypt alone to make them.

By isolating and testing the materials involved in mummification we can compare their chemical make-up with substances found in different parts of the eastern Mediterranean and begin to reconstruct the trading networks that supplied materials to Egypt. For instance, some mummy cases have black, tarry bitumen on their surface, which it is possible, by chemical analysis, to track to its source – the Dead Sea, many hundreds of miles to the north, in an area not normally under direct Egyptian control. This bitumen must have been traded. Some coffins are made of expensive cedar wood, bought in large and costly quantities from the Lebanon; when we tally such luxury wood with the titles and rank of the people whose coffins are made of it, we begin to get a sense of the ancient Egyptian economic background. The range of coffin woods, local or imported, high or low cost, as well as the quality of the woodwork, the fittings and the level of artistry of the

paintings on coffins, all reflect social income and class. Putting individuals like Hornedjitef in these wider contexts, seeing them not just as single survivors from a distant past but as parts of a complete society, is helping us to write fuller histories of ancient Egypt than those which have been possible in the past.

Most of the material that Hornedjitef had with him in his coffin was designed to guide him through the great journey to the afterlife, and to help him overcome all foreseeable difficulties. The one thing his star-map certainly did not predict was that he would ultimately wind up in London, at the British Museum. Is that as it should be? Should Hornedjitef and his possessions be here at all? Questions like this come up frequently. Where do things from the past belong now? Where are they best shown? Should everything be exhibited where it was originally made? They are important, and I will return to them at various points in the book. I asked the Egyptian writer Ahdaf Soueif how she felt about seeing so many Egyptian antiquities so far from home, here in London:

> Ultimately it's probably no bad thing to have Egyptian obelisks and stones and statues sprinkled all over the world. It reminds us of ages of colonialism, yes, but it also reminds the world of our common heritage.

In the Museum, Hornedjitef's story, like that of all the other objects housed there, continues. Their journeys are not yet finished and neither is our research, which is carried out with colleagues all over the world and which contributes all the time to our shared and growing understanding of the global past – our common heritage.

2

Olduvai Stone Chopping Tool

Tool found in Olduvai Gorge, Tanzania
1.8–2 MILLION YEARS OLD

This chopping tool is one of the earliest things that humans ever consciously made, and holding it puts us directly in touch with those who made it. In this history of the world told through things, this chipped stone from Africa – from modern Tanzania – is where it all begins.

If, as I said in the introduction, one of the points of any museum is to allow us to travel through time, our understanding of just how much time there is to travel through has expanded dramatically since the British Museum first opened its doors, in 1759. At that point, most of the visitors would probably have agreed that the world had begun in 4004 BC, to be precise at nightfall preceding Sunday 23rd October that year. This astonishingly exact date had been calculated in 1650 by Archbishop Ussher of Armagh, who preached in Lincoln's Inn, close to the British Museum, and who carefully trawled the Bible totting up the lifespans of everyone descended from Adam and Eve, then combining that with other data to reach his date. But in the past couple of centuries, archaeologists, geologists and museum curators have steadily been pushing back the chronology of human history from Archbishop Ussher's 6,000 years to an almost unimaginable two million. So if the beginning of human time was not in the Garden of Eden in 4004 BC, when was it, and where? There were many suggestions, but no conclusive answers and certainly no reliable date until 1931, when a young archaeologist called Louis Leakey set off on a British Museum-sponsored expedition bound for Africa.

Leakey's goal was Olduvai Gorge, a deep cleft in the flat savannah of northern Tanzania, not far from the border with Kenya. It is part of the East African Rift Valley, a massive tear in the Earth's surface

9

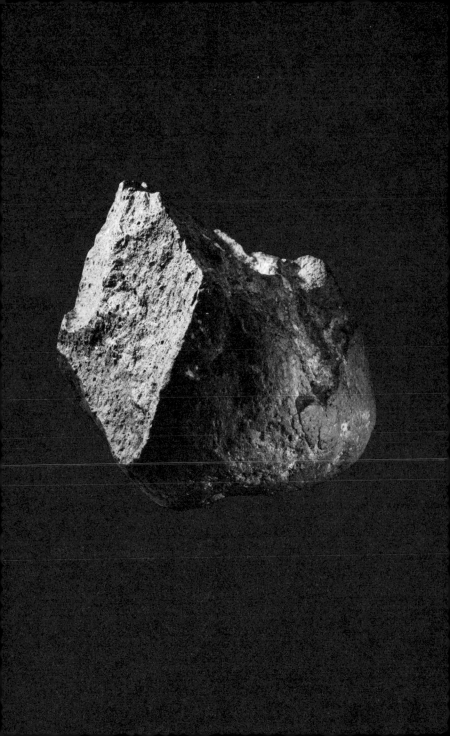

thousands of miles long. It was at Olduvai that Leakey examined exposed layers of rocks that act like a series of time capsules. As Leakey studied the rocks shaped by the sun, the wind and the rain on the savannahs, he reached a layer where the rocks were also shaped by something else – human hands. They were found next to bones, and it was clear that these stones had been shaped into butchering tools to strip meat and break into the bones of animals killed on the savannah. Geological evidence subsequently established beyond doubt that the layer where the tools were found was roughly two million years old. This was archaeological dynamite.

Leakey's excavations produced the oldest known humanly made things anywhere in the world at that time, and they demonstrated that not only human beings but also human culture had begun in Africa. This stone chopping tool was one of those that Leakey found. The great naturalist and broadcaster Sir David Attenborough expresses something of the excitement that Leakey must have felt:

> Holding this, I can feel what it was like to be out on the African savannahs, needing to cut flesh, for example, to cut into a carcass, in order to get a meal.
>
> Picking it up, your first reaction is it's very heavy, and if it's heavy of course it gives power behind your blow. The second is that it fits without any compromise into the palm of the hand, and in a position where there is a sharp edge running from my forefinger to my wrist. So I have in my hand now a sharp knife. And what is more, it's got a bulge on it so I can get a firm grip on the edge, which has been chipped specially and is sharp ... I could perfectly effectively cut meat with this. That's the sensation I have that links me with the man who actually laboriously chipped it once, twice, three times, four times, five times on one side and three times on the other ... so eight specific actions by him, knocking it with another stone to take off a flake, and to leave this almost straight line, which is a sharp edge.

We have recently made a new chopping tool using the techniques that would have been used in Olduvai Gorge. Holding the new one in my hand, it becomes very clear how well you can use it as an implement to strike meat off a carcass. I have tried using it on a bit of roast chicken. The chopping tool is quick and effective at stripping the meat off the bone, and then, with one blow, I can break the bone and get to the

marrow. But you could also use a tool like this to strip bark off trees or to peel roots, so that you could eat them as well. This is, in fact, a very versatile kitchen implement. Lots of animals, particularly apes, use objects; but what sets us apart from them is that we make tools before we need them, and once we have used them we keep them to use again. This chipped stone from Olduvai Gorge is the beginning of the tool-box.

The early humans who used chopping tools like this were probably not hunters themselves, but they were brilliant opportunists – they waited until lions, leopards or other beasts had killed their prey and then they moved in with their chopping tools, secured the meat and the marrow, and hit the protein jackpot. Marrow fat doesn't sound tremendously appetising, but it is hugely nutritious – fuel not just for physical strength but also for a large brain. The brain is an extremely power-hungry mechanism. Although it accounts for only 2 per cent of our body weight, it consumes 20 per cent of our entire energy intake, and it requires constant nourishment. Our ancestors of nearly two million years ago secured their future by giving it the food it needed to grow. When stronger, faster, fiercer predators had killed their prey and were at rest out of the heat, early humans were able to look for food. Using tools like this one to obtain bone marrow, the most nutritious part of a carcass, they set in train an ancient virtuous circle. This food for body and mind meant that the more cunning, larger-brained individuals would survive to breed larger-brained children, capable in their turn of making ever more complex tools. You and I are just the latest product of this continuing process.

The human brain carried on evolving over millions of years. One of the most important developments was that it started to become asymmetrical as it got to grips with a whole range of different functions – logic, language, the coordinated movement needed for tool-making, imagination and creative thought. The left and right hemispheres of the human brain have adapted to specialize in different skills and tasks – quite unlike the ape's brain, which remains not only smaller but symmetrical. This chopping tool represents the moment at which we became distinctly smarter, with an impulse not just to make things but to imagine how we could make things 'better'. As Sir David Attenborough says:

This object sits at the base of a process which has become almost obsessive among human beings. It is something created from a natural substance for a particular purpose, and in a particular way, with a notion in the maker's mind of what he needed it for. Is it more complex than was needed to actually serve the function which he used it for? I think you could almost say it is. Did he really need to do one, two, three, four, five chips on one side and three on the other? Could he have got away with two? I think he might have done so. I think the man or woman who held this made it just for that particular job and perhaps got some satisfaction from knowing that it was going to do it very effectively, very economically and very neatly. In time, you would say he'd done it beautifully, but maybe not yet. It was the start of a journey.

Those extra chips on the edge of the chopping tool tell us that right from the beginning, we – unlike other animals – have felt the urge to make things more sophisticated than they need to be. Objects carry powerful messages about their makers, and the chopping tool is the beginning of a relationship between humans and the things they create which is both a love affair and a dependency.

From the point where our ancestors started making tools like this, people have been unable to survive without the things they make; in this sense, it is making things that makes us human. Leakey's discoveries in the warm earth of the Rift Valley did more than push humans back in time: they made it clear that all of us descend from those African ancestors, that every one of us is part of a huge African diaspora – we all have Africa in our DNA and all our culture began there. Wangari Maathai, a Kenyan environmentalist and Nobel Peace Prize-winner, assesses the implications:

The information we have tells us that we came from somewhere in eastern Africa. Because we are so used to being divided along ethnic lines, along racial lines, and we look all the time for reasons to be different from each other, it must be surprising to some of us to realize that what differentiates us is usually very superficial, like the colour of our skin or the colour of our eyes or the texture of our hair, but that essentially we are all from the same stem, the same origin. So, I think that as we continue to understand ourselves and to appreciate each other – especially when we get to understand that we all come from the same

origin – we will shed a lot of the prejudices that we have harboured in the past.

Listening to the news on the radio, or watching it on television, it is easy to see the world as divided into rival tribes and competing civilizations. So it's good, in fact it's essential, to be reminded that the idea of our common humanity is not just an Enlightenment dream, but a genetic and cultural reality. It is something we'll see again and again in this book.

3
Olduvai Handaxe

Tool found in Olduvai Gorge, Tanzania
1.2–1.4 MILLION YEARS OLD

What do you take with you when you travel? Most of us would embark on a long list that begins with a toothbrush and ends with excess baggage. But for most of human history, there was only one thing that you really needed in order to travel – a stone handaxe. A handaxe was the Swiss Army knife of the Stone Age, an essential piece of technology with multiple uses. The pointed end could be used as a drill, while the long blades on either side would cut trees or meat or scrape bark or skins. It looks pretty straightforward, but in fact a handaxe is extremely tricky to make and, for more than a million years, it was literally the cutting edge of technology. It accompanied our ancestors through half of their history, enabling them to spread first across Africa and then across the world.

For a million years the sound of handaxes being made provided the percussion of everyday life. Anyone choosing a hundred objects to tell a history of the world would have to include a handaxe. And what makes this stone axe so interesting is how much it tells us, not just about the hand, but about the mind that made it.

The Olduvai Gorge handaxe doesn't, of course, look anything like a modern axe – there's no handle and there's no metal blade. It is a piece of volcanic rock, a very beautiful grey-green, in the shape of a teardrop. It's a lot more versatile than a modern straight axe. The stone has been chipped to give sharp edges along the long sides of the teardrop, and a sharp point at one end. When you hold it up against a human hand, you are struck by how closely the two shapes match, although this one is unusually large and is too big for a human hand to hold it comfortably. It has also been very beautifully worked,

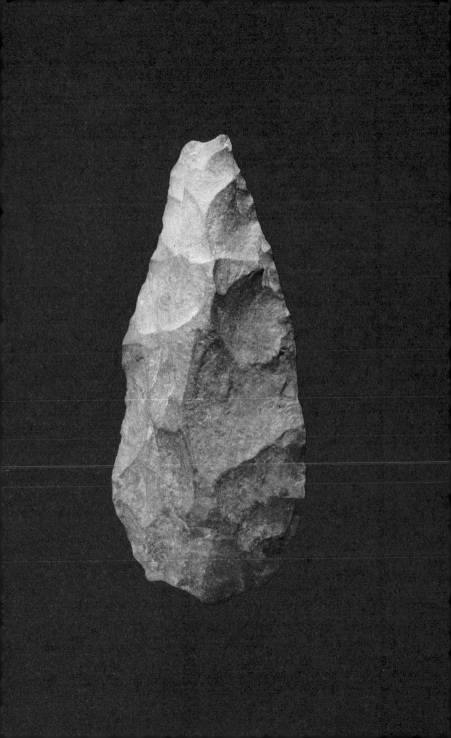

and you can see the marks of the chipping that have shaped it.

The very earliest tools, like the stone chopper we looked at in Chapter 2, strike us as pretty rudimentary. They look like chipped cobbles, and they were made by taking one large piece of stone and striking it with another, chipping off a few bits to make at least one sharp cutting edge. This handaxe is a very different matter. Simply watching a modern knapper at work shows just how many skills the maker of our handaxe must have possessed. Handaxes are not things you knock off: they are the result of experience, of careful planning and of skill, learnt and refined over a long period.

As important for our story as the great manual dexterity needed to make this chopper is the conceptual leap required – to be able to imagine in the rough lump of stone the shape that you want to make, in the way a sculptor today can see the statue waiting inside the block of stone.

This particular piece of supreme hi-tech stone is between 1.2 and 1.4 million years old. Like the chopping tool in Chapter 2, it was found in East Africa, at Olduvai Gorge, the great cleft in the savannah in Tanzania. But this comes from a higher geological layer than the chopping tool, which was made hundreds of thousands of years earlier, and there's a huge leap between those earliest stone tools and this handaxe. It's here that we find the real beginnings of modern humans. The person who made this we would have recognized as someone like us.

All the carefully focused and planned creativity required to make this axe implies an enormous advance in how our ancestors saw the world and how their brains worked. The handaxe may also contain the evidence of something even more remarkable: this chipped stone tool may hold the secret of speech, and it may have been in making things like this that we learnt how to talk to one another.

Recently, scientists have looked at what happens neurologically when a stone tool is being made. They have used modern hospital scanners to see which bits of the brain are activated as knappers work their stone. Surprisingly, the areas of the modern brain that you use when you're making a handaxe overlap considerably with those you use when you speak. It now seems very likely that if you can shape a stone you can shape a sentence.

Of course, we have no idea what the maker of our handaxe might have said, but it seems probable that he or she would have had roughly

the language abilities of a seven-year-old child. Whatever the level, this early speech would clearly have been the beginnings of a quite new capacity for communication – and that would have meant that people could sit down to exchange ideas, plan their work together or even just gossip. If they could make a decent handaxe like this one, and transmit the complex skills involved in the process, it is possible that they were well on the way to something we would all recognize as society.

So, 1.2 million years ago we could make tools, like our handaxe, that helped us control our environment and transform it – the handaxe gave us better food as well as the ability to skin animals for clothing and strip branches for fire or shelter. Not only this: we could now talk to each other and we could imagine something that wasn't physically in front of us. What next? The handaxe was about to accompany us on a huge journey; because with all these skills, we were no longer tied to our immediate environment. If we needed to – even if we just wanted to – we could move. Travel became possible, and we could move beyond the warm savannahs of Africa and survive, perhaps even flourish, in a colder climate. The handaxe became our ticket to the rest of the world, and in the study collections of the British Museum you can find handaxes from all over Africa – Nigeria, South Africa, Libya – but also from Israel and India, Spain and Korea ... even from a gravel pit near Heathrow Airport.

As they moved north out of Africa, some of these early handaxe-makers became the first Britons. The archaelogist and British Museum curator Nick Ashton elaborates:

At Happisburgh, in Norfolk, we have these thirty foot cliffs, composed of clays and silts and sands, and these were laid down by massive glaciation around 450,000 years ago. But it's beneath these clays that a local was walking his dog and found a hand axe embedded in these organic sediments. These tools were first being made in Africa 1.6 million years ago, arrived in southern Europe and parts of Asia just under a million years ago. Of course the coast then would've been several miles further out. And if you'd walked along that ancient coastline, you would have arrived in what nowadays we call the Netherlands, in the heart of Central Europe. At this time there was a major land bridge connecting Britain to mainland Europe. We don't really know why humans colonized Britain at this time, but perhaps it was due to the effectiveness of this new technology that we call the hand axe.

4

Swimming Reindeer

Sculpture carved from mammoth tusk,
found in Montastruc, France

11000 BC

Around 50,000 years ago something dramatic seems to have happened to the human brain. Across the world, humans started to create patterns that decorate and intrigue, to make jewellery to adorn the body, and to produce representations of the animals that shared their world. They were making objects that were less about physically changing the world than about exploring the order and the patterns that can be seen in it. In short, they were making art. The two reindeer represented on this piece of bone form the oldest artwork in any British gallery or museum. It was made during the end of the latest Ice Age, around 13,000 years ago. It is alarmingly delicate: we keep it in a climate-controlled case and hardly ever move it, because with any sudden shock it could just crumble to dust. It's a sculpture about 20 centimetres (8 inches) long, carved from the tusk of a mammoth – evidently from towards the end of the tusk, because it's slim and slightly curved. It was made by one of our ancestors who wanted to show his own world to himself, and in doing so he relayed that world with astonishing immediacy to us. It is a masterpiece of Ice Age art, and it's also evidence of a huge change in the way in which the human brain was working.

The stone tools we looked at previously raised the question of whether it is making things that makes us human. Could you conceive of being human without using objects to negotiate the world? I don't think I can. But there's another question that follows quite quickly once you start looking at these very ancient things. Why do all modern humans share the compulsion to make works of art? Why does man the tool-maker everywhere turn into man the artist?

The two reindeer in this artwork swim closely, one behind the other,

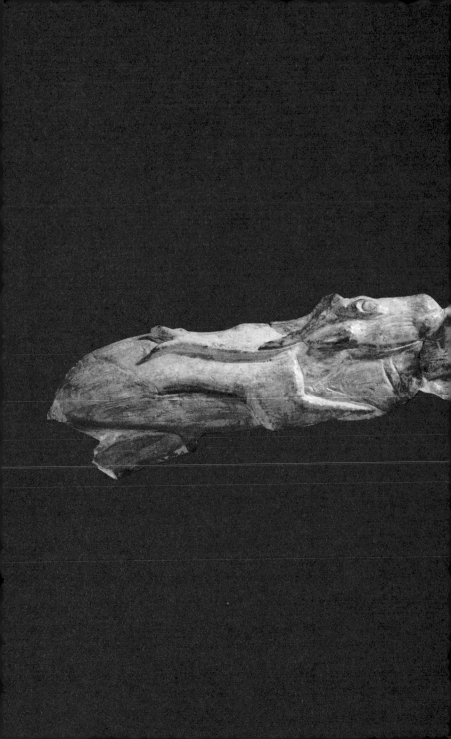

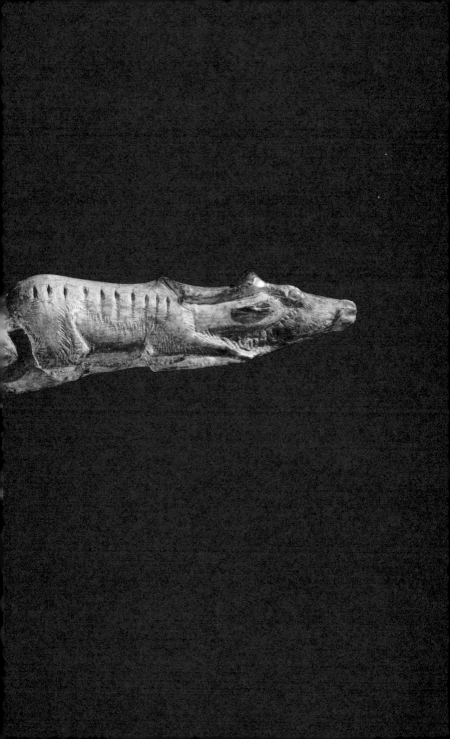

and in positioning them the sculptor has brilliantly exploited the tapering shape of the mammoth tusk. The smaller, female reindeer is in front with the very end of the tusk forming the tip of her nose; and behind her, in the fuller body of the tusk, comes the larger male. Because of the ivory's curve, both animals are shown with their chins up and their antlers tipped back, exactly as they would be when swimming, and along the undersides their legs are at full stretch, giving a marvellous impression of streamlined movement. It's a superbly observed piece – and it can only have been made by somebody who has spent a long time watching reindeer swimming across rivers.

So it's surely not merely through chance that it was found beside a river, in a rock shelter at Montastruc in France. This carving is a beautifully realistic representation of the reindeer which, 13,000 years ago, were roaming in great herds across Europe. The continent at this time was far colder than it is today; most of the landscape consisted of open, treeless plain, rather like the landscape of present-day Siberia. For human hunter-gatherers in this unforgiving terrain, reindeer were one of the most important means of survival. Their meat, skin, bones and antlers could supply pretty well all the food and clothing they needed, as well as the raw materials for tools and weapons. As long as they could hunt reindeer they would survive, and survive comfortably. So it's not surprising that our artist knew the animals very well, and that he chose to make an image of them.

The larger, male reindeer displays an impressive set of antlers, which run along almost the whole length of his back, and we can sex him quite confidently, as the artist has carved his genitals under his belly. The female has smaller antlers and four little bumps on her underside that look just like teats. But we can be even more specific than this: we're clearly looking at these animals in the autumn, at the time of rutting and the migration to winter pastures. Only in the autumn do both male and female have full sets of antlers and coats in such wonderful condition. On the female's chest the ribs and the sternum have been beautifully carved. This object was clearly made not just with the knowledge of a hunter but also with the insight of a butcher, someone who had not only looked at his animals, but had cut them up.

We know that this detailed naturalism was only one of the styles that Ice Age artists had at their disposal. In the British Museum there

is another sculpture found in that same cave at Montastruc. By a happy symmetry, that may not be coincidence: where our reindeer are carved on mammoth tusk, the other sculpture is of a mammoth carved on a reindeer antler. But the mammoth, although instantly recognizable, is drawn in a quite different way – simplified and schematized, somewhere between a caricature and an abstraction. This pairing is no one-off accident: Ice Age artists display a whole range of styles and techniques – abstract, naturalistic, even surreal – as well as using perspective and sophisticated composition. These are modern humans with modern human minds, just like our own. They still live by hunting and gathering, but they are interpreting their world through art. Professor Steven Mithen, of the University of Reading, characterizes the change:

> Something happened in the human brain, between say 50,000 and 100,000 years ago, that allowed this fantastic creativity, imagination, artistic ability, to emerge – it was probably that different parts of the brain became connected in a new way, and so could combine different

Mammoth carved from a reindeer antler about 12,500 years ago

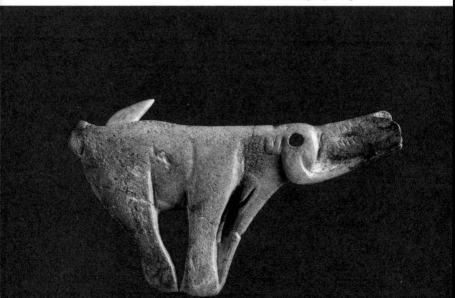

ways of thinking, including what people know about nature and what they know about making things. This gave them a new capacity to produce pieces of art. But Ice Age conditions were critical as well: it was a very challenging time for people living in harsh, long winters – the need to build up really intense social bonds, the need for ritual, the need for religion, all these related to this flowering of creative art at the time. Part of the art is an overwhelming sense of delight and appreciation and celebration of the natural world.

It is an appreciation not just of the animal world – these people know how to make the most of the rocks and minerals. This little sculpture is the result of four separate stone technologies. First, the tip of the tusk was severed with a chopping tool; then the contours of the animals were whittled with a stone knife and scraper. Then the whole thing was polished using a powdered iron oxide mixed with water, probably buffed up with a chamois leather, and finally the markings on the bodies and the details of the eyes were carefully incised with a stone engraving tool. In execution as well as in conception, this is a very complex work of art. It shows all the qualities of precise observation and skilled execution that you would look for in any great artist.

Why would you go to such trouble to make an object with no practical purpose? Dr Rowan Williams, the Archbishop of Canterbury, sees a deep meaning in all this:

> You can feel that somebody's making this who was projecting themselves with huge imaginative generosity into the world around, and saw and felt in their bones that rhythm. In the art of this period you see human beings trying to enter fully into the flow of life, so that they become part of the whole process of animal life that's going on around them, in a way which isn't just about managing the animal world, or guaranteeing them success in hunting. I think it's more than that. It's really a desire to get inside and almost to be at home in the world at a deeper level, and that's actually a very religious impulse, to be at home in the world. We sometimes tend to identify religion with not being at home in the world, as if the real stuff were elsewhere in Heaven; and yet if you look at religious origins, at a lot of the mainstream themes in the great world religions, it's the other way round – it's how to live here and now and how to be part of that flow of life.

This carving of the two swimming reindeer had no practical function, only form. Was it an image made just for its beauty? Or does it have a different purpose? By representing something, by making a picture or a sculpture of it, you give it life by a kind of magical power, and you assert your relation to it in a world that you're able not just to experience, but to imagine.

It may be that much of the art made around the world at the time of the latest Ice Age did indeed have a religious dimension, although we can now only guess at any ritual use. But this art sits in a tradition still very much alive today, an evolving religious consciousness that shapes many human societies. Objects like this sculpture of swimming reindeer take us into the minds and imaginations of people far removed from us, but very like us – into a world that they could not see but that they immediately understood.

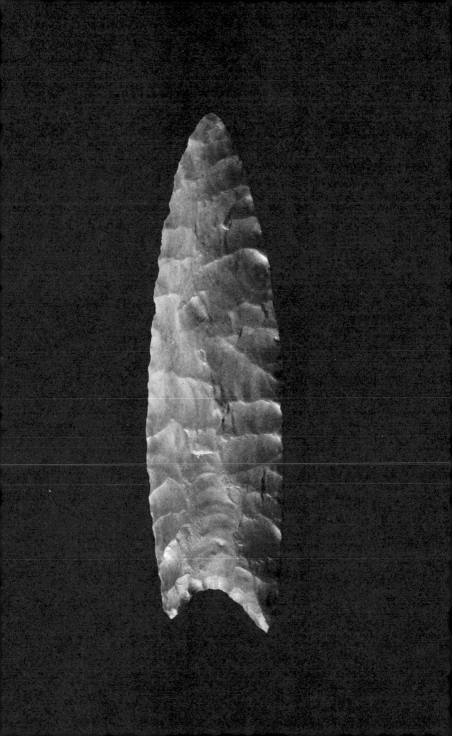

5

Clovis Spear Point

Stone spearhead, found in Arizona, USA

11000 BC

Imagine. You're in a green landscape studded with trees and bushes. You're working in a team of hunters quietly stalking a herd of mammoths. One of the mammoths, you hope, is going to be your supper. You're clutching a light spear with a sharp, pointed stone at the end of it. You get closer – you hurl your spear – and it misses. The mammoth you wanted to kill snaps the shaft under its foot. That spear is useless now. You take another one and move on – and you leave behind on the ground something that's not just a killing tool that failed, but an object that's going to become a message across time. Thousands of years after the mammoth trod on your spear, later humans will find that pointed stone spearhead and know you were here.

Things that are thrown away or lost tell us as much about the past as many of those carefully preserved for posterity. Mundane everyday items, discarded long ago as rubbish, can tell some of the most important stories of all in human history – in this case, how modern humans took over the world, and how, after populating Africa, Asia, Australia and Europe, they finally got to America.

This small object is the business end of a deadly weapon. It's made of stone and it was lost by a person like us, a modern human being, in Arizona more than 13,000 years ago. It sits in the North American gallery of the British Museum, among the magnificent feather head-dresses, in a case beside the totem poles. The spearhead is made of flint; it's about the size of a small, slim mobile phone, but in the shape of a long thin leaf. The point is still intact and still very sharp. The surface of both sides has beautiful ripples. When you look closely, you can see that these are the scars from its manufacture, where the flakes

of the flint have been carefully chipped off. It's a lovely thing to touch and stroke, and it's very well adapted to its lethal purpose.

Perhaps the most surprising fact about this spearhead is that it was found in America. Modern humans originated in Africa, and for most of our history we were confined to Africa, Asia and Europe, all connected by land. How did the people who made spears like this get to America, and who were they?

Spearheads like this are by no means rare; it is just one of thousands that have been found across North America and that are the firmest evidence yet of the first human beings to inhabit the continent. They're known as Clovis points, after the small town in the US state of New Mexico where they were first discovered in 1936, alongside the bones of the animals they had killed. So the makers of these stone points, the people who hunted with them, are known as Clovis people.

The discovery at Clovis was one of the most dramatic leaps forward in our understanding of the history of the Americas. Almost identical Clovis points have been found in clusters from Alaska to Mexico, and from California to Florida. They show that these people were able to establish small communities right across this immense area as the most recent Ice Age was coming to an end, about 13,000 years ago.

Were the Clovis people the first Americans? A leading expert in this period, Professor Gary Haynes, makes the case:

> There's some scattered evidence that people were in North America maybe before these Clovis points were made, but most of that evidence is arguable. Clovis look like the first people. If you dig an archaeological site almost anywhere in North America, the bottom levels are about 13,000 years old, and if there are any artefacts, they will be Clovis or Clovis-related. So it looks like these were the very first dispersers, who filled up the continent and became the ancestors of modern Native Americans, populating just about all of North America, and they came from somewhere up north, because the studies of genetics seem to prove that the ancestry of Native Americans is north-east Asian.

So archaeology, DNA and the bulk of academic opinion tell us that the original population of America arrived in Alaska from north-east Asia less than 15,000 years ago.

By about 40,000 years ago, humans like ourselves had spread from

Africa all over Asia and Europe, even crossing seas to get to Australia. But no humans had yet set foot in the Americas. They got their chance thanks to major changes in climate. First, about 20,000 years ago, an intensification of the Ice Age locked up a great deal of water in ice-sheets and glaciers, leading to a huge fall in sea level. The sea between Russia and Alaska (the Bering Strait) became a wide and easily passable land bridge. Animals – bison and reindeer among them – moved across to the American side, and the humans hunting them followed.

The way further south into the rest of America was through an ice-free corridor between the Rocky Mountains on the Pacific side and the vast continental ice-sheet covering Canada on the other. As the climate warmed up 15,000 years ago, it was possible for large numbers of animals, followed again by their human hunters, to get through this corridor to the rich hunting grounds across what is now the United States. This was the new American world of the Clovis points. It was clearly a great environment for those go-getting humans from north Asia, but if you were a mammoth the outlook wasn't quite so rosy. The ripples on the side of the Clovis point, which I find so beautiful, produce intense bleeding in any animal they hit, so you don't need to be a dead shot and strike a vital organ; you can hit your prey anywhere and the blood loss will gradually weaken it until you can easily finish it off. And by 10,000 BC, all the mammoths, and a lot of other big mammals, had indeed been finished off. Gary Haynes lays the blame at the door of the Clovis people:

> There's a direct connection between the first appearance of people and the last appearance of many, if not all, of the large mammals in North America. You can trace this sort of connection across the world, wherever modern *Homo sapiens* turns up. It's almost invariable that large mammals disappeared – and not just some animals but a large proportion, in North America something like two thirds to three quarters.

By around 12,000 years ago, the Clovis people and their descendants had not only spread across North America, but had also reached the southernmost tip of South America. Not long after this, warming climate and melting ice raised sea levels sharply so that the land bridge that had brought humans from Asia flooded once again. There was no way back. For the next 10,000 years or so, until the onset of sustained

European contact in the sixteenth century AD, the civilizations of the Americas would develop on their own.

So about 12,000 years ago we had reached a key moment in human history. With the exception of the islands of the Pacific, human beings had settled the whole habitable world, including Australia. We seem to be hard-wired to keep moving, always wanting to find out what's beyond the next hill. Why? The broadcaster and traveller Michael Palin has covered a good deal of the globe – what does he think drives us on?

> I've always been very restless and, from when I was very small, interested in where I wasn't, in what was over the horizon, in what was round the next corner. And the more you look at the history of *Homo sapiens*, it's all about movement, right from the very first time they decided to leave Africa. It is this restlessness which seems a very significant factor in the way the planet was settled by humans. It does seem that we are not settled. We think we are, but we are still looking for somewhere else where something is better – where it's warmer, it's more pleasant. Maybe there is an element, a spiritual element, of hope in this – that you are going to find somewhere that is wonderful. It's the search for paradise, the search for the perfect land – maybe that's at the bottom of it all, all the time.

Hope as the defining human quality – an encouraging thought. What stands out for me in our journey so far of nearly two million years is the constant human striving to do things better, to make tools that are not only more efficient but also more beautiful, to explore not just environments but ideas, to struggle towards something not yet experienced. The objects I've described have tracked that move – from tools for survival not so different from what other animals might use, to a great work of art and the possible beginnings of religion. My next chapters examine how we began to transform the natural world by starting to farm. In the process, we changed not just the landscape, but plants, animals and, above all, ourselves.

After the Ice Age: Food and Sex

9000–3500 BC

The development of farming occurred independently in at least seven different parts of the world at the end of the last Ice Age 10,000 years ago. This slow revolution took many centuries and had profound implications. Tending crops and domesticating animals meant that humans had for the first time to settle in one place. Farming created a food surplus that allowed larger groups of people to live together and changed not just how they lived but how they thought. New gods were developed to explain animal behaviour and the seasonal cycles of crops.

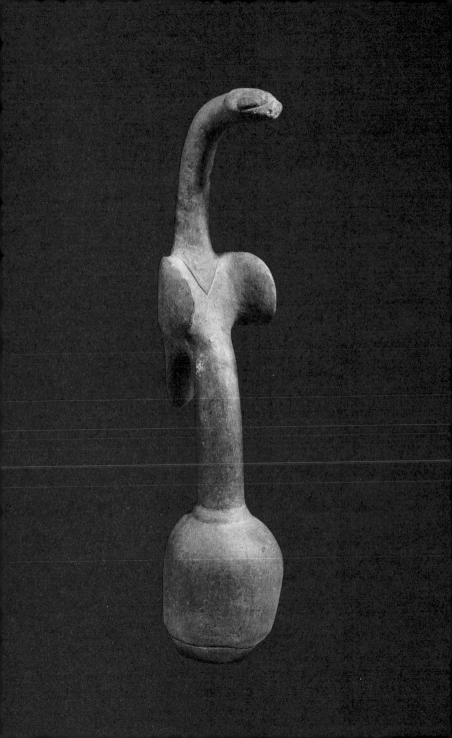

6

Bird-shaped Pestle

Stone pestle, found by the Aikora River,
Oro Province, Papua New Guinea
6000–2000 BC

Next time you are at the salad bar in a restaurant, look closely at the choice of vegetables on offer. It probably includes potato salad, rice, sweetcorn and kidney beans, all of which come originally from widely different parts of the world; nothing unusual about that nowadays, but none of them would exist in the nutritious form they do today if the plants they come from hadn't over generations been chosen, cherished and profoundly modified by our ancestors. The history of our most modern cereals and vegetables begins about 10,000 years ago.

Previously, I have looked at how our ancestors moved around the world; now I'm going to be focusing on what happened when they settled down. It was a time of newly domesticated animals, powerful gods, dangerous weather, good sex and even better food.

Around 11,000 years ago the world underwent a period of swift climate change, leading to the end of the most recent Ice Age. Temperatures increased and sea levels rose rapidly by about a hundred metres (more than 300 feet), as ice turned to water and snow gave way to grass. The consequences were slow but profound changes in the way that humans lived.

Ten thousand years ago, the sound of daily life began to change across the world, as new rhythms of grinding and pounding heralded the preparation of new foods that were going to alter our diets and our landscapes. For a long time, our ancestors had used fire to roast meat; but now they were cooking, in a way that is more familiar to us today.

There's an enormous range of objects in the British Museum that I could have chosen to illustrate this particular moment in human

history, when people started putting down roots and cultivating plants that would feed them all year round. The beginning of this sort of farming seems to have happened in many different places at more or less the same time. Archaeologists recently discovered that one of those places was Papua New Guinea, the huge island just to the north of Australia, where this bird-shaped stone pestle comes from. We think it's about 8,000 years old, and a pestle then would have been used exactly as it is now – to grind food in a mortar and break it down, so that it can be made edible. It's a big pestle, about 35 centimetres tall (just over a foot). The grinding part, at the bottom, is a stone bulb, about the size of a cricket ball; it's visibly worn and you can see that it's been much used. Above the bulb, the shaft is very easy to grasp, but the upper part of this handle has been carved in a way that's got nothing at all to do with making food – it looks like a slender, elongated bird with wings outstretched and a long neck dipping forward; indeed it looks a bit like Concorde.

It is a commonplace in every culture that preparing and sharing food unites us, either as a family or as a community. All societies mark key events with feasting, and a great deal of family memory and emotion is bound up in the pots and pans, the dishes and the wooden spoons of childhood. These sorts of associations must have been formed at the very beginning of cooking and its accompanying implements – so around 10,000 years ago, roughly the period of our pestle.

Our stone pestle is just one of many to have been found in Papua New Guinea, along with numerous mortars, showing that there were large numbers of farmers growing crops in the tropical forests and grasslands around this time. This relatively recent discovery has upset the conventional view that farming began in the Middle East, in the area from Syria to Iraq, often called the Fertile Crescent, and that from there it spread across the world. We now know that this was not the way it happened. Rather this particular chapter of the history of humanity occurred simultaneously in many different places. Wherever people were farming they began to concentrate on a small number of plants, selectively harvesting them from the wild, planting and tending them. In the Middle East, they chose particular grasses – early forms of wheat; in China, wild dry rice; in Africa, sorghum; and in Papua New Guinea, the starchy tuber, taro.

For me, the most surprising thing about these new plants is that in their natural state you very often can't eat them at all, or at least they taste pretty filthy if you do. Why would people choose to grow food that they can eat only once it's been soaked or boiled or ground to make it digestible? Martin Jones, Professor of Archaeological Science at Cambridge University, sees this as an essential strategy for survival:

> As the human species expanded across the globe, we had to compete with other animals going for the easy food. Where we couldn't compete, we had to go for the difficult food. We went for things like the small hard grass seeds we call cereals, which are indigestible if eaten raw and may even be poisonous, which we have to pulp up and turn into things like bread and dough. And we went into the poisonous giant tubers, like the yam and the taro, which also had to be leached, ground up and cooked before we could eat them. This was how we gained a competitive advantage – other animals that didn't have our kind of brain couldn't think several steps ahead to do that.

So it takes brains to get to cookery and exploit new sources of food. We don't know what gender the cooks were who used our pestle to grind taro in New Guinea, but we do know from archaeological evidence in the Middle East that cookery there was primarily a woman's activity. From examining burial sites of this period, scientists have discovered that the hips, ankles and knees of mature women are generally severely worn. The grinding of wheat then would have been done kneeling down, rocking back and forth to crush the kernels between two heavy stones. This arthritis-inducing activity must have been very tough, but the women of the Middle East and the new cooks everywhere were thereby cultivating a small range of nourishing basic foods that could sustain much larger groups of people than had been possible before. Most of these new foods were quite bland, but the pestle and mortar can also play a key part here in making them more interesting. The chef and food writer Madhur Jaffrey comments:

> If you take mustard seeds, which were known in ancient times, and leave them whole they have one taste, but if you crush them, they become pungent and bitter. You change the very nature of a seasoning by crushing it.

These new crops and seasonings helped create new kinds of communities. They could produce surpluses which could then be stored, exchanged or simply consumed in a great feast. Our pestle's long, thin elegant body looks far too delicate to have been able to withstand the vigorous daily pummelling of taro, so we should perhaps think of it more as a ritual, festive implement used to prepare special meals where people gathered, as we might do now, to trade, to dance or to celebrate key moments in life.

Today, while many of us travel freely, we depend on food grown by people who cannot move, who must stay on the same piece of land. This makes farmers across the world vulnerable to any change in climate, their prosperity dependent on regular, predictable weather. So it's not surprising that the farmers of 10,000 years ago, wherever they lived, formed a world view centred on gods of food and climate, who needed constant placation and prayer in order to ensure the continuing cycle of the seasons and safe, good harvests. Nowadays, at a time when climate is changing faster than at any time for the past 10,000 years, most people in search of solutions look not just to gods but to governments. Bob Geldof is a passionate campaigner in this new politics of food:

> The whole psychology of food, where it places us, is I think more important than almost any other aspect of our lives. Essentially, the necessity to work comes out of the necessity to eat, so the idea of food is fundamental in all human existence. It's clear that no animal can exist without being able to eat, but right now, at the beginning of the twenty-first century, it is clearly one of the top three priorities for the global powers to address. Upon their success or not will depend the future of huge sections of the world population. There are several factors, but the predominant one is climate change.

So another change in climate, like the one that around 10,000 years ago brought us agriculture in the first place, may now be threatening our survival as a global species.

7

Ain Sakhri Lovers Figurine

Stone sculpture, found at Wadi Khareitoun,
Judea, near Bethlehem

9000 BC

As the latest Ice Age came to an end, somebody picked a pebble out of a small river not far from Bethlehem. It's a pebble that must have tumbled downstream and been banged and smoothed against other stones as it went, in the process that geologists poetically describe as 'chattering'. But about 11,000 years ago, a human hand then shaped and chipped this beautifully chattered, rounded pebble into one of the most moving objects in the British Museum. It shows two naked people literally wrapped up in each other. It's the oldest known representation of a couple having sex.

In the Manuscripts Saloon at the British Museum, most people walk straight past the case that contains the carving of the lovers. Perhaps it's because from a distance it doesn't look like very much; it's a small, muted, greyish stone about the size of a clenched fist. But when you get nearer to it, you can see that it's a couple, seated, their arms and legs wrapped around each other in the closest of embraces. There are no clear facial features, but you can tell that these two people are looking into each other's eyes. I think it's one of the tenderest expressions of love that I know, comparable to the great kissing couples of Brancusi and Rodin.

At the time this pebble was shaped by human hands, human society was changing. As the climate warmed up across the world and people gradually shifted from hunting and gathering to a more settled way of life based on farming, our relationship to the natural world was transformed. From living as a minor part of a balanced ecosystem, we began trying to shape our environment, to control nature. In the Middle East the warmer weather brought a spread of rich grasslands. Until then

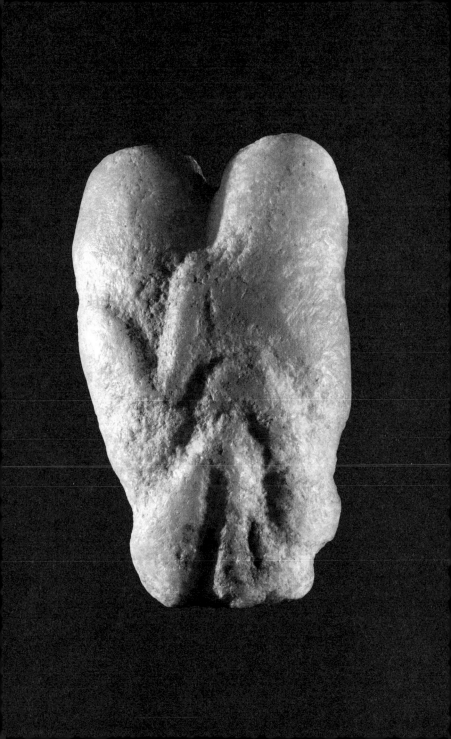

people had been moving around, hunting gazelle and gathering the seeds of lentils, chickpeas and wild grasses. But in the new, lusher savannah, gazelle were plentiful and tended to stay in one place throughout the year, so the humans settled down with them. Once they were settled, they started gathering grass grains that were still on the stalk, and, by collecting and sowing these seeds, they inadvertently carried out a very early kind of genetic engineering. Most wild grass seeds fall off the plant and are spread easily by the wind or eaten by birds, but these people selected seeds which stayed on the stalk – a very important characteristic if a grass is to be worth cultivating. They stripped these seeds, removed the husks and ground the grains to flour. Later, they would go on to sow the surplus seeds. Farming had begun – and for over 10,000 years we've been breaking and sharing bread.

These early farmers slowly created two of the world's great staple crops – wheat and barley. With this more stable life, our ancestors had time to reflect and to create. They made images that show and celebrate key elements in their changing universe: food and power, sex and love. The maker of the 'lovers' sculpture was one of these people. I asked the British sculptor Marc Quinn what he thought of it:

> We always imagine that we discovered sex, and that all other ages before us were rather prudish and simple, whereas in fact – obviously – human beings have been emotionally sophisticated since at least 10,000 BC, when this sculpture was made, and I'm sure just as sophisticated as us.
>
> What's incredible about this sculpture is that when you move it and look at it in different ways, it changes completely. From the side, you have the long shot of the embrace, you see the two figures. From another side it's a penis, from another a vagina, from another side breasts – it seems to be formally mimicking the act of making love as well as representing it. And those different sides unfold as you handle it, as you turn this object around in your hand, so they unfold in time, which I think is another important thing about the sculpture – it's not an instant thing. You walk round it and the object unfolds in real time. It's almost like in a pornographic film, you have long shots, close-ups – it has a cinematic quality as you turn it, you get all these different things. And yet it's a poignant, beautiful object about the relationship between people.

What do we know of the people captured in this lovers' embrace? The maker – or should we say the sculptor? – of the lovers belonged to a people that we now call the Natufians, who lived in a region that straddled what is today Israel, the Palestinian territories, Lebanon and Syria. Our sculpture came from south-east of Jerusalem. In 1933 the great archaeologist Abbé Henri Breuil and a French diplomat, René Neuville, visited a small museum in Bethlehem. Neuville wrote:

> Towards the end of our visit, I was shown a wooden casket containing various items from the surrounding areas, of which none, apart from this statuette, was of any value. I realized immediately the particular significance of the design involved and asked the source of these objects. I was told that they had been brought by a Bedouin who was returning from Bethlehem towards the Dead Sea.

Intrigued by the figure, Neuville wanted to know more about its discovery and sought out the Bedouin he had been told about. He managed to track down the man responsible for the find, who took him to the very cave – in the Judaean desert not far from Bethlehem – in which the sculpture had been discovered. It was called Ain Sakhri, and so these sculpted figures that had so captivated Neuville are still known as the Ain Sakhri lovers. Crucially, the sculpture had been found with objects which made it clear that the cave was a dwelling rather than a grave, and so our sculpture must have played some kind of role in domestic everyday life.

We don't know exactly what that role might have been, but we do know that this dwelling belonged to people who were living at the dawn of agriculture. Their new way of life involved the collecting and storing of food. The result was as profound a transformation for human beings as any revolution in history. This process of settling down did, of course, make them more vulnerable than hunters or nomads to crop failure, pests, diseases and, above all, to the weather; but while things were good, society boomed. A guaranteed abundant food source fuelled a sustained population explosion, and people began to live in large villages of between two and three hundred – the densest concentration of people the world had yet seen. When larders are stocked and the pressure is off, there is time to think, and these rapidly growing, settled communities had the leisure to work out new

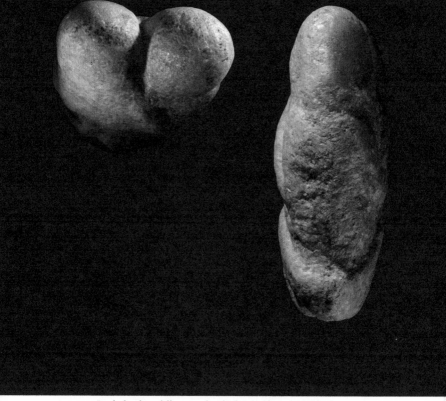

Looked at from different angles, the figurine changes completely

social relationships, to contemplate the changing pattern of their lives and to make art.

Our little sculpture of the entwined lovers may embody a key response to this new way of living – a different way of thinking about ourselves. In the depiction of the sexual act in this way and at this time, the archaeologist Ian Hodder, of Stanford University, sees evidence of a process he calls the 'domestication of the mind':

> The Natufian culture is really before fully domesticated plants and animals, but you already have a sedentary society. This particular object, because of its focus on humans and human sexuality in such a clear

way, is part of that general shift towards a greater concern with domesticating the mind, domesticating humans, domesticating human society, being more concerned with human relationships, rather than with the relationships between humans and wild animals, and the relationships between wild animals themselves.

As you hold the Ain Sakhri pebble and turn it round, it is striking not just that there are clearly two human figures rather than one, but that it's impossible, because of the way the stone has been carved, to say which is male and which is female. Could that generalized treatment, that ambiguity which forces the engagement of the viewer, have been a deliberate intention on the part of the maker? We just don't know, but we don't know either how this little statue would have been used. Some scholars think it might have been made for a fertility ritual, but Ian Hodder takes a different view:

> This object is one that could be read in many ways. At one time it would probably have been thought that these notions of sexual coupling, and sexuality itself, were linked to ideas of the mother goddess, because it's been assumed that the first farmers' main concern is the fertility of the crops. My own view is that the evidence doesn't really support this idea of a dominant mother goddess very early on, because there are now exciting new discoveries that really have no representations of women at all – most of the symbolism is very phallocentric – so my view at the moment is that sexuality is important in these early farming societies, but not in terms of reproduction/fertility, children and mothering and nurturing. It's really more clearly about the sex act itself.

To me, the tenderness of the embracing figures certainly suggests not reproductive vigour, but love. People were beginning to settle and to form more stable families, to have more food, and therefore more children, and perhaps this is the first moment in human history when a mate could become a husband or a wife.

All these ideas may be present in our sculpture of the lovers, but we're still largely in the realm of historical speculation. On another level, though, it speaks to us absolutely directly, not as a document of a changing society but as an eloquent work of art. From the Ain Sakhri lovers to Rodin's sculpture *The Kiss* there are 11,000 years of human history, but not, I think, much change in human desire.

8

Egyptian Clay Model of Cattle

Painted model, found at Abydos (near Luxor), Egypt
3500 BC

Mention excavation in Egypt, and most of us see ourselves entering Tutankhamun's tomb, discovering the hidden treasures of the pharaohs and at a stroke rewriting history. Aspiring archaeologists should be warned that this happens only very rarely. Most archaeology is a slow, dirty business, followed by an even slower recording of what has been found. And the tone of archaeological reports has a deliberate, academic, almost clerical dryness, far removed from the riotous swagger of Indiana Jones.

In 1900 a member of the Egypt Exploration Society excavated a grave in southern Egypt. He soberly labelled his discovery Grave A23 and noted the contents:

> Body, male. Baton of clay painted in red stripes, with imitation mace-head of clay. Small red pottery box, four-sided, 9 inches × 6 inches. Leg bones of small animal. Pots and stand of 4 clay cows.

The four horned cows stand side by side upon fertile land. They've been grazing on their simulated patch of grass for about five and a half thousand years. That makes them really ancient Egyptian, more ancient even than the pharaohs or the pyramids. These four little clay cows, hand-moulded out of a single lump of Nile river clay, are a long way from the glamour of the pharaohs, but you could argue that cows and what they represent have been far more important to human history. Babies have been reared on their milk, temples have been built to them, whole societies have been fed by them, economies have been built on them. Our world would have been a different and a duller place without the cow.

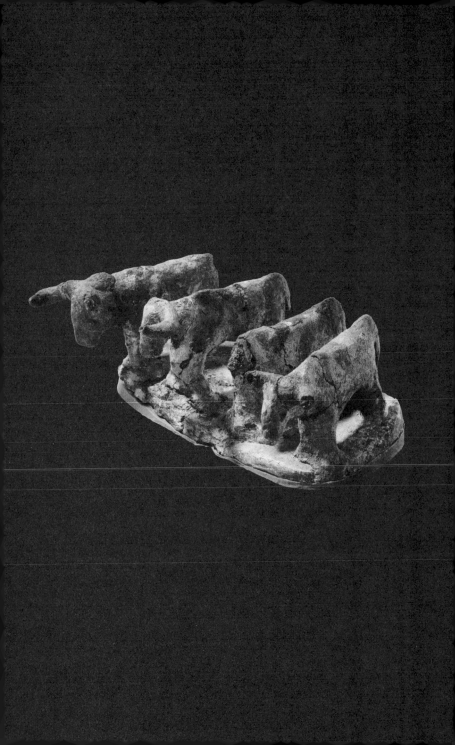

On these models you can still see faint traces of black and white paint applied after the clay had been lightly baked, making them like toy farm animals of the sort many of us played with as children. They stand only a few centimetres high, and the clay base that they share is roughly the size of a dinner plate. Like other objects we will encounter, the presence of these artefacts in Grave A23, where they were buried with a man in a cemetery near the small village of El Amra in southern Egypt, speaks of the consequences of climate change and human responses to it.

All of the objects found in this grave were intended to be useful in another world, and, in a way never imagined by the people who placed them there, they are. But they're useful for us, not for the dead. They allow us profound insights into remote societies, because the way of death casts light on the way of life of those people. They give us some idea not just of what people did but of what they thought and believed.

Most of what we know about early Egypt, before the time of the pharaohs and the hieroglyphs, is based on burial objects like these little cows. They come from a time when Egypt was populated only by small farming communities living along the Nile Valley. Compared to the spectacular gold artefacts and tomb ornaments of later Egypt, these little clay cows are modest. Funerals at that point were simpler; they didn't involve embalming or mummifying, a practice that wouldn't come for another thousand years.

The owner of our four clay cows would have been laid in an oval pit, in a crouched position and lying on a mat of rushes, facing the setting sun. And around him were his grave goods – items of value for his journey into the afterlife. Cow models like this one are quite common, so we can be quite confident that cows must have played a significant part in Egyptian daily life – such a significant part that they couldn't be left behind when the owner passed through death and on into the afterlife. How did this humble beast become so important to human beings?

The story begins more than 9,000 years ago, in the vast expanses of the Sahara. Then, instead of today's landscape of arid desert, the Sahara was a lush, open savannah with gazelles, giraffes, zebras, elephants and wild cattle roaming through it – happy hunting for humans.

But around 8,000 years ago the rains that nourished this landscape dried up. Without rain, the land began to turn into the desert that we know today, leaving people and animals to seek ever-dwindling sources of water. This dramatic change of environment meant that people had to find an alternative to hunting. Of all the different animals these humans had hunted, only one could be tamed: cattle.

Somehow they found a way to tame wild cattle. They no longer had to chase them down, one by one, for food; instead they learnt how to gather and manage herds, with which they travelled and from which they could live. Cows became almost literally the lifeblood of these new communities. The needs of fresh water and pasture for the cattle now determined the very rhythm of life, as both human and animal activity became ever more intertwined.

What role did these early Egyptian cattle play in this sort of society? What did they keep cows for? Professor Fekri Hassan has excavated and studied many of these early Egyptian graves, and the villages associated with them. He and his colleagues found remains of animal enclosures, as well as evidence for the consumption of cattle. They found the bones of these animals. And he concludes that these particular items, these four models of cattle, were probably produced a millennium or more after cattle were introduced into Egypt.

Study of the cattle bones shows the ages at which the animals were killed. Surprisingly, many of them were old, too old if they were being kept only for food. So unless the early Egyptians enjoyed tough steak, these were not in our sense beef cattle. They must have been kept alive for other reasons – perhaps to carry water or possessions on journeys. But it seems more likely they were tapped for blood, which, if it is drunk or added to vegetable stews, provides essential extra protein. This is something we find in many parts of the world, and it is still done today by the nomadic peoples in Kenya.

Our four cows may well therefore represent a walking blood-bank. We can rule out what seems at first sight the more obvious answer, that they were dairy cows, because for several reasons milk was unfortunately off the menu. Not only did these early domesticated cows produce very little milk but, more importantly for humans, getting nutrition by drinking cows' milk is an acquired skill. Martin Jones is an expert in the archaeology of food:

There is a range of other foods that our distant ancestors would not have eaten as readily as we do. Humans evolved the capacity to tolerate drinking milk as adults after cattle were domesticated, presumably because the ability to gain nutrients from cows' milk helped individuals to survive and to pass on that ability to their children. But even today a great number of modern peoples around the world can't tolerate drinking milk as adults.

So drinking cows' milk would probably have made these early Egyptians very ill, but over centuries their descendants and many other populations eventually adapted to it. It is a pattern repeated across the world: substances that are initially very hard for us to digest become, by slow adaptation, central to our diet. We are often told that we are what we eat; it might be truer to say that we are what our ancestors, with great difficulty, learnt to eat.

In early Egypt, cows were probably also kept as a kind of insurance policy. If crops were damaged by fire, communities could always fall back on the cow for nourishment as a last resort; perhaps not the best thing to eat, but always there. They were also socially and ceremonially significant, but, as Fekri Hassan explains, their importance went even deeper:

> Cattle have always had religious significance, both the bulls and the cows. In the desert a cow was the source of life, and we have many representations in rock art where we see cows with their calves in a more-or-less religious scene. We also see human female figurines, also modelled from clay, with raised arms as if they were horns. It seems that cattle were quite important in religious ideology.

The cattle from Grave A23 don't show any outward signs of being particularly special. On closer inspection, however, they don't look like the cows you find on the farm today, anywhere across Europe, North America or even modern Egypt. Their horns are strikingly different – they curve forwards and are much lower than those of any cows that we know.

All the cows alive in the world today descend from Asian stock. Our Egyptian model cows look different from the ones we know today because early Egyptian cows were descended from native African cattle, which have now become extinct.

Along the Nile Valley, the cow, a source of blood, meat, security and energy, eventually transformed human existence and became such a central part of Egyptian life that it was widely venerated. Whether actual cow worship started as early as the time of our little model is still a matter of debate, but in later Egyptian mythology the cow takes on a prominent role in religion, as the powerful cow-goddess Bat. She is typically shown with the face of a woman and the ears and horns of a cow. And the clearest sign of just how far cattle rose in status over the centuries is that Egyptian kings were subsequently honoured with the title 'Bull of his Mother'. The cow had come to be seen as the creator of the pharaohs.

9

Maya Maize God Statue

Stone statue, found in Copán, Honduras
AD 715

In the heart of the British Museum we have a god of maize. He's a bust, carved from limestone using a stone chisel and a basalt hammer, and the features are large and symmetrical, the eyes closed, the lips parted – as though this god is in communion with a different world, quietly meditating. The arms are bent, the palms of the hands face outwards – one raised, one lower – giving an impression of serene power. The head of the god is covered with an enormous headdress in the shape of a stylized corn cob, and his hair is like the silky strands that line a cob, inside the wrapping leaves.

Some archaeologists argue that food must always have had a divine role even for our earliest ancestors – just think of the cow-goddess of Egypt from the previous chapter, or Bacchus and Ceres in Classical mythology, or Annapurna, the Hindu goddess of food. But there's a particular time, after the end of the latest Ice Age, roughly between five and ten thousand years ago, when a range of new foods seems to have been accompanied by a range of new gods. As we saw in chapter 6, across the world, people began to identify particular plants that would provide them with food: in the Middle East it was wheat and barley, in China millet and rice, in Papua New Guinea taro, and in Africa sorghum. And as they did so, everywhere stories about gods emerged: gods of death and of rebirth, gods who would guarantee the cycle of the seasons and ensure the return of the crops, and gods who represent food itself, which were, or became, the food their devotees would eat. This bust is part of that worldwide process. He is a myth made material – a food god from Central America.

Originally the statue would have sat with many other similar gods

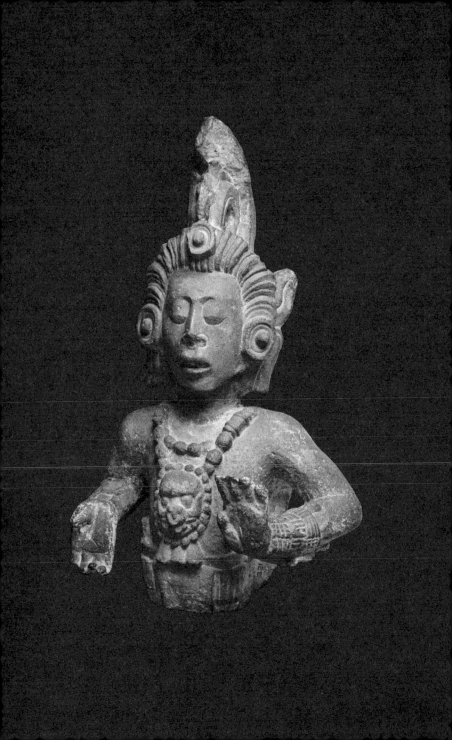

high up on a stepped pyramid temple in western Honduras. It was found in Copán, a major Mayan city and religious centre, whose monumental ruins can still be visited today. The temple's statues were commissioned by the Mayan ruler of the day to adorn a magnificent temple that he built at Copán around AD 700. Between the head and the body of this one you can very clearly see a join, and if you look carefully the head actually seems rather too big. When the temple in Copán was destroyed, all the statues fell. Heads and bodies were separated and had to be pieced together later, so this head may not have originally belonged with this body. But that does not affect the statue's meaning, for all these gods are about the central power and the pivotal role of maize in the lives of the local people.

Our statue of the maize god is comparatively new – he was made as late as AD 715 – but he comes as part of a very long tradition. Central Americans had been worshipping him and his predecessors for thousands of years, and his mythic story mirrors the annual planting and harvesting of the corn on which all Central American civilization depended. In the myth the maize god, like the maize plant, is decapitated at harvest time and is then reborn – fresh, young, and beautiful at the beginning of each new growing season. John Staller, an anthropologist and the author of *Histories of Maize*, explains why the maize god was so appealing for rich and powerful patrons, like the rulers who commissioned our sculpture:

> The elite in ancient societies focused on corn as having sacred kinds of properties which they then associated with themselves. This is pretty obvious in the young maize god – the sculpture was apparently a manifestation of mythological beings resulting from the third cycle of creation by the gods. There were eight mythological beings, four women and four men, who were believed to be the ancestors of all the Maya people. The Maya believed that their ancestors essentially came from corn, and they were formed of yellow and white maize dough. Maize was certainly a primary focus of ritual and religious veneration by ancient Meso-American people, going back all the way before the Maya and even into the Olmec civilization.

So our maize god is not just a hauntingly beautiful statue: he gives us a real insight into the way ancient American society thought about itself

and its environment. He represents both the fact of the agricultural cycle of planting, harvesting and replanting, and the faith in a parallel human cycle of birth, death and rebirth. But even more than this, he is the stuff of which the Central Americans are made. Where the Hebrew god made Adam out of dust, the Mayan gods used maize to make their humans. The mythical story is told in the most famous epic in the whole of the Americas, the Popol Vuh. For generations, this was passed on through oral traditions before finally being written down in the seventeenth century.

> And here is the beginning of the conception of humans and of the search for the ingredients of the human body ... So they spoke: the bearer, begetter, the makers, modellers – and a sovereign plumed serpent – they sought and discovered what was needed for human flesh. It was only a short while before the sun, moon and stars were to appear above the makers and modellers. Split place, bitter water place, is the name, the yellow corn, white corn, came from there. And this was when they found the staple foods, and then the yellow corn and white corn were ground. After that they put into words the making, the modelling of our first mother-father, with yellow corn, white corn alone for the flesh, food alone for the human legs and arms for our first fathers, the four human works.

Why did maize become the favoured food and the revered grain of the Americas rather than wheat or some kind of meat? The answer lies not in maize's divine connections, but in the environment that Central America offered. In that part of the world around 9,000 years ago, other food resources were very limited. There were no easily domesticated animals, such as the pigs, sheep or cattle you would find elsewhere in the world, and the staples were a trinity of plants that were slowly cultivated and tamed – squashes, beans and maize. But beans and squashes didn't become gods. Why did maize?

The plant from which maize derives, the teosinte, is wonderfully adaptable. It's able to grow in both the lush wet lowlands and the dry mountainous regions, which means that farmers can plant crops in any of their seasonal dwellings. Constant harvesting of the grain encourages the plants to grow larger and more abundantly, so maize can quickly become plentiful – farmers generally got a healthy return

on their invested labour. Crucially, maize is a rich carbohydrate that gives you a rapid energy hit. Unfortunately, it is also pretty stodgy, and so from very early on farmers cultivated an ingenious accompaniment – the indigenous chilli. It has very limited nutritional value, but it is uniquely able to liven up dull carbohydrates – and its development and widespread use across Central America is a resounding demonstration that we've been foodies for as long as we've been farmers.

By AD 1000, maize had spread north and south, virtually through the whole length of the Americas, which is perhaps surprising given that, in its earliest form, not only did maize have little taste, it was practically inedible. It couldn't just be boiled and eaten straight away as it is today. The easy digestibility of modern maize is thanks to the selective breeding of the crop by generations of farmers, each choosing seeds from the 'best' plant to cultivate for the next crop. But 9,000 years ago the maize cob was very hard, and eating it raw would have made you seriously ill. The raw kernel needed to be cooked in a mixture of water and white lime. Without this elaborate process, the two key nutrients in the cereal, the amino acids and vitamin B, would not be released. After that, it had to be ground into a paste and then made into an unleavened dough. The god of maize expected his disciples to work hard for their supper.

Even today, maize still dominates much of Mexican cuisine and carries a surprisingly powerful religious and metaphorical charge, as the restaurateur Santiago Calva knows only too well:

> The continuous spin-offs of maize into daily life are vast and complex. There will always at some stage be maize around, and it jumps any class barrier or identity. Everybody eats it and drinks it, from the richest to the poorest, from the most indigenous to the least indigenous, and that's one thing that unites us more than anything else.
>
> Maize culture faces two new problems, one being the use of maize as a bio-fuel, which has caused an increase in prices. That directly affects the Mexican population. The other problem concerns genetically modified maize. It's almost personally, and religiously, offensive that you are playing God. When you take corn to be used for purposes other than to be eaten or be worshipped, even to be put into a car, it becomes a highly controversial issue.

For some Mexicans it's unthinkable that maize, the divine food, should end up in a fuel tank. And far beyond Mexico the idea of genetic modification of crops also causes deep unease, often as much religious as scientific. The habit of seeing something divine in the crops that sustain us, formed all over the world around 10,000 years ago, is still stubbornly alive. Whatever may be the benefits of modifying plants to improve yield or to resist disease, many still have an uneasy sense that the natural order is being disturbed, that humans are trespassing on territory that's properly reserved for the gods.

IO

Jomon Pot

Clay vessel, found in Japan
5000 BC

I know that it's scientifically unrespectable, but it is sometimes nonetheless irresistible, to speculate how the great leaps forward in human object-making may have first occurred. So here is a very unscientific, very unrespectable guess about one of the biggest leaps of them all. Thousands of years ago, we can imagine that a lump of wet clay somehow ends up in a fire, dries out, hardens and forms a hollow shape; a shape that could hold things, in a tough, enduring material. By the time that the wet clay has hardened, a whole world of culinary possibilities, alcoholic delights and ceramic design has opened up. Mankind has made its first pot.

In the last few chapters, we have been looking at the way we now think humans began to domesticate animals and to cultivate plants. As a consequence, they started to eat new things and to live differently – in short, they settled down. It had long been assumed that pottery must have coincided with this shift to a more sedentary life. But we know now that, in fact, the earliest pottery was made around 16,500 years ago, in what most experts recognize as the Old Stone Age, when people were still moving about, hunting big-game animals. Nobody really expected to find pottery quite as early as that.

You'll find pots all around the world, and in museums all around the world. In the Enlightenment gallery of the British Museum there are lots of them – Greek vases with heroes squabbling on them, Ming bowls from China, full-bellied African storage jars and Wedgwood tureens. They are an essential part of any museum collection, for human history is told and written perhaps more in pots than in anything else. As Robert Browning put it: 'Time's wheel runs back or stops: Potter and clay endure.'

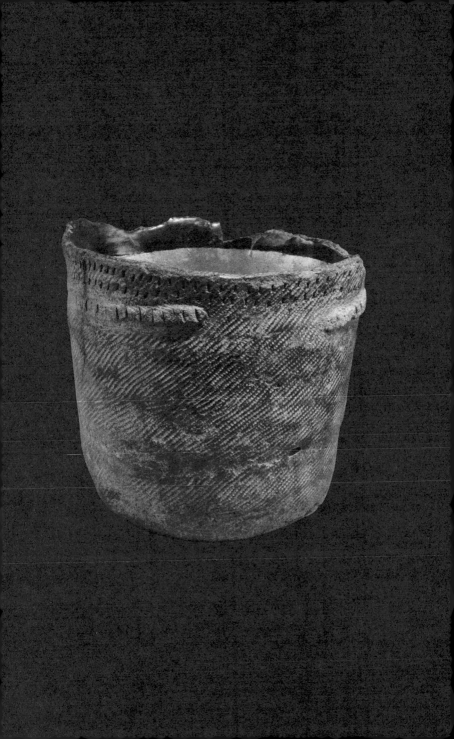

The world's first pots were made in Japan. This particular one, made there about 7,000 years ago in a tradition that even then was almost 10,000 years old, is initially quite dull to look at. It's a simple round pot about the shape and size of a bucket that children might play with on the beach. It is made of brown-grey clay and is about 15 centimetres (6 inches) high. When you look more closely, you can see that it was built up with coils of clay and then fibres were pressed into the outside, so that when you hold it you feel as though you are actually holding a basket. This small Jomon pot looks and feels like a basket in clay.

The basket-like markings on this and other Japanese ceramics of the same period are in a cord pattern. That's what the name 'Jomon' means in Japanese, but the word has come to be used not just for the pots but also for the people who made them, and even the whole historic period in which they lived. It was these Jomon people living in what is now northern Japan who created the world's first pots. Simon Kaner, of the University of East Anglia, a specialist in ancient Japanese culture, puts them in context:

> In Europe we've always assumed that people who've made pottery were farmers, and that it was only through farming that people were able to stay in one place, because they would be able to build up a surplus on which they could then subsist through the winter months, and it was only if you were going to stay in one place all the year round that you'd be making pottery, because it's an awkward thing to carry around with you. But the Japanese example is really interesting, because here we have pottery being made by people who were not farmers. It's some of the best evidence we have from prehistory anywhere in the world that people who subsisted on fishing, gathering nuts and other wild resources, and hunting wild animals also had a need for cooking pots.

The Jomon way of life seems to have been pretty comfortable. They lived near the sea and they relied on fish as a main source of food – food that came to them, so they did not have to move around as land-roaming hunter-gatherers did. They also had easy access to abundant plants with nuts and seeds, so there was no imperative to domesticate animals or to cultivate particular crops. Perhaps because of this plentiful supply of fish and food, farming took a long time to establish itself in Japan

compared to the rest of the world. Simple agriculture, in the form of rice cultivation, arrived in Japan only 2,500 years ago – very late, on the international scale; but in pots the Japanese were in the lead.

Before the invention of the pot, people stored their food in holes in the ground or in baskets. Both methods were vulnerable to insects and to all kinds of thieving creatures, and the baskets were also subject to wear and weather. Putting your food in sturdy clay containers kept freshness in and mice out. It was a great innovation. But in the shape and texture of the new pots the Jomon did not innovate: they looked at what they already had – baskets. And they decorated them magnificently. Professor Takashi Doi, Senior Archaeologist at the Agency for Cultural Affairs in Japan, describes the patterns they produced:

> The decorations were derived from what they saw around them in the natural world – trees, plants, shells, animal bones. The basic patterns were applied using twisted plant fibres or twisted cords, and there was an amazing variety in the ways you could twist your cords – there is an elaborate regional and chronological sequence that we have identified. Over the years of the Jomon period we can see over 400 local types or regional styles. You can pin down some of these styles to 25-year time slots, because they were so specific with their cord markings.

The Jomon clearly relished this elaborate aesthetic game, but they must also have been thrilled at the practical properties of their new leak-proof, heat-resistant kitchenware. Their menu would have included vegetables and nuts, but in their new pots they also cooked shellfish – oysters, cockles and clams. Meat too was pot-roasted or boiled – Japan appears to be the birthplace of the soup and the home of the stew. Simon Kaner explains how this style of cooking now helps us to date the material:

> We're quite lucky they weren't very good at washing up, these guys – and so they've left some carbonized remains of foodstuffs inside these pots, there are black deposits on the interior surfaces. In fact, some of the very early ones that are now dated to about 14,000 years ago – there are black incrustations, and it's that carbonized material that has been dated – we think they were probably used for cooking up some vegetable materials. Perhaps they were cooking up fish broths? And it's

possible they were cooking up nuts, using a wide range of nuts – including acorns – that you need to cook and boil for a long time before you can actually eat them.

This is an important point – pots change your diet. New foods become edible only once they can be boiled. Heating shellfish in liquid forces the shells to open, making it easier to get at the contents, but also, no less importantly, it sorts out which are good and which are bad – the bad ones stay closed. It's alarming to think of the trial and error involved in discovering which foods are edible, but it's a process that is greatly speeded up by cooking.

The Jomon hunter-gatherer way of life, enriched and transformed by the making of Jomon pottery, did not change significantly for more than 14,000 years. Although the oldest pots in the world were made in Japan, the technique did not spread from there. Like writing, pottery seems to have been invented in different places at different times right across the world. The first known pots from the Middle East and North Africa were made a few thousand years after the earliest Jomon pots, and in the Americas it was a few thousand years after that. But almost everywhere the invention of the pot was connected with new cuisines and a more varied menu.

Nowadays Jomon pots are used as cultural ambassadors for Japan in major exhibitions around the world. Most nations, when presenting themselves abroad, look back to imperial glories or invading armies. Remarkably, technological, economically powerful Japan proudly proclaims its identity in the creations of the early hunter-gatherers. As an outsider I find this very powerful, for the Jomon's meticulous attention to detail and patterning, the search for ever-greater aesthetic refinement and the long continuity of Jomon traditions seem already very Japanese.

But the story of our small Jomon pot doesn't end here, because I haven't yet described what is perhaps the most extraordinary thing of all about it – that the inside is carefully lined with lacquered gold leaf. One of the fascinating aspects of telling a history through objects is that they go on to have lives and destinies never dreamt of by those who made them – and that's certainly true of this pot. The gold leaf was applied somewhere between the seventeenth and nineteenth centuries,

when ancient pots were being discovered, collected and displayed by Japanese scholars. It was probably a wealthy collector who had the inside of the pot lacquered with a thin layer of gold. After 7,000 years of existence our Jomon pot then began a new life – as a *mizusashi*, or water jar, for that quintessentially Japanese ritual, the Tea Ceremony.

I don't think its maker would have minded.

PART THREE
The First Cities and States
4000–2000 BC

The world's first cities and states emerged in the river valleys of North Africa and Asia about 5,000 to 6,000 years ago. In what are today Iraq, Egypt, Pakistan and India, people came together to live for the first time in settlements larger than villages, and there is evidence of kings, rulers and great inequalities of wealth and power; at this time, too, writing first developed as a means of controlling growing populations. There are important differences between these early cities and states in the three regions: in Egypt and Iraq they were very warlike, in the Indus Valley apparently peaceable. In most of the world, people continued to live in small farming communities which were, however, often part of much larger networks of trade stretching across wide regions.

King Den's Sandal Label

Hippopotamus ivory label,
found at Abydos (near Luxor), Egypt
AROUND 2985 BC

There's a compelling, beguiling showbiz mythology of the modern big city – the energy and the abundance, the proximity to culture and power, the streets that just might be paved with gold. We've seen it and we've loved it, on stage and on screen. But we all know that in reality big cities are hard. They're noisy, potentially violent and alarmingly anonymous. We sometimes just can't cope with the sheer mass of people. And this, it seems, is not entirely surprising. Apparently, if you look at how many numbers we're likely to store in our mobile phone, or how many names we're likely to list on a social networking site, it's rare even for city dwellers to exceed a couple of hundred. Social anthropologists delightedly point out that this is the size of the social group we would have had to handle in a large Stone Age village. According to them, we're all trying to cope with modern big-city life equipped only with a Stone Age social brain. We all struggle with anonymity.

So how do you lead and control a city or a state where most people don't know each other, and you can interact personally with only a very small percentage of the inhabitants? It's been a problem for politicians for more than 5,000 years, ever since the groups we live in exceeded the size of a tribe or village. The world's first crowded cities and states grew up in fertile river valleys: the Euphrates, the Tigris and the Indus. This chapter's object is associated with the most famous river of them all, the Nile. It comes from the Egypt of the pharaohs, where the answer to the question of how to exert leadership and state control over a large population was quite simple: force.

If you want to investigate the Egypt of the pharaohs, the British

Museum gives you a spectacular range of choices – monumental sculptures, painted mummy cases, and much more – but I've chosen an object that came quite literally from the mud of the Nile. It's made from a tusk of a hippo, and it belonged to one of Egypt's first pharaohs – King Den. Perversely for an object that's going to let us explore power on a massive scale, it is tiny.

It is about 5 centimetres (2 inches) square, it's very thin, and it looks and feels a bit like a modern-day business card. In fact, it's a label that was once attached to a pair of shoes. We know this because on one side is a picture of those shoes. This little ivory plaque is a name tag for an Egyptian pharaoh, made to accompany him as he set off to the afterlife, a label which would identify him to those he met. Through it, we're immediately close to these first kings of Egypt – rulers, around 3000 BC, of a new kind of civilization that would produce some of the greatest monumental art and architecture ever made.

The nearest modern equivalent I can think of to this label is the ID card that people working in an office now have to wear round their necks to get past the security check – though it's not immediately clear who was meant to read these Egyptian labels, whether they're aimed at the gods of the afterlife or perhaps ghostly servants who might not know their way around. The images themselves are made by scratching into the ivory and then rubbing a black resin into the incisions, making a wonderful contrast between the black of the design and the cream of the ivory.

Before the first pharaohs, Egypt was a divided country, split between the east–west coastal strip of the Nile Delta, facing the Mediterranean, and the north–south string of settlements along the river itself. With the Nile flooding every year, harvests were plentiful, so there was enough food for a rapidly growing population and, frequently, surplus to trade with. But there was absolutely no extra fertile land beyond the flooding area, and as a result the ever more numerous people fought bitterly over the limited amount of land. Conflict followed conflict, with the people from the Delta eventually being conquered by the people from the south just before 3000 BC. This united Egypt was one of the earliest societies that we can think of as a state in the modern sense, and, as one of its earliest leaders, King Den had to address all

Engraved on the back of the label is a pair of sandals

the problems of control and coordination that a modern state has to confront today.

You might not expect to discover how he did this from the label on his shoes, but Den's sandals were no ordinary shoes. They were high-status items, and the Keeper of the Sandals was one of the high court officials. It's not so surprising, then, that on the back of the label we have a clear statement of how this pharaoh exercised power; nor, perhaps, that the model which evolved in Den's Egypt 5,000 years ago resonates uncannily around the world to this day.

On the other side of the label is an image of the owner of the sandals, dressed in a royal headdress with a mace in one hand and a whip in the other. King Den stands in combat, authoritatively smiting an enemy who cowers at his feet. Of course, the first thing we look for is his sandals but, disappointingly, he's barefoot.

This little label is the first image of a ruler in this history of humanity.

It's striking, perhaps a bit disheartening, that, right at the beginning, the ruler wants to be shown as commander-in-chief, conquering his foe. This is how, from earliest times, power has been projected through images, and there's something disturbingly familiar about it. In its simplified forms and its calculated manipulation of scale it is eerily reminiscent of a contemporary political cartoon.

The label-maker's job was, however, deadly serious: to keep his leader looking invincible and semi-divine, and to show that Den was the only man who could guarantee what Egyptians, like everybody else, wanted from their rulers – law and order. Within the pharaoh's realm, everybody was expected to conform and to take on a clear Egyptian identity. The message of our sandal label is that the price of opposition was high and painful.

This message is carried not only in the image but also in the writing. There are some early hieroglyphs scratched into the ivory which give us the name of King Den and, between him and the enemy, the chilling words 'they shall not exist'. This 'other' is going to be obliterated. All the tricks of savage political propaganda are already here – the ruler calm and victorious, set against the alien, defeated, misshapen enemy. Who he is we don't know, but on the right of the label is an inscription which reads: 'The first occasion of smiting the east'. As the sandy ground beneath the figures rises to the right-hand side, it has been suggested that the enemy comes from Sinai in the east.

The area that King Den's unified Egyptian state was able to coerce and control is staggering. At its height, it included virtually all the Nile Valley from the Delta to what is modern Sudan, as well as a huge area to the east up to the borders of Sinai. I asked the archaeologist Toby Wilkinson what building a state on this scale required:

> This is an early period in Egypt's history, when the nation is still being consolidated, not so much territorially as ideologically and psychologically. The king and his advisers are looking for ways to reinforce Egypt's sense of its own nationhood, and support for their regime. I think they realized, as world leaders have realized throughout history, that nothing binds a nation and a people together quite so effectively as a foreign war against a common enemy, whether that enemy is real or manufactured. And so warfare plays really a key role in the consolidation of the Egyptians' sense of their own nationhood.

It's a discouragingly familiar strategy. You win hearts and minds at home by focusing on the threats from abroad, but the weapons that you need to crush the enemy also come in handy when you're dealing with domestic opponents. The political rhetoric of foreign aggression is backed up by very brisk policing at home.

So the apparatus of the modern state had already been forged at the time of King Den, with enduring consequences which were artistic as well as political. Only power of this order could organize the enormous building projects that these early pharaohs embarked on. Den's elaborate tomb, with granite shipped from hundreds of miles away, and the later, even grander pyramids were possible only because of the extraordinary control which Egyptian pharaohs could exercise over the minds and the bodies of their subjects. Den's sandal label is a miniature masterclass in the enduring politics of power.

12

Standard of Ur

*Wooden box inlaid with mosaic, found at
the royal cemetery of Ur, southern Iraq*

2600–2400 BC

At the centre of pretty well all great cities, in the middle of the abundance and the wealth, the power and the busy-ness, you'll usually find a monument to death on a massive scale. It is the same in Paris, Washington, Berlin and London. In Whitehall, for example, just a few yards from Downing Street, the Treasury and the Ministry of Defence, the Cenotaph marks the death of millions in the great wars of the last century. Why is death at the heart of our cities? Perhaps one explanation is that in order to retain the wealth and power that our cities represent, we have to be willing to defend them from those who covet them. This object, from one of the oldest and richest cities of them all, seems to say quite clearly that the power of cities to get rich is indissolubly linked to the power to wage and win wars.

Cities started around 5,000 years ago, when some of the world's great river valleys witnessed rapid changes in human development. In just a few centuries fertile land, farmed successfully, became densely populated. On the Nile this hugely increased population led, as we have seen, to the creation of a unified Egyptian state. In Mesopotamia (modern Iraq), in the land between the rivers Tigris and Euphrates, the agricultural surplus, and the population that it could support, led to settlements of 30,000 to 40,000 people, a size never seen before, and to the first cities. Coordinating groups of people on this scale obviously required new systems of power and control, and the systems devised in Mesopotamia around 3000 BC have proved astonishingly resilient. They have pretty well set the urban model to this day. It's no

OVER: *Peace: the king and
companions feast while people
bring tribute of fish, animals
and other produce*

exaggeration to say that modern cities everywhere have Mesopotamia in their DNA.

Of all these earliest Mesopotamian cities, the most famous was the Sumerian city of Ur. So it's not surprising that it was at Ur that the great archaeologist Leonard Woolley chose to carry out his excavations in the 1920s. At Ur, Woolley found royal tombs which themselves could have been the stuff of fiction. There was a queen and the female attendants who died with her, dressed in gold ornaments; accompanying them were sumptuous headdresses; a lyre of gold and lapis lazuli; the world's earliest known board-game; and a mysterious object, which Woolley initially described as a plaque:

> In the farther chamber was a most remarkable thing, a plaque, originally of wood, 23 inches long and 7½ inches wide, covered on both sides with a mosaic in shell, red stone, and lapis; the wood had decayed, so that we have as yet little idea of what the scene is, but there are rows of human and animal figures, and when the plaque is cleaned and restored it should prove one of the best objects found in the cemetery.

This was one of Woolley's most intriguing finds. The 'plaque' was clearly a work of high art, but its greatest importance is not aesthetic: it lies in what it tells us about the exercise of power in these early Mesopotamian cities.

Woolley's find is about the size of a small briefcase, but it tapers at the top – so that it looks almost like a giant bar of Toblerone – and it's decorated all over with small mosaic scenes. Woolley called it the Standard of Ur, because he thought it might have been a battle standard that you carried high on a pole in a procession or into battle. It has kept that name, but it's hard to see how it could have been a standard of that sort, because it's obvious that the scenes are meant to be looked at from very close up. Some scholars have thought it might be a musical instrument or perhaps merely a box to keep precious things in, but we just don't know. I asked Dr Lamia al-Gailani, a leading Iraqi archaeologist who now works in London, what she thinks:

> Unfortunately, we don't know what they used it for, but for me, it represents the whole of the Sumerians. It's about war, it's about peace, it's colourful, it shows how far the Sumerians travelled – the lapis lazuli

came from Afghanistan, the red marble came from India, and all the shells came from the Gulf.

This is significant. So far, each of the objects we've looked at has been made in a single material – stone or wood, bone or pottery – all of them substances that would have been found close to where its maker was living. Now, for the first time, we have an object that is made of several different, quite exotic materials traded over long distances. Only the bitumen which held together the different pieces could have been found locally; it's a trace of what is now Mesopotamia's greatest source of wealth – oil.

What kind of society was it which was able to gather these materials in this way? First, it needed to have agricultural surplus. It then also needed a structure of power and control that allowed its leaders to mobilize that surplus and exchange it for exotic materials along extended trade routes. That surplus would also have fed and supported people freed from the constraints of agricultural work – priests, soldiers, administrators and, critically, craftsmen able to specialize in making complex luxury objects like the Standard. These are the very people that you can see on the Standard itself.

The scenes are arranged like three comic strips on top of each other. One side shows what must be any ruler's dream of how a tax system should operate. In the lower two registers, people calmly line up to offer their tribute of produce and fish, sheep, goats and oxen, and on the top register, the king and the elite, probably priests, feast on the proceeds while somebody plays the lyre. You could not have a clearer demonstration of how the structures of power work in Ur: the land workers shoulder their burdens and deliver offerings, while the elite drink with the king. To emphasize the king's pre-eminence – just as in the image of King Den – the artist has made him much bigger than anybody else, in fact so big that his head breaks through the border of the picture. In the Standard of Ur we are looking at a new model of how a society is organized. I asked a former Director of the London School of Economics, Professor Anthony Giddens, to describe this shift in social organization:

From having a surplus, you get the emergence of classes, because some people can live off the labour of others, which they couldn't do in tradi-

73 OVER: *War: the king reviews captured*
prisoners while chariots
trample the enemy

tional small agricultural communities where everybody worked. Then you get the emergence of a priestly warrior class, of organized warfare, of tribute and something like a state – which is really the creation of a new form of power. All those things hang together.

You can't have a division between rich and poor when everyone produces the same goods, so it's only when you get a surplus product which some people can live off and others have to produce, that you get a class system; and that soon emerges into a system of power and domination. You see the emergence of individuals who claim a divine right, and that integrates with the emergence of a cosmology. You have the origin of civilization there but it's bound up with blood, with dynamics, and with personal aggrandizement.

While one side of the Standard shows the ruler running a flourishing economy, the other side shows him with the army he needed to protect it. That brings me back to the thought that I began with: that it seems to be a continuous historical truth that once you get rich you then have to fight to stay rich. The king of the civil society that we see on one side has also to be the commander-in-chief we see on the other. The two faces of the Standard of Ur are in fact a superb early illustration of the military–economic nexus, of the ugly violence that frequently underlies prosperity.

Let's look at the war scenes in more detail. Once again, the king's head breaches the frame of the picture; he alone is shown wearing a full-length robe and he holds a large spear, while his men lead prisoners off either to their doom or to slavery. Victims and victors look surprisingly alike, because this is almost certainly a battle between close neighbours – in Mesopotamia neighbouring cities fought continually with each other for dominance. The losers are shown stripped naked to emphasize the humiliation of their defeat, and there is something heart-rending in their abject demeanour. In the bottom row are some of the oldest-known representations of chariots of war – indeed, of wheeled vehicles of any sort – and one of the first examples of what was to become a classic graphic device: the artist shows the asses pulling the chariots moving from a walk to a trot to a full gallop, gathering speed as they go. It's a technique that no artist would better until the arrival of film.

Woolley's discoveries at Ur in the 1920s coincided with the early years of the modern state of Iraq, created after the collapse of the Ottoman Empire at the end of the First World War. One of the key institutions of that new state was the Iraq Museum in Baghdad, which received the lion's share of the Ur excavations. From the first moment of their discovery, there was a strong connection between the antiquities of Ur and Iraqi national identity. So the looting of antiquities from the Baghdad Museum during the recent war in Iraq was felt very profoundly by all parts of the population. Here's Lamia al-Gailani again:

> For the Iraqis, we think of it as part of the oldest civilization – which is in our country and we are descendants of it. We identify with quite a lot of the objects from the Sumerian period that have survived until now ... so ancient history is really the unifying piece of Iraq today.

So Mesopotamia's past is a key part of Iraq's future. Archaeology and politics, like cities and warfare, seem set to remain closely connected.

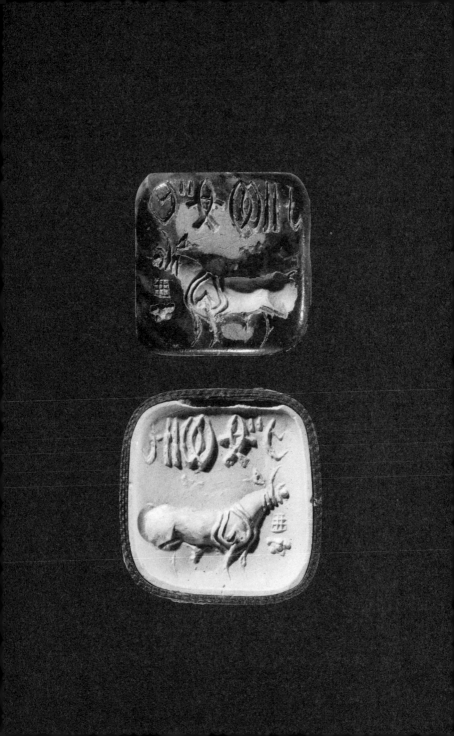

13

Indus Seal

Stone stamp, from Harappa,
the Indus Valley (Punjab) Pakistan
2500–2000 BC

In the last two objects we have seen the rise of the city and the state. But cities and states can also fall. I want to take you now not just to a city that was lost, but to an entire civilization that collapsed and then vanished from human memory for more than 3,500 years, largely due to climate change. Its rediscovery in Pakistan and north-west India was one of the great archaeological stories of the twentieth century; in the twenty-first we are still piecing the evidence together. This lost world was the civilization of the Indus Valley, and the story of its rediscovery begins with a small carved stone, used as a seal to stamp wet clay.

We have been exploring how the first cities and states grew up along the great rivers of the world, and how these new concentrations of people and of wealth were controlled. Around 5,000 years ago the Indus River flowed, as it still does today, down from the Tibetan Plateau into the Arabian Sea. The Indus civilization, which at its height encompassed nearly 200,000 square miles, grew up in the rich, fertile floodplains.

Excavations there have revealed plans of entire cities, as well as vigorous patterns of extensive international trade. Stone seals from the Indus Valley have been found as far afield as the Middle East and central Asia, but the seals in this chapter were found in the Indus Valley itself.

In the British Museum there is a small collection of stone seals, made to press into wax or clay in order to claim ownership, to sign a document or to mark a package. They were made between 2500 and 2000 BC. They are all approximately square, about the size of a modern

79

The seal mould (top) _and_
an impression from it

postage stamp, and they're made of soapstone, so they were easy to carve. And they have been beautifully carved, with wonderfully incised images of animals. There's an elephant, an ox, a kind of cross between a cow and a unicorn and, my favourite, a very skippy rhinoceros. In historical terms, the most important of them is, without question, the seal that shows a cow that looks a bit like a·unicorn; it was this seal that stimulated the discovery of the entire Indus civilization.

The seal itself was discovered in the 1850s, near the town of Harappa, in what was then British India, about 150 miles south of Lahore in modern Pakistan. Over the next fifty years three more seals like it arrived in the British Museum, but no one had any idea what they were, or when and where they'd been made. But in 1906 they caught the attention of the Director-General of the Archaeological Survey of India, John Marshall. He ordered the excavation of the ruins at Harappa, where the first seal had been found. What was discovered there led to the rewriting of world history.

Marshall's team found at Harappa the remains of an enormous city and went on to find many others nearby, all dating to between 3000 and 2000 BC. This took Indian civilization much further back in time than anyone had previously thought. It became clear that this was a land of sophisticated urban centres, trade and industry, and even writing. It must have ranked as a contemporary and an equal with ancient Egypt or Mesopotamia – and it had been totally forgotten.

The largest of the Indus Valley cities, such as Harappa and Mohenjodaro, had populations of 30,000 to 40,000 people. They were built on rigorous grid layouts, with carefully articulated housing plans and advanced sanitation systems that even incorporated home plumbing; they're a modern townplanner's dream. The architect Richard Rogers admires them greatly:

> When you are faced with a piece of ground where there are few limiting constraints, there are not many buildings and it's a sort of white piece of paper, the first thing you do is start putting a grid on it, because you want to own it and a grid is a way of owning it, a way of getting order. Architecture is really giving order, harmony, beauty, rhythm to space. You can see that in Harappa; that's exactly what they're doing. There's also an aesthetic element with it, which you can see from their sculpture

– they have an aesthetic consciousness, and they also have a conscious-
ness of order, and a consciousness of economy, and those things link us
straight over the 5,000 years to the things that we are doing today.

As we saw in Egypt and Mesopotamia, the leap from village to city
usually required one dominant ruler, able to coerce and deploy
resources. But just who ran these highly ordered Indus Valley cities
remains unclear. There is no evidence of kings or pharaohs – or indeed
of any leader at all. This is largely because, both literally and meta-
phorically, we don't know where the bodies are buried. There are none
of the rich burials which in Egypt or Mesopotamia tell us so much
about the powerful and about the society they controlled. We have to
conclude that the Indus Valley people probably cremated their dead,
and, while there may be many benefits in cremation, for archaeologists
it is, if I may use the phrase, a dead loss.

What's left of these great Indus cities gives us no indication of a
society engaged with, or threatened by, war. Not many weapons have
been found, and the cities show no signs of being fortified. There are
great communal buildings, but nothing that looks like a royal palace,
and there seems to be little difference between the homes of the rich
and the poor. It seems to be a quite different model of how to create an
urban civilization, without celebration of violence or extreme concen-
tration of individual power. Is it possible that these societies were
based not on coercion but on consensus?

We could find out more about the Indus civilization if only we could
read the writing on our seal, and others like it. Above the animal images
on the seals is a series of symbols: one looks like an oval shield; others
look like matchstick human figures; there are some single lines; and
there's a standing spear shape. But whether they are numbers, logos,
symbols – or even a language – we simply don't know. Since the early
1900s people have been trying to decipher them, nowadays of course
using computers, but we just do not have enough material – no longer
inscriptions, no bilingual texts – to make confident progress.

The seals are often pierced, so they may have been worn by their
owners, and they were probably used to stamp goods for trading –
they've been found in Iraq, Iran, Afghanistan and central Asia. Between
3000 and 2000 BC the Indus civilization was a vast network of

complex, organized cities with flourishing trade links to the world beyond, all apparently thriving. And then, around 1900 BC, it came to an end. The cities turned to mounds of earth, and even the memory of this, one of the great early urban cultures of the world, vanished. We can only hazard guesses as to why. The need for timber to fire the brick kilns of the huge building industry may have led to extensive deforestation and an environmental catastrophe. More importantly, climate change seems to have caused tributaries of the Indus to alter their course or to dry up completely.

When the ancient Indus civilization was initially unearthed, the entire subcontinent was under British rule, but its territory now straddles Pakistan and India. Professor Nayanjot Lahiri from Delhi University, a specialist on the Indus civilization, sums up its importance for both countries today:

In 1924, when the civilization was discovered, India was colonized. So to begin with there was a great sense of national pride and a sense that we were equal to if not better than our colonizers and, considering this, that the British should actually leave India. This is the exact sentiment that was expressed in the *Larkana Gazette* – Larkana is the district where Mohenjodaro is located.

After independence the newly created state of India was left with just one Indus site in Gujarat and a couple of other sites towards the north, so there was an urgency to discover more Indus sites in India. This has been among the big achievements of Indian archaeology post-independence – that hundreds of Indus sites today are known, not only in Gujarat but also in Rajasthan, in Punjab, in Haryana and even in Uttar Pradesh.

The great cities of Harappa and Mohenjodaro, which were first excavated, are in Pakistan, and subsequently one of the most important pieces of work on the Indus civilization was done by a Pakistan archaeologist – Rafique Mughal [presently a professor at Boston University], who discovered nearly 200 sites in Pakistan and Cholistan. But my own sense is that on the whole the state of Pakistan has been much more interested, not exclusively but significantly, in its Islamic heritage, so I think there is a greater interest in India as compared to Pakistan.

There is not a competition but a certain kind of poignant sentiment that I have when I think of India, Pakistan and the Indus civilization, for

no other reason than that the great remains – the artefacts, the pottery, the beads, etc., that were found at these sites – are divided between the two states. Some of the most important objects were actually divided right down the middle – like the famous girdle from Mohenjodaro. It's no longer one object, it's really two parts that have been sundered, like pre-independent India into India and Pakistan – these objects have met with a similar fate.

We need to know more about these great Indus cities, and our knowledge is still growing steadily, but of course the big breakthrough would come if we could read the signs on the seals. We just have to wait. In the meantime, the total disappearance of these great urban societies is an uncomfortable reminder of just how fragile our own city life – indeed our own civilization – is today.

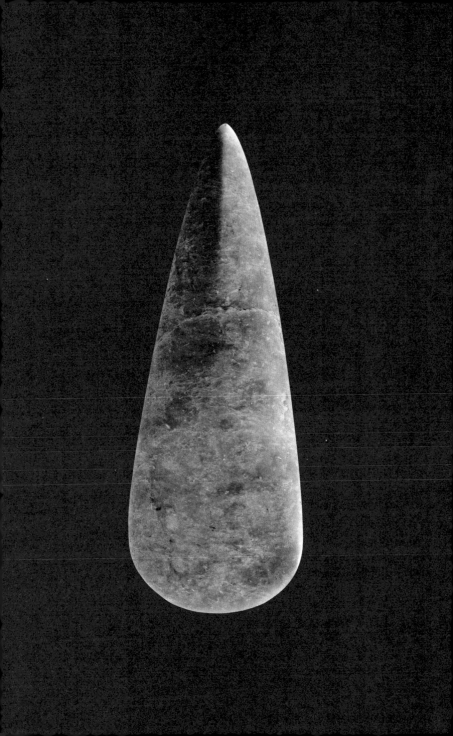

14

Jade Axe

Jade axe, found near Canterbury, England
4000–2000 BC

For most of history, to live in Britain has been to live at the edge of the world. But that doesn't mean that Britain was isolated.

We've explored how 5,000 years ago cities and states grew up along some of the great rivers of the world, in Egypt, Mesopotamia, Pakistan and India. Their styles of leadership and their architecture, their writing and the international trading networks, allowed them to acquire new skills and to exploit new materials. But in the world beyond these great river valleys, the story was different. From China to Britain, people continued to live in relatively small farming communities, with none of the problems or opportunities of the new large urban centres. What they did share with them was a taste for the expensive and the exotic. And, thanks to well-established trade routes, even in Britain, on the extreme outside edge of the Asian/European landmass, they had long been able to obtain what they wanted.

In Canterbury around 4000 BC a supreme object of desire was this polished jade axe. At first sight it looks like thousands of other stone axes in the British Museum collection, but it's thinner and wider than most of them. It still looks absolutely brand new – and it's very sharp. It's the shape of a teardrop, about 21 centimetres (8 inches) long and about 8 centimetres (3 inches) wide at the base. It's cool to the touch and extraordinarily, pleasingly smooth.

Axes occupy a special place in the human story, as we first glimpsed at the beginning of this book. The farming revolution in the Near East took generations to spread from there across the breadth of mainland Europe, but eventually, about 6,000 years ago, settlers reached British and Irish shores in skin-covered boats, bringing with them crop seeds

and domesticated animals. They found thick forests covering the land. It was stone axes that enabled them to clear the spaces they needed to sow their seeds and graze their beasts. With axes the settlers made for themselves a new wooden world: they felled timber and built fences and trackways, houses and boats. These were the people who would also construct monuments like the first Stonehenge. Stone axes were the revolutionary tool that enabled our ancestors to create in England a green and pleasant land.

Axes like this one normally have a haft – that is, they're fitted into a long wooden handle and they're used like a modern axe. But it's quite clear that our axe has never been hafted – in fact, it shows no signs of wear and tear at all. If I run my finger carefully round the blade end, I can't feel even the smallest chip. The long flat surfaces are remarkably smooth and still have a glossy, mirror-like sheen.

The conclusion is inescapable. Not only has our axe not been used – it was never intended to be used, but rather to be admired. Mark Edmonds, of York University, explains how this magnificent prestige object was made:

> If you have the good fortune to handle one of these axes – the feel in the hand, the balance, the weight, the smoothness – you can tell they have been polished to an extraordinary degree. To give that polish it will have been ground for hour upon hour against stone, then polished with fine sand or silt and water, and then rubbed backwards and forwards in the hand, perhaps with grease and leaves. That's days and days of work. It gives the edge a really sharp and resilient bite, but the polishing also emphasizes the shape, allows the control of form, and brings out that extraordinary green and black speckled quality to the stone – it makes it instantly recognizable, and visually very striking. Those things may be just as important for this particular axe as the cutting edge.

The most exciting thing about this axe head, however, is not how it has been made, but what it is made of. It doesn't have the usual grey-brown tones that you find in British stones and flints, but is a beautiful striking green. This axe is made from jade.

Jade is, of course, foreign to British soil – we tend to think of it as an exotic material from the Far East or from Central America; both the Chinese and the Central American civilizations are known to have

valued jade far more highly than gold. These sources are thousands of miles away from Britain, so archaeologists were baffled for many years by where the jade in Europe could have come from. But there are actually sources of jade in continental Europe and, only a few years ago, in 2003 – some 6,000 years after our axe head was made – the precise origin of the stone it was made from was discovered. This luxury object is in fact Italian.

Archaeologists Pierre and Anne-Marie Pétrequin spent twelve hard years surveying and exploring the mountain ranges of the Italian Alps and the northern Apennines. Finally they found the prehistoric jade quarries that our axe comes from. Pierre Pétrequin describes the adventure:

> We had worked in Papua New Guinea, and studied how the stone for the axe heads there comes from high in the mountains. This gave us the idea of going up very high in the Alps to try and find the sources of European jade. In the 1970s, many geologists had said that the axe-makers would just have used blocks of jade that had been carried down the mountains by rivers and glaciers. But that's not the case. By going much higher up, between 1,800 and 2,400 metres above sea level, we found the chipping floors and the actual source material – still with signs of its having been used.
>
> In some cases, the raw material exists as very large isolated blocks in the landscape. It's quite clear that these were exploited by setting fire against them, which would allow the craftsmen then to knock off large flakes and work them up. So the sign that's left on the stone is a slightly hollow area – a scar as it were – with a large number of chips beneath it.

The geological signature of any piece of jade can be precisely identified and matched. The Pétrequins found not only that the British Museum axe could be linked to the Italian Alps, but that the readings of the geological signatures are so accurate that the very boulder which the axe came from could be identified. No less extraordinary, Pierre Pétrequin was able to track down a geological sibling for our axe – another jade beauty found in Dorset:

> The Canterbury axe head was from the same block as one that was found in Dorset, and it's clear that people must have gone back to that

block at different times, it might be centuries apart, but because it's distinctive compositionally, it's now possible to say ... yes, that was the same block ... chips off the old block!

The boulder from which the British Museum axe was chipped 6,000 years ago still sits in a high landscape, sometimes above the clouds, with spectacular vistas stretching as far as the eye can see. The jade-seekers seem to have deliberately chosen this special spot – they could easily have taken jade that was lying loose at the base of the mountains, but they climbed up through the clouds, probably because there they could take the stone that came from a place midway between our world on Earth and the celestial realm of gods and ancestors. So this jade was treated with extreme care and reverence, as if it contained special powers.

Having quarried rough slabs of jade, the stone-workers and miners would then have had to labour to get the material back down to a place where it could be crafted. It was a long, arduous task, completed on foot and using boats. Yet big blocks of this desirable stone have been found roughly 200 kilometres (120 miles) away – an astonishing achievement – and some of the material had an even longer journey to make. Jade from the Italian Alps eventually spread throughout northern Europe – some even as far as Scandinavia.

We can only guess about the journey of our particular axe, but our guesses are informed ones. Jade is extremely hard and difficult to work, so much effort must have gone into shaping it. It's likely that first of all it was roughly sculpted in northern Italy, and then carried hundreds of miles across Europe to north-west France. It was probably polished there, because it's like several other axes found in southern Brittany, where there seems to have been a fashion for acquiring exotic treasures like this. The people of Brittany even carved impressions of the axes into the walls of their vast stone tombs. Mark Edmonds considers the implications:

> Beyond the practical tasks that you can use one of these things for, axes had a further significance – a significance that came from where they were found, who you got them from, where and when they were made, the sort of stories that were attached to them. Sometimes they were tools to be used and carried and forgotten about in the process, at other

times they would come into focus as important symbols to be held aloft, to be used as reminders in stories about the broader world, and sometimes to be handed on – in an exchange with a neighbour, with an ally, with somebody you'd fallen out with, and perhaps in exceptional circumstances, on someone's death, the axe was something that had to be dealt with. It had to be broken up like the body, or buried like the body, and we do have hundreds – if not thousands – of axes in Britain that appear to have been given that kind of treatment: buried in graves, deposited in ritual ceremonial enclosures, and even thrown into rivers.

That our axe has no signs of wear and tear is surely a consequence of the fact that its owners chose not to use it. This axe was designed to make a mark not on the landscape but in society, and its function was to be aesthetically pleasing. Its survival in such good condition suggests that people 6,000 years ago found it just as beautiful as we do today. Our love of the expensive and the exotic has a very long pedigree.

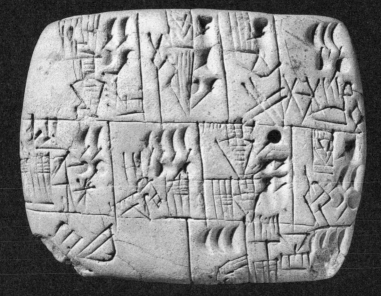

15

Early Writing Tablet

Clay tablet, found in southern Iraq
3100–3000 BC

Imagine a world without writing – without any writing at all. There would of course be no forms to fill in, no tax returns, but also no literature, no advanced science, no history. It is effectively beyond imagining, because modern life, and modern government, is based almost entirely on writing. Of all mankind's great advances, the development of writing is surely the giant: it could be argued that it has had more impact on the evolution of human society than any other single invention. But when and where did it begin – and how? A piece of clay, made just over 5,000 years ago in a Mesopotamian city, is one of the earliest examples of writing that we know; the people who gave us the Standard of Ur have also left us one of the earliest examples of writing.

It is emphatically not great literature; it is about beer and the birth of bureaucracy. It comes from what is now southern Iraq, and it's on a little clay tablet, about 9 centimetres by 7 (4 inches by 3) – almost exactly the same shape and size as the mouse that controls your computer.

Clay may not seem to us the ideal medium for writing, but the clay from the banks of the Euphrates and the Tigris proved to be invaluable for all kinds of purposes, from building cities to making pots, and even, as with our tablet, for giving a quick and easy surface on which to write. From the historian's point of view, clay has one huge advantage: it lasts. Unlike the bamboo used by the Chinese to write on, which rots quickly, and unlike paper, which is so easily destroyed, sunbaked clay will survive in dry ground for thousands of years – and as a result we're still learning from those clay tablets. In the British Museum we look after about 130,000 writing tablets from Mesopotamia, and scholars from all over the world come to study the collection.

While experts are still working hard on the early history of Meso-potamian script some points are already very apparent, and many of them are visible in this oblong of baked clay. You can see clearly how a reed stylus has pressed the marks into the soft clay, which has then been baked hard so that it is now a handsome orange. If you tap it, you can hear that this tablet is very tough indeed – that's why it has sur-vived. But even baked clay doesn't last for ever, especially if it has been exposed to damp. One of our challenges in the British Museum is that we often have to re-bake the tablets in a special kiln in order to con-solidate the surface and preserve the information inscribed on the clay.

Our little beer-rationing tablet is divided into three rows of four boxes each, and in each box the signs – typically for this date – are read from top to bottom, moving right to left, before you move on to the next box. The signs are pictographs, drawings of items which stand just for that item or something closely related to it. So the symbol for beer is an upright jar with a pointed base – a picture of the vessel that was actually used to store the beer rations. The word for 'ration' itself is conveyed graphically by a human head, juxtaposed with a bowl, from which it appears to be drinking; the signs in each of the boxes are accompanied by circular and semicircular marks which represent the number of rations recorded.

You could say that this script isn't really writing in the strict sense, that it's more a kind of mnemonic, a repertoire of signs that can be used to carry quite complex messages. The crucial breakthrough to real writing came when it was first understood that a graphic symbol, like the one for beer on the tablet, could be used to mean not just the thing it showed, but what the word for the thing sounded like. At this point writing became phonetic, and then all kinds of new communication became possible.

When the earliest cities and states grew up in the world's fertile river valleys around 5,000 years ago, one of the challenges for leaders was how to govern these new societies. How do you impose your will not just on a couple of hundred villagers, but on tens of thousands of city dwellers? Nearly all these new rulers discovered that, as well as using military force and official ideology, if you want to control popu-lations on this scale you need to write things down.

We tend to think of writing as being about poetry or fiction or history, what we might call literature. But early literature was in fact oral – learnt by heart and then recited or sung. People wrote down

what they could not learn by heart, what they couldn't turn into verse. So pretty well everywhere early writing seems to have been about record-keeping, bean-counting or, as in the case of this little tablet, beer-counting. Beer was the staple drink in Mesopotamia and was issued as rations to workers. Money, laws, trade, employment: this is the stuff of early writing, and it's writing like that on this tablet that ultimately changes the nature of state control and state power. Only later does writing move from rations to emotions; the accountants got there long before the poets. It's all thoroughly bureaucratic stuff. I asked Sir Gus O'Donnell, the head of the British civil service, for his view:

> The tablet is a first sign of writing; but it also tells you about the growth of the early beginnings of the state. You've got a civil service here, starting to come into place in order to record what's going on. Here, very clearly, is the state paying some workers for some work that's been done. They need to keep a track of the public finances, they need to know how much has been paid: it needs to be fair.

By 3000 BC the people who had to run the various city-states of Mesopotamia were discovering how to use written records for all kinds of day-to-day administration, keeping large temples running or tracking the movement and storage of goods. Most of the early clay tablets in the British Museum collection, like this one, come from the city of Uruk, roughly halfway between modern Baghdad and Basra. Uruk was just one of the large, rich city-states of Mesopotamia that had grown too big and too complex for anyone to be able to run them just by word of mouth. Gus O'Donnell elaborates:

> This is a society where the economy is in its first stages – there is no money, and no currency. How do they get around that? The symbols tell us that they've used beer. No liquidity crisis here; they are coming up with a different way of getting around the problem of the absence of a currency and, at the same time, sorting out how to have a functioning state. As this society develops, you can see that this will become more and more important. And the ability to keep track, to write things down, which is a crucial element of the modern state – to know how much money you're spending, and to know what you're getting for it – is starting to emerge. This tablet for me is the first ever equivalent of the cabinet secretary's notebook – it's that important.

When writing in the full sense was developing, with phonetic symbols replacing pictograms, life as a scribe must have been very exciting. The creation of new sound signs was probably quite a fast-moving process, and as they developed, the signs would have had to be listed – the earliest dictionaries if you like – beginning an intellectual process of categorizing words, things and the relationships between them that has never stopped since. Our little beer-ration tablet leads, directly and swiftly, to the possibility of thinking quite differently about ourselves and about the world that surrounds us.

John Searle, Professor of Philosophy at the University of California, Berkeley, describes what happens to the human mind when writing becomes part of culture:

> Writing is essential for the creation of what we think of as human civilization. It has a creative capacity that may not even have been intended. I think you don't understand the full import of the revolution brought by writing if you think of it just as preserving information into the future. There are two areas where it makes an absolutely decisive difference to the whole history of the human species. One is complex thought. There's a limit to what you can do with the spoken word. You cannot really do higher mathematics or even more complex forms of philosophical argument unless you have some way of writing it down and scanning it. So it's not adequate to think of writing just as a way of recording, for the future, facts about the past and the present. On the contrary, it is immensely creative. But there's a second thing about writing which is just as important: when you write down you don't just record what already exists, you create new entities – money, corporations, governments, complex forms of society. Writing is essential for all of them.

Writing seems to have emerged independently in Mesopotamia, Egypt, China and Central America – all of them expanding population centres – but there's fierce debate and much rivalry about who wrote first. At the moment, the Mesopotamians seem to be in the lead, but that may simply be because their evidence – being in clay – has survived.

As we have seen, rulers trying to control their subjects in the new populous cities of Egypt and Mesopotamia initially used military force to coerce them. But in writing, they found an even more powerful weapon of social control. Even a reed pen turned out to be mightier than the sword.

The Beginnings of Science and Literature

2000–700 BC

The emergence of cities and states in different parts of the world had many consequences, among them the appearance of the world's first written literature and the development of scientific and mathematical knowledge. These early cities and states did not exist in isolation, but were connected through extensive trade networks by road and sea. The majority of the world's population nevertheless still lived in scattered communities, but these people created many sophisticated objects, notably of materials such as bronze and gold which have often survived. Many of these objects were clearly made as demonstrations of power, designed to impress subjects, visitors and possibly posterity.

16

Flood Tablet

Clay writing tablet from Nineveh (near Mosul), northern Iraq
700–600 BC

The biblical story of Noah, his ark and the Great Flood has become so much part of our language that any child in Britain can tell you that the animals went in two by two. But the story of a Great Flood is one that goes back far beyond the Bible to many other societies. Which leads to a big question: we know about the Flood now because somebody long ago wrote the story down – but when did the very idea of writing down a story begin?

Locals from Bloomsbury often drop in to the British Museum. Just over 140 years ago, one of those locals, a regular lunchtime visitor, was a man called George Smith. He was an apprentice to a printing firm not far from the Museum, and he had become fascinated by the collection of ancient Mesopotamian clay tablets. He became so engrossed by these that he taught himself to read the wedge-shaped, cuneiform script in which they were written, and in due course he became one of the leading cuneiform scholars of his day. In 1872 Smith studied a particular tablet from Nineveh (in modern Iraq), and that's what I want to look at now.

The library where we keep the clay tablets from Mesopotamia – there are about 130,000 of them – is a room filled with shelves from floor to ceiling, with a narrow wooden tray on each shelf with up to a dozen clay tablets in it – most of them fragments. The piece that in 1872 particularly interested George Smith is about 15 centimetres (just under 6 inches) high and made of dark brown clay, and it's covered with densely written text organized into two close columns. From a distance, it looks a bit like the small-ads column of an old-fashioned newspaper. It would originally have been rectangular, but sections

have broken off in the past. But this fragment, once George Smith had grasped what it actually was, was going to shake the foundations of one of the great stories of the Old Testament, and raise big questions about the role of scripture and its relationship to truth.

Our tablet is about a flood – about a man who is told by his god to build a boat and to load it with his family and animals, because a deluge is about to wipe humanity from the face of the Earth. The tale on the tablet was startlingly familiar to George Smith because, as he read and deciphered, it became clear that what he had in front of him was an ancient myth that paralleled and – most importantly – predated the story of Noah and his ark. Just to remind you, here are a few snippets of the Noah story from the Bible (Genesis 6:14–7:4):

> Make thee an ark ... and of every living thing of all flesh, two of every sort shalt thou bring unto the ark ... I will cause it to rain upon the earth forty days and forty nights; and every living substance that I have made will I destroy from off the face of the earth.

And here's a snippet of what George Smith read on the clay tablet:

> demolish the house, and build a boat! Abandon wealth and seek survival. Spurn property, save life. Take on board all living things' seed! The boat you will build, her dimensions all shall be equal: her length and breadth shall be the same. Cover her with a roof, like the ocean below, and he will send you a rain of plenty.

That a Hebrew biblical story should already have been told on a Mesopotamian clay tablet was an astounding discovery – and Smith knew it, as a contemporary account tells us:

> Smith took the tablet and began to read over the lines which the conservator who had cleaned the tablet had brought to light; and when he saw that they contained the portion of the legend he had hoped to find there, he said, 'I am the first man to read that after 2,000 years of oblivion.' Setting the tablet on the table, he jumped up and rushed about the room in a great state of excitement, and, to the astonishment of those present, began to undress himself!

This really was a discovery worth taking your clothes off for. The tablet, now universally known as the Flood Tablet, had been written

down in what is now Iraq in the seventh century BC, roughly 400 years before the oldest surviving version of the Bible narrative. Was it thinkable that the Bible narrative, far from being a specially privileged revelation, was merely part of a common stock of legend that was shared by the whole Middle East?

It was one of the great moments in the nineteenth century's radical rewriting of world history. George Smith published the tablet only twelve years after the publication of Charles Darwin's *On the Origin of Species*. And, in doing so, he opened a religious Pandora's box. Professor David Damrosch, from Columbia University, gauges the Flood Tablet's seismic impact:

> People in the 1870s were obsessed by biblical history, and there was a great deal of controversy as to the truth of the biblical narratives. So it created a sensation when George Smith found this ancient version of the Flood story, clearly much older than the biblical version. Prime Minister Gladstone came to hear his lecture describing his new translation, and it was reported in front-page articles around the globe, including one in the *New York Times* in which they already noted that the tablet could be read in two quite different ways – does this prove the Bible is true, or show it's all legendary? And Smith's discovery gave further ammunition to both sides in the debate as to the truth of biblical history, debates over Darwin, evolution and geology.

What does it do to your perception of a religious text when you discover that it comes from an older society, with a very different set of beliefs? I asked the UK's Chief Rabbi, Sir Jonathan Sacks:

> Clearly there is a core event behind both narratives, which was a great flood, part of the folk memory of all the peoples of that area. What the ancient texts that tell flood stories do is talk essentially of the great forces of nature being controlled by deities who don't like human beings very much, and for whom 'might makes right'. Now the Bible comes along and retells the story, but does so in a unique way – God brings the flood because the world was filled with violence, and the result is that the story becomes moralized, and that is part of the Bible's programme. This is a radical leap from polytheism to monotheism – to a world in which people worshipped power, to the Bible's insistence that power

must be just and sometimes compassionate, and from a world in which there are many forces, many gods, fighting with one another, to this world in which the whole universe is the result of a single rational creative will. So the more we understand what the Bible is arguing against, the deeper we understand the Bible.

But the Flood Tablet was important not just for the history of religion; it is also a key document in the history of literature. Smith's tablet comes from the seventh century BC, but we now know that other versions of the Flood story had originally been written down a thousand years before that. It was only later that the Flood story was woven by storytellers into the famous Epic of Gilgamesh, the first great epic poem of world literature. Gilgamesh is a hero who sets off on a grand quest for immortality and self-knowledge. He confronts demons and monsters, he survives all kinds of perils, and, eventually, like all subsequent epic heroes, he has to confront the greatest challenge of them all: his own nature and his own mortality. Smith's tablet is just the eleventh chapter of the story. The Epic of Gilgamesh has all the elements of a cracking good tale, but it's also a turning-point in the story of writing.

Writing in the Middle East had begun as little more than bean-counting – created essentially for bureaucrats to keep records. It had been used above all for the practical tasks of the state. Stories, on the other hand, were usually told or sung, and they were learnt by heart. But gradually, around 4,000 years ago, stories like that of Gilgamesh began to be written down. Insights into the hero's hopes and fears could now be shaped, refined and fixed – an author could be sure that his particular vision of the narrative and his personal understanding of the tale would be transmitted directly, and not constantly reshaped by other storytellers. Writing moves authorship from the community to the individual. Hardly less important, a written text can be translated, and so one particular form of a story could now pass easily into many languages. Literature written down like this can become world literature. David Damrosch puts it in perspective:

> Gilgamesh is now very commonly assigned as a very first work in literature courses, and it shows a kind of early globalization. It's the first work of world literature that circulates widely around the ancient

world. The great thing about looking at Gilgamesh today is that we see that, if we go back far enough, there's no clash of civilizations between the Middle East and the West. We find in Gilgamesh the origins of a common culture – its offshoots go off into Homer, the 1001 Nights, and the Bible – so it is really a sort of common thread in our global culture.

With the Epic of Gilgamesh, represented here by Smith's Flood Tablet, writing moved from being a means of recording facts to a means of investigating ideas. It changed its nature. And it has changed 'our' nature: for literature like Gilgamesh allows us not just to explore our own thoughts but to inhabit the thought worlds of others. That, of course, is also the point of the British Museum, and indeed of the objects that make up this thread of human history that I'm attempting to trace: they offer us the chance of other existences.

The fine, small cuneiform writing of the Flood Tablet was pressed into damp clay

Rhind Mathematical Papyrus

Papyrus found at Thebes (near Luxor), Egypt

AROUND 1550 BC

In seven houses there are seven cats. Each cat catches seven mice. If each mouse were to eat seven ears of corn and each ear of corn, if sown, were to produce seven gallons of grain, how many things are mentioned in total?

This is just one of dozens of similar problems, all equally complicated, all carefully written out – with the answers and showing the working in best schoolbook manner – that are recorded in the Rhind Mathematical Papyrus. This object is the most famous mathematical papyrus to have survived from ancient Egypt, and the major source for our understanding of how the Egyptians thought about numbers.

The Rhind Papyrus gives us no sense of maths as an abstract discipline through which the world can be conceived and contemplated anew. But it does let us glimpse – and share – the daily headaches of an Egyptian administrator. Like all civil servants, he seems to be looking anxiously over his shoulder at the National Audit Office, eager to ensure that he is getting value for money. So there are calculations about how many gallons of beer, or how many loaves of bread, you should be able to get from a given amount of grain, and how to calculate whether the beer or the bread that you're paying for has been adulterated.

The whole Rhind Papyrus contains eighty-four different problems – calculations that would have been used in different scenarios to solve the practical difficulties of administrative life, for instance how to calculate the slope of a pyramid, or the amount of food necessary for different kinds of domesticated birds. It's mostly written in black, but red is used for each problem's title and solution. And, interestingly, it is

Part of the Rhind Mathematical 103
Papyrus showing how to calculate
the area of a triangle

OVER: *The papyrus contains eighty-*
four mathematical problems.
Red ink indicates the name of
or answer to a problem

written not in hieroglyphs but in a particular kind of scribbly administrative shorthand that's much quicker, much simpler, to write.

The papyrus owes its name to an Aberdeen lawyer, Alexander Rhind, who took to wintering in Egypt in the 1850s because the dry heat helped his tuberculosis. There, in Luxor, he bought this papyrus, which turned out to be the largest ancient mathematical text we know, not just from Egypt but from anywhere in the ancient world.

Because it is extremely sensitive to humidity and to light, we keep it in the Papyrus Room of the British Museum. It's pretty dry and stuffy there, and above all it's dark, all of which suits the papyrus, which rots in the damp and fades in bright light. It's the nearest we can get in Bloomsbury to conditions in an ancient Egyptian tomb, where the papyrus presumably spent most of its existence. The whole papyrus would originally have been about 5 metres (17 feet) long and would normally have been rolled up in a scroll. Today it's in three pieces. The two largest ones are in the British Museum, framed under glass to protect them (the third is in the Brooklyn Museum, New York). The papyrus is about 30 centimetres (roughly a foot) high, and if you look closely you can see the fibres of the papyrus plant.

Making papyrus is laborious but quite straightforward. The plant itself – a kind of reed which can grow to about 4.5 metres (15 feet) high – was plentiful in the Nile Delta. The pith of the plant is sliced into strips, which are soaked and pressed together to form sheets, and the sheets are then dried and rubbed smooth with a stone. Conveniently, the organic fibres of papyrus mesh together without the need for glue. The result is a wonderful surface for writing on – papyrus went on being used across the Mediterranean until about a thousand years ago, and indeed gave most European languages their very word for paper.

But papyrus was expensive – a 5-metre roll like the Rhind Papyrus would have cost two copper deben, about the same as a small goat. So this is an object for the well off.

Why would you spend so much money on a book of mathematical puzzles? I think because to own this scroll would have been a good career move. If you wanted to play any serious part in the Egyptian state, you had to be numerate. A society as complex as theirs needed people who could supervise building works, organize payments, manage food supplies, plan troop movements, compute the flood levels

of the Nile – and much more. To be a scribe, a member of the civil service of the pharaohs, you had to demonstrate your mathematical competence. As one contemporary writer put it:

> So that you may open treasuries and granaries, so that you may take delivery from one corn-bearing ship at the entrance to the granary, so that on feast days you may measure out the gods' offerings.

The Rhind Papyrus teaches you all you need to know for a dazzling administrative career. It is effectively a crammer for the Egyptian civil service exams around 1550 BC. Like self-help publications today that promise instant success, it has a wonderful title, written boldly in red on the front page:

> The correct method of reckoning, for grasping the meaning of things, and knowing everything – obscurities and all secrets.

In other words: 'All the maths you need to know. Buy me, and you buy success.'

The numeracy of the Egyptians, honed by works like the Rhind Papyrus, was widely admired across the ancient world. Plato, for example, urged the Greeks to copy the Egyptians, for whom

> The teachers, by applying the rules and practices of arithmetic to play, prepare their pupils for the tasks of marshalling and leading armies and organizing military expeditions and all together form them into persons more useful to themselves and to others and a great deal wider awake.

But if everybody agreed that training like this produced a formidable state machine, the question of what mathematics the Greeks actually did learn from the Egyptians remains a matter of debate. The problem is that we have only a very few surviving Egyptian mathematical documents – many others must have perished. So, although we have to assume that there was a flourishing higher mathematics, we just do not have the evidence for it. Professor Clive Rix, of the University of Leicester, emphasizes the significance of the Rhind Papyrus:

> The traditional view has always been that the Greeks learnt their geometry from the Egyptians. Greek writers such as Herodotus, Plato and Aristotle all refer to the outstanding skills of the Egyptians in geometry.

If we didn't have the Rhind Mathematical Papyrus, we'd actually know very little indeed about how the Egyptians did mathematics. The algebra is entirely what we would call linear algebra, straight-line equations. There are some of what we call arithmetical progressions, which are a little bit more sophisticated. The geometry's a very basic kind as well. Ahmose [the original copyist of the papyrus] tells us how to calculate the area of a circle, and how to calculate the area of a triangle. There is nothing in this papyrus that would trouble your average GCSE student, and most is rather less advanced than that.

But this is, of course, what you'd expect, because the person using the Rhind Mathematical Papyrus is not training to be a mathematician. He just needs to know enough to handle tricky practical problems – like how to divide up rations among workmen. If, for instance, you have 10 gallons of animal fat to get you through the year, how much can you consume every day? Dividing 10 by 365 was as tricky then as it is now, but it was essential if you were going to keep a workforce properly supplied and energized. Eleanor Robson, a specialist in ancient mathematics from Cambridge University, explains:

> Everyone who was writing mathematics was doing it because they were learning how to be a literate, numerate manager, a bureaucrat, a scribe – and they were learning both the technical skills and how to manage numbers and weights and measures, in order to help palaces and temples manage their large economies. There must have been a whole lot of discussion of mathematics and how to solve the problems of managing huge building projects like the pyramids and the temples, and managing the huge workforces that went with it, and feeding them all.

How that more sophisticated discussion of mathematics was conducted, or transmitted, we can only guess. The evidence that has come down to us is maddeningly fragmentary, because papyrus is so fragile that it tends to crumble, it rots in damp conditions, and it burns so easily. We don't even know where the Rhind Papyrus came from, but we presume that it must have been a tomb. There are some examples of private libraries being buried with their owners – presumably to establish their educational and administrative credentials in the afterlife.

This loss of evidence makes it very hard to form a view of how

Egypt stood in comparison with its neighbours and to understand exactly how representative Egyptian mathematics is around 1550 BC. Eleanor Robson tells us:

> The only evidence from the same time we've got to compare it with is from Babylonia, in southern Iraq, because they were the only two civilizations at that point that actually used writing. I'm sure that lots of other cultures were counting and managing with numbers, but they all did it – as far as we know – without ever writing things down. The Babylonians we know a lot more about, because they wrote on clay tablets and, unlike papyrus, clay survives very well in the ground over thousands of years. So for Egyptian mathematics we have perhaps six, maximum ten, pieces of writing about mathematics, and the biggest of course is the Rhind Papyrus.

For me, the most remarkable thing about this papyrus is how close it lets us get to the quirky details of daily life under the pharaohs, not least the culinary aspects. From it we learn that if you force-feed a

'In seven houses there are seven cats ...'

goose it needs five times as much grain as a free-range goose will eat. So did the Egyptians eat foie gras? Ancient Egypt also seems to have had battery-farming, because we're told that geese kept in a coop – presumably unable to move – will need only a quarter of the food consumed by their free-range counterparts, and so would be much cheaper to fatten for market.

In between the beer and the bread, and the hypothetical foie gras, you can see the logistical infrastructure of an enduring and powerful state, able to mobilize vast human and economic resources for public works and military campaigns. The Egypt of the pharaohs was, to its contemporaries, a land of superlatives – astonishing visitors from all over the Middle East by the colossal scale of its buildings and sculptures, as it still does us today. Like all successful states, then as now, it needed people who could do the maths.

And if you're still puzzling over the cats, and the mice, and the ears of grain in the puzzle that I began with, the answer is … 19,607.

18

Minoan Bull-leaper

Bronze statue of bull and acrobat, found in Crete, Greece
1700–1450 BC

A small bronze sculpture of a bull with a figure leaping over it is now one of the highlights of the British Museum's Minoan collection. It comes from the Mediterranean island of Crete, where it was made around 3,700 years ago.

The bull and the leaper are both made of bronze, and together they're about 5 centimetres (2 inches) long and between 10 and 13 centimetres (4 or 5 inches) high. The bull is in full gallop – legs outstretched and head raised – and the figure is leaping over it in a great arching somersault. It's probably a young man. He's seized the bull's horns and thrown his body right over, so that we see him at the point where his body has completely flipped. The two arching figures echo each other – the outward curve of the boy's body being answered by the inward curve of the bull's spine. It's a most dynamic and beautiful piece of sculpture, and it carries us at once into the reality – and, no less important, the myth – of the history of Crete.

The image is a literal representation of something that to most people today is just a metaphor – 'taking the bull by the horns' is what we're all meant to do when confronted with the big moral problems of life. But archaeology suggests that about 4,000 years ago a whole civilization seems to have been collectively fascinated by both the idea and the act of confronting the bull. Just why they were is one of the many mysteries of a society at the crossroads of Africa, Asia and Europe that played a key role in shaping what we now call the Middle East. It was a society that Homer described in lyric terms:

> Out in the middle of the wine-dark sea, there is a land called Crete, a
> rich and lovely land washed by the sea on every side; and in it are many

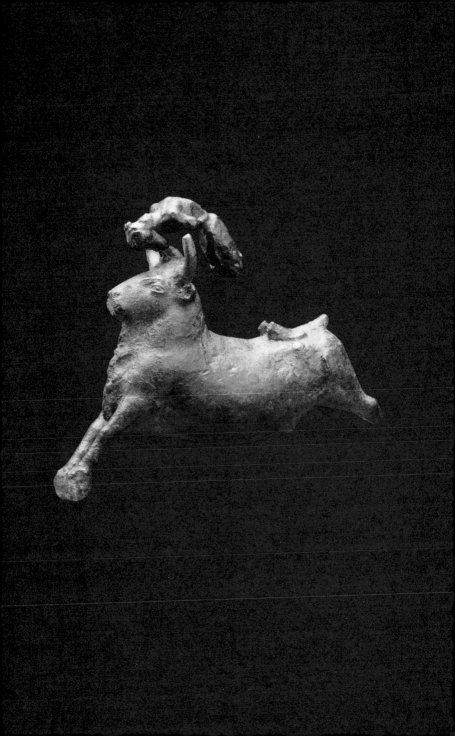

peoples and ninety cities. There, one language mingles with another ...
Among the cities is Knossos, a great city; and there Minos was nine
years king, the boon companion of mighty Zeus.

In Greek myth, Minos, ruler of Crete, had a complex relationship
with bulls. He was the son of the beautiful Europa by Zeus, king of the
gods, but in order to father him and abduct Europa, Zeus had turned
himself into a bull. Minos's wife in turn had conceived an unnatural
passion for a very beautiful bull, and the fruit of that obsession was
the Minotaur, half-man, half-bull. Minos was so ashamed of his mon-
strous stepson that he had him imprisoned in an underground laby-
rinth, and there the Minotaur devoured a regular supply of maidens
and youths sent every year by Athens – until, that is, the Greek hero
Theseus succeeded in killing him. The story of Theseus and the Mino-
taur, of man first burying then confronting and slaying his monstrous
demons, has been told and retold for centuries, by Ovid, Plutarch, Vir-
gil and others. It's part of the high canon of Greek myth, of Freudian
psychology and of European art.

Archaeologists were captivated by these tales. Just over a hundred
years ago, when Arthur Evans explored the island and decided to dig
at Knossos, the bulls and monsters, palaces and labyrinths of Crete
were very much in his mind. So although we have no idea what the
people of this rich civilization around 1700 BC actually called them-
selves, Evans, believing he was uncovering the world of Minos, called
them quite simply Minoans, and they've remained Minoans to archae-
ologists ever since. In his extensive excavations, Evans uncovered the
remains of a vast building complex, finding pottery and jewellery,
carved stone seals, ivory, gold and bronze, and colourful frescoes,
often depicting bulls; and he sought to interpret these finds in the light
of the familiar myths. He was eager to reconstruct the role that the
bulls might have played in the island's economic and ceremonial life,
so he was particularly interested in the discovery, some distance from
Knossos, of the 'Minoan' bull-leaper.

It's thought to have come from Rethymnon, a town on the north
coast of the island, and it was probably originally deposited as an
offering in a mountain shrine or in a cave sanctuary. Objects like this
are often found in these holy places of Crete, suggesting that cattle

played an important role in local religious rituals. Many scholars since Evans have tried to explain why these images were so important. They've asked what bull-leaping was for, and even if it was actually possible. Evans thought it was part of a festival in honour of a mother goddess. Others disagree, but bull-leaping has often been seen as a religious performance, possibly involving the sacrifice of the animal, and even occasionally the death of the leaper. Certainly, in this sculpture, both bull and human are engaged in a highly dangerous exercise. Being able to vault the animals would have taken months of training. We can say this with confidence, because the sport still survives today in parts of France and Spain. Sergio Delgado, a leading modern-day bull-leaper – or, to use the proper Spanish term, *recortador* – explains:

> There has always been a kind of game between men and bulls, always. There is not a proper school for *recortadores*. You just learn how to understand the animal and how he will react to the arena. You only get this knowledge with experience.
>
> There are three main techniques we had to learn: first the *recorte de riñón* [the 'kidney cut']; second it's the *quiebro* [the 'break' or the 'swing']; the third one is the *salto* [or 'leap'], which is mainly jumping right over the bull in a different variety of styles.
>
> The bulls are not injured before the match, like in bullfighting. The bull never dies in the arena. We are risking our lives here, we get butted and gored as frequently as bullfighters. The bull is unpredictable. He is the one in charge. We never lose respect for the bull.

This continuing reverence for the bull is a fascinating contemporary echo of the suggestion made by some scholars that bull-leaping on Crete at the time of this little statue probably had a religious significance. Even the valuable bronze it's made of suggests an offering to the gods.

The sculpture was made around 1700 BC, in the middle of what archaeologists call the Bronze Age, when huge advances in making metals transformed the way humans could shape the world. Bronze, an alloy of copper and tin, is much harder and cuts much better than copper or gold; once discovered, it was widely used to make tools and weapons for more than a thousand years. But it also makes very

beautiful sculpture, so it was frequently used for precious, probably devotional objects.

The British Museum bull sculpture was cast using the lost-wax technique. The artist first models his vision in wax, then he moulds clay around it. This is put into a fire, which hardens the clay and melts the wax. The molten wax is drained off, and in its place a bronze alloy is poured into the mould, so that it takes on the exact form the wax had occupied. When it cools, the mould is broken to reveal the bronze, which can then be finished – polished, inscribed or filed – to produce the final sculpture. Although the bull-leaper is quite badly corroded – it has degraded to a greenish-brown colour – when made it would have been a striking object. It would never of course have been quite as sparkling as gold, but it would have had a powerful, seductive gleam.

The bronze that made sculptures like this one gleam lets our bull move from myth into history. At first sight it is a surprise that it's made of bronze at all, since neither copper nor tin – both of which are needed to make bronze – are found on Crete. Both came from much further afield, with the copper coming from Cyprus – the very name of which means the 'copper island' – or from the eastern Mediterranean coast. But the tin had an even longer journey, travelling along trade routes from eastern Turkey, perhaps even from Afghanistan; and it was often in short supply, because those trade routes were frequently disrupted by pirates.

Within the sculpture itself you can actually see something of that struggle to secure the tin supplies. There clearly wasn't quite enough tin in the alloy, which explains why the surface is rather pock-marked, and also why the structure is weak, so that the hind legs of the bull have broken off.

But even if the proportions of the alloy were less than ideal, the very existence of the tin and copper – both from outside Crete – tells us that the Minoans were moving around and trading by sea. Indeed, Crete was a major player in a vast network of trade and diplomacy that covered the eastern Mediterranean – often focused on the exchange of metals, and all linked by maritime travel. The maritime archaeologist Dr Lucy Blue, of Southampton University, tells us more:

> The small bronze statuette from Minoan Crete is a very good indicator of this key commodity, bronze, that was sought after throughout the

eastern Mediterranean. Unfortunately, we have only a limited number of shipwrecks to substantiate these trading activities, but one of the shipwrecks that we have is that of the *Uluburun*, which was found off the Turkish coast. The *Uluburun* was carrying 15 tons of cargo, 9 tons of which was copper in the form of ingots. She was also carrying a very rich cargo of other goods – amber from the Baltic, pomegranates, pistachio nuts, and a wealth of manufactured goods, including bronze and gold statuettes, beads of different materials, large numbers of tools and weapons.

There are still many unanswered questions about the rich Minoan civilization involved in this kind of trade. The word 'palace', which Evans used to describe the large buildings he excavated, suggests royalty, but in fact these buildings seem rather to have been religious, political and economic centres. They were architecturally complex places, housing a great variety of activities, one of them the administration of trade and produce, organizing the large population of craftsmen who wove cloth and worked the imported gold, ivory and bronze. Without that whole society of skilled artisans our bull-leaper would not exist.

Frescoes in the palace at Knossos show large gatherings of people, suggesting that these were also ceremonial and religious centres. Yet despite more than a century of excavation the Minoans still remain enticingly enigmatic and our knowledge remains frustratingly fragmentary. Objects like this little bronze statue of the bull-leaper tell us a lot about one aspect of Crete's history – its central role in the mastery of metals which, in a few centuries, transformed the world. It also asserts the perpetual fascination of mythical Crete as the site where we confront in ourselves the most disturbing links between man and beast. When Picasso in the 1920s and 1930s wanted to explore the bestial elements that were denaturing European politics, he turned instinctively to the palace of Minoan Crete, to that underground labyrinth and to that encounter between man and bull that still haunts us all ... the battle with the Minotaur.

19

Mold Gold Cape

Finely worked gold cape, found in Mold, north Wales
1900–1600 BC

For the local workmen, it must have seemed as if the old Welsh legends were true. They'd been sent to quarry stone in a field known as Bryn-yr-Ellyllon, which translates as the Fairies' Hill or the Goblins' Hill. Sightings of a ghostly boy, clad in gold, a glittering apparition in the moonlight, had been reported frequently enough for travellers to avoid the hill after dark. As the workmen dug into a large mound, they uncovered a stone-lined grave. In it were hundreds of amber beads, several bronze fragments and the remains of a skeleton. And wrapped around the skeleton was a mysterious crushed object – a large and finely decorated broken sheet of pure gold.

This breathtaking object is a gold cape or, perhaps more accurately, a short golden poncho. But we call it a cape. It's a wrapping in punched gold, for the shoulders of a human being. It's about 45 centimetres (1.5 feet) wide and about 30 centimetres (1 foot) deep, and it would have been put over the head and lowered on to the shoulders, coming down to about the middle of the chest.

When you look at it closely you can see that it has been made out of a single sheet of astonishingly thin gold. The whole thing was made from an ingot about the size of a ping-pong ball. The sheet has then been worked from the inside and punched out – so that the overall effect is of strings of beads, carefully spaced and graduated, running from one shoulder to another and going all the way round the body. Looking at it now, you're struck with a sense of enormous complexity and ultimate luxury. It must have astonished the stone-breakers who uncovered it.

The workmen made the discovery at Bryn-yr-Ellyllon in 1833.

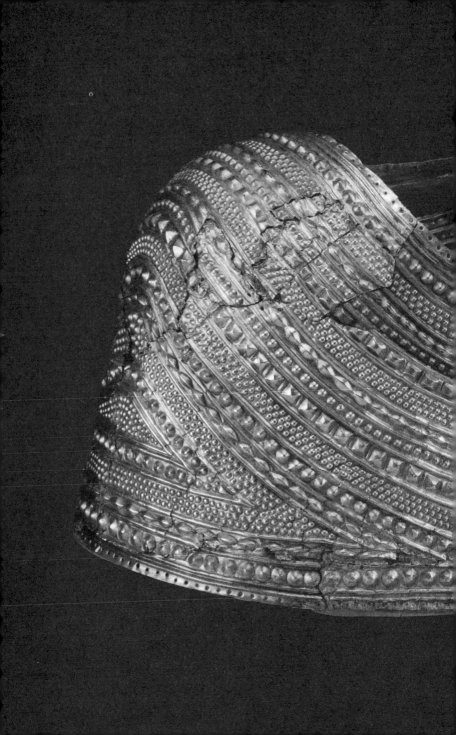

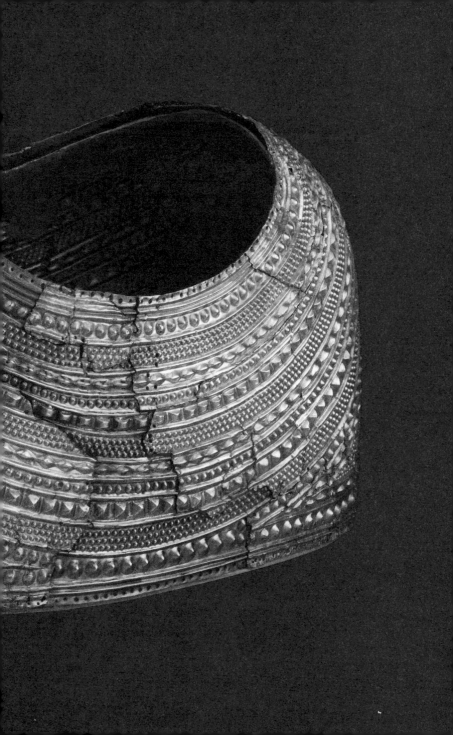

Undeterred by thoughts of ghosts or goblins, and exhilarated by the dazzling wealth of their find, the workmen eagerly shared out chunks of the gold sheet, with the tenant farmer taking the largest pieces. It would have been easy for the story to end there. In 1833, burials from a distant past, however exotic, enjoyed little legal protection. The location of the burial site, near the town of Mold, not far from the north coast of Wales, meant that the wider world could easily have continued in ignorance of its existence. That this didn't happen owes everything to the curiosity of a local vicar, Reverend C. B. Clough, who wrote an account of the find that aroused the interest of the Society of Antiquaries, hundreds of miles away in London.

Three years after the spoils from the burial had been divided, the British Museum bought from the tenant farmer the first and the largest of the fragments of gold, which had been his share of the booty. Much that the vicar recorded had disappeared by then, including virtually the whole skeleton. This left only three large and twelve small crushed and flattened fragments of the decorated gold object. It took another hundred years for the British Museum to gather together enough of the remaining fragments (some are still missing) to begin a complete reconstruction of this divided treasure.

What sort of object was it that these fragments had once composed? When had it been made? Who had worn it? As more archaeological discoveries were made in the nineteenth century, it became clear that the Mold burial dated to the newly identified Bronze Age – around 4,000 years ago. But it was not until the 1960s that the gold pieces were put together for the first time. All the conservators had were flattened fragments of paper-thin gold; some large, some small, with cracks, splits and holes all over them, altogether weighing about half a kilo, or just over a pound. It was like a three-dimensional jigsaw puzzle, and solving it took nothing less than the relearning of ancient gold-working techniques that had been lost for millennia.

We don't know who made this cape, but it's clear that they were very highly skilled. These were the Cartiers or the Tiffanys of Bronze Age Europe. What kind of society could have produced such an object? Its sheer opulence and intricate details suggest that it must have come from a centre of great wealth and power, perhaps comparable to the contemporary courts of the pharaohs of Egypt or the palaces of

Minoan Crete. And the careful drawing and planning necessary for such elaborate design suggests a long tradition of luxury production.

But archaeology has revealed no obvious palaces, cities or kingdoms anywhere in Britain at this time. There are the vast ceremonial monuments of Stonehenge and Avebury, and there are hundreds of stone circles and thousands of burial mounds which would have dominated the landscape, but little survives of any dwelling places, and what does remain indicates that these were extremely modest – thatched wooden houses that would normally suggest tribal farming societies, led by chiefs.

In the past, it was easy to dismiss British prehistoric societies as primitive people existing before recognizable civilizations emerged; and with few settlements and only burials to work from, it was often entirely reasonable to make such assumptions. But, partly through the discovery of rare objects like the Mold Gold Cape, in recent years we have come to see these societies very differently. For, while it's unique in its complexity, the cape is just one example of several precious objects that tell us that societies in Britain must then have been extremely sophisticated, both in their manufacture and in their social structure. They also tell us, like the jade axe from Canterbury (Chapter 14), that these societies were not isolated but part of a larger European trade network. For example, the collection of small amber beads that was found with the cape must have come from the Baltic – many hundreds of miles away from Mold.

By studying these precious objects – gold, amber and, above all, bronze – we can track a web of trade and exchange that reaches from north Wales to Scandinavia, and even to the Mediterranean. We can also identify the source of the wealth which made this trade possible. The Mold Cape was buried relatively close to the largest Bronze Age copper mine in north-west Europe, the Great Orme. The copper from there, and tin from Cornwall, would have provided the ingredients for the vast majority of British bronze objects. A peak of activity at the Great Orme mine has been dated between 1900 BC and 1600 BC. Recent analysis of the gold-working techniques, and the decorative style of the cape, dates the burial to this very period. So although we can only guess, it's likely that the wearers of this extraordinary object were in some way linked to the mine, which would have been a source

of great wealth, and a major trading centre for the whole of north-west Europe. But was the gold for the cape also traded from far away? Dr Mary Cahill, from the National Museum of Ireland, says:

> It has been a huge question – where did the gold come from? We have learnt a great deal about where the early copper sources are, but the nature of gold, especially if it's coming from rivers and streams – and the early workings can literally be washed away in one flood – means that it's very, very hard to identify the sites. So what we are trying to do is to look more closely at the nature of the gold ore, to look at the objects, to try to relate the analysis of one with the other, in the hope that this will lead us back to the right type of geological background, the right type of geological environment, in which the gold was actually formed. And then, by doing extensive fieldwork, we hope that we may actually identify an Early Bronze Age goldmine.
>
> A very rich source of gold must have been available, because the quantity of gold used is way above anything else of the period. The gold had to be collected over a long period of time. The object itself is made with exceptional skill. It's not just the decoration of the object that is skilful, but also the shape of it, the form in which it's made, so that it would fit on the body – we have to imagine that the goldsmith had to sit down and really work this out in advance: how he was going to form the sheet – which is a very skilful matter in itself – how he was then going to decorate it, and how the whole thing would be brought together to make the cape. And this really demonstrates more than anything the level of skill, and the sense of design, of the goldsmith who made it.

Although the expertise of the maker of the cape is clear, virtually nothing is certain about the person who may have worn it. The object itself provides a few clues. It probably had a lining, perhaps of leather, which covered the chest and the shoulders of the wearer. The cape is so fragile, and it would have so restricted the movement of arms and shoulders, that it can have been worn only rarely. There are definite signs of wear: there are holes in the top and bottom of the cape, for example, that would have been used to attach it to a costume, so it may have been brought out on ceremonial occasions, perhaps over a long period of time.

But who was wearing it? The cape is too small for a mighty warrior

chief. It will fit only a slim, small person – a woman or, perhaps more likely, a teenager. The archaeologist Marie Louise Stig Sørensen highlights the role of young people in these early societies:

> In the Early Bronze Age few people would live beyond about twenty-five years. Most children would not get older than five. Many women would die in childbirth, and only a few people would get very old; these very old people might have had a very special status in the society.
>
> It's actually difficult to know whether our concept of children applies to this society, where you very quickly became a grown-up member of the community, even if you were only ten years old, because of the average age of the communities that they lived in. That would mean that most people around then were teenagers.

This challenges our perceptions of age and responsibility. In many societies in the past, a teenager could be a parent, a full adult, a leader. So the cape may have been worn by a young person who already had considerable power. Unfortunately, the key evidence, the skeleton that was found inside the cape, was thrown away when the gold was discovered, as it clearly had no financial value. So when I look at the Mold Gold Cape now, I have a strange mix of sensations – exhilaration that such a supreme work of art has survived, and frustration that the surrounding material, which would have told us so much about this great and mysterious civilization that flourished in north Wales 4,000 years ago, was recklessly discarded.

It's why archaeologists get so agitated about illicit excavations today. For although the precious finds will usually survive, the context which explains them will be lost, and it's that context of material – often financially worthless – that turns treasure into history.

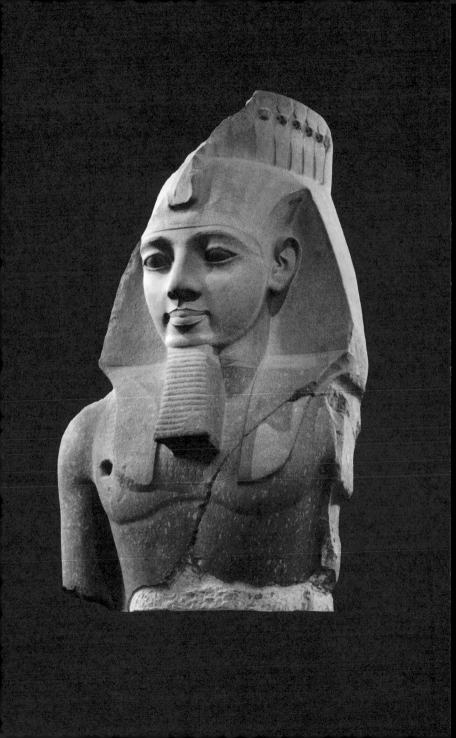

20

Statue of Ramesses II

Granite statue, found at Thebes (near Luxor), Egypt

AROUND 1250 BC

In 1818, the poet Percy Bysshe Shelley was inspired by a monumental figure in the British Museum to write some of his most widely quoted lines:

> 'My name is Ozymandias, king of kings:
> Look on my works, ye Mighty, and despair!'

Shelley's Ozymandias is actually our Ramesses II, king of Egypt from 1279 to 1213 BC. His giant head with a serenely commanding face looks down at visitors from a very great height, dominating the space around it.

When it arrived in England, this was by far the largest Egyptian sculpture that the British public had ever seen, and it was the first object that gave them a sense of the colossal scale of the Egyptian achievement. The upper body alone is about 2.5 metres (8 or 9 feet) high, and it weighs about 7 tonnes. This is a king who understood, as none before, the power of scale, the purpose of awe.

Ramesses II ruled Egypt for an astonishing sixty-six years, presiding over a golden age of prosperity and imperial power. He was lucky – he lived to be over 90, he fathered around a hundred children and, during his reign, the Nile floods obligingly produced a succession of bumper harvests. He was also a prodigious achiever. As soon as he took the throne in 1279 BC he set out on military campaigns to the north and south, he covered the land with monuments, and he was seen as such a successful ruler that nine later pharaohs took his name. He was still being worshipped as a god in the time of Cleopatra, more than a thousand years later.

Ramesses was a consummate self-publicist, and a completely unscrupulous one. To save time and money he simply changed the inscriptions on pre-existing sculptures so that they bore his name and glorified his achievements. All across his kingdom he also erected vast new temples – like Abu Simbel, cut into the rocky sides of the Nile Valley. The huge image of himself there, sculpted in the rock, inspired many later imitations, not least the vast faces of American presidents carved into Mount Rushmore.

In the far north of Egypt, facing towards neighbouring powers in the Near East and the Mediterranean, he founded a new capital city, modestly called Pi-Ramesses Aa-nakhtu, the 'House of Ramesses II, Great and Victorious'. One of his proudest achievements was his memorial complex at Thebes, near modern Luxor. It wasn't a tomb where he was going to be buried, but a temple where he would be venerated in life and then worshipped as a god for all eternity. The Ramesseum, as it's now known, covers an immense area, about the size of four football pitches, and contained temple, palace and treasuries.

There were two courtyards in the Ramesseum, and our statue sat at the entrance to the second one. But, magnificent though it is, this statue was just one of many – Ramesses was replicated again and again throughout the complex, a multiple vision of monumental power that must have had an overwhelming effect on the officials and priests who went there. The sculptor Antony Gormley, who created the Angel of the North, places such monumental sculpture in context:

> For me as a sculptor the acceptance of the material as a means of conveying the relationship between human-lived biological time and the aeons of geological time is an essential condition of the waiting quality of sculpture. Sculptures persist, endure, and life dies. And all Egyptian sculpture in some senses has this dialogue with death, with that which lies on the other side.
>
> There is something very humbling, a celebration of what a people can do together, because that is the other extraordinary thing about Egyptian architecture and sculpture, which were engaged upon by vast numbers of people, and which were a collective act of celebration of what they were able to achieve.

It is an important point. This serenely smiling sculpture is not the cre-

ation of an individual artist, but the achievement of a whole society – the result of a huge, complex process of engineering and logistics – in many ways much closer to building a motorway than making a work of art.

The granite for the sculpture was quarried from Aswan, more than 150 kilometres (90 miles) up the Nile to the south, and extracted in a single colossal block – the whole statue would have originally weighed about 20 tonnes. It was then roughly shaped before being moved on wooden sleds, pulled by large teams of labourers, from the quarry to a raft which was floated down the Nile to Luxor. The stone was then hauled from the river to the Ramesseum, where the finer stone-working took place. An enormous amount of man-power and organization was needed to erect even this one statue, and the whole workforce had to be trained, managed, coordinated and, if not paid – many of them would have been slaves – at least fed and housed. To deliver our sculpture a literate, numerate and very well-oiled bureaucratic machine was essential – and that same machine was also used to manage Egypt's international trade and to organize and equip its armies.

Ramesses undoubtedly had both great ability and real successes, but, like all supreme masters of propaganda, where he didn't actually succeed he just made it up. He was not exceptional in combat, but he was able to mobilize a considerable army and supply them with ample weaponry and equipment. Whatever the actual result of his battles, the official line was always the same – Ramesses triumphs. The whole of the Ramesseum conveyed a consistent message of imperturbable success. Here is the Egyptologist Dr Karen Exell, on Ramesses the propagandist:

> He very much understood that being visible was central to the success of the kingship, so he put up as many colossal statues as he could, very quickly. He built temples to the traditional gods of Egypt, and this kind of activity has been interpreted as being bombastic – showing off and so on – but we really need to see it in the context of the requirements of the kingship. People needed a strong leader, and they understood a strong leader to be a king who was out there campaigning on behalf of Egypt and was very visible within Egypt. We can even look at what we can regard as the 'spin' of the records of the battle of Qadesh in his year five,

which was a draw. He came back to Egypt and had the record of this battle inscribed on seven temples, and it was presented as an extraordinary success, that he alone had defeated the Hittites. So it was all spin, and he completely understood how to use that.

This king would not only convince his own people of his greatness: he would also fix the image of imperial Egypt for the whole world. Later, Europeans were mesmerized. Around 1800 the competing aggressive powers in the Middle East, then the French and the British, vied with each other to acquire the image of Ramesses. Napoleon's men tried to remove the statue from the Ramesseum in 1798, but failed. There is a hole about the size of a tennis ball drilled into the torso, just above the right breast, which experts think came from this attempt. By 1799 the statue had been broken.

In 1816 the bust was successfully removed, rather appropriately, by a circus-strongman-turned-antiquities-dealer named Giovanni Battista Belzoni. Using a specially designed system of hydraulics Belzoni organized hundreds of workmen to pull the bust on wooden rollers, by ropes, to the banks of the Nile, almost exactly the method used to bring it to the Ramesseum in the first place. It is a powerful demonstration of Ramesses' achievement that moving just half the statue was considered a great technical feat 3,000 years later. Belzoni then loaded the bust on to a boat, and the dramatic cargo went from there to Cairo, to Alexandria, and then finally to London. On arrival, it astounded everybody who saw it and began a revolution in how we Europeans view the history of our culture. The Ramesses in the British Museum was one of the first works to challenge long-held assumptions that great art had begun in Greece.

Ramesses' success lay not only in maintaining the supremacy of the Egyptian state, through the smooth running of its trade networks and taxation systems, but also in using the rich proceeds for building numerous temples and monuments. His purpose was to create a legacy that would speak to all generations of his eternal greatness. Yet, by the most poetic of ironies, his statue has come to mean exactly the opposite.

Shelley heard reports of the discovery of the bust and of its transportation to England. He was inspired by accounts of its colossal scale, but he also knew what had happened to Egypt after Ramesses – with

the crown passing to Libyans and Nubians, Persians and Macedonians, and Ramesses' statue itself squabbled over by the recent European intruders. As Antony Gormley puts it, sculptures endure, and life dies; Shelley's poem 'Ozymandias' is a meditation not on imperial grandeur but on the transience of earthly power, and in it Ramesses' statue becomes a symbol of the futility of all human achievement.

> 'My name is Ozymandias, king of kings:
> Look on my works, ye Mighty, and despair!'
> Nothing beside remains. Round the decay
> Of that colossal wreck, boundless and bare
> The lone and level sands stretch far away.

PART FIVE

Old World, New Powers

1100–300 BC

About 1000 BC new powers arose in several parts of the world, overwhelmed the existing order, and took its place. Warfare was conducted on an entirely new scale. Egypt was challenged by its former subject peoples from Sudan; in Iraq a new military power, the Assyrians, built an empire that eventually covered much of the Middle East; and in China, a group of outsiders, the Zhou, overthrew the long-established Shang Dynasty. There were also profound changes in economic behaviour: in both what is now Turkey and China coins were used for the first time, leading to a rapid growth of commercial activity. Meanwhile, quite separately, the first cities and complex societies in South America began to emerge.

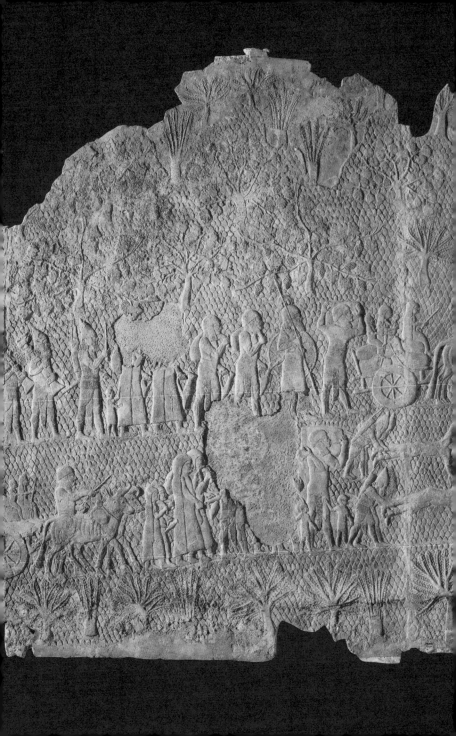

21

Lachish Reliefs

Stone panels, found at the Palace of King Sennacharib,
Nineveh (near Mosul), northern Iraq
700–692 BC

By 700 BC, the Assyrian rulers based in northern Iraq had built an empire that stretched from Iran to Egypt and covered most of the area that we now call 'the Middle East'. Indeed it could be argued this was the beginning of the very idea of the Middle East as a single theatre of conflict and control. It was the largest land empire yet created, the product of the prodigious Assyrian war-machine. The heartland of the Assyrian Empire lay on the fertile Tigris river. It was an ideal location for agriculture and trade, but it had no natural boundaries or defences, and so the Assyrians spent huge resources on a large army to police their frontiers, expand their territory and keep potential enemies at bay.

Lachish, today known as Tell ed-Duweir, over 800 kilometres (500 miles) south-west of the Assyrian heartland but only about 40 kilometres (25 miles) south-west of Jerusalem, stood at a vital strategic point on the trade routes that linked Mesopotamia to the Mediterranean and the immense wealth of Egypt. In 700 BC it was a heavily fortified hill town, the second city, after Jerusalem, in the kingdom of Judah which had managed – just – to stay independent of the Assyrians. But in the final years of the eighth century BC, Hezekiah, King of Judah, rebelled against the Assyrians. It was a big mistake. King Sennacherib mobilized the Assyrian imperial army, fought a brilliant campaign, seized the city of Lachish, killed its defenders and deported its inhabitants. An Assyrian account of the episode in the British Museum gives us Sennacherib's view of what happened, allegedly in his own words:

The people of Lachish led
into exile by the Assyrians

Because Hezekiah, King of Judah, would not submit to my yoke, I came up against him, and by force of arms and by the might of my power I took 46 of his strong-fenced cities; and of the smaller towns which were scattered about, I took and plundered a countless number. From these places I took and carried off 200,156 persons, old and young, male and female, together with horses and mules, asses and camels, oxen and sheep, a countless multitude.

Lachish was just one victim in a long series of Assyrian wars. Its story is particularly fascinating because we also know it from the other side, from the Hebrew Bible. The Book of Kings tells us that Hezekiah, King of Judah, refused to pay the tribute that Sennacherib demanded:

And the Lord was with him: and he prospered whithersoever he went forth: and he rebelled against the king of Assyria, and served him not.

The Bible understandably glosses over the disagreeable fact that Sennacherib responded by brutally seizing the cities of Judah until Hezekiah was crushed, gave in and paid up.

The resounding success of the Assyrian campaign is recorded in these carvings in shallow relief, about eight feet (2.5 metres) high. They would have run in a continuous frieze almost from floor to ceiling around one room of Sennacherib's palace at Nineveh, near modern Mosul in Iraq. They would once have been brightly painted, but even without any colour today they are astonishing historical documents – like a film in stone, an early Hollywood epic, perhaps, with a cast of thousands. The first scene shows the invading army marching in, then comes the bloody battle in the besieged town, and then we move on to the dead, the injured and the columns of passive refugees. Finally we see the victorious king presiding triumphantly over his conquest: Sennacherib, ruler of the great Assyrian Empire, and the terror of the ancient Middle East.

Like the director of any good propaganda war film, the sculptor has shown us the Lachish campaign as a perfectly executed military exercise. He sets the city among trees and vineyards, while below the Assyrian soldiers, archers and spearmen are marching. As the frieze progresses, wave after wave of Assyrians scale the city walls and eventually overwhelm the resident Judaeans. The next scene shows the

134 *Siege engines lead the way up artificial*
ramps with archers following
closely behind

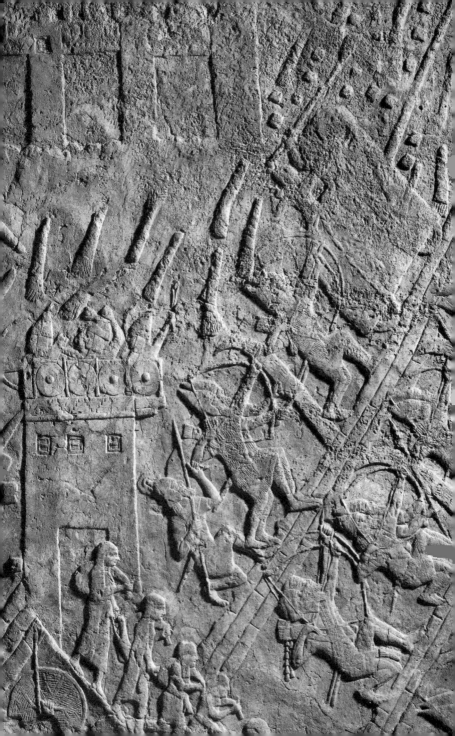

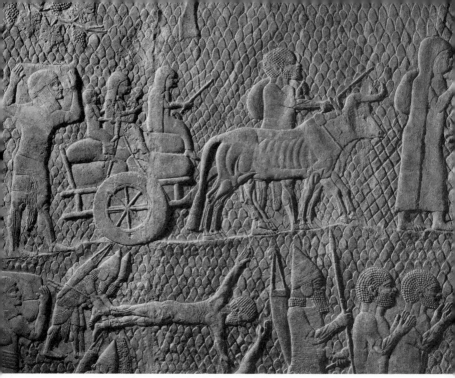

Prisoners of war and refugees are led away from Lachish

aftermath. Survivors flee the burning city, carrying what they can. These lines of people, carrying their worldly goods and heading for deportation, must be one of the earliest depictions of refugees that exists. They are almost unbearably poignant. It's impossible, looking at them close up, not to think of the millions of refugees and displaced people that this same region has seen over the centuries, and is still seeing.

We showed the Lachish Reliefs to Lord Ashdown, soldier, politician and international diplomat, who's had long experience of the human cost of military conflict, especially during his work in the Balkans:

> I saw refugee camps right across the Balkans and, frankly, I could never stop the tears coming to my eyes, because what I saw was my sister and my mother and my wife and my children. But I saw Serbs driven out by Bosnians, Bosnians driven out by Croats, Croats driven out by Serbs, and so on. I even saw the most shameful refugees of all ... the Roma

people, a huge camp of Roma people, maybe 40–50,000, and they were driven out when my army, the NATO army, was in charge. And we stood aside as their houses were burnt and they were driven from their homes. And that made me feel not just desperately sad, but also desperately ashamed. What is true, and what the reliefs show, is in a sense the immutable and unchangeable character of war. There are always wars, there are always deaths, there are always refugees. Refugees are normally the sort of flotsam and jetsam of war. They are left where they were washed up when the war finished.

The people that we see on the relief are the victims of war who pay the price of their ruler's rebellion. Families with carts packed high with bundles are being led into exile, while Assyrian soldiers carry their plundered spoils towards the enthroned King Sennacherib. An inscription credits the king himself with the victory: 'Sennacherib, King of the World, King of Assyria, sat on a throne and watched the booty of Lachish pass before him.' He presides over the sacked city and its defeated inhabitants as an almost divine overlord, watching the citizens as they are deported to another part of the Assyrian Empire. This practice of mass deportation was standard Assyrian policy. They moved large groups of troublesome people from their homelands to resettle them in other parts of the empire, including Assyria itself. Deportation on this scale must have been logistically challenging, but the Assyrian army went through so many campaigns that the programme of moving people around would have been refined to a point of industrial efficiency.

The strategy of shifting populations has been a constant phenomenon of empire ever since. Perhaps our nearest equivalent – just about in living memory – is Stalin's deportation of peoples during the 1930s. Like Sennacherib, Stalin knew the value of moving rebellious peoples out of strategic areas and relocating them far away from their homelands.

The military historian Antony Beevor puts these two imperial heavies – Sennacherib and Stalin – in historical perspective:

> Well I think one sees the way that in the past, for example in the deportation of the Judaeans after the siege of Lachish, rulers wished to establish their total power. It was a demonstration of their supremacy.
>
> By the twentieth century there was a much greater element of notions

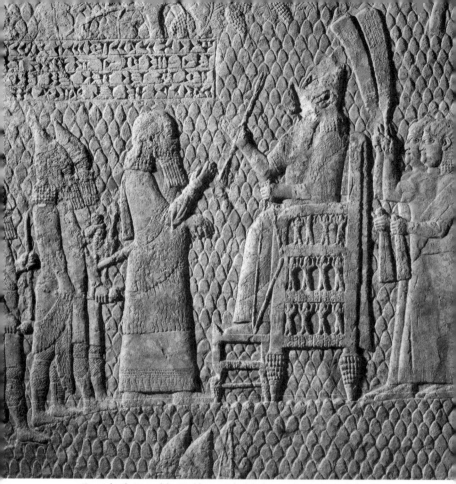

'Sennacherib, King of the World ... watched the booty of Lachish pass before him'

of treason, particularly political treason, as one saw with Stalin and the Soviet Union. When it came to the real waves of deportations which were punishing whole peoples, this was because Stalin suspected that they had collaborated with the Germans during the invasion of the Soviet Union from 1941 onwards.

And the peoples who were most famously affected were of course the Crimean Tartars, the Ingushes, the Chechens, the Kalmuks – one is certainly talking of three to three and a half million. In many cases they reckon that 40 per cent of those died during the transport, and of course

during the forced labour when they arrived. And when I say 'arrived' ... usually what happened was, a lot of them were just literally dropped by the railhead, with no tools, no seeds, and were literally left there in the desert, so it's not surprising how many died. It was interesting to see that in Lachish, in the early deportations of the pre-Christian times, that they took their sheep with them, but in these cases they had to leave everything there.

So Sennacherib was not quite as bad as Stalin. Cold comfort for the victims. The Lachish Reliefs show the misery that defeat in war always entails, though of course their main focus is not the Judaeans but Sennacherib in his moment of triumph. They do not record Sennacherib's less than glorious end – assassinated by two of his sons while he was at prayer to the gods who had appointed him ruler. He was succeeded by another son, whose own son, in his turn, conquered Egypt and defeated the pharaoh Taharqo, the subject of the next chapter. The cycle of war that the Lachish Reliefs show – brutal, pitiless and devastating for the civilian population – was about to begin all over again.

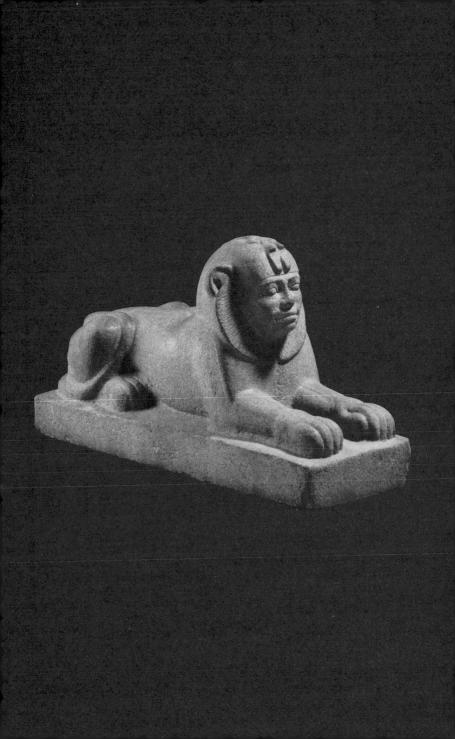

22

Sphinx of Taharqo

Granite sphinx, found at Kawa, northern Sudan

AROUND 680 BC

If you were to ask which country the Nile river belongs to, most people would immediately say Egypt. But the Nile is a river that can be claimed by nine different African countries, and, as water resources get scarcer, the question of its ownership today is a burning political issue.

A critical fact of modern Egypt's life is that most of the Nile is actually in Sudan. Egypt has always been wary of its huge southern neighbour, but for most of its history it has been by far the stronger of the two. As this object shows, though, there was a moment, around 3,000 years ago, when for a century or so it all looked very different.

Sphinxes – statues with a lion's body and a man's head – are creatures of myth and legend, but they are also one of the great symbols of Egyptian royalty and power, the most famous of all, of course, being the Great Sphinx at Giza.

Compared with the one at Giza, this sphinx is very small – about the size of a spaniel – but it is particularly interesting, because it's not just a hybrid of a man and a lion but a fusion of Egypt and the kingdom of Kush, now northern Sudan. It's made out of sandy grey granite and it's beautifully preserved. The muscular lion's back, the mane of hair and the powerful outstretched paws are all classically Egyptian – but it's not a typically Egyptian pharaoh's face, because this man is unquestionably a black African, and this sphinx is the image of a black pharaoh. Hieroglyphics on the sphinx's chest spell it out: this is a portrait of the great King Taharqo, the fourth pharaoh to rule over the combined kingdoms of Kush and Egypt.

I'm referring to the world as it was around 700 BC. Even though populations were tiny – only about 1 per cent of today's world

population occupied the whole of the globe then – large-scale conflicts were frequent and bitter. War was everywhere, and one of the features of the period was the conquest of long-established centres of wealth and civilization by poorer peoples living on the edge. In the case of Egypt, this occurred when the mighty land of the pharaohs was conquered and for a time ruled by its southern neighbour – the kingdom of Kush.

For thousands of years Egypt had looked on its southern Kushite neighbour essentially as a rich but troublesome colony that could be exploited for its raw materials – there was gold and ivory and, very importantly, slaves. In this almost colonial relationship, Egypt was very much the master. But in 728 BC the balance of power flipped. Egypt had become fragmented and weak, and the Kushite king, Piankhi, took the opportunity to send his armies north, where they picked off the cities of Egypt one by one, until finally the north was quashed, and the Kushites were in charge of an empire that ran roughly from modern Khartoum to modern Alexandria. In order to govern this new state, they created a new national identity, a hybrid that would combine both Egypt and Kush.

Taharqo, represented by the British Museum sphinx, was the most important of all the Kushite kings. He initiated a golden age for his immense new kingdom, and he succeeded largely because, rather than imposing Kushite customs on the Egyptians, he absorbed and adopted theirs. Even in Kush itself, Taharqo built pyramids on the Egyptian model, and he worshipped the Egyptian god Amun; he restored temples in the Egyptian style, and his officials wrote in Egyptian hieroglyphics. It's a pattern that we see again and again in successful conquests: the conquerors use the existing symbols and vocabulary of power, because those are the ones that are already familiar to the population. It makes sense to keep using a language of control that everybody is accustomed to accepting. The Sphinx of Taharqo, in its calculated mixture of the two different traditions, is not just a striking portrait of the Kushite ruler as a traditional Egyptian pharaoh; it's also a lesson in political method. And, for a short period, that method worked brilliantly.

This brief Sudanese conquest of Egypt has been a largely forgotten history. The official narrative of Egypt underplayed the Kushite dis-

ruption, blandly calling the reign of the Kushite kings the 25th Dynasty, thus quietly incorporating them into an unbroken story of an eternal Egypt; but Kush's historical role is now being energetically reassessed, and Sudanese history in some measure rewritten.

In the British Museum we have a curator who has been central to this work of recovery and re-evaluation. Dr Derek Welsby, a leading expert on the archaeology of the Sudan, has been digging along the Nile for many years. He has done a lot of work at Kawa, north of Khartoum, where this sphinx came from. It was made to go into a temple there, which had been restored by Taharqo. Derek's description of the working conditions at his excavation gives an idea of what this land would have been like for the Kushites:

> Often it's incredibly hot on site. Even in the middle of winter it can be very hot, but sometimes, early in the morning, it's very cold, 4 or 5 degrees centigrade. You've got a very strong wind to contend with. But by 11 o'clock it can be 35 or 40 degrees. It changes very dramatically.
>
> The temple that Taharqo built at Kawa in the heart of Kush is purely Egyptian in design – it was actually built by Egyptian workmen and architects sent by Taharqo from his capital at Memphis in Lower Egypt, but it was built in the heart of Kush. But the Egyptian influences are just a veneer over Kushite culture. The indigenous African culture continued right the way through the Kushite period.
>
> It used to be considered that the Kushites were slavishly borrowing things from Egypt and just copying Egyptian models, but now we see that they are picking and choosing. They're choosing the things that are enhancing their view of the world, the status of their ruler, and so on, and they're retaining many of their local cultural elements as well. You see this particularly in their religion. Not only do you get the Egyptian gods like Amun, but you also get the major local Kushite gods such as Apedemake, sometimes being worshipped in the same temples.

As originally placed in the temple, Taharqo's sphinx would have been seen only by the ruler and his closest circle, which would have included priests and officials from both Egypt and Kush. Coming upon it in an inner sanctuary, Kushites would have been reassured by its black African features, while Egyptians would have immediately felt at home with its peculiarly Egyptian iconography.

Taharqo's sphinx is a more sophisticated piece of political imagery than just a mix of north and south; it also combines the present with the long-distant past. The form of the lion's mane and his ears closely resemble elements found on ancient Egyptian sphinxes as far back as the 12th Dynasty, about a thousand years before this sphinx was made. The message is clear: this black pharaoh, Taharqo, stands in a long line of great Egyptian rulers, who have held dominion over all the lands of the Nile.

Taharqo was eager to expand Egypt beyond Sinai and its north-east border. This aggressive policy led to conflict with the Assyrian king, Sennacherib (whose stone reliefs were described in Chapter 21). Around 700 BC the Kushites allied themselves with Hezekiah, King of Judah, and fought alongside him.

But this challenge to the Assyrian war-machine ultimately led to Taharqo's downfall. Ten years later, the Assyrians came looking for him, seeking the colossal wealth of Egypt, and although he repelled them that time, they soon returned. In 671 BC they forced Taharqo to flee south to his native Kush. He lost his wife and his son to the enemy and, after more attacks from the Assyrians, he was finally expelled.

In the long history of Egypt, Kushite rule was a brief interlude of not even 150 years. Yet it reminds us that the border between what is now Egypt and Sudan is a constant faultline, both geographic and political, that has frequently divided the peoples of the Nile Valley and frequently been fought over. We'll see that faultline again later in this history (Chapters 35 and 94), because both the Roman and the British empires bloodily revisited this contested boundary between Egypt and Kush. Geography has determined that this will always be a frontier, because it's here that the first cataract breaks up the Nile into small, rocky channels that are very hard to navigate, making contact between north and south highly problematic. For Africans, the Nile has never been just an Egyptian river, and it's claimed as fiercely by the Sudanese now as it was in the time of Taharqo. The Sudanese-born political commentator Zeinab Badawi sees this as the cause of friction between two peoples who are really very similar:

> I wouldn't say that there are any huge ideological differences between the Sudanese and the Egyptian governments, and there is a huge affinity

between the people. The biggest source of friction and potential tension between Egypt and Sudan has been in the Nile, and how the waters of the Nile are used. The feeling that a lot of northern Sudanese might have is that the Nile runs much more through Sudan than it does through Egypt. Sudan is the biggest country in Africa. It's the tenth biggest in the world, the size of western Europe. It is the land of the Nile, and maybe there is a kind of brotherly resentment by the northern Sudanese that the Egyptians have in a sense claimed the Nile as their own, whereas the Sudanese in a sense feel they are the proper custodians of the Nile, because, after all, most of its journey is through the territory of Sudan.

This perhaps makes it clear why the union of Egypt and Sudan just under 3,000 years ago was easier to achieve in the sculpted form of Taharqo's sphinx than in the unstable world of practical politics. Recovering the story of Kush has been one of the great achievements of recent archaeology, showing how an energetic people on the edge of a great empire were able to conquer it and appropriate its traditions. A similar story was taking place somewhere else at almost exactly the same time – in China, where our next object comes from.

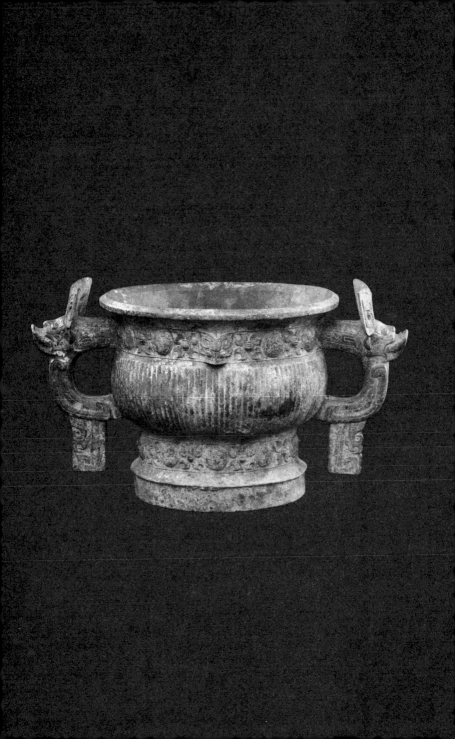

23

Chinese Zhou Ritual Vessel

Bronze gui, *found in western China*

1100–1000 BC

How often do you dine with the dead? It may seem a strange question, but if you're Chinese it may not be quite so surprising, because many Chinese, even now, believe that deceased family members watch over them from the other side of death and can help or hinder their fortunes. When somebody dies they are equipped for burial with all kinds of practical bits and pieces: a toothbrush, money, food, water – or possibly today a credit card and a computer. The Chinese afterlife often sounds depressingly (perhaps reassuringly) like our own. But there is one great difference: in China the dead are paid huge respect. A well-equipped send-off is just the beginning. Ritual feasting – holding banquets with and for the ancestors – has been for centuries a part of Chinese life. Professor Dame Jessica Rawson, a renowned expert on ancient Chinese bronzes, goes as far as to say:

> The primary and most ancient religion in China consists of preparing ceremonial meals for the dead. The first dynasties of China, the Shang [*c.* 1500–1050 BC] and the Zhou [*c.* 1050–221 BC], made large numbers of fine bronze containers for food, alcohol and water, and used them in a big ceremony, sometimes once a week, maybe once every ten days. Their belief is that if food, wine or alcohol is properly prepared, it will be received by the dead and nourish them, and those dead, the ancestors, will look after their descendants in return for this nourishment. The bronze vessels which we see were prized possessions for use *in life*. They were not made primarily for burial, but when a major figure of the elite died, it was believed that he would carry on offering ceremonies of food and wine to his ancestors in the afterlife – and indeed entertain them at banquets.

This spectacular bronze vessel, made about 3,000 years ago, is called a *gui*. *Gui* often carry inscriptions which are now a key source for Chinese history, and this bronze is just such a document. It would have been one of a set of vessels of different sizes, rather like a set of saucepans in a smart modern kitchen, and although we don't know how many companions it might once have had, each vessel would have had a clearly defined role in the preparation and serving of food at the regular banquets that were organized for the dead. This one is about the shape and size of a large punch bowl, about a foot (27 centimetres) across, with two large curved handles. There is an elaborate, flower-like decoration on bands at the top and bottom, but its most striking features are undoubtedly its handles, each of which is a large beast, with tusks, horns and huge square ears caught in the act of swallowing a bird whose beak is just emerging from its jaws. Bronze vessels like this were among the most iconic objects of ancient China, and making them was an extraordinarily complicated business. First the ores that contain copper and tin had to be smelted to make the bronze itself, then the molten bronze had to be cast – a technology in which China led the world. This *gui* was not made as a single object but as separate pieces cast in different moulds which were then joined together to make one complex and intricate work of art. The result is a vessel which at that date could have been made nowhere else in the world. The sheer skill, the effort and expense involved in making bronze vessels like these made them immediately objects of the highest value and status, fit therefore for the most solemn rituals.

In domestic ceremonies, families offered food and drink to their watchful dead; but on a grander scale governments offered them to the mighty gods. If the *gui* addressed the ancestors and the world of the past, it also emphatically asserted authority in the present – at a troubled transitional moment for China, when the link between heavenly and earthly authorities was supremely important.

The Shang Dynasty, which came to power in about 1500 BC, had seen the growth of China's first large cities. Their last capital, at Anyang on the Yellow River in north China, covered an area of 30 square kilometres (10 square miles) and had a population of 120,000 – at the time it must have been one of the largest cities in the world. Life in Shang

cities was highly regulated, with twelve-month calendars, decimal measurement, conscription and centralized taxes. As centres of wealth, the cities were also places of outstanding artistic production, in ceramics, jade and, above all, bronze. But then, about 3,000 years ago, from the Mediterranean to the Pacific, existing societies collapsed and were replaced by new powers.

The Shang, which had been in power for around 500 years, was toppled by a new dynasty, the Zhou, who came from the west, from the steppes of central Asia. Like the Kushites of Sudan who conquered Egypt at roughly the same time, the Zhou were a people from the edge who challenged and overthrew the old-established, prosperous centre. They ultimately took over the entire Shang kingdom and, again like the Kushites, appropriated not just the state they had conquered but its history, imagery and rituals too. They continued to support artistic production of many different kinds, and they continued the ritual central to Chinese political authority of elaborate feasting with the dead using vessels like our *gui*. This was in part a public assertion that the gods endorsed the new regime.

If you look inside the *gui* there is a surprise, which makes it into an instrument of power as well as an object of ritual. At the bottom, where it would have normally been hidden by food when in use, there is an inscription in Chinese characters, not unlike those still used today, which tells us that this particular bowl was made for a Zhou warrior, one of the invaders who overthrew the Shang Dynasty. At this date, any formal writing is prestigious, but writing in bronze carries a very particular authority. The inscription tells us of a significant battle in the Zhou's ultimate triumph over the Shang:

> The King, having subdued the Shang country, charged the Marquis K'ang to convert it into a border territory to be the Wei state. Since Mei Situ Yi had been associated in effecting this change, he made in honour of his late father this sacral vessel.

So the man who commissioned the *gui*, Mei Situ Yi, did so in order to honour his dead father and at the same time, as a loyal Zhou, commemorated the quashing of a Shang rebellion in about 1050 BC by the Zhou king's brother, the Marquis K'ang. As writing on bamboo or wood has perished, bronze inscriptions of this kind are now our

principal historical source, and through them we can reconstruct the continued tussling between the Shang and the Zhou.

It is not at all clear why the smaller and much less technically sophisticated Zhou were able to defeat the powerful and well-organized Shang state. They seem to have had a striking ability to absorb and to shape allies into a coherent attacking force, but above all they were buoyed up by their faith in themselves as a chosen people. In first capturing and then ruling the Shang kingdom they saw themselves – as so many conquerors do – as enacting the will of the gods; so they fought with the confidence born of knowing that they were the rightful inheritors of the land. But – and this was new – they articulated this belief in the form of a controlling concept that was to become a central idea in Chinese political history.

The Zhou were the first to formalize the idea of the 'Mandate of Heaven', the Chinese notion that heaven blesses and sustains the authority of a just ruler. An impious and incompetent ruler would displease the gods, who would withdraw their mandate from him. Accordingly it followed that the defeated Shang must have lost the Mandate of Heaven, which had passed to the virtuous, victorious Zhou. From this time on, the Mandate of Heaven became a permanent feature of Chinese political life, underpinning the authority of rulers or justifying their removal. Dr Wang Tao, an archaeologist at the University of London, describes it this way:

> The mandate transformed the Zhou, because it allowed them to rule other people. The killing of a king or senior member of the family was the most terrible crime possible, but any crime against authority could be justified by the excuse of 'the Mandate of Heaven'. The concept equates in its totemic quality to the Western idea of democracy. In China if you offended the gods, or the people, you would see omens in the skies – thunder, rain, earthquakes. Every time that China had an earthquake, its political rulers were scared, because they interpreted it as a reaction to some kind of offence against the Mandate of Heaven.

Gui like this have been found over a wide swathe of China, because the Zhou conquest continued to expand until it covered nearly twice the area of the old Shang kingdom. It was a cumbersome state, with fluctuating levels of territorial control. Nonetheless, the Zhou Dynasty

The inscription inside the gui 151
commemorates the Zhou's
suppression of a Shang rebellion

lasted for as long as the Roman Empire, indeed longer than any other dynasty in Chinese history.

And as well as the Mandate of Heaven, the Zhou bequeathed one other enduring concept to China. Three thousand years ago they gave to their lands the name of 'Zhongguo': the 'Middle Kingdom'. The Chinese have thought of themselves as the Middle Kingdom, placed in the very centre of the world, ever since.

24

Paracas Textile

Textile fragments, from the Paracas peninsula, Peru

300–200 BC

Looking at clothes is a key part of any serious look at history. But, as we all know to our cost, clothes don't last – they wear out, they fall apart and what survives gets eaten by the moths. Compared with stone, pottery or metal, clothes are pretty well non-starters in a history of the world told through 'things'. So regrettably, but not surprisingly, it's only now, well over a million years into our story, that we're coming to clothes and to all that they can tell us about economics and power structures, climate and customs, and how the living view the dead. Nor is it surprising that, given their vulnerability, the textiles we are looking at are fragments.

The South America of 500 BC, like the Middle East, was undergoing change. The South Americans' artefacts, however, were on the whole much less durable than a sphinx; there, it was textiles that played a central part in the complex public ceremonies. We're learning new things all the time about the Americas at this date, but, as there are no written sources, much is still very mysterious, compared, for example, with what we know about Asia, belonging to a world of behaviour and belief that we still struggle to interpret from fragmentary evidence like these pieces of cloth, well over 2,000 years old.

In the British Museum these textiles are usually kept in specially controlled conditions, and never exposed to ordinary light and humidity for long. The first thing that strikes you about them is their extraordinary condition. They're each about 10 centimetres (3 or 4 inches) long, and they're embroidered in stem-stitch using wool, from either llamas or alpacas, we're not sure which – both animals are native to the Andes and were soon domesticated. The figures have been very

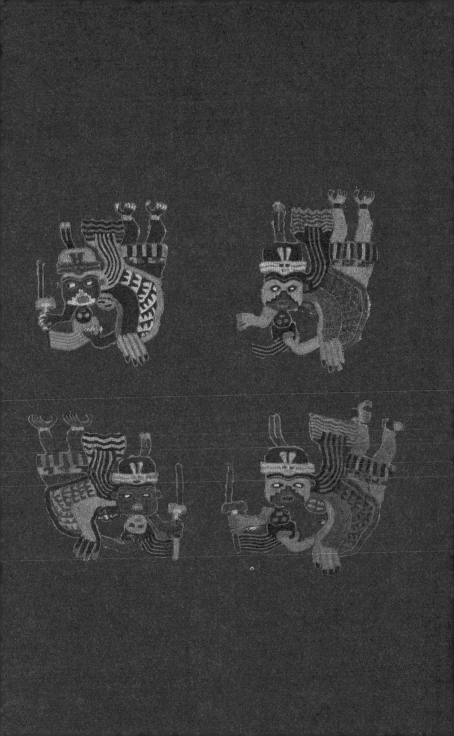

carefully cut out from a larger garment – a mantle or a cape, perhaps. They are strange beings, not entirely human in form, which seem to have talons instead of hands, and claws for feet.

At first glance you might find these figures rather charming, as they appear to be flying through the air with their long pigtails or top knots trailing behind them … but when you look more closely, they are disconcerting, because you can see that they are wielding daggers and clasping severed heads. Perhaps the most striking thing about them, though, is the intricacy of the sewing and the surviving brilliance of the colours, with their blues and pinks, yellows and greens, all sitting very carefully judged next to one another.

These jewel-like scraps of cloth were found on the Paracas peninsula, about 240 kilometres (150 miles) south of modern Lima. In the narrow coastal strip between the Andes Mountains and the Pacific, the people of Paracas produced some of the most colourful, complex and distinctive textiles that we know. These early Peruvians seem to have put all their artistic energies into textiles. Embroidered cloth was for them roughly what bronze was for the Chinese at the same date: the most revered material in their culture, and the clearest sign of status and authority. These particular pieces of cloth have come down to us because they were buried in the dry desert conditions of the Paracas peninsula. Textiles from ancient Egypt have survived from the same period, in similar dry climates thousands of miles away. Like the Egyptians, the Peruvians mummified their dead. And in Peru, as in Egypt, textiles were intended not just for wearing in daily life but also for clothing the mummies: that was the purpose of the Paracas textiles.

The Canadian weaver and textile specialist Mary Frame has been studying these Peruvian masterpieces for over thirty years, and she finds in these funeral cloths an extraordinary organization at work:

Some of the wrapping cloths in these mummy bundles were immense – one was 87 feet long. It would have been a social enactment, a happening, to lay out the yarns to make these cloths. You can have up to 500 figures on a single textile, and they are organized in very set patterns of colour repetition and symmetry. The social levels were reflected in cloth to a tremendous degree. Everything about textiles was controlled – what kind of fibre, colours, materials could be used and by what groups.

There has always been a tendency to do that in a stratified society – to use something major, like textiles, to visibly reflect the levels in the society.

There was no writing that we know of at this time in Peru, so these textiles must have been a vital part of this society's visual language. The colours must have been electrifying against the everyday palette of yellow and beige hues that dominated the landscape of the sandy Paracas peninsula. They were certainly very difficult colours to achieve. The bright red tones were extracted from the roots of plants, while the deep purples came from molluscs gathered on the shore. The background cloth would have been cotton, spun and dyed before being woven on a loom. Figures were outlined first, and then the details – like clothes and facial features – were filled in in different colours with exquisite precision, presumably by young people, as you need perfect eyesight for stitching like this.

Production would have required coordinating large numbers of differently skilled labourers – the people who reared the animals for the wool or who grew the cotton, those who gathered the dyes, and then the many who actually worked on the textiles themselves. A society that could organize all this, and devote so much energy and resource to materials for burial, must have been both prosperous and very highly structured.

Making the mummy bundles, in other words preparing the Paracas elite for burial, involved an elaborate ritual. The naked corpse was first bound with cords to fix it in a seated position. Wrapped pieces of cotton or occasionally gold were put in the mouth, and grander corpses had a golden mask strapped to the lower half of their face. After this the body was wrapped in a large embroidered textile – our fragments must come from one of these – and the encased body was then seated upright in a big shallow basket containing offerings of shell necklaces, animal skins, bird feathers from the Amazonian jungle and food, including maize and peanuts. Then body, offerings and basket, all together, were wrapped in layers of plain cotton cloth to form one giant conical mummy bundle, sometimes up to 1.5 metres (5 feet) wide.

It's impossible to know exactly what our embroidered figures represent. Apparently floating in the air, with bared teeth and clawed hands, it is easy to imagine that they are not human but creatures from

the spirit world. But as they hold daggers and severed heads, perhaps we are in the realm of ritual sacrifice. What is this killing for? And why would you embroider it on a textile? We're clearly in the presence of a very complex structure of belief and myth, and the stakes are as high as they can be. For these are embroideries about life and death. Mary Frame explains:

> The severed heads, the wounds, the strange posture, seem to be depicting a whole set of stages of transformation between the human into the mythic ancestor. Blood and fertility seem to be themes that are intertwined with this. These textiles are really directed like a supplication for success with crops. Peruvian land is very marginal – it's terrifically arid down there; the people had an intense focus on rituals that would ensure continual success. Water is necessary for plant growth – blood is conceived of as being even more potent.

When the first Europeans arrived in Central and South America 1,800 years later, they found societies structured around blood sacrifices to ensure the continuing cycle of sunshine and rain, seasons and crops. So these four little embroideries give us a certain amount of information, and can form the basis of a great deal of speculation, about how the people of the Paracas lived, died and believed. But, quite apart from that, they are great imaginative achievements, masterpieces of needlework.

It's certain that American societies at this date, even advanced ones like the Paracas, were much smaller in scale than the contemporary states that we've been looking at in the Middle East and China. It was to be many centuries yet before empires like the Incas would emerge.

But these textiles and embroideries of the Paracas, produced more than 2,000 years ago, are now considered among the greatest in the world. These textiles are seen as part of the fabric of the nation, and in contemporary Peru there is a determined effort to revitalize these traditional weaving and sewing practices in order to connect modern Peruvians directly to their ancient, indigenous, and entirely non-European past.

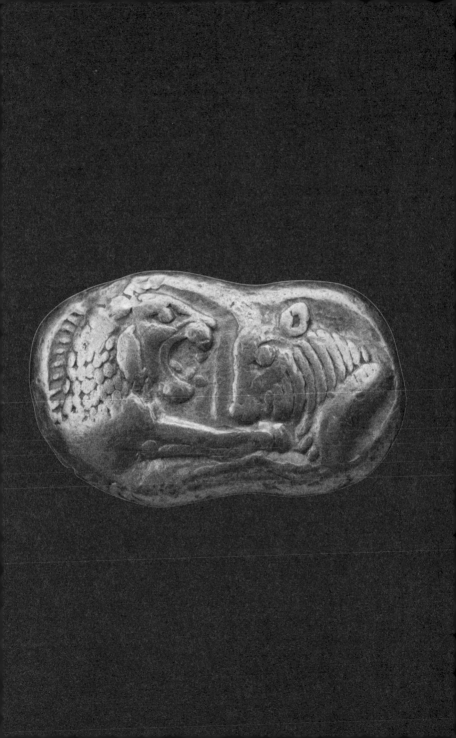

25

Gold Coin of Croesus

Gold coin, minted in Turkey

AROUND 550 BC

'As rich as Croesus'. It's a phrase that echoes down the centuries and is still used in advertisements for get-rich-quick investment wheezes. But how many of those who use it ever pause to think about the original King Croesus, who, until a twist at the end of his life, was indeed fabulously rich and, as far as we know, very happy with it?

Croesus was a king in what's now western Turkey. His kingdom, Lydia, was among the new powers that emerged across the Middle East about 3,000 years ago, and these are some of the original gold coins that made Lydia and Croesus so rich. They are examples of a new type of object that would ultimately become a power in its own right – coinage.

We've all grown so accustomed to using little round pieces of metal to buy things that it's easy to forget that coins arrived quite late in the history of the world. For more than 2,000 years states ran complex economies and international trading networks without a coin to hand. The Egyptians, for example, used a sophisticated system that measured value against standard weights of copper and gold. But as new states and new ways of organizing trade emerged, coinage began to make an appearance. Fascinatingly, it happened independently in two different parts of the world at almost the same time. The Chinese began using miniature spades and knives in very much the same way that we would now use coins, and virtually simultaneously in the Mediterranean world the Lydians started making actual coins as we would still recognize them – round shapes in precious metals.

These early Lydian coins come in many different sizes, from about the scale of a modern British 1p piece right down to something hardly bigger than a lentil. Lydian coins are not all the same shape. The largest

one here is a kind of figure-of-eight shape – an oblong, slightly squeezed in the middle – and on it are a lion and a bull facing each other as if in combat, and about to crash together head-on.

These coins were minted under Croesus around 550 BC. It's said that Croesus found his gold in the river that once belonged to the legendary Midas – he of 'the golden touch' – and it's certain that the region was rich in gold, which would have been extremely useful in the great trading metropolis of Lydia's capital city, Sardis, in north-west Turkey.

In small societies there isn't really a great need for money. You can generally trust your friends and neighbours to return any labour, food or goods in kind. The need for money, as we understand it, grows when you are dealing with strangers you may never see again and can't necessarily trust – that is, when you're trading in a cosmopolitan city like Sardis.

Before the first Lydian coins, payments were made mostly in precious metal – effectively just lumps of gold and silver. It didn't really matter what shape the metal was, just how much it weighed and how pure it was. But there is a difficulty. In their natural state, gold and silver are often found mixed with each other and, indeed, mixed with other less valuable metals. Checking a metal's purity was a tedious task, likely to hold up every business transaction. Even once the Lydians and their neighbours had invented coinage, about a hundred years before Croesus, this problem of purity still remained. They used the naturally occurring mixture of gold and silver, not the pure forms of the metals. How could you know exactly what a particular coin was made of and therefore what it was worth?

The Lydians eventually solved this problem, speeded up the market and, in the process, became hugely rich. They realized that the answer was for the state to mint coins of pure gold and pure silver, of consistent weights that would have absolutely reliable value. If the state guaranteed it, this would be a currency that you could trust completely and, without any checking, spend or accept without a qualm. How did the Lydians manage to pull this off? Dr Paul Craddock, an expert in historical metals, explains:

> The Lydians hit on the idea of the state, or the king, issuing standard weights and standard purity. The stamps on them are the guarantee of the weight and the purity. If you're guaranteeing the purity, then it is

absolutely necessary that you have the ability not just to add elements to the gold but also to take them out. To some degree, taking out elements like lead and copper is not too bad; but unfortunately the main element that came with the gold out of the ground was silver, and this had not been done before. Silver is reasonably resistant to chemical attack, and gold is very resistant to chemical attack. They took either a very fine powder of the gold straight from the mines, or else got bigger pieces of old gold hammered out into very thin sheets and put these in a pot along with common salt, sodium chloride. They then heated that in a furnace to about 800 degrees centigrade, and ultimately they were left with pretty pure gold.

So the Lydians learnt how to make pure gold coins. No less importantly, they then employed craftsmen to stamp on them symbols indicating their weight, and thus their value. These first coins have no writing on them – dates and inscriptions on coins were to come much later – but archaeological evidence allows us to date our coins to around 550 BC, the middle of Croesus's reign.

The stamp used to indicate weight on his coins was a lion, and as the size and therefore the value of the coin decreased, ever smaller parts of the lion's anatomy were used. So, for example, the smallest coin shows only a lion's paw. This new Lydian method of minting moved the responsibility for checking the purity and weight of the coins from the businessman to the ruler – a switch that made the city of Sardis an easy, swift and extremely attractive place to do business in. Because people could trust Croesus's coins, they used them far beyond the boundaries of Lydia itself, giving him a new kind of influence – financial power. Trust is of course a key component of any coinage – you've got to be able to rely on the stated value of the coin, and on the guarantee that it implies. It was Croesus who gave the world its first reliable currency. The gold standard starts here. The consequence was great wealth.

It was thanks to that wealth that Croesus was able to build the great Temple of Artemis at Ephesus – the rebuilt version of which became one of the Seven Wonders of the Ancient World. But did Croesus's money bring him happiness? We're told that he was warned by a wise Athenian statesman that no man, however rich and powerful,

could be considered happy until he knew his end. Everything would depend on whether he died happy.

Lydia was powerful and prosperous, but it was threatened from the east by the rapidly expanding power of the Persians. Croesus responded to this threat by seeking advice from the famed Oracle at Delphi. He was told that, in the coming conflict, 'a great empire would be destroyed' – the archetypal Delphic utterance that could be interpreted either way. It was his own empire, Lydia, that was conquered, and Croesus was captured by the great Persian king Cyrus. In fact, his end wasn't so bad. Cyrus shrewdly appointed Croesus as an adviser – I like to think as his financial adviser – and the victorious Persians quickly adopted the Lydian model, spreading Croesus's coins along the trade routes of the Mediterranean and Asia, and then minting their own coins in pure gold and pure silver at Croesus's mint in Sardis. It echoes the way the Kushites absorbed Egyptian culture when they conquered their northern neighbour.

It's probably not a coincidence that coinage was invented at pretty much the same time in China and in Turkey. Both developments were responses to the fundamental changes seen across the world around 3,000 years ago, from the Mediterranean to the Pacific. These military, political and economic upheavals brought us not only modern coinage, but something else that's resonated till the present day – new ideas about how people and their rulers saw themselves. In short, the beginning of modern political thinking, the world of Confucius and Classical Athens. The next stage of that journey starts with the empire that toppled Croesus – the Persians.

PART SIX

The World in the Age of Confucius

500–300 BC

Across the world different civilizations were evolving models for the government of society that would remain influential for thousands of years. While Socrates taught the people of Athens how to disagree, Confucius was propounding his political philosophy of harmony in China and the Persians found a way for different peoples to coexist under their vast empire. In Central America the Olmecs created the sophisticated calendars, religion and art that would characterize Central American civilizations for over a thousand years. In northern Europe there were no towns or cities, states or empires, no writing or coinage, but the objects that were made there nevertheless show that these civilizations had a sophisticated vision of themselves and their place in the wider world.

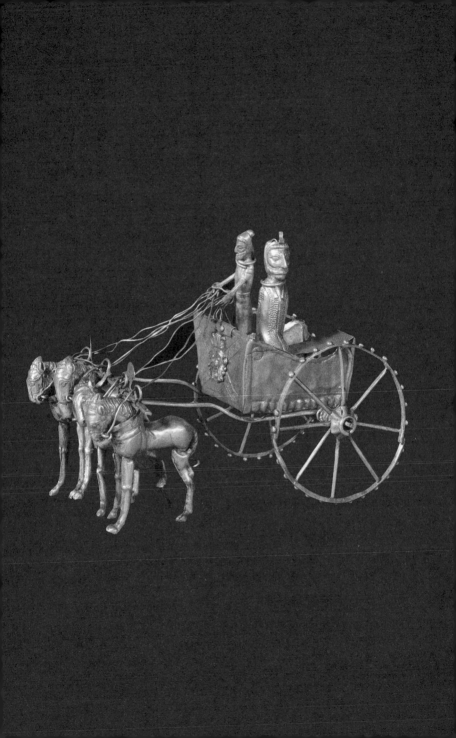

2 6

Oxus Chariot Model

Gold model, found near the Oxus river, on the
border of Afghanistan and Tajikistan

500–300 BC

In the fifth century BC, societies across the world were beginning to articulate very clear ideas about themselves and about others. They were inventing and defining what we would now call statecraft. This is the era of what some have called the 'empires of the mind'. The world superpower of 2,500 years ago was Persia, an empire that was run on a rather different principle from previous empires. As Dr Michael Axworthy, the Director of the Centre for Persian and Iranian Studies at the University of Exeter, has put it, up to that time they had generally been based on naked might being right; the Persian Empire was based on the principle of the iron fist in the velvet glove.

I want to explore that empire in this tiny golden chariot, pulled by four golden horses. It's easy to imagine a chariot like this racing along the great Persian imperial roads. There are two figures in it: the driver, who stands holding the reins, and the much larger and clearly very important passenger, who sits on a bench at his side. He is probably meant to be a senior administrator, visiting the distant province that he rules on behalf of the king of Persia.

The model was indeed found in a very distant province, on the far eastern edge of the empire, near the borders of modern Tajikistan and Afghanistan. It's part of a huge hoard of gold and silver objects, known as the Oxus treasure, that for more than a hundred years have formed one of the great collections at the British Museum.

This exquisite chariot sits quite comfortably on the palm of the hand, where it looks like an expensive toy for a privileged child. We can't, however, be certain that it was in fact a toy; it could have been

made as an offering to the gods, either asking them for a favour or thanking them for one. But whatever it meant then, this chariot today allows us today to conjure up an empire.

What kind of an empire was it? About 70 miles north of Shiraz, in Iran, the low camel-coloured hills open out into a flat windy plain. In this featureless landscape is a huge stone plinth, rising in six gigantic steps to what looks like a gabled hermit's cell. It dominates the entire landscape. It is the tomb of Cyrus, the first Persian emperor, the man who 2,500 years ago built the largest empire that the world had then seen, and changed the world – or at least the Middle East – for ever.

Centred on modern Iran, the vast Persian Empire ran from Turkey and Egypt in the west to Afghanistan and Pakistan in the east. To control an empire like this required land transport on a quite unprecedented scale; the Persian Empire is the first great 'road' empire of history.

The Persian Empire was more a collection of kingdoms than what we might immediately think of as an empire. Cyrus called himself the Shahanshah – the King of Kings – making clear that this was a confederation of allied states, each with its own ruler but all under firm Persian control. It was a model that allowed a great deal of local autonomy and all sorts of diversity – very different from the later Roman model. The historian and writer Tom Holland elaborates:

> Persian occupation could be compared to a light morning mist settling over the contours of their empire – you were aware of it, but it was never obtrusive.
>
> The Roman approach was to encourage those they had conquered to identify with their conquerors, so that ultimately everyone within the borders of the Roman Empire came to consider themselves to be Romans. Persians went for a very different approach. So as long as you paid your taxes, and you didn't revolt, then you'd pretty much be left alone. That said, however, you do not conquer a vast empire without spilling an immense amount of blood, and there was no question that if you dared to stand up to the Persian kings then you would be obliterated.

They obliterated troublesome people by sending armies along those wonderfully straight and fast imperial roads. But inside the empire bloodshed was generally avoided, thanks to a huge – and hugely effective – administrative machine. The King of Kings ultimately controlled

The tomb of Cyrus the Great, king of Persia

everything, but at the local level he was represented by a governor – a satrap – who would keep a close eye on what was going on in the subordinate kingdoms. He would enforce law and order, levy taxes and raise armies.

Which brings us back to our golden toy, because the passenger in our chariot must be a satrap on tour. He sports a stylishly patterned overcoat – he's obviously spent a great deal of money on it – and his headdress leaves you in no doubt that this is a man who is used to being in charge. His chariot is made for serious travel: the large-spoked wheels are as high as the horses themselves, and are clearly designed for long distances.

You can tell a lot about a state from its transport system, and our chariot tells us a great deal about imperial Persia. Public order was so secure that people could travel long distances without armed guards. And they could travel fast. With its horses specially bred for strength and speed, and with its large, steadying wheels, this chariot was the Ferrari or Porsche of its time. Broad dirt roads were kept wheel-worthy

in all weathers, and there were frequent staging posts. Commands from the centre could be transmitted at speed across the whole territory, thanks to an entirely reliable royal postal service that used horsemen, runners and express messengers. Foreign visitors were deeply impressed, among them the Greek historian Herodotus:

> There is nothing in the world which travels faster than these Persian couriers ... it is said that men and horses are stationed along the road, equal in number to the number of days the journey takes – a man and a horse for each day. Nothing stops these couriers from covering their allotted stage in the quickest possible time – neither snow, rain, heat, nor darkness.

But our chariot doesn't just tell us about travel and communications; it sums up the acceptance of diversity that was at the heart of the Persian imperial system. Although found on the eastern frontier near Afghanistan, it must have been made in central Persia because of the technique of its metalworking. The driver and his passenger wear the costume of the Medes, an ancient people who lived in the north-west of what is now Iran, while on the front of the chariot, prominently displayed, is the head of the Egyptian god Bes. Bes, a dwarf with bow legs, is perhaps not your most likely candidate for a divine protector, but he looked after children and people in trouble, and he was a good god to have guarding your chariot on long journeys. I suppose he's the equivalent of a modern-day St Christopher or talisman dangling from the car mirror.

But what is an Egyptian god doing protecting a Persian on the frontiers of Afghanistan? It's a perfect demonstration of the Persian Empire's striking capacity for tolerating different religions and indeed, on occasion, adopting them from the people that they conquered. This unusually inclusive empire was also perfectly happy to use foreign languages for official proclamations. Here is Herodotus again:

> No race is so ready to adopt foreign ways as the Persian; for instance, they wear the Median costume as they think it handsomer than their own, and their soldiers wear the Egyptian corselet.

The multi-faith, multicultural approach that's summed up in our little chariot, when combined with well-organized military power, created a

flexible imperial system that lasted for more than 200 years. It enabled the king to present to his subjects the image of a tolerant, accommodating empire, whatever the specific facts on the ground might have been. So, when Cyrus invaded Babylon, near modern Baghdad, in 539 BC, he could issue a grandiloquently generous decree – in Babylonian – presenting himself as the defender of the peoples that he had just conquered. He restored the cults of different gods and allowed the people taken prisoner by the Babylonians to return to their homelands. In his own words:

> When my soldiers in great numbers peacefully entered Babylon ... I did not allow anyone to terrorize the people ... I kept in view the needs of the people and all their sanctuaries to promote their well-being ... I freed all slaves.

The most famous beneficiaries of Cyrus's shrewd political judgement after the conquest of Babylon were the Jews. Taken prisoner a generation before by Nebuchadnezzar, they were now allowed to return home to Jerusalem and to rebuild their temple. It was an act of generosity that they never forgot. In the Hebrew scriptures Cyrus is hailed as a divinely inspired benefactor and hero. In 1917, when the British government declared that it would establish in Palestine a national home to which Jews could once again return, images of Cyrus were displayed alongside photographs of George V throughout eastern Europe. Not many political gambits are still paying dividends 2,500 years later.

One of the perplexing things about the Persian Empire, though, is that the Persians themselves wrote very little about how they managed it. Most of our information comes from Greek sources. As the Greeks were for long the enemies of the Persians, it's rather as if we knew the history of the British Empire only through documents written by the French. But modern archaeology has provided new sources of information, and in the past fifty years the Iranians themselves have rediscovered and reappropriated their great imperial past. Any visitor to Iran today feels it at once. Michael Axworthy explains:

> There is a huge and unavoidable pride in the past in Iran ... It's a culture that is at ease with complexity, that has faced the complexity of different races, different religions, different languages, and has found ways to

encompass them and to relate them to each other and to organize them. Not in a loose way or in a relativistic way, necessarily, but in a principled way that keeps things together. And Iranians are very keen for people to understand that they have this long, long, long history and this ancient heritage.

Axworthy's phrase 'empires of the mind' sums up pretty well the theme that I'm trying to tackle in these chapters, but perhaps 'states of mind' would be more accurate – because I'm discussing objects that show us how different people imagine and devise an effective state. For Persia I've been looking at a toy chariot; for Athens I'll be looking at a temple. As you'd imagine, because they for so long were at war, Greeks and Persians had very different ideas of what a state should be. But precisely because they were at war, each tended to define the ideal state in opposition to the other. In 480 BC Persian troops destroyed the temples on the Athenian Acropolis. In its place the Athenians built the Parthenon that we know today.

There are few objects that over the last 200 years have been so widely seen as embodying a set of ideas as the Parthenon. And I'll be discussing one of the sculptures that decorated it next.

27

Parthenon Sculpture: Centaur and Lapith

Marble relief, from the Parthenon, Athens, Greece

AROUND 440 BC

Around 1800, Lord Elgin, the British Ambassador to the Ottoman Empire, removed some of the sculptures from the ruins of the Parthenon in Athens, and a few years later put them on public show in London. For most western Europeans it was the first time they had ever been able to look closely at Greek sculpture, and they were overwhelmed and inspired by the vitality and the beauty of these works. But in the twenty-first century, the Elgin Marbles, as they have long been known, are famous less as art objects than as the focus of political controversy. For most people today, the Parthenon sculptures in the British Museum provoke only one question: should they be in London or in Athens? The Greek government insists they should be in Athens; the British Museum's Trustees believe that in London they're an integral part of the story of world cultures.

It's a passionate debate in which everyone has a view; but I want to focus on one sculpture in particular, and what that sculpture meant to the people who made it and looked at it in Athens in the fifth century BC.

The Parthenon sculptures set out to present an Athenian universe made up of gods, heroes and mortals, woven together in complex scenes drawn from myth and daily life. They are some of the most moving and uplifting sculptures ever made. They've become so familiar, and have shaped so much of European thinking, that it's hard now to recover their original impact. But at the time of their making they were a quite new vision of what it meant, intellectually and physically, to be human and, indeed, Athenian. They're the first, and supreme, achievements of a new visual language. Olga Palagia, Professor

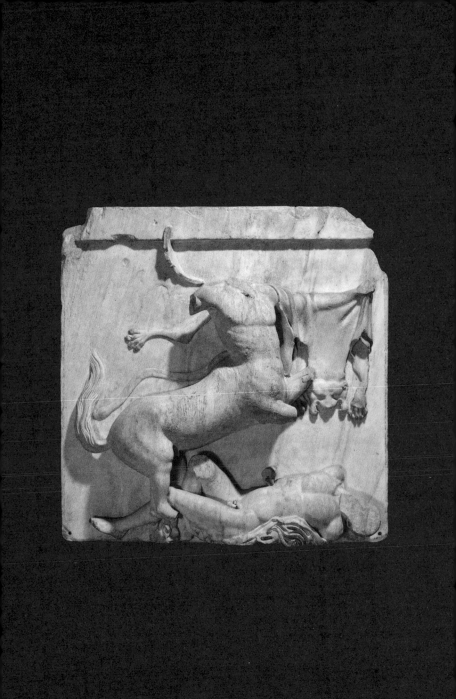

of Classical Archaeology at the University of Athens, puts them in perspective:

> The idea of the new style was to create a new equilibrium between the human body, human movement and the garments ... The object was to achieve the perfect proportions of the human body. The key words for the new Classical style were harmony and balance – that is why the sculptures of the Parthenon are so timeless, because the figures they created are indeed timeless.

The sculptures were, however, made at a particular time and with a particular purpose. They sum up how this society thought about itself. The Parthenon was a temple dedicated to the goddess Athena Parthenos, meaning Athena the Virgin. It was built on the Acropolis – a rocky citadel at the heart of the city, with a central hall that housed a colossal statue of the goddess herself, made of gold and ivory. And everywhere there was sculpture.

Around all four sides of the building, above the columns and easily seen by everybody approaching it, was a series of ninety-two square relief carvings, known as metopes. Like all the other sculpture in the building, these would originally have been brightly coloured in red and blue and gold; it's one of these metopes, now without its colour, that I have chosen as our object through which to think about Athens around 440 BC.

The metopes are all about battles – battles between the Olympian gods and the Giants, between Athenians and Amazons, and, in the ones I want to focus on, between Lapiths and Centaurs. The figures are almost free-standing, and the human ones are rather more than a metre (about 4 feet) tall. Centaurs – half-horse, half-human – are attacking the Lapiths, who are a legendary Greek people. According to the story, the Lapiths made the mistake of giving the Centaurs wine at the marriage feast of their king. The Centaurs got horribly drunk and attempted to rape the women, while their leader tried to carry off the bride. A bitter general battle ensued, and the Lapiths – the Greeks – were ultimately victorious over their half-animal Centaur enemies.

This sculpture is particularly moving; there are only two figures – a Centaur rearing triumphantly over a fallen Lapith, who lies dying on the ground. As with so many of the Parthenon sculptures, this one is

damaged, and we can no longer see the expression in the dying Lapith's face, or the aggression in the eyes of the Centaur. Nonetheless, it remains a wonderful and moving piece of sculpture. But what does it mean? And how can it sum up, in itself, a view of the Athenian state?

We are fairly certain that these sculptures are using myths to present a heroic version of recent events. A generation before the sculptures were made, Athens was one of several fiercely competitive city-states, forced into a coalition with each other by the Persian invasion of the Greek mainland. So, in the metopes, when we see Greeks fighting Centaurs, these mythical battles stand proxy for the real-life struggle between Greeks and Persians. The classicist Mary Beard, from the University of Cambridge, explains what the sculptures would have meant to the people who first saw them:

> Ancient Greece is a world which sees issues in terms of conflict, of winning, and losing. It's a conflictual society, and one of the ways that Athenians thought about their position in the world, and their relationship to those they conquered, or abominated, was to see the 'enemy' or the 'other' in terms that were not, in a sense, human. So what you have on the Parthenon is different ways of understanding the 'otherness' of your enemy. The best interpretation of the metopes is that you see the heroic conflicts as necessary in order to ensure order. Part of that is a feeling that we can very easily empathize with. We don't want to live in Centaur World. We want to live in Greek World, and Athenian World.

'Centaur World' for the Athenians would have meant not just the Persian Empire, but other competing Greek city-states, and above all Sparta, with whom Athens was frequently at war. The struggle against the Centaurs that we see on the metopes becomes an emblem of the perpetual battle that, for the Athenians, every civilized state has to fight. Rational man has to keep struggling against brute irrationality. Dehumanizing your enemy like this takes you down a dangerous path, but it's a magnificent rallying call if you're waging war. If chaos is to be kept at bay, so the message goes, reason will have to fight un-reason again and again.

I chose this particular sculpture because it gives us the bitter insight that, in the short term, reason does not always prevail. The defence of the rationally ordered state will cost some of its citizens their lives.

And yet – and this is why this sculpture is such a supreme achievement – the dying human body is shown with such pathos, the fierce struggle depicted with such balance, that the victory goes not to the strutting half-beast, but to the Athenian artist who can turn conflict into beauty. In the long run, this sculpture seems to say, intellect and reason alone can create things that endure. The victory is not just political: it is artistic and intellectual.

This is the Athenian perspective; but how was the Parthenon perceived by people who came from one of the other Greek cities? You might expect that because the Parthenon is called a temple, it would have been a place of prayer and sacrifice; in fact, it became a treasury – a war-chest to finance the defence of Greece against the Persians. In time, though, this fighting fund became protection money, demanded by Athens from the other Greek cities when Athens placed itself at the head of them. It forced them into becoming satellites of the growing Athenian maritime empire. And a great chunk of that money was siphoned off by the Athenians to fund the Acropolis building programme. Mary Beard gives us the non-Athenian view of the Parthenon:

> The Parthenon must have been the kind of building that you spat at and kicked if you could. You knew, if you were one of Athens' subjects, that this was a statement of your own subordination. There was a clear and vociferous faction in Athens when the Parthenon was built, which said the money shouldn't be spent that way. That this was, in the words of one, dressing Athens up like a 'harlot'. That's very odd for us to empathize with now, because the Parthenon sculptures seem so austerely beautiful. It's hard to think of them in terms of prostitution. It's very discomforting to think of our touchstone of good Classical taste as having appeared vulgar. But it clearly did, to some.

One of the many extraordinary things about the Parthenon is that it's meant so many different things to different people at different times. Conceived as the Temple of the Virgin Athena, it was for centuries the Christian Cathedral of the Virgin Mary, and it later became a mosque. By the end of the eighteenth century, it was a neglected ruin in a diminished Athens ruled by the Turks. But in the 1820s and 1830s, the Greeks won independence, and they were given a German king by

their European allies. The new state needed to define what kind of society it wanted to be. Olga Palagia takes up the story:

> Greece was resurrected in about 1830. We had a German king who came to Greece from Bavaria, and the Germans decided they were going to resurrect the Athens of Pericles. This initiated, I think, the perennial identification of the new Greek nation with the Parthenon. So, we have been restoring it from 1834, and I'm sure that this will never end! It will be a constant attempt to restore and redefine the Parthenon as a symbol. So the seed the Germans sowed in 1834 has really become very big and important.

So this great building had, by the 1830s, acquired yet another meaning. Not as the self-image of one ancient city, but as the emblem of a new modern country. And it was an emblem familiar to all educated Europeans, through the sculptures in the British Museum, which had been on display since 1817.

One of the most striking things about recent European history is how countries wanting to define and strengthen their present identity look to particular moments in the past. In the last hundred years or so, more and more people in Ireland, Scotland and Wales have wanted to see themselves as the heirs of a people that flourished in northern Europe at the same time as the Athenians were building the Parthenon. And it's those other Europeans of 2,500 years ago – Europeans dismissed by the Greeks as barbarians – that I'm going to focus on next.

28

Basse-Yutz Flagons

Bronze flagons, found in Moselle, north-eastern France

AROUND 450 BC

There are no written records from the people of northern Europe of 2,500 years ago; they are mentioned briefly and disparagingly by the Greeks, but we don't have their side of the story, and the only way we can really get to know these people – our close neighbours and, for some of us, our ancestors – is through the things they've left behind. Here, luckily, we've got a good deal to go on, including this spectacular pair of wine jugs, which are key objects in helping us understand the society of early northern Europe.

They were found in Lorraine, in north-eastern France, near the town of Basse-Yutz, and they're always referred to as the Basse-Yutz Flagons. They're bronze, elegant and elaborate. They are about the size of a large bottle of wine, a magnum, and they hold about the same amount of liquid, but they're in the shape of large jugs, with handle, lid and very pointed spout. They've got a broad shoulder, which tapers to a narrow, rather unstable base. But what strikes you at once about these two flagons is the extraordinary decoration at the top, where animals and birds cluster together, and it must have been what everybody would have looked at as they were feasting with these amazing objects.

These richly decorated flagons were stumbled on in 1927 by workmen digging in Basse-Yutz. Nothing quite like them had ever been found in western Europe before, and the strangeness of their style and decoration led many experts to assume that they must be fakes. But the curators at the British Museum were convinced that they were genuinely ancient; that they represented a new, unknown chapter in European history. So the flagons were acquired for the then colossal

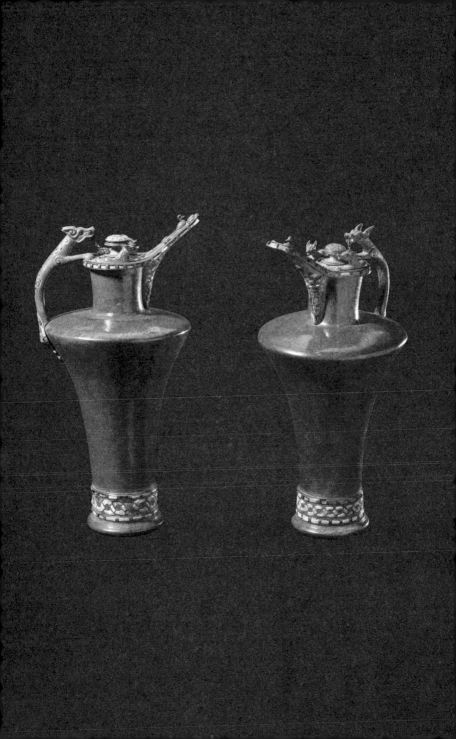

sum of £5,000. Betting the bank on this kind of acquisition is a huge gamble on curatorial knowledge, but in this case it paid off, and research has since confirmed they were indeed made about 2,500 years ago, that is, at roughly the time that the Parthenon was being built in Greece, the Persian Empire was at its zenith and Confucius was teaching in China. The Basse-Yutz Flagons are now celebrated as two of the most important and earliest pieces of Celtic art anywhere.

In northern Europe at that time, around 450 BC, there were no towns or cities, no states or empires, no writing or coinage. From the Russian Steppes to the Atlantic, there were merely small communities of farmer-warriors, connected across thousands of miles by trade, by exchange and frequently by war. It was a precarious existence for most, but life for those at the top of the pile, in the Iron Age Rhineland, could be very glamorous indeed. The smartest graves in the region where the flagons were found have wagons and chariots, hangings of silk, exotic hats, shoes and clothes – and, of course, all the equipment you needed for throwing parties. Mere death was not going to keep these northern Europeans from the good life, so the graves have lots of drinking vessels – bowls and cauldrons, drinking horns and flagons.

Many of these objects must have been traded over the Alps; there are Greek pots and vessels, and lots of flagons made in the Etruscan cities of northern Italy. A jaundiced, and misleading, way of describing the owners of the Basse-Yutz Flagons would be as the Iron Age 'nouveaux riches' – northerners looking to use Mediterranean design and taste to show off their own sophistication and aspirations. That view, first formulated by the Greek writers and rehearsed later by the Romans, has created the stereotype of an uncouth northern Europe in perpetual admiration of a cultured south. It is a stereotype that goes back more than 2,500 years, and it still shapes the way Mediterranean Europe thinks about the north – and even the way the north thinks about itself. Over the centuries this myth has, I think, done a great deal of damage.

The bronze, the design and the craftsmanship of the Basse-Yutz Flagons make a nonsense of the Greek myth of these northern Europeans as crude barbarians, and they tell us a great deal about the scope of their world. These people lived in small communities, but they were

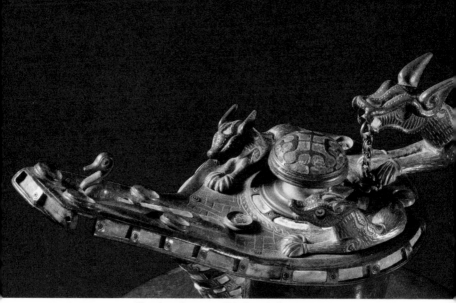

Three hounds eye a small duck on the flagon's spout

masters of complex metal technologies, and the materials from which our flagons are made make it clear that they had plenty of international contacts: the source materials for making this bronze are copper, from the Alps to the south, and tin, probably from Cornwall in the far west. Patterns on the base of the flagons are familiar from Brittany to the Balkans, while there are shapes inspired by palm fronds found in the art of ancient Egypt. And then the very idea of a flagon itself is foreign – it's a popular shape created by people living in northern Italy. A feast with these flagons at the centre would leave the visitors to these new rulers in no doubt at all that the people they were visiting were international, cosmopolitan, rich and intensely sophisticated.

On each flagon, there are at least 120 separate pieces of coral – probably from the Mediterranean. They've now faded to white, but originally they would have been bright red, giving a striking contrast to the lustrous bronze. You can imagine the flagons standing by blazing firelight, with the flames reflected in the bronze and deepening the red of the coral, while the wine, beer or mead they contained was ceremonially poured for important guests.

The animals on the flagons also tell us a great deal about the people who made them. The curved handle is a lean, elongated dog, stretch-

ing forward, fangs bared and holding in its mouth a chain that connects to the stopper. Dogs would have been an essential part of hunting life, and two more, smaller, dogs lie on either side of the lid. All three dogs have their attention focused on a tiny bronze duck that sits right at the end of the spout. It's a lovely touch, both moving and funny. When somebody poured from the flagon, it would look as though the duck was swimming on a stream of wine, mead or beer.

What would be clear to anyone whose cup was being filled from these flagons was that these luxury goods were local. No piece of Italian design ever looked like this. The extravagant shape, the unique combination of decoration, the animal imagery, all said loud and clear that these were made north of the Alps – examples of a new wave of creativity among craftsmen and designers, a rare confidence in taking elements from different foreign and local sources to forge a new visual language. It was to become one of the great languages of European art.

So, who were these drinkers who could make such wonderful things? We don't know what they called themselves, because they didn't write. The only name we have to go on is one given to them by uncomprehending foreigners, the Greeks. They called them 'Keltoi'; it is the first written reference to the peoples we know as Celts. And this is part of the reason that we call the new art style seen on these flagons Celtic art – although it is very doubtful that the people who made or used this art called themselves Celts, or indeed called the language they spoke Celtic. Sir Barry Cunliffe, former Professor of European Archaeology at the University of Oxford, explains:

> The relationship between Celtic art and people we call Celts is very complex. In most of the areas where Celtic art developed and was used, people spoke the Celtic language. That doesn't mean to say that they thought of themselves as Celts or that we can give them that sort of ethnic identity, but they probably spoke the Celtic language, therefore they could communicate with each other. In the area in which Celtic art developed in the fifth century, roughly eastern France and southern Germany, people had probably been speaking the Celtic language for a long time.

The people we call Celts today live far to the west of the Rhine Valley where our flagons were made – in Brittany, Wales, Ireland and Scotland – but throughout these Celtic lands we find artistic traditions that

echo the decoration on the Basse-Yutz Flagons. What has since the nineteenth century been called Celtic art connects our two ornate flagons with the Celtic crosses, the Book of Kells and the Lindisfarne Gospels, made in Ireland and Britain more than a thousand years later. In metalwork and stone-carving, inlays and manuscript illumination, it's possible to trace the legacy of a language of decoration, shared across much of western and central Europe, including the British Isles.

But this is no easy lineage to interpret. The problem of understanding the ancient Celts is that we are looking at a fifth-century Greek stereotype, compounded by a much later nineteenth-century British and Irish one. The Greeks constructed an image of the 'Keltoi' as a barbaric, violent people. That ancient typecasting was replaced a couple of hundred years ago by an equally fabricated image of a brooding, mystical Celtic identity, which was far removed from the greedy practicalities of the Anglo-Saxon industrial world – the romanticized 'Celtic Twilight' of Ossian and Yeats. In the twentieth century it did a great deal to shape the idea of Ireland. Since then, especially in Scotland and Wales, being Celtic has taken on further constructed connotations of national identity.

The idea of a Celtic identity, although strongly felt and articulated today by many, turns out on investigation to be disturbingly elusive, unfixed and changing. The challenge when looking at objects like the Basse-Yutz Flagons is how to get past those distorting mists of nationalist myth-making and let the objects speak as clearly as possible about their own place and their own distant world.

29

Olmec Stone Mask

Stone mask, found in south-east Mexico
900–400 BC

The people who made this mask were the Olmec, who ruled in what is now Mexico for around a thousand years, from 1400 to 400 BC. They've been called the mother culture – the *cultura madre* – of Central America. The mask is made in polished green stone, and unlike a sculpted head it's hollowed out at the back. The white, snake-like streaks in the dark stone give it its name, 'serpentine'. When you look closely, you can see the face has been pierced, and has been ritually scarred.

The previous objects in this world history have taken me along the royal roads of the Persian Empire, into mythical battles in Athens and to some heavy drinking in northern Europe. Each object has shown how the people who made it defined themselves and the world around them about 2,500 years ago. In Europe and Asia it is striking that self-definition was usually in distinction to others – partly by imitation but usually in opposition. Now I'm looking at an object from the Americas, from the lowland rainforests of south-east Mexico, and this Olmec face mask shows me a culture looking only at itself. It's an aspect of the great continuity of Mexican culture, a culture as old as that of Egypt.

Most of us in Britain don't learn a lot about Central American civilizations at school; we may be taught about the Parthenon, and even perhaps Confucius, but we don't on the whole learn a lot about the great civilizations occurring at the same time in Central America. Yet the Olmecs were a highly sophisticated people, who built the first cities in Central America, mapped the heavens, developed the first writing and probably evolved the first calendar there. They even invented one of the world's earliest ball games – which the Spanish would encounter about 3,000 years later. It was played using rubber balls – rubber being readily

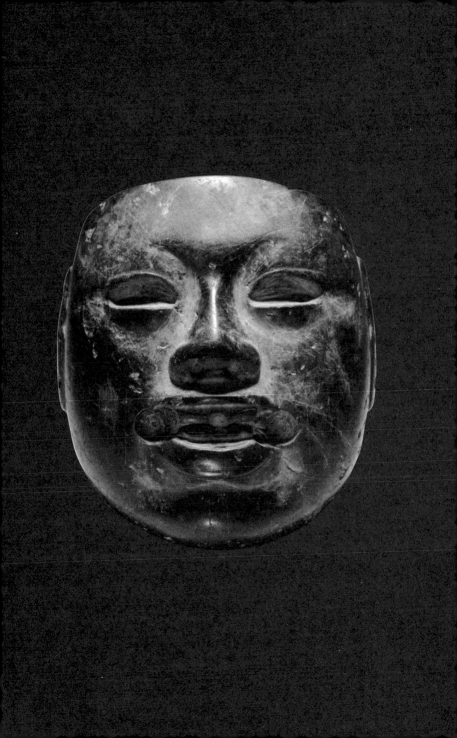

available from the local tropical gum trees – and although we don't know what the Olmecs called themselves, it's documented that the Aztecs called them the people of Olmen, meaning 'the rubber country'.

It is relatively recently that the Olmec civilization was uncovered from the jungles of Mexico; only after the First World War were their sites, their architecture and above all their sculptures found and investigated. Discovering when the Olmecs lived took even longer. From the 1950s new techniques of radiocarbon dating allowed archaeologists to suggest dates for the buildings and therefore for the people that lived in them. The results showed that this great civilization flourished about 3,000 years ago. The discovery of this ancient and long-lived culture has had a profound effect on modern Mexican notions of identity. I asked the celebrated Mexican writer Carlos Fuentes what it means to him:

> It means that I have a continuity of culture that is quite astonishing. Many Latin Americans who are merely migrants from European countries, or do not have a strong Indian culture behind them, don't appreciate the extraordinary strength of the culture of Mexico, which begins a very long time ago in the twelfth or thirteenth century before Christ.
>
> We consider ourselves heirs to all these cultures. They are a part of our make-up, a part of our race. We are basically a Mestizo country, Indian and European. The Indian culture has infiltrated into our literature, into our painting, into our habits, into our folklore. It is everywhere. It is a part of our heritage, as much as the Spanish culture, which for us is not only Iberian but also Jewish and Moorish. So Mexico is a compound of many civilizations, and part of them are the great Indian civilizations of the past.

So who were the Olmecs? Whose face does this mask show, and how was it worn? Olmec masks have been intriguing historians for a long time. Scrutinizing their features, many scholars believed that they were looking at Africans, Chinese or even Mediterranean people, who had come to colonize the New World. I suppose if you look at our mask, wanting to see an African or a Chinese face, you can just about persuade yourself that you can; but the features are, in fact, entirely characteristic of Central American people. This face is one that can still be seen in the descendants of the Olmecs living in Mexico today. But the desire

to discover European or Asian elements in ancient American societies, to find evidence of ancient links and influences, is deep and it is revealing. The similarities between the cultures of the old and the new worlds are so strong – both produced pyramids and mummification, temples and priestly rituals, social structures and buildings that function in similar ways – that scholars for a long time found it hard to believe that these American cultures could have evolved in isolation. But they did.

At only 13 centimetres (5 inches) high, the mask is obviously far too small to have been worn over anybody's face, and it's much more likely that it would have been worn round the neck or in a headdress, possibly for some kind of ceremony. Small holes have been bored at the edges and at the top of the mask, so that you could easily fasten it with a bit of twine or thread. On either cheek you can see what, to my European eyes, look like two candles standing on a holder. To the eyes of the Olmec specialist Professor Karl Taube, the four verticals most probably stand for the cardinal points of the compass, and they suggest to him that this may be the likeness of a king:

> We have great colossal heads, we have thrones, portraits of kings and, very often, the concept of centrality, placing the king at the centre of the world. And so, on this finely carved serpentine mask, we see four elements on the cheek which are probably the four cardinal directions. For the Olmec, of major concern were the world directions and world centre, with the king being the pivotal world axis in the world centre.

As well as honouring a wide range of gods, the Olmecs also revered their ancestors – so it's possible that this mask with its particular features and markings might well represent a historic king or a legendary ancestor. Karl Taube has observed that in many sculptures we find what seems to be the same person's face, with incisions that represent tattooing; as this pattern is seen often, he suggests there might have been an actual individual who had this facial marking. Olmec specialists refer to him as the 'Lord of the double scroll'.

Whoever he was, the man of the serpentine mask must have cut quite a dash when he appeared in public. The ears are pierced in several places, presumably for gold earrings. And there are what look like enormous dimples at the corners of his mouth. They must represent circular holes. We're used now to face-piercings and studs, but these

The incised symbols on the
cheeks of the Olmec mask

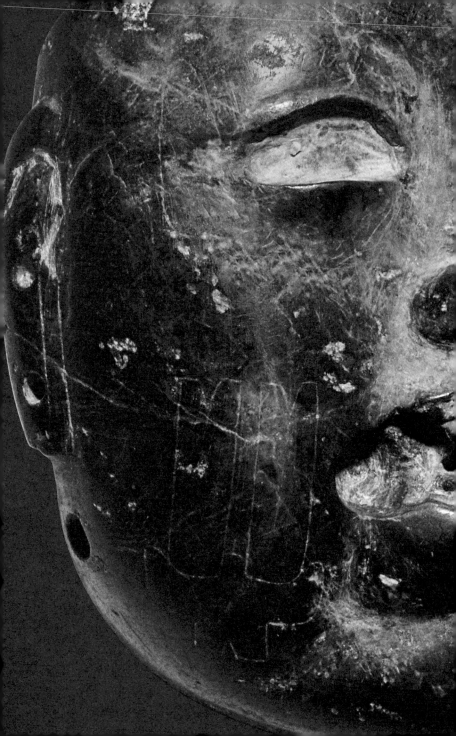

are bigger; this man must have been wearing plugs. Piercings and plugs are common throughout the history of Central America, and alterations like these, in the name of Olmec beauty, would have transformed the face. It's only in masks like this that we can have any idea of what the Olmecs might actually have looked like, for the skeletons have completely dissolved in the acid soil of the rainforest. But the Olmec sense of personal beautification could go far beyond cosmetics or jewellery, into the realms of myth and faith. Karl Taube elaborates:

> They would modify their heads – it's often called cranial deformation, but I think that's a loaded word. For them it was a mark of beauty. For newborns, they would bind their heads, and so they would become elongated – some people call it avocado head. But really what they're evoking with their head is an ear of corn. The Olmec really were the people of maize.

Sadly there are only a few Olmec inscriptions – or glyphs – now surviving, and decipherment of their writing is tentative at best. There just isn't enough continuous writing to let us be certain of what the symbols mean, so our understanding of their view of the gods and the natural cycle can be no more than speculation. But there are lots of objects such as pottery and sculptures bearing symbols, marks and glyphs, and they show us that writing was originally widespread across the Olmec heartland. One day we may know more.

Even if we can't yet read their writing, we can learn a lot about the Olmecs from the buildings and the cities that have recently been uncovered. Major cities such as La Venta, near the Gulf of Mexico, had impressive step-pyramids with temple monuments for the worship of the gods and the burials of the kings. These would have formed the centre of the city. The pyramid itself was often topped by a temple, just as the Greeks, at roughly the same time, were building the Parthenon overlooking Athens.

But whereas the Parthenon stood on the naturally formed rock of the Acropolis, the Olmecs built artificial mountains – platforms is far too mild a word – on which to put their temples to overlook the city. The layout of the city, and its placing in an ordered landscape, typified not just Olmec but most later Central American urban centres – such as those of the Mayas and the Aztecs. All were variations on the Olmec

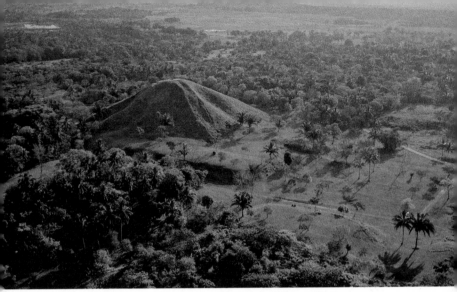

The remains of La Venta, one of the centres of Olmec civilization

model of a temple overlooking an open square, flanked by smaller temples and palaces.

By 400 BC La Venta, along with all the other Olmec centres, was deserted. It's a pattern that occurs with disconcerting frequency in Central America – great population centres are suddenly, mysteriously, abandoned. In the case of the Olmecs, it could have been the over-population of this fragile tropical river valley, or a shift in the Earth's tectonic plates making rivers change their course, the eruption of one of the local volcanoes, or a temporary climate change caused by the shifting patterns of the El Niño ocean current.

But elements of the Olmec culture lived on in central Mexico. The ancient city of Teotihuacan, a city founded several centuries after the mysterious collapse of the Olmec heartland, contains a great pyramid around 75 metres (some 240 feet) high. From the top of the pyramid you can see the ruins of Teotihuacan – the monumental avenues, lesser pyramids and public buildings of a city that in its day was the same size as ancient Rome. It's a city that owes a great deal of its shape to the models provided by the Olmecs. The culture of the Olmecs is truly the *cultura madre* for all Central America, casting a very long shadow, establishing models and patterns that were to be followed by other cultures for centuries to come.

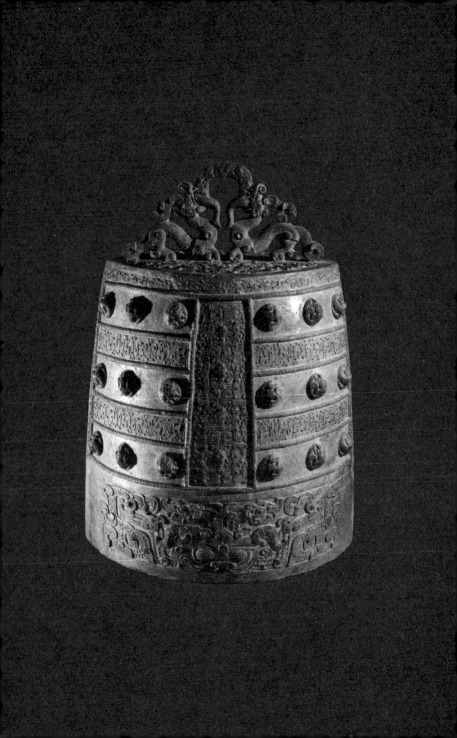

30

Chinese Bronze Bell

Bronze bell, found in Shanxi province, China
500–400 BC

The choice of music that was played at the ceremony marking Britain's handover of Hong Kong to the People's Republic of China in 1997 was, on both sides, entirely characteristic. The British played the *Last Post* on a bugle; the Chinese performed a specially composed piece of music called *Heaven, Earth, Mankind*, part of it on a set of ancient bells. On the European side, a solo instrument connected with war and conflict; on the Chinese side, a group of instruments playing in harmony. With a little stretch of the imagination, you can see in that choice of instruments two distinct and determinant views of how society works. Bells in China go back thousands of years, and they carry great resonances for Chinese people – so perhaps this was the Chinese leaders' way of reminding Hong Kong of the cultural and political traditions it would be rejoining. This bell is a contemporary of the ones played at that ceremony, about 2,500 years old, and through this bell I'm going to be exploring Confucius's ideas of how a society can function in harmony.

When this bell was first played, in the fifth century BC, China was in military and political disarray, essentially just a collection of competing fiefdoms, all battling for supremacy. There was widespread social instability, but also lively intellectual debate about what an ideal society ought to be, and by far the most famous and influential contributor to these debates was Confucius. Perhaps not surprisingly, given the insecurity of the times, he placed a very high value on peace and harmony. We're told that one of his celebrated sayings was: 'Music produces a kind of pleasure which human nature cannot do without.' For Confucius, music was a metaphor of a harmonious society, and its performance could actually help bring that better society about. It's a

view of the world that still resonates strongly in China today, and it ties in with the story of our bell.

As it's a museum piece, and of such age, we don't play our bell very often. But it is large and very handsome to look at. It's about the size of a beer barrel, and not circular, but elliptical. It reminds me of nothing so much as an outsized Swiss cowbell. It's covered in decoration, elaborate strapwork that swirls all over, round medallions with dragons' heads swallowing geese and, at the top, two magnificent standing dragons holding the handle from which the bell would have hung. This was a bell that was made not only to be heard but also to be seen.

Our bell would have originally been part of a set owned by a warlord or by a powerful official in one of the numerous small states. Owning a set of bells – and, even more, being able to afford the orchestra to play them – was a visible, and of course audible, sign of great wealth and status. The principal message of our bell would have been about its owner's power, but it would also have represented that owner's view of society and the cosmos.

Confucius spoke a great deal about music, which he saw as playing a central part in the education of the individual – and indeed in the shaping of the state. At the core of the teachings of Confucius was the fundamental need for every individual to understand and accept their place in the world. It was perhaps in this spirit that sets of Chinese bells took on such philosophical importance – reflecting the diversity but also the harmony that's created when each different bell is perfectly tuned and played in its proper sequence. Isabel Hilton, a writer and expert on modern China, elaborates:

> Harmony was very important to Confucius. The way Confucius conceived of it was that he had an idea that men could best be governed by virtue, by benevolence, by righteousness; and if the leader exemplified those virtues, then so would his people. By cultivating these virtues, you did away with the need for punishment and law, because you ruled by a sense of what was appropriate – and by shame. The application of all these ideas produces a harmonious society.

So a harmonious society is the consequence of virtuous individuals working together in a complementary way. It's a short step for a philosopher to see, in a set of highly tuned, graduated bells, a metaphor

for this ideal society – everyone in their allotted place, making music with their fellows.

Bells in China go back about 5,000 years. The earliest would have been simple hand bells, with a clapper inside to produce the sound. Later the clapper was abandoned, and bronze bells were played by being hit on the outside with a hammer. Our single bell would once have been part of a set of either nine or fourteen. Each would have been a different size, and would produce two different tones, depending on where it was struck. The percussionist Dame Evelyn Glennie is well aware of the power of bells:

> Every single bell has its own unique sound. It can be a very tiny sound that you've really got to pay attention to, or it can just be a huge, huge resonant experience that a whole community can register. I remember in the early years when I went to China, they had a whole rack of bells that decorated the back of the stage, and of course I couldn't help but go up to them and just admire the craftsmanship that went into this structure. I did ask if I could strike one, and I was given this long wooden pole, and the whole body has to be used in order to create a sound, and the right striking point is particularly important. There was this immense respect as to what actually I was going to do. It wasn't just a case of, 'Well, hit the bell,' or something. This was something that I wanted to really treasure, and it was an incredible experience to just create that one strike, and then to really live the sound experience of the resonance after that strike.

By European standards, these ancient Chinese bronze bells are enormous. Nothing on this scale would be cast in Europe until the Middle Ages, more than 1,500 years later. But the role of bells in China could go far beyond the musical. To produce perfect tones they had to have absolutely standardized shapes, and the consistency of these shapes meant that the bells could also be used to measure standard volumes. And as the amount of bronze in each one was also carefully controlled, they could just as well provide standard weights. So a set of bells in ancient China could also serve as a sort of local weights and measures office, bringing harmony to commerce as well as society.

Intriguingly, bells also played a major role in the etiquette of war. The Chinese held that no attack could be considered fair and above

board without the sounding of bells or drums; from then on you could honourably fight without restraint. But, more commonly, the bells were used for rituals and entertainments at court. Played at grand occasions, banquets and sacrificial ceremonies, the complex music of the bells marked the rhythm of court lives.

The bells, and the ancient methods of playing them, travelled well beyond the boundaries of China, and the closest surviving form of this ancient music is today found not in China but in the Korean court music that originated in the twelfth century and is still played in Korea now.

In Europe we rarely listen to music that is more than 500 or 600 years old, but the music of the ancient Chinese bells has been resonating harmoniously for more than 2,500 years, symbolizing not only the sound of an era but the underlying political ideals of an ancient society and its modern successors. It's a Confucian principle that China once again finds very appealing today – although that hasn't always been the case. Here is Isabel Hilton again:

> Confucianism was really the soul of the Chinese state for the best part of 2,000 years, but in the early twentieth century it was very strongly criticized by the modernizers, the revolutionaries, the people who blamed Confucianism for the decline of China in the previous 200 years, and it fell out of favour. But Confucianism never really went away. Curiously, harmonious society is what we hear today on the lips of Chinese leaders. What the leadership today wants is a society that is more content, in which people are content with their station, so no more class struggle; in which the leaders are seen to embody virtue as in the old Confucian idea. It is their virtue that makes people accept their right to rule. So we've seen the taking of this very old idea of harmony, and we're seeing it in a modern form to justify a static political system, a system in which the right to rule is not questioned.

And bells are still going strong. The ancient bells used for the 1997 Hong Kong ceremony were played again at the 2008 Olympic Games in Beijing. And Confucius is now, it seems, the flavour of the decade. He has his own $25 million biopic, a bestselling book, a TV series and a hundred-part animated series on his teachings. The age of Confucius has come again.

PART SEVEN

Empire Builders

300 BC—AD 10

Alexander the Great's conquest of the Persian Empire in 334 BC ushered in an age of megalomaniac rulers and great empires. Although there had been empires before, this was the first time regional superpowers emerged in different parts of the globe. In the Middle East and the Mediterranean, Alexander became a model for rulers to emulate or reject: Augustus, the first Roman emperor, imitated Alexander by using his own image to represent imperial power to his subjects. In contrast, the Greek rulers of Egypt looked back to Egypt's past in times of political weakness, and in India the Emperor Ashoka rejected oppressive rule altogether, promoting his peaceful philosophy through inscriptions on pillars across the subcontinent. While Ashoka's empire did not last long beyond his lifetime, his ideals survived. The Roman Empire continued for the next 400 years, rivalled in size, population and sophistication only by the Han Dynasty in China, where the state produced luxury goods to win both admiration and obedience.

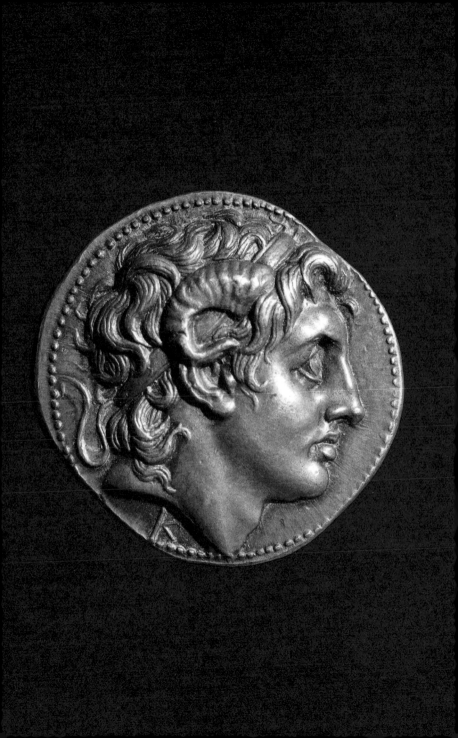

31

Coin with Head
of Alexander

Silver coin of Alexander the Great,
minted in Lampsakos (Lapseki), Turkey
MINTED 305–281 BC

Just over 2,000 years ago there were, in Europe and Asia, great empires whose legacies are still strongly felt in the world today – the Roman Empire in the West, the empire of Ashoka in India and the Han Dynasty in China. I want to examine how power in such empires is constructed and projected. Military might is just the beginning – it's the easy part. How does a ruler stamp his authority on the very minds of his subjects? In this area images are generally more effective than words, and the most effective of all images are those we see so often that we hardly notice them: coins. So the ambitious ruler shapes the currency: the message is on the money, and that message can live on long after the ruler is dead. Although this silver coin shows the image of Alexander the Great, it was struck at least forty years after his death, on the orders of one of his successors, Lysimachus.

The coin is about 3 centimetres (just over an inch) in diameter, slightly larger than a 2p piece. It bears the profile of a young man, with straight nose and strong jaw line, showing Classical good looks and strength. He's gazing keenly into the distance; the tilt of the head is commanding, suggestive of vigorous forward movement. It is an image of a dead leader, but one clearly intended to carry a political message of power and authority now.

You find exactly the same phenomenon in modern China, where the red currency notes carry the portrait of Chairman Mao. It could seem strange that the very lifeblood of what is now a spectacularly successful capitalist economy, its money, carries on it the portrait of a dead Communist revolutionary. Yet the reason is clear. Mao reminds

the Chinese people of the heroic achievements of the Communist Party, which is still in power. He stands for the recovery of Chinese unity at home and prestige abroad, and every Chinese government wants to be seen as the inheritor of his authority. This appropriation of the past, this kind of exploitation of a dead leader's image, is nothing new. It has been around for thousands of years, and what's happening today to Mao on the Chinese currency was happening more than 2,000 years ago to Alexander.

Minted around 300 BC, this is one of the earliest coins to carry the image of a leader. Alexander the Great, whose head is represented on the coin, was the most glamorized military ruler of his age – possibly of all time. We've got no way of knowing whether this is an accurate likeness of Alexander, but it must be him, because as well as human hair this man has ram's horns. It is the horn symbol, well known throughout the ancient world, that leaves the viewer in no doubt that we are looking at an image of Alexander. The horns are associated with the god Zeus-Ammon – a hybrid of the two leading Greek and Egyptian gods, Zeus and Ammon. So this small coin is making two big statements – it asserts Alexander's dominion over both Greeks and Egyptians, and it suggests that, in some sense, he is both man and god.

Alexander the man was the son of Philip II of Macedon, a small kingdom a few hundred miles north of Athens. Philip expected great things of his son, and he employed the great philosopher Aristotle as his tutor. Alexander came to the throne in 336 BC at the age of 20, with an almost limitless sense of self-belief. His stated goal was to reach the 'ends of the world and the Great Outer sea', and to do this he embarked on a series of wars, first crushing rebellions by Athens and the other Greek cities, then turning east to confront the long-standing enemy of the Greeks – Persia. Persia controlled at that point the greatest empire on earth, sprawling from Egypt across the Middle East and central Asia to India and almost to China. The young Alexander campaigned brilliantly for a total of ten years, until he defeated the whole of the Persian Empire. He was clearly a driven man. What drove him on? We asked the leading expert on Alexander, Robin Lane Fox:

> Alexander was driven by the heroic ideals that befitted a Macedonian king, ruling over Macedonians, the ideals of personal glory, prowess;

The reverse of the coin shows Athena Nikephoros, and Greek letters spell 'of King Lysimachus'

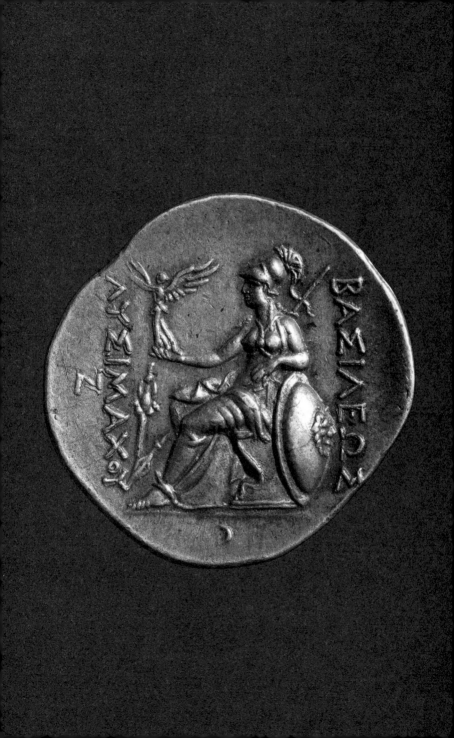

he was driven by a wish to reach the edge of the world, he was driven by a wish to excel for ever his father, Philip, who was a man of significance but who pales almost to a shadow beside Alexander's global reputation.

Alexander's victories didn't just depend on his armies. They required money – and lots of it. Luckily, Philip had conquered the rich gold and silver mines of Thrace, the area that straddles the modern borders of Greece, Bulgaria and Turkey. That precious metal financed the early campaigns, but this inheritance was later swelled by the colossal wealth Alexander captured in Persia. His imperial conquests were bankrolled by nearly five million kilos of Persian gold.

With irresistible force, huge wealth and enormous charisma, it's no wonder that Alexander became a legend, seeming to be more than mortal, literally superhuman. In one of his early campaigns into Egypt, he visited the oracle of the god Ammon, which named him not just the rightful pharaoh, but a god. He left the oracle with the title 'son of Zeus-Ammon', which explains the characteristic ram's horns in images of him like the one on our coin. He was received by many of the conquered peoples as though he were a living god, but it's not altogether clear whether he actually believed himself to be one. Robin Lane Fox suggests he saw himself more as the son of god:

> He certainly believed he was the son of Zeus, [that] in some sense, Zeus had entered into his begetting, a story possibly told to him by his mother Olympias herself, though he is, in earthly terms, the son of the great king Philip. He is honoured as a god, spontaneously, by some of the cities in his empire, and he is not displeased to receive honours equal to the gods. But he knows he's mortal.

Alexander conquered an empire of more than two million square miles and founded many cities in his name, the most famous being Alexandria in Egypt. Although nearly every large museum in Europe has an image of Alexander in its collection, they are not consistent and there's no way of knowing whether he looked like any of them. It was only after Alexander's death in 323 BC that an agreed, idealized image, constructed for public consumption, came into being – and that's the image found on our coin. The reverse of the coin reveals that

this is not Alexander's coin at all – he's making a posthumous guest appearance in somebody else's political drama.

The other side of the coin shows the goddess Athena Nikephoros, bringer of victory, carrying her spear and shield. She is the divine patroness of Greeks and a goddess of war. But it's not Alexander that she's favouring, because the Greek letters beside her tell us that this is the coin of King Lysimachus. Lysimachus had been one of Alexander's generals and companions. He ruled Thrace from Alexander's death until his own death in 281 BC. Lysimachus didn't mint a coin that showed himself. He decided instead to appropriate the glory and the authority of his predecessor. This is image manipulation – almost identity theft – on a heroic scale.

Alexander died in his early thirties, and his empire quickly disintegrated into a confusion of shifting territories under competing warlords – Lysimachus was just one of them. All of the warlords claimed that they were the true heirs of Alexander, and many of them minted coins with his image on them to prove it. This was a struggle fought out not just on the battlefield but on the currency. It's a textbook early example of a timeless political ploy: harnessing the authority and the glamour of a great leader of the past to boost yourself in the present.

Dead reputations are usually more stable and more manageable than living ones. Since the Second World War, for example, Churchill and de Gaulle have been claimed by British and French political leaders of all hues when it suited the day's agenda. But in democratic societies, this is a high-risk strategy, as the political commentator and broadcaster Andrew Marr points out:

> The more democratic a culture is, the harder it is to appropriate a previous leader. It's very interesting at the moment to see the revival of Stalin as an admired figure in Putin's Russia, having been knocked down as a bloodthirsty tyrant before. So the possibility of taking a figure from the past is always open, but the more conversational, the more confrontational, more democratic, the more argumentative a political culture is, the harder it is. You can see this in the case of Churchill, because there are still lots and lots of people who know a great deal about what Churchill thought and said. Any mainstream party which tried to say 'we are the party of Churchill' would get into trouble because Churchill

changed his mind so much that he can be quoted against you as often as he can be quoted in favour of you.

Dead rulers are still very present, and they're still on the currency. A thoughtful alien handling the banknotes of China and the United States today might well assume that one was ruled by Mao and the other by George Washington. And, in a sense, that's exactly what the Chinese and American leaders want us all to think. Political giants like these lend an aura of stability, legitimacy and above all unquestionable authority to modern regimes struggling with huge problems. Lysimachus's gambit still sets the pace for the world's superpowers.

And it worked for Lysimachus himself – up to a point. He's a mere historical footnote in comparison to Alexander; he didn't get an empire, but he did get a kingdom, and he hung on to it. Twenty years after Alexander's death, it was clear that his empire would never be reconstituted, and for the next 300 years the Middle East would be ruled by many cultured but competitive Greek-speaking kings and dynasties. The most famous monument of any of these Greek-speaking states, the Rosetta Stone, features in Chapter 33. But my next object comes from India, where the great emperor Ashoka linked himself to a different kind of authority to strengthen his political position – not the authority of a great warrior, but one of the greatest of all religious teachers – the Buddha.

Pillar of Ashoka

Stone fragment of a pillar, erected in Meerut,
Uttar Pradesh, India

AROUND 238 BC

Around 2,000 years ago the great powers of Europe and Asia established legacies that are still with us. They laid down the fundamental ideas concerning the right way for a leader to rule, how rulers construct their image and how they project their power. They also showed that a ruler can actually change the way the people think. The Indian leader Ashoka the Great took over a vast empire and, through the strength of his ideas, began a tradition that leads directly to the ideals of Mahatma Gandhi and still flourishes today – a tradition of pluralistic, humane, non-violent statecraft. Those ideas are incorporated in this object. It's a fragment of stone, sandstone to be exact, and it's about the size of a large curved brick – not much to look at all, but it opens up the story of one of the great figures of world history. On the stone are two lines of text, inscribed in round, spindly-looking letters – once described as 'pin-man script'. These two lines are the remains of a much longer text that was originally carved on a great circular column, about 9 metres (30 feet) high and just under a metre (3 feet) in diameter.

Ashoka had pillars like this put up across the whole of his empire. They were great feats of architecture, which stood by the side of highways or in city centres – much as public sculpture does in our city squares today. But these pillars are different from the Classical columns that most of us in Europe are familiar with: they've got no base and they're crowned with a capital in the shape of lotus petals. On top of the most famous of Ashoka's pillars are four lions facing outwards – lions that are still one of the emblems of India today. The pillar that our fragment comes from was originally erected in Meerut, a city just

north of Delhi, and was destroyed at the palace of a Mughal ruler by an explosion in the early eighteenth century. But many similar pillars have survived, and they range across Ashoka's empire, which covered the great bulk of the subcontinent.

These pillars were a sort of public-address system. Their purpose was to carry, carved on them, proclamations or edicts from Ashoka, which could then be promulgated all over India and beyond. We now know that there are seven major edicts that were carved on pillars, and our fragment is from what's known as the 'sixth pillar edict'; it declares the emperor Ashoka's benevolent policy towards every sect and every class in his empire:

> I consider how I may bring happiness to the people, not only to relatives of mine or residents of my capital city, but also to those who are far removed from me. I act in the same manner with respect to all. I am concerned similarly with all classes. Moreover, I have honoured all religious sects with various offerings. But I consider it my principal duty to visit the people personally.

There must have been somebody to read these words out to the mostly illiterate citizens, who would probably have received them not only with pleasure but with considerable relief, for Ashoka had not always been so concerned for their welfare. He'd started out not as a gentle and generous philosopher but as a ruthless and brutal youth, following in the military footsteps of his grandfather, Chandragupta, who had risen to the throne following a military campaign that created a huge empire reaching from Kandahar in modern Afghanistan in the west to Bangladesh in the east. This included the great majority of modern India, and was the largest empire in Indian history.

In 268 BC Ashoka took his place on the throne – but not without considerable struggle. Buddhist writings tell us that in order to do so he killed 'ninety-nine of his brothers' – presumably metaphorical as well as actual brothers. The same writings create a legend of Ashoka's pre-Buddhist days as filled with self-indulgent frivolity and cruelty. When he became emperor he set out to complete the occupation of the whole subcontinent and attacked the independent state of Kalinga – modern-day Orissa on the east coast. It was a savage, brutal assault and one which seems afterwards to have thrown Ashoka into a state

of terrible remorse. He changed his whole way of life, embracing the defining concept of *Dharma*, a virtuous path that guides the follower through a life of selflessness, piety, duty, good conduct and decency. *Dharma* is applied in many religions, including Sikhism, Jainism and of course Hinduism – but Ashoka's idea of *Dharma* was filtered through the Buddhist faith. He described his remorse and announced his conversion to his people through an edict:

> The Kalinga country was conquered by the king, Beloved of the Gods, in the eighth year of his reign. 150,000 persons were carried away captive, 100,000 were slain, and many times that number died. Immediately after the Kalingas had been conquered, the king became intensely devoted to the study of *Dharma* ...
>
> The Beloved of the Gods, conqueror of the Kalingas, is moved to remorse now. For he has felt profound sorrow and regret because the conquest of a people previously unconquered involves slaughter, death and deportation.

From then on Ashoka set out to redeem himself – to reach out to his people. To do so, he wrote his edicts not in Sanskrit, the ancient Classical language that would later become the official language of the state, but in the appropriate local dialect couched in everyday speech.

With his conversion Ashoka renounced war as an instrument of state policy and adopted human benevolence as the solution to the world's problems. While he was inspired by the teachings of Buddha – and his son was the first Buddhist missionary to Sri Lanka – he did not impose Buddhism on his empire. Ashoka's state was in a very particular sense a secular one. The Nobel Prize-winning Indian economist and philosopher Amartya Sen comments:

> The state has to keep a distance from all religion. Buddhism doesn't become an official religion. All other religions have to be tolerated and treated with respect. So secularism in the Indian form means not 'no religion in government matters', but 'no favouritism of any religion over any other'.

Religious freedom, conquest of self, the need for all citizens and leaders to listen to others and to debate ideas, human rights for all, both men and women, and the importance given to education and health,

the ideas Ashoka promulgated in his empire, all remain central in Buddhist thinking. There's still today a kingdom in the Indian subcontinent that is run on Buddhist principles – the small Kingdom of Bhutan, sandwiched between northern India and China. Michael Rutland is a Bhutanese citizen and the Hon. Consul of Bhutan to the UK. He also tutored the former king, and I asked him how Ashoka's ideas might play out in a modern Buddhist state. He began by offering me a quotation:

'Throughout my reign I will never rule you as a king. I will protect you as a parent, care for you as a brother and serve you as a son.' That could well have been written by the emperor Ashoka. But it wasn't. It was an excerpt from the coronation speech, in 2008, of the 27-year-old fifth king of Bhutan. The fourth king, the king that I had the great privilege to teach, lived and continues to live in a small log cabin. There is no ostentation to the monarchy. He is probably the only example of an absolute monarch who has voluntarily persuaded his people to take away his powers and has instituted elective democracy. The fourth king also introduced the phrase 'gross national happiness' – to be a contrast to the concept of 'gross national product'. Again, as Ashoka would have felt, the happiness and contentment of the people were more important than conquering other lands. The fifth king has very much followed the Buddhist precepts of monarchy.

Ashoka's political and moral philosophy, as he expressed it in his imperial inscriptions, initiated a tradition of religious tolerance, nonviolent debate and a commitment to the idea of happiness which has animated Indian political philosophy ever since. But – and it's a big but – his benevolent empire scarcely outlived him. And that leaves us with the uncomfortable question of whether such high ideals can survive the realities of political power. Nevertheless, this was a ruler who really did change the way that his subjects and their successors thought. Gandhi was an admirer, as was Nehru, and Ashoka's message even finds its way on to the modern currency – on all Indian banknotes we see Gandhi facing the four lions of Ashoka's pillar. The architects of Indian independence had him often in mind. But, as Amartya Sen points out, his influence extends far wider, and the whole region sees him as an inspiration and a model:

The part of his teaching that the Indians particularly empathized with at the time of independence was his secularism and democracy. But Ashoka is also a big figure in China, in Japan, in Korea, in Thailand, in Sri Lanka; he is a pan-Asian figure.

My next object involves another kind of inscription and another ruler closely linked with a religious system, but in this case the religion is now dead and the ruler is no longer of any consequence – indeed he never really was. The inscription is one of the most famous objects in the British Museum – and possibly the world.

33

Rosetta Stone

Found at el-Rashid, Egypt

196 BC

Every day when I walk through the Egyptian sculpture gallery at the British Museum there are tour guides speaking every imaginable language addressing groups of visitors, all craning to see this object. It is on every visitor's itinerary, and, with the mummies, it's the most popular object in the British Museum. Why? It's decidedly dull to look at – a grey stone about the size of one of those large suitcases you see people trundling around on wheels at airports. The rough edges show that it's been broken from a larger stone, with the fractures cutting across the text that covers one side. And when you read that text, it's pretty dull too – it's mostly bureaucratic jargon about tax concessions. But, as so often in the Museum, appearances are deceptive. This dreary bit of broken granite has played a starring role in three fascinating and different stories: the story of the Greek kings who ruled in Alexandria after Alexander the Great conquered Egypt; the story of the French and British imperial competition across the Middle East after Napoleon invaded Egypt; and the extraordinary but peaceful scholarly contest that led to the most famous decipherment in history – the cracking of hieroglyphics.

The Rosetta Stone is a particularly fascinating and special case of power projection. It's associated with a ruler who was not strong but weak, a king who had to bargain for and protect his power by borrowing the invincible strength of the gods or, more precisely, the priests. He was Ptolemy V, a Greek boy-king who came to the throne of Egypt as an orphan in 205 BC, at the age of 6.

Ptolemy V was born into a great dynasty. The first Ptolemy was one of Alexander the Great's generals who, around a hundred years earlier, had taken over Egypt following Alexander's death. The Ptolemies

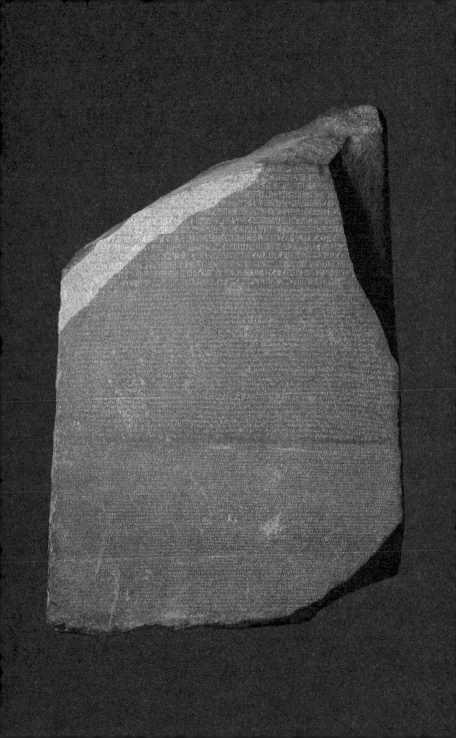

didn't trouble to learn Egyptian but made all their officials speak Greek; so Greek became the language of state administration in Egypt for a thousand years. Perhaps their greatest achievement was to make their capital city, Alexandria, into the most brilliant metropolis of the Classical world – for centuries it was second only to Rome, and intellectually probably livelier. It was a cosmopolitan magnet for goods, people and ideas. The vast Library of Alexandria was built by the Ptolemies – in it, they planned to collect all the world's knowledge. And Ptolemies I and II created the famous Pharos lighthouse, which became one of the Seven Wonders of the Ancient World. Such a lively, diverse city needed strong leadership. When Ptolemy V's father died suddenly, leaving the boy as king, the dynasty and its control of Egypt looked fragile. The boy's mother was killed, the palace was stormed by soldiers and there were revolts throughout the country that delayed the young Ptolemy's coronation for years.

It was in these volatile circumstances that Ptolemy V issued the Rosetta Stone, and others like it. The stone is not unique; there are another seventeen similar inscriptions quite like it that have survived, all in three languages and each proclaiming the greatness of the Ptolemies. They were put up in major temple complexes across Egypt. The Rosetta Stone itself was made in 196 BC, on the first anniversary of the coronation of Ptolemy V, by then a teenager. It's a decree issued by Egyptian priests, ostensibly to mark the coronation and to declare Ptolemy's new status as a living god – divinity went with the job of being a pharaoh. The priests had given him a full Egyptian coronation at the sacred city of Memphis, and this greatly strengthened his position as the rightful ruler of the country. But there was a trade-off. Ptolemy may have become a god, but to get there he had to negotiate some very unheavenly politics with his extremely powerful Egyptian priests. Dr Dorothy Thompson, of Cambridge University, explains:

> The occasion which resulted in this decree was in some respects a change. There had been previous decrees, and they take much the same form, but in this particular reign a very young king was under attack from many quarters. One of the clauses of the Memphis decree, the Rosetta Stone, is that priests should no longer come every year to Alexandria, the new Greek capital; instead they could meet at

Memphis, the old centre of Egypt. This was new, and it may be seen as a concession on the part of the royal household.

The priests were critical in keeping the hearts and minds of the Egyptian masses onside for Ptolemy, and the promise inscribed on the Rosetta Stone was their reward. Not only does the decree allow the priests to remain in Memphis, rather than coming to Alexandria, it also gives them some very attractive tax breaks. No teenager is likely to have thought this up, so somebody behind the throne was thinking strategically on the boy's behalf and, more importantly, on the dynasty's behalf.

The Rosetta Stone is therefore simultaneously an expression of power and of compromise, though to read the whole content is about as thrilling as reading a new EU regulation written in several languages. It is bureaucratic, priestly and dry.

What matters now is not what the stone says but that it says it three times and in three different languages: in Classical Greek, the language of the Greek rulers and the state administration, and then in two forms of ancient Egyptian: the everyday writing of the people (known as Demotic) and the priestly hieroglyphics which had for centuries baffled Europeans. It was the Rosetta Stone that changed all that; it dramatically opened up the entire world of ancient Egypt to scholarship.

By the time of the Rosetta Stone, hieroglyphs were no longer in general use. They were used and understood only by priests in temples. Five hundred years later, even this restricted knowledge of how to read and write them had disappeared.

The Rosetta Stone survived unread through 2,000 years of further foreign occupations. After the Greeks came Romans, Byzantines, Persians, Muslim Arabs and Ottoman Turks – all had stretches of rule in Egypt. At some point the stone was moved from the temple at Sais in the Nile Delta, where it was first erected, to the town of el-Rashid, now known as Rosetta, about forty miles away.

Then, in 1798, Napoleon arrived. The French invasion was of course primarily military (they wanted to cut the British route to India). But with the French army came scholars. Soldiers rebuilding fortifications in Rosetta dug up the stone – and accompanying experts knew immediately that they had found something of great significance.

The French seized the stone as a trophy of war, but it never made it

The inscription recording the stone's capture from Napoleon's troops

back to Paris. With his fleet destroyed by Nelson at the Battle of the Nile, Napoleon himself returned to France, leaving the French army behind. In 1801 the French surrendered to the British and Egyptian generals. The terms of the Treaty of Alexandria included the handing over of antiquities, among them the Rosetta Stone.

Most books will tell you, as I just have, that there are three languages on the Rosetta Stone, but if you look on the broken side you can see a fourth. There, painted in English, you can read: CAPTURED IN EGYPT BY THE BRITISH ARMY IN 1801 (and elsewhere) PRESENTED BY KING GEORGE III. Nothing could make it clearer that while the text on the front of the stone is about the first European empire in Africa, Alexander the Great's, the finding of the stone stands at the beginning of another European adventure: the bitter rivalry between Britain and France for dominance in the Middle East and in Africa, which continued from the time of Napoleon until the Second World War. I asked the Egyptian writer Ahdaf Soueif for her view of this history:

> This stone makes me think of how often Egypt has been the theatre of other people's battles. It's one of the earliest objects through which you can trace Western colonial interest in Egypt. The French and the British argued over it; nobody seems to have considered that it belonged to neither of them. Egypt's foreign rulers, from the Romans to the Turks to the British, have always made free with Egypt's heritage. Egypt had foreign rulers for 2,000 years, and in 1952 much was made of the fact that Nasser was the first Egyptian ruler since the pharaohs.

The last line of hieroglyphic text revealed that the glyphs were both pictorial and phonetic

The Stone was brought back to the British Museum and immediately put on display – in the public domain, freely available for every scholar in the world to see – and copies and transcriptions were published worldwide. European scholars set about the task of understanding the mysterious hieroglyphic script. The Greek inscription was the one that every scholar could read and was therefore seen to be the key. But everybody was stuck. A brilliant English polymath, Thomas Young, correctly worked out that a group of hieroglyphs repeated several times on the Rosetta Stone represented the sounds of a royal name – that of Ptolemy. It was a crucial first step, but Young hadn't quite cracked the code. A French scholar, Jean-François Champollion, then realized that not only the symbols for Ptolemy but all the hieroglyphs were both pictorial *and* phonetic – they recorded the *sound* of the Egyptian language. For example, on the last line of the hieroglyphic text on the stone, three signs spell out the sounds of the word for 'stone slab', in Egyptian *ahaj*, and then a fourth sign gives a picture showing the stone as it would originally have looked: a square slab with a rounded top. So sound and picture work together.

By 1822, Champollion had finally worked the whole thing out. From then on the world could put words to the great objects – the statues and the monuments, the mummies and papyri – of ancient Egyptian civilization.

By the time of the Rosetta Stone, Egypt had already been under Greek rule for more than a hundred years, and the Ptolemies' dynasty would rule for another 150. The dynasty ended infamously with the reign of Cleopatra VII – the Cleopatra who beguiled and seduced both Julius Caesar and Mark Antony. But with the death of Antony and Cleopatra, Egypt was conquered by Augustus, and the Egypt of the Ptolemies became part of the Roman Empire.

34
Chinese Han Lacquer Cup

Lacquer cup, found near Pyongyang, North Korea

AD 4

Throughout history, as any anthropologist will tell you, the simplest way to bind people to you has been to give them a special gift – a present only you can give and only they are worthy to receive; a present like this object. I've been considering how the leaders of vast kingdoms and empires built and retained their supremacy, whether by borrowing the image of Alexander the Great, preaching the ideals of the Buddha in India or buying off the priesthood in Egypt. In Han Dynasty China 2,000 years ago the giving of imperial gifts was an activity central to the building of influence, and one which straddled the murky boundary between diplomacy and bribery.

Our cup comes from a turbulent period in the Han Dynasty. At the centre the emperor was under severe threat, while at the edges of the empire he was struggling to keep control. The Han, who had ruled since 202 BC, extended Chinese power as far south as Vietnam, west to the steppes of central Asia and north to Korea, and in each of these places they had set up military colonies. As Han commerce and settlements grew in these outposts, so their governors gained in power, and there was always a risk that these might turn into independent fiefdoms. What the Chinese now call 'splittism' was a worry even then. The governors' loyalty to the emperor needed to be secured. And one of the ways the emperor kept them onside was to give them gifts that carried huge imperial prestige. In the British Museum we have this exquisite lacquer wine cup which was probably given by the Han emperor to one of his military commanders in North Korea around the year 4.

It is very light and more like a small serving bowl than a wine cup

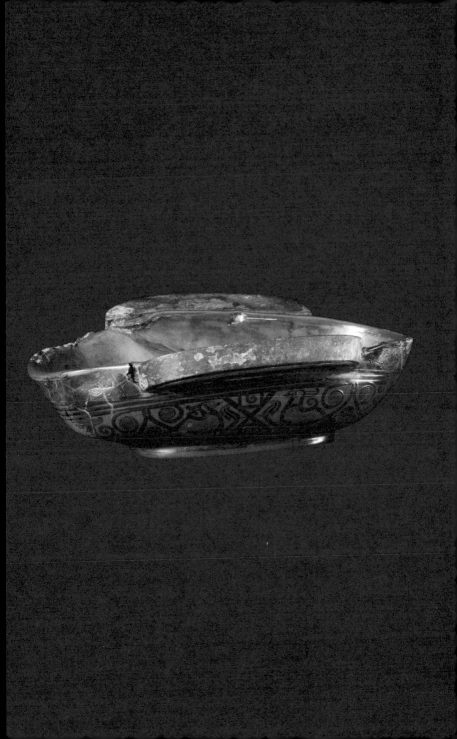

– a bowl that would hold the equivalent of a very large glass of wine. The bowl is a shallow oval about 17 centimetres (7 inches) long, roughly the size and shape of a large mango. On each of the long sides there are gilded handles which give the cup its name – it's known as an ear cup. The core of the cup is wood, and through some of the damage you can just see that wood; but most of it is covered in layer after layer of reddish-brown lacquer. The inside is plain, but the outside has been decorated with gold and bronze inlay – pairs of birds face each other, each sporting exaggerated claws against a background of geometric shapes and decorative spirals. The whole effect is of a costly, highly wrought object – elegant, stylish, confident. Everything about it speaks of assured taste and controlled opulence. Roel Sterckx, Professor of Chinese History at Cambridge University, knows exactly how much effort would go into making one of these drinking cups:

> Lacquerware takes an enormous amount of time to make. It's a very labour-intensive and a very tedious process, because the extraction of the sap of the lacquer tree is followed by all sorts of procedures, mixing with pigments, letting it cure, applying successive layers on to a wooden core to finally produce a beautiful piece. It would have involved several sets of artisans.

High-quality lacquer was brilliantly smooth and virtually indestructible. Fine pieces like our cup required thirty or more separate coats, with long drying and hardening times between each one, so it would have taken about a month to make. Hardly surprising, then, that they were inordinately expensive; you could buy more than ten bronze cups for the price of one in lacquer. So lacquer cups were strictly reserved for top management – the imperial governors controlling the frontiers of the empire.

The Han Chinese and the Roman empires covered roughly the same amount of land, but China was more populous. A census conducted in China only two years before the cup was made came up with the wonderfully precise figure of a population of 57,671,400 individuals. Roel Sterckx says:

> One of the things we need to keep in mind is that the Chinese Empire is immense and that it straddles a hugely diverse geographic region. In the

case of the Han we're talking about a distance that stretches from North Korea to Vietnam. Contact between people is not always very obvious, so the circulation of goods, the circulation of imperially sanctioned objects, together with texts, is part of that symbolical assertion of what it means to be an empire. You might not see people who are part of the same empire, but you might actually, by witnessing the goods that are produced across the empire, feel or have a sense of belonging to that greater imagined community in many ways.

Fostering that sense of an imagined community was a key imperial strategy – and it didn't come cheap. Typically, the emperor paid out a large chunk of state revenue each year to provide allies and vassal states with luxury gifts, including thousands of rolls of silk and hundreds of lacquer cups. So our cup is part of a system – it was given either as an imperial gift, or in lieu of a salary, to a senior official at the Han military garrisons near present-day Pyongyang in North Korea. Apart from its sheer monetary value, it was intended to bestow prestige and to suggest a personal link between the commander and the emperor.

At this point in the Han Dynasty's history, however, the affairs of state were not in the hands of the emperor but of the dowager empress, the formidable Grand Empress Dowager Wang, who effectively ran the state for thirty years, as none of the emperors had much time or aptitude for business. She had one emperor son, who spent a good deal of time with his concubine, Flying Swallow (who, it was said, was so light that she could dance on the palm of his hand); one emperor grandson, who was besotted with his male lover; and another grandson, on the throne at the time of our cup, who had acceded at the age of 9 and was to be poisoned with pepper wine at the age of 15, two years after our cup was made. So this lacquer cup lived in interesting times, and its making was almost certainly organized by the Grand Dowager Empress.

The machinery of the state, including the production of luxury goods, was so well structured that it could work perfectly well despite such foibles at the top. This cup is remarkable for the supreme craftsmanship of its making, and even more so because it was subjected to a level of quality control that far exceeds that of most designer luxury objects today.

Chinese characters around the base of the cup tell us who was involved in its manufacture

Around the oval base of the cup runs a thin band with sixty-seven Chinese characters on it. In Europe you might expect this kind of band to be a motto or a dedication, perhaps, but here the characters list six craftsmen responsible for the different processes involved in manufacturing the cup – making the wooden core, undercoat lacquering, top-coat lacquering, gilding the ear-handles, painting and final polishing. And then – this could surely happen only in China – it goes on to list the seven product inspectors, whose responsibility was to guarantee quality. Six craftsmen, and seven supervisors – this is the stuff of real bureaucracy. The list reads:

> The wooden core by Yi, lacquering by Li, top-coat lacquering by Dang, gilding of the ear-handles by Gu, painting by Ding, final polishing by Feng, product inspection by Ping, supervisor-foreman Zong. In charge were Government Head Supervisor Zhang, Chief Administrator Liang, his deputy Feng, their subordinate Executive Officer Long and Chief Clerk Bao.

This cup is a powerful document of the link between artisanal production and state administration; bureaucracy as a guarantee of beauty. It's not something familiar to the modern European, but for the journalist and China expert Isabel Hilton it's a continuing tradition in Chinese history:

> In Han times, the government had a major role in industry, partly to deal with its military expenditure in order to finance the kind of expeditions

that it required against the aggressive peoples of the north and the west. The government nationalized some major industries and it regulated major industries for quite a long time, so they were often run by private entrepreneurs or people who had been entrepreneurs, but under state control. There are modern parallels here, because what we've seen in the past few decades is the emergence of a hybrid system in China, from an economy that was completely under state control to a more market-oriented model, but nevertheless very firmly under state direction. If you look at where the capital gets invested, and what the structure of owner-ship is in Chinese industry, it is still largely state-controlled.

So, exploring this lacquer cup of 2,000 years ago takes us into terri-tory that is disconcertingly familiar – private enterprise under Chinese state control, cutting-edge mass production allied to high technology, deft management of relations between the Chinese capital and North Korea, and the skilful deployment of diplomatic gifts. The Chinese still know that the best gifts are always the ones that only the giver can command. In the time of the Han Dynasty, that was silk and lacquer cups. Today, when China wants to establish friendly relations, it still gives the present that nobody else can match – it's known as Panda Diplomacy.

35

Head of Augustus

Bronze statue, found in Meroë (near Shendi), Sudan

27–25 BC

Caesar Augustus, the first Roman emperor, is one of the most famous leaders in the history of the world. We have his bronze head here in the Roman galleries in the British Museum. Although tarnished, it radiates charisma and raw power. It is impossible to ignore. The eyes are dramatic and piercing; wherever you stand, they won't look at you. Augustus is looking past you, beyond you, to something much more important: his future.

The curling hair is short and boyish, slightly tousled, but it's a calculated tousle – one that clearly took a long time to arrange. This is an image that has been carefully constructed, projecting just the right mix of youth and authority, beauty and strength, will and power. The portrait was very recognizable at the time, and it's proved very enduring.

His head is a bit over life-size and tilted as if he's in conversation, so for a moment you could believe that he's just like you and me – but he's not. This is the Roman emperor who ruled at the time Christ was born. The image presents him when he has recently defeated Antony and Cleopatra and has conquered Egypt; he is well on his way now to imperial glory and is firmly embarked on an even greater journey – to becoming a god.

In previous chapters I've looked at how rulers commissioned objects that asserted their power – somewhat obliquely and essentially by association. But this is something completely different – a ruler who uses his own body and his own likeness to assert his personal power. His bronze, larger-than-life head gives a brutally clear message: I am great, I am your leader, and I stand far above everyday politics. And yet, ironically, we have this commanding head here at the Museum only because

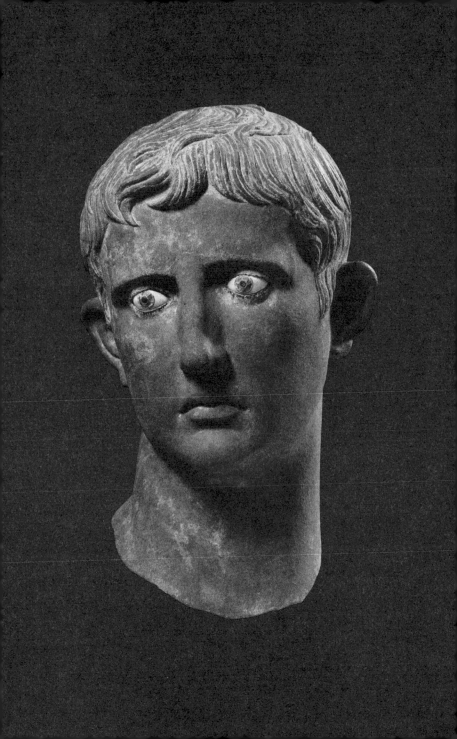

it was captured by an enemy and then humiliatingly buried. The glory of Augustus is not quite as unalloyed as he wanted us to believe.

Augustus was Julius Caesar's great-nephew. The assassination of Caesar in 44 BC left him the heir to Caesar's fortune and to his power. He was only 19 when suddenly he was catapulted into a key role in the politics of the Roman Republic.

Known at that point as Octavian, Augustus quickly outshone his peers in the scramble for absolute power. The pivotal moment in his rise was the defeat of Mark Antony and Cleopatra at the Battle of Actium in 31 BC. Already holding Italy, France, Spain, Libya and the Balkans, Augustus now followed the example of Alexander the Great and seized the richest prize of them all – Egypt. The immense wealth of the Nile kingdom was at his disposal. He made Egypt part of Rome – and then turned the Roman Republic into his personal empire. Across that empire, statues of the new ruler were erected. There were already hundreds of statues portraying him as Octavian, the man-of-action party leader; but in 27 BC the Senate acknowledged his political supremacy by awarding him the honorific title of Augustus – 'the revered one'. This new status called for a quite different kind of image, and that is what our head shows.

Our head was made a year or two after Augustus became emperor. It was part of a full-length, slightly larger-than-life statue that showed him as a warrior. It's broken off at the neck, but otherwise the bronze is in very good condition. This image, in one form or another, would have been familiar to hundreds of thousands of people, because statues like this were set up in cities all over the Roman Empire. This is how Augustus wanted his subjects to see him. And although every inch a Roman, he wanted them to know that he was also the equal of Alexander and heir to the legacy of Greece. The Roman historian Dr Susan Walker explains:

> When he had become master of the Mediterranean world and took the name Augustus, he really needed a new image. He couldn't copy Caesar's image, because Caesar looked like a crusty old Roman; he had a real warts-and-all portrait, very thin and scraggy, and bald – and very austere, very much in the manner of traditional Roman portraiture. That image had become a little bit discredited, and in any case Augustus,

as he now was, was setting up an entirely new political system, so he needed a new image to go with it. Having assumed this image when he was still in his thirties, he stayed with it until he died aged 76; there's no suggestion in his portraits of any ageing process at all.

This was an Augustus for ever powerful, for ever young. His deft, even devious, mix of patronage and military power, which he concealed behind the familiar offices of the old Republic, has served as a model and a masterclass for ambitious rulers ever since. He built new roads and established a highly efficient courier system, not only so that the empire could be ruled effectively from the centre but also so that he could be visible to his subjects everywhere. He reinvigorated the formidable army to defend and even extend the imperial borders, establishing a long-lasting peace during his forty years of steady rule. This golden period of stability and prosperity began what is famously known as the 'Pax Romana'. Having brutally fought and negotiated his way through to the top, once he was there Augustus wanted to reassure people that he would not be a tyrant. So he set to work to make people believe in him. He brilliantly turned subjects into supporters. I asked Boris Johnson, the Mayor of London and a Classicist, how he rated Augustus:

> Well, he was about the greatest politician the world has ever seen. If you wanted to have a first eleven of the world's leading politicians, the most accomplished diplomats and ideologues of all time, you'd have Augustus as your kind of midfield playmaker, captain of the eleven.
>
> He became a vital part of the glue that held the whole Roman Empire together. You could be out there in Spain or Gaul, and you could go to a temple and you would find women with images of Augustus, of this man, of this bust sewn on to their cowls. People at dinner parties in Rome would have busts exactly like this above their mantelpieces – that was how he was able to enthuse the entire Roman Empire with that sense of loyalty and adherence to Rome. If you wanted to become a local politician, in the Roman Empire, you became a priest in the cult of Augustus.

It was a cult sustained by constant propaganda. All across Europe, towns were named after him. The modern Zaragoza is the city of

Caesar Augustus, while Augsburg, Autun and Aosta all derive from Augustus. His head was on coins – and everywhere there were statues. But the British Museum's head is a head from no ordinary statue. It takes us into another story – one that shows a darker side of the imperial narrative, for it tells us not only of Rome's might, but of the problems that threatened and occasionally overwhelmed it.

This head was once part of a complete statue that stood on Rome's most southerly frontier, on the border between modern Egypt and Sudan – probably in the town of Syene, near Aswan. This region has always been a geopolitical faultline, where the Mediterranean world clashes with Africa. In 25 BC, so the writer Strabo tells us, an invading army from the Sudanese kingdom of Meroë, led by the fierce one-eyed queen Candace, captured a series of Roman forts and towns in southern Egypt. Candace and her army took our statue back to the city of Meroë and buried the severed head of the glorious Augustus beneath the steps of a temple dedicated to victory. It was a superbly calculated insult. From now on, everybody walking up the steps and into the temple would literally be crushing the Roman Emperor under their feet. And if you look closely at the head you can see tiny grains of sand from the African desert embedded in the surface of the bronze – a badge of shame still visible on the glory of Rome.

But there was further humiliation to come. The indomitable Candace sent ambassadors to negotiate the terms of a peace settlement. The case ended up before Augustus himself, who granted the ambassadors pretty much everything they asked for. He secured the Pax Romana, but at a considerable price. It was the action of a shrewd, calculating political operator, who then used the official Roman propaganda machine to airbrush this setback out of the picture.

Augustus's career became the imperial blueprint of how to achieve and retain power. A key part of retaining power was the management of his image. Susan Walker describes that image:

> Apart from presenting himself in images exactly as he did on the day that he became 'Augustus', he presented himself very modestly. He often showed himself wearing the Roman toga, drawn over his head to show piety. And sometimes he was shown as a general leading his troops into battle, even though he never actually did so. We have more than 250

images of Augustus which come from all over the Roman Empire, and they are pretty much the same – the portrait was very recognizable, and very enduring.

This eternal image would be coupled with an eternal name. After his death, Augustus was declared a god by the Senate, to be worshipped by the Romans. His titles Augustus and Caesar were adopted by every subsequent emperor, and the month of Sextilius was officially renamed August in his honour. Boris Johnson comments:

> Augustus was the first emperor of Rome and he created from the Roman Republic an institution that, in many ways, everybody has tried to imitate in the succeeding centuries. If you think about the tsars, the kaiser, the tsars of Bulgaria, Mussolini, Hitler and Napoleon, all of them have tried to imitate that Roman iconography, that Roman approach, a great part of which began with Augustus and the first 'principate', as it was called, the first imperial role that he occupied.

Great leaders like Augustus create great empires, but within those empires people are governed by the same passions, pastimes and appetites that have always governed more ordinary people's lives. It was no different under the Pax Romana. The next few objects, all from the time of the Pax Romana, provide insights into those lives. They deal with vices, and spices. And we begin with a silver cup made for a pederast in Palestine.

Ancient Pleasures, Modern Spice

AD 1–500

The objects in this section all show how attitudes to pleasure, luxury and leisure fluctuate throughout history – for example the relationships between boys and older men tolerated in the Roman Empire would be illegal today. This section also shows how many of our modern pleasures and leisure activities have their origins in ancient religion: tobacco smoking and some of the earliest team sports were elements in elaborate rituals when they are first countered, in the Americas. In the Roman empire, pepper became a marker not just of wealth, but of ostentatious refinement that some feared would bankrupt the state. In China a painting carried on its surface the record of those who over generations enjoyed its rarified message of how a lady should behave.

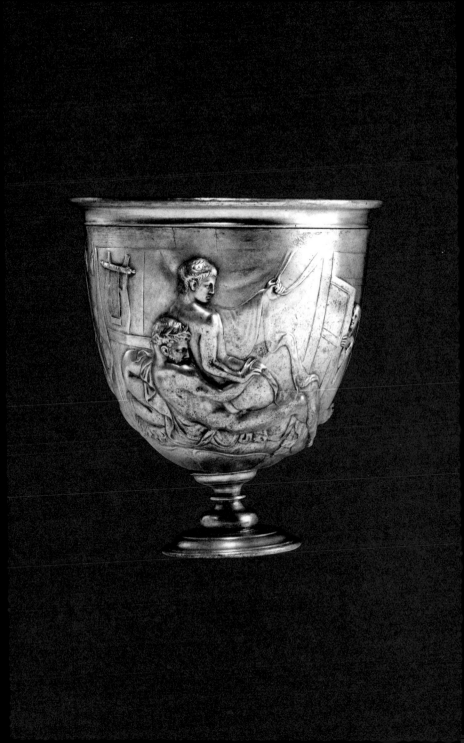

36
Warren Cup

Vessel, probably found at Bittir, near Jerusalem

AD 5–15

Two thousand years ago, the elite members of great empires like that of Rome were not solely concerned with power and conquest. Like all elites they also found time for pleasure, and art. This object incorporates both. It is a silver cup made in Palestine, in about AD 10. Before coming to the British Museum it had been in the collection of the wealthy American Edward Warren (who commissioned the most famous version of Rodin's sculpture *The Kiss*), and it tells us almost as much about twentieth-century attitudes to sex as about Roman ones.

The Warren Cup shows scenes of sexual coupling between adult men and adolescent boys. This 2,000-year-old piece of Roman silverware is a goblet that looks as though it would hold a pretty large glass of wine. It's in the shape of a modern sporting trophy, standing on a small base, and it would once have had two handles, though these are now lost. You can see at once that this is a work of supreme craftsmanship. The scenes on the cup are in relief, created by beating out the silver from the inside. It must have been used at private parties, and given the subject matter it would certainly have commanded the admiration and the attention of everybody present.

Lavish eating and drinking were among the key rituals of the Roman world. Throughout the empire, Roman officials and local bigwigs would use banquets to oil the wheels of politics and business and show off wealth and status. Roman women were generally excluded from events such as the drinking parties where our cup would have been found, and we can probably assume that it was intended for a party with an all-male guest list.

Imagine a man arriving at a grand villa near Jerusalem somewhere

around the year 10. Slaves lead him through to an opulent dining area, where he reclines with the other guests. The table is laid with silver platters and ornate vessels. This is the context in which our cup would have been passed around among the guests. On it two scenes of male love-making are set in a sumptuous private house. The lovers are depicted on draped couches similar to the ones the guests at our imaginary dinner party would be lounging on. And you can see a lyre and pipes waiting to be played as the participants settle to their sensual pleasures. The Classical historian and broadcaster Bettany Hughes elaborates:

> The cup depicts two varieties of a homosexual act. On the front there is an older man – we know he's older because he has a beard; sitting astride him is a very handsome young man. It's all very vigorous and virile, very realistic – it isn't an idealized view of homosexuality. But if you look round the back there is a more standard portrayal of homosexuality. It shows two very beautiful young men – we know that they're young because they have locks of hair hanging down their backs. One is lying on his back, and the slightly older man is looking away. It's a lot more lyrical, a rather idealized view of what homosexuality was.

Although the homosexual scenes on the cup are ones that today strike us as explicit – some might say shocking and taboo – homosexuality was very much part of Roman life. But it was a complicated part, tolerated but not entirely accepted. The standard Roman line on what was admissible in same-sex coupling is neatly summarized by the Roman playwright Plautus in his comedy *Curculio*: 'Love whatever you wish, as long as you stay away from married women, widows, virgins, young men and free boys.'

So if you wanted to show sex between men and youths who weren't slaves, it made sense to look back to the age of Classical Greece, where it was normal for older men to teach younger boys about life in general, in a mentoring relationship that included sex. The early Roman Empire had idealized Greece and adopted much of its culture, and the cup shows what is clearly a Greek scene. Is this a Roman sexual fantasy of a Classical Greek male coupling? Perhaps by placing it in a Greek past any moral discomfort is put at a safe distance, while adding to the titillation of the forbidden and exotic. And perhaps

*The other side of the
cup shows two youths*

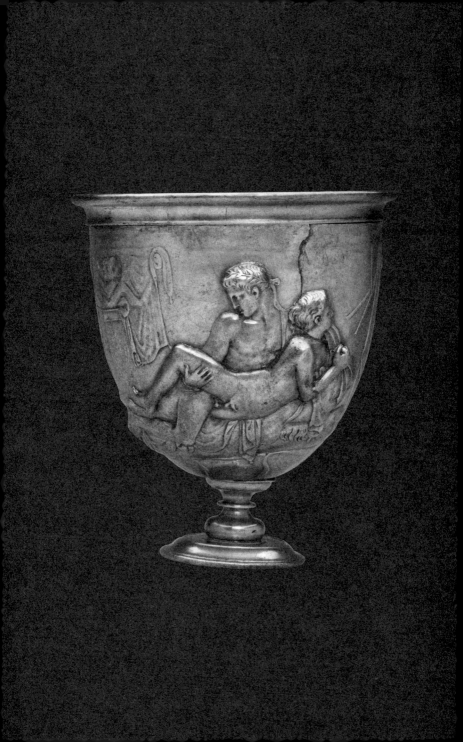

everybody believes that the best sex happens somewhere else. Professor James Davidson, author of *The Greeks and Greek Love*, explains:

> Although this cup looks back to the Classical period, the Greek vase painters, who were by no means prudish or modest when it came to depicting sex, nevertheless carefully avoided scenes of homosexual intercourse, at least penetrative intercourse. So the Romans are showing what couldn't be shown 500 years earlier. The Greek world provided an alibi that allowed societies to think about homosexuality, to talk about homosexuality, to represent homosexuality, as it did from the eighteenth century onwards and even in the Middle Ages. It made it into a piece of art more than a piece of pornography.

There's no doubt where these encounters are taking place. The musical instruments, the furniture, the clothes and the hairstyles of the lovers all point to the past – to the Classical Greece of several centuries earlier. Interestingly, we can tell from our cup that the two younger adolescents shown here were not slaves. The style of their haircuts, with a long lock trailing down the neck, is typical of freeborn Greek boys. Between 16 and 18, the hair would be cut and dedicated to the gods as part of the passage into manhood. So both the boys shown on the cup are free and from good families. But we can also see another figure, who might have been part of the Roman banquet at which the cup was used. He stands in the background, peeping at one of the scenes of love-making from behind a door – we only see half his face. He is clearly a slave, although it is impossible to know whether he is simply indulging in a bit of voyeurism or apprehensively responding to a call for 'room service'. Either way, he's a reminder that what he and we are witnessing are acts to be conducted only in private behind closed doors. Bettany Hughes comments:

> In Rome there was a notion that you have good wives and that you should manage without resorting to male sex. But we know, from the poetry, from the laws, from the back-references to homosexual relations, that actually this was something that did happen throughout the Roman world. The Warren Cup is a good bit of exquisite hard evidence which proves that. This cup is telling us what actually went on, how homosexual activity was something which took place in high aristocratic circles.

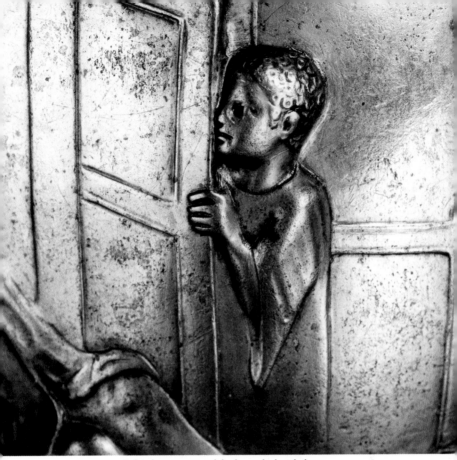

A slave boy peers around the door to look at the lovers

Silver cups of this date are now exceptionally rare, as so many were melted down, and among the survivors few can match the virtuoso skill of the Warren Cup. To buy a cup like this you would have had to be rich, for it would have cost somewhere around 250 denarii – and for that money you could have bought twenty-five jars of the best wine, two thirds of an acre of land, or even an unskilled slave like the one we see peering round the door. So this indulgent little dining piece places its owner firmly in the echelons of high society, the world that St Paul eloquently condemned for its drunkenness and its fornication.

We don't know for certain, but it's thought that the Warren Cup

was found buried near Bittir, a town a few miles south-west of Jerusalem. How it got to this location is a mystery, but we can make a guess. We can date the making of the cup to around the year 10. About fifty years or so later, the Roman occupation of Jerusalem sparked tensions between the rulers and the Jewish community, which in AD 66 exploded. The Jews took back the city by force. There were violent confrontations, and our cup may have been buried at this date by the owner before he fled from the fighting.

After this, the cup disappeared for almost 2,000 years, until it was bought by Edward Warren in Rome in 1911. For years after his death in 1928 it proved impossible to sell – the subject matter was just too shocking for any potential collector. In London, the British Museum declined to buy it, as did the Fitzwilliam Museum in Cambridge, and at one point it was even refused entry to the United States of America, when the explicit nature of its imagery offended a customs official. It was only in 1999, long after public attitudes to homosexuality had changed, that the British Museum bought the Warren Cup – then the most expensive acquisition it had ever made. A cartoon at the time showed a Roman barman saucily asking a customer, 'Do you want a straight goblet or a gay goblet?'

A hundred years after he bought it, Warren's cup is now on permanent public display here in the Museum, and it serves a very useful purpose. It's not just a superb piece of Roman imperial metalwork: from party cup to scandalous vessel and finally to an iconic museum piece, this object reminds us that the way societies view sexual relationships is never fixed.

37
North American Otter Pipe

Stone pipe, from Mound City, Ohio, USA

200 BC–AD 100

The British Museum can demonstrate the changing views of society on many matters, not just sex. Here we have an object that once carried enormous social significance but is now virtually banned from all public gatherings: the tobacco pipe. Smoking, with its pleasures and perils, has a long history, and this pipe shows that it was going strong 2,000 years ago in North America.

The pipe shown here is about the size and shape of a kazoo. It is not like a modern pipe, with a long stem and a bowl at one end; instead, it is carved in reddish stone and has a flat base about 10 centimetres (4 inches) long, so it's almost exactly the colour and size of a bourbon biscuit. One end is carved with a small hole to serve as the mouth piece. The pipe bowl is halfway down, but it's no simple hollow for holding the tobacco; it's in the shape of the upper half of a swimming otter with its paws perched on the bank of a river, as if it's just popped up out of the water to look around. The stone is smooth, and it beautifully suggests the sleek wet fur of the animal. The otter looks along the pipe so that, as you smoke it, you and the otter are gazing into each other's eyes. But in fact the smoker is even closer to this animal than that suggests: if you put it to your mouth you discover that you are nose to nose with the otter. That contact would have been even more striking originally than it is now, because the empty eye sockets would have been inlaid with freshwater pearls. This wonderfully crafted and evocative object pinpoints in history the world's earliest use of tobacco pipes. This is where the story of pipe-smoking begins.

Although smoking is now largely seen as a fatal vice, 2,000 years ago in North America pipe-smoking was a fundamental ceremonial

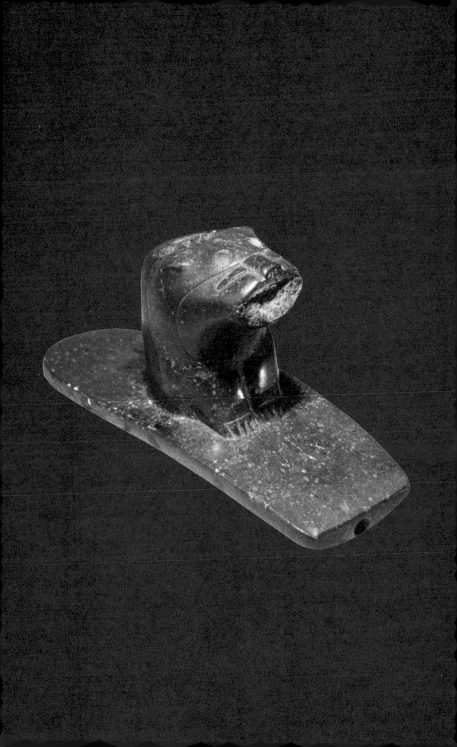

and religious part of human life. Different groups of Native Americans lived across the continent, in ways much more varied than Hollywood westerns would suggest. Those Americans living in Middle America – the lands around the mighty Mississippi and Ohio rivers, from the Gulf of Mexico to the Great Lakes – were farmers. They had no cities, but they did reshape their vast landscape with extraordinary monuments. While their small farming and trading communities seem to have lived apart, they died together, joining forces to build enormous earthworks as gathering places for ceremonies and to bury their dead. Within the earthworks were graves rich with decorative objects and weapons crafted from exotic raw materials traded over huge distances: there were the teeth of grizzly bears from the Rocky Mountains, conch shells from the Gulf of Mexico, mica from the Appalachian Mountains and copper from the Great Lakes. These spectacular sculpted burial mounds would later astonish visiting Europeans. One group in particular, popularly known as 'Mound City', is in present-day Ohio – an enclosed 13-acre site with twenty-four separate burial mounds. In one of the mounds there were around 200 stone pipes, one of which is our otter pipe.

The pipe comes from the period from which we have the earliest evidence for tobacco use in North America. Tobacco was first cultivated in Central and South America, and smoked wrapped in the leaves of other plants, rather like a cigar. In the colder north, though, there were no wrapping leaves to be had through the long winters, and smokers had to find another way of containing their tobacco – so they made pipes. The cigar/pipe divide seems in part to have been a result of climate.

Stone pipes are found consistently in the Ohio burial mounds, which indicates that they must have had some special place in the lives of the people who made and used them. Although archaeologists haven't yet understood their precise meaning, we can make an informed guess about how they may have been regarded. Here's the view of the Native American historian Dr Gabrielle Tayac, curator of the National Museum of the American Indian:

> There's a whole cosmology and theology that goes with pipes. They carry with them all of the meanings of religious teachings. They are definitely considered to be living beings that should be treated as such,

rather than as just objects, or even sacred objects, that come alive and come into their own power when the bowl is united with the stem. For example, if a pipe is made of the red pipestone, it's considered to be the blood and bones of buffalo. There are rituals and initiations and tremendous responsibilities that go along with being a pipe-carrier in particular places.

We know that 2,000 years ago only select members of the community were buried in the mounds. Many of them must have played a key part in rituals, because fragments of ceremonial costumes have been found with the bodies – headdresses made from bear, wolf and deer skulls. The animal world seems to have had a central role in the spiritual life of these people – our otter pipe is just one of a whole pipe menagerie: there are bowls shaped like wild cats, turtles, toads, squirrels, birds, fishes and even birds eating fishes. Perhaps the animals on the pipes had a role in some kind of shamanic ritual connecting the physical and spiritual worlds. The tobacco smoked at the time was *Nicotiana rustica*, which produces a heightened state of awareness and has a hallucinogenic effect: given that he or she would be eyeball to eyeball with the creature sculpted on it, we can imagine the smoker entering into a kind of transcendent state in which the animal would come to life. Perhaps each animal served as a spirit guide or totem to the person smoking; certainly for later Native American peoples it's known that they might dream of an animal whose spirit would then protect them throughout their life. Gabrielle Tayac comments:

> Native people still use tobacco, it's a very sacred item. The usage of tobacco smoke is a way of transforming prayer and thought and community expression. Pipes could either be smoked individually or passed around a community or a family, so that it's a way of unifying the mind and then sending up the power of the mind into the vast Universe or to the creator or intercessors. When you talk about the 'peace pipe' at a treaty negotiation, that is more meaningful than to sign a document. It's a way of sealing a deal not just legally but by giving a vow and confirming that to the larger Universe, so it's not just between humans, it's between humans and the greater powers that are there.

Even today among Native Americans, smoking can still be a spiritual

act – the smoke rises and mingles, bearing unified prayers skywards, and as it does so it combines the hopes and wishes of the whole community.

Europeans discovered smoking very late, in the sixteenth century. For them, smoking tobacco quickly became less about religion than about relaxation – though it has to be said that from the outset there were critics. No modern government health warning can begin to match the verve of the great *Counterblaste to Tobacco* published by King James I in 1604, just months after he had come from Edinburgh to succeed Queen Elizabeth. The newly arrived king denounced smoking as 'A custome lothsome to the eye, hatefull to the Nose, harmefull to the braine, dangerous to the Lungs, and in the blacke stinking fume thereof, neerest resembling the horrible Stigian smoke of the pit that is bottomelesse.'

But very soon tobacco began its association with money. When the British colonized Virginia the emerging tobacco market in Europe rapidly became of prime economic importance – Bremen and Bristol, Glasgow and Dieppe all grew rich on American tobacco. As Europeans penetrated deeper into the continent in the eighteenth and nineteenth centuries tobacco became an article of trade and currency in its own right. The European acquisition of tobacco and European pipe-smoking symbolize for many Native Americans the expropriation of their homeland by intruders.

From then on, in Europe and most of the world, smoking became an activity associated with pure pleasure, daily habit and considerable cool. For most of the twentieth century, film stars puffed away on screen while their cinema audiences admired them through answering clouds of smoke. Smoking was not only sophisticated: it was intellectual and meditative, and Sherlock Holmes famously described one particularly testing case as 'quite a three-pipe problem'. There was of course also the intensely enjoyable personal engagement with the physical object. The famous pipeman and politician Tony Benn fondly recalls those days:

> Stanley Baldwin smoked a pipe, Harold Wilson smoked a pipe – it was a very normal thing to do, and of course there is the pipe of peace, pipes associated with friendships and sitting round together, and so on. So

they do have a meaning over and above the satisfaction of smoking. It's a sort of hobby in a way – you scrape it and clean it and fill it and tap it and light it, it goes out and you light it again, and if you were asked a question at a meeting – not that you can smoke in meetings any more – you could light your pipe and say 'that's a very good question' – it gives you a little bit of time to think of the answer. But I wouldn't recommend anybody else to start smoking.

The overthrow of smoking in the Western world in the past thirty years has been an extraordinary revolution. In Hollywood movies now, only the 'baddies' smoke, and the audience not at all; anybody caught smoking would be hounded out of the cinema. James I would be delighted. As we saw with the Warren Cup, what societies deem allowable as pleasure is constantly and unpredictably negotiated.

38

Ceremonial Ballgame Belt

Stone belt, found in Mexico
AD 100–500

In the Mexican gallery of the British Museum we have what looks like a giant stone horseshoe – it's about 40 centimetres (15 inches) long and about 12 centimetres (4 inches) thick, and it is made of a very beautiful grey-green speckled stone. When it first came to the Museum in the 1860s it was thought to be a yoke for something like a cart-horse. But there were two immediate problems with this idea: the object is very heavy, nearly 40 kilos (90 lbs), and in any case there were no carthorses or draught animals in Central America until the Spaniards brought them from Europe in the sixteenth century.

It was only just over fifty years ago that it was generally understood that these stone sculptures had nothing to do with animals: they were carvings of objects meant to be worn by men. They represent the padded belts made of cloth or basketwork worn to protect the hips during ancient Central American ball games. Some of these stone 'belts' may have been moulds used to shape lighter cloth or leather padding, and the one we have in the Museum is so heavy that if it was worn it can only have been for a very brief time. We don't know exactly when or how it might originally have been worn; in fact we don't know if it was meant to be worn at all.

A leading expert on these games, Michael Whittington, thinks these stone belts were primarily for ceremonial use:

Wearing an object that's 75–100 lbs around your waist during an athletic competition will slow you down considerably, so they were probably worn as part of the ritual ceremonies at the beginning of the game. They do represent the real yokes that were worn during the ball game,

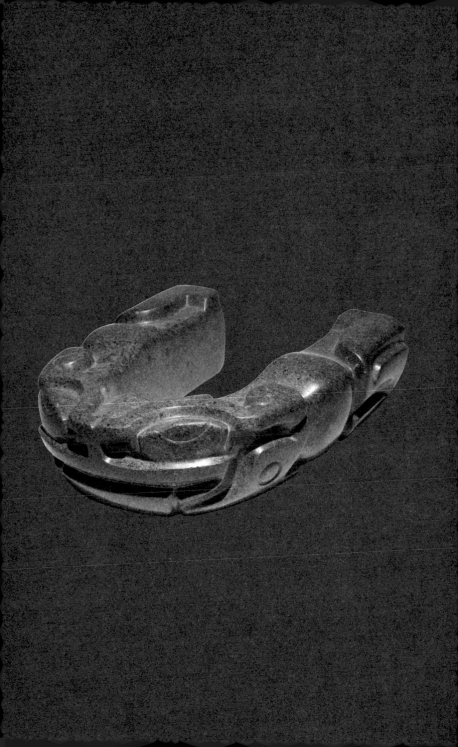

but those real yokes were of perishable materials and they in almost all circumstances have not survived.

We know a little about this Central American ball game because it was quite frequently represented by local artists, who over hundreds of years made sculptures of players and models of pitches with the public sitting on the walls of the court watching the players. Later European visitors wrote accounts the game, and several stadia built specially for it still survive today. When the Spaniards arrived they were amazed by the ball that the game was played with, because it was made of a substance entirely new to Europeans – rubber. The very first view of a bouncing ball, a round object seemingly defying gravity and shooting around in random directions, must have been extremely disconcerting. The Spanish Dominican friar Diego Durán reported a sighting:

> They call the material of this ball *hule* [rubber] ... jumping and bouncing are its qualities, upward and downward, to and fro. It can exhaust the pursuer running after it before he can catch up with it.

This was not an easy game. The rubber ball was heavy – it could weigh anywhere from 3 or 4 kilos (8 lbs) to almost 15 kilos (30 lbs) – and the aim was to keep it in the air and eventually to land it in the opponents' end of the court. Players were not allowed to use their hands, head or feet, but had to use their buttocks, forearms and above all their hips – which is where a padded belt would have been most useful. The belts actually used in the game, probably made of leather, wood and woven plants, had to be strong in order to protect the wearer from the heavy ball but light enough to allow him to move about the court. In 1528 the Spanish brought two Aztec players to Europe, and a German artist painted them in mid game, back to back, virtually naked, wearing what look like specially reinforced briefs with the ball in flight between them. The exact rules of the game are unclear and may have changed over the centuries, as well as varying throughout Central America's different communities. What we do know is that it was played in teams of between two and seven players, and scoring was based on the result of faults, as in tennis today. These faults included touching the ball with a prohibited part of the body such as the head or the hand, failing to return it and sending it out of the court.

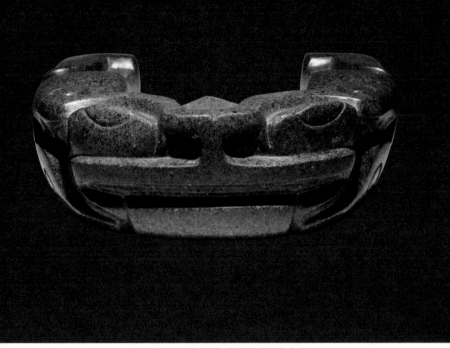

The eyes and mouth of the toad on the belt

The balls also became a kind of currency. Spaniards recorded the Aztecs' exacting tribute payments of 16,000 rubber balls. Not many balls have survived, but excavations and finds made by farmers across Mexico and Central America have turned up a few, as well as hundreds of stone belts like ours and stone reliefs and sculptures showing players with belts around their waists.

By the time our belt was made, around 2,000 years ago, elaborate stone courts built specially for the game were being used. Many were rectangular and several had long sloping walls off which the ball could be bounced. Spectators could also sit along the top of these great stone structures and watch the matches unfold. Clay models show supporters cheering on the players and enjoying the game, just as football fans do today.

But these games were far more than just competitive sports: they held a special place in the belief system of the ancient Central Americans, and our stone belt is a clue to these hidden beliefs. Along the

outside of the belt are carved designs, and on the front of the curve of the horseshoe shape, cut into the polished stone, is the stylized image of a toad. He has a broad mouth stretching the whole length of the curve and, behind the eyes, bulbous glands which extend back to the crouched hind legs. Zoologists have been able to identify the species as the Giant Mexican Toad (*Bufo marinus*). Perhaps the key to understanding this object is that this toad excretes a hallucinogenic substance, and Central Americans believed that it represented an Earth goddess. Belts for ball games were made with various underworld animals carved into them, and this tells us that they were meant to be viewed not individually but rather as part of a broader ritual. It seems that the painful intensity of the ball game symbolized the constant cosmic struggle between the forces of life and death. Michael Whittington elaborates:

> I think it's a metaphor for how Meso-Americans view the world. When you look at one of the great creation stories in Meso-America, the Popol Vuh, there are twins. Their names were Xbalanque and Hunahpuh. They were ball players, they lived in the underworld, and they played ball with the lords of death. The game re-emphasized how Meso-Americans viewed themselves in the cosmos and in relation to the gods. So they were playing out a game of gods and the lords of death every time they took to the ball court.

This is disconcertingly familiar. Whether it's Maradona's infamous 'hand of God', which he claimed scored his first goal in Argentina's match against England in the 1986 World Cup, the carrying of the flame from the sanctuary at Olympia in Greece at the start of each Olympic Games, or Welsh rugby fans singing hymns at Cardiff Arms Park, competitive sport and religion seem often to be closely related. Few supporters today, singing hymns or cheering for their teams with fanatical enthusiasm, know that the world's earliest known team sport also had a strong religious dimension or that the story began not in ancient Greece but in Central America.

But modern sportsmen don't face the hazards of their predecessors. It used to be thought that the losing team was always sacrificially slaughtered, and, though this did occasionally happen later, at the time of our belt we don't know what lay in store for the losers. Mostly the

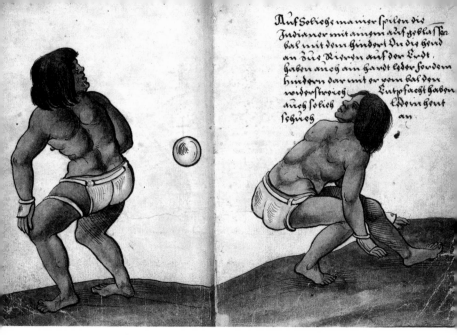

*Christoph Weiditz's drawing of Central American ballplayers
at the court of Emperor Charles V*

games were an opportunity for a community to feast, to worship, and to create and reaffirm social ties. It's thought that early on this was a game that both men and women could play, but by the time the Spanish encountered the Aztecs in the sixteenth century it was being played exclusively by men. The ball courts were designed to be sacred spaces in which offerings were buried, so making the building itself a living entity. The Spanish recognized the religious significance of the courts and wanted to replace the old local pagan religion with their new Catholic one. It is no accident that they built their cathedral in what is today Mexico City on the site of the Great Ball Court of the ancient Aztec city Tenochtitlán. But, although the courts were destroyed or abandoned, the game survived the brutal conquest of Mexico and the destruction of Aztec culture. A form of it, called *ulama,* is even played today – proof, if any was needed, that once a sport embodies a national identity as this one does, it has enormous staying power

One of the striking characteristics of organized games throughout history is their capacity to transcend cultural differences, social divisions and even political unrest. Straddling the boundary between the

sacred and the profane, they can be great social unifiers and dividers. There are few other things that we collectively care about so much in our society today. Our Mexican ceremonial belt acts as a powerful symbol of how far all societies can take their delight in mass, organized sport.

The annotation on the drawing opposite reads:

'In such manner the Indians play with the blown-up ball with the seat without moving their hands from the ground; they have also a hard leather before their seat in order that it shall receive the blow from the ball, they have also such leather gloves on.'

歡不可以瀆寵不可以專實生慢愛則極
遷致盈必損理之固然美者自美翩以
取尤冶容求好君子所仇結恩而絕寔
此之曲

39

Admonitions Scroll

Painting, from China
AD 500–800

After banqueting and gay sex in the early Roman Empire, smoking and ceremony in North America, ball games and belief in Mexico, we come to another kind of elaborate social pleasure – looking at painting. Specifically I want to look at a masterpiece of painting from China, in the form of a scroll, based on an original painted around the years AD 400 or 500. It embraces three separate art forms, in China known lyrically as 'the three perfections': painting, poetry and calligraphy. As a handscroll it was made to be viewed with selected friends, and as a fine work of art it was cherished by emperors over hundreds of years. It's known as *The Admonitions of the Instructress to the Court Ladies*, or the *Admonitions Scroll*, for short, and it's a form of ancient guide to manners, and above all to morals, for ladies of the Chinese court – it tells powerful women how to behave.

A common theme which has emerged from the objects I have described in the previous few chapters has been the changing view of what constitutes an acceptable pleasure. At different times in world history spice has turned into vice – or vice versa. But enjoying a work of art like the *Admonitions Scroll* has always been entirely acceptable, and the scroll itself carries the record of those who, through the centuries, have been lucky enough to look at it and enjoy it.

The scroll is cared for in the specially built East Asian painting conservation studio at the British Museum, where the entire painting can be laid out – it's about 3.5 metres (11 feet) long. Its creation brought together artists of different periods, and since it was completed it has been continually cherished. The starting point was a long poem written by the courtier Zhang Hua in AD 292. About a century later,

The emperor turns to reject his wife. 249
For a translation of the verse, see
page 255

around the year 400, a famous painting – now believed to be lost – incorporated the poem. The *Admonitions Scroll* was probably completed 200 years or so after that, but it faithfully copied and captured the spirit of the original great painting, indeed there are some who think that this may be the original painting itself. Whatever its precise status, this scroll is one of the most celebrated examples of early Chinese painting to have come down to us.

About half of the scroll is made up of painted scenes, each one divided from the next by lines from the poem. As the scroll was slowly unrolled, you would have read the poem and been able to see only one scene at a time; that sense of unfolding is a key part of the pleasure. One frame shows a disturbing episode. A beautiful and seductive woman of the court harem is approaching the emperor. The billowing robes and red ribbons that she's wearing accentuate her movement as she flutters coquettishly towards him. But, as we look more closely, we can see that she's actually faltering: she's just been brought up short by the emperor's outstretched arm and hand, raised in an uncompromising gesture of rejection. The emperor is above fleshly desire. Her body twists as she abruptly begins to turn away, and on her face is the expression of a shocked, thwarted vanity.

When Zhang Hua wrote the poem in AD 292, China was in a state of fragmentation following the collapse of the Han Empire. Competing forces jostled for supremacy, constantly threatening to dethrone the emperor. The emperor himself was mentally deficient, so his wife, Empress Jia, had a great deal of power, which she spectacularly misused. According to a written history of the time, Zhang Hua, who was a minister at court, was increasingly horrified by the way the empress and her clan were usurping the authority of her husband; she was jeopardizing the stability of the dynasty and of the state by murder, intrigue and riotous sexual affairs. Zhang Hua wrote the poem ostensibly to educate all the women of the court, but his real target was the empress herself. He hoped through the inspiring and beautiful medium of poetry that he would be able to lead his wayward ruler to a life of moral correctness, restraint and decorum:

> Keep an eager guard over your behaviour;
> For thence happiness will come.
> Fulfil your duties calmly and respectfully;
> Thus shall you win glory and honour.

The painting that illustrates this poem also has a high moral purpose. Although the lessons are for women, they can also speak to men. When the emperor refuses to be seduced by his vain wife he sets an example of male judgement and strength. Dr Shane McCausland, a leading expert on early Chinese painting, has studied the *Admonitions Scroll* in detail:

> It's about positive criticism. The artist is not trying to tell people what not to do, but to tell them how to do something better. Each of the scenes describes ways in which ladies of the court could improve their conduct, their behaviour, their character. Admonition is really about learning, improving yourself; but in order to do that, if your audience is very jaded, you need to inject quite a lot of wit and humour into it. That's exactly what this artist has done. It bears very closely on kingship, on the tradition of statecraft, of principled government. It's an insightful portrayal of the human interactions which go into governing.

Unfortunately, Empress Jia was impervious to the poem's moral message and carried on with her scandalous sexual exploits and her murderous activities. Some of her ruthlessness may have been warranted, since there were rebels stirring up civil war, and ultimately in AD 300 there was a successful coup. The empress was captured and forced to commit suicide.

A hundred years later, around the year 400, the court was beset by the same problems. One day the emperor Xiaowudi observed to his favourite consort, 'Now that you are 30 years old, it's time I exchanged you for somebody younger.' He meant it as a joke; but she didn't take it well, and she murdered him that evening. The court was scandalized. It was obviously time to remind everybody how to behave by re-publicizing Zhang Hua's poem in a scroll painted by the greatest artist of the day, Gu Kaizhi. The resulting masterpiece is the *Admonitions Scroll*. Dr Jan Stuart, Keeper of the Department of Asia here at the British Museum, is very familiar with this painting and its purpose:

> The scroll fits into a tradition of didactic imagery established in the Han Dynasty and influenced by the great philosopher Confucius. When you read the text alongside the images, you realize that there's a deep message being communicated. Confucius had the idea that everyone in society has a proper role and place, and if they follow that then a very healthy and effective society is ensured. That message must have been

OVER: *A lady rushes to save the emperor from a ferocious bear*

especially important at the time the poem that this scroll is based on was written. The message is that the woman, even one with great beauty, must always evince humility, must always abide by rules, and never forget her position in relationship to her husband and family; by doing so, she is a positive and active force in promoting social order.

In the *Admonitions Scroll* we find that a lady ought never to exploit the manners or weaknesses of her man. The only time that a lady should put herself before the emperor is to protect him from danger. Another scene in the scroll illustrates a real event, when a ferocious black bear escaped from its enclosure during a show put on for the emperor and the ladies of his harem. In this particular scene we first see two harem ladies running away from the wild beast and looking back in horror. We next see the emperor seated, frozen with shock, and in front of him the valiant lady who has not run away but has rushed to place herself between the emperor and the bear, which is leaping at her, snarling fiercely. But the emperor is safe. This, the picture tells us, is the kind of self-sacrifice we need and expect from our great ladies.

This scroll became the prized possession of many emperors, who may have found it to be a useful aid in subduing troublesome wives and mistresses but who also admired its sheer beauty and used the act of collecting this precious masterpiece as a way of showing just how culturally astute and powerful they were. We know exactly whose courts it was viewed in, because each imperial ruler has left their mark on it, in the form of a stamp carefully placed in the blank spaces around the paintings and the calligraphy. Some of the previous owners have also added their own comments to the scroll. This brings a kind of pleasure you can never find looking at European painting: the sense that you are sharing your delight with people from centuries past, that you are now joining a community of discerning art lovers who have cherished this painting over centuries. For example, the eighteenth-century Qianlong emperor – a contemporary of George III – sums up his appreciation of the scroll:

> Gu Kaizhi's picture of the *Admonitions of the Instructress*, with text. Authentic relic. A treasure of divine quality belonging to the Inner Palace.

It was such a treasured relic that only very small audiences would ever have been given access to it. That's true now as well, but for a different reason: the silk that it is painted on suffers greatly if exposed to light, so it is too delicate to be put on display except very rarely. But, although we're not allowed to put our own stamp on it to record our delight, thanks to modern reproductive technology we can all join the Qian-long emperor and the other people who through the decades have so enjoyed gazing at the *Admonitions Scroll*. Thanks to the internet, the private pleasure of the Chinese imperial court has become universal.

The verse in the illustration on page 248 reads:

No one can please forever; / Affection cannot be for one alone; / If it be so, it will end in disgust. / When love has reached its highest pitch, it changes its object; / For whatever has reached fullness must decline. / This law is absolute. / The 'beautiful wife who knew herself to be beautiful' / Was soon hated. / If by a mincing air you seek to please, / Wise men will abhor you. / From this cause truly comes / The breaking of favour's bond.

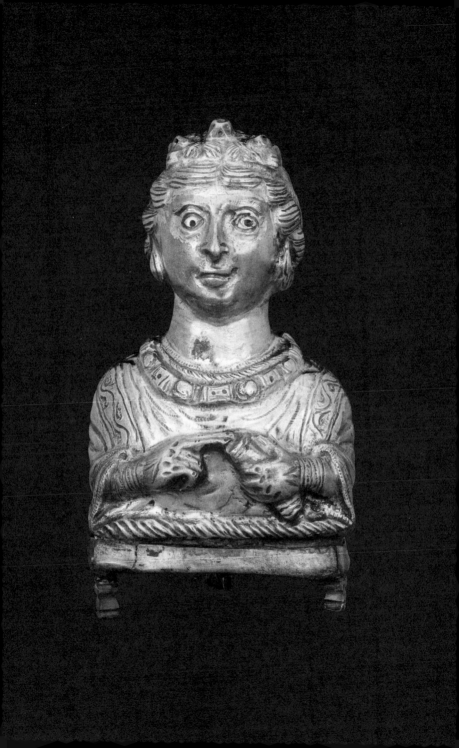

40

Hoxne Pepper Pot

Silver pot, found in Hoxne, Suffolk, England
AD 350–400

For thousands of years western Europeans have been entranced by the spices of the East. Long before curry became a British national dish, we dreamt of transforming our dull island food with exotic flavours from India. For the poet George Herbert the phrase 'the land of spices' evoked a metaphorical perfection at once unimaginably remote and infinitely desirable. So it's perhaps not surprising that through the centuries spice has always been not just high poetry but big business. The spice trade between the Far East and Europe funded the Portuguese and Dutch empires and provoked many bloody wars. Already at the beginning of the fifth century it was a trade that embraced the whole of the Roman Empire. When Visigoths attacked the city of Rome in AD 408, they were induced to leave only on the payment of a huge ransom that included gold, silver, large quantities of silk and one further luxury – a tonne of pepper. This precious spice had made its lucrative way all over the Roman Empire, from India to East Anglia, which is where this object was found.

What we think of as Suffolk the Romans might have called the Far West. Around the year 400, centuries of unprecedented peace and prosperity in Britain were about to end in chaos. Across western Europe the Roman Empire was fragmenting into a series of failed states, and in Britain the Roman leadership was conducting a phased withdrawal. At moments like this it is tricky to be rich. There was no longer any organized military force to protect the wealthy or their possessions, and as they fled they left behind them some of the finest treasure ever found. Our object belongs to a fabulous collection of

gold and silver buried in a field at Hoxne, Suffolk, around 410 and found nearly 1,600 years later, in 1992.

It looks like a small statue of the upper half of a Roman matron wearing elaborate clothes and long dangly earrings. Her hair is fantastically complicated, twisted and plaited: she is obviously a seriously *grande dame* and very fashionable. She's about 10 centimetres (3 inches) high, the size of a pepper pot. Indeed that is exactly what she *is* – a silver pepper pot. On the underside there is a clever mechanism that allows you to determine how much pepper will come out. You turn the handle and you can either close it completely, have it fully open, or set it to a kind of sprinkling mode. This pepper pot would clearly have been owned by very wealthy people, and it's obviously designed to amuse. Although the face is of silver, the eyes and the lips are picked out in gold so that, as the candles flickered, the eyes and the lips would appear to move. She must have been quite a talking point at Suffolk banquets.

Britain became part of the Roman Empire in the year 43, so by the time of our pepper pot it had been a Roman province for more than 300 years. Native Britons and Romans had intermingled and intermarried and in England everyone did as the Romans did. The Roman trade expert Dr Roberta Tomber elucidates:

> When the Romans came to Britain they brought a lot of material culture and a lot of habits with them that made the people of Britain feel Roman; they identified with the Roman culture. Wine was one of these – olive oil was another – and pepper would have been a more valuable one in this same sort of 'set' of Romanitas.

The Romans were particularly serious about their food. Slave chefs would man the kitchens to create great delicacies for their consumption. A high-end menu could include dormice sprinkled with honey and poppy seeds, then a whole wild boar being suckled by piglets made of cake, in which were placed live thrushes, and to finish, quince, apples and pork disguised as fowls and fish. None of these opulent culinary inventions would have been created without ample seasoning – and the primary spice would have been pepper.

Why has this particular spice remained so constantly attractive for us? I asked the author Christine McFadden about the importance of a bit of pepper in your recipe:

They just couldn't get enough of it. Wars were fought over it, and if you look at Roman recipes, every one starts with 'take pepper and mix with ...'.

An early twentieth-century chef said that no other spice can do so much for so many different types of food, both sweet and savoury. It contains an alkaloid called piperine, which is responsible for the pungency. It promotes sweating, which cools the body – essential for comfort in hot climates. It also aids digestion, titillates the taste buds and makes the mouth water.

The closest place to Rome where pepper actually grew was India, so the Romans had to find a way of sending ships to and fro across the Indian Ocean and then carrying their cargo overland to the Mediterranean. Whole fleets and caravans laden with pepper would travel from India to the Red Sea, then across the desert to the Nile. It was then traded around the Roman Empire by river, sea and road. This was an immense network, complicated and dangerous, but highly profitable. Roberta Tomber fills in the details:

> Strabo in the first century AD says that 120 boats left every year from Myos Hormos – a port on the Red Sea – to India. Of course, there were other ports on the Red Sea and other countries sending ships to India. The actual value of the trade was enormous – one hint we have of this is from a second-century papyrus known as the Muziris Papyrus. In that they discuss the cost of a shipload estimated today at 7 million sestertia. At that same time a soldier in the Roman army would have earned about 800 sestertia a year.

Regularly filling a single large silver pepper pot like ours would therefore have taken a big chunk out of the grocery budget, yet the household that owned our pepper pot had another three silver pots, for pepper or other spices – one shaped as Hercules in action and two in the shapes of animals. This is dizzying extravagance. But the pepper pots are just a tiny part of the great hoard of buried treasure. They were found in a chest containing seventy-eight spoons, twenty ladles, twenty-nine pieces of spectacular gold jewellery, and more than 15,000 gold and silver coins. Fifteen different emperors are represented on the coins; the latest is Constantine III, who came to power in 407. This

helps us to date the hoard, which must have been buried for safekeeping some time after that year – when Roman authority in Britain was rapidly breaking down.

This brings us back to our pepper pot in the shape of a high-born Roman matron. With her right forefinger she points to a scroll, which she holds proudly, rather like a graduate showing off a degree certificate in a graduation photograph. This tells us that the woman is not only from a wealthy family but that she was also educated. Although Roman women were not allowed to practise professions such as law or politics, they were taught to be accomplished in the arts. Singing, playing instruments, reading, writing and drawing were all talents expected of a well-bred lady. And, while a woman like this could not hold public office, she would certainly have been in a position to exercise power.

We don't know who this woman was, but there are clues to be found on other objects from the hoard – a gold bracelet is inscribed UTERE FELIX DOMINA IULIANE, meaning 'Use this happily, Lady Juliane'. We will never know if this is the lady on our pepper pot, but she may well have been its owner. Another name, Aurelius Ursicinus, is found on several of the other objects – could this have been Juliane's husband? All the objects are small but extremely precious. This was the mobile wealth of a rich Roman family – precisely the type of person who is in danger when the state fails. There were no Swiss bank accounts in the ancient world – the only thing to do was bury your treasure and hope that you lived to come back and find it. But Juliane and Aurelius never did come back and the buried treasure remained in the ground. That is, until 1,600 years later, when in 1992 a farmer, Eric Lawes, went to look for a missing hammer. What he found, with the help of his metal detector, was this spectacular hoard. And he found the hammer too – which is now also part of the British Museum's collection.

Many of the objects in this history would mean little to us were it not for the work of thousands of people – archaeologists, anthropologists, historians and numerous others – and we wouldn't even have found many of these objects without metal detectorists like Eric Lawes, who in recent years have been rewriting the history of Britain. When he found the first few objects he alerted local archaeologists so that

they could record the detail of the site and lift the hoard out in blocks of earth. Weeks of careful micro-excavation in the laboratories of the British Museum revealed not only the objects but the way in which they were packed. Although their original container, a wooden chest about 60 centimetres (2 feet) wide, had largely perished, its contents remained in their original positions. Our pepper pot was buried alongside a stack of ladles, some small silver jugs and a beautiful silver handle in the shape of a prancing tigress. Right at the top, lovingly wrapped in cloth, were necklaces, rings and gold chains, placed there by people uncertain of when or whether they would ever wear them again. These are objects that bring us very close to the terrifying events that must have been overwhelming these people's lives.

Written on one of the spoons in the hoard is VIVAS IN DEO ('May you live in God') – a common Christian prayer – and it is likely that our fleeing family was Christian. By this date Christianity had been the official religion of the Empire for nearly a hundred years. Like pepper, it had come to Britain via Rome, and both survived the fall of the Roman Empire.

PART NINE

The Rise of World Faiths

AD 100–600

Striving to comprehend the infinite, a small number of major faiths have shaped the world over the last 2,000 years. Strikingly, the defining representational traditions of Buddhism, Christianity and Hinduism all developed within a few hundred years of each other: Buddhism first began to allow images of the Buddha in human form from AD 100 to 200, and the oldest images of Jesus Christ coincide with the acceptance of Christianity as the predominant religion of the Roman Empire in AD 312. At a similar time, Hinduism established the conventions for depicting its gods that are still familiar today. In Iran, Zoroastrianism, the state religion, articulated the ritual duties of the ruler to secure order in the world. The birth of the Prophet Muhammad in AD 570 set the scene for the rise of Islam, which eventually overwhelmed the many local gods who had been worshipped in Arabia.

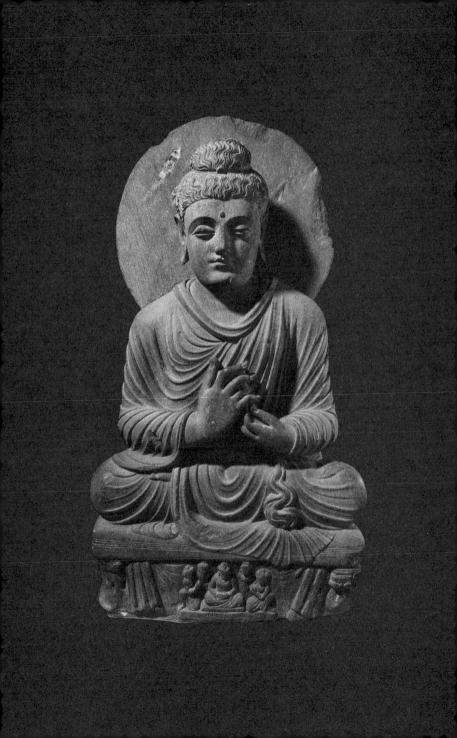

41

Seated Buddha from Gandhara

Stone statue, from Pakistan

100–300 AD

Battersea Park in London, just south of the Thames, isn't the obvious place to encounter the Buddha. But there, next to the Peace Pagoda, a Japanese Buddhist monk, watched by four gilded Buddha statues, drums his way over the grass each day. His name is the Reverend Gyoro Nagase, and he knows these gilded Buddhas very well. But then in a sense so do we all: here, looking out over the Thames, is the Buddha sitting cross-legged, his hands touching in front of his chest. I hardly need to describe the figure any further, because the seated Buddha is one of the most familiar and most enduring images in world religion.

In the British Museum we have a Buddha sculpture carved from grey schist, a rock that contains fragments of crystal which make the stone glint and gleam in the light. The Buddha's hands and face are more or less life-size, but the body is smaller, and he sits cross-legged in the lotus position, with his hands raised in front of him. On both shoulders he wears an over-robe, and the folds of the drapery form thick, rounded ridges and terraces. This drapery hides most of his feet, except for a couple of the toes on the upturned right foot, which you can just see. His hair is gathered up into what seems to be a bun but which is in fact a symbol of the Buddha's wisdom and enlightened state. He looks serenely into the distance, his eyelids lowered. And rising from the top of his shoulders, surrounding his head, is what looks like a large grey dinner plate – but of course it is his halo.

Today, you can find statues of the Buddha, seated and serene, all over the world. But the Buddha hasn't always been there for us to contemplate. For centuries he was represented only through a set of symbols. The story of how this changed, and how the Buddha came to

be shown in human form, begins in Pakistan around 1,800 years ago.

By that time Buddhism had already been in existence for centuries. According to Buddhist tradition, the historical Buddha was a prince of the Ganges region in north India in the fifth century BC who abandoned his royal life to become a wandering ascetic, wanting to comprehend and therefore to overcome the roots of human suffering. After many experiences he finally sat under a pipal tree and meditated without moving for forty-nine days until, at last, he achieved enlightenment – freedom from greed, hate and delusion. At this moment he became the Buddha – the 'Enlightened' or the 'Awakened One'. He passed on his *dharma* – his teaching, his way – to monks and missionaries who eventually travelled across vast expanses of Asia. As the Buddhist message spread north, it passed into the region known as Gandhara, in what is now north-eastern Pakistan, around Peshawar in the foothills of the Himalayas.

All religions have to confront the key question – how can the infinite, the boundless, be apprehended? How can we humans draw near to the other, to god? Some aim to achieve this through chanting, some through words alone, but most religions have found images useful for focusing human attention on the divine. A little under 2,000 years ago, this tendency strikingly gained impetus among a number of great religions. Is it more than an extraordinary coincidence that at about the same moment Christianity, Hinduism and Buddhism first start showing Christ, Hindu gods and the Buddha in human form? Coincidence or not, it is at this point that all three religions established artistic conventions which are still very much alive today.

In Gandhara, from the 1850s onwards, large numbers of Buddhist shrines and sculptures were discovered and investigated – in fact more Buddhist sculpture and architecture comes from Gandhara than from any other part of ancient India. Our virtually life-size and lifelike figure is one of these. It must have been a startling sight for any Buddhist 1,800 years ago. Until shortly before then the Buddha had been represented only by sets of symbols – the tree under which he achieved enlightenment, a pair of footprints, and so on. To give him human form was entirely new.

The move towards representing Buddha as a man is described by the historian Claudine Bautze-Picron, who teaches Indian art history at the Free University of Brussels:

The Buddha was a real historical character, so he was not a god. There was a movement 2,000 years or so ago when they started representing various deities and human wise men who had lived a few hundred years before. The first evocation of the Buddha's presence is carved around the circular monuments called stupas. There the Buddha is referred to through the tree below which he sat, where he became awakened, which is in fact the meaning of 'Buddha' – to be awakened. The worship of footprints is a major element in India still today; they refer to a person who is no longer there but who has left traces on Earth. This developed towards an even more elaborated structure, where you have a flaming pillar in place of the tree, which means that light emerges out of the Buddha. So there were symbols which were creeping in to the artistic world and which really opened the way to the physical image of the Buddha.

Our sculpture – one of the earliest known – probably dates from the third century AD, when Gandhara was ruled by the Kushan kings of northern India, whose empire stretched from Kabul to Islamabad. It was a wealthy region thanks to its position on the Silk Road, the trade routes linking China, India and the Mediterranean. From Gandhara the main route ran west through Iran to Alexandria in Egypt. Gandhara's prosperity and political stability allowed the construction of a great landscape of Buddhist shrines, monuments and sculpture, as well as supporting further missionary expansion. The religions that survive today are the ones that were spread and sustained by trade and power. It's profoundly paradoxical: Buddhism, the religion founded by an ascetic who spurned all comfort and riches, flourished thanks to the international trade in luxury goods. With those valuable commodities, like silk, went the monks and the missionaries, and with them went the Buddha, in human form, perhaps because such an image helps when you are teaching across a language barrier.

There are four standard poses for the Buddha that we know today: he can be shown lying, sitting, standing or walking. Each pose reflects a particular aspect of his life and activity, rather than a moment or an event. Our sculpture shows him in his enlightened state. He is robed as a monk, as might be expected, but unlike a monk his head is not shaved. He has dispensed with finery and removed his princely jewellery. His ears are no longer weighted down with gold – but the elongated lobes still have the empty holes that show that this man was once

a prince. His cross-legged lotus position is a pose used for meditation and, as here, for teaching.

But this statue, and the thousands made later that look so like it, has a purpose. Thupten Jinpa, a former monk and translator for the Dalai Lama, explains how you use an image like this one as a help on your journey towards enlightenment:

> Religious practitioners internalize the image of the Buddha by first looking at the image and then bringing that image of the Buddha within themselves in a sort of mental image. And then they reflect upon the qualities of the Buddha – Buddha's body, speech and mind. The image of the Buddha plays a role of recalling in the mind of the devotee, the historical teacher, the Buddha, his experience of awakening and the key events in his life. There are different forms of the Buddha that actually symbolize those events. For example, there is a very famous posture of the Buddha seated but with his hand in a gesture of preaching. Technically this hand gesture is referred to as the gesture of turning the wheel of *Dharma*: *Dharmachakra*.

This is the hand gesture of our seated Buddha. The *Dharmachakra*, or 'Wheel of Law', is a symbol that represents the path to enlightenment. It's one of the oldest known Buddhist symbols found in Indian art. In the sculpture Buddha's fingers stand in for the spokes of the wheel and he's 'setting in motion the Wheel of Law' to his followers, who will eventually be able to renounce the material states of illusion, suffering and individuality for the immaterial state of 'the highest happiness' – Nirvana. The Buddha teaches that:

> It is only the fool who is deceived by the outward show of beauty; for where is the beauty when the decorations of the person are taken away, the jewels removed, the gaudy dress laid aside, the flowers and chaplets withered and dead? The wise man, seeing the vanity of all such fictitious charms, regards them as a dream, a mirage, a fantasy.

All Buddhist art aims to detach the faithful from the physical world, even if it uses a physical image like our statue to do so. In the next chapter we have a religion that believes in the delights of material abundance, and it has a profusion of gods: it is Hinduism.

42

Gold Coins of Kumaragupta I

Gold coins, from India

MINTED AD 415–450

In north-west London is what must be one of the most startling build-
ings in the capital, indeed in the whole of the UK. It's the BAPS Shri
Swaminarayan Mandir, the Neasden Hindu temple – a huge white
building, made of marble quarried in Italy, elaborately carved in India
by more than 1,500 craftsmen and then shipped to England.

After taking their shoes off, visitors enter a large hall, sumptuously
decorated with sculptures of the Hindu gods, carved in white Carrara
marble. They cannot enter in the middle of the day – at that time the
gods are asleep, and music is played every day, at around 4 o'clock in
the afternoon, to wake them up. Images like these sculptures, of Shiva,
Vishnu and the other Hindu gods, strike us now as timeless, but there
was one particular moment when this way of seeing the gods began.
The visual language of Hinduism, just like Buddhism and Christianity,
crystallized somewhere around the year 400, and the forms of these
deities now in Neasden can be traced back to India's great Gupta
Empire of around 1,600 years ago.

To interact with gods we need to be able to recognize them – but
how are they to be identified? Hinduism is a religion that, although it
has its ascetic aspect, acknowledges the delights of material abun-
dance, and it has a profusion of gods, to be found in temples covered
in decorations, flowers and garlands. The great gods Shiva and Vishnu
are easily recognizable, Shiva with his wife Parvati and his trident, and
Vishnu sitting with his four arms, holding discus and lotus flower.
Often found nearby is a god who was particularly important for the
Gupta kings of some 1,600 years ago, Shiva's son Kumara (more
familiar now as Karttikeya). All these Hindu gods began to assume the

shapes we recognize today in the brand-new temples built by the Gupta kings of northern India around the year 400.

In the Coins and Medals Department of the Museum we have two coins of the Indian king Kumaragupta I, who ruled from AD 414 to 455. They show very different aspects of this king's religious life. They are each almost exactly the size of a 1p coin but are made of solid gold, so they sit quite heavily in the hand. On the first coin, where you would normally expect to see the king, there is a horse – a magnificent standing stallion. He is decorated with ribbons, and a great pennant flutters over his head. Around the coin, in Sanskrit, is an inscription that translates as 'King Kumaragupta, the supreme lord, who has conquered his enemies'.

Why put a horse on the coin instead of the king? This design looks back to an ancient sacrificial ritual, established long before Hinduism, that had been observed by the Indian kings of the past and was preserved and continued by the Guptas. It was an awesome and elaborate year-long process that a king might do once in a lifetime – it cost a fortune and culminated in a massive theatrical act of sacrifice. Kumaragupta decided that he would perform this rite.

A stallion was selected and ritually purified, then released to roam for a year, followed and observed by an escort of princes, heralds and attendants. A key part of their job was to prevent it from mating: the stallion had to remain pure. At the end of its year of sexually frustrated freedom, the horse was retrieved in a complex set of ceremonies before being killed by the king himself, using a gold knife, in front of a large crowd of spectators. Our gold coin commemorates Kumaragupta's performance of this ancient pre-Hindu ritual that reaffirmed his legitimacy and his supremacy. But, at the same time, Kumaragupta was vigorously promoting other, newer religious practices, invoking other gods in support of his earthly power. He was spending large sums of money on building temples and filling them with statues and paintings of the Hindu gods, making them manifest to their worshippers in a new and striking form. He and his contemporaries were, in effect, creating the gods anew.

The Gupta Dynasty began a little after the year 300 and rapidly expanded from its base in northern India until it covered much of the Indian subcontinent. By 450 the Gupta Empire was a regional

Gold coin showing a horse on 271
one side and a goddess, probably
Lakshmi, on the other

superpower, ranking with Iran and the Eastern Roman Empire, Byzantium. Not long after Constantine had granted tolerance to Christianity in Rome in 313 the Gupta kings in northern India set down many of the enduring forms of Hinduism – creating the complex apparatus of the faith, with its temples and priests, and commissioning the images of the gods that we know now.

Why did this happen at this point in history? As with Christianity and Buddhism it seems to relate to empire, wealth, a faith that is gaining new devotees and the power of art. Only stable, rich and powerful states can commission great art and architecture that, unlike text or language, can be instantly understood by anyone – a great advantage in multilingual empires. And once buildings and sculptures exist, they last, and become the pattern for the future. But whereas in Rome Christianity was soon imposed as the exclusive religion of the Empire, for the Gupta kings worship of the Hindu gods was always only one of the ways in which the divine could be apprehended and embraced. This is a world which seems to be at ease with complexity, happy to live with many truths and, indeed, to proclaim them all as an official part of the state.

What sort of relationship between devotee and deity was being fostered during this flourishing of Hinduism under the Guptas? Shaunaka Rishi Das, the Hindu cleric and Director of the Oxford Centre for Hindu Studies, explains:

> Hindus will see a deity, on the whole, as God present. God can manifest anywhere, so the physical manifestation of the image is considered to be a great aid in gaining the presence of God. By going to the temple, you see this image that is the presence. Or you can have the image in your own home – Hindus will invite God to come into this deity-form, they will wake god up in the morning with an offering of sweets. The deity will have been put to bed *in* a bed the night before, raised up, it will be bathed in warm water, ghee, honey, yoghurt, and then dressed in handmade dresses – usually made of silk – and garlanded with beautiful flowers and then set up for worship for the day. It's a very interesting process of practising the presence of God.

The god whose presence Kumaragupta chose to celebrate most intensely is obvious from his name; he selected Kumara, god of war, and it is Kumara that we see on our second gold coin. Naked to the

Gold coin showing a statue of the god Kumara riding a peacock on one side and King Kumaragupta himself on the other

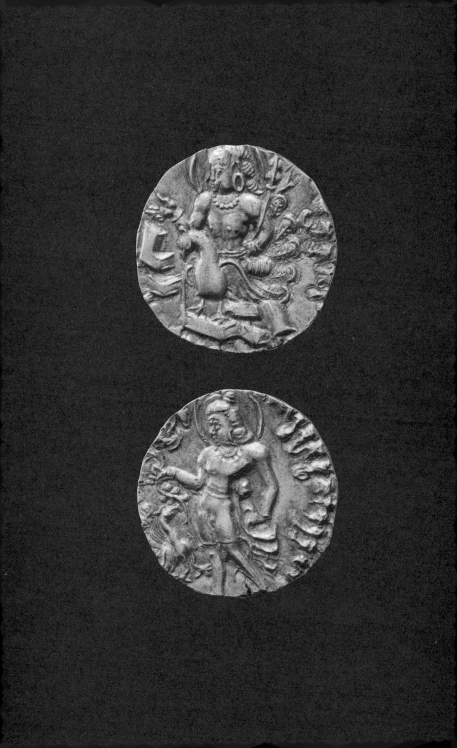

waist, he holds a spear and is mounted on a sacred peacock – not the vainglorious peacock of Western tradition, but an aggressive and terrifying bird that he is riding into war. This image, created 1,600 years ago, is still immediately recognizable today: you can see it in many shrines. But there's one detail worth mentioning – Kumara and his peacock are shown standing on a plinth. We are looking at an image not of a god, but of a statue of the god as it would have been seen in a temple, just the sort of statue that Kumaragupta himself might have commissioned. It's a tradition of temple imagery that emerges at this point and continues to the present day.

On the other side of the coin is King Kumaragupta himself, also with a peacock, but unlike Kumara he doesn't ride it. Instead, he elegantly offers grapes to his god's sacred bird. Crowned and haloed, the king wears heavy earrings and an elaborate necklace, and the inscription tells us that this is 'Kumaragupta, deservedly victorious with an abundance of virtues'.

The gold coin does what coins have always done uniquely well: they tell everyone who handles them that their ruler enjoys the special favour of heaven and, in this case, the special favour of heaven's commander-in-chief, because he is linked in a particular way to the god Kumara. It's a form of mass communication invented around the death of Alexander (see Chapter 31) that rulers have exploited ever since: the Grace of God claimed for the Queen on every British penny stands in the same tradition as Kumaragupta's coin. But Kumaragupta's image of his god is about much more than the theology of power – it speaks also of a universal human desire. It is evidence of the longing for a direct personal connection with the divine that everyone – not just the king – could access. Mediated by statues and images, it is a relationship that has been central to Hinduism every since.

Under the Guptas, the main deities of Hinduism and their worship assumed a form that has dominated the religious landscape of India from that day to this, and in recent years this Hindu aspect of the Guptas' religious activities has loomed large in historians' accounts of their reign. As Romila Thapar, Professor Emerita of Ancient Indian History at the Jawaharlal Nehru University, New Delhi, explains, the Guptas continue to make their presence felt in India today – not only in the monuments left behind, but also in the way the period is used politically:

When colonial history began to be written, when there was nationalist historical writing, the Gupta period was latched on to as the 'golden age'. In the last few decades there has grown in India a way of thinking which has been called Hindutva, which is an attempt to suggest that the only person that has legitimacy as a citizen of India is the Hindu, because the Hindu is supposed to be the indigenous inhabitant. Everybody else – the Muslims, the Christians, the Parsees – all came later and came from outside. They were foreign. Never mind the fact that 99 per cent of them are of Indian blood. The Gupta period then came in for a great deal of attention as a result of this kind of thinking.

This seems surprising. As these two coins show, although the Guptas established temple Hinduism in something like its modern form, they also honoured older religious traditions, and, far from being exclusive, were generous protectors of both Buddhism and Jainism. In short, Kumaragupta takes his place in the great Indian tradition inspired by Ashoka, the Buddhist king of 600 years earlier – a tradition that sees the state as tolerant of many faiths, later embraced by the Islamic Mughal emperors, by the British and by the founders of modern India.

The BAPS Shri Swaminarayan Mandir, the Neasden Hindu temple, rising out of the London suburbs

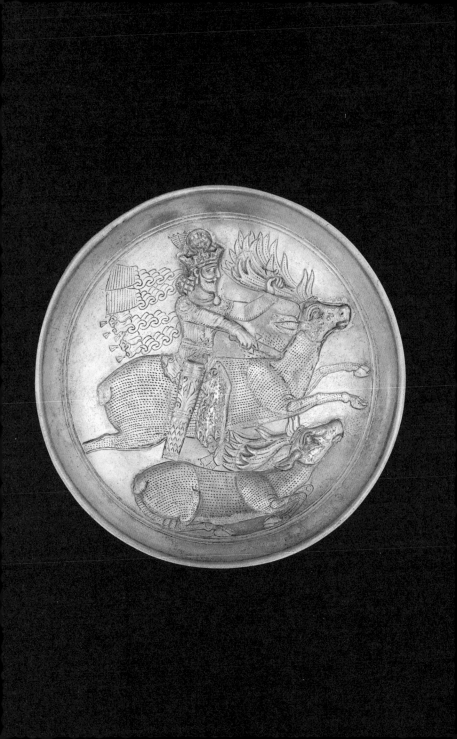

43

Plate showing Shapur II

Silver plate, from Iran

AD 309–379

Richard Strauss's symphonic poem *Thus Spake Zarathustra* is famil-
iar to many people from its use in the soundtrack of the film *2001: A
Space Odyssey*. But few of us know what Zarathustra actually did
speak, or even who he was. This is perhaps surprising, because Zar-
athustra – or, as he is more widely known, Zoroaster – was the founder
of one of the great religions of the world. For centuries, along with
Judaism, Christianity and Islam, Zoroastrianism was one of the four
dominant faiths of the Middle East. It was the oldest of the four – the
first of all the text-based religions – and it profoundly influenced the
other three. There are still significant Zoroastrian communities all
over the world, especially in the religion's homeland, Iran. Indeed, the
Islamic Republic today guarantees reserved seats in its parliament for
Jews, Christians and Zoroastrians. In the Iran of 2,000 years ago,
Zoroastrianism was the state religion of what was then the Middle
Eastern superpower.

The object shown here is a dramatic visualization of power and
faith in that Iranian empire. It's a silver dish from the fourth century,
and it shows the king apparently out hunting. In fact, he's keeping the
world safe from chaos.

In Rome at that time Christianity had just become the state religion.
Almost contemporaneously, in Iran, the Sasanian Dynasty built a
highly centralized state in which secular and religious authority were
bound together. At its height this Iranian empire stretched from the
Euphrates to the Indus – in modern terms, from Syria to Pakistan. For
several centuries it was the equal – and the rival – of Rome in the long
struggle to control the Middle East. The Sasanian king shown out

hunting on this silver dish is Shapur II, who ruled with resounding success for seventy years, from 309 to 379.

It is a shallow silver dish, about the size and the shape of a small frisbee, made of very high-quality silver, and as you move it around you can see that it has highlights in gold. The king sits confidently astride his mount, and on his head he wears a very large crown with what looks like a winged globe on the top of it. Behind him ribbons flutter over the silver, giving an impression of movement. Everything about his dress is rich – pendant earrings, long-sleeved tunic with carefully embroidered shoulder pads, highly decorated trousers and ribboned shoes. It is an elaborate, carefully worked-out ceremonial image of wealth and power.

You might think that this is pretty predictable: kings have always shown themselves overdressed and dominating animals. But this is much more than a conventional display of prowess and privilege. For the Sasanian kings were not just secular rulers: they were agents of god, and Shapur's full titles emphasize his religious role: 'the good worshipper of god, Shapur, the king of Iran and non-Iran, of the divine race of God, the King of Kings'. The god here is of course the god of Zoroastrianism, the religion of the state. The historian Tom Holland tells us about the great prophet and poet Zoroaster:

> Zoroaster is the very first prophet in the sense that you would describe Moses or Muhammad as a prophet. No one is entirely sure when, or indeed if, he lived, but if he really did exist then he probably lived in the central Asian steppes in around 1000 BC. Gradually over the course of the centuries and then the millennia his teachings became the focus for what we could probably call a Zoroastrian church. This increasingly became the state faith of the Iranian people, and therefore of the Sasanian Empire when it was established.
>
> The teachings of Zoroaster will sound very familiar to anyone who has been brought up as a Jew, a Christian or a Muslim. Zoroaster was the first prophet to teach that the universe is a battleground between rival forces of good and evil. He was the first to teach that time does not go round in an endless cycle but will come to an end – that there will be an end of days; there will be a day of judgement. All of these notions have passed into the Abrahamic mainstream of Judaism, Christianity and Islam.

It is when you come to the animal that the king is riding on the silver dish that you get a shock. He is not on a horse but on a fully antlered stag. He straddles the beast without either stirrups or saddle, gripping it by the antlers with his left hand, while his right hand deftly plunges a sword right into its neck – blood sprays out, and at the bottom of the plate we see the same stag in the throes of death. This whole image is a fantasy, from the great crown at the top, which would quite clearly have fallen off if you'd been riding, to the idea of killing your own mount in full leap.

So what is really going on here? In the Middle East hunting scenes had been a common way of representing royal power for centuries. Assyrian kings, well protected in their chariots, are shown bravely killing lions, from a safe distance. Shapur is doing something else. This is the monarch in single combat with the beast, and he's risking himself not out of pointless bravado but for the benefit of his subjects. As a protective ruler we see him killing certain kinds of animals, the beasts that threatened his subjects – big cats which preyed on cattle and poultry, wild boar and deer which ravaged crops and pastures. So images like this one are visual metaphors for royal power conceived in Zoroastrian terms. In killing the wild deer the hunter-king is imposing divine order on demonic chaos. Shapur, acting as agent for the supreme Zoroastrian god of goodness, will defeat the forces of primal evil and so fulfil his central role as king.

Guitty Azarpay, Professor of Asian Art at the University of California, Berkeley, highlights the dual role of the king:

> It is both a secular image – because of course hunting was enjoyed by most people, by most nations and especially in Iran – and also an expression of the Zoroastrian ideology of the time. Man is God's weapon against darkness and evil, and he serves the ultimate victory of the cre-ator by following the principle of right measure, leading a life that is prescribed as having good speech, good words and good actions. In this way, the pious Zoroastrian can hope for the best of existence in this life and the best paradise spiritually in the hereafter. The best king is one who as head of state and guardian of religion creates justice and order, is a supreme warrior and a heroic hunter.

This dish is quite clearly meant not just to be seen but to be shown off. It's an ostentatiously expensive object made from a heavy single piece

of silver, and the figures have been hammered out from the back in high relief. The various surface textures have been beautifully rendered by the craftsman, who has chosen different kinds of stippling for the flesh of the animal and the clothing of the king. And the key elements of the scene – the king's crown and clothing, the heads, tails and hooves of the stags – are highlighted in gold. When this was displayed in the flickering candlelight of a banquet, the gold would have animated the scene and focused attention on the central conflict between the king and the beast. This is how Shapur wanted himself to be seen and his kingdom to be understood. Silver dishes like this one were used by the Sasanian kings in vast quantities, sent as diplomatic gifts across the whole of Asia.

As well as sending silver dishes with symbolic images Shapur also sent Zoroastrian missionaries. It was an identification of the faith with the state that was ultimately to prove very dangerous, especially after the Sasanian Dynasty was swept away and Iran was conquered by the armies of Islam. Tom Holland explains:

> Zoroastrianism has really pinned its colours to the Sasanian mast. It has defined itself through the empire and through the monarchy. And so when those collapse, Zoroastrianism is really crippled. Although over time it became accepted that Zoroastrianism should be tolerated, Islam never afforded it the measure of respect that it gave to Christians or to Jews. A further problem was that Christians – even those who had been conquered by Muslims – could look to independent Christian empires, independent Christian kingdoms, and know that there was such a thing as Christendom still in existence. Zoroastrians didn't have that option – everywhere that had been Zoroastrian had been conquered by Islam. Today, even in the land of its birth, Iran, Zoroastrians are a tiny minority.

But if Zoroastrians today are relatively few in number, some of their faith's core teachings about the eternal conflict of good and evil, and about the ending of the world, are still very powerful. The politics of the Middle East remain haunted and in some measure shaped by belief in an eventual apocalypse and the triumph of justice – an idea that Judaism, Christianity and Islam all derived from Zoroastrianism. And when politicians in Tehran talk of the Great Satan, and politicians in Washington denounce the Empire of Evil, one is tempted to point out that 'Thus Spake Zarathustra'.

44

Hinton St Mary Mosaic

Roman mosaic, from Hinton St Mary, Dorset, England

AD 300–400

In the gallery of the British Museum devoted to objects from the time when Britain was part of the Roman Empire, around 1,700 years ago, there is an array of gods. There is a diminutive Mars, Bacchus with his wine cup, Pan piping on a silver dish – and what looks like another pagan god, this time in mosaic. It's a shoulder-length portrait, roughly life-size, of a clean-shaven man, with fair hair swept back. He's wearing a tunic and a robe tightly wrapped around his shoulders. Behind his head are the two superimposed Greek letters *chi* and *rho*, and these tell us at once who he is: they are the first two letters of the word *Christos*, and this is one of the earliest images of Christ we have anywhere. It's an astonishing survival – made not for a church in the eastern Mediterranean or in imperial Rome, but for the floor of a villa in Dorset sometime around AD 350.

The floor was mostly made of local Dorset materials – black, red and yellowish stones, all of them set in that greatest of Roman building inventions, cement. Entering the room, the first thing you would see on the floor was a roundel with the mythical hero Bellerophon riding the flying horse Pegasus and overcoming the Chimaera, a monster combining a lion, a goat and a serpent. It was a popular image in the Roman world, the hero zapping the forces of evil, rather as we saw in the Plate of Shapur II (Chapter 43). But at the far end of the room, facing in the other direction, was another roundel. In earlier times in this sort of position you would have expected to find either Orpheus charming the world with his music or the universally popular wine god, Bacchus. But here we find Christ.

For the first two or three Christian centuries the very idea of

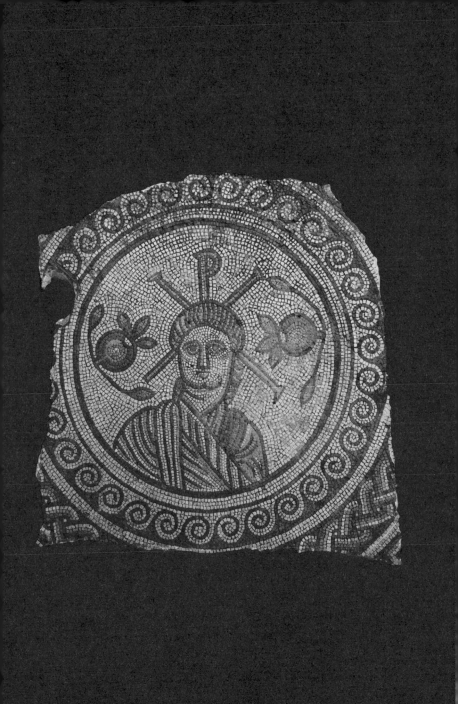

looking on the face of God, even of a god in human form, would have been inconceivable, first because there was no record of Christ's appearance that artists could have based a likeness on, but even more because the Jewish inheritance was of a god to be worshipped in spirit and in truth but emphatically not to be represented in art. This inhibited the early Christians from any such attempt. Yet we live now in a world where the likeness of Christ is commonplace, a face that can be instantly recognized. How did we get here? The decision to try to depict the face of Christ – probably taken because the Roman elite were so used to seeing their gods in statues, paintings and mosaics – was both a major theological step and one of the decisive turning points in European visual culture.

This face of Christ from Dorset was made in the last century of Roman rule in Britain. In many ways this was a golden age. It was a lavish world in which the ruling class could spend enormous sums of money decorating their villas and putting their wealth on display in the form of spectacular tableware. In the cases around the gallery in which the image of Christ is displayed you can see hoards of silver vessels, spoons and even pepper pots like the one in Chapter 40. They show a society that seems to have accommodated itself comfortably to both paganism and Christianity. A great silver dish found at Mildenhall in Suffolk shows Bacchus drunkenly cavorting with pliant nymphs, while the spoons found in the same hoard carry Christian symbols. A pagan dish with Christian spoons: that pretty well sums up Britain at this period, and it wouldn't have disconcerted anybody at the time. In the Britain of the third and fourth centuries Christ was merely one god among many others, so the pairing of Christ with Bellerophon is not as incongruous as it might initially seem to us. The historian Professor Eamon Duffy explains how Jesus fitted in to the pantheon:

> The image of Christ is not, I think, an attractive one; there's that Desperate Dan chin! What impresses me is the juxtaposition of the image of Christ with powerful imagery from pagan mythology, the whole story of Bellerophon, Pegasus and the Chimaera. Christianity adapts that material for its own purposes to convey the message of resurrection, the triumph of life over death, and the implicit comparison of Christ's work on the cross to a hero slaying a monster. That paradox – that the defeat of the founder of Christianity is actually a heroic victory ...

Bellerophon is a figure of life triumphing over the powers of darkness. Eventually that kind of symbolic imagery would find its own Christian versions in figures like St George killing the dragon, or St Michael the archangel fighting the devil.

I wonder how many of the people who crossed this floor realized that they were walking from one world to another, from the familiar realm of myth to the new modern world of faith. Everybody would recognize the energetic Bellerophon. They might be less sure who was represented by the still figure facing away from them on the other side of the room, because very few of them would ever before have seen Christ represented. After all, how do you represent a god that you have never seen? There was nothing to go on – no likeness, no model, no description of what Christ looked like. It is a testing conundrum, both theologically and artistically, and I think we can all sympathize with the Dorset artist who had to confront it. Orpheus and Bacchus would have been easy in comparison – Orpheus would be wistful, young, artistic-looking, Bacchus energetic and sexy, clearly ready for a good time. And both of these would be recognizable by their attributes – Orpheus would have his lyre, Bacchus a bunch of grapes or something similar. At this time there were no such physical attributes associated with Jesus. Few people would have wanted to show the victorious, all-powerful Christ with that shameful instrument of suffering, the cross. He had told his disciples that he was the way, the truth and the life, but it is very difficult to show any of those physically. He had announced that he was the light of the world, but it's really hard to show light in a mosaic, especially if, as here, the artist was, frankly, not very good. Instead of a symbol, the mosaicist at Hinton St Mary gave him the monogram with which we started – the Greek ☧ ('*Chi Rho*'). In our mosaic, it lies like a halo behind Christ's head.

The *Chi Rho* was the symbol adopted by the Roman emperor Constantine after his conversion to Christianity in the year 312. Our floor was almost certainly made about forty years later. (We can be pretty confident of that, because both Christ and Bellerophon wear their hair in the fashion of about 350.) And it was Constantine's conversion at the Battle of the Milvian Bridge that made our floor possible. Before he converted, no villa owner would have dared display their Christian faith so brazenly – practising Christians had been persecuted. But now,

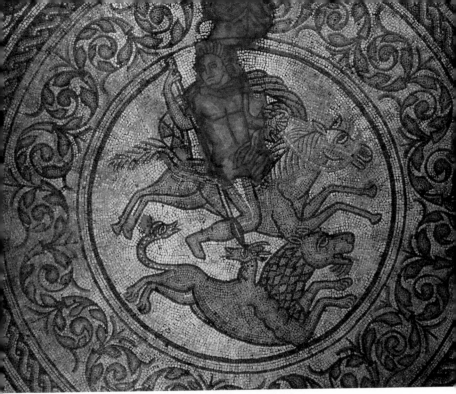

*The roundel showing Bellerophon riding Pegasus
and overcoming the Chimaera*

everything was different. Professor Dame Averil Cameron, of Oxford University, explains:

> The emperor Constantine is supposed to have seen a vision of a cross in the sky some time before the battle and seems to have converted himself to Christianity. Thereafter he never deviated from giving privileges to Christians, which was a complete overturning of what had been happening when Christianity had not even been legal. What he did was to give tax privileges to Christian priests, to intervene in Christian disputes, to declare Christianity a legal religion, to give money to Christian churches, to start building Christian churches. All of those actions together gave a great fillip to Christianity.

It was this fillip that must have given the owner of our villa the confidence to show us Christ looking out at us, full face, unequivocally a

man of power. He wears the rich robes and the stylish hairdo that might well have been sported by the villa owner himself, but this is no local ruler and indeed no local god. The ☧ monogram makes it clear that what we are being shown is Jesus Christ. There is a further clue to this man's true nature: on either side of Christ's head the artist has put pomegranates. To any educated visitor this would recall at once the myth of Persephone carried off to the Underworld, rescued by her mother, and brought back to the land of the living. While in the Underworld Persephone had eaten seeds from a pomegranate, and so had to spend part of every year in darkness. Her myth is a great allegory of the cycle of the seasons, of death and rebirth, of descent into hell and return to the light. By the inclusion of this simple fruit the artist links Jesus to the pagan gods who had also been gods of dying and returning – to Orpheus, who went to the Underworld in search of Eurydice and returned, and to Bacchus, who was similarly associated with resurrection. This Dorset Christ thus pulls together all the hopes of the ancient world, and the deepest of all human hopes: that death is only part of a larger story that will culminate in abundance of life and even greater fruitfulness.

We don't know what kind of room this mosaic was in. In grand Roman villas the room with the best mosaic was usually the dining room, but in this case that seems unlikely. There was no under-floor heating in the room and it faced north, so it would have been far too cold for Dorset dining. Normally the walls, as well as the floor, would indicate a room's purpose, but the walls of this room are long gone. There is one intriguing possibility – the figure of Christ faces east, and there would have been just enough space for an altar between it and the wall. So this room might have been an early house church.

People have often worried about the idea of Christ being shown on a floor, and eventually this worried the Romans too. In 427 the emperor specifically banned the making of images of Christ on mosaic floors and ordered all existing ones to be removed. But by the time of this proclamation Britain had ceased to be a part of the Roman Empire. The villa at Hinton St Mary had probably been abandoned and so its floor remained untouched. On the whole, the withdrawal of Roman power spelt cultural catastrophe, but in this instance we should perhaps be grateful.

45

Arabian Bronze Hand

Bronze hand, from Yemen

AD 100–300

In recent chapters we have been looking at images of the Buddha, of Hindu gods and of Christ. This object is a right hand, cast in bronze, but it is not the hand of a god: it is a gift to a god. It is a human hand, an almost literal manifestation of the expression 'to give your right hand for something'. The man whose hand is represented here wished to put his hand into the hand of his particular god and to gain his favour – he even shared the god's name, Ta'lab.

About 1,700 years ago there were far more religions in the world than today, and many more gods. Gods then tended to have strictly local responsibilities, not the worldwide embrace that we're used to now. In Mecca, for example, before Muhammad, pilgrims worshipped in a temple that had a statue of a different god for every day of the year. Our latest object was a gift to one of those numberless Arabian gods that did not survive the coming of Muhammad. His full name was Ta'lab Riyam, meaning 'the strong one of Riyam'. Riyam was a Yemeni hill town, and Ta'lab protected the local hill people. Yemen in the third century AD was a prosperous place, a hub of international trade that produced some of the most sought-after commodities for the vast markets of the Mediterranean, the Middle East and India. It was Yemen that supplied the whole Roman Empire with frankincense and myrrh.

The bronze hand once belonged to a man called Wahab Ta'lab. It is life-size, slightly smaller than my own hand, made of bronze and surprisingly heavy. It's very lifelike but as it has no arm attached to it, it does look as though it's been severed. But, according to Jeremy Field, orthopaedic and hand surgeon at Cheltenham General Hospital, this is not the case:

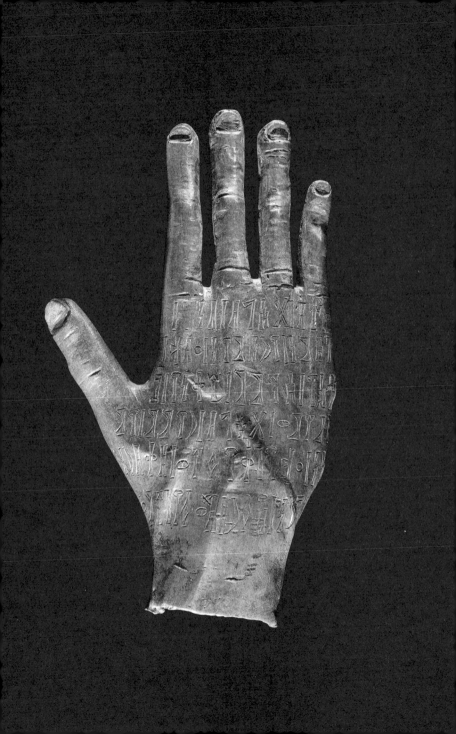

They have done the impression of the veins so carefully, which would probably go against its being some form of amputation. If a hand was amputated the veins would be empty because obviously the blood drains out. These are very carefully crafted and really quite beautiful. I'm sure this is a cast of a human hand, but there are certain things that are slightly odd about it. The nails are spoon-shaped, indicative of someone who might have had anaemia; the fingers are really thin and spindly, and also there is a deformity of the little finger, which I think has probably been broken at some stage.

It is small medical details like these that after 1,700 years of oblivion bring Wahab Ta'lab back to life. I find myself wondering how old he was – the veins on the back of the hand are very prominent – and above all wondering how he broke his little finger. Was it perhaps in battle? It doesn't look as though it was in the fields – this doesn't seem like the hand of a labourer. A fortune-teller of course would look at once for the lines on the palm of the hand; but the palm of this hand has been left unworked. There are lines, though, but they are on the back, and they are lines of text, written in an ancient Yemeni language which is linked both to modern Hebrew and to Arabic. The inscription tells us what this object was for and where it was displayed:

> Son of Hisam, [the] Yursamite, subject of the Banu Sukhaym, has dedicated for his well-being this his right hand to their patron Ta'lab Riyam in his the god's shrine dhu-Qabrat in the city of Zafar.

It is a pretty baffling series of names and places, but for historians trying to reconstruct the society and the religion of ancient Yemen almost all you have to go on is inscriptions like this one, and it does contain a great deal of information. When the inscription is teased out by experts, we learn that this bronze hand was dedicated at the temple of the god Ta'lab Riyam in a place called Zafar, high in the Yemeni hills. The owner of the hand, Wahab Ta'lab, tells us that he belongs to a clan and that that clan in turn is part of a larger tribal organization whose god was Ta'lab. So Wahab Ta'lab had obviously been named after his own god, and as a further sign of faith he has dedicated his hand publicly to Ta'lab at the centre of the city of Zafar, where it would have been seen along with other offerings of gold, bronze or alabaster representing

human figures, animals, arrows and spear heads. In return for these offerings, the god Ta'lab was expected in general terms to bring good fortune to the donors.

Wahab Ta'lab must have been fairly well established to start with – only a man of real wealth could offer a bronze hand as beautifully made as this. But by the international standards of the day his whole society was wealthy. At the time our hand was made most of south Arabia was effectively one state – a confederation of tribes like Wahab Ta'lab's, known to historians as the Himyarite kingdom. Many monumental buildings survive along with numerous inscriptions, which are evidence of a rich, sophisticated and in some measure literate society. Yemen at this point was no backwater; it dominated the entrance to the Red Sea and with it the great trade route that linked Egypt and the rest of the Roman Empire to India. Writing before AD 79, the Roman author Pliny the Elder explained why the Yemenis were so rich:

> The chief productions of Arabia are frankincense and myrrh ... they are the richest nations in the world, seeing that such vast wealth flows in upon them from both the Roman and the Parthian empires; for they sell the produce of the sea or of their forests, while they purchase nothing whatever in return.

The 'Incense Road' was in its way as important for the exchange of goods and ideas as the Silk Road. Frankincense was used by the Romans in vast quantities and was the principal form of incense in the ancient world. The altar of every god in the Roman Empire, from Syria to Cirencester, burned with Yemeni incense. Myrrh had various uses: as an antiseptic for dressing wounds; for embalming – it was essential for Egyptian mummification; and in perfume. Although it's not a strong fragrance, it has the longest life of any scent known. Indeed it was myrrh that lay behind 'all the perfumes of Arabia' that could not sweeten Lady Macbeth's bloodstained hand, although they would certainly have washed and sweetened Wahab Ta'lab's. Both frankincense and myrrh were very expensive. A pound of frankincense cost the equivalent of a Roman labourer's salary for a month, and a pound of myrrh twice as much. So when the Magi bring frankincense and myrrh to the infant Jesus, they are bringing gifts not only fit for a god – they are also as valuable as their other gift, gold.

We have no other contemporary written sources from the Yemen apart from terse and opaque inscriptions like this one, but this hand, together with other pieces of bronze sculpture of similar quality and the ancient industrial slag recently discovered in south Arabia, show that Yemen was then a major centre of bronze production. Wahab Ta'lab's hand is clearly the product of skilled metalworkers. If you look at it carefully you can see that it has been cast using the lost-wax technique (see Chapter 18) and is very beautifully finished at the wrist. So our bronze hand is definitely a complete object, not a fragment broken off from a larger sculpture.

Offering replica body parts to the gods was by no means peculiar to Arabia – you find them in Greek temples, in medieval pilgrim shrines and in many modern Roman Catholic churches, used to ask a god or a saint for bodily healing or as a thank you for recovery. Wahab Ta'lab's hand speaks to us from a religious world that was dominated by local gods who looked after particular places and peoples. But it was a world that was not going to last; Arabian aromatics had powered the religious life of the pagan Roman Empire, but when that empire converted to Christianity and no longer needed frankincense for worship, the incense trade was dealt a massive blow, contributing to a collapse in the Yemen economy. Local gods like Ta'lab disappeared, perhaps because they were no longer delivering the promised prosperity. Suddenly, in the 370s, offerings to traditional gods just stopped and their place was taken by other gods with a wider, universal reach. These are the religions of today. Within the next couple of centuries the rulers of Yemen shifted from Judaism to Christianity to Zoroastrianism and finally, in 628, to Islam, which has remained the dominant religion of Yemen ever since. Local gods like Ta'lab no longer stood a chance in the face of great supra-national faiths.

But some elements of Ta'lab's world did live on. We know, for example, that like many Arabian gods he was venerated through pilgrimages to his shrine. The religious historian Professor Philip Jenkins, of Pennsylvania State University, is fascinated by elusive survivals like this:

> There are aspects of the old pagan Arabian religion which do live on into Islam and into Muslim times, especially in the practice of the pilgrimage, the Hajj, to Mecca. Muslims would absolutely reject any

pagan context, obviously. They frame it in terms of Abraham and his story; but probably the events of the Hajj closely recall what would have happened in pagan times at that centre.

I've suggested that religions die. But perhaps they leave ghosts – and you can see across the Middle East many ghosts, many survivals of older religions in the newly successful religions. So, as you look at Islam, for example, you see many survivals from Christianity and Judaism – the Qur'an is littered with stories which make no sense except in terms of what the Christians and Jews of that time would have understood. Also, in terms of the buildings of Islam, the institutions of Islam and the mystical practices of Islam, you can see a great many of these ghostly survivals. Then as Islam spreads it carries on drawing in new kinds of pattern from older religions and evokes new ghosts.

Eventually that spreading Islam would conquer most of the world we've been looking at in this section; indeed it would conquer all the places from which our objects have come, except Dorset. Next I will be examining how those victorious Islamic rulers administered their conquests.

The Silk Road and Beyond

AD 400–800

The Silk Road from China to the Mediterranean was at its peak between AD 500 and 800, the time of the so-called 'Dark Ages' in western Europe. This trade route connected a revived Tang Dynasty China with the newly formed Islamic caliphate, which erupted from Arabia and conquered the Middle East and North Africa with astonishing rapidity. It was not only people and goods that spread along the Silk Road but also ideas. Along it, Buddhism spread from India into China and then beyond, into the newly formed kingdom of Korea. South Asian products even made their way to remote Britain, as we can see from the gems found in the Sutton Hoo burial. At the same time, but entirely separately, the first organized states in South America were flourishing.

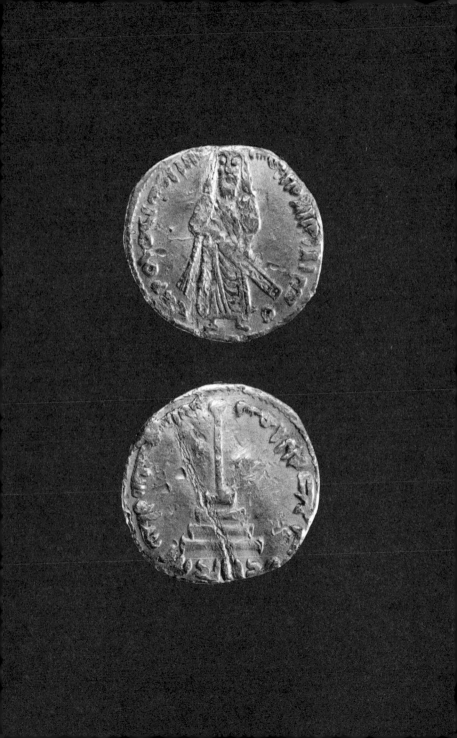

46

Gold Coins of Abd al-Malik

Gold coins, minted in Damascus, Syria
MINTED AD 696–697

These two dinar coins sum up one of the greatest political and religious upheavals ever – the permanent transformation of the Middle East in the years following the death of the Prophet Muhammad. For Muslims, the clock of history was reset when Muhammad and his followers moved from Mecca to Medina. That event, the Hijra, which took place in the year 622 by Christian reckoning, marked for Islam the beginning of year 1 in a new calendar. For his followers, the Prophet's teachings had so transformed society that time had begun again. The next few objects will show something of what the world looked like at this pivotal moment. They were all made in the years around Muhammad's death in the Hijra year 11, or AD 632, and they come from Syria, China, England, Peru and Korea. Everywhere they give insight into the interaction of power and faith.

In the fifty years after the death of the Prophet, Arabian armies shattered the political status quo across the Middle East, conquering Egypt and Syria, Iraq and Iran. The power of Islam had spread as far in a few decades as Christianity and Buddhism had in as many centuries. In Damascus in the mid 690s the inhabitants of the city must have had a strong sense that their world was being totally transformed. Still in appearance a Christian Roman metropolis, Damascus, conquered by Muslim armies in 635, had become the capital of a new Islamic empire. The head of this burgeoning empire, the caliph, was remote in his palace, and the Islamic armies were segregated in their barracks, but the people in the bazaars and streets of Damascus were about to have their new reality brought home to them in something they handled every day – money.

Gold coin issued by Abd al-Malik 295
showing an image of the caliph himself
(top)

In the early 690s Damascus merchants might not have understood that their world had changed permanently. Despite decades of Islamic rule they were still using the coins of their former rulers, the Christian Byzantine emperors, and those coins were full of Christian symbolism. It was quite reasonable to think that, sooner or later, the emperor would return to defeat his enemies, as he had several times before. But he did not. Damascus has remained a Muslim city to this day, and perhaps the most visible sign that this new Islamic regime was going to last was the change in the coinage.

The man who issued the two coins I want to discuss was Abd al-Malik, who ruled as the ninth caliph, or leader of the faithful, in succession to the Prophet Muhammad. Both coins were issued in Damascus within twelve months, across the Hijri years 76 and 77 – that is, AD 696–7. They are both of gold and are the same size, the size of a British penny though a little bit heavier. But they are utterly different in design. One coin shows the caliph; the other has no image at all. The change reveals how, in these critical early years, Islam was defining itself not just as a religious but also as a political system.

On the front of the first coin, where a Byzantine coin would have had the emperor, is a full-length figure of the caliph Abd al-Malik. It's the earliest known depiction of a Muslim. And on the back, where the Byzantines would have put a cross, there is a column with a sphere at the top.

Abd al-Malik is shown full-figure, standing and bearded, wearing Arab robes and a Bedouin scarf headdress, with his hand resting on a sword at his waist. It's a fascinating image – a unique source for our knowledge of the dress and the regalia of the early caliphs. His pose is menacing, and he looks as though he's about to draw his sword. The lines below his waist are almost certainly meant to represent a whip. It is an image to inspire fear and respect, an image that makes it clear that the eastern Mediterranean now has a new faith and a formidable new ruler.

A letter from one of his governors echoes the image's implicit message:

> It is Abd al-Malik, the commander of believers, a man with no weaknesses, from whom rebels can expect no indulgence! On the one who defies him falls his whip!

He cuts an impressive figure – although a less reverential source tells us that he had such appalling halitosis that he was nicknamed 'the fly-killer'. But, bad breath or not, Abd al-Malik was the most important Muslim leader since Muhammad himself, because he transformed what might have been merely a string of ephemeral conquests into a state that would survive in one form or another until the end of the First World War.

Abd al-Malik was a new breed of Islamic leader. He had no personal memory of Muhammad, and he shrewdly saw how best to exploit the traditions of earlier empires – especially Rome and Byzantium – in order to establish his own, as Professor Hugh Kennedy, of the School of Oriental and African Studies in London, explains:

> In the years that followed the Prophet Muhammad's death in 632, the caliphs were essentially the political and religious leaders of the Muslim community. All Arab Muslims in the first century of Islam realized that this was a new state – that what went on before wasn't really relevant. These caliphs were not the successors of the Byzantine emperors or of the Sasanian king of kings. They might look to these people for solutions to administrative problems – how you collect money and indeed what sort of money you make – but they wouldn't see themselves performing the same sort of role. This was a new dispensation.

One of the administrative solutions that Abd al-Malik borrowed from the Byzantine emperors was how to manage the currency. Until now, the new Islamic empire had used hand-me-down coins from the pre-conquest era, or imported gold coins, especially those from Byzantium. But Abd al-Malik quickly saw that there would be economic instability if the quantity and the quality of the money supply was not controlled. He understood that coins are literally the stamp of authority, announcing the dominant power in the society using them – and he knew that that power was now his. In the pre-modern world, coinage was usually the only mass-produced item in daily use, and it was therefore a supremely significant element in the visual culture of a society.

So Abd al-Malik himself was stamped on this first overtly Islamic coinage. The leader of the faithful had ousted and replaced the emperors of Byzantium. But something quite unexpected happened to those coins with Abd al-Malik standing on them. After a few years they

simply vanished. During the Hijri year 77 (AD 697), the standing caliph coin was suddenly replaced with a design that could hardly be more different. There is no caliph, no figure, only words. It is a defining moment for Islamic public art. From now on no human image would be used in such a public arena for well over a thousand years.

The later coin is exactly the same size and weight as the earlier one, and it's also made of solid gold. But this coin says that it was made in the year 77, just one year later than the earlier one, and now there is nothing to see but text. On the front it reads: 'There is no god except God alone, he has no partner; Muhammad is the Messenger of God whom he sent with guidance and the religion of truth that he may make it victorious over every other religion.' This is an adaptation of a text from the Qur'an. On the back of the coin is another Qur'anic text: 'God is One, God is the Eternal. He begets not, neither is He begotten.'

The inscriptions on this coin raise two interesting points. First, this is almost the oldest Qur'anic text to have survived anywhere. Before Muhammad, Arabic was barely a written language at all, but now there was a vital need to record God's words accurately, and so the first developed Arabic script – the 'kufic' script – was created. It is the script which appears on our coin. But this coin also tells us something else. If coins declare the dominant power in a society, it is clear that the dominant power in this empire is now not the emperor but the word of God. Portraiture or figurative art has no place in the official documents of such a state. The tradition of placing the ruler's likeness on the coin, familiar across the Middle East since the days of Alexander nearly 1,000 years before, had been decisively abandoned, and the text-only coin remained the norm in all Islamic states until the First World War. Arabic, the language of God, inscribed on an Islamic coinage, became a fundamental tool for the integration and survival of the first Islamic state.

Abd al-Malik, Khallifat Allah, Deputy of God, Ninth Caliph and Ruler of the Faithful, died in AD 705. But the message proclaimed on his coins of a universal empire of faith still has a powerful resonance.

Today there is no caliph. The title was long claimed by the Turkish sultans, but the office itself was abolished in 1924. A universally accepted caliph has historically been a rare thing, but the dream of a single Islamic empire – a caliphate – remains potent in the modern

The new coin issued by Abd al-Malik
showing text adapted from the Qur'an

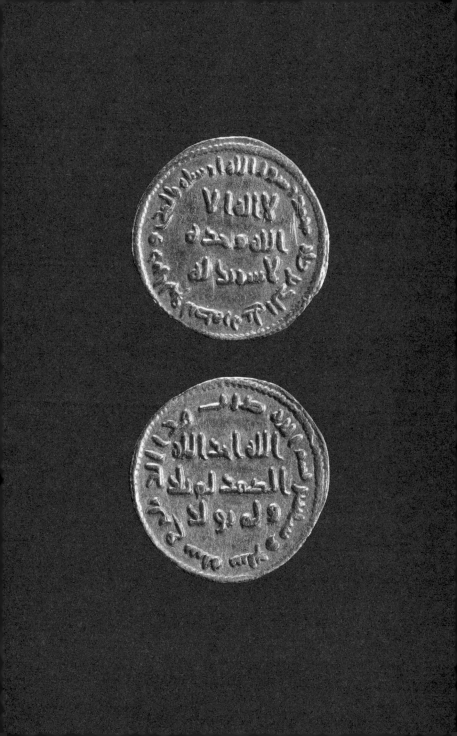

Islamic world. I asked the social anthropologist Professor Madawi al-Rasheed to comment:

> Muslims today, at least some sections of the Muslim community world-wide, aspire to this ideal of the caliphate as the embodiment of the Muslim community. It is related to the spread of the internet, of new communication technology that allows Muslims from different backgrounds to imagine some kind of relationship with other Muslims, regardless of their culture, language or ethnic group. So it can be found among second-generation Muslims in Britain, let's say, those who have lost the cultural background of their parents and have developed linkages with other Muslims of their age who may have come from different parts of the Muslim world. It aspires towards a globalized identity, an identity where you have bonds based on belief rather than ethnic background or even nationality.

The yearning for one Islamic community, inspired and guided by the word of God alone – that dream, first clearly articulated in physical form on the coin struck in Damascus more than 1,300 years ago, is still very much alive.

47

Sutton Hoo Helmet

Anglo-Saxon helmet, found at Sutton Hoo, Suffolk, England
600–650 AD

From the heat of Arabia, the rise of the Islamic empire and the reshaping of Middle Eastern politics after the death of the Prophet Muhammad, the next object takes us to the chill of East Anglia and a place where, just over seventy years ago, poetry and archaeology unexpectedly intersected and transformed our understanding of British national identity. The discovery of this object – a helmet – was part of one of the great archaeological finds of modern times. It speaks to us across the centuries, of poetry and battle and of a world centred on the North Sea.

At Sutton Hoo, a few miles from the Suffolk coast, one of the most exciting discoveries in British archaeology was made in the summer of 1939. Uncovering the tomb of an Anglo-Saxon who had been buried there in the early 600s, it profoundly changed the way people thought about what had been called the 'Dark Ages' – those centuries that followed the collapse of Roman rule in Britain. Angus Wainwright, the National Trust archaeologist for the East of England, sets the scene:

> There are a number of large mounds, high up on an exposed ridge –
> about 100 feet up – looking down towards the River Deben. One of the
> biggest mounds, which we call, excitingly, Mound 1, is where the great
> ship grave was discovered in 1939, and we've got about eighteen or
> twenty other mounds around.

It was in this grave ship that the famous Sutton Hoo helmet was found, together with an astonishing range of valuable goods drawn from all over Europe: weapons and armour, elaborate gold jewellery, silver vessels for feasting, and many coins. Nothing like this had ever been found before from Anglo-Saxon England. The big puzzle, when the

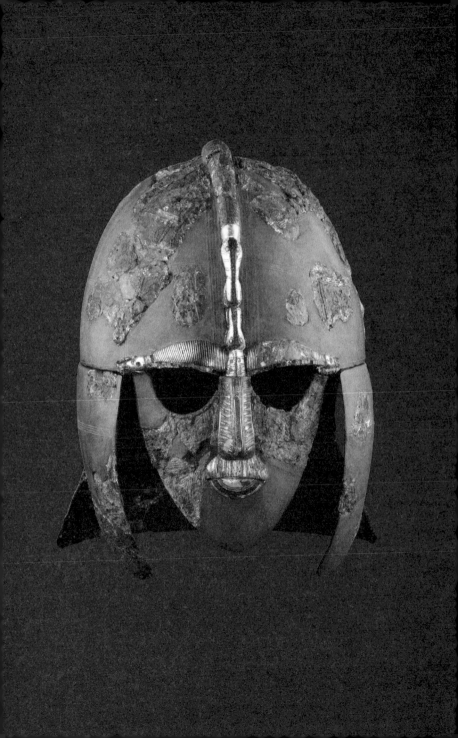

excavation took place, was that there was no body in the grave. But Angus Wainwright has an explanation:

> People wondered whether this could be a cenotaph, a burial where the body had been lost – a sort of symbolic burial. But nowadays we think a body was buried in the grave but because of the special acidic conditions of this soil it just dissolved away. What you have to remember is that a ship is a watertight vessel, and when you put it in the ground the water percolating through the soil builds up in it and it basically forms an acid bath, in which all these organic things like the body and the leatherwork and the wood dissolve away, leaving nothing.

The discovery of this ship burial captured the British public's imagination – it was hailed as the 'British Tutankhamen'. But the politics of 1939 lent a disturbing dimension to the find: not only did the excavation have to be hurried because of the approaching war, but the burial itself spoke of an earlier, and successful, invasion of England by a Germanic-speaking people. Angus Wainwright describes what they found:

> Very early on in the excavation they discovered ship rivets – the iron rivets that hold together the planks of a ship. They also discovered that the wood that had made up the ship had rotted completely away, but by a rather mysterious process the shape of the wood was preserved in a kind of crusted blackened sand. So by careful excavation they gradually uncovered the whole ship. The ship is 27 metres long; it's the biggest, most complete Anglo-Saxon ship ever found.
>
> Ships were very important to these people. The rivers and the sea were their means of communication. It was much easier to go by water than it was by land at this time, so that people in, say, modern Swindon would have been on the edge of the world to these people, whereas people in Denmark and Holland would have been close neighbours.

We still don't know who the owner of the boat was, but the Sutton Hoo helmet put a face on an elusive past, a face that has ever since gazed sternly out from books, magazines and newspapers. It has become one of the iconic objects of Britain's history.

It is the helmet of a hero, and when it was found, people were at once reminded of the great Anglo-Saxon epic poem *Beowulf*. Until

1939, it had been taken for granted that *Beowulf* was essentially fantasy, set in an imaginary world of warrior splendour and great feasts. The Sutton Hoo grave ship, with its cauldrons, drinking horns and musical instruments, its highly wrought weapons and lavish skins and furs, and not least its hoard of gold and silver, was evidence that *Beowulf*, far from being just poetic invention, was a surprisingly accurate memory of a splendid, lost, preliterate world.

Look at the helmet, decorated with animal motifs made out of gilded bronze and silver wire and bearing the marks of battle. Then see what *Beowulf* has to say:

> To guard his head he had a glittering helmet
> that was due to be muddied on the mere-bottom
> and blurred in the upswirl. It was of beaten gold,
> princely headgear hooped and hasped
> by a weapon-smith who had worked wonders
> in days gone by and embellished it with boar-shapes;
> since then it had resisted every sword.

Clearly the Anglo-Saxon poet must have looked closely at something very like the Sutton Hoo helmet.

I asked the Nobel laureate and poet Seamus Heaney, who made that translation of *Beowulf,* what the Sutton Hoo helmet means to him:

I never thought of the helmet in relation to any historical character. In my own imagination it arrives out of the world of *Beowulf* and gleams at the centre of the poem and disappears back into the mound. The way to imagine it best is when it goes into the ground with the historical king or whoever it was buried with, then its gleam under the earth gradually disappearing. There's a marvellous section in the *Beowulf* poem itself, 'The Last Veteran', the last person of his tribe burying treasure in the hoard and saying, lie there, treasure, you belong to earls – the world has changed. And he takes farewell of the treasure and buries it in the ground. That sense of elegy, a farewell to beauty and farewell to the treasured objects, hangs round the helmet, I think. So it belongs in the poem but obviously it belonged within the burial chamber in Sutton Hoo. But it has entered imagination, it has left the tomb and entered the entrancement of the readers of the poem, and the viewers of the object in the British Museum.

The Sutton Hoo helmet belonged of course not to an imagined poetic hero but to an actual historical ruler. The problem is, we don't know which one. It is generally supposed that the man buried with such style must have been a great warrior chieftain. Because all of us want to link finds in the ground with names in the texts, for a long time the favoured candidate was Raedwald, King of the East Angles, mentioned by the Venerable Bede in his *Ecclesiastical History of the English People* and probably the most powerful king in all England around 620.

But we can't be sure, and it's quite possible that we may be looking at one of Raedwald's successors or, indeed, at a leader who's left no record at all. So the helmet still floats intriguingly in an uncertain realm on the margins of history and imagination. Seamus Heaney says:

> Especially after 11 September 2001, when the firemen were so involved in New York, the helmet attained new significance for me personally because I had been given a fireman's helmet way back in the 1980s by a Boston fireman which was heavy, which was classically made, made of leather with copper and a metal spine on it and so on. I was given this and I had a great sense of receiving a ritual gift, not unlike the way Beowulf receives the gift from Hrothgar after he kills Grendel.

In a sense, the whole Sutton Hoo burial ship is a great ritual gift, a spectacular assertion of wealth and power on behalf of two people – the man who was buried there and commanded huge respect, and the man who organized this lavish farewell and commanded huge resources.

The Sutton Hoo grave ship brought the poetry of *Beowulf* unexpectedly close to historical fact. In the process it profoundly changed our understanding of this whole chapter of British history. Long dismissed as the Dark Ages, this period, the centuries after the Romans withdrew, could now be seen as a time of high sophistication and extensive international contacts that linked East Anglia not just to Scandinavia and the Atlantic but ultimately to the eastern Mediterranean and beyond.

The very idea of ship burial is Scandinavian, and the Sutton Hoo ship was of a kind that easily crossed the North Sea, so making East Anglia an integral part of a world that included modern Denmark, Norway and Sweden. The helmet is, as you might expect, of Scandinavian design. But the ship also contained gold coins from France,

Celtic hanging bowls from the west of Britain, imperial table silver from Byzantium and garnets which may have come from India or Sri Lanka. And while ship burial is essentially pagan, two silver spoons clearly show contact – direct or indirect – with the Christian world. These discoveries force us to think differently, not just about the Anglo-Saxons, but about Britain, for, whatever may be the case for the Atlantic side of the country, on the East Anglian side the British have always been part of the wider European story, with contacts, trade and migrations going back thousands of years.

As Seamus Heaney reminds us, the Anglo-Saxon ship burial here takes us at once to the world of *Beowulf*, the foundation stone of English poetry. Yet not a single one of the characters in *Beowulf* is actually English. They are Swedes and Danes, warriors from the whole of northern Europe, while the ship burial at Sutton Hoo contains treasures from the eastern Mediterranean and from India. The history of Britain that these objects tell is a history of the sea as much as of the land, of an island long connected to Europe and to Asia, which even in AD 600 was being shaped and reshaped by the world beyond its shores.

48

Moche Warrior Pot

Clay pot, from Peru
AD 100–700

In Peru, a largely forgotten people have left to history not just a face, like the helmet from Sutton Hoo, but an entire three-dimensional portrait of a warrior. From this small sculpture – from the clothes and the weapons it shows, from the way it was made and buried – we can begin to reconstruct the elements of a lost civilization. That civilization could not possibly have had any contact with the societies flourishing in Europe and Asia at around the same time – but, astonishingly, it shows a great number of similarities with them.

History has been kind to only a few American cultures. The Aztecs and the Incas have an unshakable place in our collective imagination, but few of us know where the Moche are from. Experts in early American history are now slowly recovering the civilizations that ran in parallel with, and were every bit as sophisticated as, their most advanced European counterparts. The Moche are at the centre of that rethinking of the American past.

Around 2,000 years ago the Moche people built a society that incorporated probably the first real state structure in the whole of South America. It was a civilization that developed in the narrow strip of almost desert land between the Pacific Ocean and the Andes mountains, and it lasted more than 800 years – roughly from the time of the expansion of Rome around 200 BC to the Islamic conquests around AD 650. The history of that civilization is accessible to us now only through archaeology, as the Moche left no writing. But what we do have from them is pots.

In the Enlightenment gallery at the British Museum we have an array of these South American pots on show. They are more than

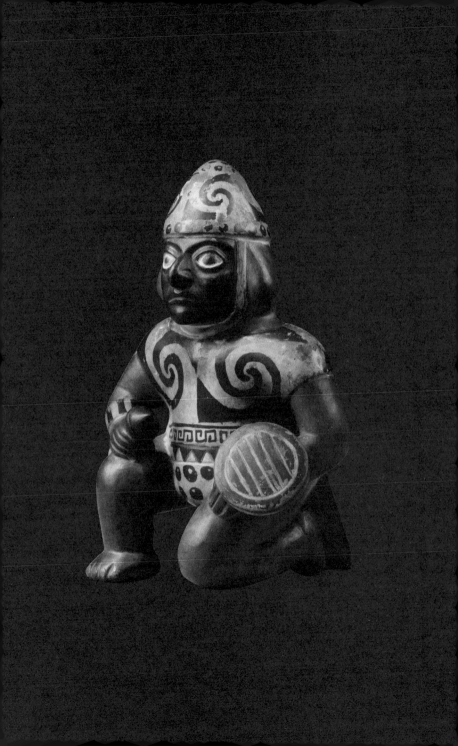

1,300 years old and make an extraordinary sight ranged on the shelves: a series of small clay sculptures about 23 centimetres (9 inches) high, brown with cream painting on them. They conjure up a whole world. There are a pair of owls, a bat, a sealion eating a fish; there are priests and warriors; and all of them sit like small sculptures, but with a looped handle and a spout because, as well as being statues, they are jugs. This is a pottery representation of the Moche universe.

The pot I have chosen to take us further into that world of Peru 1,300 years ago is in the form of a young Moche warrior, kneeling. In his right hand he holds something that looks quite like a microphone but is actually a club, literally a head cracker, and on his left forearm he carries a small circular shield. His skin is a deep copper colour, and his eyes are staring white with an arresting gaze.

Besides using the pots to obtain information about the society they represent, we can of course admire them simply as great works of art. The Moche were master potters, so their creations can best be judged by another master potter, the Turner Prize-winning Grayson Perry:

> They're beautifully modelled: they almost look like they've been burnished. If I wanted to get this effect, I'd probably use the back of a spoon, but they've probably used some sort of bone implement. They were experts in mould technology, and they used a lot of moulds to replicate these things a number of times. You imagine the person who's made it has made hundreds of these things, and they're incredibly confident when they're making it.

Archaeological excavations of Moche burials often uncover large numbers of these decorated pots – sometimes many dozens of them – all carefully ordered and organized around repeated themes and subjects. The sheer quantity of Moche pots that survive tells us that Moche society must have operated on a considerable scale. Making pots like this must have been an industry with elaborate structures of training, mass-production and distribution.

Moche territory stretched for about 350 miles along the Pacific coast of what is now Peru. Theirs was, literally, a narrow existence – bounded by the ocean on one side and the mountains on the other, usually with only desert in between. But their largest settlement, where now we find the southern outskirts of the modern Peruvian city of

Trujillo, was the first real city in South America, with streets, canals, plazas and industrial areas that any contemporary Roman town would have been proud of. The remains of the canal network, which they used to channel the rivers flowing from the mountains, are still visible today. They also exploited the extremely rich waters of the Pacific for fish, shellfish, seals, whales and birds – there is one pot in the British Museum that shows a Moche fisherman in a large boat catching tuna. Carefully managing and irrigating their environment, the Moche grew maize and beans, farmed llamas, ducks and guinea pigs, and as a result they were able to sustain a population three times as large as the area does today.

And yet, as is usually the case in human history, it is not the great acts of water engineering or agriculture that a society honours in its works of art. It is war. The celebration of war and warriors is a central aspect of Moche art, and this reflects the importance of the warrior to their society – just like the Romans or the Anglo-Saxons in Europe. For the Moche, though, war and religion were joined together in a way that would perhaps be less familiar to Europeans. Fighting for the Moche had a very strong ritual aspect to it. For protection this warrior carries a small round shield, not much bigger than a dinner plate, and for attack a heavy wooden club that could crack a skull with ease. His decorated clothes suggest he is a young man of high status, but he is clearly a foot soldier. There were no horses at this time in South America – those came later with the Europeans. So even the elite amongst the Moche travelled and fought on foot.

Other pots show scenes of warriors fighting each other in single combat, armed, like this figure, with clubs and small shields. These may well be scenes of real fighting, but they also appear to be part of a common Moche myth that we can piece together from groups of pots. These pots seem to have been made entirely for burials and sacrifice and to be about life and death at its most solemn. Taken as a whole, they tell a gruesome story. To lose a contest like this meant much more than just losing face. The defeated warrior would be sacrificed – decapitated by an animal-headed figure and his blood then drunk by others. This bloody narrative told by the Moche pots is by no means just an artistic invention. Dr Steven Bourget, a leading archaeologist, has found evidence that it really happened:

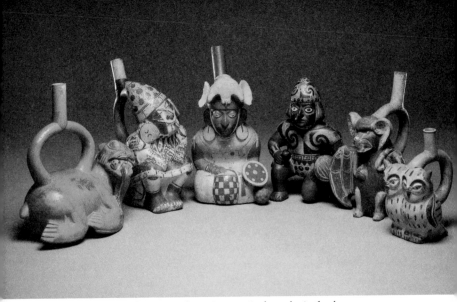

Moche pots – sea-lion, priests, warrior, bat and pair of owls

We excavated a sacrificial site which included about seventy-five male warriors sacrificed during various rituals, and we also found the tombs of two sacrificers. One of the tombs also included a wooden club covered with human blood, so we had the 'smoking gun' and the victims themselves side by side within the temple.

We found that these were male warriors – robust, strong males aged between 18 and more or less 39. They had a lot of ancient injuries consistent with battles, but also a lot of fresh injuries – a lot of cut marks on the throats, on the arms, on the faces, indicating that most of them have had their throats cut and a few of them had the skin of their face removed, or arms separated from their bodies. Some of them were defleshed completely and transformed into skeletons – even in one case two human heads were transformed into some kind of container.

There's a lot of mystery still to unravel about this grim but gripping material. The Moche stopped making these horror-movie pots and indeed pretty much everything else in the seventh century – roughly at about the time of the Sutton Hoo ship burial (see Chapter 47). There are no written records to tell us why, but the best bet seems to be climate change. There were several decades of intense rain followed by a

drought that upset the delicate ecology of their agriculture and wrecked much of the infrastructure and farmlands of the Moche state. People did not entirely abandon the area, but their skills seem to have been used above all for the building of fortresses, which suggests a world splintering in a desperate competition for diminishing natural resources. Whatever the cause, in the decades around AD 600, the Moche state and civilization collapsed.

To most of us in Europe today, the Moche and other South American cultures are unfamiliar and unnerving. In part, that's because they belong to a cultural tradition that followed a very different pattern from Africa, Asia and Europe; for thousands of years, the Americas had a separate parallel history of their own. But, as excavation unearths more of their story, we can see that they are caught in exactly the same predicaments as everybody else – harnessing nature and resources, avoiding famine, placating the gods, waging war – and, as everywhere else, they addressed these problems by trying to construct coherent and enduring states. In the Americas, as all over the world, these ignored histories are now being recovered to shape modern identities, as Steve Bourget details:

> One of the fascinating things that I am looking at when I look at Peru today is that they are in the process of doing what also happens in Mexico, perhaps in Egypt, and eventually I would believe China, where these countries who have a great ancient past build their identity through this past and it becomes part of their present. So the past of Peru will be its future. And eventually the Moche will I think become a name just as much as the Maya or the Inca, or the Aztec for that matter. Eventually it will become part of the world legacy.

The more we look at these American civilizations the more we can see that their story is part of a coherent and strikingly similar worldwide pattern; a story that seems destined to acquire an ever greater modern political significance. And next we're going to see what events of 1,300 years ago meant in contemporary Korea.

49

Korean Roof Tile

Ceramic tile, from South Korea
700–800 AD

If you use a mobile phone, drive a car or watch a television, the chances are that at least one of those objects will have been made in Korea. Korea is one of Asia's 'tiger' economies, a provider of high technology to the world. We tend to think of it as a new player on the global stage – but that is not how Koreans see themselves, for Korea has always been pivotal in relations between China and Japan, and it has a long tradition of technological innovation. It was Korea, for example, that pioneered movable metal type, and it did it well before it was developed in Europe. Besides its technology, the other thing which everybody knows about Korea today is that, since the end of the Korean War in 1953, it has been bitterly divided between a communist north and a capitalist south.

This roof tile comes from Korea around the year 700, when the newly unified state was enjoying great prosperity. It is a moment in Korea's history that is now read differently by north and south, but it is still central to any modern definition of Korean identity.

By 700, Korea was already a rich, urbanized country, a major trade player at the end of the famous Silk Road. But this object isn't made of precious silk; it's cheap clay – but clay that tells us a great deal about Korea's 'golden age'.

One of the fascinating things about this period is that on both edges of the Eurasian landmass similar political developments were under way. Tribes and little kingdoms were coalescing into larger units that would eventually become some of the nation states that we know today: England and Denmark on one side, Japan and Korea on the other. For all these countries, these were the critical centuries.

Lying between north-east China and Japan, the Korean peninsula was, like England at the same date, fragmented into competing kingdoms. In 668 the southernmost kingdom, Silla, with the backing of Tang Dynasty China – then, as now, the regional superpower – conquered its neighbours and imposed its rule from the far south to somewhere well north of what is now Pyongyang. It never controlled the far north (the border with modern China), but for the next 300 years the unified Silla kingdom ruled most of what is now Korea from its imperial capital in the south, Kyongju, a city splendidly adorned with grand new buildings. The ceramic roof tile in the British Museum comes from one of those new buildings, in this case a temple, and it tells us a great deal about the achievements and apprehensions of the young Silla state around the year 700.

The tile is about the size of a large old-fashioned roof slate – just under 30 centimetres by 30 (12 inches by 12) – and it's made of heavy cream-coloured clay. The top and the sides are edged with a roughly decorated border, and in the middle is a fearsome face looking straight out, with a squashed nose, bulging eyes, small horns and abundant whiskers. It looks like a cross between a Chinese dragon and a Pekinese dog. The tile is very similar to ones made in Tang China at the same time, but this is emphatically not a Chinese object. Unlike the broad grin of a Chinese dragon, the mouth here is small and aggressive – and the modelling of the tile has a rough vigour that is very un-Chinese.

It looks a bit like an oriental gargoyle – and that is pretty well what it was. It would have had a similar position to a gargoyle, high up on a temple or a grand house. The features of the face are quite rough, and it's obvious that it has been made by pushing the wet clay into a fairly simple mould. This is clearly a mass-produced object, but that is why it's so interesting; this is just one of tens of thousands of tiles designed to cover roofs that would once have been thatched but in prosperous Silla were now tiled with objects like this.

The Korean specialist Dr Jane Portal explains why the Silla wanted to build such a grand capital as Kyongju, and why they needed so many new houses:

The city of Kyongju was based on the Chinese capital Chang'an, which was at the time the biggest city in the world, and Kyongju developed

hugely once Silla had unified most of the Korean peninsula. A lot of the aristocrats from the kingdoms which were defeated by Silla had to come and live in Kyongju, and they had magnificent houses with tiled roofs. This was a new thing, to have tiled roofs, so this tile would have been a sort of status symbol.

Tiles were sought after not only because they were expensive to make but, above all, because they didn't catch fire like traditional thatch; burning thatch was the greatest physical threat to any ancient city. By contrast, a tiled city was a safe city, and so it is perfectly understandable that a ninth-century Korean commentator, singing the splendours of the city at the height of its prosperity, should dwell lyrically on its roofs:

> The capital, Kyongju, consisted of 178,936 houses ... There was a villa and pleasure garden for each of the four seasons, to which the aristocrats resorted. Houses with tiled roofs stood in rows in the capital, and not a thatched roof was to be seen. Gentle rain came with harmonious blessings and all the harvests were plentiful.

But this tile wasn't intended merely to protect against the 'gentle rain'. That was the job of the more prosaic, undecorated tiles covering the whole roof. Sitting at the decorated end of a ridge, glaring out across the city, our dragon tile was meant to ward off a teeming invisible army of hostile spirits and ghosts – protecting not just against the weather but against the forces of evil.

The dragon on our roof tile was, in a sense, just a humble foot soldier in the great battle of the spirits that was being perpetually fought out at roof level, high above the streets of Kyongju. It was only one of forty different classes of protective beings that formed a defensive shield against spirit missiles, which could be deployed at all times to protect the people and the state. But, at ground level, there were other threats: there were always potential rebels within the state – the aristocrats who had been forced to live in Kyongju, for example – and on the coast there were Japanese pirates. A dragon would provide security for the household, but every Silla king had to negotiate one great and ongoing political predicament that even dragon-faced house tiles could not deal with: how to maintain freedom of action in the looming shadow of his mighty neighbour, Tang China.

The Chinese had supported the Silla in their campaign to unify Korea, but only as an intended preliminary to China taking over the new kingdom itself, so the Silla king had to be both nimble and resolute in holding the Chinese emperor at bay while maintaining the political alliance. In cultural terms, the same subtle balancing act between dependence and autonomy has been going on for centuries and continues to this day to be a key element of Korean foreign policy.

In Korean history the united Silla kingdom, prosperous and secure at the end of the Silk Road, stands as one of the great periods of creativity and learning, a 'golden age' of architecture and literature, astronomy and mathematics. Fearsome dragon roof tiles like this one long continued to be a feature of the roofscape in Kyongju and beyond, and the legacy of the Silla is apparent in Korea even today, as Dr Choe Kwang-Shik, Director-General of the National Museum of Korea, tells us:

> The cultural aspect of the roof tile still remains in Korean culture. If you go to the city of Kyongju now you can see in the streets that the patterns still remain on the road, for instance. So, in that aspect, the artefact has now become ancient, but it survives through the culture. In a sense, I think Koreans feel that it is an entity, as if it's a mother figure. So in that sense Silla is one of the most important periods in Korean history.

But, in spite of surviving street patterns and strong cultural continuities, not everyone in Korea today will read the Silla legacy in the same way, or indeed claim the Silla as their mother culture. Jane Portal explains what it means now:

> What Koreans think about Silla today depends on where they live. If they live in South Korea, the Silla represents this proud moment of repelling aggression from China, and it meant that the Korean peninsula could develop independently from China. But if they live in North Korea, they feel that Silla has been overemphasized historically, because actually Silla only unified the southern two thirds of the peninsula. What Silla means today depends on which side of the Demilitarized Zone you live.

Not least among the many questions at issue between North and South Korea today is what was really going on 1,300 years ago. As so often, how you read history depends on where you're reading it from.

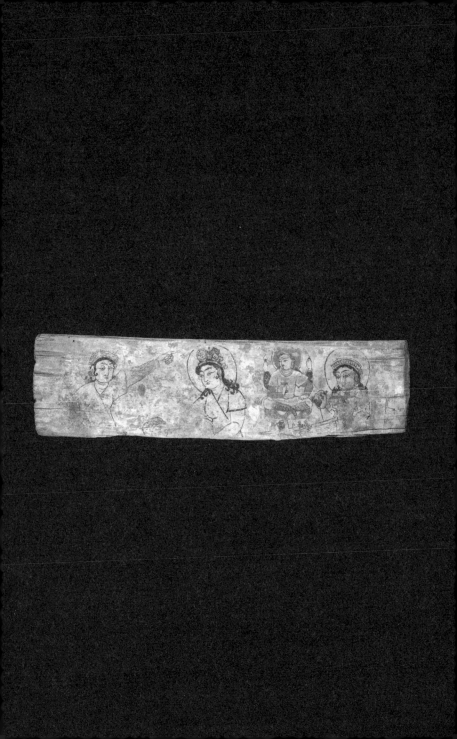

50

Silk Princess Painting

Silk painting, from Xinjiang province, China
600–800 AD

Once upon a time, in the high and far off days of long ago, there was a beautiful princess who lived in the land of silk. One day her father, the emperor, told her she must marry the king of the distant land of jade. The jade king could not make silk, because the emperor kept the secret to himself. And so the princess decided to bring the gift of silk to her new people. She thought of a trick – she hid everything that was needed – the silk worms, the mulberry seeds – everything – in her royal headdress. She knew that her father's guards would not dare to search her as she left for her new home. And that, my Best Beloved, is the story of how Khotan got its silk.

This is my version of a 'Just So' story to explain one of the greatest technology thefts of history. It is known as *The Legend of the Silk Princess* and it is presented to us in paint on a plank of wood that is around 1,300 years old. It is now in the British Museum, but it was found in a long-deserted city on the fabled Silk Road.

In the world around 700, a world of enormous movement of people and of goods, one of the busiest highways of all, then as now, ran from China: the Silk Road – not in fact one single road, but a network of routes that spanned 4,000 miles and effectively linked the Pacific to the Mediterranean. The goods on that highway were rare and exotic – gold, precious stones, spices, silk. And with the goods came stories, ideas, beliefs and – key to our story here – technologies.

This painting comes from the oasis kingdom of Khotan in central Asia. Khotan is now in western China, but in the eighth century it was a separate kingdom and the linchpin of the Silk Road, vital for water and refreshment and a major manufacturer of silk. Khotanese storytellers

created a legend to explain how the secrets of silk production – for thousands of years a Chinese monopoly – had came to Khotan. The result was the story of the Silk Princess, as told in our painting.

The wooden board on which the story is painted was found in a small abandoned Buddhist shrine in Khotan. The shrine was just one in a small city of shrines and monasteries which had vanished beneath the sand for more than a thousand years and which were rediscovered at the end of the nineteenth century by the polymath Sir Aurel Stein, one of the pioneering archaeologists of the Silk Road. It was Stein who revealed Khotan's importance as a vital trading and cultural centre.

The picture is painted on a rough plank that is almost exactly the size of a computer keyboard. The figures are fairly simply drawn in black and white, with here and there touches of red and blue. It is pretty unprepossessing as a work of art, but then it was never intended to be one; this painting was made essentially to help the storyteller tell their story. It is an *aide-mémoire*. Right in the middle is the Silk Princess herself, with her large and prominent headdress. To make absolutely sure we recognize that this is the focal point of the story, a servant woman on the left is melodramatically pointing at it. The storyteller would then have revealed that inside it is everything you need to make silk: worms of the silk moth, the silk cocoons that they produce, and mulberry seeds – because mulberry leaves are what silk worms eat. Then, in front of the princess, we see what happens next – the silk cocoons are piled up in a basket and on the far right there is a man hard at work weaving the silk threads into cloth. The princess has obviously arrived safely in Khotan, and her ruse has worked. This story, plainly set out in three scenes, is a quirky document of a transforming shift of knowledge and skill from the East to the West.

We have known for a long time that the Silk Road was vitally important in the economic and intellectual world of the eighth century, but it is only relatively recently that it acquired its romantic reputation, as the travel-writer and novelist Colin Thubron knows well:

The importance of the Silk Road in history is almost impossible to exaggerate, in terms of the movement of peoples, the movement of goods, the transport of inventions in particular, and ideas – and of course in the movement of religions. Whether it's Buddhism north from India and

eastward into China or the advance of Islam deep into Asia – all this is a Silk Road phenomenon.

The term 'Silk Road' was coined by a German geographer called Ferdinand von Richthofen as late as 1887. It was never called the Silk Road before then; but that, of course, then fed into it all the romance of silk itself, its beauty, its luxury.

Mysteries often generate stories to explain them, and since silk was by far the most important product travelling along this route the mystery of making it inevitably inspired its own myth. Luxurious, beautiful and enduring, silk is almost synonymous with the land that first produced it more than 4,000 years ago and monopolized it for so long – ancient China. Long before the Roman Empire appeared, silk was already cultivated in China and exported on an industrial scale. The method of its production was a highly protected secret; but secrets as profitable as this one never last, and Khotan was one of the beneficiaries.

Coming back to our painted plank, we can see a fourth figure in the story, a man with four arms holding a silk weaver's comb and a shuttle. He is the god of silk, who presides over the whole scene, giving spiritual sanction and making sure we see the princess not as an industrial thief but as a brave benefactress. And so the fairy tale takes on the status of myth: the Silk Princess may not be quite on a par with Prometheus, who stole fire from the gods, but she is firmly in the tradition of great mythological gift-givers, bringing knowledge and skill to a particular people.

The written versions of our painted story tell us what happened next: the princess gave thanks to the gods and ensured that Khotan would keep the secrets of silk for ever:

> Then she founded this monastery on the spot where the first silkworms were bred; and there are about here many old mulberry tree trunks, which they say are the remains of the trees first planted. From old time till now this kingdom has possessed silkworms, which nobody is allowed to kill.

Silk production is still a major industry in Khotan, employing more than a thousand workers and producing around 150 million metres of silk a year as cloth, clothes and carpets.

OVER: (left to right) The Silk Princess, the god of silk, and a worker weaving silk threads

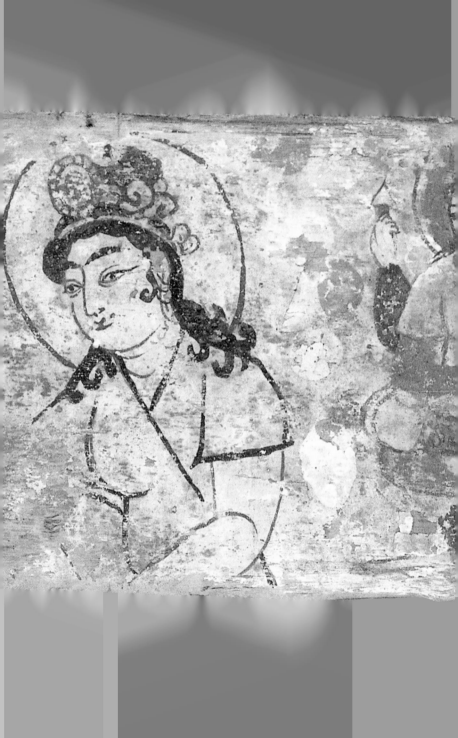

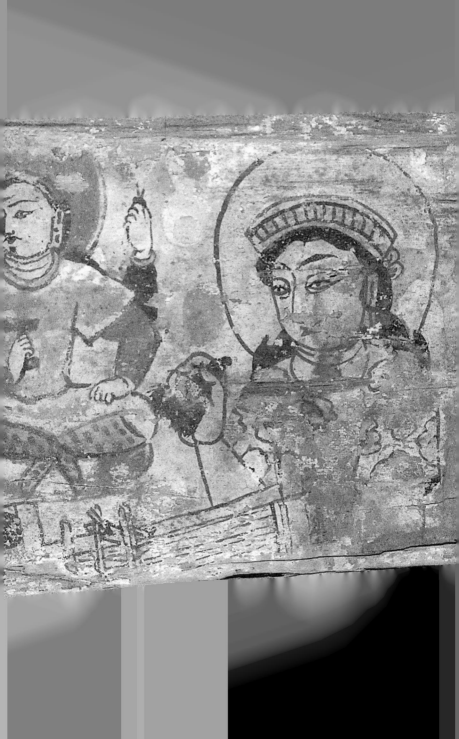

Of course, we've no idea how silk actually came to Khotan, but we do know that ideas, stories, gods and silk all moved along the Silk Road in both directions. The cellist and composer Yo-Yo Ma has long been involved in Silk Road studies:

> I am particularly interested in how music may have travelled. We have recordings only from about a hundred years ago, so you have to look at the oral traditions, and other kinds of iconography such as what's in museums, stories, and get a picture of how things were traded back and forth, in the realm of both ideas and material objects. The more you look at anything, at the origins of where things come from, you find elements of the world within the local. That's a big thing to think about, but it actually is reduced to common objects – stories, fables, materials – and silk is one of those stories.

I'm using the painted panel here just as it was intended to be used – as a vehicle for storytelling. Who used it originally we don't know, but we do know that Aurel Stein was surprised and moved by the shrine in which he found it:

> These painted tablets, like all the others subsequently discovered ... were undoubtedly still in the same position in which they had originally been deposited as votive offerings by pious worshippers. The last days of worship at this small shrine were vividly recalled by far humbler yet equally touching relics. On the floor near the principal base, and near the corners, I discovered several ancient brooms, which had manifestly been used by the last attendants to keep the sacred objects clear of the invading dust and sand.

It was not just the painting of the Silk Princess that these brooms kept clean – this Buddhist shrine also contained painted images of the Buddha as well as the Hindu gods Shiva and Brahma. Other shrines in the complex have pictures of Buddhist, Hindu and Iranian gods as well as very local deities. The gods that travelled the Silk Road were, like the traders themselves, happy to share accommodation.

Inside the Palace: Secrets at Court

AD 700–900

This section explores life in great royal courts across the world through objects that were intimate, private expressions of public power. Although made for different settings, all these objects were created so that the rulers of the world could state and re-state the full extent of their authority, to themselves, to their courtiers and their gods. Sometimes they also suggest the very real obligations they saw as going with that authority. The civilizations of Tang China, the Islamic Empire and the Maya in Meso-America were all at their peak during these centuries. Although medieval Europe suffered periods of chaos, there were moments of high artistic achievement, such as those at the court of the Frankish emperor.

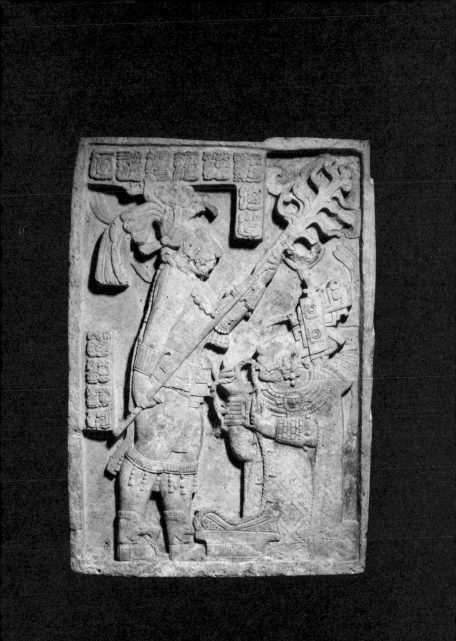

51

Maya Relief of Royal Blood-letting

Stone relief, from, Yaxchilan (Chiapas), Mexico
700–750 AD

It's tough at the top – at least, that's what those at the top like us to think. The long hours, the public exposure, the responsibility. In return, though, most of us would argue, they get the status and the pay – and many people, it seems, are willing to settle for that particular trade-off. But almost everyone would think twice about envying anyone, however privileged, whose regular duty was to go though an ordeal like the one portrayed here. I find it hard even to look at the image.

It is a limestone relief carving, about the size of a small coffee table. It's rectangular and it shows two human figures. A man stands holding a blazing torch over the kneeling figure of a woman. Both are elaborately costumed, with wonderfully extravagant headdresses. So far, so innocuous. But when you look more closely at the woman the scene becomes horribly disconcerting, because you can see that she is pulling a rope through her tongue – and the rope contains large thorns which are piercing and lacerating her.

My squeamish European eye keeps focusing on this stupefying act, but for the Maya of around AD 700 this would have been a scene of their king and his wife together in a devotional partnership, jointly performing a ceremony of fundamental significance for their position and their power. It was commissioned by the king for the queen's private building, and it was certainly intended to be seen by only a very select few.

The great Maya civilization collapsed not long after this stone slab was carved, and its deserted cities bewildered the first Spanish visitors in the sixteenth century. For hundreds of years afterwards, explorers travelling in southern Mexico and Guatemala came across huge abandoned

cities hidden in dense jungle. One of the first modern visitors, the American John Lloyd Stephens, tried to describe his wonderment in 1839:

> Of the moral effect of the monuments themselves, standing as they do in the depths of the tropical forest, silent and solemn, different from the works of any other people, their uses and purposes and whole history so entirely unknown, with hieroglyphs explaining all but perfectly unintelligible, I shall not pretend to convey any idea.

Maya territory covered modern Honduras, Guatemala, Belize and southern Mexico. The first Maya cities have their beginnings around 500 BC, just a little before the Parthenon was built in Athens, and the Maya civilization continued for well over a thousand years. The greatest cities had tens of thousands of inhabitants, and at their centre were pyramids, public monuments and palaces. Thanks to the relatively recent deciphering of Maya script, we can now read the glyphs on their monuments, which baffled Stephens, as the names and histories of actual rulers. In the course of the twentieth century the Maya ceased to be a mythologized lost race and became a historical people.

Our stone sculpture of the queen lacerating her tongue comes from the city of Yaxchilan. Between AD 600 and 800, late in the Classic Maya age, Yaxchilan became a large and important city, the major power in the region. It owed its new eminence to the king shown on the stone lintel, Shield Jaguar, who at the age of 75 commissioned a building programme to celebrate the successes of what would eventually be his sixty-year reign. The lintel sculpture comes from a temple that seems to have been dedicated to his wife, Lady K'abal Xook.

On the carving King Shield Jaguar and his wife are both magnificently dressed, their spectacular headdresses probably made of jade and shell mosaic and decorated with the shimmering green feathers of the quetzal bird. On top of the king's headdress you can see the shrunken head of a past sacrificial victim, possibly a defeated enemy leader. On his breast he wears an ornament in the shape of the sun god, his sandals are of spotted jaguar pelt, and at his knees there are bands of jade. His wife has particularly elaborate necklaces and bracelets.

This image is one of three found in the temple, each one positioned above an entrance. Together they make it clear that the act of pulling thorns through the tongue was not just to make the Queen's blood

flow as an offering but was deliberately intended to create intense pain – pain which, after due ritual preparation, would send her into a visionary trance.

Sado-masochism, on the whole, receives a bad press. Most of us take quite a lot of trouble to avoid pain, and wilful 'self-harm' suggests an unstable psychological condition. But around the world there have always been believers who see self-inflicted pain as a route to transcendental experience. To the average twenty-first-century citizen, and certainly to me, this willed suffering has about it something deeply shocking.

For the queen to inflict such agony on herself was a great act of piety – it was her pain that summoned and propitiated the kingdom's gods, and that ultimately made possible the king's success. The psychotherapist and writer on women's psychology, Dr Susie Orbach:

> If you can create a feeling of pain in the body and you survive it, you can move into a state of, not quite ecstasy, but out-of-the-ordinariness, a sense that you can transcend, you can do something rather special.
>
> What I find interesting about this image, which is quite startlingly horrific, is how visible the woman's pain is. I think that, in the present day, we've come to hide our pain. We have jokes about our capacity for pain but we don't really show it.
>
> What we see here is something that women can understand and can reflect upon, although it's very exaggerated; the kind of relation to self and to a husband that a woman often makes – or to her children. And it's not that men are extracting them. It's that women experience their sense of self by doing these things, by enacting them. They give them a sense of their own identity. And I'm sure that was true for her.

The next lintel in the series shows us the consequence of the queen's self-mortification. The ritual blood-letting and the pain have combined to transform Lady K'abal Xook's consciousness, and they enable her to see, rising from the offering bowl that holds her blood, a vision of a sacred serpent. From the mouth of the snake a warrior brandishing a spear appears – the founding ancestor of the Yaxchilan royal dynasty, establishing the king's connection with his ancestors and therefore his right to rule.

For the Maya, blood-letting was an ancient tradition, and it marked

all the major points of Maya life – especially the path to royal and sacred power. In the sixteenth century, 800 years after this lintel was carved, and long after the Maya civilization had collapsed, the Spanish encountered similar blood-letting rites that still survived, as the first Catholic bishop of Yucatán reported:

> They offered sacrifices of their own blood, sometimes cutting themselves around in pieces and they left them in this way as a sign. Sometimes they scarified certain parts of their bodies, at others they pierced their tongues in a slanting direction from side to side and passed bits of straw through the holes with horrible suffering; others slit the superfluous part of the virile member leaving it as they did their ears.

The unusual thing about our sculpture is that it shows a woman playing the principal role in the ritual. Lady K'abal Xook came from a powerful local lineage in Yaxchilan, and by taking her as a wife the king was allying two powerful families. This particular lintel is an extraordinary example of the kinds of rights and ceremonies that a queen would engage in. We don't have a series like it from any other Maya city.

K'abal Xook's husband, Shield Jaguar, had an immensely long reign for the age, but within a few decades of the deaths of the couple, all the great cities of the Maya were in chaos. On the later Maya monuments, warfare is the dominant image, and the last monuments date to around AD 900. An ancient political system that had lasted for more than a thousand years had disintegrated, and a landscape where millions had lived seems to have become desolate. Why this should have happened remains unclear.

Environmental factors are a popular explanation – there is some evidence of a prolonged drought, and, given the density of the population, the decline in resources a drought would cause could well have been catastrophic. But the Maya people did not vanish. Mayan settlements continued in several areas, and a functioning Mayan society lasted right up to the Spanish Conquest. Today there are about six million Mayans, and their sense of heritage is strong. New roads now open up access to the formerly 'lost' cities – Yaxchilan, where our sculpture came from, used to be accessible only by light plane or a river trip across hundreds of miles, but since the 1990s it is just an hour's boat ride from the nearest town and a big draw for tourists.

330 *A vision of a sacred serpent and warrior ancestor rises from Lady K'abal Xook's offering bowl*

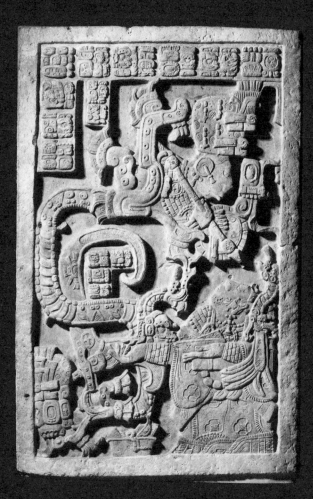

There was a Maya uprising as recently as 1994, when the Zapatista Army of National Liberation, as they called themselves, declared war on the Mexican state. Their independence movement profoundly shook modern Mexico. 'We are in the new "Time of the Mayas",' a local play proclaimed, as statues of the Spanish conquistadors were toppled and beaten into rubble. Today, the Maya are using their past to renegotiate their identity and seeking to restore their monuments and their language to a central role in national life.

52

Harem Wall-painting Fragments

Fragments of wall-painting, from Samarra, Iraq
800–900 AD

The world of the *Arabian Nights* – the 1,001 tales supposedly told by the beautiful Scheherazade to stop the king from killing her – transports us to the Middle East of twelve centuries ago:

> The girls sat around me, and when night came, five of them rose and set up a banquet with plenty of nuts and fragrant herbs. Then they brought the wine vessels and we sat to drink. With the girls sitting all around me, some singing, some playing the flute, the psalter, the lute, and all other musical instruments, while the bowls and cups went round, I was so happy that I forgot every sorrow in the world, saying to myself, 'This is the life; alas, that it is fleeting.' Then they said to me, 'O our lord, choose from among us whomever you wish to spend this night with you.'

So Scheherazade entertains the king, with tantalizing tales which are always to be continued.

Today, we mostly know the *Arabian Nights* through the distorting filters of Hollywood and pantomime. They summon up a kaleidoscope of characters – Sinbad, Aladdin and the Thief of Baghdad; caliphs and sorcerers, viziers and merchants; and lots of girls, many of them slaves, but still talented and outspoken. We see all of them within the vast bustling landscapes of the great Muslim cities of the age: Baghdad at its height, of course, but also Cairo and, most importantly for these portraits, Samarra, the city that straddles the River Tigris north of Baghdad in modern Iraq.

Although we regard the *Arabian Nights* as exotic fiction, they tell us a lot about real life in the court of the Abbasid caliphs, the supreme rulers of the vast Islamic empire which in the eighth to tenth centuries

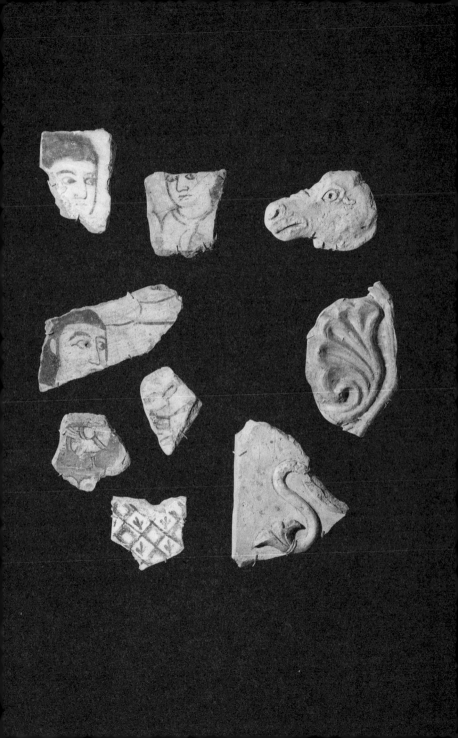

stretched from central Asia to Spain. The historian Dr Robert Irwin has written a companion to the *Arabian Nights* and has traced its various historical connections:

> Some of these stories do reflect the realities of Baghdad in the eighth and ninth centuries. The Abbasid caliphs employed a group of people known as Nudama – professional cup companions, whose job was to sit with the caliph as he ate and drank, and entertain him with edifying information, jokes, discussions of food and stories. So some of the stories in the *Arabian Nights* are part of the repertoire of these cup companions.
>
> It was a closed society. Few people ventured within its walls, and it's been said that when a pious Muslim was summoned to see the caliph, he took with him his shroud – ordinary people rather feared what went on within the walls of the caliph's palaces. I say 'palaces' advisedly, since the Abbasid caliphs seem to have had rather a disposable attitude towards them; once they had used one up they went and built another, and then abandoned it. So you get a succession of palaces, one after another in Baghdad, and then they moved to Samarra, where they did the same thing.

Most of the Abbasid palaces, both in Baghdad and in Samarra, are now in ruins. But some elements survive. At the British Museum we have a few fragments of painted plaster from the harem quarters of an Abbasid caliph, which take us back into the heart of the Islamic empire of the ninth century and show us the real counterparts of the girls from the *Arabian Nights*. For me, these fragments have more magic than any movie. They're haunting glances across the centuries and could themselves inspire 1,001 stories.

The little portraits are probably all of women, although some may show boys. They are fragments of larger wall-paintings, and they link us directly to medieval Iraq. In Baghdad itself hardly anything architectural survives from this great age of glory around AD 800, because the city was later destroyed by the Mongols. But luckily we can still get quite a good idea of what the Abbasid court looked like, because for almost sixty years its capital was moved seventy miles north to the brand new city of Samarra, and a lot of ancient Samarra survives.

At first sight these pictures are not very much to look at – they are really just scraps of paintings, and the largest is no bigger than a CD

disc. They are drawn fairly simply, with black outlines on a yellow ochre background, with just a few sketchy lines to capture the features, but there are flecks of gold in the painting which give us a hint of their earlier opulence. Like random pieces from a jigsaw puzzle, they make it difficult to guess what the bigger picture that they once came from might have been. Indeed, they're not all portraits – some of the fragments show animals, some show bits of clothing and bodies. But the faces that are caught here have a definite sense of personality – there's a clear air of melancholy in the eyes, as they look out at us from their enclosed, distant world.

These small pieces of plaster were excavated by archaeologists from the ruins of the Dar al-Khilafa palace, the main residence of the caliph in Samarra and the ceremonial heart of the new purpose-built capital city. Pleasure was built into the very name of the city, which was interpreted at the court as a shortened form of 'Surra Man Ra'a' – 'He who sees it is delighted'. But beneath the frolicking there were ominous undercurrents. The decision in 836 to move the court from Baghdad to Samarra was taken in order to defuse dangerous tensions between the caliph's armed guards and the inhabitants of Baghdad – tensions that had already ignited a string of riots. Samarra was intended to provide both a haven for the court and a safe base for the caliph's army.

The new city of Samarra was on a grand scale, with palaces gigantic by the standards of any age, built at great cost; more than 6,000 different buildings have been identified. A contemporary description gives some impression of the spectacular nature of one of palaces of the caliph, al-Mutawakkil, perhaps the greatest builder of all the Abbasids:

> He made in it great pictures of gold and silver, and a great basin, whose surfacing outside and inside was plates of silver, and he put on it a tree of gold in which birds twittered and whistled ... there was made for him a great throne of gold, on which were two depictions of great lions, and the steps to it had depictions of lions and eagles and other things. The walls of the palace were covered inside and outside with mosaics and gilded marble.

This was building mania with a purpose: this city of palaces and barracks was intended to dazzle visitors, to be the unforgettable centre of the huge Islamic empire.

Hidden away in a warren of small rooms in the caliph's palace were the harem quarters with wall-paintings showing scenes of enjoyment and entertainment, and it's here that our portrait fragments were found. They show us the faces of the caliph's slaves and servants, the women and possibly the boys of his intimate world and of his pleasures. The women housed in these rooms were slaves, but slaves who enjoyed considerable privileges. Dr Amira Bennison, who teaches Islamic studies at the University of Cambridge, comments on the portraits that have survived:

> They hint at the entertainment the caliphs enjoyed, which would have ranged from having salon sessions with intellectuals and religious scholars, to lighter events where characters such as those depicted in the wall-paintings, dancing or singing girls, would have performed before the rulers. One thing that is important to note is that these kinds of women were very highly trained – a little similar to geishas. To become part of the caliph's household – a better word than harem – was actually something women could aspire to, and if you were of humble origins but you were good at singing or dancing, and you trained properly, this was very much a career move.

Here, there could be self-indulgence and boisterousness. Caliph al-Mutawakkil's sense of humour doesn't seem to have been especially sophisticated, and he repeatedly had a court poet, Abu al-'Ibar, catapulted into one of his ornamental ponds. Less happily, a tale in the *Arabian Nights* records al-Mutawakkil's assassination following a night of music performed by his singing girls. After the drunken caliph quarrelled violently with his son, so the story tells us, his Turkish soldiers killed him, while the girls and the courtiers scattered in horror.

That story from the *Arabian Nights* is true. Al-Mutawakkil was indeed murdered by his Turkish commanders in 861, and his death was the beginning of the end for Samarra as a capital. Within a decade the army had left the city, and Baghdad resumed its status as capital, leaving the palace at Samarra as a decaying ghost. The court lions were put down and the slave girls and singers of our portraits dispersed. The last coin to be struck in Samarra is dated 892.

Samarra was built at the end of the heroic days of the Abbasids and, in a sense, it is a monument to their political failure. The tensions that

led to the assassination of al-Mutawakkil ultimately led to the frag-
mentation of the empire. A poet, exiled in the now decaying Samarra,
mused elegiacally on its decline:

> My acquaintance with it, when it was peopled and joyous,
> Was heedless of the disasters of Time and its calamities.
> There lions of a realm strutted
> Around a crowned imam;
> Then his Turks turned treacherous – and they were transformed
> Into owls, crying of loss and destruction.

Samarra was the capital of a major empire for less than fifty years, but
it is still a significant place of pilgrimage in the world of Shi'a Islam,
for it is the burial place of two of the great imams. Modern Samarra
also has a tragic history: in 2006 the great dome of the famous
al-Askari mosque was destroyed by bombs. A year later, the archae-
logical ruins of the ancient city, which include the Great Mosque with
its famous spiral minaret, were recognized and protected as a World
Heritage Site by UNESCO.

The anonymous faces of the girls and boys of Samarra were never
meant to be viewed by anyone other than the familiars of a caliph.
They have survived as a rare record of the people of the Abbasid age,
and they now remain to look at us, as we look at them. Ironically, and
rather wonderfully, instead of the images of the grand caliphs who
built Samarra we see their slaves and their servants – retrieved from
Hollywood cartoon caricature to poignant historical reality.

53

Lothair Crystal

Rock crystal depicting Susanna and the Elders,
probably made in Germany
AD 855–869

Royal divorces generally mean political trouble. The marital prob-
lems of Henry VIII plunged England into decades of religious strife,
and when Edward VIII wanted to marry a divorced woman it caused
a constitutional crisis that cost him his throne. This object is associ-
ated with a king whose protracted attempts to divorce his queen were
intended to safeguard the kingdom. His failure to do so probably
killed him, and it certainly led to the termination not only of his line
but of his kingdom as well. The object, an engraved rock crystal, tells
us his name. Written in Latin, the inscription reads: 'Lothair, king of
the Franks, caused me to be made'.

The Lothair Crystal, also known as the Susanna Crystal, is a flat
disc of rock crystal about 18 centimetres (7 inches) in diameter, and
carved into it is a biblical (or in some traditions an apocryphal) story
in eight separate scenes, like a crystal cartoon strip. It is a story based
in Babylon, where the beautiful young Susanna is the wife of a rich
merchant. While she is bathing in her husband's orchard, two older
men intrude and try to bully her into having sex with them. She calls
her servants for help, and the furious elders falsely claim that they saw
her in the act of adultery. We then see Susanna being led away to
almost certain death by stoning, but at that point the brilliant young
prophet Daniel intervenes and challenges the evidence for her convic-
tion. Separating the elders, Daniel asks each of them one searching
question in a classic courtroom drama: under what kind of tree did
they see Susanna having sex? The men give conflicting answers, their
story is exposed as fabricated, and it is they who are stoned to death,
for perjury. In the final scene Susanna is declared innocent and gives

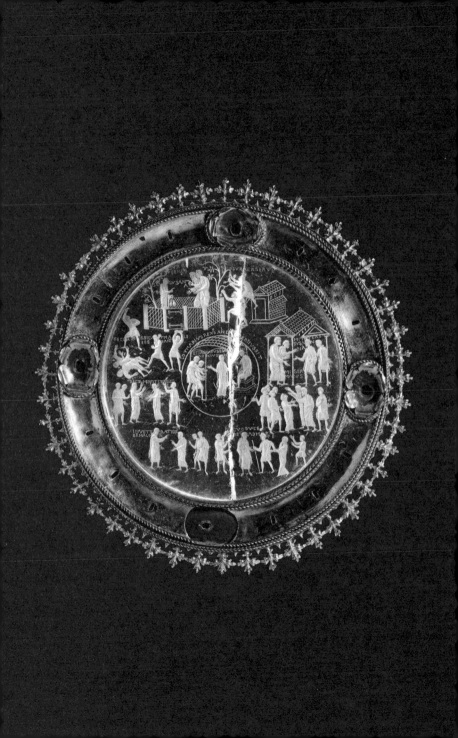

thanks to God. I asked Lord Bingham, former Lord Chief Justice and Senior Law Lord, to give us a lawyer's perspective on the story:

> Daniel did what Rumpole of the Old Bailey would do if he thought he was cross-examining witnesses who were telling lies. In real life Daniel would have been extremely lucky to have been thought to have demolished the witnesses and to demonstrate their dishonesty by asking them one question each, but the principle is quite clear, and Daniel was clearly a very skilful cross-examiner.

Each scene on the crystal is a masterpiece of miniature carving, and in every scene the artist has also found space for a small text in Latin, explaining what is going on. In the final scene is the ringing phrase *Et salvatus est sanguis innoxius in die illa* – 'And that day, innocent blood was saved'. It's around this scene that we find the text naming King Lothair.

The king who commissioned the Susanna Crystal was descended from one of the great figures of medieval Europe – Charlemagne. Around the year 800, Charlemagne, King of the Franks, had created an empire that covered most of western Europe, including northern Italy, western Germany and modern France. It was the largest state western Europe had seen since the fall of Rome, and the stability and prosperity of Charlemagne's empire allowed a great flourishing of the arts in the years that followed. Our crystal is a magnificent example of this so-called 'Carolingian Renaissance'.

It is a jewel that has almost always been valued. For most of its existence it was in the abbey of Waulsort, in modern Belgium, in the centre of Charlemagne's empire. It was certainly there in the twelfth century, when the abbey's chronicle clearly describes it:

> This desirable treasure was made ... at the request of the famed Lothair, King of the Franks. A beryl stone placed in the middle contains a depiction of how in Daniel, Susanna was evilly condemned by the old judges. [The stone] shows the skill of its art by the variety of its work.

It probably remained at Waulsort until French revolutionary troops looted the abbey in the 1790s. Perhaps it was they who threw the crystal – clearly made for royalty, which they despised – into the nearby River Meuse. When it was found it was cracked, but otherwise completely

undamaged, because rock crystal is astonishingly tough. It is very hard and cannot be chiselled, but must be ground with abrasive powders. The whole thing would have taken an immense amount of time and great skill to work, which is why crystals like this one were such luxury objects. We don't know what the original purpose of our Susanna Crystal was – possibly an offering to a shrine – but it was in every sense an object fit for a king.

By the time the crystal was made, Charlemagne's empire had broken down, and the whole of north-west Europe was divided among three members of his squabbling and profoundly dysfunctional family. The squabbles ultimately resulted in the empire splitting into three parts: an eastern kingdom that would later become Germany, a western kingdom that would become France, and Lothair's 'Middle Kingdom', called Lotharingia, which ran from modern Belgium down through Provence into Italy. This Middle Kingdom was always the weakest of the three, forever threatened by wicked uncles on either side. Lotharingia needed to be able to defend itself: it needed a strong king.

Rosamond McKitterick, Professor of Medieval History at Cambridge University, sets the scene:

> We know almost nothing about the court of Lothair the Second, simply because most of our sources devoted to him are in two particular categories. One is made up of narrative sources describing the vulnerability of his own little kingdom in the middle of the west and the east Frankish kingdoms, where his uncles, Charles the Bald in the west and Louis the German in the east, were casting their greedy eyes upon his kingdom. The other category is much more pertinent to this crystal, because it concerns the attempts Lothair made to get rid of his wife, Theutberga. He seems to have married her very soon after he inherited the throne, even though he had a long-standing mistress called Waldrada, from whom he had a son and a daughter. When he married Theutberga, she had no children and she continued to bear no children. Lothair seems to have decided Waldrada would be a better bet. So he recruited his two bishops, of Cologne and Trier, to have the marriage annulled on the grounds of Theutberga's incest with her brother.

Lothair's bid to divorce his wife and marry his mistress was no self-indulgent whim: he needed to have a legitimate heir, which was his

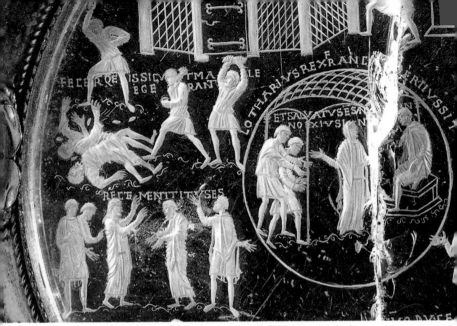

The final scenes of the crystal show the elders being stoned to death and Susannah declared innocent

only chance to preserve his inheritance and his kingdom. But royal divorce, then as now, was political dynamite.

The bishops of Cologne and Trier had actually obtained confessions from the queen, possibly through torture, that she had committed incest with her brother. But Theutberga appealed to the Pope, who investigated the case and declared her innocent. This was a huge dynastic setback for Lothair, but he seems to have accepted the Pope's decision. Although he continued to try to find another way of divorcing her, he seems to have acknowledged publicly that the claims against Theutberga were groundless and that the slandered woman was entirely innocent.

Because of the strong parallels with the Susanna story, it's always been tempting to see the crystal as connected to this royal drama. Perhaps it was made as a present for Theutberga to show Lothair's sincerity in accepting that she was blameless – if so, it's a kind of private statement marking a temporary truce in their marital hostilities. But aspects of the way in which the final scene is treated hint that it is almost certainly something much more significant. In the last scene,

the artist deviates from the biblical text and shows Susanna being declared innocent by a king sitting in judgement, and the inscription specifically names Lothair. The message is clear: one of the key duties of the king is to ensure that justice is done – in short, the king must secure and respect the rule of law, even at great personal cost to himself. Justice is almost *the* defining royal virtue.

A treatise, probably written for Lothair himself, spells this out:

> The just and peaceful king carefully thinks about each case, and not despising the sick and poor of his people, speaks just judgements, putting down the wicked and raising the good.

These ideals, articulated more than a thousand years ago, are still central to European political life today. Lord Bingham told me:

> In the centre of the crystal, one sees the king who commissioned it in the role of judge. This is of considerable interest and importance because historically the crown and monarchy has always been regarded as the fount of justice. When Queen Elizabeth II took her Coronation Oath in 1953 she swore a very old oath, prescribed by an Act of 1688, that she would do justice and mercy in all her judgements. This is exactly the role in which one sees King Lothair – in the role of actually personally administering justice, which, of course, the Queen no longer does, but the judges who do it in her name are very proud to be called Her Majesty's judges.

The Susanna Crystal was made for a king without an heir in a kingdom without a future. In 869, when Lothair died undivorced, his uncles did indeed partition his lands, and all that remains of Lotharingia today is the name of Lorraine. For more than a thousand years, indeed until 1945, Lothair's Middle Kingdom was bitterly fought over by the successors of the wicked uncles, France and Germany. If Lothair had succeeded in divorcing his wife, and had had a legitimate heir, Lorraine might now rank with Spain, France and Germany as one of the great states of continental Europe. Lotharingia perished, but the principle that Lothair's Crystal proclaims has survived: a central duty of the ruler of the state is to guarantee that justice is done, dispassionately and in open court. Innocence must be protected. The Lothair Crystal is one of the first European images of the notion of the rule of law.

54

Statue of Tara

Bronze statue, from Sri Lanka
AD 700–900

Almost every religion has spirits or saints, gods or goddesses, that can be called upon to see us through troubled times. If you were a Sri Lankan around AD 800 you would probably have invoked the name of Tara, the spirit of generous compassion. Over the centuries many artists have given Tara physical form, but it is hard to imagine many more beautiful than the golden, nearly life-size figure which now presides serenely over the long Asia gallery at the British Museum.

The statue of Tara is cast in a single piece of solid bronze, which has then been covered in gold. When new, and seen under the Sri Lankan sun, she must have been dazzling. Even now, when her gilding is rather worn and illuminated only by the cool light of Bloomsbury, she still has a compelling lustre. She is about three quarters life-size, and she stands, as she always would have, on a plinth, so that as you look up at her she benignly gazes down at you. Her face tells you at once that she comes from southern Asia. But that's not the first thing that strikes visitors as they look at her: she has a quite impossible hour-glass figure and her upper body is completely naked. Her full and perfectly rounded breasts float above a tiny wasp waist. Below, a flimsy sarong is draped in gleaming folds that cling to and beguilingly reveal her shapely lower body.

When Tara arrived at the British Museum in the 1830s she was at once put into the store rooms and kept there for thirty years, viewed only by specialist scholars on request. Possibly she was seen as too dangerously erotic and voluptuous for public display. But this statue was not made to titillate. She is a religious being, one of the spiritual protectors to whom the Buddhist faithful can turn in distress, from a religious

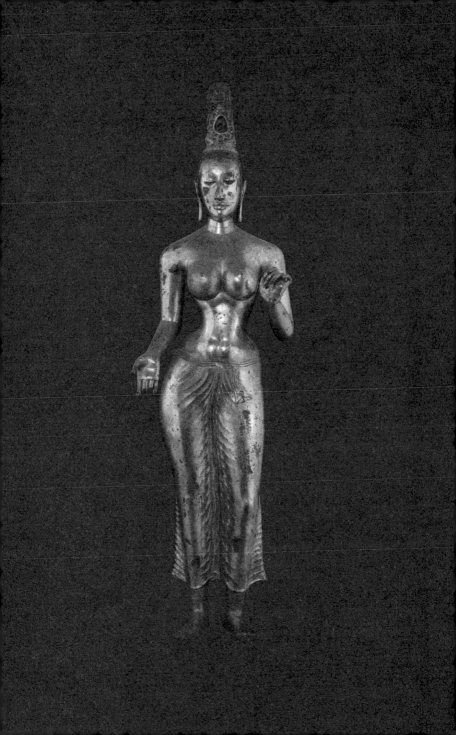

tradition that has no difficulty in happily combining divinity and sensuality. The statue of Tara takes us into a world where faith and bodily beauty converge to move us beyond ourselves. It also tells us a great deal about the world of Sri Lanka and southern Asia 1,200 years ago.

The island of Sri Lanka, separated from India by only twenty miles of shallow water, has always been an important hub in the seaborne trade that stitches the lands of the Indian Ocean together. In the years around AD 800 Sri Lanka was in close, indeed constant, contact not only with the neighbouring kingdoms of southern India but also with the Islamic Abbasid Empire in the Middle East, with Indonesia and with Tang China. Sri Lankan gems were highly prized; 1,200 years ago rubies and garnets from the island were regularly being traded to east and west, reaching the Mediterranean and possibly even Britain. Some of the gems from the great Anglo-Saxon ship burial at Sutton Hoo (see Chapter 47) may well have come from Sri Lanka.

But it was not only goods that travelled. The teachings of the Buddha, who lived and preached in northern India some time around 500 BC (see Chapter 41), had gradually evolved into a complex philosophical and spiritual system of conduct designed to liberate the individual soul from the illusion and suffering of this world. The new faith spread rapidly along the trade routes of India. So when this sculpture of Tara was made, Sri Lanka had been predominantly Buddhist for more than a thousand years. The particular strand of Buddhism that flourished in Sri Lanka at that time gave a special place to divine beings called Bodhisattvas, who could help the faithful live better lives. Tara is one of them.

Professor Richard Gombrich, a leading expert on Buddhist history and thought, explains her background:

She is a personification. She represents in person, symbolically, the power of a Buddha to save you, to take you across the ocean that is this world into which, according to most Buddhists, you are continually reborn until you find your way out. There is a particular future Buddha, Bodhisattva, called Avalokiteshvara, first found in texts which probably date from the first century AD. Initially he operates by himself, but after a few centuries the idea came that his power to save could be personified as a goddess. She represents his compassion and his power. Tara is simply an aspect of Avalokiteshvara.

Tara probably stood inside a temple, and originally there must have been a matching sculpture of her male consort, Avalokiteshvara, nearby, but his image has not survived.

Strictly speaking, Tara was not made to be worshipped but to be a focus for meditation on the qualities she embodies – compassion and the power to save. She would have been seen essentially by priests or monks from a privileged elite; relatively few people would actually have been able to meditate on her image.

Standing in front of her and knowing something of what she meant to believers, we can better understand why her makers chose to represent her as they did. Her beauty and serenity speak of her endless compassion. Her right hand, held down by her side, is not at rest but in the position known as *varadamudra*, the gesture of granting a wish – a clear demonstration of her prime role as the generous helper of the faithful. Her gilded skin and the jewels that once adorned her make it clear that this statue of Tara can only have been commissioned by people in command of great wealth.

It's very rare for a statue as big as this to survive and escape being melted down; indeed we know of no other example of this size from medieval Sri Lanka. At that date most large bronze statues would be cast by pouring the metal around a clay core to make a hollow figure. Tara, by contrast, is bronze through and through. Whoever made her must have had a great deal of bronze, rare skill and a lot of experience of this very challenging kind of work. Tara is not just a beautiful object; she is a remarkable technical achievement, and must have been very expensive.

We don't know who paid for Tara to be made – it could have been the ruler of any one of several kingdoms which squabbled and fought over territory in Sri Lanka around AD 800. Whoever it was clearly wanted her help on the path to salvation. In Sri Lanka, as anywhere else, gifts to religious institutions were also an important part of the political strategies of rulers, a means of asserting publicly their privileged links to the divine.

One of the fascinating things about this sculpture is that at the time it was made Tara was a relatively recent convert to Buddhism. She had originally been a Hindu mother goddess and was only later adopted by Buddhists – a typical but particularly beautiful example of the con-

stant dialogue and exchange between Buddhism and Hinduism that went on for centuries and which can be seen today in statues and buildings all over south-east Asia. Tara shows that Buddhism and Hinduism are not tightly defined codes of belief, but ways of being and acting that can, in different contexts, absorb each other's insights. Tara is, in modern parlance, a strikingly inclusive image: made for a Buddhist, Sinhala-speaking court in Sri Lanka but stylistically part of the wider world that embraced the Tamil-speaking, Hindu courts of southern India. Indeed Sri Lanka was shared, then as now, between Sinhala and Tamil, Hindu and Buddhist, and there were close links and many exchanges through diplomacy, marriage and, frequently, war.

Nira Wickramasinghe, Professor of History and International Relations at Leiden University, in the Netherlands, describes for us what this long-established pattern means for the region today.

> In many ways you can speak of a south Indian/Sri Lankan region with many points in common, culturally and politically as well. There has also been a two-way flow of influences in art, religion and technology. Of course, it has not always been a peaceful relationship; there have also been invasions and wars between southern states of India and chiefdoms in Sri Lanka.
>
> It's really trade that brought people from India to Sri Lanka. You have certain communities which are fairly recent migrants from south India, in the ninth to the thirteenth centuries. They merged their south Indian identity with a more Sri Lankan identity, and what is curious now is that many of these are the most ardent Sinhala nationalists.

The complex working-out of the relationships that we see embodied in Tara, between Sinhalese and Tamil, between Sri Lanka and southern India, between Buddhists and Hindus, still goes on 1,200 years later – relationships that in Sri Lanka have tragically included the recent long and bloody civil war.

But Tara may actually have survived thanks to war. Marks on the surface of the sculpture suggest that she was buried at some point, perhaps to avoid her being looted by invaders and then melted down. Unfortunately, nothing is known about how or when the statue was found, nor how it came, around 1820, to be in the possession of the then Governor of Ceylon (as the island was known at the time), the

soldier Sir Robert Brownrigg. Ceylon had been taken over by the British from its Dutch rulers during the Napoleonic Wars, and in 1815 Robert Brownrigg had conquered the last remaining independent Sri Lankan kingdom on the island; he brought Tara to Britain in 1822.

Many centuries before that the island had abandoned the particular strand of Buddhism in which Tara had played such a prominent part, and her statue may well have been removed from the temple and buried for safekeeping during that religious upheaval. But, although no longer revered in Sri Lanka as she was in the past, Tara is a living force in many places, especially in Nepal and Tibet. Millions of people all over the world still turn, as they did in Sri Lanka 1,200 years ago, to Tara to see them through.

55

Chinese Tang Tomb Figures

Ceramic sculptures, from Henan Province, China

AROUND AD 728

I t's a sure sign of middle age, they say, if, when you pick up the news-paper, you turn first to the obituaries. But middle-aged or not, most of us, I suspect, would love to know what people will actually say about us when we die. In Tang China around AD 700, powerful figures didn't just wonder what would be said about them: eager to fix their place in posterity, they simply wrote or commissioned their own obituaries, so that the ancestors and the gods would know precisely how important and how admirable they were.

In the Asia gallery at the north of the British Museum stand two statues of the judges of the Chinese Underworld, recording the good and the bad deeds of those who had died. These judges were exactly the people whom the Tang elite wanted to impress. In front of them stand a gloriously lively troupe of ceramic figures. They're all between 60 and 110 centimetres (25 and 40 inches) high, and there are twelve of them – human, animal and something in between. They're from the tomb of one of the great figures of Tang China, Liu Tingxun, general of the Zhongwu army, lieutenant of Henan and Huinan district and Imperial Privy Councillor, who died at the advanced age of 72 in 728.

Liu Tingxun tells us this, and a great deal more besides, in a glow-ing obituary that he commissioned for himself and which was buried along with his ceramic entourage. Together, figures and text give us an intriguing glimpse of China 1,300 years ago; but, above all, they are a shamelessly barefaced bid for everlasting admiration and applause.

Wanting to control your own reputation after death isn't unknown today, as Anthony Howard, former Obituaries Editor at *The Times*, recalls:

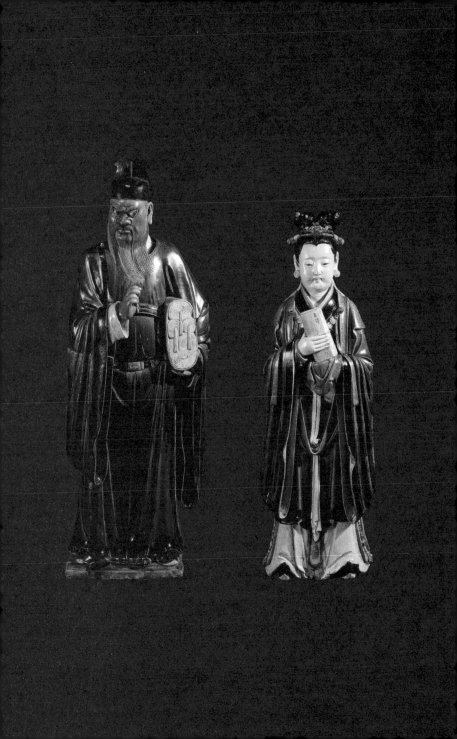

I used to get lots of letters saying, 'I do not seem to be getting any younger and I thought it might be helpful to let you have a few notes on my life.' They were unbelievable. People's self-conceit – saying things like, 'Though a man of unusual charm', and this kind of thing. I couldn't believe that people would write this about themselves. Of course no one nowadays commissions their own obituary, and those that were sent always ended up straight in the wastepaper basket.

I used to rather boast that on the obits page of *The Times*, 'We are writing the first version of the history of our generation,' and that is what I think it ought to be. It certainly isn't for the family or even the friends of the deceased.

The Tang obituaries were not for family and friends, either; but nor were they the first version of history for their generation. The intended audience for the obituary of Liu Tingxun was not earthly readers but the judges of the Underworld, who would recognize his rank and his abilities and award him the prestigious place among the dead that was his due.

Liu's obituary tablet is a model of colourful self-praise, and he aims a great deal higher than Anthony Howard's 'man of unusual charm'. He tells us that his behaviour set a standard that was destined to cause a revolution in popular manners. In public life he was an exemplar of 'benevolence, justice, statesmanship, modesty, loyalty, truthfulness and deference', and his military skills were comparable to those of the fabled heroes of the past. In one great feat, we are assured, he beat off invading troops 'as a man brushes flies from his nose'.

Liu Tingxun pursued his illustrious, if turbulent, career in the high days of the Tang Dynasty, which ran from 618 to 906. The Tang era represents for many Chinese a golden age of achievement, both at home and abroad, a time when this great outward-looking empire, along with the Abbasid Islamic Empire in the Middle East, created what was effectively a huge single market for luxury goods that ran from Morocco to Japan. You won't find it written in many European histories, but these two giants, the Tang and the Abbasid empires, shaped and dominated the early medieval world. By contrast, when Liu Tingxun died in 728 and our tomb figures were created, western Europe was a remote and underdeveloped backwater, an unstable

The two judges of the
Chinese Underworld

OVER: *A gloriously lively troupe*
of ceramic tomb figures

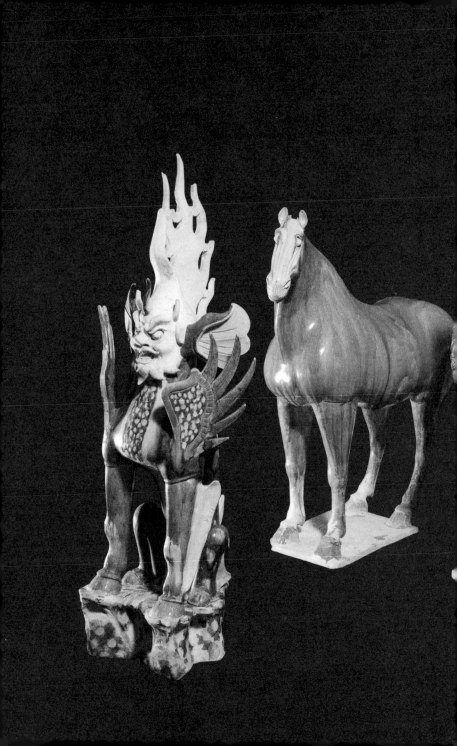

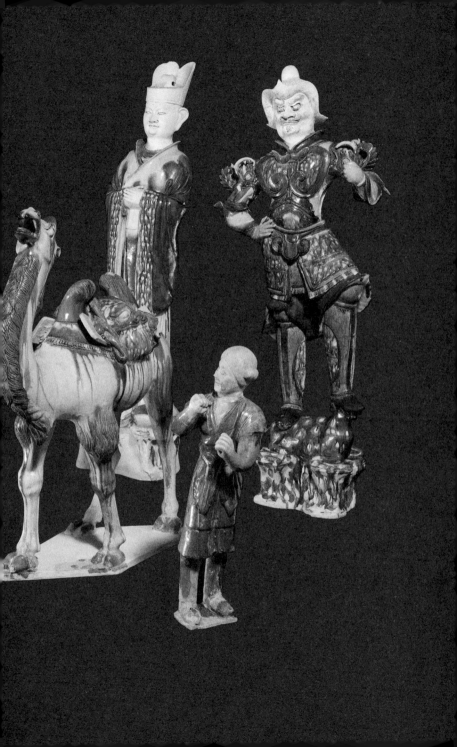

patchwork of small kingdoms and precarious urban communities. The Tang ruled a unified state that stretched from Korea in the north to Vietnam in the south and far west, along the Silk Road, by then well established, into central Asia. The power and the structure of this state – along with its enormous cultural confidence – are vividly embodied in Liu Tingxun's ceramic tomb figures.

The figures are arranged in six pairs, and all of them are of just three colours: amber-yellow, green and brown. It's a two-by-two procession. At the front is a pair of monsters, dramatic half-human creatures with clownish grimaces, spikes on their heads, wings and hoofed legs. They are fabulous figures heading up the line, guardians to protect the tomb's occupant. Behind them comes another pair of protectors, these ones entirely human in shape, and their appearance clearly owes a great deal to India. Next in line, contained and austere, and definitely Chinese, are two civil servants, who stand, arms politely folded, braced for their specific job – to draft and to present the case for Liu Tingxun to the judges of the Underworld. The last human figures in this procession are two little grooms, but they are completely overwhelmed by the magnificent beasts in their charge that come behind them. First, two splendid horses, just under a metre high, one cream splashed with yellow and green and the other entirely brown, and then, bringing up the rear, a wonderful couple of Bactrian camels, each with two humps, their heads thrown back as though whinnying. Liu Tingxun was setting off for the next world magnificently accompanied.

The horses and the camels in the entourage show that Liu Tingxun was, as you might expect, seriously rich, but they also underline Tang China's close commercial and trading links with central Asia and the lands beyond, through the Silk Road. The ceramic horses almost certainly represent a prized new breed, tall and muscular, brought to China from the west along what was then one of the great trade routes of the world. And if the horses are the glamorous end of Silk Road traffic, the Bentleys or the Porsches, so to speak, the two Bactrian camels are the heavy-goods vehicles, each capable of carrying up to 120 kilograms (260 lbs) of high-value goods – silk, perfumes, medicines, spices – over vast stretches of inhospitable terrain.

Ceramic figures like these were made in huge numbers for about fifty years, around AD 700, their sole purpose being to be placed in

high-status tombs. They have been found all around the great Tang cities of north-west China where Liu Tingxun held office. The ancient Chinese believed you needed to have in the grave all the things that were essential to you in life. So the figures were just one element in the contents of Liu Tingxun's tomb, which would also have contained sumptuous burial objects of silk and lacquer, silver and gold. While the animal and human statues would serve and entertain him, the supernatural guardian figures warded off malevolent spirits.

Between their manufacture and their entombment, the ceramic figures would have been displayed to the living only once, when they were carried in the funeral cortège. They were not intended to be seen again. Once in the tomb, they took up their unchanging positions around the coffin, and then the stone door was firmly closed for eternity. A Tang poet of the time, Zhang Yue, commented:

> All who come and go follow this road,
> But living and dead do not return together

Like so much else in eighth-century China, the production of ceramic figures like these was controlled by an official bureau, just one small part of the enormous civil service that powered the Tang state. Liu Tingxun, as a very high-ranking official in that state, brought two ceramic bureaucrats with him into his tomb, presumably to take care of the everlasting admin. Dr Oliver Moore has studied this elite bureaucratic class, which has become so synonymous with the Chinese state that we still refer to senior civil servants as mandarins:

Administration combined very old aristocratic families with what we could call new men. They were divided into various ministries – public works, the economy, a military board; and the largest of all was ritual. They would organize recurrent annual or monthly rituals, celebrations of the emperor's birthday, or princes' and princesses' birthdays, seasonal observances – things like the ploughing rite, where the emperor would open the agricultural season by symbolically ploughing a field somewhere in the palace. There was a very small group, whose significance grew throughout the dynasty, who took examinations and competed for state degrees. Later on, this system became magnified, so that by the year 1000, you had something like 15,000 men coming to the capital to take

exams, of whom only around 1,500 would get a degree. This is a system in which the largest number, well over 90 per cent, will fail – repeatedly for the whole of their lives – and at the same time this is a system which fostered loyalty to the dynasty – which is quite remarkable.

Liu Tingxun was a loyal servant of the dynasty, and the whole assemblage of his tomb – figures, animals and obituary text – sums up many aspects of Tang China at its zenith, showing the close link between the military and the civil administration, the orderly prosperity that allowed, and controlled, such sophisticated artistic production, and the confidence with which power was exercised both at home and abroad.

Pilgrims, Raiders and Traders

AD 800–1300

Medieval Europe was not isolated from Africa and Asia: warriors, pilgrims and merchants regularly crossed the continents, carrying with them goods and ideas. The Scandinavian Vikings travelled and traded from Greenland to Central Asia. In the Indian Ocean a vast maritime economic network connected Africa, the Middle East, India and China. Buddhism and Hinduism spread along these trade routes from India to Indonesia. Even the Crusades did not prevent commerce flourishing between Christian Europe and the Islamic world. In contrast, Japan, lying at the end of all the great Asian trade routes, chose to cut itself off, even from its neighbour, China,

for the next 300 years.

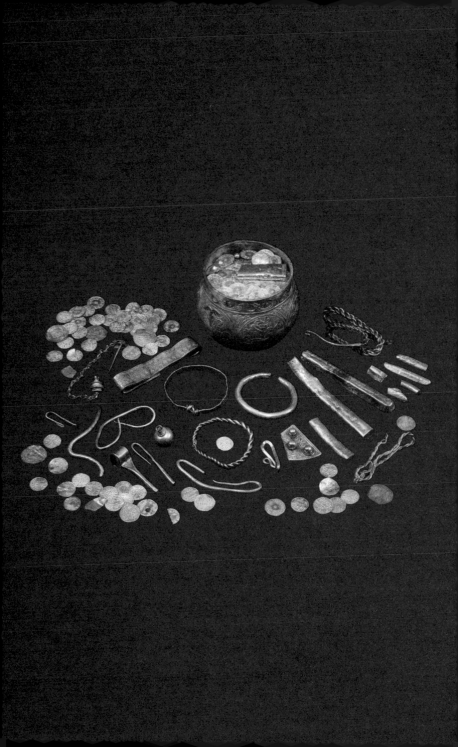

56

Vale of York Hoard

Viking objects, found near Harrogate, England

BURIED AROUND AD 927

On the surface, everything is idyllic: a broad green field in Yorkshire, in the distance rolling hills, woods and a light morning mist. It's the epitome of a peaceful, unchanging England, but scratch this surface or, more appropriately, wave a metal detector over it, and a different England emerges, a land of violence and panic, not at all secure behind its defending sea but terrifyingly vulnerable to invasion. It was in a field like this, 1,100 years ago, that a frightened man buried a great collection of silver, jewellery and coins that linked this part of England to what would then have seemed unimaginably distant parts of the world – to Russia, the Middle East and Asia. The man was a Viking and this was his treasure.

With the next five objects we're sweeping across the huge expanse of Europe and Asia between the ninth and fourteenth centuries. We will be dealing with two great arcs of trade – one that begins in Iraq and Afghanistan, rises north into Russia and ends in Britain – and another in the south, spanning the Indian Ocean from Indonesia to Africa.

When you use the words 'traders and raiders', one group of people above all springs to mind: the Vikings. Vikings have always excited the European imagination, and their reputation has fluctuated violently. In the nineteenth century, the British saw them as savage bad guys – horn-helmeted rapers and looters. For the Scandinavians, of course, it was different: the Vikings there were the all-conquering heroes of Nordic legend. The Vikings then went through a stage of being seen by historians as rather civilized – more tradesmen and travellers than pillagers. The recent discovery of the Vale of York hoard makes them seem a little less cuddly and looks set to revive the aggressive Vikings

of popular tradition, but now with a dash of cosmopolitan glamour. The truth is that that's what the Vikings have always been about: glitz with violence.

The England of the early 900s was divided between territories occupied by the Vikings – most of the north and the east – and the great Anglo-Saxon kingdom of Wessex, in the south and the west. The reconquest of the Viking territories by the Anglo-Saxons was the key event of tenth-century Britain, and our treasure both pinpoints one tiny part of this national epic and connects it to the immense world of Viking trade.

The hoard was found in the winter of 2007, when father and son David and Andrew Whelan were metal-detecting in a field to the south of Harrogate, in north Yorkshire.

The hoard that they found was contained in a beautifully worked silver bowl, about the size of a small melon. Astonishingly, it contained more than 600 coins, all silver and roughly the same diameter as a modern £1 coin, but wafer thin. They are mostly from Anglo-Saxon territory, but there are also some Viking coins produced in York, as well as exotic imports from western Europe and central Asia. Along with the coins were one gold and five silver arm-rings. And then – the ingredient that makes it absolutely certain that this is not an Anglo-Saxon but a Viking hoard – there's what archaeologists call hack silver, chopped-up fragments of brooches and rings and thin silver bars, mostly a couple of centimetres long, that the Vikings used as currency.

The hoard pitches us into a key moment in the history of England – when an Anglo-Saxon king, Athelstan, at last defeated the Viking invaders and built the beginnings of the kingdom of England. Above all, it shows us the range of contacts enjoyed by the Vikings while they were running northern England. These Scandinavians were extremely well connected, as the historian Michael Wood makes clear:

> There's a Viking arm-ring from Ireland, there are coins minted as far away as Samarkand and Afghanistan and Baghdad. This gives you a sense of the reach of the age; these Viking kings and their agents and their trade routes spread across western Europe, Ireland, Scandinavia. You read Arab accounts of Viking slave dealers on the banks of the Caspian

Coins from the hoard: (top) *dihram,* (middle) *coin with name of St Peter,* (bottom) *coin issued by Athelstan*

Sea; Guli the Russian, so called because of his Russian hat but actually Irish, was dealing in slaves out there on the Caspian and those kinds of trade routes, the river routes down to the Black Sea through Novgorod and Kiev and those kinds of places. You can see how, in a very short time, coins minted in Samarkand in, say, 915 could end up in Yorkshire in the 920s.

The Vale of York hoard makes it clear that Viking England did indeed operate on a transcontinental scale. There is a dirham from Samarkand, and there are other Islamic coins from central Asia. Like York, Kiev was a great Viking city, and there merchants from Iraq, Iran and Afghanistan traded their goods via Russia and the Baltic to the whole of northern Europe. In the process, the people around Kiev became very rich. An Arab merchant of the time describes them making neck-rings for their wives by melting down the gold and silver coins they'd amassed from trade:

> Round her neck she wears gold or silver rings; when a man amasses 10,000 dirhams, he makes his wife one ring; when he has 20,000 he makes two ... and often a woman has many of these rings.

And indeed there's a fragment of one of these Russian rings in the hoard.

Although Kiev and York were both Viking cities, contact between them would only very rarely have been direct. Normally, the trade route would have been constructed through a series of relays, with spices and silver coins and jewellery moving north, as amber and fur moved in the other direction, and at every stage there would have been a profit. But this trade route also carried the dark side of the Vikings' reputation. All through eastern Europe, Vikings captured people to sell as slaves in the great market of Kiev – which explains why in so many European languages the words for 'slave' and 'Slav' are still closely connected.

This hoard also tells us a great deal of what was happening back in York. There, the Vikings were becoming Christian; but, as so often, the new converts were reluctant to abandon the symbols of their old religion. The Norse gods were not entirely dead. And so, on one coin minted at York around 920, we find the sword and name of the Christian St Peter but, intriguingly, the 'i' of Petri – Peter – is in the shape of

a hammer, the emblem of the old Norse god, Thor. The new faith uses the weapons of the old.

We can be pretty certain that this treasure was buried soon after 927. That was the year Athelstan, king of Wessex, finally defeated the Vikings, conquered York and received the homage of rulers from Scotland and Wales. It was the biggest political event in Britain since the departure of the Romans, and the hoard contains one of the silver coins that Athelstan issued to celebrate it. On it he gives himself a new title, never used before by any ruler: *Athelstan Rex totius Britanniae*: Athelstan, King of All Britain. The modern idea of a united Britain starts here, although it was 800 years before it became a reality. But there is a sense in which Athelstan is the maker of England. Michael Wood explains:

> The wonderful thing about the treasure is that it homes in on the very moment that England was created as a kingdom and as a state. The early tenth century is the moment when these 'national identities' start to be used for the first time, and that's why all the later kings of the English, whether Normans or Plantagenets or Tudors, looked back to Athelstan as the founder of their kingdom. In one sense you could say they go back to that moment in 927.

Yet it was a pretty messy moment, and the hoard demonstrates that the struggle between Viking and Anglo-Saxon wasn't yet over. The treasure must have belonged to a rich and powerful Viking who stayed on in Yorkshire under the new Anglo-Saxon regime, because some of the coins in his hoard were minted by Athelstan in York in 927. Something must then have gone wrong for our Viking, which led him to bury the hoard – but he did it so carefully that he must have intended to return. Was he killed in the ongoing skirmish between Vikings and Anglo-Saxons? Did he go back to Scandinavia, or on to Ireland? Whatever happened to the treasure-owner, most of the Vikings in England stayed on and, in due course, were assimilated. In north-east England today places with names ending in 'by' and 'thorpe' – like Grimsby and Cleethorpes – are living survivals of the long Viking presence. The Vale of York hoard reminds us that these places were also at one end of the huge trade route that, around 900, stretched from Scunthorpe to Samarkand.

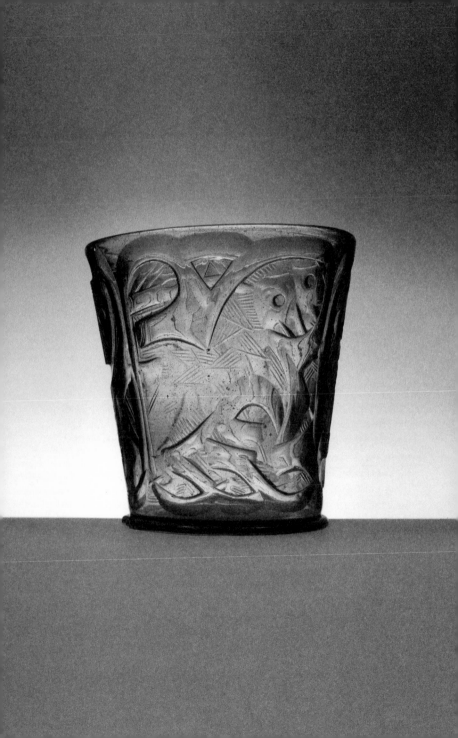

57

Hedwig Beaker

Glass, probably made in Syria

1100–1200 AD

For many people, the name Hedwig, if it means anything at all, conjures up the obliging owl that delivers messages to Harry Potter. But if you come from central Europe, and especially if you come from Poland, Hedwig means something quite different: she's a royal saint who, around 1200, became a national and religious symbol and who through the centuries has delivered not messages but miracles. The most famous of all Hedwig's miracles was that the water in her glass turned regularly into wine, and across central Europe there is to this day a small, puzzling group of distinctive glass beakers alleged to be the very glasses from which she drank the miraculous liquid.

One of Hedwig's beakers is now in the British Museum, and it takes us at once to the high religious politics at the time of the Crusades, the great age of Richard the Lionheart and Saladin, and to the unexpected fact that the war between Christians and Muslims was accompanied by a great flourishing of trade. Recent research is now leading us to think that Hedwig's beakers, revered in central Europe as evidence of a Christian miracle, were most probably made by Islamic glassworkers in the Middle East.

Hedwig was married to Henry the Bearded, Duke of Silesia – a territory that straddles the modern Polish, German and Czech borders. Henry and Hedwig had seven children, including the deliciously named Konrad the Curly, and then in 1209 – perhaps not surprisingly – they took vows of abstinence. By then, the duchess was already displaying distinctly saintly tendencies; she founded a hospital for female lepers and she treated nuns in the local convents with disconcerting reverence:

She used the water in which the nuns had washed their feet to wash her eyes, often her entire face. And more wonderful yet, she used this same water to rinse the faces and heads of her small grandchildren, her son's children. She was firmly convinced that the sanctity of the nuns who had touched the water would profit the children's salvation.

Although a duchess, she dressed poorly and went barefoot, even in the snow, where it was reported she left bloody footprints. Almost unheard of in those days, she drank only water. This teetotal behaviour worried her husband a good deal: drinking wine was much safer than water, because water was usually unclean, and he was afraid that she would fall ill. But one day, so the legend goes, the duke watched her raise her glass of water to her lips, and saw that it miraculously turned into wine. Her sainthood, and presumably her health, was assured from then on.

And so was the fame of her glass. Medieval Europe had an insatiable hunger for relics connected to miracles. Among the most famous of them all was a cup that had allegedly been used at the wedding at Cana, where Christ performed his first miracle of turning water into wine. Hedwig's beakers were part of a proud tradition.

The Hedwig beaker we have in the British Museum – one of the dozen or so glass beakers, all strikingly similar, which were identified by the pious as the vessels from which Hedwig had drunk – is really much more like a small vase than a drinking glass. It is made of thick glass, a smoky topaz colour, about 14 centimetres (6 inches) high. You need two hands to grasp it, and it is not at all easy to drink out of. If I put some water into it, and then try to take a proper gulp, the rim is so wide that it spills. And, sadly, the water does not turn into wine.

But it is a miracle of a different sort that a dozen or so vulnerable, fragile glass objects like this should all have survived the centuries intact. They must have been carefully cherished, and we know that many of them were preserved in princely collections and in church treasuries, so it is probable that many of them were in fact used as chalices in royal chapels and churches. Many of the surviving Hedwig beakers have been mounted with precious metal for use in the mass, and when you look at the foot and the sides of our beaker, you can see that it too once had metal mounts.

Significantly, Hedwig was one of a new sort of saint. By the time she was canonized, in 1267, the number of women saints was at an all time high in the history of the church. This is the point where women broke through the glass ceiling of sanctity. A quarter of all new saints were female. This may have had something to do with the religious revival fostered by the new preaching orders, the Franciscans and the Dominicans, who believed that the true Christian life should be lived not in the cloister but in the town, and who insisted that women should play a full part in it. So they encouraged royal women to do good works. Hedwig's support of the lepers was typical, and we all know from Diana, Princess of Wales's work with AIDS sufferers how powerful such a royal example can be. The medieval church strengthened that example by making the women saints after their death, and the roll call of royal saints is impressive: St Cunegunde, Holy Roman Empress; St Margaret, Princess of Hungary; St Agnes, Princess of Bohemia; and St Hedwig, Duchess of Silesia. All of them were credited with miracles, but only Hedwig received the miracle of the wine.

As another demonstration of religious renewal, the friars were calling not just for good works but for a good war, and the Franciscans and Dominicans were among the most effective advocates of the Crusades. As St Hedwig drank her wine, the Crusades were in full swing. In 1217 her brother-in-law, the king of Hungary, took the cross and led an armed expedition to the Holy Land. The curious thing is that, despite this military activity – or perhaps because of it – trade seems to have flourished. David Abulafia, Professor of Mediterranean History at the University of Cambridge, elaborates:

> The contact between Europe and the Middle East in the twelfth and thirteenth centuries was built around some quite intense trading. The Venetians, Genoese, Pisans in particular, managed to carry on their business – this sometimes caused a certain amount of scandal as you can imagine, that they were still present in the port in Alexandria for instance, while Saladin was preparing his campaigns against the Christians in the Holy Land. The basis of this trade was the exchange of raw materials from the west for luxury goods which came out of the Islamic world, notably silks, glassware, ceramics, things like this, which could not be produced to anything like the same quality within western Europe.

It is this phenomenon of trade coexisting with war that explains one of the most extraordinary things about the Hedwig beaker.

The designs of the Hedwig beakers all feature similar images: a lion, a griffin, an eagle, flowers and geometric motifs. But this beaker is the only one that combines all these elements. There is a lion and a griffin each raising a paw in homage to the eagle that stands between them, and the deep-cut design runs all the way round the glass. A mould must have been pressed into the glass while it was still hot and soft, and details of the texture and pattern were then meticulously carved. There is a real sense of feather and fur, but, above all, there is a strong sense of style. I think many people, shown this without explanation, would think it was a great piece of 1930s Art Deco glass, possibly from Scandinavia. The Hedwig beakers certainly don't look like anything produced in medieval Europe, which may well be why this extraordinary group of glasses was associated with a miracle.

These beakers clearly did not originate in the world in which they were found. The question of where they did originate is one people have been asking for more than 200 years. We may now be nearer an answer, because scientific analysis of this glass, and other Hedwig beakers, shows that they were made not out of the potash glass of European tradition but out of the soda ash glass of the coast of modern Israel, Lebanon and Syria. The Hedwig beakers are all so similar in shape, material and style that they must have been produced together, in a single workshop, and that workshop must have been in one of those coastal cities – the glass was almost certainly made by Muslim craftsmen. We know that at this period a lot of Islamic glass was made for export to Europe: 'Damascus glass' appears in the inventories of many medieval treasuries. Acre, the main trading centre of the Crusader kingdom of Jerusalem, was the principal port for this trade. Professor Jonathan Riley-Smith, a historian of the Crusades, sets the scene:

> Acre, which is now in Israel, became the most important commercial port in the eastern Mediterranean, which meant that shipping from the West was bringing out European cloth and bringing back spices to the West. We have a fascinating list of commodities traded in the port of Acre in the middle of the thirteenth century, with the customs duties that were due on each commodity. It doesn't actually mention these

glass beakers, but it mentions Muslim pottery as one of the main items that would have been taxed. So the appearance or survival of beakers of this sort in Europe has to be seen in the context of the enormous trade between the West and the Levant, and further east to furthest Asia, that was passing through a Crusader port.

All this opens up an intriguing possibility. We know that Hedwig's brother-in-law, the king of Hungary, spent some time in the city of Acre. Could he have commissioned the beakers while he was there? It would explain why they were later connected to Hedwig, the family saint, and how they came to central Europe. A fragment from a Hedwig beaker has been found in his royal palace in Budapest, so it is a realistic possibility. It can't, of course, be any more than a guess, but it is a beguiling hypothesis, and it might just be the solution to the long-running puzzle of the Hedwig beakers.

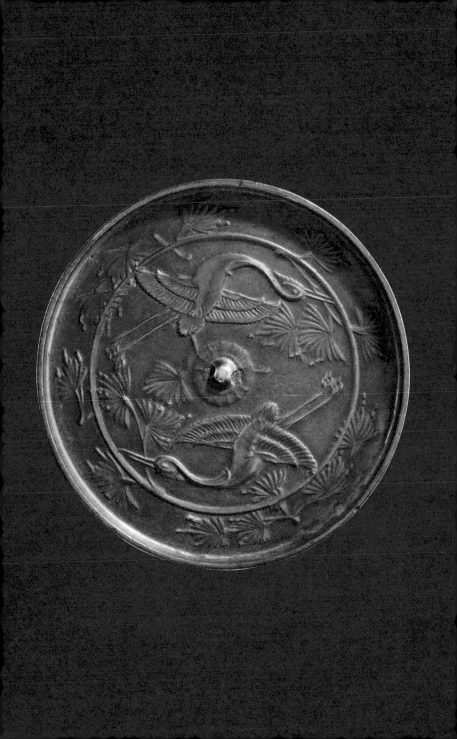

Japanese Bronze Mirror

Bronze mirror, from Japan
1100–1200 AD

Most people have thrown a coin or two into a wishing well or a fountain for luck. Every day at the famous Trevi Fountain in Rome, tourists throw in coins worth about 3,000 euros to secure good luck and a return visit to Rome. People have been throwing valuable things into water for thousands of years. It is an extraordinary compulsion, and it hasn't always been coins tossed with a light-hearted wish; in the past, it was often a deadly serious plea to the gods. In rivers and lakes across Britain archaeologists regularly discover weapons, jewellery and precious metals that were given to the gods thousands of years ago. In the British Museum we have objects from all over the world that were once solemnly or joyously deposited in water. One of the most fascinating is a mirror thrown into a temple pool around 900 years ago in Japan.

In a famous Japanese history called *The Great Mirror*, written around 1100, the mirror not only has a voice, but the power to reveal Japan to itself:

> I am a plain old-fashioned mirror from a bygone age, made of good white metal that stays clear without being polished ... I am going to discuss serious matters now. Pay close attention, everyone. You should think, as you listen to me, that you are hearing the Chronicles of Japan ...

The British Museum's mirror was made at about the same time, although it's only very recently that we've found out exactly where it came from and what that new information tells us about the Japan of 900 years ago. The story our mirror can now tell is about lovers and poets, court women and goddesses, priests and emperors.

The mirror is circular, about the size of a saucer, and it sits comfortably in my hand. There isn't a handle, but it would originally have had a loop fixed to it so that you could hang it from a hook. It is not made of silvered glass – the modern, silver-backed mirror we are all familiar with didn't come into use until around the sixteenth century. Early mirrors like this bronze one were all made of metal, which was then so highly polished that you could see your face in it.

Like much else in Japanese culture, mirrors first came to Japan from China. Around 1,000 years ago, societies across Eurasia were vigorously trading goods and exchanging ideas and beliefs. Throughout the eighth and ninth centuries Japan had been an energetic participant in these exchanges, particularly with China. But lying right at the end of all the great Asian trade routes and isolated by sea, Japan, unlike almost any other culture, was able to opt out of this interconnected world. It is an option Japan has exercised several times in its history, as it did most strikingly in the year 894, when it stopped all official contact with China and effectively cut itself off from the rest of the world. Untroubled by outside influences or new arrivals, Japan turned inwards for several centuries, a decision which still resonates today, and developed its own highly idiosyncratic culture. At the court in Kyoto every aspect of life was constantly refined and aestheticized in the pursuit of ever more sophisticated pleasure. It was a society in which women played a key cultural role. It is also the era of the first significant literature written in Japanese – written, in fact, by women. As a result, it is a world we know quite a lot about, and it's the world of our mirror. The person who first used it could well have been reading that first great Japanese novel – indeed one of the first great novels of the world – *The Tale of Genji*, written by the court Lady Murasaki Shikibu. Ian Buruma, an author and expert on Japanese culture, fills in the background:

> Lady Murasaki was a little bit like Jane Austen. *The Tale of Genji* gives an extraordinary insight into what life was like in that aristocratic hothouse of the Heian period.
>
> One thing that distinguishes medieval Japanese culture is that it was extremely aestheticized; it turned beauty into a kind of cult. And that included everything in daily life; not just objects – like mirrors, or chop-

sticks or whatever it was – but life itself, which was of course highly ritualized. In an aristocratic society it always is. That's true of all aristocratic societies, but possibly the aristocracy of the Heian period went further than any other culture before or since. People communicated by writing poetry, they had incense-smelling contests, they were connoisseurs of every kind of aesthetic pursuit, and that included the relations between men and women. Of course, feelings came into it, and so that led to jealousies and all the normal forms of human behaviour which Murasaki recorded so beautifully.

We can see something of Lady Murasaki's world of aesthetic refinement and incense-smelling contests in our mirror. On the back, the elegant decoration shows a pair of cranes in flight, their heads thrown back, their wings outstretched and pine branches in their beaks. Their necks curve to match exactly the curve of the circular mirror. On the outer edge are more decorative pine fronds. It's a rigorously balanced, perfectly composed work of art. But as well as being beautiful, our mirror also had a meaning: cranes had a reputation for longevity – the Japanese believed that they lived for a thousand years. Lady Murasaki tells us of one of her contemporaries who, at a particular court event, wore a gown decorated with cranes on a seashore:

> Ben-no-Naishi showed on her train a beach with cranes on it painted with silver. It was something new. She had also embroidered pine branches; she is clever, for all these things are emblematic of a long life.

The cranes also carry another meaning – these birds mate for life, and so are symbols of marital fidelity. The message on the back of our mirror is quite simply one of enduring love. At one point in *The Tale of Genji* the princely hero, before setting off for a long absence, takes a mirror, recites into it a passionate love poem and then gives it to his beloved, so that by holding the mirror once he is gone she will be able to hold both his message of love and within its polished surface the image of Genji himself. Our mirror with its faithful cranes would have been a particularly appropriate vehicle for such a declaration of love.

Japanese mirrors could also communicate darker messages, and not just between humans – through them we can enter the world of the spirits and indeed speak to the gods. Ian Buruma explains:

The mirror in Japanese culture does have several meanings, and some of them may seem contradictory. One is that it's an object to ward off evil spirits, on the other hand it can also attract them, which is why if you go into a rather traditional household in Japan even today people often cover up their mirror when they don't use it – they have a cloth that they hang in front of it because it might attract evil spirits. At the same time it's a sacred object. In the holiest shrine in Japan, in Ise, the holiest of holy parts that nobody ever gets to see has one of the three great national treasures, which is indeed a mirror ...

The mirror at Ise is in fact the mirror of the great Japanese sun goddess, Amaterasu. By ancient tradition, at the dawn of time Amaterasu ordered her grandson to descend from Heaven to rule over Japan, and to help him in this imperial task she gave him a sacred mirror that would give him and his successors perpetual access to the divine sun. To this day the sacred mirror of Amaterasu is used in the enthronement ceremonies of the Japanese emperor.

It is this particular ability of Japanese mirrors to allow humans to speak to gods that has ensured the survival of our mirror, which with eighteen others was given to the British Museum in 1927. All these mirrors are made of bronze and all have the same distinctive matt surface. But it was only in 2009 that a Japanese scholar researching in the British Museum was – for the first time – able to tell us why all nineteen mirrors look like this. It is because all of them came from the same place – all were found in a sacred pond beneath the mountain-shrine of Haguro-san in the north of Japan. At the beginning of the twentieth century this pond was drained in order to build a bridge for pilgrims. To the astonishment of the engineers, deep in the mud at the bottom of the pond they found around 600 mirrors (ours among them) which over the centuries had been consigned to the water. The visiting Japanese scholar, the archaeologist Harada Masayuki, sets the scene:

> People started to make pilgrimages to the mountain because they found the landscape quite spiritual and holy, a suitable abode for gods. For example, the white snow that stays for a long time had spiritual significance. So the pond itself became a centre of worship, and people thought that there was a god in that pond. There was a belief among the Japanese people that in order to be reborn you had to do good things in this

life. It was probably an extension of this idea that these exquisitely made and expensive mirrors were offered, entrusted, to a Buddhist priest, as a sign of piety – to dedicate to the god so that the giver could come back to the world again.

So we can now make an informed guess at the entire life story of our mirror. It was made in the sophisticated bronze-casting workshops of Kyoto around 1100, to be used in the rarefied world of courtly ritual and display, an indispensable tool for any lady or gentleman to prepare themselves for an aesthetic public appearance. At some point its owner decided to despatch it, in the care of a priest, on a long journey to the northern shrine, and there it was thrown into the sacred pond – still holding within it the likeness of its owner and carrying a message to the other world. What neither owner nor priest could have guessed was that it would one day be a message to us. And like the 'Great Mirror' itself, it tells to a modern audience a chronicle of Old Japan.

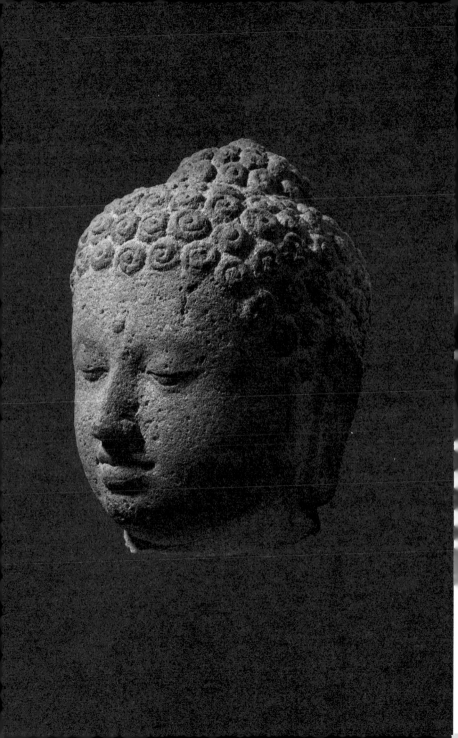

59

Borobudur Buddha Head

Stone head of the Buddha, from Java, Indonesia
AD 780–840

We are tracing the great arcs of trade that linked Asia, Europe and Africa around a thousand years ago. Through this stone head of the Buddha we can plot an extensive network of connections across the China Sea and the Indian Ocean by which goods and ideas, languages and religions, were exchanged among the peoples of south-east Asia. It comes from Borobudur, on the Indonesian island of Java, just a few degrees south of the equator. Borobudur is one of the greatest Buddhist monuments in the world and one of the great cultural achievements of humanity – a huge, square, terraced pyramid, representing the Buddhist view of the cosmos in stone, decorated with well over a thousand relief carvings and peopled with hundreds of statues of the Buddha. As pilgrims climb it, they are treading a physical path that mirrors a spiritual journey, symbolically transporting the walker from this world to a higher plane of being. Here, on the rich and strategically important island of Java, at the monument of Borobudur, is the supreme example of how the network of maritime trade allowed Buddhism to spread beyond the boundaries of its birth and become a world religion.

Dominating a volcanic plain in the middle of the island, Borobudur is a stepped pyramid built from more than one and a half million blocks of stone, around the year 800. It consists of seven mounting terraces, diminishing in size as they rise: four square terraces below, then three circular ones above. At the top of the whole structure is a large domed shrine.

As you climb through the different levels, you take a material road to a spiritual enlightenment. On the lowest level, the sculptured reliefs

present us with the illusions and disappointments of ordinary life, with all its troubles and shortcomings; they show us the punishments meted out to adulterers, murderers and thieves – a Dante-like vision of sin and its inevitable punishment. Higher up, the reliefs show the life of the historical Buddha himself as he negotiated this imperfect world, moving from his princely birth and family wealth to renunciation and eventual enlightenment. After that come single statues of the Buddha, meditating and teaching, showing pilgrims how to continue their journey of renunciation towards the realms of the spirit.

When Islam became the dominant religion in Java in the sixteenth century, Buddhist Borobudur was abandoned, and for centuries it lay overgrown and almost invisible. Three centuries later, in 1814, it was rediscovered by the first modern visitor to describe it, the British administrator, scholar and soldier Sir Thomas Stamford Raffles. Raffles had been appointed lieutenant-governor of Java after the British captured the island during the Napoleonic Wars, and he became passionate about the people and their past. He heard about a 'hill of statues' and ordered a team to investigate. The news they brought back was so exciting that Raffles went to see for himself the monument which at that time he knew as Boro Boro:

> Boro Boro is admirable as a majestic work of art. The great extent of the masses of building covered in some parts with the luxuriant vegetation of the climate, the beauty and delicate execution of the separate portions, the symmetry and regularity of the whole. The great number and interesting character of the statues and reliefs, with which they are ornamented, excite our wonder that they were not earlier examined, sketched and described.

The monument had been badly damaged by earthquakes and largely buried under volcanic ash. Even today, many stone fragments stand in rows around the site, surrounded by grass and flowers. Nevertheless, Raffles was enraptured; he knew at once that this was a supreme architectural and cultural achievement, and he collected two of the fallen stone heads of the Buddha.

Raffles' rediscovery of Borobudur, and his later uncovering of important Hindu monuments on the island – for Java had embraced both Hinduism and Buddhism – led to a fundamental reassessment of

Borobudur, covered with relief carvings and statues of the Buddha

Javanese history. Raffles wanted to persuade Europeans that Java was indeed a great civilization, as the anthropologist Dr Nigel Barley explains:

> Raffles believed fervently in the concept of civilization; he never defines it, but it has a number of clear markers. One of them is the possession of a writing system, another is social hierarchy, and yet another is the possession of complex stone architecture. So, if you like, Borobudur was one of the proofs that Java was a great civilization – the equal of ancient Greece and Rome – and the whole of his collection at the British Museum, the Raffles Collection, and the whole of that book he wrote, *The History of Java*, is an attempt to establish that proposition.

The Raffles Collection includes the two heads and some fragments gathered at Borobudur, and a modest number of Hindu and Islamic works of art; but Raffles also collected objects that for him summed up the Javanese culture of his own day. This was a very particular kind of collecting: he hoped that the objects themselves would plead the cause of this Indonesian civilization, and would make it clear that the culture of Java was part of a great south Asian cultural tradition,

which Europeans should recognize as the equal of their own. Raffles was attempting a cultural revolution – a view of world history that did not have the Mediterranean at its centre and its climax.

One of the fallen stone heads of the Buddha that Raffles found in the ruins at Borobudur stands in the section of the East Asia gallery in the Museum devoted to Java. It is slightly larger than life-size and it shows the Buddha with his eyes lowered, in a state of peaceful inner contemplation. His mouth has the classic serene half-smile, his hair is tightly curled, and the elongated earlobes, intended to suggest long years of wearing heavy gold earrings, tell us of his life as a prince before he became enlightened. We are immediately reminded of the first human images of the Buddha made about 500 years earlier, in north-western India, described in Chapter 41. Raffles knew India very well, and it was clear to him that the statues of Borobudur, and indeed of much of Javanese culture, owed a great deal to long and sustained contacts with India.

These contacts had been taking place for well over a thousand years before Borobudur was built. People used to think that these connections were the result of conquest or emigration from India, but we now see them as part of a great land and sea trading network, which inevitably transported not just people and goods but skills, ideas and beliefs. It was this network that brought Buddhism to Java and beyond, travelling along the Silk Road to China, Korea and Japan, and sailing across the south Asian seas to Sri Lanka and Indonesia. But Buddhism was never an exclusive faith, and, at roughly the time that Borobudur was rising out of the landscape, great Hindu temples were being built nearby on a comparable scale.

To construct monuments like these required manpower and money. Manpower has never been a problem in Java – it is so fertile that it has always supported a huge population – and in the years around 800 the island was immensely rich. Beside its agriculture, it was a key staging post for international trade, especially the spices – cloves above all – coming from further east. From Java these luxury goods were shipped on to China, and all over the Indian Ocean.

One of the reliefs at Borobudur, a superb carved panel showing a ship of around 800, gives us the best and most vivid evidence for this kind of seaborne contact. It is an image of great vigour and skill, deeply

Carving of a ship at Borobudur

carved, with a lot of energy and, indeed, humour – right at the front under the figurehead you can see a sailor grimly clinging on to the anchor. But, above all, it offers us visual evidence for the kind of ship that was able to make these long sea journeys, a ship with multiple sails and masts well suited to the long runs from China and Vietnam to Java, Sri Lanka, India and indeed to East Africa.

I suppose it is true of all great religious buildings, but on a visit to Borobudur I was particularly struck by what I think is a universal paradox: that you need huge material wealth, acquired through intense engagement with the affairs of the world, to build monuments which inspire us to abandon wealth and to leave the world behind. The Buddhist teacher and writer Stephen Batchelor agrees:

> It clearly was a very grandiose equivalent to one of these great Gothic European cathedrals, and it would have taken probably seventy-five to a hundred years to construct it, similar to the cathedrals here in Europe. And so it's a great symbol of the Buddhist world, the Buddhist vision, and it's an intellectual exercise at some level, but because it is so brutally

physical, it is so concrete, it's more than that. It embodies something that goes beyond just metaphysics or religious doctrine and stands for something vital about what the human spirit can achieve.

The experience of climbing the terraces of Borobudur is a powerful one. As you emerge from the enclosed corridors of the lower terraces into the clear open spaces above surrounded by a circle of volcanoes, you are very conscious of having escaped from physical constraints and entered a larger world. Even the most hardened tourist has the sense that this is not a site visit, but a pilgrim's progress. The builders of Borobudur understood perfectly how stone can shape thought.

When I reached the three circular terraces on the top, I found that the teaching stops. There are no longer any reliefs telling stories, simply bell-shaped stupas with a seated Buddha inside each one. We have left behind and below us the illusory world of representation and reality; this is the world of formlessness. At the very summit of Borobudur, there is a huge bell-shaped stupa. Inside it there is nothing, the void – the ultimate goal of this spiritual journey.

60

Kilwa Pot Sherds

*Ceramic fragments, found on a beach
at Kilwa Kisiwani, Tanzania*

AD 900–1400

It's amazing what a few broken pots and plates can tell us. This chapter is about pottery – but it is not about the high ceramic art which usually survives only in treasuries or in ancient graves; it is about the crockery of everyday life, which as we all know usually survives only in fragments. It is striking that when a plate or a vase is whole it is alarmingly fragile; once it is smashed the pieces of pottery are almost indestructible. Broken bits of pot have told us more than almost anything else about the daily life of the distant past.

Pictured here is a handful of fragments that survived for about a thousand years on a beach in East Africa. An alert beachcomber picked them up in 1948 and presented them to the British Museum in 1974, realizing that these broken oddments, of no financial value at all, would open up not just life in East Africa a thousand years ago, but the whole world of the Indian Ocean.

For much of history, history itself has been landlocked. Most of us tend to think in terms of towns and cities, mountains and rivers, continents and countries. But if we stop thinking about, say, the Asian landmass or a history of India and instead put the oceans in the foreground, we have a completely different perspective on our past. I've been looking in recent chapters at the ways in which ideas, beliefs, religions and people travelled along the great trade routes across Europe and Asia between the ninth and fourteenth centuries; but the trade routes also crossed the high seas, sailing around the Indian Ocean. Africa and Indonesia are nearly 5,000 miles apart, yet they can communicate with each other easily, just as they can communicate with the Middle East, India and China, thanks to the Indian Ocean winds, which obligingly

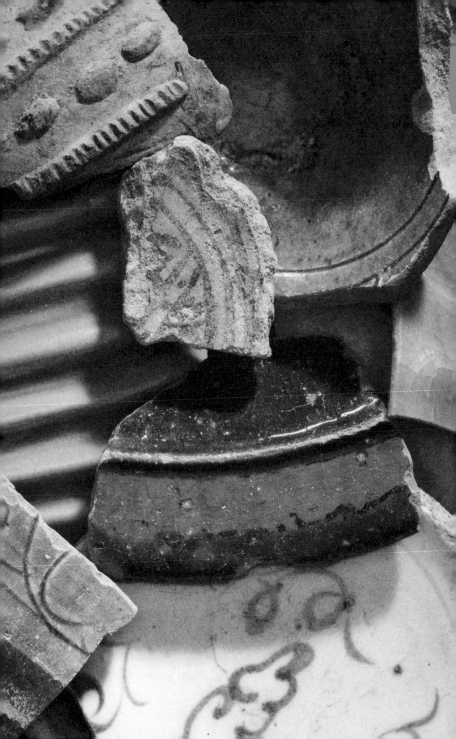

blow north-easterly for one half of the year and south-westerly for the other. This means that traders can sail long distances knowing they will be able to come back. Merchant sailors have been criss-crossing these seas for thousands of years and they carried not just cargoes of goods, but plants and animals, people, languages and religions. It is no accident that the people of Madagascar speak an Indonesian language. The shores of the Indian Ocean, however diverse and however far apart, belong to one great community, a community whose extent and complexity can be glimpsed in our broken bits of pot.

The handful that I've picked out can tell us a great deal. The largest piece is about the size of a postcard, the smallest roughly half the size of a credit card. The pieces fall into three distinct groups. There are a couple of smooth, pale green pieces that look very like expensive modern china; there are other small pieces with blue patterning; and there is a third group of unglazed natural clay decorated in quite high relief. The pots of which these fragments were once part come from widely different parts of the world, but between 600 and 900 years ago they were thrown away in one place – on the same beach in East Africa. They were found at the bottom of a low crumbling cliff at Kilwa Kisiwani island.

Today Kilwa is a quiet Tanzanian island with a few small fishing villages, but around the year 1200 it was a thriving port city. You can still find the ruins of its great stone buildings and of the largest mosque of its time in sub-Saharan Africa. A later Portuguese visitor described the city as he found it in 1502:

> The city comes down to the shore and is surrounded by a wall and towers, within which there may be 12,000 inhabitants ... The streets are very narrow, as the houses are very high, of three and four storeys, and one can run along the tops of them upon the terraces, as the houses are very close together ... and in the port are many ships.

Kilwa was the southernmost and the richest of a chain of towns and cities strung along the East African coast, running from Tanzania north through Mombasa, in modern Kenya, to Mogadishu in Somalia. These communities were always in touch with each other, sailing up and down the coast, and they also mixed constantly with traders coming across the ocean.

The evidence of all this trade – the broken crockery – is full of information. It is quite clear even to me that the pale green sherds are Chinese porcelain, fragments from beautiful luxury bowls or jars – Celadon ware, which the Chinese were manufacturing in industrial quantities and exporting not just to south-east Asia but across the Indian Ocean to the Middle East and Africa. The Tanzanian novelist Abdulrazak Gurnah remembers finding his own bits of Chinese pottery on the beach as a child:

> We used to see these things, these bits of pottery, on the beaches. And sometimes older people would say to us, 'That's Chinese pottery.' And we'd think 'Yeah, yeah,' we'd heard lots of stories of this kind of thing – flying carpets, princes lost, etc. – so we took it as just another one of those stories. It was only later on, when you begin to go in to museums or hear these persistent stories of great Chinese armadas that visited East Africa, that the object then becomes something valuable, something that is a signifier of something important – a connection. And then you see the object itself and you see its completeness, and its weight, and its beauty, and it makes inescapable this presence over centuries of a culture as far away as China.

As well as the Chinese porcelain, there are other bits of pot here that have clearly travelled a long way to get to Kilwa. A blue piece with black geometric patterning on it obviously comes from the Arab world; when you look at this fragment under the microscope, you can tell from the composition of the clay that it was made in Iraq or Syria. Other pieces come from Oman or different parts of the Gulf. These fragments alone would be enough to demonstrate the strength and the extent of Kilwa's links with the Islamic Middle East.

The people of Kilwa clearly loved foreign pottery. They used it for dining and they also decorated their houses and mosques with bowls set into walls and arches. Pottery, of course, was only one element in the thriving import–export trade that made Kilwa's fortune – but as it was the toughest and the most enduring product, it is the evidence that has survived. Also coming in were cottons from India – a trade that continues to this day – Chinese silks, glass, jewellery and cosmetics. Another Portuguese visitor conjured up the rich exchanges that took place at harbours like Kilwa:

They are great traders in cloth, gold, ivory and diverse other wares with
the Moors and other heathens of India; and to their harbour come every
year many ships with cargoes of merchandise, from which they get great
stores of gold, ivory and wax.

Exports from Africa included iron ingots much in demand in India,
timber used for building in the Gulf, rhino horn, turtle shell, leopard
skin and, of course, gold and slaves. Many of these were brought
over huge distances from inland Africa; gold, for instance, came
from Zimbabwe far to the south. It was the trade through Kilwa that
800 years ago made Zimbabwe such a rich and powerful kingdom,
capable of constructing as its capital city that supreme and mysterious
monument, Great Zimbabwe.

All this trade made Kilwa very rich, but it changed it in more than
material ways. Because the ocean winds blow north-east for one half
of the year and south-west for the other, this was a trade with a dis-
tinct annual rhythm, and merchants from the Gulf and India usually
had to spend months waiting for the wind home. In these months
they inevitably mixed closely with the local African community – and
transformed it. In due course, thanks to these Arab traders, the coastal
towns were converted to Islam, and Arabic and Persian words were
absorbed into the local Bantu language to create a new lingua franca
– Swahili. The result was a remarkable cultural community running
through the coastal cities from Somalia to Tanzania, from Mogadishu
to Kilwa – a kind of Swahili strip, Islamic in faith and cosmopolitan
in outlook. But the core of Swahili culture remains unquestionably
African, as the historian Professor Bertram Mapunda explains:

> We know that when these immigrants came to East Africa they came
> because one of the attractions was trade: it was because of these local
> people who had attracted them that the Swahili culture was later born.
> So it's not true to say 'This is something that was brought from outside,'
> when we know that there were local people here who had contributed
> the starting point, and, from there, people from outside came and were
> interested.

The last piece of pottery makes this point very well. It's a brown frag-
ment of fired clay with bold raised decoration. It is pottery made for

cooking and everyday use; the clay is local and the manufacture is distinctly African. It shows that the African inhabitants of Kilwa, while happily enjoying and collecting foreign pottery, continued, as people always do, to cook in their own traditional way with their own traditional pots. Pots like this one also tell us that the Africans themselves were sailing and trading across the Indian Ocean, because fragments like these have been found in ports across the Middle East. We know from other sources that African merchants traded to India and that cities of the Swahili strip were sending their own envoys to the Chinese court. Seas usually unite more than they separate the peoples who live on their shores. Like the Mediterranean, the Indian Ocean has created a huge interconnected world, where local history is always likely to be intercontinental.

PART THIRTEEN
Status Symbols
AD 1100–1500

Despite the Black Death and the chaos caused by the Mongol invasions of Asia and Europe, these four centuries were also a period of great learning and cultural achievement. Technological advances led to the creation of magnificent objects used by the wealthy to reflect their status and to show off their taste and intellect. In Mongol-ruled China iconic 'blue and white' porcelain was first developed and went on to be desired across the globe. In Ife, one of the first city-states to arise in West Africa, court artists created lifelike sculptures using sophisticated bronze-working techniques. Within the Islamic world, arts and sciences flourished, and European scholars benefited from Islamic advances in astronomy, maths and even chess, which became a pastime of the elite across all of Europe. In the pre-Columbian Caribbean a ruler's status was closely tied to their relationship with the ritual thrones that gave access to the world of the spirits.

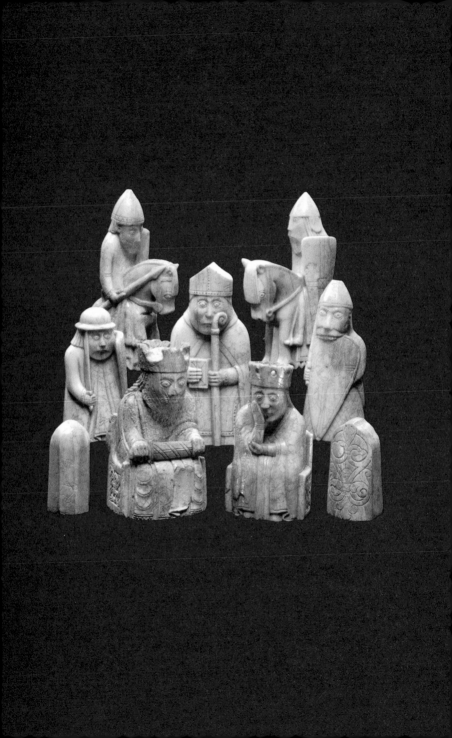

61

The Lewis Chessmen

Walrus ivory and whales' teeth chessmen, probably made in Norway, found on the Isle of Lewis, Scotland

AD 1150–1200

In 1972 the world was gripped by one of the great battles of the Cold War. It was fought in Iceland and it was a chess match – between the American Bobby Fischer and the Russian Boris Spassky.

At the time, Fischer declared that 'Chess is war on a board,' and at that moment in history it certainly seemed like it. But then it always has; if all games are to some degree surrogates for violence and war, no game so closely compares to a set-piece battle as chess. Two opposing armies line up to march across the board, foot-soldier pawns in front, officers behind. Every chess-set shows a society at war; whether that society is Indian, Middle Eastern or European, the way the pieces are named and shaped tells us a great deal about how that society functions. So, if we want to visualize European society around the year 1200, we could hardly do better than look at how they played chess. No chess pieces offer richer insights than the seventy-eight mixed pieces found on the Hebridean island of Lewis in 1831, and known ever since as the Lewis Chessmen.

Sixty-seven of the pieces are now in the British Museum; eleven are in the National Museums of Scotland. Between them, these much-loved pieces take us into the heart of the medieval world.

People have been playing board games for more than 5,000 years, but chess is a relative newcomer – it seems to have been invented in India at some point after the year 500. Over the next few hundred years, the game spread through the Middle East and on into Christian Europe, and in every place the chess pieces changed to reflect the society that played it. So, in India there are pieces named 'war elephants', while in the Middle East, Islamic reservations about the human image

ensured that all the pieces were virtually abstract. European pieces, by contrast, are often intensely human, and the Lewis Chessmen not only seem to show us particular kinds of characters, but strikingly reflect the structures of the great medieval power game as it was fought out across northern Europe, from Iceland and Ireland to Scandinavia and the Baltic.

They are much bigger than the figures that most of us play with today; the king, for instance, is about 8 centimetres (3 inches) high, and he comfortably fills a clenched fist. Most of them are carved out of walrus tusks, although a few are made out of whales' teeth. Some of the pieces would originally have been coloured red rather than the black that is more common today, but all of them are now a pale creamy brown.

Let's begin with the pawns. One of the puzzles of the Lewis Chessmen is that there are lots of major pieces and very few pawns. We have pieces from several incomplete sets, but only nineteen pawns among them. The pawns are the only pieces that aren't human; they're simply small ivory slabs that stand upright like gravestones. In medieval society, these represent the peasants brutally conscripted on to the battlefield. All societies tend to think of the people at the bottom of the heap as interchangeably identical, and the foot soldiers here are shown with no individuality at all.

The main pieces, on the other hand, are full of personality: elite guards, knights on horseback, commanding kings and meditative queens. Pride of place goes to the ultimate source of legitimate power: the king – capture him, and all fighting stops. All the Lewis kings sit on ornate thrones, a sword across their knees. Guarding the kings are two kinds of specialist warrior. One is immediately familiar to us – the knight, fast-moving, versatile and mounted on horseback. From the very beginnings of chess in India, the mounted warrior is a constant: he is in every age and in every country and is largely unchanged today. But these familiar knights are flanked by something much more sinister. At the edges of the board where we now have castles are the ultimate shock troops of the Scandinavian world. They stand menacingly, some of them working themselves into a frenzy of bloodlust by chewing the tops of their shields.

These are the fighters called *berserkers*. *Berserker* is an Icelandic

word for a soldier wearing a shirt made of bearskin, and the word 'berserk' even today is synonymous with wild, destructive violence. More than any piece on this board, the berserkers take us to the terrifying world of Norse warfare.

Around 1200, the Isle of Lewis, on the north-west edge of what is now Scotland, was at the heart of this Norse world. It was part of the kingdom of Norway. The language was Norwegian and its archbishop had his cathedral in Trondheim, 250 miles north of Oslo. Trondheim was one of the great centres for carving walrus ivory, and the style of the Lewis Chessmen is very close to pieces made there. We know that similar chess pieces have also been found in Ireland, and Lewis was a staging-post on the thriving sea route between Trondheim and Dublin. The medieval historian Professor Miri Rubin elaborates:

> I believe that they come from Norway and probably came from somewhere around Trondheim; they look like so much that's produced there. But if we think of Great Britain not as very much connected to the central and southern European sphere, as it is now, but instead of the North Sea as a sort of 'connector' of regions, there is that whole North Sea region – that's where the Vikings came from, that's where the predecessors of the Normans who ultimately conquered England came from. So if we think of that as a sort of Commonwealth, a northern Commonwealth, that became rich because it had these amazing raw materials of wood and amber and fur and metals, then we can imagine better how something produced in Norway could end up on the west coast of Scotland.

The Lewis Chessmen were discovered in 1831, at Uig Bay on Lewis, in a small stone chamber concealed in a sandbank. By far the most likely explanation for their being there is that they were hidden for safety by a merchant, who may have been intending to sell them on Lewis itself. A thirteenth-century poem, for example, names a powerful figure, Angus Mór of Islay, as king of Lewis, and has him inheriting his father's set of ivory chess pieces:

> To you he left his position, yours his breastplate, each treasure ... his slender swords, his brown ivory chessmen.

By playing chess, a ruler like Angus Mór indicated that although his power base was on the extreme outer edge of the continent, he was

nonetheless part of an elite high culture that embraced all the courts of Europe. And the figure on the board which represents these European courts more than any other is the queen.

Unlike in Islamic society, where the rulers' wives would generally have remained hidden from public view, the European queen enjoyed a public role and the high status of adviser to the king. In Europe, land and power could sometimes pass through the female line. So, whereas on the Islamic chessboard the king is accompanied by his male adviser, the vizier, on the European board the king sits beside his queen. In the Lewis chess pieces, the queens all sit staring into the distance, holding their chin in their right hand – permanently suggesting to their contemporaries intense thought and wise counsel, but looking to us comically glum.

Perhaps, though, these queens had something to be glum about. In medieval chess, the queen didn't actually have much power – she could move only one diagonal space at a time. Her modern sister, on the other hand, is the most powerful piece on the board. Apart from the queen, surprisingly little has actually changed in chess since medieval times, least of all the formidable mathematics of the possible moves. This sedentary, cerebral game has always aroused passionate emotion. The writer Martin Amis has long been fascinated by both aspects:

> The maths of chess is very interesting, in that after four moves each the possibilities are already in the billions. It is the supreme board game. Very occasionally you glimpse a combination that a great player would be seeing all the time; and suddenly the board looks tremendously rich – it seems to bristle with possibilities. And combative will is what you see in all the great players – they've all got the killer instinct.

Sometimes, it is literally the killer instinct: an English court record from 1279 tells us that when one David de Bristol was playing chess against a certain Juliana le Cordwaner, they quarrelled so violently that he struck her in the thigh with a sword and she died immediately.

There's one piece I have not mentioned yet, but which is perhaps the most fascinating figure of all the Lewis Chessmen, one that gives a crucial insight into the society that made it. It is the bishop, who in medieval Europe was one of the great powers of the state, not only controlling spiritual life but also commanding land and men. The

Archbishop of Trondheim would have been a real force in Lewis. The bishops of the Lewis Chessmen are the oldest in existence, powerful reminders that across the whole of Europe the church was an essential part of any state's war machine. The story of the Crusades to the Holy Land and the role that the church played in them is well known, but at the same time there was also a northern crusade, led by the Teutonic knights, which conquered and Christianized parts of eastern Europe; while in the south, Castile and central Spain, with bishops playing a prominent part, were being reclaimed for Christendom from their Islamic rulers.

It is from that Spain, newly Christian but with Muslim and Jewish citizens, that the next object comes – the versatile, multifunctional smart phone of its time, the astrolabe.

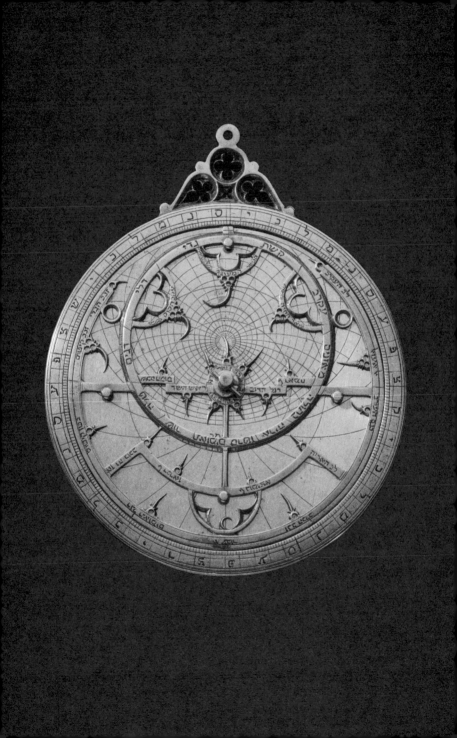

62

Hebrew Astrolabe

Brass astrolabe, probably from Spain
AD 1345–1355

This is a portable model of the heavens, in the shape of an exquisite, circular brass instrument, which looks a bit like a large brass pocket watch. It's an astrolabe, and with it in my hands I can tell the time, do some surveying, or work out my position in the world by sun or stars and, if I have enough information, cast your horoscope.

Although familiar to ancient Greeks, the astrolabe was an instrument that was particularly important for the Islamic world, as it allowed the faithful to find the direction of Mecca, so it is not surprising that the oldest astrolabe to survive is an Islamic one from the tenth century. But the astrolabe pictured here is a Jewish one made about 650 years ago in Spain. It is inscribed with Hebrew lettering, but it also contains Arabic and Spanish words, and it combines both Islamic and European decorative elements. It is not just an advanced scientific instrument, but also an emblem of a very particular moment in Europe's religious and political history.

We don't know exactly who owned this particular Hebrew astrolabe, but it tells us a great deal about how Jewish and Islamic scholars revitalized science and astronomy by developing the inheritance of Classical Greece and Rome. The instrument speaks of a great intellectual synthesis, and about a time when the three religions – Christianity, Judaism and Islam – coexisted peacefully. There was no religious synthesis, but the three faiths lived together in fruitful friction, and between them they made medieval Spain the intellectual powerhouse of Europe.

An astrolabe makes accessible in compact form the sum total of medieval astronomical lore. Like the latest developments today, this was must-have technology, a demonstration that you were right at the

cutting edge. There is a wonderfully funny and touching letter written by Chaucer to his ten-year-old son Lewis, who was obviously like techie boys in every generation and clamouring to get to grips with an astrolabe. As well as writing him a letter, Chaucer also wrote him a little instruction manual, telling the boy how to use the instrument and warning him just how difficult he was going to find it – although I suspect that, like most children today, Lewis quickly left his father behind.

> Little Lewis, I have perceived well thy ability to learn sciences touching numbers and proportions; and I have also considered thy earnest prayer specially to learn the Treatise of the Astrolabe. Here is an Astrolabe of our horizon and a little treatise to teach a certain number of conclusions appertaining to the same instrument.
>
> Trust well that all the conclusions that can be found, or else possibly might be found in so noble an instrument as an Astrolabe, are not perfectly understood by any mortal man in this region, and I have seen that there be some instructions that will not in all things deliver their intended results; and some of them be too hard for thy tender age of ten years to understand …

At first sight this astrolabe looks like an outsized old-fashioned pocket watch with an entirely brass face. It is a gleaming assemblage of interlocking brasswork, with five wafer-thin discs, one on top of another, held together by a central pin. On top of this are several pointers that can be lined up with various symbols on the discs to give you astronomical readings or help you to determine your position. An astrolabe like this one is designed for the particular latitude in which it is going to be used – the five discs here will allow you to get an accurate reading from any position between the latitudes of the Pyrenees and North Africa. In the middle of that range are the latitudes for the Spanish cities of Seville and Toledo.

This tells us that this astrolabe was almost certainly made for somebody based in Spain, who might travel between North Africa and France, and the writing on the astrolabe tells us clearly what kind of person must have been using it. The owner is Jewish and is learned.

Dr Silke Ackermann, the curator of scientific instruments here at the British Museum, has spent a lot of time studying this astrolabe:

The inscriptions are all in Hebrew – you can see the finely engraved Hebrew letters quite clearly. But what's so intriguing about the piece is that not *all* the words are Hebrew. Some of them have Arabic origins and some are medieval Spanish. So, for example, beside a star in the constellation that we call Aquila – the eagle – we can see written in Hebrew *nesher me'offel* – 'the flying eagle'. But other star names are given in their Arabic form: so Aldabaran in Taurus has its Arabic name *al-dabaran* written in Hebrew letters. And when you read out the Hebrew letters for the names of the months, they give you the medieval Spanish names like October, November, December. So what you have here is the knowledge of the Classical Greek astronomers who charted the heavens, combined with the contributions of Muslim, Jewish and Christian scholars – and all in the palm of your hand.

The Spain in which this astrolabe was made was the only place in Christian-ruled Europe where there were significant populations of Muslims; it was also home to an extensive Jewish population. From the eighth to the fifteenth centuries, the mixing in medieval Spain of the people of these three religions was one of Spanish society's most distinctive elements. Of course, there was no such country as Spain yet – in the fourteenth century it was still a patchwork of states. The biggest was Castile, which shared a border with the last independent Muslim state in the peninsula, the kingdom of Granada. In many parts of Christian Spain there were large numbers of Jews and Muslims, all three groups living together but keeping their separate traditions, in what might be described as an early example of multiculturalism. This coexistence, extremely rare in this period of European history, is often referred to by the Spanish term *convivencia*.

The distinguished historian of Spain Professor Sir John Elliott explains how this mixed society emerged:

As I see it, the essence of multiculturalism is the preservation of the distinctive identity of the different religious and ethnic communities in a society. And for much of the period of Islamic rule, the policy of the rulers was to accept that diversity, even if it regarded Christians and Jews as adherents of inferior faiths. When the Christian rulers took over they did much the same, because they had no other option, really, though at the same time, of course, intermarriage was forbidden within these

communities, so it was a limited multiculturalism. That didn't prevent a great deal of mutual interaction, particularly at the cultural level. So the result was a civilization which was vibrant and creative and original because of this contact between the three races.

A couple of centuries earlier this mutual interaction had put medieval Spain at the forefront of the expansion of knowledge in Europe. Not only was there growing scientific knowledge around astronomical instruments like our astrolabe, but it was also in Spain that the works of the ancient Greek philosophers, above all Aristotle, were translated into Latin and entered the intellectual bloodstream of medieval Europe. This pioneering work depended on constant interchange between Muslim, Jewish and Christian scholars, and by the fourteenth century, this scholarly legacy was embedded in European thought – in science and medicine as well as philosophy and theology. The astrolabe became the indispensable tool of astronomers, astrologers, doctors, geographers or indeed anyone with intellectual aspirations – even a ten-year-old English boy like Chaucer's son. Eventually, this one intricate object that could do so many things would be displaced by a whole range of separate instruments – the globe, the printed map, the sextant, the chronometer and the compass, each doing one of the numerous jobs the astrolabe could do on its own.

The shared inheritance of Islamic, Christian and Jewish thinkers would survive for centuries, but the *convivencia* of the three faiths did not. Although medieval Spain is today often hailed by politicians as a beacon of tolerance and the model for multi-faith coexistence, the historical truth is distinctly less comfortable. This is Sir John Elliott again:

> As regards actual religious tolerance, it's rather less clear-cut than co-existence ... Christendom in general was a pretty intolerant society, very opposed to deviants of all kinds, and that intolerance was particularly directed against the Jews. For instance, England expelled its Jews in 1290, and France more than a decade later, and as far as Christian–Muslim relations were concerned there was a hardening of religious attitudes from the twelfth century onwards. As the Christians preached the Crusades, and the Almohads who moved into Spain from North Africa preached the Jihad, there was an increasing aggressiveness on both sides.

Against this background, Christian Spain could still seem compara-tively tolerant. But there were already signs of trouble, and the sur-vival of Muslim Granada was a reminder of unfinished business. The intellectual alliance of Christians, Jews and Muslims would soon be swept away by a militant Spanish monarchy, intent on following the rest of Europe and asserting Christian dominance. In the years around 1500, Jews and Muslims would be persecuted and expelled from Spain. The *convivencia* was over.

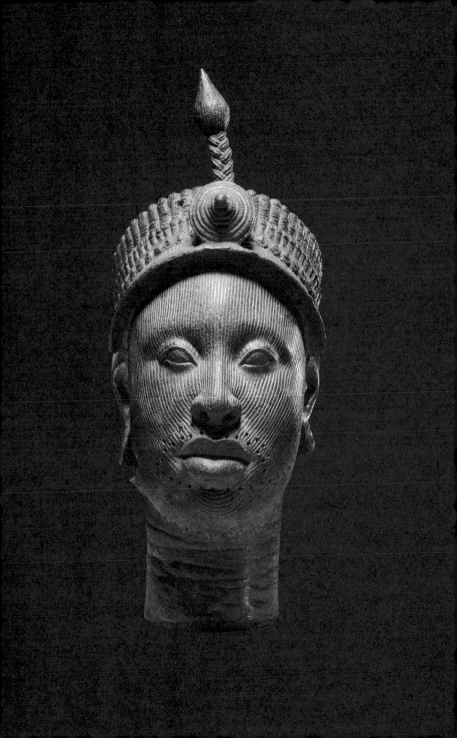

Ife Head

Brass statue, from Nigeria
1400–1500 AD

So far in this history of the world through things, we have encountered all kinds of objects, all eloquent, but many of them neither beautiful nor valuable. This object, however, a head cast in brass, is undoubtedly a great work of art. It is quite clearly the portrait of a person – though we don't know who; it is without question by a very great artist – though we don't know who; and it must have been made for a ceremony – though we don't know what kind. What is certain is that the head is African, it is royal, and it epitomizes the great medieval civilizations of West Africa of about 600 years ago. It is one of a group of thirteen heads, superbly cast in brass, all discovered in 1938 in the grounds of a royal palace in Ife, Nigeria, which astonished the world with their beauty. They were immediately recognized as supreme documents of a culture that had left no written record, and they embody the history of an African kingdom that was one of the most advanced and urbanized of its day. The sculptures of Ife exploded European notions of the history of art, and they forced Europeans to rethink Africa's place in the cultural history of the world. Today they play a key part in how Africans read their own narrative.

The Ife head is in the Africa gallery of the Museum, where it seems to be looking at its visitors. It is a little smaller than life-size and is made of brass, which has darkened with age. The shape of the face is an elegant oval, covered with finely incised vertical lines – but it is a facial scarring so perfectly symmetrical that it contains rather than disturbs the features. He wears a crown – a high beaded diadem with a striking vertical plume projecting from the top, which still has quite a lot of original red paint. This is an object with extraordinary presence. The

alert gaze, the high curve of the cheek, the lips parted as though about to speak – all these are captured with absolute confidence. To grasp the structure of a face like this is possible only after long training and meticulous observation. There is no doubt that this represents a real person, and reality not just rendered but transformed. The details of the face have been generalized and abstracted to give an impression of repose. Standing face to face with this brass sculpture I know that I'm in the presence of a ruler imbued with the high serenity of power. When Ben Okri, the Nigerian-born novelist, looks at the Ife head he sees not only a ruler but a society and a civilization:

> It has the effect on me that certain sculptures of the Buddha have. The presence of tranquillity in a work of art speaks of a great internal civilization, because you can't have tranquillity without reflection, without having asked the great questions about your place in the universe and having answered those questions to some degree of satisfaction. That for me is what civilization is.

The idea of black African civilization on this level was quite simply unimaginable to a European a hundred years ago. In 1910, when the German anthropologist Leo Frobenius found the first brass head in a shrine outside the city of Ife, he was so overwhelmed by its technical and aesthetic assurance that he immediately associated it with the greatest art that he knew – the Classical sculptures of ancient Greece. But what possible connection could there have been between ancient Greece and Nigeria? There's no record of contact in the literature or in the archaeology. For Frobenius there was an obvious and exhilarating solution to the conundrum: the lost island of Atlantis must have sunk off the coast of Nigeria and the Greek survivors stepped ashore to make this astonishing sculpture.

It's easy to mock Frobenius, but at the beginning of the twentieth century Europeans had very limited knowledge of the traditions of African art. For painters like Picasso, Nolde or Matisse, African art was Dionysiac, exuberant and frenetic, visceral and emotional. But the restrained, rational, Apollonian sculptures of Ife clearly came from an orderly world of technological sophistication, sacred power and courtly hierarchy, a world in every way comparable with the historic societies of Europe and Asia. As with all great artistic trad-

itions, the sculptures of Ife present a particular view of what it means to be human. Babatunde Lawal, Professor of Art History at Virginia Commonwealth University, explains:

> Frobenius around 1910 assumed that the survivors of the Greek lost Atlantis might have made these heads, and he predicted that if a full figure were to be found, the figure would reflect the typical Greek proportions, the head constituting about one seventh of the whole body. But when a full figure was eventually discovered at Ife the head was just about a quarter of the body, complying with the typical proportion characterizing much of African art – the emphasis on the head because it is the crown of the body, the seat of the soul, the site of identity, perception and communication.

Given this traditional emphasis, it is perhaps not surprising that nearly all of the Ife metal sculptures that we know – and there are only about thirty – are heads. The discovery of thirteen of those heads in 1938 meant there could no longer be any doubt that this was a totally African tradition. The *Illustrated London News* of 8 April 1939 reported the find. In an extraordinary article, the writer, still using the conventional (to us, racist) language of the 1930s, recognizes that what he calls the Negro tradition – a word then associated with slavery and primitivism – must, with the Ife sculptures, now take its place in the canon of world art. The word 'Negro' could never again be used in quite the same way.

> One does not have to be a connoisseur or an expert to appreciate the beauty of their modelling, their virility, their reposeful realism, their dignity and their simplicity. No Greek or Roman sculpture of the best periods, not Cellini, not Houdon, ever produced anything that made a more immediate appeal to the senses or is more immediately satisfying to European ideas of proportion.

It is hard to exaggerate what a profound reversal of prejudice and hierarchy this represented. Along with Greece and Rome, Florence and Paris, now stood Nigeria. If you want an example of how things can change thought, the impact of the Ife heads in 1939 are I think as good as you'll find.

Recent research suggests that the heads we know were all made

over quite a short stretch of time, possibly in the middle of the fifteenth century. At that point Ife had already been a leading political, economic and spiritual centre for centuries. It was a world of forest farming dominated by cities, which developed in the lands west of the Niger river. And it was river networks that connected Ife to the regional trade networks of West Africa and to the great routes that carried ivory and gold by camel across the Sahara to the Mediterranean coast. In return came the metals that would make the Ife heads. The world of the Mediterranean had provided not the artists, as Frobenius supposed, merely the raw materials.

The forest cities were presided over by their senior ruler, the Ooni of Ife. The Ooni's role was not just political – he also had a great range of spiritual and ritual duties, and the city of Ife has always been the leading religious centre of the Yoruba people. There is still an Ooni today. He has high ceremonial status and moral authority, and his headgear still echoes that of the sculpted head of about 600 years ago.

Our head is almost certainly the portrait of an Ooni, but it is not at all obvious how such a portrait would have been used. It was clearly not meant to stand on its own, so it might well have been mounted on a wooden body – there is what looks like a nail hole at the neck that could have been used to attach it. It has been suggested that it might have been carried in processions or that in certain ceremonies it could have stood in for an absent or even for a dead Ooni.

Around the mouth there are a series of small holes. Again, we can't be quite certain what these are for, but they were possibly used to attach a beaded veil that would hide the mouth and the lower part of the face. We know that the Ooni today still covers his face completely on some ritual occasions – a powerful marker of his distinct status as a person apart, not like other human beings.

There is a sense in which the Ife sculptures have also become embodiments of a whole continent, of a modern, post-colonial Africa confident in its ancient cultural traditions. Babatunde Lawal explains:

Today, many Africans, and Nigerians in particular, are proud of their past, a past that was once denigrated as being crude, primitive. Then to realize that their ancestors were not as backward as they were portrayed was a double source of joy to them. This discovery unfurled a new kind

of nationalism in them, and they started walking tall, feeling proud of their past. Contemporary artists now seek inspiration from this past to energize their quest for identity in the global village that our world has become.

The discovery of the art of Ife is a textbook example of a widespread cultural and political phenomenon: that as we discover our past, so we discover ourselves – and more. To become what we want to be, we have to decide what we were. Like individuals, nations and states define and redefine themselves by revisiting their histories, and the sculptures of Ife are now markers of a distinctive national and regional identity.

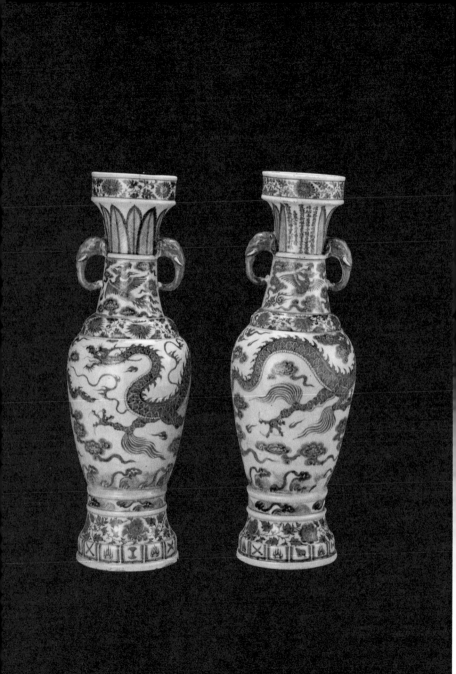

64

The David Vases

Porcelain, from Yushan county, China

AD 1351

In Xanadu did Kubla Khan
A stately pleasure-dome decree:
Where Alph, the sacred river, ran
Through caverns measureless to man
Down to a sunless sea.

The thrilling opening lines of Coleridge's opium-fuelled fantasy still send a tingle down the spine. As a teenager I was mesmerized by his vision of exotic and mysterious pleasures, but I had no idea that Coleridge was in fact writing about a historical figure. Qubilai Khan was a thirteenth-century Chinese emperor. Xanadu is merely the English form of Shangdu, his imperial summer capital. Qubilai Khan was the grandson of Genghis Khan, ruler of the Mongols from 1206 and terror of the world. Wreaking havoc everywhere, Genghis Khan established the Mongol Empire – a superpower that ran from the Black Sea to the Sea of Japan and from Cambodia to the Arctic. Qubilai Khan extended the empire even further and became emperor of China.

Under the Mongol emperors, China developed one of the most enduring and successful luxury products in the history of the world – a product fit for stately pleasure-domes, but which spread in a matter of centuries from grand palaces to simple parlours all over the world: Chinese blue and white porcelain. We now think of blue and white as quintessentially Chinese, but that is not how it began. This archetypal Chinese aesthetic in fact comes from Iran. Thanks to the long Chinese habit of writing on objects, we know exactly who commissioned these two blue and white porcelain vases, which gods they were offered to, and indeed the very day on which they were dedicated.

The importance of Chinese porcelain is hard to overstate. Admired and imitated for more than a thousand years, it has influenced virtually every ceramic tradition in the world, and it has played a crucial role in cross-cultural exchanges. In Europe, blue and white porcelain is practically synonymous with China, and is always associated with the Ming Dynasty. But the David Vases, now in the British Museum, make us rethink this history, for they predate the Ming and were made under Qubilai Khan's Mongol dynasty, known as the Yuan, which controlled all of China until the middle of the fourteenth century.

Seven hundred years ago most of Asia and a large part of Europe were reeling from the invasions of the Mongols. We all know Genghis Khan as the ultimate destroyer, and the sack of Baghdad by his son still lives in Iraqi folk memory. Genghis's grandson Qubilai was also a great warrior, but under him Mongol rule became more settled and more ordered. As emperor of China he supported scholarship and the arts, and he encouraged the manufacture of luxury goods. Once the empire was established, a 'Pax Mongolica' ensued, a Mongolian Peace which, like the Pax Romana, ensured a long period of stability and prosperity. The Mongol Empire spread along the ancient Silk Road and made it safe. It was thanks to the Pax Mongolica that Marco Polo was able to travel from Italy to China in the middle of the thirteenth century and then return to tell Europe what he'd seen.

One of the startling things he had seen was porcelain; indeed, the very word 'porcelain' comes to us from Marco Polo's description of his travels in Qubilai Khan's China. The Italian *porcellana*, 'little piglet', is a slang word for cowry shells, which do indeed look a little like curled-up piglets. And the only thing that Marco Polo could think of to give his readers an idea of the shell-like sheen of the hard, fine ceramics that he saw in China was a cowry shell, a *porcellana*. And so we've called it 'little piglets', porcelain, ever since – that is if we're not just calling it 'china'. I don't think there's another country in the world whose name has become interchangeable with its defining export.

The David Vases are so called because they were bought by Sir Percival David, whose collection of more than 1,500 Chinese ceramics is now in a special gallery at the British Museum. We've put the vases right at the entrance to the gallery to make it quite clear that they are the stars of the show: David acquired them separately from two differ-

ent private collections, and was able to reunite them in 1935. They're big, just over 60 centimetres (24 inches) high and about 20 centimetres (8 inches) across at the widest, with an elegant shape, narrower at top and bottom, swelling in the centre. Apparently floating between the white porcelain body and the clear glaze on top lies the blue, made of cobalt and painted in elaborate figures and patterns with great assurance. There are leaves and flowers at the foot and neck of the vases, but the main body of each vase has a slender Chinese dragon flying around it – elongated, scaled and bearded, with piercing claws and surrounded by trailing clouds. At the neck are two handles in the shape of elephant heads. These two vases are obviously luxury porcelain productions made by artist-craftsmen delighting in their material.

Porcelain is a special ceramic fired at very high temperatures: 1200–1400 degrees Celsius. The heat vitrifies the clay so that like glass it can hold liquid, in contrast to porous earthenware, and also makes it very tough. White, hard and translucent porcelain was admired and desired everywhere, well before the creation of blue and white.

The savagery of the Mongol invasion destabilized and destroyed local pottery industries across the Middle East, especially in Iran. So, when peace returned, these became major new markets for Chinese exports. Blue and white ware had long been popular in the markets, so the porcelain the Chinese made for them mirrored the local style, and Chinese potters used the Iranian blue pigment cobalt to meet local Iranian taste. The cobalt from Iran was known in China as *huihui qing* – Muslim blue – clear evidence that the blue and white tradition is Middle Eastern and not Chinese. Professor Craig Clunas, an expert on Chinese cultural history, places this phenomenon in a wider context:

> Iran and what is now Iraq are the kinds of areas where this sort of colouring comes in. This is a technique that comes from elsewhere, and therefore it tells us something about this period when China is unprecedentedly open to the rest of Asia as part of this huge empire of the Mongols, which stretches all the way from the Pacific almost to the Mediterranean. Certainly the openness to the rest of Asia is what brings about things like blue and white, and it probably had an impact on forms of literature. So from the point of view of cultural forms coming into being the Yuan period is extraordinarily important.

The David Vases are among the happy consequences of this cultural openness. Their crucial significance is that as well as their decoration, they have inscriptions – inscriptions that tell us that they were dedicated on Tuesday 13 May 1351 – a level of precision that is wonderfully Chinese and proof positive that fine-quality blue and white porcelain predates the Ming. But the inscriptions tell us much more than that. There are slight differences between the inscriptions on the two vases. This is the translation of the one on the left:

> Zhang Wenjin, from Jingtang community, Dejiao village, Shuncheng township, Yushan county, Xinzhou circuit, a disciple of the Holy Gods, is pleased to offer a set comprising one incense burner and a pair of flower vases to General Hu Jingyi at the Original Palace in Xingyuan, as a prayer for the protection and blessing of the whole family and for the peace of his sons and daughters. Carefully offered on an auspicious day in the Fourth Month, Eleventh Year of the Zhizheng reign.

There's a lot of information here. We're told that the vases were purpose-made to be offered as donations at a temple and that the name of their donor is Zhang Wenjin, who describes himself with great solemnity as 'a disciple of the Holy Gods'. It gives his home town, Shuncheng, in what is now Jiangxi province, a few hundred miles south-west of Shanghai. He is offering these two grand vases along with an incense burner (the three would have formed a typical set for an altar), though the incense burner has not yet been found. The specific deity receiving the offering – General Hu Jingyi, a military figure of the thirteenth century who was elevated to divine status because of his supernatural power and wisdom and his ability to foretell the future – had only recently become a god. Zhang Wenjin's altar set is offered in exchange for this new god's protection.

Foreign rulers, the Mongols; foreign materials, Muslim blue; and foreign markets, Iran and Iraq – all played an essential, if paradoxical, part in the creation of what to many outside China is still the most Chinese of objects, blue and white porcelain. Soon these ceramics were being exported from China in very large quantities, to Japan and south-east Asia, across the Indian Ocean to Africa, the Middle East, and beyond.

Eventually, centuries after its creation in Muslim Iran and its trans-

formation in Mongol China, blue and white arrived in Europe and triumphed. Like all successful products, it was widely copied by local manufacturers. Willow-pattern, the style that many people think of when blue and white is mentioned, was in fact invented – or should we say pirated? – in England in the 1790s by Thomas Minton. It was an instant success, and of course it was as much a fantasy view of China as Coleridge's poem. Coleridge may indeed even have been drinking his tea out of a Willow-pattern cup as he emerged from his opium dream of Kubla Khan's Xanadu.

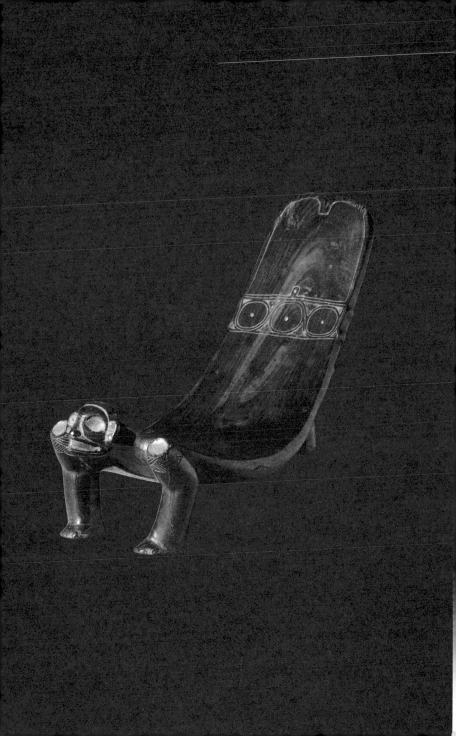

65

Taino Ritual Seat

Wooden stool, from Santo Domingo, Dominican Republic

AD 1200–1500

Recent chapters have described high-status objects that belonged to leaders and thinkers around the world about 700 years ago, objects reflecting the societies that produced them in Scandinavia and Nigeria, Spain and China. This object is a stool from the Caribbean, from what is now the Dominican Republic. It too tells a rich story – in this case of the Taino people, who lived in the Caribbean islands before the arrival of Christopher Columbus. In this history of the world the stool is the first object since the Clovis spear point (Chapter 5) in which the separate narratives of the Americas on the one hand, and Europe, Asia and Africa on the other, intersect – or, perhaps more accurately, collide. But this is no ordinary domestic thing – it is a stool of great power, a strange and exotic ceremonial seat carved into the shape of an otherworldly being, half-human, half-animal, which would take its owners travelling between worlds and which gave them the power of prophecy. We do not know if the seat helped them foretell it, but we do know that the people who made this seat had a terrible future ahead of them.

Within a century of the arrival of the Spanish in 1492 most of the Taino died of European diseases and their land was shared out among the European conquerors. It was a pattern that was repeated across the Americas, but the Taino were among the first with whom Europeans made contact, and they suffered more, perhaps, than any other Native American people. They had no writing, and so it is only thanks to a small number of objects like this stool that we can even begin to grasp how the Taino imagined their world and how they sought to control it.

The term 'Taino' is generally used to describe the dominant group of people that inhabited the larger Caribbean islands: Cuba, Jamaica,

Puerto Rico and Hispaniola (now divided between Haiti and the Dominican Republic), where our stool was found. Across the islands ritual artefacts have been found that give us some idea of Taino life and thought. There are face-like masks, for example, designed to be worn on the body, wooden statuettes and inhalers for sniffing a mind-altering substance. The most evocative of all these surviving traces of the Taino are the carved ceremonial stools known as *duhos*. They are the physical expression of a distinctive Taino world view.

The Taino people believed that they lived in parallel with an invisible world of ancestors and gods, from whom their leaders could seek knowledge of the future. A *duho* would be owned only by the most important members of a community, and it was the vital means of access to the realm of the spirits. It was in one sense a throne, but it was also a portal and a vehicle to the supernatural world.

It is about the size of a foot stool – a small curved seat carved out of rich dark wood, highly polished and gleaming. Carved at the front is a grimacing, goggle-eyed creature that looks almost human, with an enormous mouth, wide ears and two arms planted on the ground, which form the front two legs of the stool. From there a broad curve of wood sweeps upwards, like a wide beaver tail, supported at the back by two more legs. This creature looks like nothing on Earth – but one thing is certain: it's male. Underneath this strange composite being and between the hind legs are carved male genitals.

This is a seat for a leader – for the chief of a village or a region. Taino leaders could be either male or female, and the *duho* embodied their social, political and religious power; it was crucial to their function in society. In at least one instance a leader was buried sitting on his *duho*. Dr José Oliver, an archaeologist who has been doing new work on the Taino, explains how *duhos* would have been used:

> The *duho* is not a piece of furniture but rather a symbolic location of where the chief would stand. This particular object is too small for a human being to sit on it. What is interesting is that all the wooden seats that we know of in the Caribbean, including this one, tend to be male or they are marked with the male gender, and sometimes show the male genitalia under the seat. That's because this seat is actually an anthropomorphic personage. Think of it as a human being on four legs and what

The grimacing face of the stool's half-human, half-animal creature

you sit on is the back of this personage. You sit on top almost like you are sitting over a donkey or a horse. So the chief is mounting this object, which happens to also be a sentient being. They thought of these things as having a *cemi*, that is, a soul.

So the gaping, boggle-eyed figure at the front of our seat, humanoid but not human, is the link to the *cemi*, to the spirit or the ancestor.

One of the chief's key roles was to access the domain of the sacred, the realm of the *cemis*. Seated, or perched, on the *duho*, he sniffed a hallucinogenic snuff made from the charred seeds of the *cohoba* tree. It begins to work within half an hour, and the resulting effects last for two to three hours, creating colourful patterns, strange sounds and voices, leading to full dream-like hallucinations.

One of the early Spanish recorders of the Taino culture, and probably the most sympathetic, was Bartolomé de las Casas. He arrived on

Hispaniola in 1502 and described the rituals in which the *duho* had its role – he calls the chief a Lord:

> They had the custom of convening meetings to determine arduous things, such as mobilizing for war and other things that they thought important for performing their *cohoba* ceremony. The first to start was the Lord, and while he was doing it the rest remained quiet and were absorbed while seated on low and well-carved benches they call *duhos*. Having done his *cohoba* (which is inhaling through the nostrils those powders), he remained for a while with his head turned sideward and with his arms resting on his knees. He would give them an account of his vision, telling them that the *cemi* spoke to him and certified the good or adverse times to come, or that they would have children or that they would die, or that they would have conflict or war with their neighbours.

The Taino world was run by chiefdoms – centres of power whose leaders fought, negotiated and allied among themselves. They generally lived in settlements of a few thousand people, in large circular houses, each accommodating perhaps a dozen families, clustered around a central square. The chief's house, which would also double as the local sacred space or temple where the *duho* was put to work, would stand some distance away.

We don't know who would have made these *duhos*, but certainly the materials were very deliberately chosen. The wood of the *duho* is native to the Caribbean, and it fascinated the Europeans who encountered it. They called it *lignum vitae* – the 'wood of life' – because of its remarkable qualities. Its resin was used to treat a wide range of ailments, from sore throats to syphilis. It is also one of the few woods so dense that it sinks in water. One Spaniard wrote admiringly of the *duhos*: 'they are made of such beautiful, smooth and perfect wood, that nothing else more beautiful was ever made of gold or silver.'

Actually, there is gold on our *duho* as well. The wide gaping mouth and the straining, boggling eyes of the humanoid head at the front are emphasized by being inlaid with gold discs, adding enormously to the frightening power of the object. It was gold like this that made the Spaniards believe that they might find in Hispaniola the treasure they had been hoping for. They were disappointed: gold in the Dominican Republic is found only in the rivers, in small quantities accumulated over many

generations. Like the special wood, this rare, precious gold marked out the *duho* as an exceptional object, something able to mediate between the earthly and the supernatural worlds.

It could also mediate between living leaders. Important visitors would be ceremonially seated on *duhos*, and Christopher Columbus himself received this honour. But of all the futures that could have been foretold by the Taino chiefs sitting on their *duhos*, nothing could have matched what actually happened. The Spaniards brought with them smallpox and typhoid – and even the common cold was catastrophic to the Taino communities, who had no immunity. Those who survived were resettled by the Spanish, so kinship groups were torn apart, and then African slaves were brought in to replace the vanishing local labour force.

How much of the Taino inheritance, or identity, survived? In the Caribbean today this is the subject of much contentious public debate. Professor Gabriel Haslip-Viera, author of *Taino Revival*, considers the claims of those who say they are of Taino descent:

> The Taino people as a pure ethnic group essentially came to an end by 1600, about a hundred years after the arrival of the Spaniards. The small number of survivors essentially mixed in with the Spanish colonists and the Africans that were brought into the Caribbean to replace them as the main labour force. Because primarily the mixture in the Spanish-speaking Caribbean is an African/European mix, that's what has been coming out in the recent studies, the so-called admixture tests that geneticists have been doing in recent years. Those tests have demonstrated overwhelmingly that the peoples of the Spanish-speaking Caribbean, of the Greater Antilles, are people of mixed background and that the mixture is primarily European and African.

The Taino may have been virtually wiped out hundreds of years ago, but we still have echoes of the lost Taino world in a few words familiar to us, words which reflect Taino experience and culture: hurricane, barbecue, hammock, canoe and tobacco. These are, in the Caribbean context, everyday things, but the physical survivals of the Taino world, like the *duho* stool, speak of the universal human need to connect with what is beyond the local, with the world of spirits and gods. This constant human need provides the unifying theme for my next choice of objects.

Meeting the Gods

AD 1200–1500

Across the world different religious systems used objects to bridge the gap between the human and the divine, to aid the dialogue between individuals, communities or even empires and their gods. In the western Christian Church, pilgrims flocked to shrines to see holy relics, including the body parts of saints. In the eastern Orthodox Christian Church, images of Jesus and the saints were venerated in the form of icons. Hindu worshippers in India used temple statues to develop personal relationships with individual Hindu gods. In Huastec Mexico, penitents visited statues of the mother goddess asking for cleansing and forgiveness. In the Pacific, the religion of the Easter Islanders evolved to reflect their deteriorating environment: they stopped venerating statues of their ancestors and instead created a cult centred on the island's diminishing bird population.

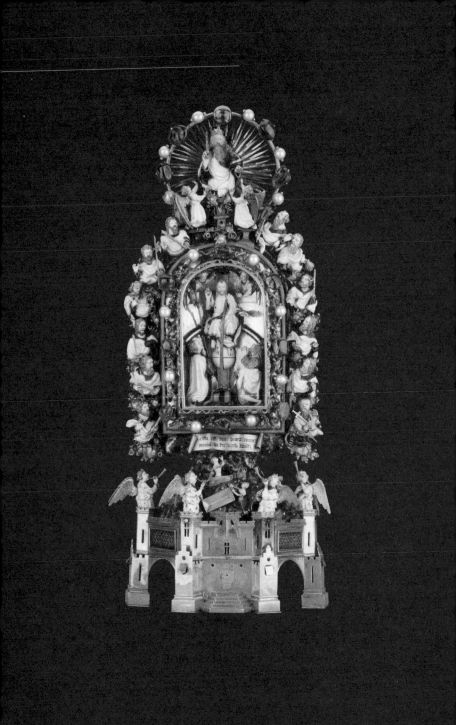

66

Holy Thorn Reliquary

Reliquary made of gold, jewels and enamel, from Paris, France
AD 1350–1400

Around 600 years ago religion and society all round the world were
so closely connected that it would have been impossible for most peo-
ple to say where one ended and the other began. Perhaps that's why
unworldly hopes were so often articulated through worldly wealth –
in temples and precious objects. It is a paradox that we see in extreme
form in the Holy Thorn Reliquary. The reliquary was built to show-
case what was believed to be one of the thorns from the Crown of
Thorns placed on Christ's head before the crucifixion – a relic of the
utmost sanctity.

The crown itself is now held in the cathedral of Notre-Dame in
Paris, but was originally housed in the Sainte-Chapelle, the palace
church of the kings of France built in the 1240s to hold what were
then the most precious objects in Europe – supreme among them,
without question, the Crown of Thorns. For medieval Christendom
the central purpose of life in this world was to secure salvation in the
next. Relics of the saints offered a direct line to heaven, and no relics
were more powerful, or more valuable, than those associated with the
suffering of Christ himself. The amazing church of the Sainte-Chapelle,
created to exhibit the king's collection of relics, cost 40,000 livres to
build; the Crown of Thorns alone cost the king over three times that
amount. It was probably the most valuable thing in Europe. The most
precious gift that the king of France could make was a single thorn
detached from the crown.

One of those detached thorns is the centrepiece of the Holy Thorn
Reliquary, a 20-centimetre (8-inch) high theatre made of solid gold
and encrusted with jewels. In it we watch the terrifying drama of the

end of the world, the day on which we, along with all the other dead, will be raised and will face judgement. This is a drama in which one day every spectator will be a participant. It is in three acts. At the bottom, as angels blow their trumpets at the Earth's imagined corners, graves open on an enamel hillside of vivid green. Four figures – two men, two women, naked in white enamel and still in their coffins – look up and raise their hands in supplication. Far above them, at the very top of the reliquary, is God the Father sitting in judgement, among radiant gold and precious gems. In between is the focus of the whole reliquary.

For medieval Christians the only hope of escaping the torments of hell lay in the redeeming blood that Christ had shed. So, at the very centre of the reliquary is Christ, showing us his wounds, and just below him is one of the long, needle-like thorns that caused that holy blood to flow. *Ista est una spinea corone Domini nostri Ihesu Christi*, reads the enamel label: 'This is a thorn from the crown of our lord Jesus Christ'.

The Roman Catholic Bishop of Leeds, the Right Reverend Arthur Roche, emphasizes its significance:

> It certainly becomes a focus for the reflection on deeper things as to the cost of suffering. Especially when you think that if that thorn is authentic, then it was actually piercing the head of Christ during the course of his suffering and his crucifixion, and in some sense connects our suffering on this earth to his suffering for us; the focus gives us a strength to endure the things that we are presently going through.

It is impossible to exaggerate how powerfully this object would affect any believer kneeling in front of it. The blood drawn by this worthless thorn will save immortal souls, and so nothing earthly can be too precious for it, neither the sapphire it stands on, nor the rock crystal that protects it, nor the rubies and the pearls that frame it. This is a sermon in gold and jewels, an aid to intense contemplation and a source of the deepest comfort.

There is no way now of proving that this was a thorn that actually pierced the head of Christ, but we can say with confidence that it is a type of buckthorn that still grows around Jerusalem. The first mention of the Crown of Thorns as a relic is in Jerusalem around 400. It was

later taken from the Holy Land to Constantinople, the Christian capital of the Eastern Roman Empire, where it was kept and venerated for centuries. But shortly after 1200 the impecunious emperor pawned the crown to the Venetians for a mammoth sum. This shocked his cousin, the crusader king of France, Louis IX, but it also gave him an opportunity. He paid off the emperor's debt and redeemed the relic. So, although Louis as a crusader failed to conquer the Holy Land, the site of Christ's suffering, he did acquire the Crown of Thorns. So great was its power in medieval people's eyes that through it Louis was linked directly to Christ himself. To house his incomparable relic Louis built not just a reliquary, but a whole church. He called it his Holy Chapel – the Sainte-Chapelle.

The stained-glass windows of the Sainte-Chapelle leave us in no doubt that Paris and the kingdom of France are to be permanently transformed by the arrival of the Crown of Thorns. Louis, who became St Louis when canonized in 1297, is shown paired with Solomon; the Sainte-Chapelle is his temple and Paris has become Jerusalem. When the crown arrived, it was described as being on deposit with the king of France until the Day of Judgement, when Christ would return to collect it and the kingdom of France would become the kingdom of Heaven. When this chapel was completed and dedicated in 1248, the archbishop proclaimed: 'Just as the Lord Jesus Christ chose the Holy Land for the display of the mysteries of his redemption, so he has specially chosen our France for the more devoted veneration of the triumph of his Passion.' The Crown of Thorns has played a long and fascinating part in the international politics of piety – it allowed St Louis to claim for France a unique status among the kingdoms of Europe, and every French ruler since St Louis has wanted to follow his example.

The historian Sister Benedicta Ward sees this as something more than a religious quest:

> To have a relic particularly connected with the passion of Christ was the best thing you could have. But there were also relics of the saints, particularly the martyrs. I think they provoked a lot of envy, especially the French collections. The rivalry in England was intense: 'We want to have a better relic than they have because we are a better nation than

they are.' They are subject to all kinds of external influences. Like every-
thing else it can be part of commerce. Politics, commerce, exchange –
this is certainly all round the relics.

In the complex economy of political influence, a thorn from the crown
became the ultimate French royal gift. In the late fourteenth century
one came into the possession of a powerful French prince, Jean, duc de
Berry, and we can be absolutely confident that the reliquary in the
British Museum belonged to him. It has his coat of arms enamelled on
to it, and it also sums up many of his preoccupations: he commis-
sioned some of the greatest religious art of the period and he was a
passionate collector of relics. He had what were claimed to be the mar-
riage ring of the Virgin, a cup used at the wedding at Cana, a fragment
of the Burning Bush and a complete body of one of the holy innocents,
the children murdered by Herod. He was also an enthusiastic builder
of castles, and so, appropriately, the base of our reliquary is a castle
made out of solid gold. This Holy Thorn Reliquary is certainly one of
the supreme achievements of medieval European metalwork, but sadly
there is no way of knowing if it was the greatest artefact in Jean de
Berry's collection. The bulk of his goldsmiths' work was broken up
and melted down within months of his death, when the English occu-
pied Paris after the Battle of Agincourt in 1415. The survival of this
reliquary means that he must have given it away before he died.

We are not sure who he gave it to, but by 1544 it was in the treasury
of the Habsburg emperors in Vienna, and from there its secularization
begins – the gold, enamel and jewels becoming far more valuable and
interesting than the humble thorn that they house. In the 1860s it was
sent for restoration to a dishonest antique dealer, who, instead of car-
rying out the repairs, created a forgery which he sent back in its place
to the imperial treasury, keeping the original himself. Eventually the
genuine reliquary was bought by the head of the Vienna branch of the
Rothschild bank, and donated to the British Museum by Baron Ferdi-
nand de Rothschild in 1898 as part of the Waddesdon Bequest, which
now occupies the whole of a small gallery at the Museum.

You could almost say the Holy Thorn Reliquary is itself a single-
object museum, if an incomparably lavish one – one exhibit mounted
on sapphire, displayed behind rock crystal and labelled on enamel.

Solomon and the Queen of Sheba in the
central diamond of a window in the
Sainte-Chapelle

But its purpose is the same as that of any museum: to provide a worthy setting for a great thing. We can't know exactly how visitors approach objects on display in the British Museum, but many still use the Holy Thorn Reliquary for its original devotional purpose of contemplation and prayer.

The veneration of the Crown of Thorns itself remains very much alive. Napoleon decided that it should be housed permanently in Notre-Dame, and there, on the first Friday of every month, the whole Crown of Thorns, from which our one thorn was taken more than 600 years ago, is still shown to crowds of faithful worshippers.

67

Icon of the Triumph
of Orthodoxy

Tempera and gold leaf on a wooden panel,
from Constantinople (Istanbul), Turkey
AD 1350–1400

W hat does a great empire do when faced with imminent invasion
and destruction? It can rearm at home and seek allies abroad; but more
cunningly it can revisit its history to forge a myth that will unite the
people and carry them through to victory, a myth that will demonstrate
to everyone that their country has been specially chosen by history to
uphold justice and righteousness. It is what the French did in 1914 and
the British in 1940. In such circumstances, history reimagined can be a
very powerful weapon. When the Christian Byzantine Empire faced
obliteration at the hands of the Ottoman Turks around 1400, it too
turned to its past, found an event that proclaimed its unique and
divinely ordained purpose, and turned it into a national myth. The Byz-
antines promoted their myth in the most public medium at their dis-
posal: they established a new religious feast day and commissioned a
religious icon to mark it.

For the Byzantine Empire it had never been more important to seek
divine help. The successor to the Roman Empire, the defender of
Orthodox Christianity, and for centuries the superpower of the Mid-
dle East, the empire had shrunk to a shadow of its former greatness.
By 1370 it was no more than a minor state that extended barely
beyond the walls of Constantinople, modern Istanbul. All its prov-
inces had been lost, most of them conquered by the Muslim Ottoman
Turks who now threatened the city on every side; even the survival of
Orthodox Christianity itself seemed to be in question.

There was little hope of military help from further away. Two
brave attempts from western Europe to send reinforcements had been

catastrophically defeated in the Balkans. On several occasions the emperor himself travelled from Constantinople to the kingdoms of the West – even as far as London – to plead for money and soldiers, but to no avail. By 1370 it was clear that there was going to be no earthly salvation. Only God could help in a situation so desperate. These were the bleak circumstances in which the icon of the Triumph of Orthodoxy was painted. It shows the world of the Byzantine Empire not as it actually was, but as it needed to be if God was going to protect it.

'Icon' is simply the Greek word for picture, and this picture is about 40 centimetres (16 inches) high, almost exactly the same shape as the screen of a laptop computer. It is painted on a wooden panel, the figures in black and red, the background shining gold. In the centre, at the top, we see two angels holding up a picture for veneration – the most famous of all Orthodox icons and one particularly connected to Constantinople. Known as the Hodegetria, it shows the Virgin Mary with the Christ Child in her arms. The Hodegetria is being venerated by a host of saints, by the head of the Orthodox Church – the Patriarch – and by the imperial family. Between them, they represent all Constantinople, temporal and spiritual. This icon is a picture about the use of a picture, and it is a celebration of the central role that icons play in the Orthodox Church.

This is how Diarmaid MacCulloch, Professor of the History of the Church at Oxford University, describes the function of an icon:

> The icon is like a pair of spectacles which you put on to see heaven. You're drawn through this picture into heaven because Orthodox Christianity believes very strongly that you and I can meet the godhead, that we can almost become like gods. It's that extraordinary, frightening statement that Western Christianity is very shy of.

The painting of icons was primarily a spiritual rather than an artistic activity, and it was governed by strict guidelines. The particular artist is not important: the key is motivation and methodology. This is an aspect of icons that fascinates the American artist Bill Viola, who quotes from a medieval document:

> This is a short text from the Middle Ages called *The Rules for the Icon Painter*.

Number one, before starting work make the sign of the cross, pray in silence and pardon your enemies. Two, work with care on every detail of your icon as if you were working in front of the Lord himself. Three, during work, pray in order ... Nine, never forget the joy of spreading icons in the world, the joy of the work of icon painting, the joy of giving the Saint the possibility to shine through his icon, the joy of being in union with a Saint whose face you are painting.

What exactly is the Triumph of Orthodoxy as shown in our painting? To find out we have to go back another 700 years. Given the centrality of icons in Orthodox worship and the fervour with which they are described, it comes as a shock to discover that for 150 years they were not only forbidden in Orthodox churches but actively sought out and smashed. Around the year 700, the Byzantine Empire nearly succumbed to the armies of a new faith, Islam. In striking distinction to Christianity, Islam forbade the use of religious images – and it was clearly an alarmingly successful faith. Had Christianity taken a wrong turn? Was it breaking the Second Commandment – the one that forbids the making of graven images? Was the state church on the wrong track? Was that why the military campaigns were going so badly? Suddenly, the use of images in church seemed to raise a huge and fundamental question, as Diarmaid MacCulloch explains:

> Can you picture God or can't you? The huge dispute in the Byzantine Empire is one of those classic instances where that simple question is debated and becomes an issue which is actually very political. It split the empire down the middle. The Byzantine Empire met an extraordinary trauma, Islam, which came from nowhere and smashed the empire into smithereens. Naturally the Byzantines wondered 'What's this all about? Why is God favouring these Muslims who have come from nowhere?' The one big thing that struck them about Islam was that there were no pictures of God and that this might be the answer. They thought that if you turned Christianity away from having pictures of God then the Byzantine Empire might get God's favour back. That seems to be one of the motives in attacking images, icons, within the Byzantine Empire.

So a great wave of iconoclastic violence swept the Orthodox Church in the years following 700. The theological debates went on for well over

a century and were very complex. But throughout, ordinary people remained on the whole firmly attached to their icons, and eventually, thanks in part to support from the women of the imperial family, the veneration of icons was restored by the empress Theodora in 843. This is the event known as the Triumph of Orthodoxy, which re-established such veneration as the touchstone of the true Orthodox faith, the central focus of Byzantine devotion, and a vital ingredient in the survival and the flourishing of the empire. And indeed for another 500 years the empire was able to keep the Islamic threat at bay. So when that threat returned even stronger than before, it was natural for the leaders of Constantinople to encourage people to look back to the great moment of 843 when the faith had been reordered and their empire restored and to draw comfort from the past as they faced a frightening future. In 1370 the feast of the Triumph of Orthodoxy was established, and some time after that our icon was painted.

It shows us the empress Theodora and that great restoration of 843. She stands beside the Hodegetria image of the Virgin and Child, and with her is her child, the boy emperor Michael, both of them wearing elaborate imperial crowns. Below them, in the bottom of the picture, stands a line of eleven saints and martyrs, crowded together as if they're posing for a group photograph, some of them holding icons in their hands like prizes that they have just been awarded. Any viewer around 1400 would have known at once that all these saints had suffered in the great struggle to re-establish the use of icons. All of them are neatly labelled with their names written in red paint. My favourite is the one on the far left. She is St Theodosia, the only woman in the group, a feisty nun who was put to death essentially for killing a policeman. She saw an imperial guard climbing a ladder to remove an image of Christ from the entrance to the palace: she pushed away the ladder and he fell to his death. Naturally, she was promptly executed.

What the viewer around 1400 might not have realized is that some of these saints and martyrs were not even born in 843. The icon of the Triumph of Orthodoxy shows a whole society revisiting its past through a work of art, begging God to secure its future. It is a powerful and poignant image. The artist Bill Viola says this:

It is an extraordinary and innovative picture, which represents a really ingenious way of uniting the temporal world of the past, present and future with the eternal and the divine. I feel it's almost a post-modern image, using the idea of the frame within the frame. There are icons within the icons, images within the image.

The Triumph of Orthodoxy – celebrated in feast and icon – did not secure the survival of the Byzantine Empire. In 1453 the city fell to the Turks, Constantinople became the capital of the Ottoman Empire, and the great cathedral of Hagia Sophia became a mosque. The world's balance of power changed. But although the Byzantine state had foundered, the Orthodox Church survived. The faith we see proclaimed in our painting was strong enough to ensure that even under Muslim rule the traditions of Orthodox Christianity, with the veneration of icons as its defining feature, endured. In one sense we could argue that this icon achieved exactly what was intended. Although the Byzantine Empire fell, Orthodoxy survived, and every year on the first Sunday in Lent the Orthodox Church throughout the world celebrates the event shown in our icon: the Triumph of Orthodoxy, a ceremony in which the image and the music of the human voice come together in an overwhelming expression of spiritual yearning.

68

Shiva and Parvati Sculpture

Stone statue, from Orissa, India
AD 1100–1300

There are many surprises about working in the British Museum, and one of them is that we occasionally find offerings of flowers or fruit reverently placed in front of the Hindu sculptures. It is another touching demonstration that religious objects don't need to lose their sacred dimension when they move into a secular museum – and a reminder that in the census of 2001 nearly 5 per cent of the population of England and Wales stated that their family origins were in the Indian subcontinent.

This is all part of a long-shared history that has been sometimes violent and always intense. For centuries the British have been fascinated by the cultures of India, and have struggled with greater or lesser success to understand them. For the eighteenth-century European, the most intriguing mystery of India was Hinduism, a faith that confusingly seemed to advocate both world-denying asceticism and riotous physical pleasure. Why were some Hindu temples, unlike English cathedrals, richly decorated with erotic sculpture? Where the Christian God endured unbearable suffering, Hindu gods seemed to rejoice in sex. Around 1800, one man, Charles Stuart, decided to explain to the British that Hinduism should be seriously studied and greatly admired. As part of this campaign, he collected and displayed pieces of ancient Indian temple sculpture; one of those pieces is the object of this chapter.

It comes from Orissa, a densely populated rice-producing state in north-east India, on the Bay of Bengal. In around 1300 it was a prosperous, sophisticated Hindu kingdom, which built thousands of magnificent temples. This was the great period of Orissan religious architecture, and the buildings that were most admired were the ones

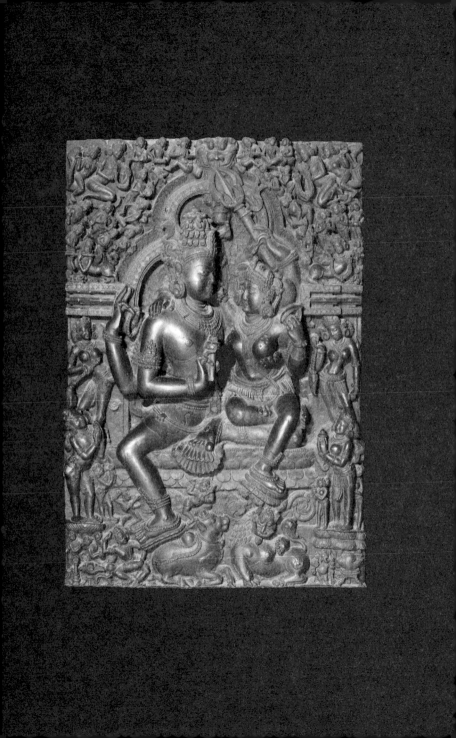

that had the most extravagant ornamentation. Most of these temples were dedicated to the god Shiva. For the people of Orissa, Shiva – one of the three central deities of Hinduism, the god of paradoxes, the god who forever creates and destroys – was the lord of their land. In Shiva, all opposites are reconciled.

This sculpture comes from one of the many Orissan Shiva temples. It's a stone slab about 2 metres (6 feet 6 inches) high by 1 metre wide, and although it may originally have been brightly coloured it is now a deep gleaming black. It would hardly be possible to carve more decoration on to it. Dozens of tiny figures swarm around the edges, and in the middle, on a much larger scale, is Shiva himself – we know it is Shiva because he is carrying his trademark trident and rests one foot on the back of the sacred bull that he often rides. The sculptor has carved the body of Shiva in very full relief, so as visitors approach it they have a growing sense of a god who is physically present. The sculpture is designed to bring the viewer close to the god, to allow them in a sense to converse with Shiva. The Hindu academic and cleric Shaunaka Rishi Das explains:

> The physical manifestation of the image is considered to be a great aid in focusing the mind, and in gaining what they call *darshan*, or the presence of god. So you practise the presence of god in your life by going to the temple, you see this image that is the presence, you bow down in front of the image, you offer food or incense and so on, you say your prayers, or you just enjoy the presence of god.
>
> If you brought god into your home, for instance, then if god is right there in your living room you don't have big blazing rows, you don't do things that you wouldn't do in the presence of god – which is quite a challenge to our false ego. Devotees of the deity would be developing their real ego – that of being an eternal servant of god.

So although our sculpture was certainly made for a temple, a very public place, it is very much about a continuing one-to-one contact with god. The experience of encountering this sculpture would be only part of a relationship with the divine, a form of conversation that you might begin in the temple and then carry on at home. Looking at the sculpture is simply the starting point for a daily dialogue that will ultimately shape every part of your existence.

But, in our sculpture, Shiva is not alone: nestling in his lap, and lovingly encircled by one of his four arms, is his wife Parvati. Both are similarly dressed in decorated loin cloths, with naked torsos and wearing heavy necklaces and ornamented headdresses. Husband and wife are turned towards each other and look lovingly into each other's eyes, so engrossed in each other that they are oblivious to their swirling entourage. Their mutual devotion is mirrored by the animals at their feet, Shiva's bull echoing his master's doting gaze, and Parvati's lion smiling bashfully in response. There is such a strong erotic charge in this carving that you might well imagine that Shiva and Parvati are about to move into a fuller, closer embrace. But no – or at least not yet – for the couple are expecting guests or, more precisely, worshippers. Our sculpture would probably have been at the door of a temple, welcoming families as they approached, and offerings would have been made not just to Shiva but also to Parvati, to the pair of them as a divine couple.

This smiling sensuous image doesn't just show us a model couple that any husband and wife might emulate: the sculpture of Shiva and Parvati is a meditation on the very nature of God, for they are as the same person manifest in two different forms. Shaunaka Rishi Das explains:

> God is male and female. The thinking behind that is that God cannot be something less than we are. God cannot be not-female, because there are females here, so God has to have a female aspect.
>
> Parvati is a very good wife who doesn't like people making fun of her husband. So worshippers have to be careful always to give respect to Parvati first and then approach Shiva. That's considered to be the respectable thing to do and the safe thing to do. But both of them are very munificent. You don't have to do much to please them, and they give to you very liberally.

It is the presence of Parvati, the female aspect of God, which is perhaps most disconcerting to a non-Hindu viewer, especially to one raised in monotheism. This is a very particular view of the divine. A monotheistic god is, by definition, alone – cannot engage with other gods, cannot be part of a dynamic sexual relationship – and in Judaism, Christianity and Islam that monotheistic god is not just single but has, by long tradition, been male. In the Hindu tradition, by con-

trast, Shiva needs Parvati. Karen Armstrong, historian of religion, explains:

> In the monotheisms, particularly in Christianity, we've found questions of sex and gender difficult. Some of the faiths that start out with a positive view of women, like Christianity and also Islam, get hijacked a few generations after the foundation and dragged back to the old patriarchy. I think there's a big difference, however, in the way people view sexuality. When you see sexuality as a divine attribute, as a way in which one can apprehend the divine, that must have an effect – you see it in the Hindu marriage service, where this is a divine act. Questions of gender and sexuality have always been the Achilles heel of Christianity, and that shows that there's a sort of failure of integration here, a failure to integrate a basic fact of life.

It was Hinduism's generous capacity to embrace all aspects of life, not least sexuality, that beguiled the man who collected our sculpture – Charles Stuart, an officer in the East India Company, who so vigorously embraced the values and virtues of Hinduism that he was nicknamed 'Hindoo Stuart' by his shocked compatriots. Stuart admired almost every aspect of Indian life. He studied Indian languages and religions and he even urged English women to wear 'sensible and sensual' Indian saris. The memsahibs declined.

As part of his study of Indian cultures, Stuart put together a huge collection of sculpture – our relief was part of it – designed to include examples of each deity as a visual encyclopedia of religions and customs. His collection was displayed to the public at his home in Calcutta. It was one of the first serious attempts to present Indian culture in a systematic way to a European audience. Far from finding Hinduism disconcerting, Stuart saw in it an admirable framework for living that was at least the moral equal of Christianity, and in 1808 he published his views in a pamphlet, *Vindication of the Hindoos*:

> Wherever I look around me, in the vast ocean of Hindu mythology, I discover Piety ... Morality ... and as far as I can rely on my judgement, it appears the most complete and ample system of Moral Allegory the world has ever produced.

Stuart spoke out strongly against missionary attempts to convert

Hindus to Christianity. He thought it simply impertinent, and his intention always was that his collection should be seen in England to persuade the British to honour this great world religion. Stuart would, I'm sure, be pleased that after 200 years his sculpture of Shiva and Parvati, made around 1300 to welcome worshippers to a temple in Orissa, is still on show to the public – and he'd be delighted that many of those who now come to see it are British Hindus.

Although the stories of Hinduism are increasingly taught in British schools, some of us not brought up as Hindus struggle to master the complicated theology that embraces many deities in many manifestations. Yet it would be hard to stand in front of this sculpture and not grasp immediately one of the central insights of this great religious tradition: that God may perhaps best be conceived not as a single isolated spirit but as a joyous loving couple, and that physical love is not evidence of fallen humanity but an essential part of the divine.

69

Sculpture of Huastec Goddess

Stone statue, from Mexico

AD 900–1521

There is an old adage that an act of translation is always an act of betrayal. When we want to translate complex ideas from a lost culture with no written language, the situation is no better: we usually need to work our way through layers of later interpretation by people with quite different ways of thinking, and with no words designed to express alien thoughts.

To get anywhere near an original understanding of this object, we have to go through a filter of two later cultures with two different languages, and even then we're not quite sure where we stand. It is an object that has always intrigued me, and I am less and less sure that I understand it. It is the statue of a woman, from what is now northern Mexico, but which around 1400 was the land of the Huastec people.

The story of the Aztecs and how the great Aztec Empire was conquered by the Spaniards in the 1520s is widely known. We hear much less, though, about the people that the Aztecs themselves had conquered to build their empire. One of the most interesting peoples subjugated by the Aztecs were their northern neighbours, the Huastecs. We know that the Huastecs lived on Mexico's northern Gulf coast, in the area around modern Veracruz, and that between the tenth and fifteenth centuries they had a flourishing city culture. But around 1400 this prosperous world was overwhelmed by the aggressive Aztec state to the south, and the Huastec ruling class was effectively liquidated. There is very little now that would enable us to reconstruct the world and the ideas of the Huastecs: there is no trace of any Huastec writing, and the only written evidence we have are Aztec accounts of the people they conquered, as transmitted through the Spanish after they

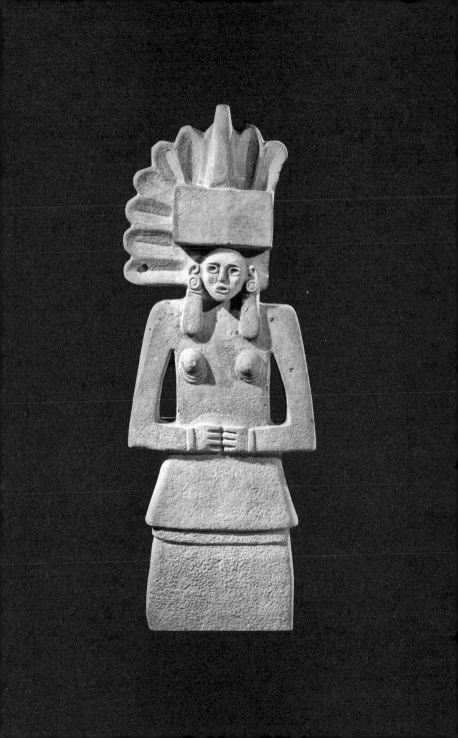

in turn had defeated the Aztecs. So if we want the Huastec to speak to us directly, we have to go to the objects they left behind. These are their only documents, and among the most eloquent of them are groups of highly distinctive stone statues.

This statue of a Huastec woman in the Mexico gallery at the British Museum presides over a group of companions – three sandstone sisters, all carved to the same design. Our statue is about 1.5 metres (5 feet) high, so more or less life-size, but she's not at all lifelike. She looks as though she's been shaped by a giant pastry cutter – the contours of the body are straight lines, the surface is flat – you might almost imagine she is a huge gingerbread woman. When you step to the side, you can see that she is carved out of a very thin piece of sandstone. Edge-on, she is less than 10 centimetres (4 inches) thick. She folds her hands over her stomach and her arms are held out from her sides, making two triangular spaces. In fact, she is really just a series of geometric shapes. Her breasts are perfect hemispheres, and below the waist she wears a rectangular skirt that falls flat and undecorated to the plinth. This is a lady of straight lines and hard edges, clearly not somebody you would choose to mess with. But she does have two humanizing aspects: her small head is unexpectedly animated – she seems to be looking up and to the side towards something – and her lips are open, as though she may even be speaking. And below her breasts are the only surface details on the entire body – curved lines of sagging stone flesh, signs certainly of maturity, possibly of maternity, which lead many people to believe that she may be a mother goddess.

We know virtually nothing about the Huastec mother goddess, but we do know that for the conquering Aztecs she was the same being as their own goddess Tlazolteotl. You might imagine that all mother goddesses have a pretty straightforward job description – ensuring fertility and seeing everybody safely into adulthood – but, as the cultural historian Marina Warner points out, it is often much more complicated:

> It's important to see that all mother goddesses are not the same. A lot of times the mother goddesses are related to the spring, to vegetation, to that kind of fertility – not just human, animal fertility. Then in terms of fertility you enter the area of extreme danger, because of the great threat of death to either mothers or children in childbirth. That's been a constant in

human history until fairly recently. There is also a very strong sense that this contact with the danger of perpetuating life will actually brush you very close to pollution. In Christianity that's very strong. Augustine said, 'We are born between faeces and urine,' and he was very worried about the animal aspect of human parturition. Mother goddesses on the whole have to help human beings confront this anxiety – there's a danger of pollution, that death and birth can be mixed up together.

Childbirth and infancy are always messy affairs. To achieve even a minimum level of hygiene means devising systems for coping with filth – and mother goddesses have to deal with filth on a cosmic scale.

So it isn't at all surprising that the name Tlazolteotl literally means, in the Aztec language, 'filth goddess'. She was a figure of fertility, vegetation and renewal, the ultimate green goddess, transforming organic waste and excrement into healthy new life, guaranteeing the great cycle of natural regeneration. This is a goddess who gets her hands dirty, and, according to Aztec myth, not just her hands: another of her names is 'eater of filth' – she consumes dirt and purifies it. So, if we can read our goddess in the same light as the Aztecs, this is, perhaps disconcertingly, why her mouth is open and her eyes are rolling upwards.

Just as Tlazolteotl was held to consume actual filth and thus restore life and goodness, so she did the same in moral terms. She was, the Aztecs told the Spaniards, the goddess who received confessions of sexual sin:

> One recited before her all vanities; one spread before her all unclean works, however ugly, however grave ... Indeed all was exposed, told before her.

To the Spanish friar Bernardino de Sahagún, this seemed an uncanny parallel to Christian views on sexual sin and confession. We have to wonder how far the Spaniards are seeing the Aztec, and through them the Huastec, goddesses in terms of their own traditions, especially of Mary. But the Christian tradition had removed Mary from any connection with sex, and the Spanish were disturbed by Tlazolteotl's inherent engagement with what they saw as filth. Sahagún deplores the fact that she is also 'mistress of lust and debauchery', and the Aztecs in their turn despised their Huastec subjects as hopelessly licentious.

It is hard to come to any view about our statue's meaning, and some scholars even question whether she is a goddess at all. What more can the evidence of the statue tell us?

Her most striking feature is a huge, fan-shaped headdress, about ten times the size of her head. Although part of it is broken off, you can see that, like the rest of her, it is conceived as an assemblage of geometric shapes. In the middle, resting directly on her head, is a plain oblong slab; sitting on that, an unadorned cone. Both are framed in a great semicircle of what look like stone ostrich feathers. They may be feathers or perhaps barkwood, but the original paint that would have told us has long gone. A headdress like this must have been a totally unambiguous statement of who this figure was. Maddeningly, it is a statement that we cannot now read with any confidence.

The Huastec expert Kim Richter gives us her more secular understanding of the statue:

> I've argued that the sculptures represent the Huastec elite, who dressed up with these fancy costume elements that were actually common within the international elite of Meso-America. I've linked the Huastec headdresses to similar types of headdresses found in other regions.
>
> I think it's the fashion of the day but also so much more ... it's not unlike, for example, a Gucci bag today. You see it in wealthy people all over the world – it's a symbol of status and it symbolizes the connections between these different regions of the globe today, and these headdresses had a very similar function. They showed to their own people that they were part of this larger Meso-American culture.

Kim Richter may be right, and these statues may simply be representations of the local elite, but I find it hard to believe that these geometric naked female statues are aristocratic family likenesses, even of the most ritualized sort. We know that groups of them stood high up above their communities, on artificial mounds where people could congregate for ceremonies and processions, but it is hard to be certain about anything in the face of our statue. And, sadly, there is nobody now who can tell us. Kim Richter says:

> I don't think the sculptures really have much meaning to local people there today. So when I was in the field and I spoke to indigenous people,

they were interested and curious, and they wanted to learn more, but they didn't know anything about these sculptures. I heard a report that in one of the sites the farmers would shoot at sculptures and use them as target practice.

This object reveals more about what we don't know than what we do. Our statue's physical presence speaks to us with peremptory directness, but of all the objects in our history, she is perhaps the hardest to read confidently through the filters of the historical record. With the next object, I will also try to reconstruct a lost spiritual world, but there is much more evidence to go on. It involves investigating one of the last places on earth to be settled by human beings – Easter Island – with some of the most instantly recognizable sculptures in the world.

70

Hoa Hakananai'a
Easter Island Statue

Stone statue, from Easter Island (Rapa Nui), Chile
AD 1000–1200

Rapa Nui – Easter Island – is the most remote inhabited island, not just in the Pacific, but in the world. It's about half the size of the Isle of Wight, approximately 2,000 kilometres (1,200 miles) from the nearest inhabited island and 3,200 kilometres (2,000 miles) from the nearest landmass. Not surprisingly, it took human beings a long time to get there. The people of the southern Pacific Ocean, the Polynesians, were the supreme open ocean voyagers in the history of the world, and their ability to move in double-hulled canoes over the vast expanses of the Pacific is one of the greatest achievements of humanity. They settled both Hawaii and New Zealand, and between 700 and 900 they got to Rapa Nui, bringing to an end one immense chapter of human history – for Easter Island was probably one of the last places on Earth to be permanently inhabited.

It was another thousand years before European sailors matched the Polynesian feats of navigation, and when they reached Rapa Nui on Easter Day 1722 they were astonished to find a large population already established. Even more astonishing were the objects that the inhabitants had made. The great monoliths of Easter Island are like nothing else in the Pacific, or indeed anywhere, and they've become some of the most famous sculptures in the world. This is one of them. He's called Hoa Hakananai'a – the name has been roughly translated as 'hidden friend'. He came to London in 1869, and he has been one of the most admired inhabitants of the British Museum ever since.

It is a constant of human history that societies devote huge amounts of time and resource to ensuring that the gods are on their side, but few societies have ever done it on such a heroic scale as those of Rapa

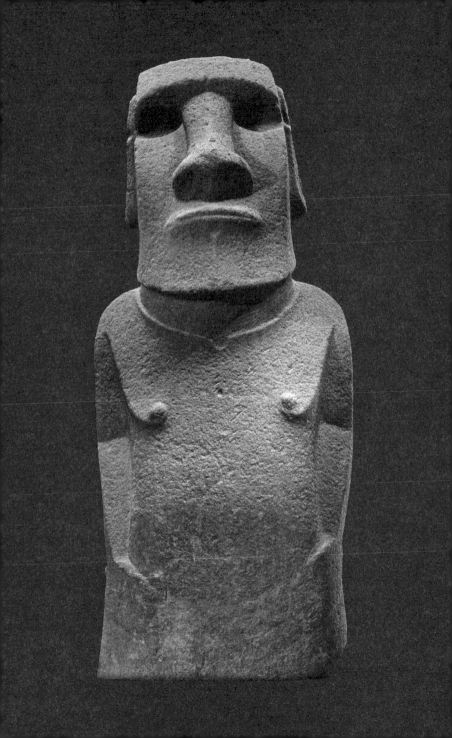

Nui. The population was probably never any more than about 15,000, but in a few hundred years the inhabitants of this tiny island quarried, carved and erected more than a thousand massive stone sculptures. Hoa Hakananai'a was one of them. He was probably made around the year 1200, and was almost certainly intended to house an ancestral spirit: he is a stone being, which an ancestor may from time to time visit and inhabit.

Standing below him you are immediately conscious of the solid basalt rock he is made out of. Although we see him only from the waist up, he is about 2.7 metres (9 feet) high and dominates whatever gallery he's in. When you're working hard stone like this and have only stone tools to chip away with, you can't do detail, so everything about this giant had to be big – and bold. The heavy rectangular head is huge, almost as wide as the torso below. The overhanging brow is one straight line running across the whole width of the head. Below it are cavernous eye sockets and a straight nose with flaring nostrils. The square jaw juts assertively forward and the lips are closed in a strong frowning pout. In comparison to the head, the torso is only sketched in. The arms are barely modelled at all and the hands disappear into the stone block of a swelling paunch. The only details on the body are the prominent nipples.

Hoa Hakananai'a is a rare combination of physical mass and evocative potency. For the sculptor Sir Anthony Caro, this is the essence of sculpture:

> I see sculpture, the setting up of a stone, as a basic human activity. You're investing that stone with some sort of emotive power, some sort of presence. That way of making a sculpture is a religious activity. What the Easter Island sculpture does is give just the essence of a person. Every sculptor since Rodin has looked to primitive sculpture, because all the unnecessary elements are removed. Anything that is left in is what stresses the power of the stone. We are down to the essence; its size, its simplicity, its monumentality and its placement – those are all things that matter.

The statues were placed on specially built platforms ranged along the coastline – a sacred geography reflecting the tribal divisions of Rapa Nui. Moving these statues would have taken days and a large

workforce. Hoa Hakananai'a would have stood on his platform with his giant stone companions in a formidable line, their backs to the sea, keeping watch over the island. These uncompromising ancestor figures must have made a haunting – and daunting – vision to any potential invaders and a suitably imposing welcome party for any visiting dignitaries. They have also been credited with a whole range of miracle-working powers. The anthropologist and art historian Professor Steven Hooper explains:

> It was a way of human beings who were alive relating to and exchanging with their ancestors, who have very great influence on human life. Ancestors can affect fertility, prosperity, abundance. They are colossal. This one in the British Museum is relatively small – there is one unfinished in a quarry in Easter Island that is over 70 feet tall – how they ever would have erected it goodness only knows! It does put me in mind of medieval cathedral-building in Europe or in Britain, where you have extraordinary constructions involving enormous amounts of time and labour and skill ... it's almost as if these sculptures scattered around the slopes of Easter Island, large sculptures, are equivalent to these medieval churches. You don't actually need them all, and they are sending messages not only about piety, but also about social and political competition.

So there was a populous island, effectively organized, practising religion in a carefully structured, competitive way. And then, it seems quite suddenly around 1600, the monolith-making stopped. No one has a very clear idea why. Certainly all islands like this are fragile ecosystems, and this one was being pushed beyond what was comfortably sustainable. The islanders had gradually cut down most of the trees and had hunted land birds almost to extinction. The sea birds, above all the sooty terns, moved away to nest on safer offshore rocks and islands. It must have seemed as if the favour of the gods was being withdrawn.

Where the people of Constantinople confronted crisis by looking back to an old religious practice, the inhabitants of Rapa Nui invented a new one, turning to a ritual that, not surprisingly, was all about scarce resources. The Birdman cult, as it has been called, focused on an annual competition to collect the first egg of the migrating sooty tern from a neighbouring islet. The man who pulled off the feat of bringing

The back of Hoa Hakananai'a,
with symbols of the birdman
cult in low relief

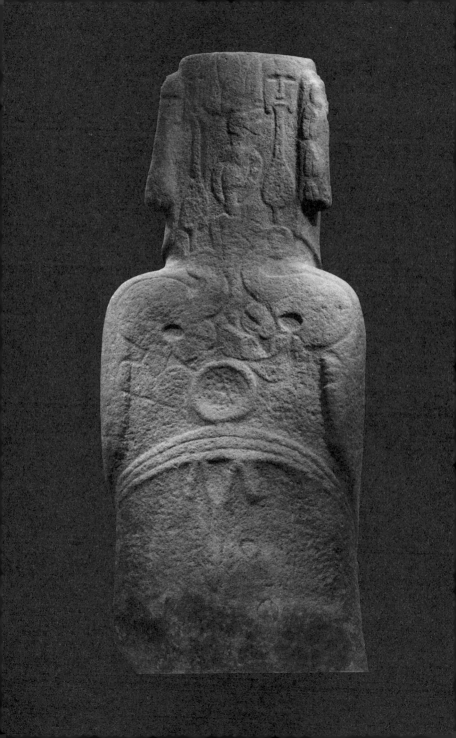

an egg back, unbroken, through the sea and over cliffs, would for a year become the Birdman. Invested with sacred power, he would live in isolation, grow his nails like bird talons and wield a ceremonial paddle as a symbol of prestige. Surprisingly, we can tell this story, and the change in religious practice, through our sculpture. Rather than being abandoned along with the other monoliths, Hoa Hakananai'a was incorporated into the Birdman cult, was moved, placed in a hut and now entered a new phase of his life.

All the key elements of this later ritual are present in our statue, carved on his back. They must have been added several hundred years after the statue was first made, and the carving style here could hardly be more different from that of the front. It is in low relief, the scale is small, and the sculptor has tried to accommodate a large range of disparate details. Each shoulder blade has been turned into a symbol of the Birdman; two frigate birds with human arms and feet face each other, their beaks touching at the back of the statue's neck. On the back of the statue's head are two stylized paddles, each with what looks like a miniature version of our statue's face at the upper end, and between the paddles is a standing bird which is thought to be a young sooty tern, whose eggs were so central to the Birdman ritual. This carving on the back of the statue could never have been very legible as sculpture. We know it was painted in bright colours, so that this cluster of potent symbols could be easily recognized and understood. Now, without its colour, the carving looks to my eyes feeble, fussy, diminished – a confused and timid postscript to the confident vigour of the front.

It is seldom that you see ecological change recorded in stone. There is something poignant in this dialogue between the two sides of Hoa Hakananai'a, a sculpted lesson that no way of living or thinking can endure forever. His face speaks of the hope we all have of unchanging certainty; his back of the shifting expediencies that have always been the reality of life. He is Everyman.

And Everyman is usually a survivor. The Easter Islanders seem to have adapted reasonably well to their changing ecological circumstances, as Polynesians have always had to. But in the nineteenth century there were challenges of a completely different order – from across the sea came slavery, disease and Christianity. When the British ship HMS *Topaze* arrived in 1868, there were only a few hundred

people left on the island. The chiefs, by now baptized, presented Hoa Hakananai'a to the officers of the *Topaze*. We don't know why they wanted him to leave the island, but perhaps the old ancestral sculpture was seen as a threat to the new Christian faith. A troop of islanders moved him to the ship, and he was taken to England to be presented to Queen Victoria, and then sent to be housed at the British Museum. He faces south-east, looking towards Rapa Nui, 14,000 kilometres (8,500 miles) away.

Hoa Hakananai'a now stands in the gallery devoted to Living and Dying, surrounded by objects that show how other societies in the Pacific and the Americas have addressed the predicaments that confront humanity everywhere. He is a supremely powerful statement of the fact that all societies keep looking for new ways to make sense of their changing world and to ensure that they survive in it. In 1400, none of the cultures shown in this gallery were known to Europeans. But this was about to change. In the rest of this history, we will be looking at the way in which these many different worlds – even islands as remote as Rapa Nui – became, whether they wanted to or not, integral parts of one global system. It's a history that is in many ways familiar, but, as always, objects have the power to engage, to surprise and to enlighten.

The Threshold of the Modern World

AD 1375–1550

For thousands of years objects had travelled huge distances over land and sea. In spite of these connections, the world before 1500 was essentially still a series of networks. Nobody could take a global view because nobody had ever travelled round the world. These chapters are about the great empires of the world at that last pre-modern moment, when it was still unthinkable for one person to visit them all, and when even superpowers dominated only their regions.

71

Tughra of Suleiman the Magnificent

Calligraphy, from Constantinople (Istanbul), Turkey
AD 1520–1566

Between about 1350 and 1550 great swathes of the world were occupied by the superpowers of their day – from the Inca in South America to the Ming in China, the Timurids in central Asia and the vigorous Ottoman Empire, which spanned three continents and ran from Algiers to the Caspian, from Budapest to Mecca. Two of these empires lasted for centuries; the other two collapsed within a couple of generations. The ones that lasted endured not only by the sword but also by the pen – that is, they had flourishing and successful bureaucracies which could sustain them through tough times and incompetent leaders. The paper tiger, paradoxically, is the one that lasts. The enduring power we are looking at in this chapter is the great Islamic Ottoman Empire, which by 1500 had conquered Constantinople and was moving, with the confidence born of secure borders and expanding strength, from being a military power to an administrative one. In the modern world, as the Ottomans demonstrated, paper is power.

And what a piece of paper this is. It is a very beautiful painted drawing – it is a badge of state, a stamp of authority and a work of the highest art. It is called a tughra. This tughra has been drawn on heavy paper in bold lines of blue cobalt ink, enclosing what looks like a tiny meadow of colourful, golden flowers. On the left there is a sweeping, decorated loop, a generous oval, then in the centre three strong upright lines, and a curving decorated tail to the right. It's an elegant, elaborate monogram cut from the top of an official document, and the whole design spells the title of the sultan whose authority it represents. The words are: 'Suleiman, son of Selim Khan, ever victorious'. This simple Arabic phrase, elaborated into an emblem made out of lavish and opulent materials, speaks clearly of

458

great wealth; it is no surprise that this ever-victorious sultan, the contemporary of Henry VIII and the Holy Roman Emperor Charles V, was later called by Europeans Suleiman the Magnificent.

Suleiman inherited an already expanding empire when he came to power in 1520. He went on to consolidate and extend his territory with almost unstoppable energy. Within a few years his armies had shattered the kingdom of Hungary, taken the Greek island of Rhodes, secured Tunis and fought the Portuguese for control of the Red Sea. Italy was now in the front-line. Suleiman seemed to envisage a restoration of the Roman Empire under Muslim rule – the dream of recovering an ancient Roman glory, which fired the Renaissance in western Europe, was also a spur to the greatest Ottoman achievements. The two hostile worlds shared the same impossible dream. When a Venetian ambassador expressed the hope of one day welcoming the sultan as a visitor to his city, Suleiman replied, 'Certainly, but after I have captured Rome.' He never did capture Rome, but today he is considered the greatest of all the Ottoman emperors.

The novelist Elif Shafak gives a Turkish perspective:

> Suleiman was an unforgettable sultan for many people, for the Turks definitely – he reigned for forty-six years. In the West he was known as Suleiman the Magnificent, but we know him as *Suleiman Kanuni* – Suleiman 'the law maker' – because he changed the legal system. When I look at this signature, it speaks of power, glory, great magnificence. Suleiman was very interested in conquering East and West, and that's why many historians think he was inspired by Alexander the Great. I see that statement, that world power, in this calligraphy as well.

How do you govern an empire of the size of Suleiman's and ensure that power in the centre is properly deployed at the periphery? You need a bureaucracy. Administrators all over the empire need to demonstrate that they have the authority of the ruler, which is done by issuing a visible emblem that can be carried and shown to everyone. That emblem is the tughra. It acted like a royal warrant, or a sheriff's star, giving officers of the empire a badge of power. The tughra would be at the top of all important official documents, and Suleiman issued about 150,000 in his reign. He was industrious in establishing diplomatic ties, creating a formidable civil service and promulgating new laws. All

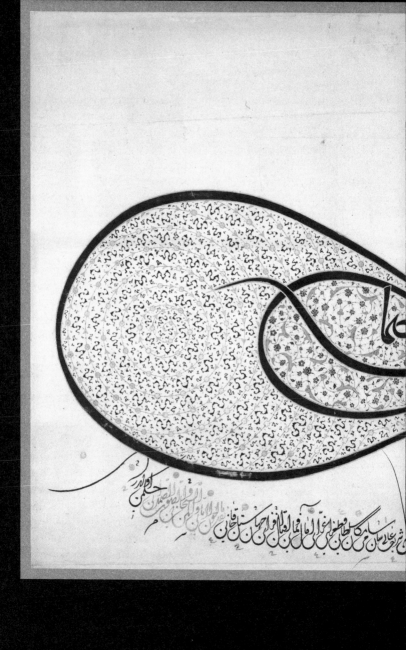

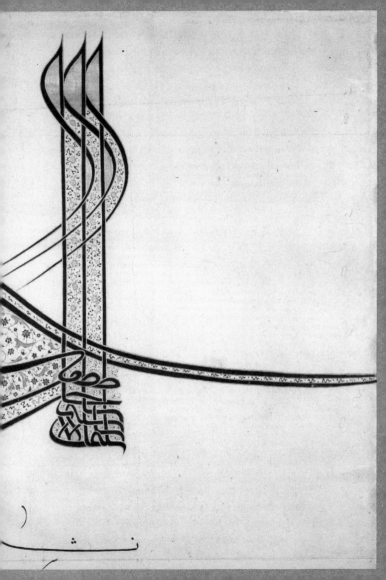

of this required letters of state, instructions to ambassadors and legal documents, all of which would begin with his tughra.

The tughra itself names the sultan, while the line below reads, 'This is the noble and exalted sign of the Sultan's name, the revered monogram that gives light to the world. May this instruction, with the help of the Lord and the protection of the Eternal, be given force and effect. The Sultan orders that ...' At this point our paper has been cut, but the document below would have continued with a particular instruction, law or command. Interestingly, there are two languages here: the tughra names the sultan in Arabic, reminding us that Suleiman is protector of the faithful with a duty to the whole Islamic world; the words below it are in Turkish, and proclaim his role as sultan, ruler of the Ottoman Empire. Arabic for the spiritual world, Turkish for the temporal.

Turkish would certainly have been the language of the official to whom this document was addressed. Given the opulent artistry of this tughra, the recipient had to be very grand, so it might be a governor, a general, a diplomat, or perhaps a member of the ruling house; and it could have been sent to any part of Suleiman fast-growing empire, as the historian Caroline Finkel explains:

> He overthrew the Mamluk Empire, so Egypt and Syria with all their Arab population, the Hejaz [in south-west Saudi Arabia] as well, with the Holy Places which were extremely important, all these people were now Ottoman subjects, for better or worse. Suleiman's tughra could be seen as far as the Persian border, where their great rival in the East, the Shi'a Safavid Empire, was always trying to challenge the Ottomans; in North Africa, where Ottoman naval expeditions were having great success against the Spanish Habsburgs in the western Mediterranean; and up into the lower reaches of what we now call Russia.

Suleiman's Ottoman Empire controlled the whole coastline of the eastern Mediterranean, from Tunis all the way round almost to Trieste. After 800 years the Eastern Roman Empire had been re-established, but now as a Muslim imperium. It was this huge new state that compelled the western Europeans to look for other ways of travelling to and trading with the East, forcing them from the Mediterranean out into the Atlantic. But that is for a later chapter.

Most official documents get lost, destroyed or thrown away. Our

driving licences, our tax bills, don't usually survive death. Similarly, the huge bulk of the official paper of the Ottoman Empire is lost to us. The most common reason for keeping any official document is that it has to do with land, because subsequent generations need to know the authority by which land is owned. So the best guess is that our tughra was at the head of a document giving a major grant of land, conferring or confirming ownership of a huge estate. That would explain why the document survived long enough for a later collector, probably in the nineteenth century, to cut off the tughra from the document and sell it as a separate work of art.

And it certainly is a work of art. In between the lines of cobalt blue enlivened with gold leaf are great loops containing riotous flowerbeds of swirling lotus and pomegranate, tulips, roses and hyacinths. This is magnificent Islamic decoration, rejoicing in natural forms while avoiding showing the human body. It is also a virtuoso demonstration of calligraphy, of sheer skill and joy in writing. The Ottoman Turks, like their predecessors and contemporaries in the Islamic world, held the art of writing in high esteem. The word of God had to be written with all the beauty of holiness. Calligraphers were important bureaucrats who staffed the Turkish chancery, the *Divan*, which gave its name to the official script of the Ottoman Empire, known as 'Divani'. The calligraphers developed beautiful and extremely intricate forms of this script. It is notoriously difficult to read – deliberately so – and is designed to prevent extra words being inserted into the text and forgery of official documents. The calligraphers were artists as well as bureaucrats, often belonging to dynasties of craftsmen, passing skills from one generation to the next. In the Islamic world, red tape is often high art.

Modern politicians proudly announce their desire to sweep away bureaucracy. The contemporary prejudice is that it slows you down, clogs things up; but if you take a historical view, it is bureaucracy that sees you through the rocky patches and enables the state to survive. Bureaucracy is not evidence of inertia, as we saw in Chapter 15; it can be life-saving continuity – and nowhere is that clearer than in China. China is the longest surviving state in the world and it is no coincidence that it has the longest tradition of bureaucracy. My next object is a piece of Chinese paper that, like the tughra, is a powerful tool of the state: paper money.

大明通行寶鈔

壹貫

戶部

奏准印造

大明寶鈔與銅錢通行

使用偽造者斬告

捕者賞銀貳佰伍拾兩

仍給犯人財產

洪武　年　月　日

72

Ming Banknote

Paper money, from China
AD 1375–1425

'Do you believe in fairies? Say quick that you believe. If you believe, clap your hands!'

The famous moment when Peter Pan asks the audience to save Tinkerbell by joining him in believing in fairies is an unfailing winner. That ability to convince others to believe in something they can't see but wish to be true is a trick that has been effective in all sorts of ways throughout history. Take the case of paper money: someone in China centuries ago printed a value on a piece of paper and asked everyone else to agree with them that the paper was actually *worth* what it said it was. You could say that the paper notes, like the Darling children in Peter Pan, were supposed to be 'as good as gold', or in this case as good as copper – literally worth the number of copper coins printed on the note. The whole modern banking system of paper and credit is built on this one simple act of faith. Paper money is truly one of the revolutionary inventions of human history.

This object is one of these early paper money notes, which the Chinese called *feiqian* – 'flying cash' – and it's from the time of the Ming, around 1400. Mervyn King, the Governor of the Bank of England, has this to say on the reasons for this invention:

> I think in some way the right aphorism is that 'evil is the root of all money'! Money was invented in order to get round the problems of trusting other individuals. But then the issue was – could you trust the person issuing the money? So the state became the natural issuer of money. And then the question is, can we trust the state? And in many ways that's a question about whether we can trust ourselves in the future.

Most of the world until this time was exchanging money in coins of gold, silver and copper that had an intrinsic value you could judge by weight. But the Chinese saw that paper money has obvious advantages over quantities of coin: it's light, easily transportable and big enough to carry words and images to announce not only its value but the authority of the government that backs it and the assumptions on which it rests. Properly managed, paper money is a powerful tool in maintaining an effective state.

At first glance, this note doesn't look at all like modern paper money. It is paper, obviously enough, and it's larger than a sheet of A4. It's a soft, velvety grey colour, and it's made out of mulberry bark, which was the legally approved material for Chinese paper money at the time. The fibres of mulberry bark are long and flexible, so even today, though it's around 600 years old, the paper is still soft and pliable.

It is fully printed on only one side, a woodblock stamp in black ink with Chinese characters and decorative features arranged in a series of rows and columns. Along the top, six bold characters announce that this is the 'Great Ming Circulating Treasure Certificate'. Below this there is a decorative border of dragons going all round the sheet – dragons of course being one of the traditional symbols of China and of its emperor. Just inside the border are two columns of text, the one on the left announcing again that this is the 'Great Ming Treasure Certificate' and the one on the right saying that this is 'To Circulate for Ever'.

That's quite a claim. How permanent can for ever be? In stamping the promise on to the very note, the Ming state seems to be asserting that it too will be around for ever to honour it. I asked Mervyn King to comment on this brave assertion:

> I think it's a contract, an implicit contract, between people and the decisions they believe will be taken in the years and decades to come, about preserving the value of that money. It is a piece of paper – there is nothing intrinsic in value to it – its value is determined by the stability of the institutions that lie behind the issuance of that paper money. If people have confidence that those institutions will continue, if they have confidence that their commitment to stability can be believed, then they will accept and use paper money, and it will become a normal part of circulation. When that breaks down, as it has done in countries where the

regime has been destroyed through war or revolution, then the currency collapses.

And indeed this is exactly what had happened in China around 1350, as the Mongol Empire disintegrated. So one of the challenges for the new Ming Dynasty, which took over in 1368, was not just to reorder the state, but to re-establish the currency. The first Ming emperor was a rough provincial warlord, Zhu Yuanzhang, who as a ruler embarked on an ambitious programme to build a Chinese society which would be stable, highly educated and shaped by the principles of the great philosopher Confucius, as the historian Timothy Brook details:

> The goal of the founding Ming emperor was that children should be able to read, write and count. It was an idea that he had that everyone should be literate, and he thought literacy was a good idea because it had commercial implications – the economy would run more effectively – and it had moral implications: he wanted school children to read the sayings of Confucius, to read the basic texts about filial piety and respecting elders, and he hoped that literacy would accompany the general re-stabilization of the realm. I would imagine a quarter of the population could read what's on this note, which by European standards at the time was remarkable.

As part of this impressive political programme, the new Ming emperor decided to relaunch the paper currency. A sound but flexible monetary system would, he knew, encourage a stable society. So he founded the Imperial Board of Revenue and then, in 1374, a 'treasure note control bureau'. Paper notes began to be issued the following year.

The first challenge was fighting forgery. All paper currencies run the risk of counterfeiting, because of the enormous gulf between the low real value of the piece of paper and the high promissory value that appears on it. This Ming note carries on it a government promise of a reward to anyone who denounces a counterfeiter. And alongside this carrot, there was a terrifying stick for any potential forger:

> To counterfeit is death. The informant will receive 250 taels of silver and in addition the entire property of the criminal.

The much bigger challenge was to keep the worth of the new currency intact. Here, the key monetary decision of the Ming was to ensure that

the paper note could always be converted into copper coins – the value of the paper would equal the value of a specific number of coins. Europeans called these coins quite simply 'cash' – they are round coins, with a square hole in the middle, which the Chinese had already been using for well over a thousand years. One of the things I love about this Ming note is that right in the middle of it is a picture of the actual coins that the paper note represents. There are ten stacks of coins with a hundred in each pile, so a total of a thousand cash or, as it says in writing on the note, one guan. You can get some idea of just how useful and welcome this early paper must have been when you compare carrying the paper around with the actual coins represented. Pictured here is 1,000 cash: 1.5 metres (5 feet) of copper coins all on a piece of string. They weigh about 3 kilos (7 lbs), are extremely cumbersome to handle, and are very difficult to subdivide and pay out. This note must have made life, for some people, very much easier. A contemporary wrote:

> Whenever paper money is presented, copper coins will be paid out, and whenever paper money is issued, copper coins will be paid in. This will never prove unworkable. It is like water in a pool.

It sounds easy. But the words 'never prove unworkable' would come back to haunt the Ming emperor. As usual, the practice turned out to be more complicated than the theory. The exchange of paper for copper, copper for paper, never flowed smoothly, and, like so many governments since, the Ming just couldn't resist the temptation of simply printing more money. The value of its paper money dived, and fifteen years after the first Ming banknote was issued, one official noted that a 1,000-cash note like this one had plummeted to an exchange value of a mere 250. What had gone wrong? Mervyn King explains:

> They didn't have a central bank, and they issued too much paper money. It was backed by copper coin, in principle – that was the idea behind it. But in fact that link broke down, and once people *realized* the link had broken down, then the question of how much it was worth was really a judgement about whether a future administration would issue even more, and devalue its real value in terms of purchasing power. In the end this money did become worthless.
>
> But I don't think paper money is always doomed to failure, and I think if you'd asked me four or five years ago before the financial crisis

The middle of the note shows a string of ten stacks of coins

I would have said, 'I think we've now worked out how to manage paper money.' Perhaps in the light of the financial crisis we should be a bit more cautious, and maybe – to quote Zhou Enlai, another great Chinese figure, when asked about the French Revolution: 'Well, it's too soon to tell'. Maybe we should say about paper money after 700 years it is perhaps too soon to tell.

Eventually, around 1425, the Chinese government gave up the struggle and suspended the use of paper money. The fairies had fled – or, in grander language, the faith structure needed for paper money to work had collapsed. Silver bullion became the basis of the Ming monetary world. But however difficult to manage, paper currency has so many advantages that inevitably the world came back to it, and no modern state could now think of functioning without it. And the memory of that very early paper currency of the Ming, printed on Chinese mulberry paper, lives on today in a little garden in the middle of London. In the 1920s the Bank of England, in conscious homage to those early paper notes, planted a little stand of mulberry trees.

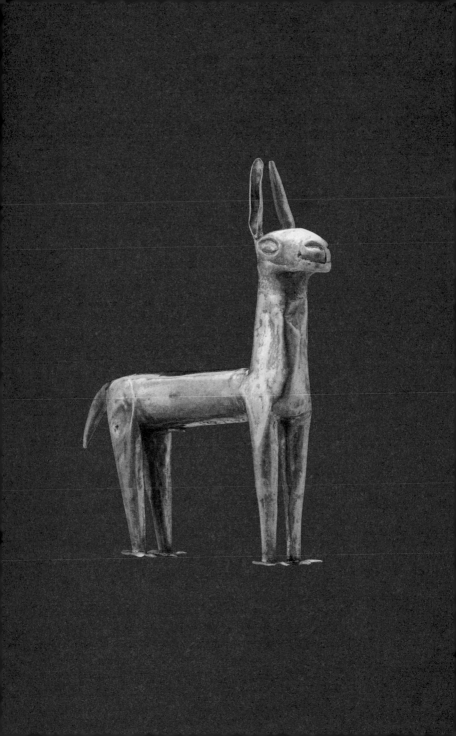

73

Inca Gold Llama

Gold figurine, from Peru
AD 1400–1550

Around 500 years ago the empire of the Incas was bigger than Ottoman Turkey, bigger than Ming China – in fact, it was the largest empire in the world. At its height, around 1500, it ran for more than 3,000 miles down the Andes and ruled over 12 million people from Columbia to Chile and from the Pacific Coast to the Amazonian jungle. In the 1520s the Spanish would come and everything would collapse; but until then, the Inca Empire flourished. It didn't have writing, but it was an efficient military society, an ordered, productive and wealthy civilization centred on Cusco, in Peru. Its economy was driven by manpower and, just as important, llama power – a vast human labour force and hundreds of thousands of llamas. And though it was the biggest empire of the time, it is represented by the smallest object in this section of our history – a tiny, gold messenger from a mountain-topped world.

Although this empire was highly organized militarily, socially and politically, the Incas had no script, so we are heavily dependent on the accounts of their Spanish conquerors. We know from these and the objects left behind that the making of the Inca Empire is one of the most extraordinary achievements in the history of the world. As the Ming Dynasty was starting in China and the Ottomans were conquering Constantinople, the Inca were constructing their vast empire. Inca control had spread from their heartland in southern Peru to a territory ten times bigger by 1500.

Andean territory is forbiddingly mountainous – this was a vertical empire that made terraced fields on mountainsides and roads that ran over the peaks. Irrigation projects and canals changed the courses of rivers and turned mountainsides into lush, terraced fields. Well-stocked

storehouses and extensive highways showed detailed concern with planning and provisioning. The Incas made the impassable passable, and the key to their success was the llama. But a state's dependency on animals was nothing new, as the scientist and writer Jared Diamond can tell us:

> The availability and type of domestic animals has had a huge effect on human history and on human culture. For example, in the Old World, in Europe and Asia, the big domestic animals of Eurasia – the horse, cow, goat, sheep and pig – provided meat and protein and milk. Some of them were big enough to provide transport. Some of them – the horse, camels and donkeys – were big enough to ride, and some of them, particularly cattle and horses, were able to pull carts. The horses and camels that could be ridden became war animals and provided an enormous advantage for Eurasian people over peoples of other continents. One can say that domestic animals became not only a big spur to the development of settled living and provided us with our food, but they also provided a weapon of conquest.

The zoological lottery that Jared Diamond describes – the pure chance of whether your local animals can be domesticated – enormously favoured Europe and Asia. Australia, by contrast, drew a very short straw. It is hard to domesticate an emu, and no one ever rode a kangaroo into battle. The Americas were almost as badly off, but they did have the llama. Llamas cannot compete with horses for speed, or donkeys for pack power; they also have an infuriating habit, when tired, of just stopping and refusing to move. But they are extraordinarily well adapted to high altitude; they cope well with the cold and can forage for their own food; they can provide wool, meat and manure; and, although they cannot carry people, a healthy llama can comfortably transport about 30 kilograms (60 lbs) of goods – more than today's average baggage allowance for air travel – so they can be very useful indeed for carrying the kind of supplies required for military campaigns. As they expanded down the great spine of the Andes, the Incas bred huge numbers of llamas as army pack animals. Not surprisingly, they also made models of this hardy creature that was so fundamental to the lives of the people and the running of the empire.

Our little gold llama is so small that it can stand comfortably in my

hand – it is only a little over 6 cm (2½ inches) high. It's hollow, made up of hammered-out thin leaves of gold, and therefore very light. It's an engagingly sprightly figure – straight neck, ears upright and alert, large eyes and a mouth that's clearly smiling, making an unusually cheerful-looking example of a creature from a species which usually seems to veer between amused condescension and a spitting sneer. Many little figures like this have been found, in gold and silver, all over Inca territory, frequently buried as offerings on mountain peaks.

That territory was on three distinct levels: there was the flat coastal strip; then the mountainsides, with the famous Andean terraced fields producing crops on very difficult terrain; and then the mountain plateaus with high grasslands, 3,500 metres (12,000 feet) above sea level. The llama unified these three disparate Inca worlds and held this vast empire together. It was a world of different peoples, languages and gods, whose communities had often been at war with each other, and the full range of imperial techniques was deployed to control this swiftly created state. Some local elites were ruthlessly eliminated; others were co-opted, given private land and excused taxation. Late-conquered territories, in northern Ecuador for example, could operate more as client states instead of being fully incorporated into the Inca system. This cultural mosaic was welded together into a powerful empire by the Inca military machine, which depended on thousands upon thousands of llamas to provide portage and food. We know that after an early battle against the Spanish, the defeated Incas abandoned 15,000 of the animals.

Our little llama is made of gold, a key substance in Inca myth. Gold was the attribute of the great Inca sun god and represented his generative powers – gold was described as the 'sweat of the Sun', while silver was the 'tears of the Moon'. Gold was therefore related to masculine power, above all to the power of the Inca himself, the emperor, child of the Sun. Today, Inca objects in gold and silver are rare survivals: tiny scraps of the dizzying opulence that was described by the Spanish when they arrived in the 1520s. They wrote of palaces walled with sheets of gold, of gold and silver statues of humans and animals, and of miniature golden gardens inhabited by glittering birds, reptiles and insects. All of these would be surrendered to or seized by the Spanish. Nearly all were melted down for bullion and sent to Spain.

As in all societies, planting and harvesting were accompanied by rituals and offerings to the gods, and with the Inca this often involved sacrifice of living beings, from guinea pigs to children of the elite. And as the Peruvian Inca expert Gabriel Ramon explains, llamas were sacrificed by the thousand:

> There were two calendars during the Incan period. One was the official imperial calendar, and at the same time they have lots of small calendars from the provinces or territories that they conquered. But in the official calendar they tried to match the agricultural calendar, the main times for harvesting and planting, with the main ceremonies, and it's in this official calendar that you have several ceremonies with the llama. There is one mentioned by Guaman Poma, a colonial writer, in October, and for that ceremony, to bring the rain, you need to kill white llamas.

The greatest Inca religious rite was the Festival of the Sun. A Spanish chronicler has left us a full description:

> Then came the Inca priests with a great number of young, female and male llamas of all colours, for the Peruvian llama is found in all colours, like horses in Spain. All the llamas belonged to the Sun. The first sacrifice of a young black llama was intended to observe the auguries and omens of the festival. They took the llama and placed it with its head facing the east. While still alive, its left side was opened, and by inserting the hand they drew forth the heart, lungs and entrails; the whole must come out together from the throat downwards. They regarded it as a most happy omen if the lungs came out still quivering. After they had sacrificed the llama lamb, a great quantity of other young, female and male llamas was brought for the common sacrifice. Their throats were cut and they were flayed. Their blood and hearts were all kept and offered to the Sun. Everything was burned to ashes.

The same Spanish writer tells us that while real llamas were being slaughtered, the rulers of the provinces also brought to the Incas models of llamas made of gold and silver as tokens of the great animal wealth of the region. Our llama may have been one of these tokens. Alternatively, and less comfortably, it may have been part of one of the other Inca religious rituals. Selected children of the elite were ritually exposed and left on the mountain peaks as living sacrifices to the

mountain spirits, and little gold llamas like ours have been found beside their dead bodies.

The wealth of the Inca Empire depended not only on the vast herds of llamas but also on the Incas' ability to force their conquered subjects to work for them. The subjects, however, weren't by any means as docile as the llamas, and many Andeans – dispossessed and exploited – resented the Incas as alien aggressors:

> Inca tyranny is at our gate ... If we yield to the Inca, we shall be obliged to give up our former freedom, our best land, our most beautiful women and girls, our customs, our laws ... We shall become for all time this tyrant's vassals and servitors.

The Inca hold on many of its provinces was fragile. Continuous rebellions tell of potential weakness, which turned out to be crucial when Pizarro returned to conquer Peru in 1532. Some of the local elites immediately seized the opportunity to ally with the incomers and throw off the Inca yoke.

As well as being joined by a growing number of rebels, the Spanish had swords, armour and guns, none of which the Incas possessed – and crucially they also had horses. The Inca had never before seen men on the backs of animals, nor had they seen the speed and agility with which this combination of man and beast could move. The Inca llamas must have suddenly looked hopelessly delicate and slow. It was all over fairly quickly – a mere couple of hundred Spaniards massacred the Inca army, captured their emperor, installed a puppet ruler and seized and melted down their gold treasures. Our little llama is one of the rare survivors.

The Spanish had come to Peru lured by tales of enormous quantities of gold. But they discovered instead the richest silver mines in the world and began to mint the coins that would power the world's first global currency. The Inca measured the wealth of their empire in llamas. The Spanish would measure theirs, as we shall see in Chapter 80, in silver pieces of eight.

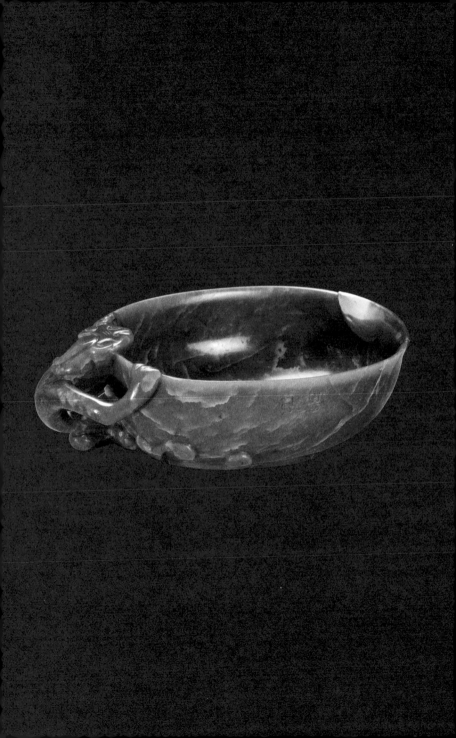

74

Jade Dragon Cup

Jade cup, from central Asia
AD 1417–1449

W̄e'll lead you to the stately tent of war,
Where you shall hear the Scythian Tamburlaine
Threatening the world with high astounding terms,
And scourging kingdoms with his conquering sword.

In these words Christopher Marlowe fixed for ever the European image of Tamburlaine, still a legendary force in Elizabethan England. A couple of hundred years earlier, by 1400, the real Tamerlane had become the ruler of all the Mongol lands except China. The heart of his empire was the region we now know as the 'stans' – Uzbekistan, Kazakhstan, Turkmenistan, Tajikistan. That huge area in central Asia has always had a fluctuating history, where empires build, crumble and fade – until another empire rises and the cycle begins again. It is a region that has inevitably had two faces – one looking towards China in the east and the other towards Turkey and Iran in the west. Samarkand, Tamerlane's capital, was a major city on the great Silk Road that linked these two worlds. Much of this complex cultural and religious history is embodied in this small jade cup, which belonged to Tamerlane's astronomer grandson, Ulugh Beg.

The surface of the Moon is dimpled with hundreds of craters. For the Moon-watcher they add interest and texture, but their names also provide another kind of pleasure: they form a kind of dictionary of great scientists. There are craters honouring Halley, Galileo and Copernicus and many more astronomers – and among them is Ulugh Beg, who lived in central Asia at the start of the fifteenth century. Ulugh Beg built a great observatory in Samarkand, in modern Uzbekistan, and compiled a famous catalogue of just under a thousand stars, which

became a standard work of reference in both Asia and Europe, and was translated into Latin in Oxford in the seventeenth century – it was this which earned him the honour of that crater on the Moon. He was also briefly the ruler of one of the world's great powers – the Timurid Empire, which at its height ruled not only central Asia, but also Iran and Afghanistan, as well as parts of Iraq, Pakistan and India. The Timurid Empire had been founded by the redoubtable Tamerlane in the years around 1400. The name of his grandson, the astronomer prince Ulugh Beg, is incised on the cup pictured here.

The Uzbek writer Hamid Ismailov says:

> It is extremely exciting that this object belonged to Ulugh Beg, because I can see here in Arabic *Ulugh Beg Kuragan* and imagine that it served Ulugh Beg while he was looking at the stars. It's magnificent.

Ulugh Beg's cup is oval, just over 6 centimetres (2½ inches) high and 20 centimetres (7 inches) long – more a small bowl than a cup – and made from a superbly grained olive-green jade with natural cloud-like markings drifting across the glossy stone. It is very beautiful, but jade was valued in central Asia not just for its beauty, but also for its powers of protection: jade would keep you safe against lightning and earthquakes and – especially important in a cup – against poison. Poison placed in a jade cup, so it was said, would result in the vessel splitting. The owner of this cup could drink without fear.

The cup's handle is a splendid Chinese dragon. It has its back feet firmly planted on the underside of the bowl, while its mouth and webbed front feet cling to the edge at the top. It peeps over the rim of the bowl, so you can put your finger through the space left by its curving body. It's a sensuous, intimate experience.

The style of the handle may be Chinese, but the inscription – Ulugh Beg Kuragan – carved into the cup is in Arabic script. Kuragan is a title that literally means 'royal son-in-law', but it was used by Tamerlane

The Arabic inscription reading 'Ulugh Beg Kuragan'

A later repair carries a Turkish inscription: 'There is no limit to the beneficence of God'

and later by Ulugh Beg. They had both married princesses of the house of Genghis Khan, and by calling themselves sons-in-law they declared themselves the heirs to the universal sovereignty of Genghis Khan's Mongol Empire.

So, the cup was probably made in Samarkand, with a handle showing connections east to China, and an inscription looking west to the Islamic world. The Arabic inscription reminds us that this new Timurid Empire created by Tamerlane was energetically Muslim. This is the time of the building of the great mosques of Bukhara and Samarkand, Tashkent and Herat, conceived and executed on a monumental scale, a central Asian equivalent of the European Renaissance.

From about 1410 Ulugh Beg governed Samarkand for his father, and there he built the observatory in which he revised and corrected the astronomical computations of the ancient Greek Ptolemy – the same fusion of Classical Greek and Arab scholarship that we saw in the medieval Hebrew Astrolabe (see Chapter 62). But this central Asian Renaissance prince didn't take after his military, empire-building grandfather Tamerlane. The historian Beatrice Forbes Manz sums him up:

He was a very poor commander and probably not a great governor in certain ways. He was, however, an excellent cultural patron, famous especially for his patronage of mathematics and astronomy. These were his real passions, much more I think than government or military campaigning. He also had a passion for jade, so it's not surprising to find that cup in his possession, and he had a fairly high-living court, looser morally than his father's. Ulugh Beg was pious, he knew the Qur'an by heart, but he, like many rulers, took a certain amount of licence. So there was a lot of drinking, for instance, at his court.

An envoy from Ming China who visited Samarkand around 1415 was taken aback at the free-wheeling manners of the Timurid capital, which still smacked of the easy-going informality of a semi-nomadic society. It was an odd city, designed to accommodate both modern buildings and traditional tents, the yurts that the Timurids had brought with them from the steppes. For the rarefied Chinese visitor, Samarkand was the Wild West:

> They have no principles or propriety. When inferiors meet superiors, they come forward, shake hands, and that is all! When women go out, they ride horses and mules. If they meet someone on the road, they chat, laugh and fool around with no sense of shame. Moreover they utter lewd words when conversing. The men are even more despicable.

Perhaps it is not surprising that the Timurid Empire, bound together only by personal loyalties, didn't survive long. It was run by people more at home on the steppes than in a government office. There was no established habit of orderly central power and barely any working bureaucracy. The death of every ruler brought chaos. Ulugh Beg's father had struggled to rebuild the Timurid Empire, but after his death in 1447 Ulugh Beg would reign for only two years before he lost control. He tried hard to use the reputation of Tamerlane to bolster his authority, burying his illustrious grandfather under a monument made of rare black jade, inscribed in Arabic for all to see: 'When I rise, the world will tremble'. He must have longed for the return of a power that he knew he himself could never match. The earth was unlikely to tremble at Ulugh Beg. Hamid Ismailov sees a poetic, metaphorical meaning in his green jade cup:

> The symbolism of this cup is seen throughout the whole region as a sort of destiny of a person. When we say 'the cup is filled', so destiny is fulfilled. And so, for example, Babur, who was a great poet as well as the nephew of Ulugh Beg, says in one of his poems that troops of sadness are countless, and the only way to deal with them is bringing thicker wine and keeping a cup as a shield. That is the symbolism of the cup – it's a shield, a metaphysical shield against the troops of sadness.

But it was a shield that failed, and towards the end of his life, the troops of sadness came crowding in on Ulugh Beg. His two-year rule of the

empire was as disastrous as it was brief. Very unmetaphorical troops invaded Samarkand, and in 1449 he was defeated and captured by his own eldest son, handed over to a slave and decapitated. But Ulugh Beg was not forgotten. His great-nephew Babur, who became the first Mughal emperor of India, honoured him by interring his remains in the black jade monument alongside those of the great Tamerlane.

By that time the Timurid Empire was over. Once again central Asia fragmented and became the theatre of competing influences, among them the great new power in the West, the Ottoman Empire. That later development, too, is recorded in our cup. At some point, presumably long after Ulugh Beg's death, the precious jade cup must have been dropped, because it is badly cracked at one end. But the crack has been covered up by a repair in silver, and on the silver is an inscription. It was probably engraved in the seventeenth or eighteenth century, 300 years after its owner's execution. The inscription is in Ottoman Turkish, so the cup by then had probably found its way to Istanbul. It reads, 'There is no limit to the beneficence of God'.

The unfortunate Ulugh Beg might not have agreed. By the time this cup was re-inscribed in Turkish, Russia was already expanding into the old Timurid Empire. In the nineteenth century the whole region would become part of the Russian imperial scheme, and Samarkand would be absorbed into another central Asian empire – first Tsarist, then Soviet, until in 1989 that in its turn collapsed, an upheaval which to the Timurids would have been very familiar.

One of the new states to emerge in the post-Soviet order is Uzbekistan. As it strives to define its identity it seeks in its past elements that are neither Russian, nor Chinese, nor Iranian, nor Turkish. The banknotes of modern Uzbekistan declare to the world that this new state is in fact the heir to the Timurid Empire: we see on them the mausoleum that houses the black jade monument where Tamerlane and Ulugh Beg lie buried.

There can be no doubt that Ulugh Beg achieved more as a scholar of the stars than as a ruler of his collapsing empire, so perhaps it is fitting that the crater on the Moon named after him is near the Oceanus Procellarum – the sea of storms – storms against which his jade cup might have given him solace, but not protection.

75

Dürer's *Rhinoceros*

Woodcut, from Nuremberg, Germany

AD 1515

The tiny island of St Helena, in the middle of the South Atlantic, is famous above all as the open prison of Napoleon Bonaparte, banished there after the Battle of Waterloo in 1815. But another great wonder of Europe also once stayed on St Helena – a being much less destructive than the French emperor and one that in the Europe of 1515 was truly a wonder: an Indian rhinoceros. He, too, was in captivity, but in a Portuguese ship stopping off on the long journey from India to Lisbon – a journey that was a triumph of navigation. Europe was on the brink of a great expansion that would lead to the exploration, mapping and conquest of much of the world, all made possible by new technologies in ships and sails. There was intense interest in recording and disseminating this rapidly expanding knowledge through another new technology – printing. All these disparate developments coincide in this object, one of the most famous images of Renaissance art. The Indian rhinoceros, in one respect at least, was luckier than Napoleon: his portrait was made by Albrecht Dürer.

In recent chapters I have been examining objects from four great land empires, all of them controlling huge tracts of the globe around 500 years ago. This object introduces a fledgling maritime empire, that of Portugal. For centuries there had been a steady trade in spices between the Indian Ocean and Europe, but by the late-fifteenth century the Ottomans dominated the eastern Mediterranean and blocked the traditional trade routes (see Chapter 71). Spain and Portugal began searching for new ways to gain access to Asian goods. Both ventured into the Atlantic – a very difficult ocean for long-distance sailing. In the quest for the Indies, Spain went west and found the Americas; the

Portuguese went south, down the seemingly endless coast of Africa until they rounded the Cape of Good Hope and made their way into the Indian Ocean and to the wealth of the East. In Africa and Asia they established a slender network of stopping points – harbours and trading stations – and along that network travelled spices and other exotic goods, and also our rhinoceros.

Dürer's Rhinoceros is a woodcut print, and it shows a massive beast, nicely identified over its head by the word RHINOCERVS, with the date 1515 above and the AD monogram of the artist below. The rhino is side on, looking to the right. Dürer has cunningly framed it to give a great sense of pent up force, packing the body into a tightly drawn frame which only just contains it – the end of its tail is partially cut off and its horn pushes aggressively against the right-hand edge. This animal will try to escape, we think – and it is going to be trouble.

Above the animal in its printed box is a text in German:

[In May 1515] Brought from India to the great and powerful King Emanuel of Portugal at Lisbon a live animal called a rhinoceros. His form is here represented. It has the colour of a speckled tortoise and it is covered with thick scales. It is like an elephant in size, but lower on its legs and almost invulnerable ... It is also said that the rhinoceros is fast, lively and cunning.

The story of how the rhino came to Europe tells us that the Portuguese were not just trading with India but were trying to establish permanent bases there – this is the very beginning of the European land presence in Asia. They succeeded largely thanks to Alfonso d'Albuquerque, the first governor and effective founder of the Portuguese empire in India, and the man who brought us the rhino. In 1514 Albuquerque approached the sultan of Gujarat to negotiate the use of an island, accompanying his embassy with lavish presents. The sultan responded with gifts in return – including a live rhinoceros. Albuquerque seems to have been somewhat flummoxed by this living gift, so he took advantage of a passing Portuguese flotilla and sent the beast to Lisbon as a special present to the king. Getting a rhino weighing between one and a half and two tons on to a sixteenth-century ship must have been quite a task.

Nach Christus gepurt.1513.Jar.Adi.j.May. Hat man dem grosmechtigen Kunig von P
Rhinocerus.Das ist hye mit aller seiner gestalt Abcondertset.Es hat ein farb wie ein gespreckelt
Aber nydertrechtiger von paynen/vnd fast weihafftig.Es hat ein scharff starck Horn vorn a
sanz todt seyndt.Der Helffandt furcht es fast vbel/dann wo es In ankumbt/so lauffe Im da
vñ erwürgt In/des mag er sich nit erwern.Dann das Thier ist also gewapent/das Im der H

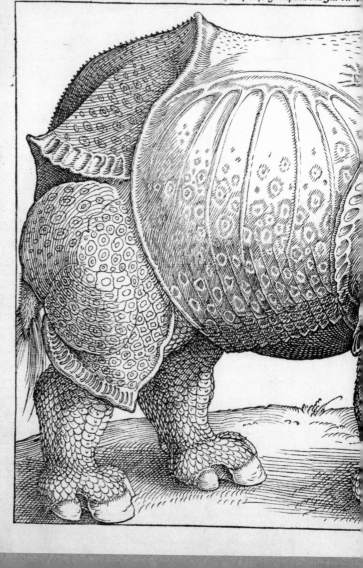

yall Em amell gen Lysabona pracht auß India/ein sollich lebendig Thier. Das nennen sie
childtkro t. Und ist vō dicken Schalen vberlegt fast fest. Und ist in der gröſſ als der Helfandt
der nasen/ Das begyndte es alweg zu werzen wo es bey ſtaynen ist. Das doſig Thier ist des Helf
hier mit dem kopff zwiſchen dye fordern payn/vnd reyſt den Helffandt vnden am pauch auff
andt nicht ts kan thün. Sie ſagen auch das der Rhynocerus Schnell/ Fraydig vnd Liſtig ſey.

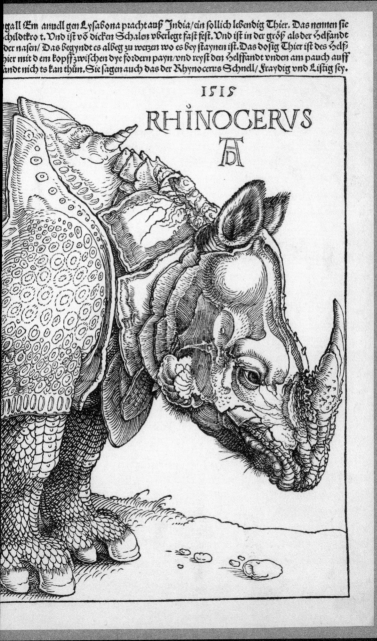

A little Italian poem celebrates the voyage that astonished all of Europe:

> I am the rhinoceros brought hither from dusky India,
> From the vestibule of light and the gateway of the day.
> I boarded the fleet bound for the west, its bold sails undaunted,
> Daring new lands, to see a different sun.

The rhino began its journey from India in early January 1515. He was accompanied by his Indian keeper, Osem, and vast quantities of rice – an odd choice of diet for a rhino but much less bulky than his usual fodder. We don't know how the rhino liked his food, but he seems to have thrived, and after a sea journey of 120 days, with only three stops in port – at Mozambique, St Helena and the Azores – he arrived in Lisbon on 20 May. Crowds flocked in amazement to watch.

The rhino arrived in a Europe that was obsessed not only with a possible future that lay beyond its shores, but also with recovering its own deep past at home. Ancient Roman buildings and statues were being excavated with huge excitement in Italy, archaeological work that was uncovering the reality of the Classical world. The appearance of the rhinoceros – this exotic creature from the East – was, for educated Europeans, another piece of antiquity recovered. The Roman author Pliny had described such a beast, and they had starred in Roman amphitheatres, but none had been seen in Europe for more than a thousand years. It was an exhilarating retrieval of Classical antiquity – a kind of living zoological Renaissance with the added allure of exotic Eastern wealth. It's not surprising that Dürer responded so strongly. The historian Felipe Fernandez-Armesto explains:

> The rhinoceros was so important because people looked at him and saw the embodiment of one of the most famous texts in the Classical world, Pliny's *Natural History*, which devotes a very short chapter to the rhinoceros. And when people saw it they said, 'You know, Pliny was right! This creature really exists! Here we've got evidence of the reliability of these texts from antiquity ...' That's why Dürer drew him, that's why engravings of him were sought after all over Europe.

The Portuguese king decided to send the rhino on as a present to the Pope, whose support he needed in establishing his claims to empire in

the East. He knew that the Pope and all Rome would be enthralled by the creature. But the poor beast never made it to Italy. The ship carrying it was hit by a storm off La Spezia and sank with all hands. Although rhinos are competent swimmers, since it was chained to the deck it also drowned.

But the rhino lived on by reputation, and even while it was alive, accounts, poems and sketches of the exotic creature spread across Europe. One sketch reached Dürer, in Nuremberg; of course, Dürer had never seen a rhinoceros. We have no idea how much detail this sketch contained, but the finished print that Dürer derived from it clearly owes a great deal to the artist's imagination. At first glance it looks very much as an Indian rhino should look – thick, solid legs, armoured back, a tail with a feathered end and, of course, the single horn. But something isn't quite right – a lot of things, in fact, when compared with an actual rhino. The legs are scaled and end in large, splayed-out toes. The skin is pleated and lined and stands out stiffly from the legs – this is armour plating, not skin. It has a peculiar little extra horn on its neck – no one really knows where this came from – and the abnormally whiskery creature is covered in small scales and swirls which manage to look at once military and decorative.

It's a long way from any actual rhino, but with the real animal drowned, Dürer's imagined rhinoceros quickly became the reality for millions of Europeans. And he was able to satisfy the enormous curiosity in the beast by mass-producing its image, thanks to the new technology of wood-block printing.

Nuremberg, where Dürer lived, was a great commercial centre and home to the earliest printing shops and publishers. By 1515 Dürer himself was the master printmaker of the age, so he was ideally placed to convert his rhino drawing into a profitable print. Around 4,000–5,000 copies of Dürer's rhino were sold in his lifetime, and many millions have sold in other forms since. The image stuck: in works of natural history, above all, Dürer's rhino was unshiftable, even when more accurate depictions of the rhino later became available. In the seventeenth century copies could be seen everywhere, from the doors of Pisa Cathedral to a church fresco in Colombia, South America. And it now appears on mugs, T-shirts and fridge magnets.

Five years after Dürer produced his rhino, he had another exotic

encounter. In 1520 in Brussels he viewed Aztec mosaics in the shape of masks and animals every bit as alien and exhilarating as the rhino: 'all kinds of wonderful objects', he wrote, 'of various uses, more beautiful to me than miracles'. The new worlds that Europeans were encountering were going to change profoundly the way they could think about themselves.

The First Global Economy

AD 1450–1650

These were the years in which Europeans ventured far beyond their own continent for the first time, most significantly down the coast of western Africa into the Indian Ocean and across the Atlantic. The maritime empires that resulted were made possible by major developments in naval technology and brought about the first global economy, which used Spanish pieces of eight as its currency, from Europe to the Americas, China and Japan. Within that economy, the Dutch East India Company became the world's first multinational company, transporting goods from the Far East to a European market. These explorers and traders brought different cultures into contact with each other for the first time, with varying results: when Spanish explorers arrived in Mexico it led to the destruction of the Aztec Empire; in contrast, the relationship between the Portuguese and the kingdom of Benin was mutually beneficial, with Portuguese sailors providing much-desired brass in exchange for ivory and palm oil.

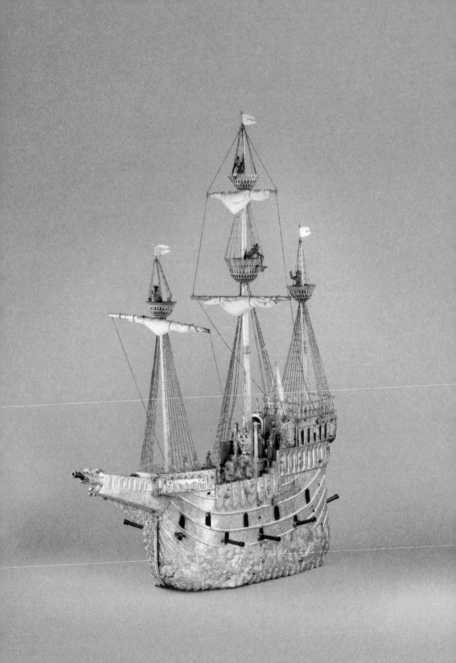

76

Mechanical Galleon

Mechanical galleon, from Augsburg, Germany
AD 1585

The magnificent ship is masted and rigged, ready to sail. High on the stern sits the Holy Roman Emperor of the German nation. In front of him his grandest subjects parade one after another, turning and making obeisance. Deep in the hull of the vessel an organ plays music. Then the cannons fire in an explosion of noise and smoke, and the imperial galleon moves majestically forward.

All this is happening in miniature. Our ship is an elaborately crafted model made of gilded copper and iron, which stands about one metre (40 inches) high. It was designed not to sail the seas but to trundle across a very grand table. It is a decoration, but also a clock and a musical box – all in the shape of a masted galleon of the kind developed in the sixteenth century across Europe to expand trade and to make war. Its intricate inner workings did once create noise, smoke and movement. Nowadays the ship is silent, calmly berthed in the British Museum. Yet it still looks magnificent. This fantastical mechanical galleon is one of the grandest executive toys of the European Renaissance, and it sums up not just shipbuilding in Europe but Europe itself between 1450 and 1650. In the course of those 200 years Europe's view of the world and its place in it was completely transformed. The workhorse of European expansion was the galleon, a new kind of ship specially designed for ocean-going and particularly well adapted to the winds of the Atlantic. In ships like this, European adventurers set off across the high seas to encounter other societies on all continents, many for the first time.

Our galleon crossed nothing more turbulent or more dangerous than a princely European dinner table, but it is a very fair likeness of

those great European ocean-going vessels; it is the kind of galleon that Henry VIII had in his *Mary Rose*, and most notably the kind of ship that Spain sent against England in the Great Armada of 1588. They were normally three-masted, round-hulled war vessels designed to carry both troops and guns, and they were the key element in any sixteenth-century state's navy. Absurdly, they were also popular table decorations, always referred to by the French word for this kind of ship – a *nef*.

The marine archaeologist Christopher Dobbs, who is in charge of the *Mary Rose* at Portsmouth dockyard, compares it to our gilded nef:

> The *Mary Rose* is a little different from the nef – it's a slightly earlier ship – but the *Mary Rose* is a very important part of naval warfare, because it was one of the first to have purpose-built lidded gun ports close to the waterline. These ships were so important, they were the powerful symbols of the time. This is the equivalent of the Space Shuttle. And I think that's why they would have been so proud to have a nef that would trundle along the tables at a great dinner, because it wasn't only a fantastic mechanical object but it also reflected the glory of the warships, perhaps the most advanced technological features of their time.

These great ships were the largest and most complex machines in the Europe of their day. The miniature gilded galleon is also a wonderfully constructed object, a masterpiece of both technological skill and high artistic decoration, of mechanics and goldsmithery. Paradoxically, this little ship was created for a society hundreds of miles from any sea, and it is highly likely that Hans Schlottheim, the landlocked craftsman who made it, had never seen a sea-going vessel. It was made towards the end of the sixteenth century in the rich banking city of Augsburg, in southern Germany, a Free City within the Holy Roman Empire, and so part of a huge sprawling territory that ran from Poland in the east to the Belgian channel ports in the west, all of which owed allegiance to the emperor, Rudolph II.

It is Rudolph that we see sitting in state on the deck of our ship. In front of the emperor are the seven electors, those princes of church and state in the German-speaking world who chose each new emperor and enriched themselves by bribes in the process. It is very likely that this ship was made for one of those electors, Augustus I of Saxony.

High on the stern of the ship sits the Holy Roman Emperor, circled by the seven electors

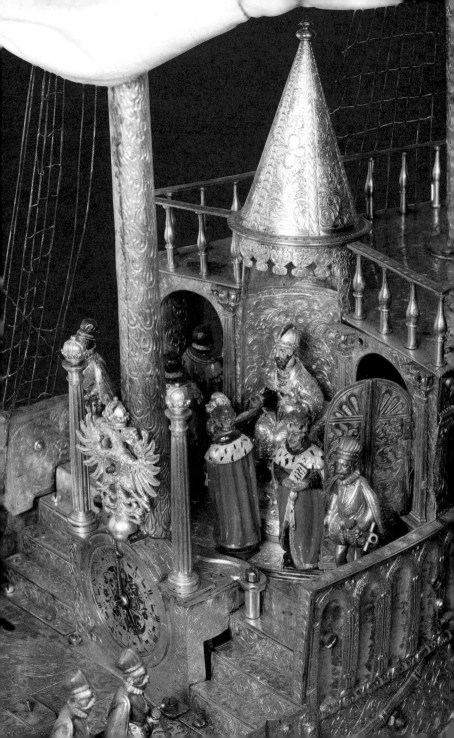

Augustus's inventory includes a description that almost exactly matches the British Museum's galleon, so much so that we think it must refer to our nef.

> A gilded Ship, skilfully made, with a quarter- and full-hour striking clock which is to be wound every 24 hours. Above with three masts, in the crow's nests of which the sailors revolve and strike the quarters and hours with hammers on the bells. Inside, the Holy Roman Emperor sits on the Imperial throne, and in front of him pass the seven Electors with Heralds, paying homage as they receive their fiefs. Furthermore ten trumpeters and a kettle-drummer alternately announce the banquet. Also a drummer and three guardsmen, and sixteen small cannons, eleven of which may be loaded and fired automatically.

What would those south German dinner guests have thought as they watched and listened to this amusing and amazing object in action? They would, of course, have admired the clockwork brilliance of the playful automaton, but they must also have been fully aware that this was a metaphor in motion, a symbol of the ship of state. That idea of the state as a ship and its ruler as the helmsman or captain is a very old one in European culture. It is frequently used by Cicero, and indeed our word 'governor' comes from the Latin for 'helmsman' – *guberna-tor*. Even more enticingly, the root of *gubernator* is the Greek *kuber-netes*, which is also the origin of our word 'cybernetics'; so the notions of ruling, steering and robotics all coincide in our language – and in this galleon.

The state that this model ship symbolized was like no other. The Holy Roman Empire was a unique phenomenon in Europe. Covering the area of modern Germany and a great deal beyond, it was a mechanism every bit as complex as our galleon. It was not a state in the modern sense of the word but an intricate meshing of church lands, huge princely holdings and small, rich, city-states. It was an old European dream that so many diverse elements could coexist in peace, all held together by loyalty to the person of the emperor, and a dream that had proved astonishingly adaptable.

By the time of our gilded galleon the ancient metaphor of the ship of state was acquiring a new layer of meaning. Ships had become the focus of an intense interest in mechanics and technology, subjects

which were absorbing, indeed obsessing, rulers right across Europe. The historian Lisa Jardine explains:

> The rich, the wealthy of all kinds, the aristocracy, everybody wanted to own a bit of technology – something with cogs and wheels and winding bits, a very ornamental clock or a very ornamental position-finding instrument. It was fashionable to own scientific instruments, because they were the means of expansion and discovery. Clockwork is fundamentally European, and it develops in the early sixteenth century, at least on a small scale. It's all hand-worked, minute craftsmanship, not mass-produced at all, and it's mostly done by gold and silversmiths. It immediately fascinates everyone that you can wind something up and it goes without your touching it. Clockwork is magic in the sixteenth century.

Magic it may have been, but clockwork was also big business in sixteenth-century Germany. In our ship, the greatest technical skill is not the modelling or the gilding of the galleon itself but the engineering of the clock and the automated moving parts. Observers repeatedly stressed the precision, the orderliness, the grace of mechanisms like this one, which embodied the ideal of the early modern European state as it ought to have been and rarely was, with everything working together harmoniously under the control of one guiding idea and one beneficent sovereign. Its appeal went far beyond Europe: automata like our galleon were presented as gifts to the emperor of China and the Ottoman sultan and were greatly prized. What ruler, from Dresden to Kyoto, would not gaze in delight as figures moved to his command in strict and unswerving order? So unlike the messiness of rule in the real world.

Even in the sixteenth century, automata like this were far more than just toys for the rich: they were central to the experimental sciences, mechanics, engineering and the search for perpetual motion, the growing desire to control the world by taking possession of the secrets of its workings. Even more fundamentally, they speak of that urge to imitate life by mechanical means, which would ultimately be the basis of modern automation and cybernetics. You can say that it is around 1600 that our understanding of the whole world as a mechanism really begins to crystallize, seeing the cosmos as a kind of machine, complex and difficult to understand but ultimately manageable and controllable.

The state that the galleon symbolizes, the Holy Roman Empire, was handicapped by its cumbersome structures of government and weakened by religious division, and was heading into very stormy seas. Hemmed in to the east by the Turks, it was about to be overshadowed by the Atlantic-facing states of western Europe – Portugal and Spain, France, England, the Netherlands. These states, backed by the new ocean-going technologies represented by the galleon, were embarking on a dialogue with the rest of the world that would make them rich as never before and ultimately overturn the balance of power in Europe. Sailing in ships like this gilded galleon, they would encounter kingdoms and empires around the world whose sophistication dazzled them, with whom they would trade, whom they would often misunderstand and some of whom they would ultimately destroy. Those ocean-going expeditions have in large measure shaped the world we live in today. In the next chapter I will be looking at the first part of the world that these new ships allowed the Europeans to visit: West Africa.

77

Benin Plaque: The Oba
with Europeans

Brass plaque, from Benin, Nigeria
AD 1500–1600

In 2001 the UK National Census recorded that more than 1 in 20 Londoners were of black African descent, a figure that has continued to rise in the years since. Modern British life and culture now have a strong African component. This development is merely the latest chapter in the history of relations between Africa and western Europe, and in that long and turbulent history the Benin Bronzes, as they used to be known, hold a unique place.

Made in what is now modern Nigeria in the sixteenth century, the Benin plaques are actually made of brass, not bronze. They are each about the size of an A3 piece of paper and show figures in high relief that celebrate the victories of the Benin ruler, the Oba, and the rituals of the Oba's court. They are not only great works of art and triumphs of metal-casting; they also document two quite distinct moments of Euro-African contact – the first peaceful and commercial, the second bloody.

In these chapters we are looking at objects that chart how Europe first encountered and then traded with the wider world in the sixteenth century. These magnificent sculptures record the encounter from the African side. There are several hundred Benin plaques now in European and American museums, and they offer us a remarkable picture of the structure of this West African kingdom. Their main subject is the glorification of the Oba and of his prowess as a hunter and soldier, but they also tell us how the people of Benin saw their first European trading partners.

This plaque is dominated by the majestic figure of the Oba himself. It is about 40 centimetres (16 inches) square; its colour strikes you as coppery rather than brassy, and there are five figures on it, three Africans

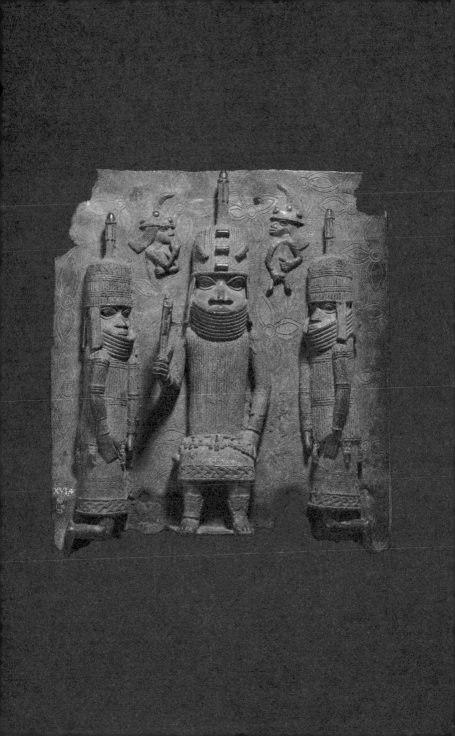

and two Europeans. In the proudest relief, on his throne, wearing a high helmet-like crown and looking straight out at us, is the Oba. His neck is completely invisible – a series of large rings runs from his shoulders right the way up to his lower lip. In his right hand he holds up a ceremonial axe. To either side kneel two high-court functionaries, dressed very like the Oba, but with plainer headdresses and fewer neck-rings. They wear belts hung with small crocodile heads, the emblem of those authorized to conduct business with Europeans – and the heads and shoulders of two tiny Europeans can be seen floating in the background.

The Europeans are Portuguese, who from the 1470s were sailing down the west coast of Africa in their galleons on their way to the Indies, but who were also seriously interested in West African pepper, ivory and gold. They were the first Europeans to arrive by sea in West Africa, and their large ocean-going ships astonished the local inhabitants. Before then, any trade between West Africa and Europe had been conducted through a series of middlemen, who transported goods over the Sahara by camel. The Portuguese galleons, cutting out all the middlemen and able to carry much bigger cargoes, offered a totally new kind of trading opportunity. They and their Dutch and English competitors, who followed later in the sixteenth century, carried gold and ivory to Europe and in return brought commodities from all over the world that were greatly valued by the Oba's court, including coral from the Mediterranean, cowry shells from the Indian Ocean to serve as money, cloth from the Far East and, from Europe itself, larger quantities of brass than had ever before reached West Africa. This was the raw material from which the Benin plaques were made.

All European visitors were struck by the Oba's position as both the spiritual and the secular head of the kingdom, and the Benin brass plaques are principally concerned with praising him. They were nailed to the walls of his palace, rather in the same way that tapestries might be hung in a European court, allowing the visitor to admire both the achievements of the ruler and the wealth of the kingdom. The overall effect was described in detail by an early Dutch visitor:

> The king's court is square ... It is divided into many magnificent palaces, houses and apartments of the courtiers, and comprises beautiful and long square galleries, about as large as the Exchange at Amsterdam,

from top to bottom covered with cast copper, on which are engraved the pictures of their war exploits and battles, and are kept very clean.

Europeans visiting Benin in the fifteenth and sixteenth centuries discovered a society every bit as organized and structured as the royal courts of Europe, with an administration able to control all aspects of life, not least foreign trade. The court of Benin was a thoroughly international place, and this is one aspect of the Benin plaques that fascinates the Nigerian-born sculptor Sokari Douglas Camp.

> Even when you see contemporary pictures of the Oba, he has more coral rings than anybody else and his chest piece has more coral on it. The remarkable thing about Nigeria is that all the coral and things don't actually come from our coast, they come from Portugal and places like that. So all of that conversation has always been very important to me – we have things that are supposed to be totally traditional yet they are traditional through trade.

The brass needed to make the plaques was usually transported in the form of large bracelets – called *manillas* – and the quantities involved are staggering. In 1548 just one German merchant house agreed to provide Portugal with 432 tons of brass *manillas* for the West African market. When we look again at the plaque, we can see that one of the Europeans is indeed holding a *manilla*, and this is the key to the whole scene: the Oba is with his officials who manage and control the European trade. The three Africans are in the foreground and are on a far bigger scale than the diminutive Europeans, both of whom are shown with long hair and elaborate feathered hats. The *manilla* shows that the brass brought from Europe is merely the raw material from which Benin craftsmen would create works of art like this; and the plaque itself is a document that makes clear that this whole process is controlled by the Africans. Part of that control was a total prohibition on the export of the brass plaques. So, although carved ivories were exported from Benin in the sixteenth century and were well known in Europe, the Benin plaques were reserved to the Oba himself and were not allowed to leave the country. None had been seen in Europe before 1897.

On 13 January 1897, *The Times* announced news of a 'Benin Disaster'. A British delegation seeking to enter Benin City during an

important religious ceremony had been attacked and some of its members killed. The details of what actually happened are far from clear and have been vigorously disputed. Whatever the real facts, the British, in ostensible revenge for the killing, organized a punitive expedition which raided Benin City, exiled the Oba and created the protectorate of Southern Nigeria. The booty from the attack on Benin included carved ivory tusks, coral jewellery and hundreds of brass statues and plaques. Many of these objects were auctioned off to cover the costs of the expedition and were bought by museums across the world.

The arrival and the reception of these completely unknown sculptures caused a sensation in Europe. It is not too much to say that they changed European understanding of African history and African culture. One of the first people to encounter the plaques, and to recognize their quality and their significance, was the British Museum curator Charles Hercules Read:

> It need scarcely be said that at the first sight of these remarkable works of art we were at once astounded at such an unexpected find, and puzzled to account for so highly developed an art among a race so entirely barbarous ...

Many wild theories were put forward. It was thought that the plaques must have come from ancient Egypt, or perhaps that the people of Benin were one of the lost tribes of Israel. Or the sculptures must have derived from European influence (after all, these were the contemporaries of Michelangelo, Donatello and Cellini). But research quickly established that the Benin plaques were entirely West African creations, made without European influence. The Europeans had to revisit, and to overhaul, their assumptions of easy cultural superiority.

It is a bewildering fact that by the end of the nineteenth century the broadly equal and harmonious contacts between Europeans and West Africans established in the sixteenth century had disappeared from European memory almost without leaving any trace. This is probably because the relationship was later dominated by the transatlantic slave trade and, later still, by the European scramble for Africa, in which the punitive expedition of 1897 was merely one bloody incident. That raid and the removal of some of Benin's great artworks may have spread knowledge and admiration of Benin's culture to the world, but

it has left a wound in the consciousness of many Nigerians – a wound that is still felt keenly today, as Wole Soyinka, the Nigerian writer and Nobel laureate, describes:

> When I see a Benin Bronze, I immediately think of the mastery of technology and art – the welding of the two. I think immediately of a cohesive ancient civilization. It increases a sense of self-esteem because it makes you understand that African society actually produced some great civilizations, established some great cultures, and today it contributes to one's sense of the degradation that has overtaken many African societies, to the extent that we forget that we were once a functioning people before the negative incursion of foreign powers. The looted objects are still today politically loaded. The Benin Bronzes, like other artefacts, are still very much a part of the politics of contemporary Africa and, of course, Nigeria in particular.

The Benin plaques, powerfully charged objects, still move us today as they did when they first arrived in Europe, a hundred years ago. They are arresting works of art, evidence that in the sixteenth century Europe and Africa were able to deal with each other on equal terms, but also contested objects of the colonial narrative.

Double-headed Serpent

Mosaic-decorated figurine, from Mexico
AD 1400–1600

Any visitor to Mexico City today is likely to hear the sounds of busk-
ers beating Aztec-style drums and wearing feathers and body paint.
These buskers are not just trying to entertain passers-by: they are trying
to keep alive the memory of the lost Aztec Empire, that powerful, highly
structured state that dominated Mexico in the fifteenth century. The
buskers would have us believe, and you can believe it if you like, that
they are heirs of Moctezuma II, the emperor whose realm was brutally
overthrown by the Spaniards in the great conquest of 1521.

In the course of the Spanish conquest much of Aztec culture was
destroyed. So how much can we actually know about the Aztecs whom
these buskers are honouring? Virtually all the accounts of the Aztec
Empire were written by the Spaniards who overthrew it, so they have
to be read with considerable scepticism. It is all the more important,
then, to be able to examine what we can consider unadulterated Aztec
sources, the things made by them that have survived. These things are
the documents of this defeated people, and through them we can, I
think, hear the vanquished speak.

At the beginning of the sixteenth century the Aztecs, of course, had
no idea that they were on the brink of destruction – they were a young
and vigorous empire triumphantly in possession of territory and trad-
ing networks that ran from Texas in the north to Guatemala in the
south and included the great bulk of modern Mexico. They had a
flourishing culture that produced elaborate works of art more precious
to them than gold – turquoise mosaics.

When some of these mosaics and other Aztec treasures were
first brought to Europe by the Spanish in the 1520s they caused an

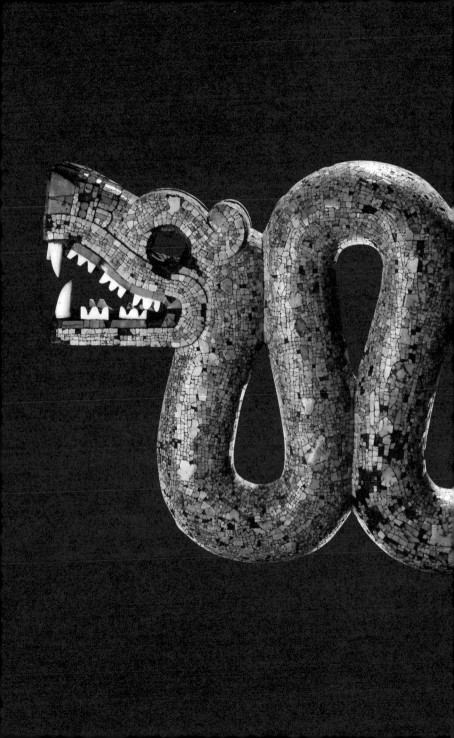

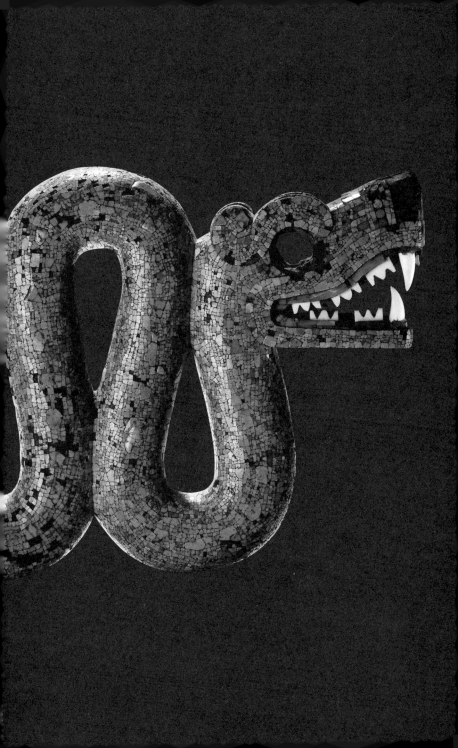

enormous stir – this was the first glimpse of a great civilization in the Americas, completely unknown to Europeans, and evidently every bit as sophisticated and luxurious as their own. This double-headed serpent is one of the most highly crafted and strangely compelling of these rare Aztec survivals.

The serpent is made out of about 2,000 small pieces of turquoise set on to a curved wooden frame, about 40 centimetres (16 inches) wide and half as high. The snake, one body shared by two heads, is in profile; the body curls up and down in a W shape, to finish at each end in a savage, snarling, head. The body of the snake is entirely in turquoise, but a brilliant red shell has been used for the snouts and the gums, and the teeth are picked out in white shell culminating in huge, terrifying fangs. As you move up and down in front of it, and let the light play over the turquoise, the changing colours seem to live, and the pieces look not so much like scales on a snake as feathers shimmering in the sunlight. It is an object which is at once both snake and bird. It is mysterious and disturbing, a work of high artifice and a vehicle of primal power. You know you are in the presence of magic.

The way that the serpent was made gives us a lot of useful information. In the British Museum's Conservation Department, Rebecca Stacey has been examining the materials that make up the object, as well as the resins or glue that hold the 2,000-odd pieces together.

> We have done a range of analyses and looked at the variety of different shells that are present. The bright red shell used on the mouth and around the nose is from the thorny oyster, which was a really highly prized shell in ancient Mexico because of this fabulous scarlet red colour and also because it involved diving to great depths. Even the adhesives, which are plant resins, were important ritual materials because they are the same materials that were used as incense and as ritual offerings – a very important ceremonial life of their own. A number of different plant resins were used: pine resin, fairly familiar, and also tropical bursera resin, which is a much more aromatic resin very much associated with incense and still used in incense in Mexico today.

So the different elements of this magical object are held together – almost literally – by the glue of faith. Rebecca Stacey and scientists across the world have established that turquoise in Aztec Mexico was

transported over huge distances – some pieces were mined more than a thousand miles from the capital Tenochtitlán, now Mexico City. Goods like turquoise and the shells and resin were traded widely across the region, but it is more likely that the components of our serpent were forcibly exacted as tribute – compulsory levies from peoples whom the Aztecs had conquered. This empire had been created in the 1430s, less than a century before the Spaniards arrived, and was maintained by aggressive military power and tribute of gold, slaves and turquoise sent regularly (and reluctantly) to Tenochtitlán from the subject provinces. The wealth generated by this trade and tribute allowed the Aztecs to build roads and causeways, canals and aqueducts, as well as major cities – urban landscapes that astonished the Spaniards as they marched through the empire:

> During the morning, we arrived at a broad causeway and continued our march ... and when we saw so many cities and villages built in the water and other great towns on dry land, we were amazed and said that it was like the enchantments they tell of in the legends of Amadis, on account of the great towers and buildings rising from the water and all built of masonry. And some of our soldiers even asked whether the things that we saw were not a dream.

Turquoise was highly prized and was the focus of great rituals, designed both to impress and to intimidate – part of the 'shock and awe' that keeps imperial administrations in place. We know about this through the writings of Diego Durán, a Dominican friar who was extremely sympathetic to the Aztecs, learning their language and transmitting their culture and their history. So although he was Spanish we can probably rely on his account of a tribute ceremony:

> People attended with their tribute of gold, jewels, finery, feathers and precious stones, all of the highest value and in great quantities ... so many riches that they could not be counted or valued. All of this was done to show off magnificence and lordship in front of their enemies, guests and strangers, and to instil fear and dread.

Turquoise was also a key element in the regalia of the Aztec ruler Moctezuma II, who conducted great rites of human sacrifice wearing a turquoise diadem, turquoise nose plug and a loin cloth with turquoise

beads. The two-headed serpent was almost certainly worn or carried in such a religious ceremony, perhaps even at Moctezuma's accession to the throne in 1502. It would have held great symbolic value, not only because of its precious turquoise but also because it is fashioned as a fabulous snake. The poet and writer Adriana Diaz Enciso explains the snake's connection to the Aztec gods, especially the great feathered serpent god, Quetzalcóatl.

> The snake was important for the Aztecs as a symbol of regeneration and resurrection. In the temple of Quetzalcóatl in Tenochtitlán you can see some sculptural reliefs of snakes that are pouring water out of their mouths and the water is falling on the crops to help them grow. So it has that meaning of fertility. You see them also painted on the walls of the pyramids and the temples. The figure of Quetzalcóatl is seen in several sculptures and drawings as a snake with a body covered with feathers. The fusion of this bird, the quetzal, and the snake, which is a symbol of the earth, is a fusion of the powers of heaven and the powers of the earth, so in that sense it's also a symbol of eternity and of renewal.

When we look again at the double-headed snake, it becomes clear that the tiny, carefully angled turquoise pieces are not far off the colour of the blue-green tail feathers of the quetzal bird, and they have been cut and bevelled to shimmer and flash just like the quetzal's iridescent feathers. The double-headed serpent may indeed be a representation of the god Quetzalcóatl and, if so, this would link it directly to the momentous events surrounding the Spanish general Hernán Cortés's arrival in Mexico.

Spanish accounts at the time recorded the encounter between Cortés and Moctezuma, and state that Moctezuma saw Cortés as an incarnation of the god Quetzalcóatl. Aztec legend told that Quetzalcóatl had floated out into the Atlantic and would one day return as a bearded and fair-skinned man; so, the Spanish tell us, instead of summoning his troops, Moctezuma presented Cortés with the homage and the exotic gifts fit for a god. One of these was reported to be 'a serpent wand inlaid with turquoise'. It might even have been this double-headed serpent.

We shall never know the full truth. But we do know that the Aztec tribute system was fiercely resented and led many of the subject peoples to join the Spanish invaders. Without the support of these disaffected

local armies, the Spanish would never have been able to conquer Mexico. Appropriately, the double-headed serpent tells both stories. It is a document of the Aztec Empire at the height of its artistic, religious and political power; it is also evidence of the systematic oppression of its subject peoples that ultimately destroyed it. Soon Moctezuma was dead and Tenochtitlán was reduced by the Spaniards to smoking rubble. With no emperor and no capital, the Aztec empire was effectively at an end. These catastrophes were swiftly followed by the impact of devastating European diseases, especially smallpox. It has been suggested that as much as 90 per cent of the local population died within a couple of decades of the arrival of the Spaniards. Mexico would become just one important part of Spain's vast empire in the Americas that stretched from California to Chile and Argentina – an empire, as we will see, that would have an impact beyond just Spain and the Americas.

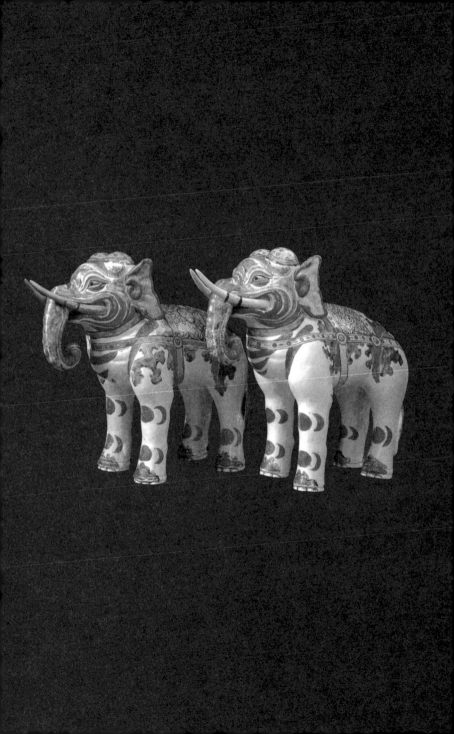

79

Kakiemon Elephants

Porcelain figurines, from Japan
AD 1650–1700

For a large part of the world, white elephants have always been signs of power and portent. They were prized by monarchs of south-east Asia; the Buddha's mother dreamt of one before giving birth to him. They were also a mixed blessing – as a gift from a king, they could not honourably be put to work and were horribly expensive to keep. A 'white elephant' has become our term for a useless extravagance. We have two almost white elephants in the British Museum. They're perfectly useless and they're expensive (they would have cost thousands of pounds in today's terms) but they're exceedingly jolly to look at, and they tell an unexpected story of the triangular power struggles between China, Japan and Korea in the seventeenth century – and of the birth of the modern multinational company.

The elephants in the British Museum were shipped to Europe from Japan sometime between 1660 and 1700. They are about the size of Yorkshire terriers, and you know they are elephants essentially because they have trunks and tusks. Otherwise they are pretty startling. The body is of white porcelain, a beautiful milky white, and over that, painted in enamel, is broad decoration – patches of red on the legs, blue patterning over the backs, which is clearly meant to represent a harness, and a primrose-yellow edged in red on the insides of the ears – which are clearly the ears of an Asian elephant. The eyes, equally clearly, are Japanese eyes. There can be little doubt that the artist who made these elephants is imagining a creature that he has never seen, and there is no doubt at all that this artist is Japanese.

Our high-spirited porcelain elephants are a direct consequence of Japan's complex relations with her neighbours China and Korea, but

they also show the impact of the close trading links between Asia and western Europe in the sixteenth and seventeenth centuries. Ever since this direct contact began, Europe has periodically been seized by a passion for the arts and crafts of Japan. It all started in the seventeenth century with a craze for Kakiemon-style porcelain, a specific technique said to have been devised by an entrepreneur potter named Kakiemon that became a traditional Japanese craft technique, passing through generations of potters. Our elephants are Kakiemon-style elephants, and they and other Kakiemon creatures rampaged decoratively over furniture and mantelpieces in the great houses of seventeenth-century Europe. One of the finest and earliest collections of these Japanese porcelain animals is at Burghley House in Lincolnshire, which also has Kakiemon elephants.

Miranda Rock, a direct descendant of the Lord Exeter who collected the porcelain, describes how he came by the objects:

> This porcelain is really the success of our great collector John, the fifth Earl of Exeter, and his wife, Anne Cavendish, who were very enthusiastic Grand Tourists. We know the Japanese porcelain was here in 1688 because it is mentioned in the inventory, but we have to assume that there was a very astute dealer who John had close contact with, because there is an enormous amount of it here at Burghley and it was much in vogue at the time. And we've got some lovely pieces here with Japanese figures and these wonderful elephants.

We have tracked down the potter Kakiemon the 14th, who claims descent from the technique's original creators and is today himself a Japanese Living National Treasure. He may indeed be the direct descendant of the very craftsman who decorated Lord Exeter's menagerie around 400 years ago. He lives and works in Arita, the birthplace of Japanese porcelain, where his family have been potters for centuries:

> The Kakiemon family has been making coloured porcelain in the Kakiemon style for nearly 400 years. There is plenty of porcelain stone in and around Arita that has weathered and naturally oxidized over thousands of years. The Kakiemon family has used this natural material since the Edo period. It normally takes around thirty to forty years to master the technique and acquire the skill, and training the next generation is always a big challenge.

The glaze applied to the elephants' skin is called *nigoshide*. This technique was particularly developed in Arita, and we have been trying to preserve it. It's not a pure white but a warm, milky white. I can say that it's the starting point of the Kakiemon-style porcelain in the Edo period.

I use traditional tools. This is true of many Japanese craftsmen and keeps the traditional techniques alive. Japan has its own aesthetic and strives to maintain it. People may think that I am only following the old path, but I think my work is contemporary with traditional elements incorporated. We consider the British Museum elephants unique. I myself own one small elephant at home.

China is, as we all know, the home of porcelain and had for centuries been exporting it in industrial quantities. By the sixteenth century Europe was in the grip of porcelain mania, with a particular hunger for the famous blue and white (see Chapter 64). The appetite of the European rich was insatiable and Chinese supply struggled to keep up with demand, as a frustrated Italian merchant recorded in 1583:

> Now there remain to us nothing but the leavings, for here they deal with porcelain as a hungry man with a plate of figs, who begins with the ripest, and then feels the others with his fingers, and chooses one after another of the least firm until none are left.

But new suppliers were about to enter this burgeoning market. By the fifteenth century, Korea had acquired from the Chinese the skill and the knowledge to make porcelain. It was war that spread those secrets on to Japan. In the late sixteenth century, Japan was united under a single military leader of massive ambition – Toyotomi Hideyoshi – who in the 1590s launched two attacks on Korea which he saw as mere preliminaries to taking over China from the Ming Dynasty. The takeover of China and Korea failed, but in the process Japan picked up valuable potting skills – and some of the potters who practised them – from the Korean peninsula. The Korean scholar Gina Ha-Gorlan describes the long dynamic between the three cultures:

> Korea, China and Japan have kept close relationships since pre-historic times. In cultural exchanges, China often developed and advanced skills and techniques first, Korea then adopted them and then introduced them to Japan. Sampan Lee was a Korean potter who was taken from

Korea to Japan during the Japanese invasion of the late sixteenth century. It's interesting to note that this war is often referred to as the 'potters war', because so many Korean potters were taken to Japan in an attempt to transfer the white-porcelain manufacturing skills to Japan. So this Kakiemon elephant statue is a combination of Korean manufacturing technique, Chinese decorative skills and Japanese taste.

Around 1600 Japanese ceramics had two great strokes of luck. First there was the great boost, both in manpower and technology, given to the ceramics industry as a result of the Korean wars of the 1590s. Then, in 1644, the Ming Dynasty in China was overthrown, and in the ensuing political chaos Chinese production of porcelain collapsed, leaving the European market wide open. It was the perfect opportunity for the Japanese, who stepped in to take China's place in the porcelain export business and for a brief period were able to dominate the European market. Kakiemon-style production expanded swiftly in response to European taste, creating new shapes, sizes, designs and, above all, colours, adding brilliant reds and yellows to the traditional Chinese blue and white. Europeans bought them in large quantities and, eventually, began to copy them. By the eighteenth century, Germany, England and France had all started to produce their own home-grown 'Kakiemon'. So, in one of those bizarre and unpredictable twists of history, the first porcelain to be imitated by Europeans came not from China but from Japan.

The agent for all this, driving innovation both in Europe and in Japan, was the world's first multinational – the Dutch East India Company, with its unparalleled concentration of resources, contacts and experience. From their magnificent new headquarters in Amsterdam, the merchants and administrators of the Company operated an ocean-spanning trading operation that for nearly a century would dominate the commerce of the whole world.

Japan was at this point being run by the Shoguns, who in 1639, to strengthen their control of the country closed off contact with the outside world. The Japanese kept open just a few carefully managed 'gateways', especially the port of Nagasaki, and there they allowed a few privileged states to conduct business. These states included Korea and China, and just one European partner – the Dutch East India Company. This exclusivity allowed the Company to transport Japanese

porcelain to Europe in ever-growing quantities, and, as a monopoly supplier, they could charge high prices and make very large profits. The first substantial shipment from Japan, for example, arrived in Holland in 1659 and contained 65,000 items. Our elephants certainly came to Europe on a Dutch East India Company ship.

The British Museum's Kakiemon elephants tell a story of the whole world in the seventeenth century. Japanese craftsmen, although cut off from the outside world, were using techniques borrowed from China and Korea to make images of animals from India, to suit the tastes of purchasers in England, mediated by the Dutch through the first trading company with a truly global reach. It is a fine example of how the continents of the world were for the first time being linked together by ships and by trade. This new world now needed a functioning means of exchange – an international currency. The next chapter describes what underpinned these early years of worldwide commercial activity: silver, mined in South America, minted into Spanish pieces of eight and exported to the world – the first global money.

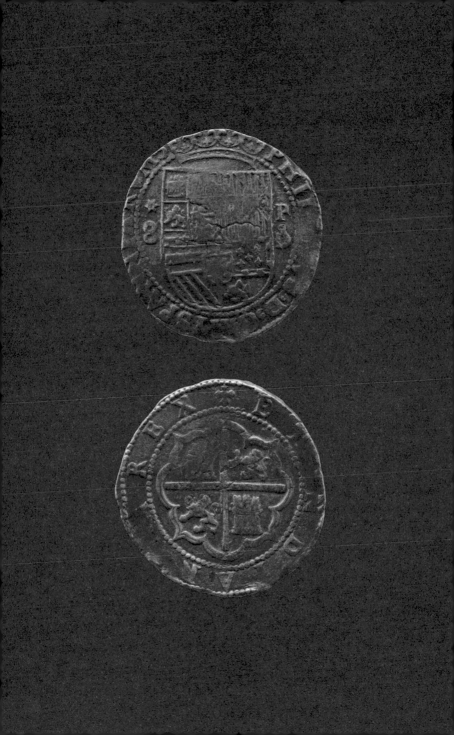

80

Pieces of Eight

Spanish coins, minted in Potosí, Bolivia
MINTED AD 1573–1598

Money, advertisers assure us, will let us buy our dreams. But some money, and especially coins, is already the stuff of dreams, with names that ring to the magic of history and legend – ducats and florins, groats, guineas and sovereigns. But none of those can compare with the most famous coins of all – pieces of eight. Familiar in books and films from *Treasure Island* to *Pirates of the Caribbean*, they carry with them a freight of associations – of armadas and treasure fleets, wrecks, battles and pirates, the high seas and the Spanish Main.

But it isn't just thanks to Long John Silver's parrot that pieces of eight are the supreme celebrity among world currencies. For the *peso de ocho reales*, the Spanish piece of eight, was the first truly global money. It was produced in huge numbers, and within twenty-five years of its first minting in the 1570s it had spread across Asia, Europe, Africa and the Americas, establishing a global dominance that it was to maintain until well into the nineteenth century.

By modern standards a piece of eight is a large coin. It is about 4 centimetres (1.5 inches) across and has a good weight – roughly the same as three £1 coins. This particular coin is a dullish silver colour, thanks to surface corrosion, but when it was freshly minted a piece of eight would have glittered and shone. Around 1600 this piece of eight would probably have bought, in modern terms, something like £50 worth of goods – and could have been spent practically anywhere in the world.

The Spaniards had been drawn to America by the lure of gold, but what made them rich there was silver. They quickly found and exploited silver mines in Aztec Mexico, but it was in Peru, in the 1540s, that they really hit the silver jackpot – at the southern end of the Inca

Empire at a mountainous place called Potosí, now in Bolivia, which quickly became known as the Silver Mountain. Within a few years of the discovery of the Potosí mines, silver from Spanish America began to pour across the Atlantic, growing from a modest 148 kilos a year in the 1520s to nearly three million kilos a year in the 1590s. In the economic history of the world, nothing on this colossal scale, or with such grave consequences, had ever happened before.

The isolated hill of Potosí sits 3,700 metres (12,000 feet) above sea level, on a high, arid and very cold plateau in the Andes – one of the most inaccessible parts of South America. Despite this remoteness, the silver mines required so much labour that by 1610 the population of this village had grown to 150,000, making it a major city by European standards of the day, and an unimaginably rich one. In 1640, a Spanish priest rhapsodized about the mine and what it was producing:

> The abundance of silver ores ... is so great that, if there were no other silver mines in the world, they alone would suffice to fill it with wealth. In their midst is the hill of Potosí, never sufficiently praised and admired, the treasures whereof have been distributed in generous measure to all the nations of the world.

Without Potosí, the history of sixteenth-century Europe would be very different. It was American silver that made the Spanish kings Europe's most powerful rulers and paid for their armies and armadas. It was American silver that allowed the Spanish monarchy to fight the French and the Dutch, the English and the Turks, establishing a pattern of expenditure that was ultimately to prove ruinous. Yet for decades the flow of silver provided rock-solid credit for Spain through the direst crises and bankruptcies: it was assumed that next year there would *always* be another treasure fleet, and there always was. 'In silver lies the security and strength of my monarchy,' said King Philip IV.

The production of this wealth came at a huge cost in human life. At Potosí young native American men were conscripted and forced to labour in the mines. Conditions were brutal, indeed lethal. In 1585 one eyewitness reported:

> The only relief they have from their labours is to be told they are dogs, and to be beaten on the pretext of having brought up too little metal, or

taken too long, or that what they have brought is earth, or that they have stolen some metal. And less than four months ago, a mine-owner tried to chastise an Indian in this fashion, and the leader, fearful of the club with which the man wished to beat him, fled to hide in the mine, and so frightened was he that he fell and broke into a hundred thousand pieces.

In the freezing high altitude of the mountains, pneumonia was a constant danger, and mercury poisoning frequently killed those involved in the refining process. From around 1600, as the death rate soared among the local Indian communities, tens of thousands of African slaves were brought to Potosí to replace them. They proved more resilient than the local population, but they, too, died in large numbers. Forced labour in the silver mines of Potosí remains the historic symbol of Spanish colonial oppression.

Disturbingly, and to the dismay of many Bolivians, the Potosí silver mine is still a tough and unhealthy place to work. The Bolivian former head of a Potosí UNESCO project, Tuti Prado, tells us about it:

> Potosí, for today's population, is one of the poorest places in the country. Of course, the technology is different, but the poorness, the health, is as bad as 400 years ago. We have a lot of children working in the mines, and many of the miners don't live more than 40–45 years – even 35 years of age – because of silicosis of the lungs and because of the dust.

The Potosí mines produced the raw material that made Spain rich, but it was the Potosí mint, fashioning the silver pieces of eight, which laid the foundations of a global currency. From Potosí the coins were loaded on to llamas for the two-month trek over the Andes to Lima and the Pacific coast. There, Spanish treasure fleets took the silver from Peru up to Panama, where it was carried by land over the isthmus and then across the Atlantic in convoys.

But this silver trade was not centred only on Europe – Spain also had an Asian empire, based in Manila in the Philippines, and pieces of eight were soon crossing the Pacific in huge numbers. In Manila, pieces of eight were exchanged, usually with Chinese merchants, for silks and spices, ivory, lacquer and, above all, porcelain. The arrival of Spanish-American silver destabilized the East Asian economies and caused financial chaos in Ming China. Indeed there was hardly any

part of the world that remained unaffected by these ubiquitous coins.

In the coin collection of the British Museum there is a display that gives a wonderfully clear idea of the global role of pieces of eight made in the Spanish-American mints. One coin has been counter-stamped by a local sultan in Indonesia, while others were stamped by the Spanish themselves for use in their province of Brabant, now in modern Belgium. Other coins here have been inscribed with Chinese merchants' stamps, and a coin from Potosí was found near Tobermory in the Hebridean islands off the west coast of Scotland; it comes from a ship that was once part of the Spanish Armada, wrecked in 1588. Pieces of eight even reached Australia in the nineteenth century. When the British authorities ran out of currency there, they bought Spanish pieces of eight, cut out the Spanish king's face and re-engraved them to read FIVE SHILLINGS, NEW SOUTH WALES. The presence of these coins from the Hebrides to New South Wales shows that, both as a commodity and as a coin, pieces of eight engendered a fundamental shift in world commerce, as the financial historian William Bernstein describes:

> This was a godsend, this Peruvian and Mexican silver, and very quickly hundreds of millions and perhaps even billions of these coins got minted, and they became the global monetary system. They were the Visa and the MasterCard and the American Express of the sixteenth through to the nineteenth centuries. They are pervasive enough that when you, for example, read about the tea trade in the eighteenth and nineteenth centuries in China, which was a vast trade, you see prices accounted for in dollars, with dollar signs; and of course what they were talking about were Spanish dollars – these pieces of eight.

Across Europe, Spanish-American treasure inaugurated an age of silver, 'the wealth which walketh about all the countries of Europe'.

But the very abundance of silver brought a new set of problems. It increased the money supply – much like governments printing money in modern terms. The consequence was inflation. In Spain there was bemusement, as the wealth of empire in both political and economic terms often seemed more apparent than real. Ironically, silver coin became a rarity within Spain itself, as it haemorrhaged out to pay for foreign goods while local economic activity declined.

As gold and silver vanished from Spain, its intellectuals grappled

When the British authorities in Australia wanted to create a local currency, they converted Spanish pieces of eight into five-shilling coins

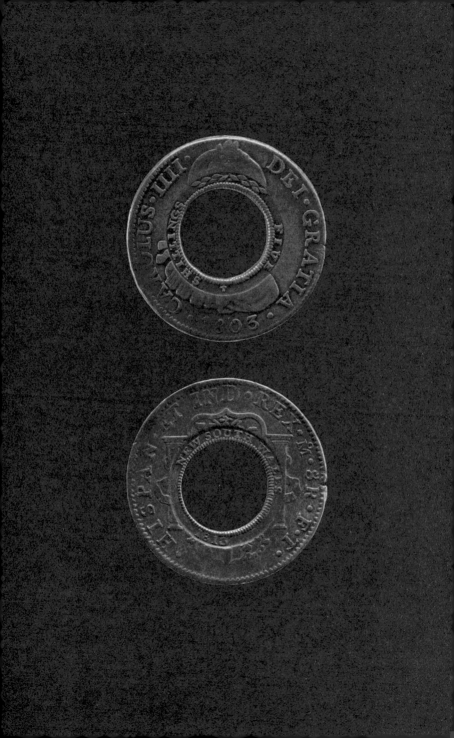

with the gulf between the illusion and the reality of wealth, and the moral consequences of the country's unexpected economic troubles. One writer in 1600 describes it like this:

> The cause of the ruin of Spain is that riches ride on the wind, and have always so ridden in the form of contract deeds, of bills of exchange, of silver and gold, instead of goods that bear fruit and which, because of their greater worth, attract to themselves riches from foreign parts, and so our inhabitants are ruined. We therefore see that the reason for the lack of gold and silver money in Spain is that there is too much of it and Spain is poor because she is rich.

More than four centuries later we are still struggling to understand world financial markets and to control inflation.

Potosí remains proverbial for its wealth. Spaniards today still say something is 'vale un Potosí – 'worth a fortune' – and the Spanish piece of eight lives on as a romantic prop in fantasy pirate stories. But it was in fact one of the foundation stones of the modern world, underpinning the first world empire, both prefiguring and making possible the modern global economy.

PART SEVENTEEN

Tolerance and Intolerance

AD 1550–1700

The Protestant Reformation split the western Christian Church into two rival factions and triggered major religious wars. The failure of either side to achieve victory in the Thirty Years War would lead, through exhaustion, to a period of religious tolerance in Europe. Three great Islamic powers dominated Eurasia: the Ottomans in Turkey, the Mughals in India and the Safavids in Iran. The Mughals promoted religious tolerance, allowing the Indian subcontinent's largely non-Islamic population to continue to worship as they pleased. In Iran the Safavids created the world's first major Shi'a state. At the same time, conquest and trade redrew the religious map of the world, and both Catholicism in the Americas and Islam in south-east Asia sought to accommodate the existing rituals of their new converts.

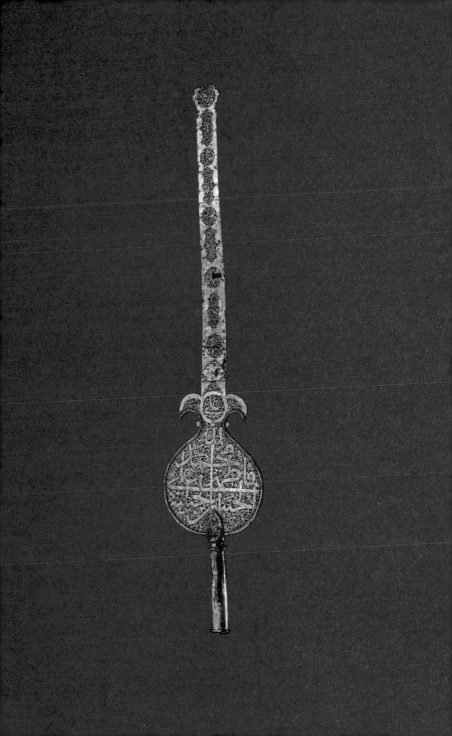

81

Shi'a Religious Parade Standard

Gilded brass parade standard, from Iran
AD 1650–1700

It comes as a surprise to most tourists visiting Isfahan, the capital of Shi'a Iran in the seventeenth century, to discover in that very Islamic city one of the world's great Christian cathedrals, full of silver crucifixes and wall-paintings telling the narratives of biblical redemption. This cathedral was built in the first half of the seventeenth century by Shah Abbas I, the great ruler of early modern Iran, and provides a superb example of how the world map of religion was redrawn in the sixteenth and seventeenth centuries. The question at the centre of that redrawing was whether a state could hold more than one faith; the answer to it, in sixteenth- and seventeenth century Iran, was that it most certainly could. But the monotheistic faiths have always found it difficult to live together for long, and religious tolerance among them is usually both contested and fragile. In this chapter I will be exploring the situation in seventeenth-century Iran through an 'alam – a lavishly gilded ceremonial brass standard. 'Alams were originally battle standards, designed to be carried like flags into the fight, but in seventeenth-century Iran they were used in great religious processions and rallied not warriors but the faithful.

Shah Abbas was a member of the Safavid Dynasty, which came to power around 1500 and established Shi'a Islam as the state religion of Iran, a position it has held ever since. There is an interesting parallel with events in Tudor England, which became officially Protestant at about the same time as Iran became Shi'a. In both countries religion became a defining element of national identity, setting the nation apart from its hostile neighbours – Protestant England from Catholic Spain, Shi'a Iran from its Sunni neighbours, above all Turkey.

Shah Abbas, a contemporary of Elizabeth I of England, was a ruler of rare political nous and even rarer religious pragmatism. Like Elizabeth, he was keen to develop international trade and contact. He invited the world to visit his capital in Isfahan, welcoming Chinese envoys at the same time as hiring Englishmen as advisers; he expanded his borders and in the process captured Armenian Christians whom he brought back to Isfahan. There the Armenians developed the highly profitable trade in silks and textiles with the Middle East and Europe, and in return Shah Abbas built for them a Christian cathedral. Visiting Europeans were astonished by this active religious tolerance, with Christians and Jews, each with their own places of worship, peacefully accommodated within a Muslim state – a level of religious diversity unthinkable in Christian Europe at the time. Isfahan was of course a centre for Islamic scholarship and a place where architecture, painting and high craft in silks, ceramics and metalwork were all put to the service of the faith.

This Shi'a Iran of the Safavid shahs, sophisticated and cosmopolitan, prosperous and devout, which lasted for more than 200 years, can still be seen in this 'alam, made around 1700. It is approximately sword-shaped, with a disc between the blade and the handle, and is 127 centimetres (50 inches) high. It is made of gilded brass typical of the metalworking tradition that had evolved in Iran and especially in Isfahan, where merchants and craftsmen from India, the Near East and Europe met and traded.

But however cosmopolitan the style and skill, this 'alam was made specifically for use in a Shi'a Muslim ceremony, mounted on a long pole and carried high in procession through the streets. The blade of the sword has been transformed into a filigree of words and patterns. The words are effectively a declaration of faith, and words like this are part of the physical fabric of Shi'a Isfahan.

The Mosque of Shaykh Lutfallah was built by Shah Abbas at the same time as he built the cathedral for the Christians. It is a monument to the word: the structural elements of the architecture are all marked out and decorated with inscriptions, the words of God, the words of the Prophet or other holy texts. In fact, the words appear to hold the building up. Over the mihrab, the central niche, which marks the direction of Mecca towards which the faithful should pray, are

Isfahan Cathedral, built in the first half of the seventeenth century by Shah Abbas I, combines Christian iconography with Islamic design

written the names of the Ahl al-Bayt, the family of the house – that is, the family of the Prophet. There are the names of the Prophet Muhammad himself, Fatima, the Prophet's daughter, her husband Ali, and their sons Hassan and Husain.

We find the same names on the 'alam in the British Museum's galleries. Ali is mentioned three times. For Shi'a Muslims, Ali was the first imam, or spiritual leader, of the faithful, and this kind of 'alam is known as 'The Sword of Ali'. Elsewhere on the 'alam are the names of the ten other Shi'a imams – all descended from Ali and all, like him, martyred. As this 'alam was carried through the streets the faithful would see the names of the Prophet, of Fatima, of Ali and of all the other imams.

Shi'ites hold that the office of imam – infallible religious guide – belongs to the house of Muhammad alone and so to the descendants of Ali, the Prophet's son-in-law. By contrast, the majority of Sunni Muslims accepted the authority of the caliph, originally an elected office. In the decades after the Prophet's death, these differing views led to bloody conflict, during which Ali and his sons were all killed – the beginning of a tradition of martyred Shi'a imams.

The Shi'ism of the Safavids was *Ithna 'Ashari*, or Twelver Shi'ism, which holds that there are twelve imams, of whom eleven died as martyrs and are named on the 'alam itself. The Twelfth Imam is said to have vanished in 873 and to be in hiding, awaited by the faithful and to be restored by God when it pleases him, at which point Shi'a dominion will be established on earth. Until then, the Safavid shahs, who also claimed descent from the Prophet, were the temporary proxy for the hidden imam. Authority in religious matters, however, lay not with the shah, but with the ulema – the body of Islamic scholars and jurists responsible for interpreting Islamic law, as indeed they still are today.

Haleh Afshar, an Iranian-born academic, reflects on the position of Shi'ism in the life and politics of Iran over the centuries, and its role in both the Constitutional Revolution of 1907 and the Islamic Revolution of 1979:

Shi'ism for centuries was the small part of Islam that was very different and a group which was not a part of any establishment. In fact Shi'ites were always in the process of contestation and on the margins. With the arrival of the Safavids, who declared Shi'ism as the national religion of

The names of the family of the Prophet 529
are written above the central mihrab of
the Mosque of Shaykh Lutfallah

Iran, we begin to have the establishment of a religious institution with a hierarchy and one that has some kind of influence on policy. That is something quite new in terms of Iranian history. It is a process that has continued through the centuries, and the religious establishment very often has been at the forefront of revolutions, for example the Constitutional Revolution in 1907, in which religious leaders were demanding the establishment of a house of justice and a constitution, and also the 1979 revolution, again in the name of justice, which is a constant theme at the core of Shi'ism.

This heightened sense of justice perhaps has its roots in the very essence of Shi'ism – its focus on victims and martyrs. By the late seventeenth century, when this 'alam was made, elaborate ceremonial processions commemorating the deaths of the martyrs featured chain-swinging flagellants, rhythmic movement, music and chanting. This illustrates the paradoxical nature of the British Museum's 'alam. Sword-like in form and name and thus at first sight triumphalist and aggressive, it was in fact used in Shi'a ceremonies that commemorated defeat, suffering and martyrdom.

Present-day 'alams are sometimes enormous. No longer a single blade of metal, they are great structures covered in decorated cloth, which can span a whole road's width – and yet they are often borne by one man.

We spoke to one of the elders of the Iranian community in northwest London, Hossein Pourtahmasbi, who describes how the tradition of carrying 'alams continues today:

First of all you have to be a good weightlifter, because it's quite heavy. It sometimes goes up to 100 kilograms, but it's not just a matter of weight – it's the balancing and unbalancing shape of the 'alam, which is huge and wide. You have to be very physically fit for that, and the people are either wrestlers or weightlifters and physically strong and well known by that society. But to be a strong man is not enough: in that community the people have got to know you as well, because it's tradition that gives you admission. It's keeping the memory alive, and it keeps you strong; you keep singing the songs, keeping the tradition and carry on!

By the time our 'alam was made, around 1700, this kind of muscular fervour had become a key element of Shi'a ceremonies. But the equilibrium between different faiths achieved by Shah Abbas was abandoned by his successors. The last Safavid shah, Husayn, was harshly intolerant of non-Shi'ites and gave religious leaders extensive powers to regulate public behaviour, a religious repression that may have contributed to his downfall. In 1722 Husayn was overthrown, the long Safavid era ended, and Iran condemned to several decades of political chaos. But the legacy of Shah Abbas is still evident in Iran today. The state is officially Shi'a, but Christians, Jews and Zoroastrians are all by the terms of the Constitution free to practise their religion in public. As in the seventeenth century, Iran is still a multi-faith society, with a tolerance of religious difference that surprises and impresses many visitors.

Miniature of a Mughal Prince

Painting on paper, from India
ABOUT AD 1610

In today's world of global politics image is – almost – everything. We are all familiar with the carefully staged photographs of leaders who know exactly what it means to be pictured with a particular royal, politician or celebrity. In the politics of faith, it is even more important in some places to be seen with the right religious leader – although this can be risky, too: to be seen shaking hands with the Pope or the Dalai Lama, for example, may bring immediate electoral benefits, but it can also have tricky political consequences. And few political leaders now would risk being seen receiving religious instruction, let alone reprimand.

In seventeenth-century India, the dialogue between power and faith was as complex and as explosive as it is today. But around 1610 the picture opportunities were very different: no press photographs, no 24-hour television news, just painting, and often painting aimed at a very targeted audience. This miniature from Mughal India embodies a rare, perhaps unique, relationship between the world of the ruler and the realm of faith.

In the sixteenth and seventeenth centuries, Europe and Asia were dominated by three great Islamic empires: the Ottomans in the Middle East and eastern Europe, the Safavids in Iran, and the Mughals in south Asia, of which the last was by far the richest. It reached its height in the years around 1600 under Emperor Akbar, another contemporary of England's Elizabeth I, as was Shah Abbas, and it continued to flourish under his son Jahangir, in whose reign our painting was made. The Mughal Empire was vast, stretching from Kabul in Afghanistan in the west across 1,400 miles to Dhaka in modern Bangladesh in the east;

but, unlike the Iranian Safavids or the Ottoman Turks, the Muslim rulers of the Mughal Empire governed an overwhelmingly non-Muslim people. Besides Jains and Buddhists, perhaps 75 per cent of their population were Hindu.

Unlike Christians and Jews, Hindus are not recognized in the Qur'an as other 'people of the book', so in theory they were not even necessarily to be tolerated by Islamic rulers, as the Mughal emperors always had to be aware. They managed this potential difficulty by adopting a policy of wide religious inclusion. Akbar and Jahangir worked easily with many faiths. They had Hindu generals in their armies, and close contacts with holy men, Muslim or Hindu, were a fundamental part of the life and outlook of the Mughal elite. Regular meetings with religious figures were a political strategy of the state, publicized through visits and through the media of the day – paintings like this miniature.

Miniature painting was an art form popular at courts from London and Paris to Isfahan and Lahore. Mughal miniatures show that Indian painters were well aware of developments in both Persia and Europe. Ours, which is about the size of a hardback book, has been dated to around 1610, and shows an encounter between a rich young nobleman, perhaps a prince of the ruling Mughal Dynasty, and a holy man who has neither wealth nor power. The holy man is on the left, grey-haired, bearded and wearing a relatively simple robe, cloak and turban, with in front of him a forked stick – the distinctive armrest or crutch of the dervish, or Islamic holy man. The young man facing him is wearing a purple costume covered with gold embroidery, a jewelled dagger at his waist (an obligatory accoutrement for a noble) and a green turban, a sign of high status. These two figures, the ascetic dervish and the lavishly dressed prince, kneel on a slightly raised platform in front of a small domed pavilion, clearly an Islamic shrine built around the tomb of some revered religious figure. A delicately painted tree overshadows them, at its base a solitary blue iris. Behind, a rolling green landscape disappears into the distance.

In Mughal painting landscape is often every bit as important as the figures. The Mughals were famous for their ornamental gardens, which were not merely places of pleasure but also physical metaphors for the Islamic paradise. So this landscape is an appropriate setting for

our rich young man to be discussing belief with a Muslim teacher. In this idyllic scene power has met piety, and they are in debate.

I asked Asok Kumar Das, an expert in Mughal painting, to tell me about the purpose of the painting and the possible presence of both Muslim and Hindu figures in one painting:

> Initially these were specifically meant for the eyes of the king or the members of the royal family whom the king wanted to see them, but later on they became fairly universal and we find the same painting or similar paintings in albums and in other books. It does have a specific message to convey, because when Akbar started his great empire-building process there were wars, but at the same time he sent the message that he was not open to war but open to friendship; and there were matrimonial relationships between the Hindus and other princes and that is something very unusual for a Muslim ruler of the sixteenth century. Some of his closest nobles and his principal courtiers were Hindus, and they remained Hindus. There was no animosity between the faith of the king, the ruler, and them. So the message is that here is one king who is not only going to be tolerant but also be very friendly and coexist in peace and harmony.

In India this sort of encounter, in which a powerful ruler humbles himself before the wisdom of a holy man, has a very long history. The tradition of these meetings interacted with another tradition, that of religious tolerance, which was perceived as a legacy of the Mughals' great ancestors, Genghis Khan and Tamerlane. It was one of the distinctive features of their conquests and differentiated the Mughal Empire from other Islamic states. In the opening section of his autobiography, Jahangir celebrates the tolerance of his father Akbar in contrast to the attitudes of his contemporaries in Turkey and Iran. In Akbar's India, Jahangir writes,

> There was room for the professors of opposite religions, and for beliefs, good and bad, and the road to altercation was closed. Sunnis and Shi'as met in one mosque and Christians and Jews in one church, and observed their form of worship.

Britain's first ambassador to India, Sir Thomas Roe, who arrived in 1617, memorably recorded Jahangir's own affirmation of religious tolerance, voiced during what was clearly a not unusual drunken evening:

The good king fell to dispute of the laws of Moses, Jesus and Muhammad; and in drink was so kind that he turned to me, and said: 'Am I a king? You shall be welcome.' Christians, Moors, Jews, he meddled not with their faith: they came all in love and he would protect them from wrong: they lived under his safety and none should oppress them; and this was often repeated; but in extreme drunkenness he fell to weeping and to divers Passions and so kept us till midnight.

Whether drunk or sober, Jahangir was a strikingly tolerant ruler. As he travelled through his empire, thousands would have been present to watch his visits to holy men and to their shrines, and to witness the public demonstration of a multi-faith society in action. But Jahangir seems also to have been driven by a personal desire to explore the spiritual truths of other religious traditions. He had many private meetings with a renowned Hindu hermit, Gosa'in Jadrup, and describes one of them in his autobiography:

The place he had chosen to live in was a hole on the side of a hill which had been dug out and a door made . . . In this narrow and dark hole he passes his time in solitude. In the cold days of winter, though he is quite naked, with the exception of a piece of rag that he has in front and behind, he never lights a fire . . . I conversed with him and he spoke well, so much as to make a great impression on me.

The tone of Jahangir's narrative suggests that such encounters were spiritually as well as politically significant in the life of the Mughal ruling elite; and certainly meetings like these showing the powerful and the rich learning from the holy poor are hard to match elsewhere. It is almost impossible to imagine a European ruler at this date, or indeed any date, being represented so submissively taking instruction in faith. The Indian historian Aman Nath reflects on the encounters between politicians and holy men in India across the centuries:

Born in India and being part of its culture, civilization, history, it seems to me a very normal scene. Even today not much has changed, because people in power and politicians go and visit holy people, though perhaps for the wrong reasons. But in the painting that we're talking about faith is far above power and politics. A prince who has other priorities as a young man is conditioned to think that if you get the blessings of

holy people then all will be well in your reign. And the fact that he is not coerced, he just visits a Sufi saint and bends his neck, that, I think, is the key thing in the painting: a man of greater wealth, power, ambition, sits on the ground and kneels before a man who has sacrificed everything. Less is more in India, and just as well, because there's so much poverty that that 'less than' gets related to the divine and it becomes a form of compensation to say that holy men want nothing, it's only foolish men and greedy people who seek everything.

In spite of all the political upheavals in India since the time of Jahangir, this tradition of the state accommodating all religions with equal respect has endured and became one of the founding ideals of modern India.

Shadow Puppet of Bima

Shadow puppet, from Java, Indonesia
AD 1600–1800

W hen the young Barack Obama was taken to Java to live with his new Indonesian stepfather, he was astonished to see, standing astride the road, a giant statue with the body of a man and the head of an ape. He was told that it was Hanuman, the Hindu monkey god. The reason why a huge Hindu god was being portrayed in the streets of modern Muslim Indonesia is a fascinating story of tolerance and absorption, a relaxed compromise between religions unlike any of the other solutions to the problems of multi-faith societies that we have been looking at. And it is a story that can in some ways be summed up by a puppet from the Indonesian shadow theatre, a celebrated art form that is living but ancient, utterly traditional but also full of contemporary politics. Through this puppet and his companions, we can explore a great expanse of religious and political transformation which began in south-east Asia 500 years ago and which still affects the region today.

The puppet shown here, one of several hundred that we have in the collection, dating from over 200 years ago to the present day, is from the Indonesian island of Java. It stands about 70 centimetres (30 inches) high, and represents a male character in stark dramatic profile. His name is Bima. Bima has very distinctive, almost caricature facial features – a very long nose, for example – and long thin arms, each ending in a single large claw. Over his body are delicate lace-like perforations that would have made his shadow even more dramatic during performance. Bima's face is black, but he is wearing gold clothes and brightly coloured decorations. Although he is lifeless and fragile now, once he would have enthralled audiences in all-night performances at a

Javanese court. This kind of performance was known then, and still is known, as the Theatre of Shadows.

The puppet's actual shape is the product of one of the most dramatic religious changes of the fifteenth and sixteenth centuries. While Spain was converting the New World to Catholicism, Islam spread across what is today Malaysia, Indonesia and the southern Philippines, and by 1600 most Javanese people were Muslim. But the Theatre of Shadows had been a feature of life in Java long before the arrival of Islam. Bima himself is a character known not just in Java but across the whole of India, because he figures in the great Hindu epic the Mahabharata. In Java, though, this Hindu character came to be operated by Muslim puppeteers and performed in front of audiences who were also Muslim. Nobody seems to have minded, and the Indonesian Theatre of Shadows has continued to combine pagan, Hindu and Muslim elements right up to the present day.

Making a puppet like our Bima was, and still is, an immensely skilled job, requiring several different craftsmen. It is made out of carefully prepared buffalo hide, which has been scraped and stretched until it has become thin and translucent. It was this material that provided the Javanese name for the theatre – *Wayang Kulit* – 'skin theatre'. The puppet was then gilded and painted, and movable arms were added and handles made from buffalo horn fixed to the body and arms to control its movements.

Historically, performances in the Theatre of Shadows lasted throughout the night. Light from an oil lamp behind the puppeteer's head cast the shadows from the puppets on to a white sheet. Some members of the audience – usually the women and children – sat on the shadow side of the screen, while the men would sit on the favoured other side. The puppeteer, known as a *dalang*, would not only control the puppets but also conduct the accompanying music performed by a Gamelan orchestra.

Sumarsam, a leading *dalang* in the Theatre of Shadows today, gives us an idea of how complicated it is to pull off a smooth shadow-puppet performance:

> You need to control the puppets themselves, sometimes two, three or sometimes up to six puppets at one time, and the puppet master will

have to know when to give a signal to the musicians to play. And of course the puppet master also gives voices to the puppets in different dialogues, and sometimes also he sings mood songs to set up the atmosphere of different scenes. He will have to use his arms and legs – all of this to be done while he is sitting down cross-legged. It's fun to do it, but also a fairly challenging task. The stories can be updated, but the structure of the plot is always the same.

The stories told in the Theatre of Shadows are drawn largely from two great Hindu Indian epics – the Mahabharata and the Ramayana, both written well over 2,000 years ago. They have always been widely known in Java, for Hinduism, with Buddhism, had been the main religion there before Islam became the dominant faith.

Like the Buddhism that inspired Borobudur around 800 (see Chapter 59) and the Hinduism that created the Mahabharata, Islam came to Java through the maritime trading routes that linked Indonesia to India and the Middle East. Local Javanese rulers quickly saw advantages in becoming Muslim: besides any spiritual attraction, it facilitated both their trade with the existing Muslim world and their diplomatic relations with the great Islamic powers of Ottoman Turkey and Mughal India. The new religion brought major changes in many aspects of life, but on the whole local Javanese culture and belief absorbed Islam, rather than being totally replaced by it.

The newly Islamic rulers seem to have gone along with this – they actively patronized the Theatre of Shadows and its Hindu stories, which remained as popular as ever. The audience, then as now, would immediately recognize the Bima puppet. In the Mahabharata, Bima is one of five heroic brothers (you can follow their exploits today in animations on the internet) and the great warrior among them – noble, plain-speaking and superhumanly strong, equal to 10,000 elephants, but also with a very good line in banter and something of a celebrity cook. One touch of his claw-like nails means death to his enemies.

The Bima puppet's black face expresses inner calm and serenity, unlike depictions of the 'bad guys' in the Theatre of Shadows, who are often coloured red for vindictiveness and cruelty. But his shape also tells us that an Islamic influence has found its way into this traditional Hindu art. This becomes obvious if we compare our Javanese puppet

of Bima, with its caricature nose and claw hands, and another puppet of Bima made on the nearby island of Bali, which remained Hindu. The figure from Bali has rounded, more natural facial features, and his arms and legs are in more normal proportions to his body. Many in Java today would argue that these differences are explained by religion; and that the traditional Hindu puppets were deliberately reshaped by their Javanese Muslim makers in order to avoid the Islamic prohibition on creating images of humans and gods. Stories are told of attempts in the sixteenth or seventeenth century to ban the Theatre of Shadows; others tell of Sunan Giri, a noted Muslim saint, who ingeniously came up with the idea of distorting the features of the puppets in order to get around the prohibition – a happy compromise that may explain our Bima's odd appearance.

Today Indonesia, with 245 million inhabitants, is the world's most populous Islamic nation, and the Theatre of Shadows is still very much alive. The Malaysian-born author Tash Aw describes the continuing role of shadow theatre:

> Even today there is a great consciousness of what goes on in the realms of shadow theatre. It's an art form that is constantly being refreshed, that's constantly being put to new and very exciting use. And, although the body of the works are drawn largely still from the Ramayana and the Mahabharata, younger puppeteers are constantly using the shadow theatre to inject life and humour and a sort of bawdy commentary on Indonesian politics, which is difficult to replicate elsewhere. Just after the financial crisis in 1997, I remember a virtuoso monologue in Jakarta which roughly translates as 'The tongue is still comatose' or 'The tongue is still mute', in which the current President Habibie was cast as a ridiculous character called Gareng, who is short with beady eyes, incredibly earnest, but very inefficient. So, in many ways shadow theatre has become a source of social and political satire in a way that is difficult for TV, radio and newspapers to do, because those are much more easily censored; the shadow theatre is much more malleable, much more in touch with the grass roots and therefore much more difficult to control.

But it's not just the opposition who make use of the Theatre of Shadows. The former president Sukarno, the first president after Indonesia gained independence from the Dutch following the Second World War,

A puppet of Bima from Bali shows
more naturalistic features

liked to identify himself with shadow-puppet characters, and especially with Bima – a righteous, mighty fighter, speaking like the common man rather than in elite language. Sukarno was often referred to as the *dalang*, the puppet master, of the Indonesian people – the one to give them voice and direct them in their new state, leading them in their national epic, as indeed he did for twenty years before being ousted in 1967.

But why is *this* Bima now in the British Museum? The answer, as so often, lies in European politics. For five years between 1811 and 1816, as part of the worldwide struggle against Napoleonic France, Britain occupied Java. The new British governor, Thomas Stamford Raffles, who would later found Singapore (see Chapter 59), was a serious scholar and a great admirer of Javanese culture of every period and, like all rulers of Java, he patronized the Theatre of Shadows and collected puppets. Our Bima comes from him. That short period of British rule explains something else – why the car from which the young Barack Obama saw a Hindu god in the streets of Muslim Jakarta was driving on the left-hand side of the road.

84

Mexican Codex Map

Map painted on bark, made in Tlaxcala, Mexico
AD 1550–1600

The Shi'a 'alam, Mughal miniature and Javanese shadow puppet represent cultures in which different faiths have managed to find reasonably positive ways of living together – in India, Iran and Indonesia in the sixteenth and seventeenth centuries religious tolerance was a hallmark of effective statecraft. But in Mexico around that time Christianity came as an instrument of conquest and was only slowly absorbed by the indigenous population. Now, 500 years later, more than 80 per cent of the population of Mexico is Catholic. In the process the physical landscape changed too: the invaders crushed temples and raised churches all over the Aztec Empire. It looks today like the most brutal and most complete replacement imaginable of one culture by another.

In the Zócalo, the main square of Mexico City, the palace of the Spanish viceroy stands on the very site of the demolished palace of Moctezuma. Nearby are the ruins of what was once the Aztec temple, whose sacred precinct is now largely taken up by the huge Spanish Baroque cathedral dedicated to the Virgin Mary. From the Zócalo, it looks as if the Spanish conquest of Mexico in 1521 was in every way cataclysmic for indigenous traditions, and that is how the story has generally been told. The reality, however, was more gradual and perhaps more interesting. The local people kept their own languages – and, for the most part, their own land, although the fatal diseases which the Spanish had unwittingly brought with them meant that much land was freed up for the new settlers from Spain. The object in this chapter shows us something of how the complex amalgamation of faiths took place, and in it we can see both Spanish imperial methods and the resilience of local traditions.

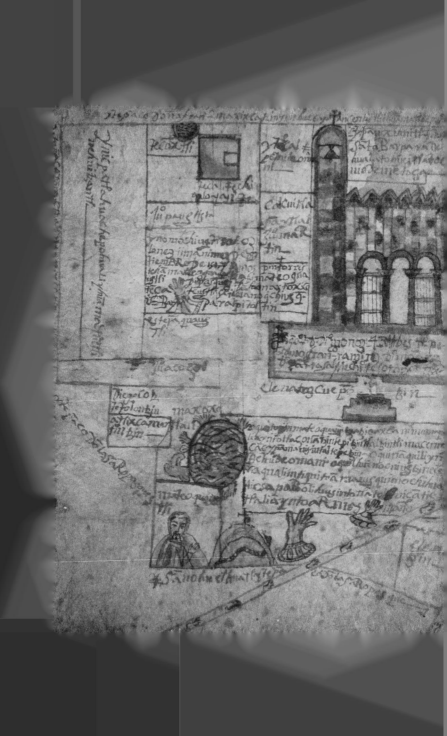

It is an annotated map about 75 centimetres (30 inches) wide and 50 centimetres (20 inches) tall, painted on very rough paper, in fact Mexican bark that has been beaten into a sheet. On the map are geometrically drawn lines indicating, presumably, divisions of fields, with names written into them to show the owners, a small blue river with wavy lines, and a forking road, with feet on it showing that it is a thoroughfare. Then on top of this diagram are painted images – in the middle a tree, and under it three figures wearing European dress, and then two large churches with bell towers, painted in bright colours of blue, pink and yellow, the principal features of the map. One of them is named Santa Barbara, the other Santa Ana.

The map represents an area in the province of Tlaxcala, to the east of Mexico City, a region whose people had bitterly resented Aztec rule and who had enthusiastically joined the Spaniards in defeating them (see Chapter 78). This may explain why so many of the names of land holders on the map show marriages between Spanish settlers and native Indian aristocrats, evidence of a remarkable fusion between the two peoples and the emergence of a new, mixed, ruling class. More surprisingly, a similar fusion took place in the church. For example, many communities in the Tlaxcala area had been protected by the indigenous Toci, grandmother of the Mexican gods, who after the conquest was replaced as local patroness by St Anne (Santa Ana), in Catholic tradition the grandmother of Christ. The grandmother may have changed her name, but it is unlikely that for the local worshippers she had in any serious way changed her nature.

Apart from disease, religion was the most significant new aspect of Mexican life under the Spanish. Catholic missionaries came with the conquerors in the 1520s and transformed the spiritual landscape. While in many places the conquest was violent, the conversion of local people to Catholicism was not usually forced: the missionaries were genuinely intent on instilling the true faith, so regarded compulsory conversion as worthless. Even if many Indians willingly converted, it is hard to believe they would have welcomed the destruction of their previous places of worship, yet this was a key part of Spanish policy. A Franciscan friar writing ten years after the conquest boasts of the achievements of this new, Mexican, church triumphant:

More than 250,000 men have been baptized, 500 temples have been destroyed and more than 26,000 figures of demons, which the Indians worshipped, have been demolished and burned.

The churches of Santa Barbara and Santa Ana dominate the landscape on our map; one has clearly been built on top of a destroyed native temple. The art historian Samuel Edgerton describes the technique:

> Many of these Mexican churches are built on the platforms of old pagan temples. It's a very clever ruse to help the Indians feel comfortable in the new churches, which were literally on top of the old church or temples. The central church has in front of it a large courtyard, what is today called an *atrio* or a *patio*. This was an innovation that the friars introduced to the buildings of these churches in Mexico because in the beginning the churches were often small, and you could not crowd in all the Indians who were being brought in here to be converted. So you had them stand in this large courtyard, and there they were preached to from an open chapel – it was easier for the church then to work as a 'theatre for conversion'.

The churches on our map – these theatres of conversion – were built within an existing landscape of roads, watercourses and houses. Names and places are given in a mixture of Spanish and the local Nahuatl language: for example, the church of Santa Barbara is in a village called Santa Barbara Tamasolco. *Tamasolco* means place of the toad, which almost certainly had a pre-Christian religious significance, now lost. The artist has painted a toad on the map, and the two religious traditions live on in the eccentric place-name 'Santa Barbara at the Place of the Toad'.

They also clearly lived on in the minds of the converted. An inscription on the map tells us: 'Juan Bernabe said to his wife: "Sister of mine, let us give soul to our offspring, let us plant the willows that shall be our memory."' In this lyrical glimpse of private faith, Juan Bernabe, despite bearing two Christian saints' names, obviously still believes that his children's salvation will be achieved in communion with the natural world of native tradition, rather than, or at least as well as, inside the Catholic church down the road.

The babies of this 'New Spain', as the invaders called it, were, like

Juan Bernabe, given new Christian names at baptism, but, again like Juan Bernabe, this didn't necessarily make them good Catholics. Later reformers would crack down on continuing pre-Christian practices and old rituals – incantations, divination and mask-wearing were punished as sorcery or idolatry. But many ceremonies survived through the sheer tenacity of the indigenous people. The most striking modern example is perhaps the way pre-Christian ancestor veneration has merged with the Christian All Souls' Day to create the Day of the Dead, an entirely Mexican celebration, still vigorously alive, in which on 2 November every year the living remember their dead, with skulls and skeletons in colourful costumes, festive music, special offerings and food – a celebration that owes as much or more to native Indian religious practices as to Catholic piety.

The Nahuatl language that appears on our map has just about survived. A census carried out in 2000 revealed that only 1.49 per cent of the population could still speak it. Recently, however, the mayor of Mexico City has said he wants all city employees to learn Nahuatl, in an effort to revive the ancient tongue. Quite a few Nahuatl words do in fact survive today – although probably few of us realize we are using Nahuatl when we talk about tomato, chocolate or avocado. Significantly, but not surprisingly, no religious Nahuatl words have stayed with us – the missionaries' teaching saw to that.

Five centuries after the conquest, the Mexican people today are increasingly eager to revive their pre-Hispanic past as a defining element of their national identity. But in the realm of faith, the legacy of the Christian conversion is still overwhelming. In spite of the great communist anti-clerical revolutions of the twentieth century, as the Mexican-born historian Dr Fernando Cervantes emphasizes, Mexico remains inextricably linked to the Catholic faith:

> There is a very strong anti-religious, anti-clerical nationalist ideology in Mexico, but it's very ambivalent because even the most atheistic Mexicans will never deny that they are devoted to the Virgin of Guadalupe, for instance. This is where the Catholic substratum comes through very strongly. You can't really square the circle of being Mexican and not being in some senses Catholic. So I think that this is where you can see how strong the early evangelization was and how alive it still is.

Crowds flood to the shrine of the Virgin of Guadalupe

Everything that Dr Cervantes is talking about, indeed everything that our little map reveals about the Christianization of Mexico, is summed up on a colossal scale at the shrine of Guadalupe in the suburbs of Mexico City. After the Vatican, it is now the most visited Catholic shrine in the world. It was there, on the site of an Aztec shrine, that in December 1531, just ten years after the conquest, the Virgin Mary appeared to a young Aztec man whom the Spaniards called Juan Diego. She asked him to trust in her and she miraculously imprinted her image on his cloak. A church was built on the site of Juan Diego's vision, the image on the cloak produced miracles, and conversions followed in huge numbers. The crowds flooded into Guadalupe. For a long time the Catholic clergy were worried that this was in fact the worship of an Aztec goddess being continued where there had once been an Aztec shrine; but the combined forces of the two religious traditions have over the centuries proved irresistible. There are now so many visitors to Guadalupe that you have to move in front of the miraculous image on a conveyer belt. In 1737 the Virgin of Guadalupe was declared patroness of Mexico, and in 2002 Pope John-Paul II declared Juan Diego, the young Aztec born under Moctezuma, a saint of the universal Catholic Church.

85

Reformation
Centenary Broadsheet

Woodblock print, from Leipzig, Germany
AD 1617

You can hardly turn on the radio or open a newspaper these days without being bombarded by yet another anniversary – a hundred years since this, two hundred years since that. Our popular history seems to be written increasingly in centenaries, all generating books and exhibitions, T-shirts and special souvenir issues, in a frenzy of commemoration. Where did this habit of anniversary festivities begin? The answer takes us to the great struggle for religious freedoms played out across northern Europe in the seventeenth century. The first of all these modern centenary celebrations seems to have been organized in Germany, in Saxony in 1617; the event it was commemorating had taken place a hundred years earlier. In 1517, the story goes, Martin Luther picked up a hammer and nailed what was effectively his religious manifesto – his ninety-five theses – to a church door; in doing so he triggered the religious turmoil that would become the Protestant Reformation. The object in this chapter is a souvenir poster showing Luther's famous act, on a large single sheet of paper called a broadsheet, made for the centenary. And it isn't just a celebration, it's about getting ready for war.

In 1617, when this broadsheet was made, European Protestants were facing an uncertain and dangerous future. The New Year had opened with public prayers by the Pope in Rome calling for the reunion of Christendom and the eradication of heresy. He was effectively calling the Catholic Church to arms against the Reformation. It was clear to many that a terrible religious war was about to break out. In

response the Protestants tried to find a way of rallying their supporters for the fight, but unlike the Catholic Church they had no central authority to issue directions to the faithful. Protestants had to find other ways of insisting that the Reformation had been part of God's plan for the world, that individuals had no need of priests to gain access to God's mercy, that the Roman church was corrupt, and that Luther's Reformation was essential to the salvation of every living soul. Above all, they needed a view of their past that would give all Protestants strength to face the terrifying future.

Before this point, no particular day or moment had been identified as the beginning of the Reformation. But leading Protestants in Saxony realized that it was now a hundred years since the heroic moment when, on 31 October 1517, Luther had first publicly challenged the authority of the Pope, so it was said, by nailing his ninety-five theses on to the door of the Castle Church at Wittenberg in Saxony. So, with a masterly sense of media management, they launched the first centenary celebration in the modern sense. All the familiar razzmatazz was there: ceremonies and processions, souvenirs, medals, paintings, printed sermons, and the broadsheet – a woodblock print which illustrates the critical day that Protestants now saw as the beginning of the first step on their radical religious journey.

The broadsheet is a crowded composition, but the message is quite clear: in a dream, God is revealing to the elector of Saxony the historic role of Martin Luther. We see the elector asleep. Below him, Luther reads the Bible in a great shaft of light coming down from heaven, where the Trinity is blessing him. As Luther looks up, light pours down on to the page in front of him: here, scripture is the word of God, and to read the scripture is to encounter God – and this is not happening inside a church. You could not have a simpler statement that for Protestants, Bible-reading is the foundation of faith, a foundation which, thanks to the new technology of printing, was now available to all believers in their own homes.

This broadsheet was produced in Leipzig, which in 1617 was a centre of the European printing trade. As the religious historian Karen Armstrong describes, by then the whole pattern of religion in northern Europe had been changed by this new emphasis on reading the word of God:

Göttlicher Schrifftmessiger / woldenc

böliche / Gottselige Churfürst Friederich zu Sachsen / rc. der Weise ge

nemlich die Nacht für aller Heiligen Abend / 1517. zur Schweiniß dreymal nach e

Johann Tetzels Ablaßkrämerey / an der Schloßkirchenthür zu Wittenberg angeschlag

GLeICh aM erften reChten EVa

Vom Ab
laß.

Rom

würdiger Traum / welchen der Hoch

t / aus sonderer Offenbarung Gottes / gleich jtzo für hundert Jahren

der gehabt / Als folgenden Tages D. Martin Luther seine Sprüche wider

Allen jetzo jubilierenden Christen nützlich zu wissen / in dieser Figur eigentlich fürgebildet.

Chen LVther | Chen IVbeLfest.

It is very noticeable in this picture, the emphasis on the written word. Up until this point religion had been precisely about listening for what lay beyond language. People had thought not so much in terms of words or concepts or arguments but in terms of images, of icons, in terms of music, of action. Now, because of the invention of printing, which helped Luther disseminate his ideas, everything is going to become much more wordy. That has been rather the plague of Western religion ever since, because we are endlessly now stuck in words. Printing enabled people for the first time to own their own Bibles, and this meant that they read them in an entirely different way.

Without printing, the Reformation might well not have survived, and the broadsheet's combination of text and illustration shows that along with words the image was still very much alive. Seventeenth-century Europe was still largely illiterate – even in the cities no more than a third of people could read – so prints with images and just a few key words were the most effective means of mass communication. Even today we all know a well-crafted cartoon can be lethal in public debate.

The front of the print shows Luther writing on the church door, with the world's biggest quill pen, the words *Vom Ablass* – 'About Indulgence' – the title of his virulent attack on the Catholic sale of indulgences, the system by which souls spent less time in purgatory in return for cash paid to the church during their lifetime. The selling of indulgences had fuelled anti-papal feeling in Germany. Luther's quill stretches half way across the print – to a walled city, helpfully labelled Rome, and straight through the head of a lion labelled Pope Leo X, who squats on top of it. As if that wasn't enough, the quill then knocks the papal crown off the head of the Pope shown in human form. Never was a pen mightier than this one. The message is coarse but clear – Luther, inspired by reading the scriptures, has destroyed papal authority by the power of his pen.

Woodblocks like this were the first mass medium – with print runs in the tens of thousands, allowing each single copy to cost just a few pfennigs – the price of a pair of sausages or a couple of pints of ale. Satirical prints were pinned up in inns and market places and then widely discussed. This is in every sense popular art, the equivalent of

the tabloid press or a satirical magazine, like *Private Eye*. We asked *Private Eye*'s editor, Ian Hislop, to comment:

> The editor of this broadsheet has done exactly what you'd expect. He's cracked his hero up, he's demonized the enemy, turned him into an animal, and then into a ludicrous figure, a sort of blank-looking rather stupid person, who has his hat knocked off. All around the pen there are bits of it fallen off, so that everyone else has got a pen as well – this is about writing, about the word and, even more, about printing, because now the Bible can be printed, and we see that we're up in heaven here and the word of God comes down from heaven straight on to the page.
>
> So no priests in the way, no Pope, no nothing, to get between you and the word of God. The thing I love about it is that it's like reading a magazine, there are big pictures with obviously cartoony jokes, and then there are captions everywhere to make sure that you don't miss anything. My German isn't really good enough to get a lot of the jokes, but looking at it, I just put my own in. I imagine someone here saying, 'Abandon Pope all ye who enter here,' or Luther with the pen is saying 'It's the quill of God,' or a lot of very strict Catholics saying, 'Yes, but your interpretation is much Luther.' In fact I hope the jokes are better than that, but it's pretty clear what's going on in this picture, and I think it's terrific.

The broadsheet was obviously aimed at a very wide public, but it has one particular viewer in mind: the elector of Saxony. If religious differences were going to come to open warfare, Protestantism would survive only if its princely champions fought to defend it. The elector of Saxony in 1617 would have to be just as resolute as his predecessor in 1517 and so would all the other Protestant rulers in Germany.

War came the very next year, 1618, and for thirty years devastated central Europe. By 1648 the two exhausted sides recognized that this was not a winnable contest. The bloodshed of the Thirty Years War forced the reluctant combatants to recognize that the only basis for lasting peace would be pragmatic tolerance and legal equality between Catholic and Protestant states.

In this part of the book, I have been looking at how very different societies across the seventeenth-century world addressed the political

consequences of religious diversity – Protestant and Catholic, Sunni and Shi'a, Hindu and Muslim. Safavid Iran and Mughal India contrived more-or-less peaceful accommodations. Christian Europe foundered in war. But in the 1680s the English philosopher John Locke, in his *Letter Concerning Toleration*, held out the possibility of an ultimate happy outcome even in Europe:

> The toleration of those who hold different opinions on matters of religion is so agreeable to the Gospel and to reason, that it seems monstrous for men to be blind in so clear a light.

This conviction, dearly and bloodily bought, that there are many ways to truth, changed the intellectual and political life of Europe, so that in 1717, when the bicentenary of Luther nailing his theses to the church door came round and new broadsheets were produced, the whole continent was well on the way to a revolution just as profound as the Reformation and, in many ways, a consequence of it – the Enlightenment.

Exploration, Exploitation and Enlightenment

AD 1680–1820

The European Enlightenment (1680–1820) was an age in which scientific learning and philosophy flourished. Although often – rightly – associated with reason, liberty and progress, the Enlightenment was also a period of European imperial expansion, when the transatlantic slave trade was at its height. Important advances in navigation allowed European sailors to explore the Pacific more thoroughly, and for the first time the indigenous cultures of Hawaii and Australia were connected to the rest of the world. The dialogues and exchanges, the difficult transactions and misunderstandings, the straightforward clashes which resulted from encounters between Europeans and non-Europeans all over the world created an often deeply troubling history, since much of it resulted in the suppression of peoples and the fracturing of societies. Europe, however, was not the world's only successful growing economy: China under the Qing Dynasty was regarded by many Europeans as the best-governed empire in history, and was enjoying its own version of the Enlightenment.

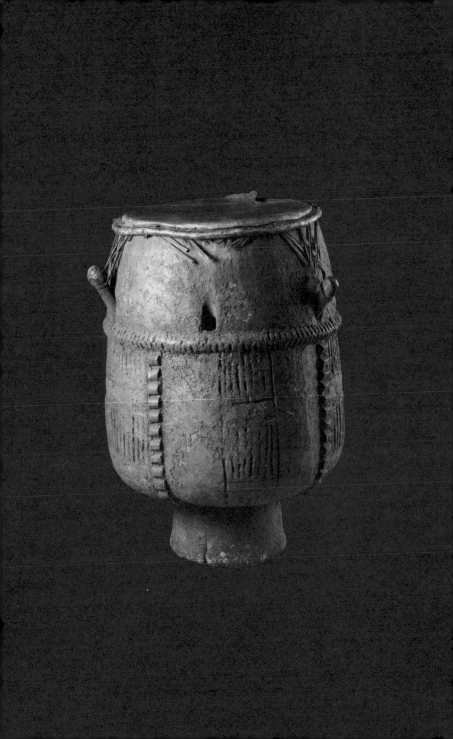

86

Akan Drum

Drum, made in West Africa, found in Virginia, USA
AD 1700–1750

*T*he *true spirit of jazz is a joyous revolt from convention, custom, authority, boredom, even sorrow – from everything that would confine the soul of man and hinder its riding free on the air.*

These are the words of the black American historian J. A. Rogers, writing in the 1920s about the nature of jazz – a music of freedom and rebellion that can trace its roots back to the terrible days of the slave trade between Africa and America in the eighteenth century, when drums were brought over from Africa to America along with the slaves, and music gave the enslaved and displaced a voice, connected their communities, and provided a language that would ultimately cross continents. Drums like this one stand at the head of that whole African-American musical tradition which dominated the twentieth century. Blues and jazz are just two of the great musical genres which begin here – music of poignant regret, or exuberance and rebellion – the music of liberty.

This is the earliest African-American object in the British Museum. From this drum – made in Africa, taken to America, sent on to England – and others like it, we can recover some of the story of one of the biggest forced migrations in history. These utterly dispossessed people were allowed to bring nothing with them – but they brought the music in their heads, and one or two instruments were carried on the ships. With them came the very beginnings of African-American music. Kwame Anthony Appiah, who teaches at Princeton University, comments:

> These drums are important to life, and if you could take one with you to the New World, it would have been a kind of source of memory that

you could take with you, and that's one of the things that people taken into slavery tried to hold on to.

When the British Museum opened its doors for the first time, in 1753, Europe's engagement with the rest of the world – the Enlightenment enterprise of gathering together all the world's knowledge – was in full swing. The founding collection was mostly the legacy of Sir Hans Sloane, an Irish physician with wide-ranging interests, and consisted of scientific instruments, plants and materials, stuffed animals and wildly various and intriguing human-made objects from around the globe. Part of the collection was this drum, acquired in Virginia around 1730 and in the eighteenth century thought to be an American Indian drum. It retained that identification until 1906, when a curator in the Museum guessed that it could not be any such thing: it looked more like drums from West Africa. Much later, his hunch was confirmed through scientific examination by colleagues at Kew Gardens and at the Museum. We now know that the main body of the drum is made of wood from the tree *Cordia africana*, which is prevalent in West Africa, and other parts of the drum – pegs and cords – derive from wood and plants from the same region. This is unquestionably a West African drum, which by 1730 had travelled from West Africa to Virginia.

The first African slaves arrived in British North America in 1619, brought to the American colonies on European-owned ships to provide labour for the ever-expanding plantations. At first they were put to work cultivating sugar and rice, later tobacco, and then, finally and most famously, cotton. By the early 1700s the trade in enslaved people had become the most lucrative business between the European maritime powers and West African rulers. Overall, around 12 million Africans were transported to America from Africa, and both sides – European and African – were profitably involved. Kwame Anthony Appiah has heritage from both sides.

> I always like to tell people I have slave traders on both sides of my family: some of both my English ancestors and my Ghanaian ancestors were involved in the slave trade. You have to understand that it was a trading relationship – as the trade developed, by the eighteenth century in a place like Asante where I grew up, and where the drum comes from,

they had become very dependent on the slave trade. They were going out in warfare, capturing large numbers of people, and sending them down to the coast, exchanging them for the goods they were getting from Europe, which would have included guns that made it possible for them to proceed with more warfare.

The drum comes from the Akan people, a group which includes the Asante and Fante kingdoms, and was possibly used at court, probably as part of a drum orchestra – music and dance were fundamental ingredients of ceremonial and social life.

We assume the drum was taken on a slave ship – but not by a slave. Slaves took nothing. It may have been a gift to the captain, or taken by a chief's son – we know they sometimes sailed with the slavers to America as part of their education. On board, the drum had little to do with the joy of communal music-making. Drums like this were used for what was grotesquely called 'dancing the slaves':

> As soon as the Ship has its Complement [of slaves], it immediately makes off; the poor Wretches, while yet in sight of their Country, fall into Sickness and die ... The only sure means to preserve 'em, is to have some Musical Instrument play to 'em, be it ever so mean.

Slaves were taken on to the decks and forced to dance to the rhythms of the drum to keep them healthy and to combat depression, which the slave captains knew could lead to suicide or mass revolt. Once on the plantations in America, the slaves were allowed to drum and make music for themselves, but it was not long before slave owners grew anxious that drumming, used once again for communal communication, would not prevent rebellion but incite it, and indeed in South Carolina in 1739 drums were used as a call to arms at the outbreak of a violent slave rebellion. It prompted the colony to prohibit drums by law and classify them as weapons.

Hans Sloane, who had the drum brought to London, was himself a slave owner in Jamaica and published one of the very first transcriptions of slave music. Sloane also described the slaves' instruments and explained why the authorities in Jamaica ultimately banned them:

> Slaves formerly on their Festivals were allowed the use of Trumpets after their fashion and Drums made of a piece of a hollow Tree ... But

making use of these in their Wars at home in Africa, it was thought too much inciting them to Rebellion, and so they were prohibited by the Customs of the Island.

This Akan drum, collected for Sloane in the early 1700s, might have been confiscated in one of the drum bans on the plantations. It is just over 40 centimetres (16 inches) high and carved into patterns around the wooden body, which sits on a narrow foot. Intriguingly, the material stretched over the drum is deerskin, almost certainly North American, which could well have been acquired in trade with a local Native American. The complicated relationships between African Americans and Native Americans in the eighteenth century are often overlooked, but there was a good deal of contact, including intermarriage. Some Native Americans had their own slaves – both Native American and African. This is a history that is not often mentioned, but it adds another resonance to the identification of the object itself in the eighteenth century as an 'Indian drum'.

The story of the drum is a story of global displacement: enslaved Africans transported to the Americas; Native Americans forced westward by encroaching slave plantations; the drum itself taken from Africa to Virginia and, in the latest phase of its life, to London. And here the most extraordinary thing has happened – like the drum, the children of slaves have now also come to England. Many descendants of all those once involved in the slave trade – British, West African and Afro-Caribbean – now live together in the same cosmopolitan city. The Akan drum has become a typical twenty-first-century Londoner. Bonnie Greer, an African-American playwright and Trustee of the British Museum who now lives in London, explains:

> The drum itself represents to me the idea of voyage, and crossing. I crossed the Atlantic to be here, and the drum did too. And so it represents for me that passage of my ancestors. And the ancestors of a good number of black British citizens as well.
>
> As a person of African descent and also having Native American ancestry as well ... it represents those two strands of myself, and of many African Americans, and of many people from the Caribbean as well ... and I always say that the thing that's remarkable about these objects for us who were taken forcibly, from our environment, is that

these objects have travelled with us. And they've actually become what we have become, and they have accompanied us here to live in this place and to thrive in this place. And because we are part of that object, and it's part of us, it's quite right that it is here.

The drum is a record of many dialogues. The next object is a record of no dialogue, just misunderstanding. It is from the other side of the world, and it was collected by Captain James Cook. It makes no sound, but it too is eloquent testimony to the clash of cultures.

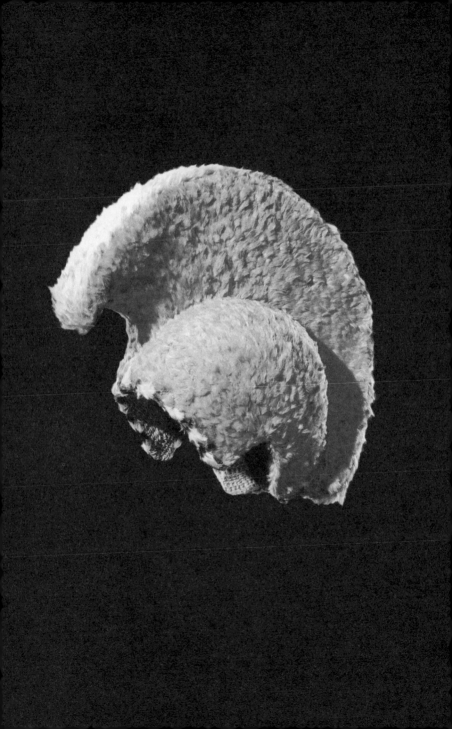

87

Hawaiian Feather Helmet

Feather helmet, from Hawaii, USA
AD 1700–1800

In 1778 the explorer Captain James Cook was in the Pacific, on board HMS *Resolution*, looking for the North-West Passage, hoping to find a sea route north of Canada that would connect the Atlantic and Pacific oceans. He didn't find the North-West Passage, but he did redraw the map of the Pacific. He was charting coastlines and islands, collecting specimens of plants and animals. At the end of 1778 he and his crew landed in Hawaii, returning again in early 1779. It is impossible to imagine what the islanders made of these European sailors, the first outsiders to visit Hawaii for more than 500 years. Whoever or whatever the Hawaiians thought Cook was, their king presented him with magnificent gifts, among them chieftains' helmets – rare and precious objects made of yellow and red feathers. Cook recognized these as an acknowledgement by one ruler of another, a clear sign of honour. But a few weeks later, Cook was dead, killed by the same people who gave him the helmets. Something had gone drastically wrong.

This is one of the feathered helmets given to Cook and his crew, and it stands now as a vivid emblem of the kind of fatal misunderstandings that have run through European contacts with people across the globe. I began this history of the world by saying that objects connect us in our common humanity more often than they separate us, but looking at some of the objects I'm not quite so sure. Can we ever really grasp how a very different society imagines the world and orders itself? And can we find words for concepts that we have never known?

In the eighteenth century European explorers, Cook above all, set about accurately mapping and charting the oceans – especially the huge and unknown Pacific. Before the great Egyptian collections

arrived at the British Museum (see Chapter 1), it was the objects from Cook's voyages in the South Sea that everybody wanted to see – glimpses of a new and other world. The Hawaiian feathered helmet, so delicate that the red, yellow and black feathers which cover it could come off at the slightest movement, was one of the prize exhibits. Like an ancient Greek helmet, it fits close to the head but has a thick, high crest running over the top from front to back – like a Mohican haircut. The top of the crest has alternating rows of yellow and red, the sides and body of the helmet are scarlet, and the front edge has a thin black and yellow edging. The colouring is vivid and radiant, and the wearer would instantly have stood out from the crowd. The red feathers are from the i'iwi bird, a species of honeycreeper, the yellow ones from a honeyeater, which has mostly black plumage but also a few yellow feathers. These tiny birds were first caught, then plucked and finally released, or killed. The feathers were then painstakingly attached to fibre netting moulded to a wickerwork frame. Feathers were the most valuable raw material at the Hawaiians' disposal; their equivalent of turquoise in Mexico, jade in China or gold in Europe.

This is a helmet in every way worthy of a king, and it probably belonged to the overall chief of Hawaii Island, by far the largest of the Hawaiian archipelago, which lies around 3,600 kilometres (2,300 miles) from the American mainland. Polynesians had established settlements on the islands by about AD 800, part of that great ocean-going expansion which also settled Easter Island and New Zealand. It seems that from about 1200 to 1700 they were utterly isolated; Cook was the first stranger to visit for 500 years. But he was probably less surprised by them than they were by him. During their isolation the Hawaiians had developed social structures, customs, agriculture and craft skills that, although superficially alien and exotic, nonetheless seemed to make sense to the Europeans. The anthropologist and expert on Polynesian culture Nicholas Thomas explains:

> When Cook arrived in Polynesia, he encountered societies that struck Europeans as possessing their own sophistication ... In Hawaii in particular, extraordinary kingdoms had emerged that embraced whole islands and that were caught up in complex trading relationships among different islands. They were encountering complex and dynamic societies with

aesthetics and cultural forms that impressed Europeans in all sorts of ways ... How could such cultural practices exist in places that were so remote from the great centres of Classical civilization?

In many ways, it seemed not unlike eighteenth-century Europe. A large population was ruled by an elite of chiefly families and priests. Under these families came the professionals – craftsmen and builders, singers and dancers, genealogists and healers – who in turn were supported by the main population, who farmed and fished. The maker of the feathered helmet would have been a professional craftsman. Kyle Nakanelua, from Maui, Hawaii, has examined the helmet:

> If you figure that only four of those feathers can be taken from one bird at a time, and that looks like about 10,000 feathers, you get how many birds you need. At one given time, this chief has a retinue of people with the occupation of collecting, storing and caring for these feathers, and then manufacturing them into these kinds of products. So you're talking about an industry of anywhere from 150 to 200 people just collecting and storing and manufacturing, and it could have been that they were collecting these feathers for generations before putting one of these articles together.

Chiefs donned feather helmets and capes to make contact with the gods – when making offerings to ensure a successful harvest, for instance, to avert disasters such as famine or illness, or to propitiate the gods before a battle. The feather costumes were the equivalents of the great helmets and coats of arms of medieval chivalry – highly visible ceremonial clothes worn by chiefs to lead their men into the fight. Above all, these costumes gave access to the gods. Made from the feathers of birds, themselves spiritual messengers and divine manifestations which moved between earth and heaven, they gave the person who wore them supernatural protection and sacred power. Here's Nicholas Thomas again

> Feathers were particularly sacred, and not just because they were pretty or attractive: they were associated with divinity. Legends often had it that gods were born as bloody babies covered with feathers, saturated, in a sense, with divine power and associations from the other world, particularly when they came in sacred colours of yellow and red.

These ideas were not so strange to Cook. Of course, English kings weren't born covered in feathers, but they were divinely anointed monarchs who carried out priestly functions in elaborate ceremonial robes in a cult where the Holy Spirit was represented by a bird. Cook seems to have 'read' this society as, at bottom, like his own. But he could not grasp the Hawaiians' very particular sense of the sacred, which is hedged around by terrifying prohibitions. The word *taboo* is Polynesian, its resonances both holy and lethal.

When Cook returned to Hawaii in 1779 it was during a festival devoted to the god Lono in the season of peace. He was given a grand reception by the paramount chief – a vast red feather cape was thrown round him and a helmet placed on his head. In other words, he was treated like a great chieftain with godly status. He spent a month peacefully on the island repairing his ships and taking precise measurements of latitude and longitude. Then he left to sail north, but a month later a sudden storm forced him back to Hawaii. This time things went very differently. It was now the season devoted to Ku, the god of war; the local people were much less welcoming and incidents broke out between them and Cook's crew, including the theft of a boat from one of Cook's ships. Cook planned to use a tactic he had used before – he decided to invite the chief on board his ship and hold him hostage until the missing items were returned. But as he and the chief walked on the beach at Kealakekua Bay the chief's men raised the alarm and in the ensuing mêlée Cook was killed.

Why did it happen? Did the Hawaiians think Cook was a god, as some suggest, who was then unmasked as human? We will never know, and the circumstances of Cook's death have become a textbook study in anthropological misunderstandings.

The islands were permanently changed by his arrival. European and American traders brought deadly disease, and missionaries transformed the islands' cultures. Hawaii itself was never colonized by Europeans, and instead a local chief was able to use the contacts inaugurated by Cook to create an independent Hawaiian monarchy that survived for over a century, until Hawaii's annexation by the United States in 1898.

I began this chapter wondering how far it is ever possible to understand a totally different society, and it is a difficulty that greatly exercised eighteenth-century travellers. The surgeon David Samwell, who

sailed with Cook on HMS *Discovery*, mused upon the problems of communication with this other world as he recorded his observations with admirable humility:

> There is not much dependence to be placed upon these Constructions that we put upon Signs and Words which we understand but very little of, & at best can only give a probable Guess at their Meaning.

This is a salutary reminder of the limits to certainty. It is now impossible to know exactly what objects like this feather helmet meant to Hawaiians of the 1770s. What is clear, as Nicholas Thomas explains, is that they are now taking on a new significance for the Hawaiians of the twenty-first century:

> It's an expression of that Oceanic art tradition, but it also expresses a particular moment of exchange that marked the beginnings of a very traumatic history that in some ways is still unfolding. Hawaiians are still affirming their sovereignty and trying to create a different space in the world.

And for Hawaiians like Kaholokula, from the island of Oahu, these feathered objects take their place in a very particular political debate:

> It's a symbol of what we lost but a symbol of what could be again for Hawaiians today. So it's a symbol of our chiefs, it's a symbol of our lost leadership and our lost nation, of loss for the Hawaiian people, but also encouragement for our future and the rebuilding of our nation as we seek independence from the United States.

88

North American
Buckskin Map

Map drawn on animal hide, from midwestern USA
AD 1774–1775

In the middle of the eighteenth century a philosophical Chinese visitor came to London and commented on the intense rivalry – hilarious, bitter, bloody – between Britain and its neighbour over the Channel, France:

> The English and French seem to place themselves foremost among the champion states of Europe. Though parted by a narrow sea, yet are they entirely of opposite characters; and from their vicinity are taught to fear and admire each other. They are at present engaged in a very destructive war, have already spilled much blood, are excessively irritated; and all upon account of one side's desiring to wear greater quantities of furs than the other.
>
> The pretext of the war is about some lands a thousand leagues off; a country cold, desolate, and hideous: a country belonging to a people who were in possession for time immemorial.

This Chinese visitor is in fact fictional, a latter-day Gulliver invented by the satirical writer Oliver Goldsmith in his book *The Citizen of the World*, published in 1762 and designed to show the British how ridiculous their behaviour must seem to the rest of the world. The war was the Seven Years War between Britain and France, a drawn-out battle for trade and territory fought in Europe and Asia, Africa and America. The 'hideous land' turns out to be Canada. Goldsmith makes it very clear that Britain and France are despoiling the legitimate inhabitants of the countries they first explore and then exploit.

From Canada the war moved south, and this buckskin map, drawn on the skin of a deer, shows part of the area the British moved into as they captured the line of French forts from the Great Lakes to the

Mississippi, as far south as St Louis. It was made around 1774 by a Native American – one of the people who had, in Goldsmith's words, been in possession from 'time immemorial' – and provides insight into the thirteen years between 1763, when the British threw out the French from the American north, and the outbreak of the American War of Independence in 1776.

The Seven Years War left the British government in charge of the lands to the west of the existing British colonies, from the Great Lakes down to the Mississippi. This is the area shown on the map. But if the French had gone, the British colonial governors now had their own countrymen to contend with. British settlers were eager to move west, disturbing agreements already struck with the Native American leaders, and were negotiating illegal land deals with local tribes – a recipe for future conflict. The map was made for one of these deals. It shows us an encounter not just between different worlds, but between different ways of imagining the world. The frontiers between the lands that were being discussed represent also the frontiers between two cultures which had different conceptual, spiritual and social ways of being. Mapping, for Europeans, was a central technique of control – partly intellectual control, the pursuit of knowledge of the world, partly military. For Native Americans, mapping was about something quite else.

The map is roughly 100 by 126 centimetres (40 by 50 inches), and its shape is defined by the deerskin it is drawn on. The deer itself seems very present, for we can see exactly how it died: there are holes in the skin from a musket ball that passed from the animal's right shoulder to its rear left flank, almost certainly going through the heart. This deer was killed by a top-class shot, someone who knew how to hunt. The map is only faintly visible on the skin now, but if we compare it with a modern map, we can see we are surveying the vast drainage basin formed by the confluence of the Ohio and the Mississippi, an area of more than 40,000 square miles in a V-shaped region between the rivers. We are just below Lake Michigan, in what will become the states of Illinois, Indiana and Missouri.

It is this area that after 1763 British settler companies wanted to exploit, and the map is the record of one of many conversations between these invasive settlers and the Native Americans. Near the centre of the map is the phrase 'Piankishwa sold'.

The Piankishwa (or Pinkashaw) were a tribe of Native Americans living in an area that now includes modern Indiana and Ohio. The map was probably made for the Wabash Land Company, which had been set up to buy tracts of territory along the River Wabash from the Piankishwa in 1774–5. G. Malcolm Lewis, an expert on maps and North American Native cultures, elaborates:

> It was almost certainly made in connection with an attempt by a Philadelphia firm of merchants to purchase land in the Wabash Valley on what is now the border between Indiana and Illinois. This involved the use of the map, which shows boundaries that were obviously being intended for purchase. In fact, the whole project came to an end because this was the very eve of the Revolutionary War. So it was almost certainly made and used in 1774–5, in connection with the attempted Wabash land purchase. It is undoubtedly Indian in style: it has all the characteristics of an Indian map. Rivers, for example, never show the sinuosities, they're almost always straight … it was almost certainly used in the process of negotiating with the Piankishwa Indians to try and buy land.

The words 'Piankishwa sold' suggest that the map is a record of an already agreed land transaction, but in fact this deal was never ratified by the British colonial authorities. It was illegal, breaching official treaties. In any case, it is unclear what it could have meant to the Piankishwa Indians. The Wabash Company used interpreters, but plenty was lost in translation.

> They have deposed that they served as interpreters … with the chiefs of the different tribes of the savage nation of Pinkashaws, relative to the purchase of lands as above mentioned, specified and written in the aforesaid act … the said witnesses, in their quality as interpreters, have done for the best in their souls and consciences and have faithfully and plainly explained to the said chiefs … to which they have set their ordinary marks, with their own hands.

Although this report says everything has been 'faithfully and plainly explained' to the chiefs, the Piankishwa could have had no concept of European-style land purchase. Settler approaches to land were completely alien to Native Americans, who thought of their land as both a

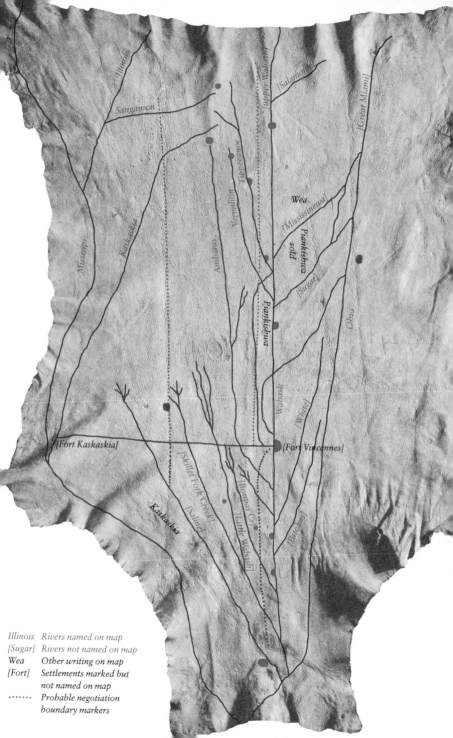

Illinois Rivers named on map
[Sugar] Rivers not named on map
Wea Other writing on map
[Fort] Settlements marked but
 not named on map
······· Probable negotiation
 boundary markers

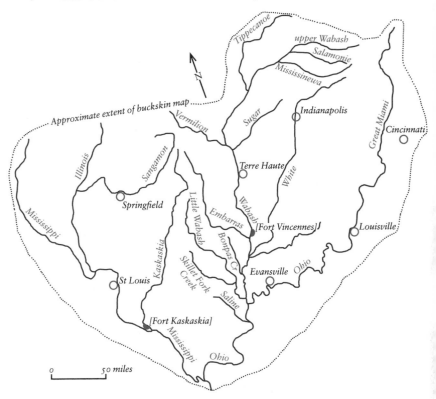

Illinois Rivers named on buckskin map
○ Modern cities
◗ Settlements marked but not named on buckskin map

Tippecanoe

upper Wabash

Salamonie

Mississinewa

Approximate extent of buckskin map

Vermilion

Sugar

Indianapolis

Great Miami

Cincinnati

Illinois

Sangamon

Terre Haute

White

Wabash

Mississippi

Springfield

Little Wabash

Embarras

[Fort Vincennes]

Louisville

Kaskaskia

Bompas Cr

Skillet Fork Creek

Evansville

Ohio

St Louis

Saline

[Fort Kaskaskia]

Mississippi

Ohio

0 50 miles

The map on the left is a transcript and interpretation of the marks on the buckskin map. It primarily identifies and names rivers, but additionally shows the road built between the forts at Kaskaskia and Vincennes and two dotted boundary markers; it identifies some other native settlements without naming them, and shows the areas occupied by the Piankishwa, Wea and Kaskaskia peoples. The map above is a modern topographical map of the area depicted in the buckskin map.

literal and a spiritual birthplace – not territory that could be given away or sold.

What the map shows above all is rivers. In the centre, running down the spine of the deer, is the Wabash River – hence the Wabash Land Company – into which other rivers come in as straight, angled lines placed like vertebrae, except for the Mississippi, which runs down the left and curves around the bottom to the right. It shows the rivers, where the people are grouped together, not the land over which they roam and hunt. This is a map about communities, not geography, about habits of use, not patterns of ownership. So, rather like the map of the London Underground, it does not show accurately the physical distances on the ground. Instead, it indicates the the time it takes to travel between them. The Native Americans, like everybody else, mapped what mattered to them. Tellingly, although the map includes all the rivers, it shows almost exclusively the settlements of the Indians. Virtually none of the European settlements are there. St Louis, for example, which was already a great centre of trade and communications, just is not shown. European maps of the same area do effectively the same in reverse, showing the European settlements but not the Indian ones, plotting the space not in use. Two quite different readings of the same physical experience: you could hardly have a better demonstration of a central Enlightenment problem, the difficulty of any society in trying to understand another.

If the Indians didn't understand the notion of exclusive land ownership, the Europeans could not grasp the Indians' intense spiritual relationship to their land, the notion that the loss of earth was in some measure the loss of heaven. David Edmunds, Professor of American History at the University of Texas, elaborates:

> I think the Native American relationship with the land is very important. You have to understand that land for tribal people is not a commodity. It was never a commodity, it was a place where you lived, that you shared, that you utilized, but it was not something that you particularly owned. One could not any more own the land than one could own the air above the land or the rain that fell on it or the animals that lived on it. Land is so important and place is so important to tribal people that history for them is more a function of place than of time. People

are associated with a particular region, the region is the centre of their world ... consequently, that land is so intricately bound into the very soul of most tribal people that it's not something that you trade back and forth. And when they were forced to trade lands in the early part of the nineteenth century, and to give up land, in order to survive, it was a very traumatic experience for them. Another thing to remember is that most of the religious beliefs of tribal people are site-specific, and by that I mean that their cosmology, the powers in their universe, are also tied to the particular area in which they live.

The settlers failed to push through this particular land deal, which was struck down by the British colonial governors. A few years later, this tension between settlers wanting land and the British Crown eager to maintain good relations with the Native American chiefs would be one of the elements that triggered the War of Independence. But independence did not make the problem go away. US state governors faced the same dilemma as their British predecessors, and they, too, had to strike down more attempts at land sales between the Wabash Company and the Piankishwa that breached existing treaties. The map and the abortive negotiations around it remain as evidence of three quite different ways of thinking about the world – those of the Native Americans, whose land it has been from time immemorial, the settlers who wanted to appropriate it, and the authorities in London, mindful of Goldsmith's strictures, who tried to mediate a solution, but were powerless to enforce it.

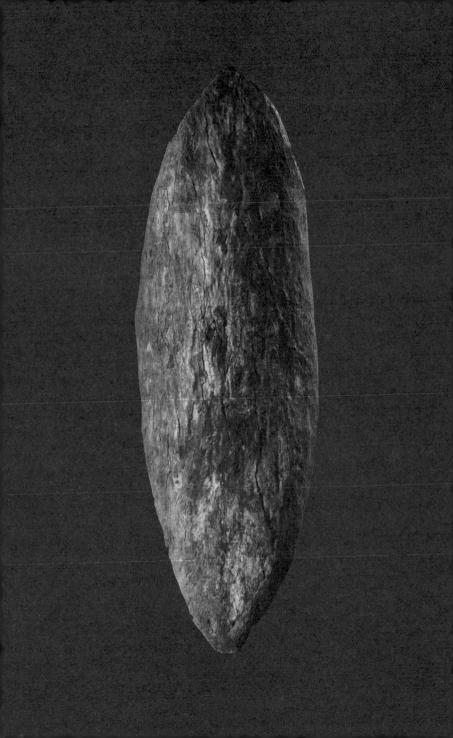

Australian Bark Shield

Wooden shield, from Botany Bay, New South Wales, Australia

AROUND AD 1770

This is one of the most potent objects in the book, one which has become symbolically charged, freighted with layers of history, legend, global politics and race relations. It is an Aboriginal shield, one of the very first objects brought to England from Australia. It was brought here by James Cook, eight years before the fateful encounter described in Chapter 87. We know the precise date it came into Cook's hands – 29 April 1770 – because we have written accounts of the day from Cook himself and from others who were with him. But the indigenous Australian who owned the shield did not write, which is why a history from objects can be so important: for the unnamed man confronting his first European on the shore at Botany Bay nearly 250 years ago, this shield is his statement.

Cook's log records his arrival on the east coast of Australia, just south of the site of modern Sydney, on 'Sunday 29th in the afternoon winds southerly and clear weather with which we stood into the bay and anchored under the south shore'. The ship anchored at what would come to be called Botany Bay, thanks to the collecting work of the botanist Joseph Banks, who travelled with Cook. The ship's log continues:

Saw as we came in on both points of the bay several of the natives and a few huts … as we approached the shore they all made off except two men who seemed resolved to oppose our landing – as soon as I saw this I ordered the boats to lay upon their oars in order to speak to them, but this was to little purpose for neither us nor Tupia could understand one word they said … I thought they beckoned to us to come ashore, but in this we were mistaken for as soon as we put the boat in they again came

to oppose us, upon which I fired a musket between the two, which had no other effect than to make them retire back where bundles of their darts lay and one of them took up a stone and threw it at us, which caused my firing a second musket load with small shot and although some of the shot struck the man, yet it had no other effect than to make him lay hold of a shield or target to defend himself.

At this point the diary of Joseph Banks picks up the story:

... a man who attempted to oppose our Landing came down to the Beach with a shield ... made of the bark of a tree; this he left behind when he ran away, and we found upon taking it up that it plainly had been pierced through with a single pointed lance near the centre.

This must be that very shield. It has the hole near the centre mentioned by Banks, and traces of white colouring, as recorded by the expedition's illustrators. It's rough-hewn, a rich reddish brown, about a metre (40 inches) high and 30 centimetres (12 inches) wide – quite narrow for protecting a man – and gently curved. You can sense the trunk from which it was cut. It is made of red mangrove wood, one of the woods chosen for making Australian shields, because it is tough enough to absorb the impact of a spear or deflect a club or boomerang and is extremely resistant to insects and rot, even when submerged in seawater. At the back is a handle made out of flexible green mangrove wood that has dried to a firm shape for a good grip. The person who made this shield knew precisely what materials were fittest for purpose.

This shield was owned by a man living in a land that his ancestors had occupied for some 60,000 years. Phil Gordon, Aboriginal heritage officer at the Australian Museum in Sydney, describes the way of life in the area:

One of the great myths about Aboriginal Australia, of course, is that it was a hand-to-mouth existence, for want of a better word. The living around Sydney and in the Sydney region and a vast majority of the coastal part of Australia was very good; the fish levels in the harbours were high ... Sydney harbour would have been a great place to live. The climate was good; the economic existence was good. That allowed people then to involve themselves in the spiritual side of their existence and the other parts of their culture.

Cook and Banks would later remark on how happy and contented the people seemed, although we know that there were conflicts between tribal groups. As well as the shield, the men had spears, and indeed the hole here in the centre of the shield was made by a wooden spear or lance, presumably in combat. This piercing, as well as marks and scrapes on the surface, make it clear that the shield had seen action before it came up against Cook's musket shot. The shield also seems to have indicated individual identity or tribal allegiance: the traces of white paint have been found to be white kaolin clay, and it is likely there was a painted white mark or symbol at the centre of the shield. Phil Gordon elaborates:

> There was warfare in Aboriginal Australia, of course; there were blood feuds, group against group, all those sorts of things. But they're also a marker of your cultural grip, so the shape of your shield would be different from other areas, and the design on the shield would be different, which would equate to your status within the group and your standing among the groups all around you, too. So shields were distinctively different from coastal New South Wales to the Kimberley coasts region in Western Australia.

Cook, of course, knew nothing about indigenous customs – no European could – and the potential for misunderstanding in this First Encounter was limitless. In retrospect, neither side seemed to have wanted to kill or maim the other. The indigenous men threw stones and spears, but they missed everyone. Given that they were hunter-gatherers who lived by the accurate use of a spear, it seems highly likely that these were warning shots – telling this group of white strangers to go away and leave them alone. Cook, on his side, claims he thought the spears might have poison tips, so justifying the musket shot that he aimed at the legs of the men. When they ran off, Cook and his crew disembarked and went into the nearby woods:

> We found here a few small huts made of the bark of trees in one of which were four or five small children with whom we left some strings of beads, etc. ...

Cook had found in the Pacific islands that trading and bartering were quick ways of striking up peaceful relationships and of getting some

sense of how the local society functioned. But here there was no interest in his offerings. When he came back the next day,

> the strings of beads etc. we had left with the children last night were found laying in the hut this morning; probably the natives were afraid to take them away.

Perhaps they were less afraid than uninterested – or perhaps, more accurately, unwilling to engage, because to do so would have involved them in an obligation they did not want. It's not the case that these people did not trade – they traded and exchanged goods over great distances, as the shield itself can tell us. The red mangrove wood the shield is made of comes from trees that grow about 200 miles north of Sydney, so to source the wood the people at Botany Bay must have been trading with other indigenous Australians.

With no direct encounters or exchange of gifts, Cook gave up. After a week collecting botanical specimens he sailed on up the coast. When he reached the northern tip of Australia, Cook formally declared the whole east coast a British possession.

> I now once more hoisted English Colours and in the Name of His Majesty King George the Third took possession of the whole Eastern Coast by the name New South Wales ... after which we fired three Volleys of small Arms which were Answerd by the like number from the Ship.

This was not Cook's usual procedure where land was already inhabited. His normal practice was to acknowledge the rights of existing populations to the land they occupied, as for example in Hawaii. Perhaps he failed to grasp how intimately the indigenous Australians occupied and controlled their continent. We do not know what lay behind this momentous first step in expropriation. Not long after the expedition returned to England, Banks and others recommended Botany Bay as a Penal Colony to the British Parliament, so beginning the long and tragic story that for some indigenous Australians spelt the end of their communities.

The historian Maria Nugent looks at how Cook has been viewed since this first encounter:

> In Australian history Cook has mainly been seen as a precursor to colonization ... So he's seen as a founding father. Which in a way cancels out

the fact that there had been other European nations who had already 'discovered' or charted parts of Australia. But since he's British he gets a prominent place because we became a British colony. And he held that position for quite some time; probably until the politics of the 1960s and 1970s, in which Aboriginal people vocally and prominently criticize Cook as a founding figure. And they see him as a symbol of colonization, of death and destruction ... I think we're going through a new phase now, and there's a kind of renovation of Cook's reputation, and he's being seen more perhaps as a figure through which we can understand an Australian history which is about interactions between Aboriginal people and outsiders. And some people refer to this as a kind of history of encounter. But Cook is still, I think, a provocative figure in Australia, particularly for indigenous Australians.

The bark shield stands at the head of centuries of misunderstanding, deprivation and genocide. One of the big questions in Australia today remains how or indeed whether any meaningful reparation can be made. It is a process in which objects like this bark shield, held in European and Australian museums, have a small but significant part to play. Programmes of research, carried out together with the indigenous communities, are exploring surviving artefacts, recording myth and legend, skills and practice, to recover what can still be recovered of a history largely lost. This bark shield, present at the beginning of the encounter, might now play its part in a dialogue that failed to materialize 250 years ago.

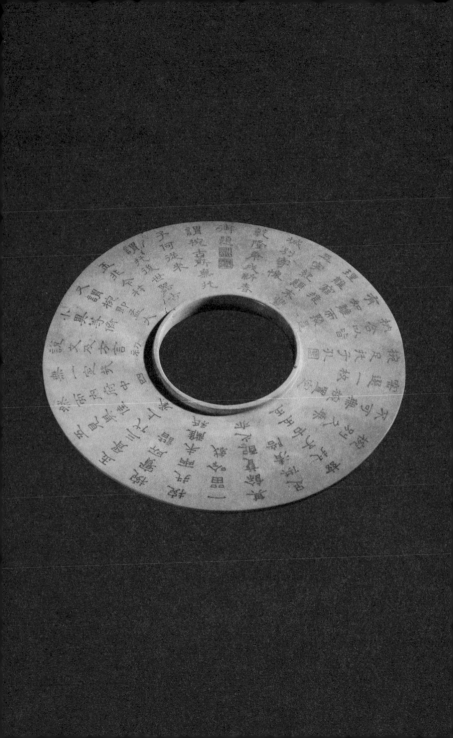

90

Jade *Bi*

Ring of jade, from Beijing, China

AROUND 1200 BC, WITH AD 1790 INSCRIPTION

The last four chapters have been about the European Enlightenment project of discovering, mapping and seeking to understand new lands. This object is from China at a time when it was having its own Enlightenment, under the rule of the Qing Dynasty that had displaced the Ming in 1644 and which would rule China right up to the early twentieth century. The Qing ruler of the time, the Qianlong emperor, roughly contemporary with George III, devoted considerable attention to exploring the world beyond China. In 1756, for example, he decided to map the territories he had annexed in Asia, so he sent out a multicultural taskforce, two Jesuit priests trained in map-making, a Chinese astronomer and two Tibetan lamas, which produced such useful geographic data that the knowledge spread across the world, along with the emperor's reputation.

The object here, a jade ring called a *bi* (pronounced 'bee'), is another product of the emperor's intellectual curiosity, this time about the Chinese past. This *bi* – a fine, plain disc with a hole in the centre, of a type often found in ancient Chinese tombs – was already more than 3,000 years old when the emperor decided to study it. The emperor took the ancient, unadorned *bi* and had his own words inscribed all over it. In doing so, he transformed the ancient *bi* into an object of the eighteenth-century Chinese Enlightenment.

For Enlightenment Europe, China was a model state, wisely governed by learned emperors. The author and philosopher Voltaire wrote in 1764, 'One need not be obsessed with the merits of the Chinese to recognize . . . that their empire is the best that the world has ever seen.' Rulers everywhere wanted a piece of China at their court. In Berlin,

The Qianlong emperor in his study

Frederick the Great designed and built a Chinese pavilion in his palace at Sanssouci. In England, George III erected a ten-storey Chinese pagoda in Kew Gardens.

In the fifty-nine years of the Qianlong emperor's reign, from 1736 to 1795, China's population doubled, its economy boomed and the empire grew to its greatest size for five centuries, more or less to its modern extent – covering more than four and a half million square miles. The Qianlong emperor was a tough leader, happy to proclaim the superiority of his own territorial conquests over those of his predecessors and to assert for his Qing Dynasty the backing of the heavenly powers – in other words, to claim for himself the Mandate of Heaven:

> The military strength of the majestic Great Qing is at its height... How can the Han, Tang, Song or Ming dynasties, which exhausted the wealth

of China without getting an additional inch of ground for it, compare to us? ... No fortification has failed to submit, no people have failed to surrender ... In this, truly we look up gratefully to the blessings of the blue sky above to proclaim our great achievement.

This emperor was also a shrewd intellectual, an adroit propagandist and a man of culture – a renowned calligrapher and poet, a passionate collector of paintings, ceramics and antiquities. The prodigious Chinese collections in the Palace Museums today hold many of his precious objects.

It is not hard to understand why this *bi* thoroughly engaged the emperor's attention, for it is a strange and intriguing thing, a pale beige thin disc of jade, about the size of a small dinner plate but with a hole in the middle and a raised edge round it. Nowadays we know from similar objects found in tombs that this *bi* was made probably around 1200 BC. We don't know what it was for, but we can see clearly enough that it is very beautifully crafted.

When the Qianlong emperor examined this *bi*, he also thought it was very beautiful and was moved to write a poem recording his thoughts on studying it. In his collected poems his *bi* poem is entitled: 'Verses Composed on Matching a Ding-ware Ceramic with an Ancient Jade Bowl Stand':

> It is said there were no bowls in antiquity / but if so, then where did this stand come from? It is said that this stand dates to later times / but the jade is antique. It is also said that a bowl called *wan* is the same as a basin called *yu*, but only differing from it in size.

While modern scholars know jade *bi* discs are found in tombs but are unsure of their exact use or meaning, the Qianlong emperor didn't struggle with any doubt. He thinks the *bi* looks like a bowl stand, a type of object used since antiquity in China. He shows off his knowledge of history by discussing arcane facts about ancient bowls and then decides he cannot leave it without a bowl, even if no antique bowl is to be found:

> This stand is made of ancient jade / but the jade bowl that once went with it is long gone. As one cannot show a stand without a bowl / we have selected a ceramic from the Ding kiln for it.

The bowl in the Palace Museum, Beijing, that the Qianlong emperor matched with the bi

By combining the *bi* with a much later object, the emperor has ensured that, in his eyes at least, the *bi* now fulfils its aesthetic destiny. This is a very typical Qianlong, eighteenth-century Chinese way of addressing the past. You admire the beauty, research the historical context and present your conclusions to the world as a poem, so creating a new work of art.

In this case the *bi* itself became the new work of art. The emperor's musings were incised in beautiful calligraphy on the wide ring of the disc, so fusing object and interpretation, as he saw it, in an aesthetically pleasing form. Chinese words, or characters, are spaced so they radiate out from the central hole like the spokes of a wheel, the very words I have been quoting. Most of us would see that as a defacing – a desecration – but that's not how the Qianlong emperor saw it. He thought the writing augmented the beauty of the *bi*. But he also had a more worldly, political purpose in making his inscription. The historian of China Jonathan Spence explains:

There was very much a sense that China's past had a kind of coherency to it, so this new Qing Dynasty wanted to be enrolled, as it were, in the

records of the past as having inherited the glories of the past and being able to build on them, to make China even more glorious. Qianlong was, there's no doubt about it, a great collector; and in the eighteenth century, when Qianlong was collecting, China was expanding. There is a bit of nationalism about his collecting, I think; he wanted to show that Beijing was the centre of this Asian cultural world ... And the Chinese, according to Voltaire and other thinkers in the French Enlightenment, did indeed have things to tell Europeans in the seventeenth and eighteenth centuries, important things about life, morality, behaviours, learning, genteel culture, the delicate arts, the domestic arts ...

And politics. The Qing Dynasty had one major internal political handicap. They were not Chinese – they came from modern Manchuria, on the north-eastern border. They remained a tiny ethnic minority, outnumbered by the native Han Chinese by about 250 to 1, and were famous for a number of un-Chinese things – among them, an appetite for large quantities of milk and cream. Was Chinese culture safe with them? In this context, the Qianlong emperor's appropriation of ancient Chinese history is a deft act of political integration, but only one act among many. His greatest cultural achievement was the Complete Library of the Four Treasuries, the largest anthology of writing in human history, encompassing the whole canon of Chinese writing from its origins to the eighteenth century. Digitized, today it fills 167 CD-ROMs.

The modern Chinese poet Yang Lian recognizes the propaganda element in the Qianlong emperor's lyrical inscription on the *bi*, and takes a rather dim view of his poetry:

> When I look at this *bi* I have some very complex feelings. On one side I am very much appreciative: I love this feeling of a link with the ancient Chinese cultural tradition, because it was a very unique phenomenon which started a long time ago and never broke, continually developed until today through many difficult times ... In that case the jade always represented the great past. But on the darker side, the beautiful things were often used by rulers and powers who had bad taste, so they don't mind destroying ancient things with bad writing. So they can carve the emperor's poem on the beautiful piece and also do a little propaganda, which for me is very familiar!

Like his contemporary Frederick the Great, the Qianlong emperor was no master of poetry – he seems to have mixed Classical Chinese with vernacular forms to poor effect. But that didn't hold him back – he published more than 40,000 compositions in his lifetime, part of his elaborate campaign to secure his place in history.

He was largely successful. Although the Qianlong emperor's reputation dipped dramatically in the Communist period, it is once again strong in China. And a very satisfying discovery has just been made. As we saw a moment ago, the emperor wrote: 'As one cannot show a stand without a bowl / we have selected a ceramic from the Ding kiln for it.' Very recently a scholar in the Palace Museum collections in Beijing found a bowl that carries exactly the same inscription as the one on this disc. It is undoubtedly the very bowl chosen by the emperor to sit in the *bi*.

As he handled and thought about the *bi*, the Qianlong emperor was doing something central to any history based on objects. Exploring a distant world through things is not only about knowledge but about imagination, and necessarily involves an element of poetic reconstruction; with the *bi*, for example, the emperor knows it is an ancient and a cherished object, and he wants it to look its best. He believes it is a stand, and he finds a bowl that seems to be a perfect match – a choice made with his sense of supreme self-assurance that he is doing the right thing. It is unlikely his assumption about the *bi* being a stand was correct, but I find myself admiring and applauding his method.

Mass Production, Mass Persuasion

AD 1780–1914

Between the French Revolution and the First World War the countries of Europe and the USA were transformed from agricultural to industrial economies. At the same time, their empires around the world grew, providing many of the raw materials and the markets these booming industries required. Eventually all of Asia and Africa were compelled to become part of the new economic and political order. Technological innovation led to mass production of goods and growing international trade: consumer goods that had previously been luxuries, such as tea, became widely affordable to the masses. In many countries, mass movements campaigned for political and social reforms, including the right for all men and women to be able to vote. Only one non-western country, Japan, successfully, if involuntarily, embraced modernization and emerged as an imperial power in its own right.

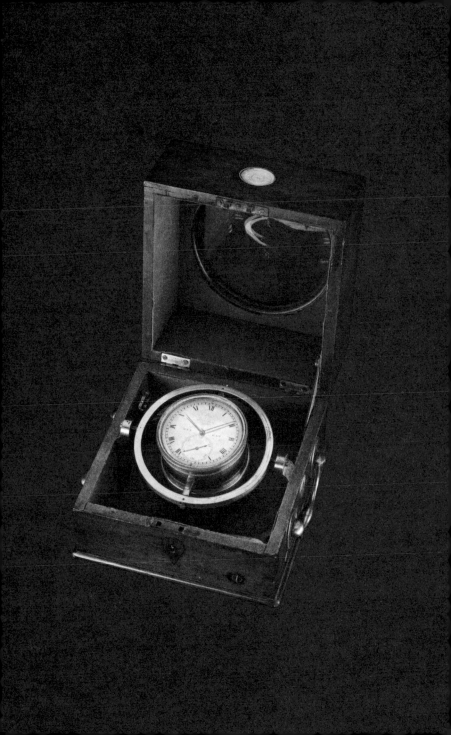

Ship's Chronometer
from HMS *Beagle*

Brass chronometer, from England
AD 1800–1850

W hy does the whole world measure its time and define its position in relation to the Greenwich Meridian, a line passing through a spot on the banks of the Thames in south-east London? The story begins with the invention in London of a sea-going clock that allowed sailors to find their longitude. The object pictured here is one of those clocks – a marine chronometer made around 1800 – which could keep perfect time even in rolling seas.

During what is sometimes called the 'long' nineteenth century, from the French Revolution to the First World War, the countries of western Europe and America were transformed from agricultural societies into industrial powerhouses. This Industrial Revolution generated many others. New technologies led for the first time to mass production of luxury goods: societies reorganized themselves politically at home, while overseas, empires expanded to secure raw materials and new markets. Technological advances also led to revolutions in thought: it is hardly an exaggeration, for example, to say that the whole idea of time changed in the nineteenth century, and in consequence so did our idea of ourselves and our understanding of humanity's proper place in history.

In the seventeenth and eighteenth centuries clockmaking was a vital European technology, and London was at its cutting edge. As a maritime nation, the British were concerned with one problem in particular: they could make clocks that kept very good time as long as they stayed perfectly still but not when they were shaken about, and particularly not on board a rolling ship. If you wanted to sail, it was impossible to keep a precise record of time. And at sea, if you can't tell the time, you don't how far east or west you are. It is relatively easy to

calculate latitude – your distance north or south of the equator – by measuring the height of the Sun above the horizon at noon; but this won't let you calculate longitude – your position east or west.

The problem of accurate timekeeping at sea was finally cracked in the middle of the eighteenth century by John Harrison, who invented a clock – a marine chronometer – which could go on accurately telling the time in spite of fluctuations in temperature and humidity and the constant movement of a ship, thus making it possible for the first time for ships anywhere to establish their longitude. Before a ship set sail, its chronometer would be set to the local time in harbour – for the British this was usually Greenwich. Once at sea, you could then compare the time at Greenwich with the time of noon on board ship, which you fixed by the Sun; the difference between the two times gave you your longitude. There are twenty-four hours in the day so, as the Earth rotates, every hour the Sun apparently 'moves' across the sky one twenty-fourth of a complete circle of the globe – that is, 15 degrees. If you are three hours behind the time in Greenwich, you are 45 degrees west – in the middle of the Atlantic. If you are three hours ahead you are 45 degrees east – on the same latitude as Greenwich, you would be somewhere south-west of Moscow.

Harrison's chronometers were pioneering, high-precision instruments made in tiny numbers and affordable only to the Admiralty. It was not until around 1800 that two London clockmakers managed to simplify the chronometer mechanisms so that virtually any ship – and certainly the larger ships of the Royal Navy – could carry them as routine equipment. Our object is one of those lower-cost chronometers, made in 1800 by Thomas Earnshaw. It is made of brass and is around the size of a large pocket watch, with a normal clock dial showing roman numerals and a smaller dial at the bottom for the second hand. The clock is suspended inside a swivelling brass ring fitted to the inside of a wooden box – this is the key to keeping the chronometer level even in an unsteady ship. The geographer Professor Nigel Thrift assesses the background:

> The chronometer is the pinnacle of a long history of clockmaking, and it is very important to realize that clocks have been around since 1283 in England. Everyone talks about Harrison and the fact that he was a

genius. He was, but you have to understand the innovative efforts made by hundreds and thousands of clockmakers and general mechanics that, in the end, produced that object. Gradually, all of those things are incorporated into this extraordinarily efficient machine. These kinds of chronometers were phenomenally accurate; for example, one of the first was used by Captain Cook on his second voyage of exploration to the Pacific, and when Cook made final landfall in Plymouth in 1775 after circumnavigating the globe it gave an error of less than eight miles in calculated longitude.

This particular chronometer sailed on many ships – always issued and set, as others were, at Greenwich; but it is famous because in 1831 it was issued to HMS *Beagle*, the ship that carried Charles Darwin on his great voyage to South America, the Galapagos Islands and on around the world, which ultimately led to his theory of evolution and his great work *On the Origin of Species*.

The *Beagle* was on a mission to map the coastline of South America, work which relied on very accurate measurements of longitude and latitude. The chronometer for the first time allowed absolutely accurate charting of the oceans, with all that implied for establishing safe and rapid shipping routes. It was another great step in the Enlightenment project of mapping – and therefore controlling – the world. To allow for any discrepancies or failures, the *Beagle* carried twenty-two chronometers: eighteen, including ours, were provided by the Admiralty, and four by the captain, Robert FitzRoy, who felt that eighteen was not enough for such a lengthy and important job. After five years at sea, the eleven chronometers still working at the end of the voyage showed a discrepancy of just thirty-three seconds from Greenwich time. For the first time, a detailed chronometric girdle had been put around the Earth.

By the middle of the nineteenth century it was established that all British shipping would take Greenwich as its point of reference for time and therefore for longitude, and all the oceans of the world had been mapped by British ships on that basis. As a result, the Greenwich Meridian and Greenwich Mean Time were increasingly widely used by the international community until, in 1884, the Washington Convention formally ratified the practice. There was one notable

exception: the French defiantly stuck to their Paris Meridian for some decades more, but eventually they too fell into line, and every country now fixes its time zone by reference to Greenwich Mean Time. For the first moment in history the world was working to one timetable. Global time, a concept almost unimaginable 100 years earlier, had arrived.

But on the *Beagle* our chronometer was also witness to another, quite separate shift in the nineteenth century's understanding of time. Darwin's voyage on the *Beagle* and his subsequent work on evolution pushed human origins – and indeed the origins of life itself – into an unthinkably distant past. Geologists had already demonstrated that the Earth was far older than previously believed, undermining the calculation made by Archbishop Ussher (see Chapter 2). This new concept of deep time – going back tens of millions of years – destroyed the established historical and biblical frameworks of thought. The shifting parameters of time and change forced the nineteenth century to rethink from scratch the very nature and meaning of human existence. Professor Steve Jones, a geneticist and expert on Darwin and evolution, considers the significance of the discovery of deep time:

> I think what deep time did was to make people realize that the Earth was not unchanging. The biggest transformation since the Enlightenment has been a shift in our attitude to time, the feeling that time is effectively infinite, both the time that's gone and the time that's to come. It's worth remembering that the summit of Everest, not long ago in the context of deep time, was at the bottom of the ocean; and some of the best fossils of whales are actually found high in the Himalayas.

These were enormous and belief-shattering ideas for many people in the nineteenth century, but time was also changing in a much more day-to-day, or rather hour-to-hour, way. Thanks to clockmakers like Earnshaw, precise and reliable clocks and watches became ever more affordable. Before long the whole of Britain was running by the clock, and the measurement of time had been severed from the natural cycle of days and seasons. The clock ruled every aspect of life – shops and schools, pleasure and work. As Charles Dickens wrote, 'There was even railway time observed in clocks, as if the sun itself had given in.' Nigel Thrift explains:

The chronometer, an exceptionally accurate clock, meant that gradually an ever more accurate measure of time became possible, and that of course worked through other things in the nineteenth century to produce ever more standardized time. A good example of that is the railway, where standard time based on the meridian was first applied by the Great Western Railway in 1840 and gradually that standard time became general. By 1855, 95 per cent of towns had switched to GMT, and by 1880 GMT became the reference point across the UK by Act of Parliament. But it is worth remembering that until that point, certainly until the beginning of railway time, places had all run to local time, and if you were travelling, Leeds, for example, was six minutes behind London; Bristol was ten minutes. It didn't matter then. But it mattered when you started getting fast travel. Everyone went on to one time, gradually but very certainly.

Just as people adopted a common standard time, so numerous aspects of working and daily life were becoming rigidly fixed by the clock, from clocking on at work to school hours and tea-time – which is the subject of our next chapter.

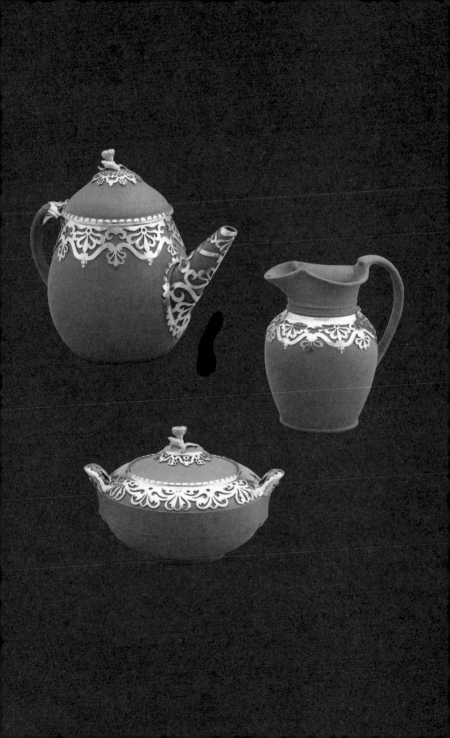

Early Victorian Tea Set

Stoneware and silver tea set, from Staffordshire, England
AD 1840–1845

W hat could be more domestic, more unremarkable, more *British*, than a nice cup of tea? You could of course put the question the other way round and ask what could be less British than a cup of tea, given that tea is made from plants grown in India or China and often sweetened by sugar from the Caribbean. It is one of the ironies of British national identity – or perhaps it says everything about our national identity – that the drink which has become the worldwide caricature of Britishness has nothing indigenous about it, but is the result of centuries of global trade and a complex imperial history. Behind the modern British cup of tea lie the high politics of Victorian Britain, the stories of nineteenth-century empire, of mass production and of mass consumption, the taming of an industrial working class, the reshaping of the agriculture of continents, the movement of millions of people, and a worldwide shipping industry.

By the middle of the nineteenth century in Britain some luxuries came to be seen as not only desirable but essential. The most ubiquitous of all was tea, a vital ingredient of life for every part of the British population. The object that highlights this change is a tea set made up of three pieces of red-brown stoneware: a smallish teapot about 14 centimetres (6 inches) high with a short straight spout, a sugar bowl and a milk jug. They were made – as we can read on their bases – at Wedgwood's Etruria factory in Stoke-on-Trent, Staffordshire, in the heart of the Potteries. In the eighteenth century Josiah Wedgwood had made some of the most expensive stoneware ceramics – in jasper and basalt – in Britain, but this tea set shows that by the 1840s, when Wedgwood produced it, the company was aiming at a much wider

market. This is quite clearly mid-range pottery, simple earthenware of a sort that many quite modest British households were then able to afford. But the owners of this particular set must have had serious social aspirations, because all three pieces have been decorated with a drape of lacy hallmarked silver. The historian Celina Fox explains that tea-time had become a very smart event:

> In the 1840s the Duchess of Bedford introduces the ritual of afternoon tea, because by this time dinner had become so late, seven-thirty to eight o'clock, that it was a bit of a gap for the British tummy between lunch-time and evening. For a while there was a revival of tea-drinking, as a sort of meal for sandwiches and so forth, around four o'clock.

Among the upper classes, tea had been popular since before 1700. It received celebrity endorsement from Charles II's queen, Catherine of Braganza, and from Queen Anne. It came from China, it was expensive, refreshingly bitter and drunk in tiny cups without milk or sugar. People kept their tea in locked tea caddies, as if it were a drug; for those who could afford it, it often was. In the 1750s Samuel Johnson confessed himself a happy addict:

> A hardened and shameless tea drinker, who has for twenty years diluted his meals with only the infusion of this fascinating plant, whose kettle scarcely has time to cool, who with Tea amuses the evening, with Tea solaces the midnights, and with Tea welcomes the morning.

Desire for the drink increased in the eighteenth century, but government taxes kept the price high, so a vigorous smuggling trade developed to avoid the excise duty. By the 1770s most of the tea entering Britain was smuggled – it was estimated that 7 million lbs (3 million kilograms) of tea were illicitly trafficked into Britain, against only 5 million lbs (2 million kilograms) imported legally. In 1785, under pressure from the law-abiding tea traders, the government slashed the duty on tea, which wiped out the illegal smuggling trade virtually overnight. The price of tea dropped sharply. It could now become a truly popular drink. But cheapness was only one factor in the nation's growing taste for tea. At some point early in the eighteenth century, people had started adding milk and sugar, which transformed bitter refinement into sustaining sweetness. Consumption rocketed. Unlike

coffee, tea was positively marketed as a respectable drink for both sexes – with women particularly targeted. Tea houses and tea gardens flourished in London and china tea sets became an essential part of the fashionable household, while less costly versions in pottery – like the object in this chapter – spread through society.

As it got cheaper, tea also spread rapidly to the working classes. By 1800, as foreigners remarked, it was the new national drink. By 1900 the average tea consumption per person in Britain was a staggering 6 lbs (3 kilograms) a year. In 1809 the Swede Erik Gustav Geijer commented:

> Next to water, tea is the Englishman's proper element. All classes consume it ... in the morning one may see in many places small tables set up under the open sky, around which coal-carters and workmen empty their cups of delicious beverage.

The ruling classes had a real interest in promoting tea drinking among the growing urban population, who were poor, vulnerable to disease and perceived as prone to disorderly drunkenness. Beer, port and gin had become a significant part of the diet of men, women and even children, partly because alcohol as a mild antiseptic was much safer to drink than unpurified city water. But by the nineteenth century alcohol was a growing social problem. Religious leaders and temperance movements made common cause to proclaim the merits of tea. A cup of sweet, milky tea was cheap, energy-giving, refreshing and tasted very good. Celina Fox explains how it was also a wonderful instrument of social control:

> Temperance was huge. Drink for the Victorians was a very big issue. The desire to have a working population that was sober and industrious was very strong, and there was a great deal of propaganda to that effect. Sobriety was tied in with dissent, Methodism and so on, and tea really was the drink of choice. So it's happening on two levels: dissent and having an upright and working population which gets to the factory on time and isn't drunk out of its mind, which always seems to be a British problem, and on top of that you have the ritual of afternoon tea. So tea drinking really takes off in a massive way in the nineteenth century.

As tea displaced beer as the defining national drink, it became a symbol of the rebranded British character – polite and respectable, with

none of the old boisterous conviviality. An anonymous temperance poem from the nineteenth century makes the point:

> With you I see, in ages yet unborn,
> Thy votaries the British Isles adorn,
> Till rosy Bacchus shall his wreaths resign,
> And love and tea triumph o'er the vine.

But a loving, tranquil cup of tea has a violent hinterland. When all tea came into Europe from China, the British East India Company traded opium for silver and used that silver to buy tea. The trade was so important that it brought the two countries to war. The first of the conflicts, which we still refer to as the Opium Wars – they were in fact just as much about tea – broke out more or less as our teapot was leaving the Wedgwood factory. Partly because of these difficulties with China, in the 1830s the British set up plantations in the area around Calcutta and Indian tea was exempted from import duty to encourage demand. Strong, dark Assam tea became the patriotic British cuppa – and sustained the empire. As the century went on, tea plantations were established in Ceylon, now Sri Lanka, and large numbers of Tamils were moved from south India to Ceylon to work on them. Monique Simmonds, from Kew Gardens, describes the impact:

> You would have had hundreds of acres being turned over to tea, especially in northern parts of India. They also had success when they took it to places like Ceylon. It would have had an impact on the local population but it did bring jobs to the area, although low-paid jobs – it started off with males being employed, but it was mostly females clipping the tea. Local communities in parts of India and China were benefiting from growing the material and also being able to sell it. But added value from the trade and packaging would have really occurred within the empire and especially within Britain.

Fortunes were made in shipping. The tea trade required huge numbers of fast clipper ships for the long voyage from the Far East, which docked in British harbours alongside vessels bringing sugar from the Caribbean. To get sugar on to a British tea table had until very recently involved at least as much violence as was needed to fill the teapot. The first African slaves in the Americas worked on sugar plantations, the

start of the long and terrible triangular trade that carried European goods to Africa, African slaves to the Americas (as we saw in Chapter 86) and slave-produced sugar to Europe. After a long campaign involving many of the people who supported temperance movements, slavery in the British West Indies was abolished in 1833. But in the 1840s there was still a great deal of slave sugar around – Cuba was a massive producer – and it was of course cheaper than the sugar produced on free plantations. The ethics of sugar were complex and intensely political.

The most peaceful part of the tea set is, not surprisingly, the milk jug, though it too is part of a huge social and economic transformation. Until the 1830s, for urban dwellers to have milk, cows had to live in the city – an aspect of nineteenth-century life we're now barely aware of. Suburban railways changed all that. Thanks to them, the cows could leave town, as an 1853 article in the *Journal of the Royal Agricultural Society of England* makes clear:

> A new trade has been opened in Surrey since the completion of the South-Western Railway. Several dairies of 20 to 30 cows are kept and the milk is sent to the various stations of the South-Western Railway, and conveyed to the Waterloo terminus for the supply of the London Market.

So our tea set is really a three-piece social history of nineteenth-century Britain. It is also a lens through which historians such as Linda Colley can look at a large part of the history of the world:

> It does underline how much empire, consciously or not, eventually impacts on everybody in this country. If in the nineteenth century you are sitting at a mahogany table drinking tea with sugar, you are linked to virtually every continent on the globe. You are linked with the Royal Navy, which is guarding the sea routes between these continents, you are linked with this great tentacular capital machinery through which the British control so many parts of the world and ransack them for commodities, including commodities that can be consumed by the ordinary civilian at home.

The next object comes from another tea-drinking island nation, Japan. But, unlike Britain, Japan had done all it could to keep the rest of the world at bay and joined the global economy only when forced to do so by the United States – literally at gunpoint.

93
Hokusai's *The Great Wave*

Woodblock print, from Japan
AD 1830–1833

In the early nineteenth century Japan had been effectively closed off from the world for 200 years. It had simply opted out of the community of nations.

> Kings are burning somewhere,
> Wheels are turning somewhere,
> Trains are being run,
> Wars are being won,
> Things are being done
> Somewhere out there, not here.
> Here we paint screens.
> Yes ... the arrangement of the screens.

This is Stephen Sondheim's musical tableau of the secluded and calmly self-contained country in 1853, just before American gunships forced its harbours to open to the world. It is a witty caricature of the dreamy and aesthetic Japanese, serenely painting screens while across the seas Europe and America industrialize and political turmoil rages.

This is an image the Japanese themselves have sometimes wanted to project, and it is how the most famous of all Japanese images, *The Great Wave*, is sometimes read. This bestselling woodblock print, made around 1830 by the great artist Hokusai, is one of his series of thirty-six Views of Mount Fuji. The Museum has three impressions of *The Great Wave*. The one shown here is an early one, taken when the woodblock was still crisp, which means it has sharp lines and clear, well-integrated colours. At first sight it presents a beautiful picture of a deep blue wave curling above the sea with, far in the distance, the

tranquil, snow-capped peak of Mount Fuji. It is, you might think, a stylized, decorative image of a timeless Japan. But there are other ways of reading Hokusai's *Great Wave*. Look a little closer and you see that the beautiful wave is about to engulf three boats with frightened fishermen, and Mount Fuji is so small that you, the spectator, share the feeling that the sailors in the boats must have as they look to shore – it's unreachable, and you are lost. This is, I think, an image of instability and uncertainty. *The Great Wave* tells us about Japan's state of mind as it stood on the threshold of the modern world, which the US was soon going to force it to join.

In the middle of the nineteenth century, as the Industrial Revolution began, the great manufacturing powers, above all Britain and the United States, were aggressively looking for new sources of raw materials and new markets for their products. The world, these free-traders believed, was their oyster, and it was one they intended to force open. To them, it seemed incomprehensible – indeed intolerable – that Japan should refuse to play its full part in the global economy. Japan, on the other hand, saw no need to trade with these pushy would-be partners. Its existing arrangements suited it very well.

The country had closed almost all its ports at the end of the 1630s, expelling traders, missionaries and foreigners. Japanese citizens were not permitted to leave the country, nor could foreigners enter – disobedience was punished by death. Exceptions were made only for Dutch and Chinese merchants, whose shipping and trade were restricted to the port city of Nagasaki. There goods were regularly imported and exported (as we saw in Chapter 79, the Japanese were quick to jump into the gap in the European porcelain market left by political problems in China in the mid seventeenth century) but on terms of trade laid down solely by the Japanese. In dealing with the rest of the world, they called the shots. This was not so much splendid isolation as selective engagement.

If foreign people could not enter Japan, foreign things most certainly could. We can see this very clearly if we look closely at the composition, physical and pictorial, of *The Great Wave*. We see a rather traditional-looking Japanese scene – the enormous wave curling over the long, open fishing boats, dwarfing them and dwarfing even Mount Fuji in the distance. It is printed on traditional Japanese

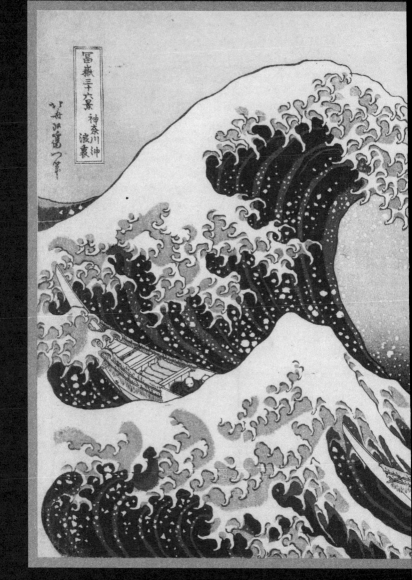

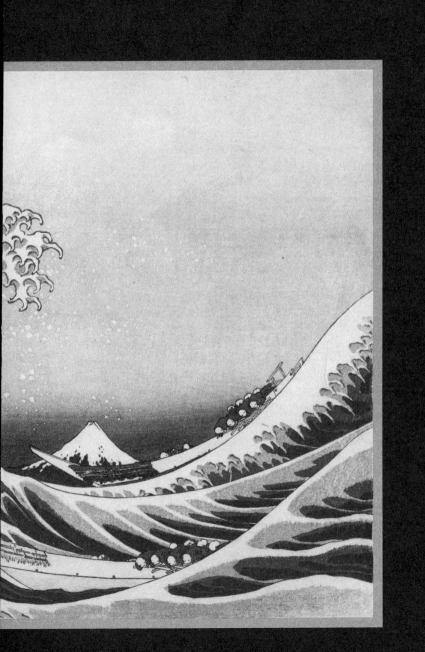

mulberry paper, just under the size of a sheet of A3, in subtle shades of yellow, grey and pink, but it is the deep, rich blue that dominates – and startles. For this is not a Japanese blue – it is Prussian blue or Berlin blue, a synthetic dye invented in Germany in the early eighteenth century and much less prone to fading than traditional blues. Prussian blue was imported either directly by Dutch traders or, more probably, via China, where it was being manufactured from the 1820s. The blueness of the *Great Wave* shows us Japan taking from Europe what it wants to take, and with absolute confidence. The Views of Mount Fuji series was promoted to the public partly on the basis of the exotic, beautiful blue used in its printing – prized because of its very foreignness. Hokusai has taken more than colour from the West – he has also borrowed the conventions of European perspective to push Mount Fuji far into the distance. It is clear that Hokusai must have studied European prints, which the Dutch had imported into Japan and which circulated among artists and collectors. So *The Great Wave,* far from being the quintessence of Japan, is a hybrid work, a fusion of European materials and conventions with a Japanese sensibility. No wonder this image has been so loved in Europe: it is an exotic relative, not a complete stranger.

It also, I think, shows a peculiarly Japanese ambivalence. As a viewer, you have no place to stand, no footing. You too must be in a boat, under the Great Wave, and in danger. The dangerous sea over which European things and ideas travelled has, however, been drawn with a profound ambiguity. Christine Guth has studied Hokusai's work, especially *The Great Wave*, in depth:

> It was produced at a time when the Japanese were beginning to become concerned about foreign incursions into the islands. So this great wave seemed, on the one hand, to be a symbolic barrier for the protection of Japan, but at the same time it had also suggested the potential for the Japanese to travel abroad, for ideas to move, for things to move back and forth. So I think it was closely tied to the beginnings of the opening of Japan.

In the long years of relative seclusion Japan, governed by a military oligarchy, had enjoyed peace and stability. There were strict codes of public behaviour for all classes, with laws on private conduct,

marriage, weapons and much else for the ruling elite. In this highly controlled atmosphere, the arts had flourished. But all this depended on the rest of the world staying away, and by the 1850s there were many outsiders who wanted to share in the profits and privileges enjoyed by the Chinese and the Dutch, and to trade with this prosperous and populous country. Japan's rulers were reluctant to change, and the Americans came to the conclusion that free trade would have to be imposed by force. The story told in Stephen Sondheim's ironically titled *Pacific Overtures* actually happened in 1853, when Japan's self-imposed isolation was breached by the very real Commodore Matthew Perry of the US Navy, who sailed into Tokyo Bay uninvited and demanded that the Japanese begin to trade with the US. Here's a snatch of the letter from the president of the United States that Perry delivered to the Japanese emperor:

> Many of the large ships-of-war destined to visit Japan have not yet arrived in these seas, and the undersigned, as an evidence of his friendly intentions, has brought but four of the smaller ones, designing, should it become necessary, to return to Edo in the ensuing spring with a much larger force.
>
> But it is expected that the government of your imperial majesty will render such return unnecessary, by acceding at once to the very reasonable and pacific overtures contained in the president's letter ...

This was textbook gunboat diplomacy, and it worked. Japanese resistance melted, and very quickly the Japanese embraced the new economic model, becoming energetic players in the international markets they had been forced to join. They began to think differently about the sea that surrounded them, and their awareness of the possible opportunities in the world beyond grew fast.

The Japanologist Donald Keene, from Columbia University, sees the wave as a metaphor for the changes in Japanese society:

> The Japanese have a word for insular which is literally the mental state of the people living on islands: *shimaguni konjo. Shimaguni* is 'island nations' *konjo* is 'character'. The idea is they are surrounded by water and, unlike the British Isles, which were in sight of the continent, are far away. The uniqueness of Japan is often brought up as a great virtue. A

new change of interest in the world, breaking down the classical barriers, begins to emerge. I think the interest in waves suggests the allure of going elsewhere, the possibility of finding new treasures outside Japan, and some Japanese at this time secretly wrote accounts of why Japan should have colonies in different parts of the world in order to augment their own riches.

The Great Wave, like the other images in the series, was printed in at least 5,000 impressions, possibly as many as 8,000, and we know that in 1842 the price of a single sheet was officially fixed at 16 mon, the equivalent of a double helping of noodles. This was cheap, popular art; but when printed in such quantities, to exquisite technical standards, it could be highly profitable.

After Commodore Perry's forced opening of the Japanese ports in 1853 and 1854, Japan resumed sustained contact with the outside world. It had learnt that no nation would be allowed to opt out of the global economic system. Japanese prints were exported in large numbers to Europe, where they were quickly discovered and celebrated by artists like Whistler, Van Gogh and Monet; the Japanese artist who had been so influenced by European prints now influenced the Europeans in return. *Japonisme* became a craze and was absorbed into the artistic traditions of Europe and America, influencing the fine and applied arts well into the twentieth century. In time, Japan followed the industrial, commercial West and was transformed in the process into an imperial economic power. Yet just as Constable's *Haywain*, painted at roughly the same time, became the iconic image of a rural, pre-industrial England, so Hokusai's *Great Wave* became – and in the modern imagination has remained – the emblem of a timeless Japan, reproduced on everything from textiles to tea cups.

94

Sudanese Slit Drum

Drum, from Central Africa
AD 1850–1900

Horatio Herbert Kitchener, 1st Earl Kitchener, was one of the media stars of the First World War. The famous recruitment poster has him pointing straight at us in full uniform, finger in the foreground, handle-bar moustache not far behind, with the words 'Your country needs YOU'. By then Kitchener was already legendary as Kitchener of Khar-toum, and this Central African wooden drum, which he captured and presented to Queen Victoria in 1898, just after his army had killed around 11,000 Sudanese soldiers in the Battle of Omdurman, is part of how he earned his title.

The biography of this slit drum, as it's called, is a story of Sudan in the nineteenth century, when Ottoman Egypt, Britain and France all converged on this enormous Nile country which had long been divided between an African south, which practised traditional beliefs, and an Islamic north. It is another document of the enduring geopolitical fault-line around the Nile cataracts that we have encountered twice before: in the sphinx of Taharqo (Chapter 22) and the head of Augustus (Chapter 35). This drum is part of the history of indigenous African culture, of the East African slave trade centred on Khartoum, and of the European scramble for Africa at the end of the nineteenth century.

The slit drum began its life in Central Africa, in the region where Sudan and the Congo share a frontier, and it would have been part of the court orchestra of a powerful chief. It is in the shape of a short-horned buffalo or bush cow, about 270 centimetres (110 inches) long from nose to tail, and about 80 centimetres (30 inches) high, so about the size of a big calf with very short legs. The head is small, and the tail short – the bulk is concentrated entirely in the body, which has been hollowed out

and has a narrow slit running across its back. The flanks of the drum have been carved to different thicknesses, so that a skilled drummer with a traditional drumstick can produce at least two tones and as many as four distinct pitches. It is made from a single piece of reddish African coralwood, a durable hardwood found in the forested areas of Central Africa and valued for making drums because it stands up well to repeated striking, maintains a constant tone and is resistant to termites.

The main function of the drum was music-making, marking community events such as births, deaths and feasts. Europeans dubbed these slit drums 'talking drums', because they were used to 'speak' to people at ceremonies and also to transmit messages over long distances – their sound could carry for miles – calling men either to a hunt or to war.

In the late nineteenth century, Sudan was a society under threat. European and Middle Eastern powers had long had a presence in Central Africa, drawn by its abundance of ivory and of slaves. For centuries slaves had been taken from southern Sudan and Central Africa, brought north to Egypt and then sold on across the Ottoman Empire; many Central African chiefs collaborated with the slave-traders to carry out joint raids on their enemies, selling the captives and sharing the proceeds. This intensified when the Egyptians took control of Sudan in the 1820s, and slave raiding and trading became one of the most profitable and powerful industries of the region. It was centralized by the Egyptian government in Khartoum, which by the late nineteenth century had become the greatest slave market in the world, servicing the whole of the Middle East. The writer Dominic Green assesses the situation:

> The Egyptians had built up a substantial slave-trading empire, running from the fourth cataract of the Nile all the way down towards the northern shores of Lake Victoria. They had done this with some support from European governments, who were obviously concerned to get their hands on ivory as opposed to slaves, but were also concerned about the humanitarian aspect. The Egyptian khedives, the rulers of Egypt, played a double game, where they signed on to anti-slaving conventions pushed on them by the Europeans, and then pretty much continued to make money out of the slave trade.

The drum, which could have been seized as booty by slave-raiders or given by a local chief, almost certainly came to Khartoum as part of that trade. Once it arrived in Khartoum it began a new chapter of its life and was refashioned to take its place in this Islamic society. We can see this when we look at its sides: on each flank a long rectangle has been carved, running almost the whole length of the body, containing circles and geometric patterns – recognizably Islamic designs added by the new owners to protect against the evil eye. On one side the design is incised in the body of the wood, but on the other the wood has been cut away so that the design stands proud. This thinning would materially change the sound of the drum, evidence that although it might continue to be used for its original purpose of music-making or calling people to arms, it would now do so with a different voice. A musical instrument had become a trophy, and the new carvings were in fact branding, a statement of the north's political dominance over Central Africa and of allegiance to Islam.

The drum had come to Khartoum at a critical moment in Sudanese history. The Egyptian occupation had brought with it many aspects of European technology and modernization, and a new kind of profoundly Islamic resistance was on the rise against it. Egypt was then technically part of the Islamic Ottoman Empire, but many Sudanese Muslims rejected what they saw as a very easy-going Islam that nevertheless brought with it political repression. In 1881 a religious and military leader arose: Muhammad Ahmad declared himself the *mahdi* – the one guided by God – and summoned an army to jihad, to reclaim Sudan from the lax, Europeanized Egyptians. It was called the Mahdist Revolt, and it was the first time in modern history that a self-consciously Islamic army took on the forces of imperialism. For a time, it swept all before it.

Britain had a fundamental strategic interest in a stable Egyptian government. The Suez Canal, built by the French and Egyptians in 1869, was an economic lifeline, the critical link between the Mediterranean and British India. But the building of the canal, other large-scale projects and chronic financial mismanagement by the Egyptian khedive had caused soaring national debt. When the Mahdist Revolt in Sudan added to the strain, Egypt looked as if it was going to founder in bankruptcy and civil war. In 1882, concerned for the security of the

canal, the British moved to protect their national interests. They invaded, leaving an Egyptian government to rule with British advisers. Not long after, when the Mahdists besieged Khartoum, the British turned their attention to Sudan. As the power of the mahdi grew, the Egyptian government sent General Gordon to lead the Egyptian Army in the Sudan. His forces were cut off; Gordon was hacked to death in Khartoum and became a martyr in Britain. The Mahdists took over Sudan, as Dominic Green describes:

> Gordon underwent one of those terrible Victorian deaths of being chopped to pieces and then reconstituted in marble statues and oil paintings all over Britain. Khartoum fell in January 1885, and once the outcry had subsided Sudan was pretty much forgotten about by the British until the mid 1890s. This was the time of the 'scramble for Africa'; the British strategy was essentially to build a north–south connection from Cape, as they said, to Cairo. The French were working from east to west, or west to east, and an expedition under a Captain Marchand was despatched. It landed in West Africa and started staggering through the swamps towards the Nile. The British realized this and sent a force, a relatively small one, under Horatio Herbert Kitchener, and eventually in 1898, thirteen years after the siege, Kitchener's army faced off against the Mahdist army.

On 2 September 1898 Kitchener's Anglo-Egyptian army destroyed the Mahdist forces at Omdurman – the battle included one of the last cavalry charges of the British Army, and one of the participants was the young Winston Churchill. On the Sudanese side about 11,000 died and 13,000 were wounded. The Anglo-Egyptian army lost under fifty men. It was a brutal result – justified by the British as protecting their regional interest against the French, but also as avenging Gordon's death at Khartoum and putting an end to what they saw as the shameful slave trade.

The drum was found by Kitchener's army near Khartoum after the Anglo-Egyptian reconquest of the city. Once again it was re-carved – or re-branded – to make a political statement: near the tail of the bush calf Kitchener added the emblem of the British Crown. It was then presented to Queen Victoria.

Sudan was ruled as an Anglo-Egyptian territory from 1899 until

independence in 1956. For most of that time, the British policy was to divide the country into two essentially separate regions – the Islamic, Arabized north and the increasingly Christian African south. The Sudanese journalist Zeinab Badawi's grandfather fought on the Sudanese side at Omdurman, and her father was a leading figure in the modern politics of this divided country:

> It's an interesting drum because it's been etched with the Arabic script, because it fell into the hands of the Mahdi, and obviously Arabic is the lingua franca of Sudan and it's the language spoken by the northern tribes. The drum is very apt, because Sudan is this fusion between Black Africa proper and the Arab world, the real crossroads, like the confluence of the Nile, where the White Nile meets the Blue Nile, in Khartoum. I showed a picture of this drum to my father, and he told me that back in the 1940s and 1950s, when my father was vice-president of the Sudanese Socialist Party and he was in southern Sudan, a fracas broke out between the southern Sudanese and the northerners who were there. At one stage he thinks he saw somebody get a drum, which looked very much like this but obviously newer, and start drumming on it to encourage other southern Sudanese to come to show their strength, to stop this argument getting out of hand between the northerners and the southerners.

Since independence, Sudan has struggled under decades of civil war and sectarian violence, with enormous loss of life. Recently the south has asked for a peaceful separation from the north, and in 2011 there will be a referendum to decide how far such a separation might go. The story of which this slit drum is a part is by no means finished.

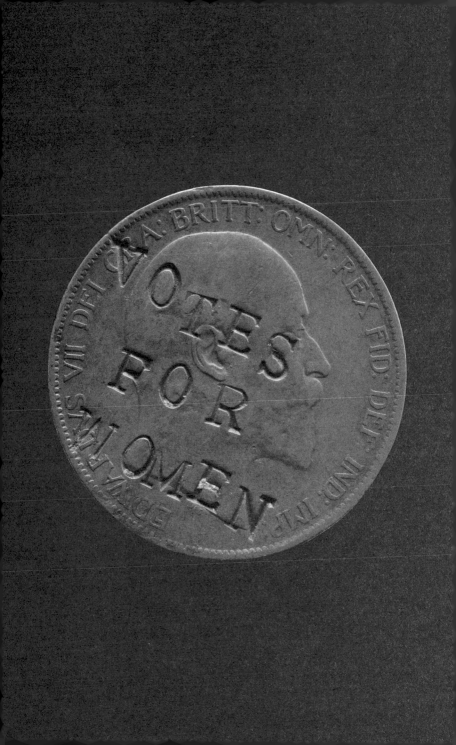

95
Suffragette-defaced Penny

Edward VII penny, from England
AD 1903–1918

O ur history has now reached the beginning of the twentieth century. Previously, we have been largely in a world of things that were made, commissioned, or owned by men. This object has on it the image of a king, but this particular example has been appropriated by women – disfigured by a slogan as an act of female protest against the laws of the state. It is a British penny with King Edward VII in elegant profile, but his image has been defaced in what was then a criminal act. Stamped all over the king's head in crude capitals are the words VOTES FOR WOMEN. This suffragette coin stands for all those who fought for the right to vote. Recent objects have been about nineteenth-century mass production and mass consumption – this one is about the rise of mass political engagement.

Power is usually not willingly given, but forcefully taken; and in both Europe and America the nineteenth century was punctuated by political protest, with periodic revolutions on the continent, the Civil War in America and, in Britain, a steady struggle to widen the suffrage.

The process of redefining the British political nation was a slow one. It began in the 1820s, and by the 1880s roughly 60 per cent of the male population had the right to vote – but no women. The campaign for women's suffrage had begun shortly after the Great Reform Act of 1832, but the battle only really got going at the start of the twentieth century, when the suffragette movement was born and with it a new level of female assertiveness, indeed violence. Here are the words of Dame Ethel Smyth, who composed the song 'March of the Women', which was a battle hymn of the suffragettes:

At exactly 5.30 one memorable evening in 1912 relays of women produced hammers from their muffs and handbags and proceeded methodically to smash shop windows in all the big London thoroughfares inspired by the knowledge that exactly at that moment Mrs Pankhurst was opening the ball with a stone aimed at a window of 10 Downing Street.

Smyth was jailed, along with many other women. One day a prison visitor found her leaning out of a window, using her toothbrush to conduct her co-suffragettes in singing the song during their exercises.

The British establishment was stunned by the vision of highly respectable women deliberately committing criminal acts. It was a big step beyond the posters, pamphlets, rallies and songs that had so far been the norm. Defacing a coin of the realm is a more subtle crime – one with no evident victims – but perhaps a more effective attack on the authority of a state that excluded women from political life. As a campaigning strategy it was a stroke of genius. The artist Felicity Powell has a special interest in subversive medals:

> The idea is incredibly clever, because it uses the potential that coinage has, a bit like the internet today, to be widely circulated. Pennies probably were the most used coin, and so to be able to get the message out, subversively, into the public realm, to those who would be consoled by it as well as those who would be shocked by it, is a brilliant idea.
>
> This particular coin makes full use of the fact that coins have two sides, not visible at once, and on the other side there's an image of Britannia, which hasn't been defaced. An image of a woman standing there, very strongly, symbolizing nationhood. There's a real potential for shock value, real subversion, when you see what's on the other side.

On the other side is the profile of Edward VII – balding, bearded and gazing off to the right. He's in his early sixties – this coin is dated 1903. Surrounding him, running round the edge of the coin, is the Latin inscription which translates as *Edward VII by the grace of God, King of all Britain, Defender of the Faith, Emperor of India*. A mighty title, redolent of both ancient rights and new imperial power – an entire political order devised over centuries and sanctioned by God. But running across the top of the king's ear and right over his face in wobbly

capital letters is the word VOTES, below his ear, FOR, and through his neck, WOMEN. A campaigner hammered the letters into the surface of the penny one by one, using a separate punch for each letter. It would have taken considerable force, and the result is powerfully crude, as Felicity Powell describes:

> It literally is defacement, right across the king. And what's interesting to me is the way that the ear becomes very central. As these letters are hammered home, the ear is left more or less intact, and it's a bit like, 'Are you listening?' It's got that real force to it.

Our Edward VII bronze penny was struck in the year of the formation of the Women's Social and Political Union (the WSPU), whose founders included Emmeline Pankhurst and her daughter Christabel. There had been other peaceful female pressure groups before then, but none had achieved their goal. Thirty-three years before, Emmeline's husband had drafted the first Women's Suffrage Bill for Parliament, which was doing well in the House of Commons until the prime minister, William Gladstone, spoke out against it:

> I have no fear lest the woman should encroach upon the power of the man. The fear I have is, lest we should invite her unwittingly to trespass against the delicacy, the purity, the refinement, the elevation of her own nature, which are the present sources of its power.

By invoking the delicacy and refinement of women, Gladstone made a calculated appeal to traditional, repressive ideas of how a lady should behave. So although the campaign for women's votes continued and the Bill was repeatedly brought back to Parliament, for nearly a generation most women held back from direct action and unladylike encroachment on the established power of men.

But by 1903, the Pankhursts and others had had enough. (At this point they were still calling themselves suffragists, but after a few years of activism the *Daily Mail* would dub these new, feisty protestors 'suffragettes' – a derisory, diminutive term to distinguish them from women who stuck to peaceful means.) Under Mrs Pankhurst's leadership the suffragettes swung into direct action. Defacing coins was just one tactic among many, but the choice of the penny was particularly ingenious: pre-decimal bronze pennies, about the same diameter as

the modern £2 coin, were big enough to carry easily legible lettering, but too numerous and too low in value to make it practical for the banks to recall them, so the message on the coin was guaranteed to circulate widely and indefinitely. The suffragettes also embraced the cause in person: they disrupted trials in court by calling for votes, as Emmeline Pankhurst herself did:

> The reasons why women should have the vote are obvious to every fair-minded person. The British constitution provides that taxation and representation shall go together, therefore women taxpayers are entitled to vote.

The moderation in Mrs Pankhurst's words belies the escalating violence of the movement. Famously, the *Rokeby Venus*, a painting by Velázquez in the National Gallery, was slashed by Mary Richardson, who vigorously justified her action:

> I have tried to destroy the picture of the most beautiful woman in mythological history as a protest against the government for destroying Mrs Pankhurst, who is the most beautiful character in modern history.

Suffragettes embraced many other tactics that can still shock us now: they chained themselves to the railings of 10 Downing Street; letter bombs were placed in postboxes; when put in jail they went on hunger strike. The most violent, self-inflicted action came when Emily Davison was killed as she threw herself in front of the king's horse at the 1913 Derby. The suffragettes became systematic lawbreakers in order to change the law, and defacing the penny was just one element in a campaign that went far beyond civil disobedience. How permissible is this kind of violence? The human rights lawyer and reformer Baroness Helena Kennedy considers the acceptable limits:

> Defacing coinage is against the law, so there is that issue of whether it's ethical to break the law in certain circumstances. My argument would be that there are some times when in pursuit of human rights it is the only thing that people can do. As a lawyer I'm not supposed to say that, but I think there are occasions when the general public would agree, that somehow one has to stand up to be counted. Obviously there have to be limits of what we consider to be acceptable in terms of civil disobedience. There are some political acts which one would never condone, and grappling with the ethics of where it is appropriate and what is appro-

priate is difficult. The courage of these women was extraordinary, in that they were prepared to sacrifice their lives. Now of course today we have people who are also prepared to sacrifice their lives and one has to consider when and where that is appropriate. And I think most of us would say anything that involved harm to others has to be unacceptable.

The suffragette campaign was interrupted by the outbreak of the First World War, but the war itself provided powerful, indeed conclusive, arguments for giving women the vote. Suddenly women had the chance to prove their ability in traditionally male and distinctly 'unladylike' environments – battlefield medicine, munitions, agriculture and industry – and once the war was over they could not be slotted back into a stereotype of delicate refinement.

In 1918 British women over the age of 30 were given the right to vote, and in 1928 the Equal Franchise Act extended the vote to all women over the age of 21, on the same terms as men. And 100 years after our penny was stamped with VOTES FOR WOMEN, a new 50p piece was issued to mark the centenary of the Women's Social and Political Union. On the front, the queen, a woman, and on the back a woman – a suffragette chained to a railing with a billboard next to her carrying the words, legitimately on the coin this time, GIVE WOMEN THE VOTE.

A new 50p piece was issued in 2003 to mark the centenary of the WSPO

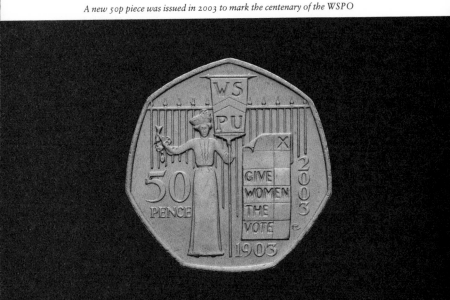

PART TWENTY

The World of Our Making

AD 1914–2010

The twentieth century and beginning of the twenty-first were an era of unprecedented conflict, social change and scientific development. Technological innovation enabled more objects to be produced and used by humankind than at any previous time in history, changing the way we relate to each other and to the material world. But many of these objects (particularly since the invention of plastic) have been ephemeral and disposable, which has given urgency to questions about the environment and global resources. As has been true for almost two million years, the objects we have produced over the last century convey our concerns, our creativity and our aspirations, and will continue to reveal them to future generations.

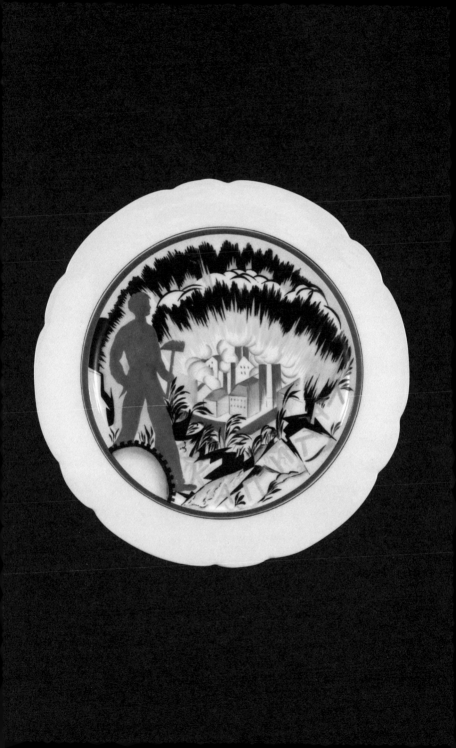

Russian Revolutionary Plate

Porcelain plate, from St Petersburg, Russia

PAINTED AD 1921

Arise, ye workers from your slumber,
Arise, ye prisoners of want.
For reason in revolt now thunders,
and at last ends the age of cant!
Away with all your superstitions,
Servile masses, arise, arise!
We'll change henceforth the old tradition,
And spurn the dust to win the prize!

Those are the words of 'The Internationale', the great socialist hymn
written in France in 1871. In Russia in the 1920s, it was adopted by
the Bolsheviks as the anthem of the Russian Revolution. The original
words were about looking forward to a time of future revolution, but
significantly the Bolsheviks changed the tense in the Russian transla-
tion, moving it from the future to the present – the Revolution was
now. The workers, at least in theory, had taken control.

Throughout this book we have seen images of individual rulers –
from Ramesses II and Alexander the Great, to the Oba of Benin and
King Edward VII – but here we have the image of a new kind of ruler,
not an 'I' but a 'We', not an individual but a whole class, for in Soviet
Russia we see the power of the people, or, rather, the dictatorship of
the proletariat. The object in this chapter is a painted porcelain plate
that celebrates the Russian Revolution and the new ruling class. In
vivid orange, red, black and white, it shows a revolutionary factory
glowing with energy and productivity, and, in the foreground, a sym-
bolic member of the proletariat striding into the future. Seven decades
of communism are about to begin.

The twentieth century was dominated by ideologies and war: two world wars; fights for independence from colonial powers, and post-colonial civil wars; fascism in Europe, military dictatorships across the world; and revolution in Russia. The great political contest, lasting for most of the century, was between liberal democracy on the one hand, and central state direction on the other. By 1921, the year in which the plate was painted, the Bolsheviks had imposed on Russia a new political system based on Marxist theories of class and economics, and were setting about building a new world. It was a Herculean task – the country had been abjectly defeated in the First World War and the new regime was under threat from foreign invasion and civil war. The Bolsheviks needed to motivate and lead the Soviet workers with whatever means they had at their disposal. One of those means was art.

The designer has exploited the circular shape of the plate to intensify the image's symbolic power. At the centre, in the distance, is a factory painted in red – this is clearly a factory that belongs to the workers – puffing white smoke, evidence of healthy productivity, with a radiant sunburst of vivid yellow and orange driving away the dark forces of the repressive past. On a hill in the foreground, a man strides in from the left of the picture. He's aglow, like the factory, with a golden aura around him, painted in red silhouette without any detail, but we know he is young and that he is looking fervently ahead. He clearly represents not an individual but the entire proletariat, moving into the brighter future that they are going to create. At his foot is an industrial cogwheel and in his hand the hammer of the industrial workers. With his next stride he will trample over a barren piece of ground where the word KAPITAL lies broken, its letters scattered over the rocks. The plate had been made twenty years earlier, in 1901, and left blank. The artist who designed it, Mikhail Mikhailovich Adamovich, transformed a piece of imperial porcelain into lucid and effective Soviet propaganda. It is this re-purposing that fascinates the Marxist historian Eric Hobsbawm:

> The most interesting thing about this is precisely that in one object you can see the old regime and the new regime, and the change from the one to the other. There are very few objects like this where historic change is so clearly present before you. Ideology is important as far as the artists were concerned. There was this enormous sense, among the people who

felt themselves to have made the revolution, that we have done something that nobody in the world has done. We are creating a completely new world, which won't be complete until both Russia and the world are transformed, and we have the duty of showing it and pushing it forward – that's the ideology.

Not long after the Bolshevik takeover, the Imperial Porcelain Factory was nationalized, renamed the State Porcelain Factory and placed under the authority of an official with the ringing utopian title of 'The People's Commissar of Enlightenment'. As the Commissar of the State Porcelain Factory wrote to the Commissar of Enlightenment:

> The Porcelain and Glass Factories ... cannot be just factory and industrial enterprises. They must be scientific and artistic centres. Their aim is to encourage the development of Russia's ceramic and glass industry, to seek and develop new paths in production ... to study and develop artistic form.

In the Russia of 1921, the year of our plate, there was an acute need for striking messages of unity and hope. The country was embroiled in civil war, deprivation, drought and famine: over four million Russians starved to death. The worker-owned factories like the one shown on our plate were producing a fraction of what they had done before the Revolution. Eric Hobsbawm sees the art typified by the plate as indicating the power of hope in a seemingly hopeless situation:

> It was made at a time when almost all the people engaged in it were hungry. There was famine in the Volga and people died of hunger and typhus. It was a time when you would say, 'This is a country lying flat on its back, how can it recover?' And what I think one has to re-create by imagination is the sheer impetus of people doing it, saying: in spite of everything we are still building this future, and we are looking forward to the future with enormous confidence.

The plate brings us what one of the ceramic artists called 'news from a radiant future'. Normally regimes will revisit and reorder the past, appropriating it to their current needs, as we have seen many times, but the Bolsheviks wanted people to believe that the past was over and that the new world was going to be built from scratch.

This image of the new egalitarian world of the proletariat is painted on porcelain – the luxury material historically associated with aristocratic culture and privilege. Painted by hand over the glaze, it was for display, not for use. The plate is scallop-edged and very fine – it was in fact a blank made before the Revolution that had been left over from the Porcelain Factory's imperial days. The Empress Elizabeth had set up the Imperial Porcelain Factory near St Petersburg in the eighteenth century, to produce porcelain which would rival the best that Europe could offer, for use at court and for official imperial gifts, as Mikhail Piotrovsky, Director of Russia's State Hermitage Museum, explains:

> Russian porcelain became an important part of Russian cultural production. Russian Imperial Porcelain became famous: beautiful dishes that are now extremely expensive at world auctions. It is a good example of art in connection with economy and politics, because it was always a kind of expression of Russian empire – military pictures, military parades, the love of life of ordinary people, pictures from the Hermitage – everything which Russia wanted to present to the world and to itself in a beautiful manner.

This plate is an example in microcosm of the way in which the Soviet rhetoric of total rupture could never match the reality: given the speed of the Revolution, the Bolsheviks had to take over existing structures where they could, so much of Soviet Russia continued to echo Tsarist patterns. They had to do it that way – but in this case, they deliberately *chose* to do it. On the back of the plate are two factory marks. Underneath the glaze, applied when the blank plate was first made, is the Imperial Porcelain Factory mark of Tsar Nicholas II for the year 1901. Over the glaze is painted the hammer and sickle of the Soviet State Porcelain Factory and the date 1921. This painted plate was made in two stages, twenty years apart, and in astonishingly different political circumstances.

You would have expected the Tsar's monogram to have been painted over, blotting out the imperial connection, and it often was. But, as somebody at the factory realized, there was a great advantage in leaving both marks visible. It made what was already a collector's item even more desirable, so it could be sold abroad for a much higher price. The regime was desperate to raise foreign currency, and the sale

The imperial factory mark of Tsar Nicholas II and the hammer and sickle of the Soviet state

of artistic and historic objects like this plate was one obvious part of the solution. The records of the new State Porcelain Factory report that, 'For foreign markets the presence of these marks alongside the Soviet marks is of great interest, and prices for the objects abroad shall doubtless be set higher if the earlier marks are not painted over.'

So we have the surprising situation of a socialist revolutionary regime making luxury goods to sell to the capitalist world. And you could argue this was perfectly coherent: profits from the plate supported Soviet international action, designed to undermine the very capitalists they were selling to, while at the same time the porcelain propaganda promulgated the Soviet message to Russian enemies. 'Artistic industry,' wrote the critic Yakov Tugenkhold in 1923, 'is that happy battering ram which has already broken down the wall of international isolation.'

This conflicted, symbiotic relationship between the Soviet and the capitalist worlds – initially seen as a transitional necessity until the West was won for workers and communism – became the norm for the rest of the century. The front of the plate shows us the compelling clarity of the early Bolshevik dream. The back shows us pragmatic compromise – negotiation with the imperial past and political realities, and a complex economic modus vivendi with the capitalist world. Broadly, this is the pattern that would be sustained for the next seventy years as the world settled into two huge, competing but in many ways interdependent ideological blocs. The front and back of this plate chart the path from worldwide revolution to the stability of the Cold War.

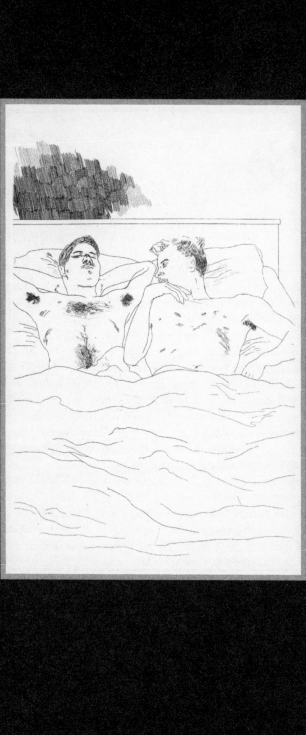

97

Hockney's *In the Dull Village*

Etching, from England
AD 1966

> Sexual intercourse began
> In nineteen sixty-three
> (which was rather late for me) –
> Between the end of the 'Chatterley' ban
> And The Beatles' first LP.

So wrote the poet Philip Larkin, master of the regretful lyric, in one of his jollier verses, pinpointing what were for him the key aspects of the Swinging Sixties – sex, music and then more sex. All generations think they have invented sex, but none thought they had done it as thoroughly as the young people of the 1960s. Of course there was a great deal more to the sixties than that, but the decade has now taken on mythic status as a time of transforming freedom – or destructive self-indulgence – and the myths are not unjustified. All over the world established structures of authority and society were challenged, and in some cases brought down, by spontaneous mass activism in pursuit of political, social and sexual freedoms.

In the previous two chapters we examined big political issues – the realization of rights for whole sections of society, whether votes for women or power (in theory) for the proletariat. In the 1960s the campaigns were more about ensuring that every individual citizen could exercise those rights, asserting that everybody should be free to play their full part in society and to live the way they wished, as long as they caused no harm. Some of these new freedoms were hard won, and people paid with their lives: this was the decade of Martin Luther King and black civil rights in the United States; of the Prague Spring,

the heroic Czech rebellion against Soviet Communism; of the 1968 Paris student uprisings and waves of campus discontent across Europe and America; of the campaigns oppposing war in Vietnam and supporting Nuclear Disarmament.

It was also the decade of the psychedelic Summer of Love – played out to the sounds of Woodstock and San Francisco, the Beatles and the Grateful Dead. In the private realm there was a sexual revolution – Women's Liberation, the contraceptive pill – and the legalization of homosexual relations. There is no earlier decade in which David Hockney's etching *In the Dull Village* could have been published. Hockney began his art studies in the 1950s, but it was the 1960s that formed him, and he in turn helped shape the decade. He was gay and prepared to be open about it, both in his life and his work, at a time when in the UK homosexual activity between men was criminal, and prosecutions were frequent. He divided his time between California, where he made his famous paintings of naked young men in deep blue swimming pools, and Britain, where he drew and painted his family and friends.

In this etching, two naked men, who could be in their 20s, lie side by side in bed, half covered by a blanket; we are looking down at them from its foot. One lies with his arms behind his head, his eyes closed as if dozing, while the other looks eagerly at him. We have no idea whether the relationship between the two men is recent or of long standing, but at first sight this looks like a calm, entirely satisfactory morning after.

It is one of a series of etchings inspired by the poems of the Greek poet Constantine Cavafy, on which Hockney began work in 1966, while the Home Secretary, Roy Jenkins, was drafting the legislation to decriminalize homosexuality in England and Wales ; and it was published in 1967, just as Parliament passed Jenkins's Sexual Offences Act. Hockney's image was shocking for many then, and for some is still shocking today, even though there is nothing at all explicit about it – the blanket covers both men up to the waist. Yet it raises perplexing questions about what societies find acceptable or unacceptable, about the limits of tolerance and individual freedom, and about shifting moral structures over thousands of years of human history.

One of the constants of this history of the world, not surprisingly,

has been sex – or, more precisely, sexual attraction and love. Among our hundred examined objects, we have the oldest-known representation of a couple making love, a small stone carved 11,000 years ago near Jerusalem, we have harem women, voluptuous goddesses and gay sex on a Roman cup. Surprisingly, given this long tradition of representing human sexuality, David Hockney's relatively decorous print was nonetheless a courageous – indeed provocative – act in the Britain of his day.

The young men in Hockney's etching could be American or British; but they inhabit the place of the picture's title, which matches that of Cavafy's poem – 'In the Dull Village'. The poem is about a young man trapped by his circumstances, who escapes his dreary surroundings by dreaming of the perfect love partner. So perhaps Hockney's dozing boy is gently fantasizing his ardent companion, who is imagined, rather than actually present in the longed-for flesh.

> He lay in his bed tonight sick with what love meant,
> All his youth in desire of the flesh alight
> In a lovely tension all his lovely youth.
> And in his sleep delight came to him; in his sleep
> He sees and holds the form and flesh he wanted ...

The cosmopolitan family of Constantine Cavafy (1863–1933) had moved between Turkey, Britain and Egypt and was part of the huge Greek diaspora that for 2,000 years had dominated the economic, intellectual and cultural life of the eastern Mediterranean. He lived in a broad, Greek-speaking world, which defined itself essentially less in terms of mainland Greece than in the twin centres of Constantinople and Alexandria. It was a world created by Alexander's conquest of Egypt in the fourth century BC and which ended only in the middle of the twentieth century – a world we have encountered several times before in our history, notably in the Rosetta Stone, where the languages of Greece and Egypt appear side by side. Cavafy was very aware of this rich inheritance, and his Alexandrian poetry has a deep sense of ancient history, and of a Greek world in which love between males was an accepted part of life.

The world of Bradford as experienced by the young Hockney was a very different place. In Yorkshire in the 1950s, homosexuality was

an unmentionable subject and for an artist a risky one. So the poems of Cavafy, which Hockney found in the Bradford library, were a revelation.

> I read more of his poems and I was struck by their directness and sim-
> plicity; and then I found the John Mavrogordato translation in the
> library in Bradford in that summer of 1960, and I stole it. I've still got it,
> I'm sure. I don't feel bad now because it's been redone, but you couldn't
> buy it then, it was completely out of print. Mind you, in the library in
> Bradford you had to ask for that book, it was never on the shelves.

The fourteen poems that Hockney later chose for his series of etch-ings, poems of longing and loss, of the first meeting of future loves and intoxicating, passionate encounters, were both exciting material that he could use for his own art and an example of how an artist could make a public statement out of such private experience. Brought up by his enlightened parents to follow his own line and not worry about what neighbours thought, Hockney felt a responsibility to stand up, through his art, for his own rights and to join the growing campaign for the rights of others like him. Characteristically, he was determined that his approach would not be heavy handed. These etchings don't preach, they laugh and they sing:

> What one must remember about some of these pictures is that they were
> partly propaganda of something that hadn't been propagandized, espe-
> cially among students, as a subject: homosexuality. I felt it should be
> done. It was part of me; it was a subject I could treat humorously.

Gay rights were of course only one of the many freedoms asserted and fought for during the sixties, but they were a particularly challenging issue in the context of universal human rights. Most of these concerned groups of people discriminated against on the grounds of gender, reli-gion or race, and there was a wide consensus in the aftermath of the Second World War that such discrimination was wrong. Sexual orien-tation and behaviour, on the other hand, were seen as something quite different – indeed they were not even mentioned in the Universal Dec-laration of Human Rights adopted by the United Nations in 1948. Hockney and campaigners like him eventually changed the terms of the debate, taking questions of sexuality firmly into the arena of

human rights in Europe and America. In some countries, their campaigning changed the law, but in many parts of the world private sexual acts that deviate from an accepted norm are still considered religiously unacceptable or a threat to society, deemed criminal and punished – in some cases by death.

In 2008 the United Nations General Assembly considered a statement condemning killings and executions, torture and arbitrary arrest based on sexual orientation or gender identity. The statement was endorsed by over fifty countries, but prompted a counter-statement opposing it and the matter remains unresolved.

Hockney's etching is arrestingly sparse. A few black lines suggest a wall here, a blanket there. There is nothing to tell us where this bed is. We do not even know whether both figures are really present or just dreamt of. This insistently unspecific image reminds us that sexual behaviour, although totally private, is also totally universal. Society's responses to it, on the other hand, are most definitely not. Forty years later, the frontier of human rights is still being bloodily negotiated: our world is less global than we like to think.

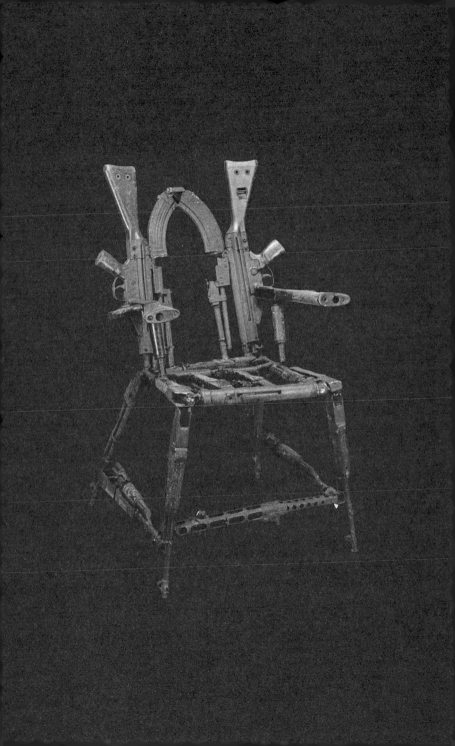

Throne of Weapons

Chair made of weapon parts, from Maputo, Mozambique

AD 2001

For the first time in this history we are examining an object that is a record of war but which does not glorify war or the ruler who waged it. The Throne of Weapons is a chair – or throne – constructed out of parts of guns that were made all over the world and exported to Africa. If a striking feature of the nineteenth century was the growth of mass markets and mass consumption, the twentieth century can be characterized by mass warfare and mass killing: the two world wars, Stalin's purges, the Holocaust, Hiroshima, Cambodia's killing fields, Rwanda – the list goes on. If there is one small, positive side to all this devastation it is that the twentieth century has more than any previous one recorded and articulated the mass suffering of ordinary victims of war – the soldiers and civilians who paid with their lives. Across the world there are Tombs of Unknown Soldiers; the Throne of Weapons is in this tradition. It is a monument to all the victims of the Mozambique civil war and a record of crimes against a whole country – indeed a continent. It is also, most unusually for such a commemorative piece, a work of art that speaks to us of hope and resolution. The Throne of Weapons is about human tragedy and human triumph in equal measure.

These closing chapters of our history chart the fading of empires that flourished and grew throughout the nineteenth century and the rise of new global ideologies and national identities. Nowhere has this been played out so bloodily as in post-colonial Africa. The late nineteenth-century 'Scramble for Africa' resulted in the parcelling up of the continent among Britain, France and Portugal as the leading colonial powers, alongside Germany, Italy, Spain and Belgium. After the Second World War there were moves throughout the continent

for independence, and from 1960 onwards it was gradually achieved. But this separation from European powers was usually bitterly fought over, and because independence was so often attained only after fighting, it frequently contributed to great internal problems for the new states, including civil war. The Ghanaian diplomat and former Secretary General of the United Nations, Kofi Annan, has had personal and professional experience of this:

> I think we have to start from the premise that most of these countries had not had experience of governing – running a nation, managing issues – and had to start almost from scratch. Given the history of their countries, there were civil servants, but very few of them had actually led and organized a country. And I think the skills that you need to fight for independence are not the same skills you require to govern, but there was an automatic assumption that those who fought for independence were prepared and ready to govern. So there was quite a bit of learning on the job, and also jealousies between groups and a feeling that one tribe, or one group, had more power or benefits than the other, and this often led to tensions and conflict over scarce resources – tense and brutal at times.

These fragile, inexperienced governments could look for support to either communist East or capitalist West, and both those blocs were eager to enlist supporters. After the nineteenth-century territorial scrambles for Africa came the twentieth century's ideological ones. The consequence was a huge influx of arms to the continent and a series of bitter civil wars. The Mozambique civil war was among the bloodiest of them all.

Although it is entirely made from chopped-up guns, in its shape the Throne of Weapons looks like a conventional wooden armchair – the homely sort you might find in a kitchen or at a dinner table. But that's the only conventional thing about it. The guns that make up this chair in fact track the twentieth-century history of Mozambique. The oldest, forming the back, are two antiquated Portuguese G3 rifles – appropriately so, as Portugal was the country's colonial master for nearly 500 years until independence in 1975. That independence was won by a left-wing resistance movement, FRELIMO, which was supported by the Soviet Union and its allies. This explains why all the other ele-

ments of the chair are dismembered guns manufactured in the communist bloc: the arms of the chair are from Soviet AK47s, the seat is formed from Polish and Czechoslovakian rifles, and one of the front legs is the barrel of a North Korean AKM. This is the Cold War as furniture, the Eastern Bloc in action, fighting for communism in Africa and across the world.

When FRELIMO came to power in 1975, the new Mozambique became a Marxist-Leninist state with a declared hostility to the political regimes of its neighbours – white-controlled Rhodesia, now Zimbabwe, and apartheid South Africa. In response, the Rhodesian and South African regimes created and backed an opposition group named RENAMO and attempted to destabilize the country; so the first decades of Mozambican independence were years of economic collapse and murderous civil war. The guns in the throne are the ones with which this civil war was fought. It left a million dead, millions of refugees and 300,000 war orphans in need of care. Peace came only after fifteen years, when in 1992 a settlement was brokered and the country's leaders began to rebuild their state. But although the war was over, the guns were still very much present. As Kofi Annan knows, it is notoriously difficult to re-educate a militarized generation to take their place in a peaceful civilian society, and in this case many of the soldiers had known nothing but war:

> It reminds me of the conflict in Sierra Leone, where lots of boy soldiers were involved. Soldiers as young as 8, 10, carrying Kalashnikovs, almost as tall as they were, trained to kill. I recall as Head of Peacekeeping Operations touring Sierra Leone with some of our peacekeepers and trying to see how we redeem these boys, and put them through training, prepare them for a life after this conflict.
>
> There are a couple of things which are absolutely essential if a society is going to deal with the past. They need to be able to work on reconciliation. You also need to look at the society and ask the questions, 'What happened?', 'How did we get here?', 'What can we do to ensure that this horror is not repeated?'

The main challenge in Mozambique was to decommission the millions of surviving guns and to equip the former soldiers and their families to rebuild their lives. The Throne of Weapons became an inspirational

element in this recovery process. It was made as part of a peace project called Transforming Arms into Tools, which is still going today, and in which weapons once used by combatants on both sides were voluntarily surrendered under amnesty, and in exchange the people who gave them up received practical and positive tools – hoes, sewing machines, bicycles, roofing materials. Surrendering the guns was an act of real bravery on the part of these ex-soldiers and one of enormous significance for their families and the whole country. It helped break the addiction to the gun and to the culture of violence that had afflicted Mozambique for so many years. Since the beginning of the project more than 600,000 weapons have been relinquished and handed over to artists to be disabled and turned into sculpture. In the words of the project's patron, Graça Machel, widow of Mozambique's first independent ruler Samora Machel and now wife of Nelson Mandela, the aim was 'to take away instruments of death from the hands of young people and to give them an opportunity to develop a productive life'. The guns themselves were to be turned into works of art. The project was started in 1995 by the Anglican Bishop Dinis Sengulane, of the Christian Council of Mozambique, with the support of Christian Aid:

> The purpose of the project is to disarm the minds of people and to disarm the hands of people. Why should this world have hungry people? Why should this world have a shortage of medicines? And yet, the amount of money which can be made available almost instantly for armament purposes is just amazing, and I would say shocking.
>
> I felt I should be part of shaping that peace. And of course we find the Book of Micah and the Book of Isaiah in the Bible, where it says they will turn their swords into ploughshares, and people will sit under their trees and nothing will frighten them.
>
> We discovered that many monuments were a glorification of war, and we know that monuments are made by artists. So we invited artists and we said, 'What about using your skills to glorify peace? We have got these guns – could you see whether you could convey a message of peace by using the bits and pieces of these guns?' It was in that context that artists began to make different works of art. And one of the items produced was the Throne of Weapons.

The throne was made by a Mozambican artist known as Kester. He

chose to make a chair and call it a throne, which immediately makes a particular statement. Chairs, as distinct from stools, are rare in traditional African societies, reserved for tribal heads, princes and kings; they are 'thrones' in the truest sense of the word. But this is a throne on which no one is meant to sit; it is not for an individual ruler but is intended as an expression of the governing spirit of the new Mozambique – peaceful reconciliation.

This piece seems to me to have a very special pathos, precisely because it has been made in the form of a chair. When we talk about chairs we always speak as though they were human beings – we say they have arms, legs, backs. They are, after all, made to be an echo of the human form, and they become almost a metaphor for living people. So there is something particularly disturbing about a chair made out of weapons designed specifically to maim backs and arms, legs and feet.

Members of Kester's family were themselves maimed in the conflict:

> I wasn't affected directly by the civil war, but I have two relatives who lost their legs. One stepped into a minefield and she lost her leg, and the other, a cousin of mine, lost his leg because he was fighting with FRELIMO.

And yet Kester made this throne as a means of conveying hope. Two rifle butts form the back of the chair. If you look closely at them it seems as though they have faces – two screw holes for eyes and a strap slot for the mouth. They almost seem to be smiling. It is a visual accident that Kester spotted and decided to exploit which denies the guns their central purpose and gives this work of art its fundamental meaning, as he himself explains:

> There is no conflict between us any more. I didn't carve the smile, it's part of the rifle butt. The screw holes and the mark left from where the strap was attached to the gun. So I chose the guns and the weapons that had the most expression. At the top you can see a smiling face. And there is another smiling face – the other rifle butt. And they are smiling at each other as if to say, 'Now we are free.'

HSBC ◆◆
Amanah

Gold

1234 1234 1234 1234

4249 VALID
 THRU 06/11

TARIQ ADEL

99
Credit Card
Issued in the United Arab Emirates
AD 2009

If you were to ask people which twentieth-century invention had most impact on their daily lives today, instant answers might be their mobile phone or their PC: not many people would think first of the little plastic rectangles that fill their wallets and purses. And yet, since they first emerged in the late 1950s, credit cards and their kin have become part of the fabric of modern life. Bank credit is, for the first time in history, no longer the prerogative of the elite, and – maybe as a result – long-dormant religious and ethical issues about the use and abuse of money have been reborn in the face of this ultimate symbol of economic freedom for millions, as some would see it, or, for others, of triumphant Anglo-American consumer culture.

In the last two chapters, we examined sex and war. Now it is the turn of that third great constant of human affairs, money. Money has featured throughout this history, from the gold coins of the legendarily rich King Croesus of Lydia (Chapter 25), and the paper money of the first Ming emperor (Chapter 72), to the first world currency, the king of Spain's silver pieces of eight (Chapter 80). Now it is the turn of the modern manifestation of money – plastic.

The modern credit card is an American creation, the successor to retail credit schemes pioneered in the early twentieth century. After the end of the Second World War, wartime restrictions on lending were lifted and the credit boom began. The first general-purpose charge card was the Diners Club card, introduced in 1950. In 1958 the next step came with the appearance of the first real credit card, issued by a bank and generally accepted by large numbers of businesses. This was the BankAmericard, ancestor of Visa, and the first universal credit

card to be made of plastic. But only in the 1990s did credit cards become truly global, widespread beyond North America and the UK.

Of course, a credit card isn't itself money – it is a physical object that provides a way of spending money, moving it and promising it. Money is now more likely to be numbers and digits on statements and invoices than physical coins and notes. None of us is ever likely to see most of our savings turned into actual cash, even in a bank vault. Credit and debit cards bring home to us daily the fact that money has now lost its essential materiality; money spent through them is always new, fresh and unused. It can be called up virtually anywhere in the world instantaneously, regardless of national boundaries. Where as all the coins or banknotes we have looked at so far had king and country marked on them, our card acknowledges no ruler or nation in its design and no limit to its reach, other than an expiry date. This new money is supranational, and it seems to have conquered the world. And yet even on credit cards the echo of traditional money remains: the card that is telling our story is keen to present itself as a Gold Card.

What the card does of course is to guarantee payment. A complete stranger can be confident that he will ultimately be paid. For Mervyn King, Governor of the Bank of England, these cards are merely a new solution to an age-old problem:

> As in all types of money or cards used to finance transactions, the acceptability, the trust which the other side of the transaction puts in it, is paramount. I could give a different example, which I think illustrates the importance of trust here: when Argentina had its financial collapse, and reneged on its national debt, in the 1990s, its currency became worthless, and in some of the villages of Argentina the use of IOUs as a substitute for paper currency started to grow up. But the problem with the IOU is that the U has to trust the I, and that may not always be the case. So what happened was that in the villages some people would take the IOU to the local priest and ask him to endorse it. Now here we have an example in terms of the use of religion that was not fundamentally about religion as such, but which was about enhancing the trust that people had in the instrument that was being used.

In the absence of a village priest with global reach to endorse our IOUs, we use credit cards which span the world.

This credit card, issued in the UAE, has both English and Arabic writing on it

This particular Gold Card is issued by the London-based bank called HSBC, the Hong Kong and Shanghai Banking Corporation. It functions through the backing of the US-based credit association, VISA, and has on it writing in Arabic – it is in short connected to the whole world, part of a global financial system, backed by a complex electronic superstructure that many of us barely think about as we key in our PINs. All our credit-card transactions are tracked and recorded, building a huge dossier of our movements, writing our economic biographies on the other side of the world.

The scale of modern banks is far beyond anything previously known, and their global power now transcends national boundaries. As Mervyn King emphasizes:

The spread of a wide range of financial transactions, whether using cards used by international banks or the other services that they offer, has created institutions which are trans-national, which are bigger than the ability of national regulators to control, and which, if they do get into financial difficulties – fortunately not many have – can cause enormous financial mayhem.

In the past rulers could walk away from their debt and leave banks to collapse, but today, it is apparently more difficult to allow a bank to fail than it is to see a government fall.

Some aspects of a credit card need no describing. Every credit card in the world is of the same internationally agreed size and shape, to fit in all the 'holes in the wall' that now puncture our urban world. In one respect, cards are like traditional coins and banknotes. They have two sides, each holding important information. If you turn this card over, the back shows us a magnetic strip, part of the electronic verification system that allows us to move money around the world relatively securely and permits instant communication, instant transactions and instant gratification. Many cards now incorporate an even more sophisticated piece of electronics, a microchip. It is this microtechnology, one of the great global achievements of the last generation, that has made the worldwide credit card possible – and with it, the worldwide banks. This little black strip is the hero – or villain – of this chapter. All the rest is simply a consequence of it.

Credit cards do something which for most people was never possible before: they allow you to borrow while avoiding both the traditional pawnbroker and the loan-shark. Inevitably, opportunities bring risk. Easy credit undermines traditional values like thrift, because it sets you free from having to save before you spend. So it is not surprising that credit cards have drawn the attention of moralists and been categorized as dangerous, even sinful in their very nature. There is little doubt at all that paying by credit card does increase customers' willingness to spend – often more than they can afford. So this is an area of banking that leads rapidly to debates about ethics and religion.

Perhaps surprisingly, religion is represented on our card itself. There is a decoration in the middle of it, a red fretwork, which looks like hollow stars, set in a rectangular strip. It is curiously reminiscent of an object we discussed earlier (Chapter 94): the Islamic patterning carved on the side of the Sudanese slit drum when it was taken to the Islamic north of Sudan, to proclaim the new world to which it belonged. Similar patterning makes the same point on our card, for this one is not just issued by HSBC but by HSBC Amanah, the Islamic banking wing of the corporation. This credit card is marketed as being compliant with Shariah law.

All Abrahamic religions have worried about the social evils of usury, lending at interest, that can all too easily result in the poor being driven into debt and eventual destitution. Both the Bible and the Qur'an have forthright things to say about usury, from the prohibitions of Leviticus – 'Thou shalt not give him money upon usury, nor lend him thy victuals for increase' – to the scathing words of the Qur'an: 'Those that live on usury shall rise up before God like men whom Satan has demented by his touch.'

As a result, Judaism, Christianity and Islam have all struggled with the ethics of advanced financial systems: the separation of money from goods, and cash from effort, and above all the social consequences of encouraging debt. The most recent manifestation of this millennial concern has been the rise of Shariah-compliant Islamic banking since the 1990s – Islamic banks now offer services consistent with Islamic religious belief and social behaviour in more than sixty countries. Razi Fakih, Deputy Global CEO of HSBC Amanah, explains:

> Islamic finance is a very new industry. Conventional banking and finance has been around for as long as we all remember. Islamic finance started some time in the 1960s in Egypt, and I think it was only in the 1990s that it actually took off, so it's just less than two decades old in that context.

This credit card is of course the result of the growing economic importance of the Middle East. But it is also a sign of something else, because this banking development runs counter to what, throughout the twentieth century, had become a received wisdom. Most intellectuals and economists from the French Revolution onwards – including Karl Marx – assumed that religion would steadily dwindle as a force in public life, that in the long run the forces of God would yield to the forces of Mammon. One of the striking facts of the first decade of the twenty-first century has been the return of religion to the centre of the political and economic stage in many parts of the world. Our gold credit card is a small but significant part of a growing global phenomenon.

100

Solar-powered Lamp and Charger

Manufactured in Shenzhen, Guandong, China

AD 2010

How should this history of the world end? What single object can possibly sum up the world in 2010, embody the concerns and aspirations of humanity, speak of universal experience and at the same time be of practical, material importance to a great many of us in the world now?

With hindsight, it will of course be self-evident. The Director of the British Museum in 2110 will, I am sure, have a very clear idea of what we should have acquired to keep the story up to date, and will smile – or sneer – at what we have in fact chosen. By then it will be obvious what major events or developments shaped the first decades of the twenty-first century. But we have to decide in the ignorance of now.

We wondered if it should be an object from Antarctica – the last place on the planet where humans have settled and now live permanently, the ultimate end of the exodus from Africa. We can live there only because of equipment we are able to make, so a suit of clothing designed for living and working in Antarctica would epitomise the paradox of man the toolmaker: it is things we make that allow us to dominate our environment, and then we come to be totally dependent on them for survival. But it seems unduly perverse to present as a climax of human endeavour clothes designed for the most inhospitable place on earth, to be worn by at most a few thousand people.

One of the most striking developments of the last decades of the twentieth century has been the migration of millions of people to cities, sometimes over huge distances. These migrants have changed the demographics of the world. They have created the totally new phenomenon of the global city, with inhabitants from every continent living closely

together, mostly in relative harmony. London's residents, for example, now speak over 300 mother tongues. It is a universal fact that whatever people leave behind when they migrate, they always take with them their cooking; humanity in that respect is constant. So we thought our 100th object could be a range of cooking utensils that would give a glimpse of the astonishing variety of cultures and cuisines that now cohabit in the world's great cities. But this history has already traced cooking, eating and drinking and the growth of cities over thousands of years, and the international array of broken pots found in Kilwa (Chapter 60) reflected what even a thousand years ago was an interconnected culinary world. So no utensils.

There is one taste, however, that has become entirely global: football. The dominant flavour of 2010 was without doubt the World Cup in South Africa. Sport has long united communities, as we saw in Chapter 38 on the ceremonial ballgame belt, but now football seems to have united the world: West African stars play for English clubs owned by Russian businessmen; copies of their team shirts are manufactured in Asia and sold and worn in South America. So we have bought a football shirt for the Museum's collection. It speaks light-heartedly of the present – but perhaps it tells us little of the great issues of the future.

In the end, though, we decided that the 100th object must in some sense be technological, as new devices are almost year by year changing how human beings relate to each other and how we manage our affairs. The mobile phone, or more precisely the smartphone, is a good example. It is roughly the same size as the Mesopotamian clay tablets that were humanity's first attempt to communicate at a distance, and it has transformed the skill of writing, making textspeak the new cuneiform. It links millions instantaneously across the globe, can summon huge crowds more effectively than any war-drum and, where internet access is available, opens up realms of knowledge far beyond the Enlightenment's dreams. In advanced societies life without mobile phones is now scarcely thinkable. But they depend on electricity being always available. Without electricity mobile phones are useless.

So, for our 100th object we have chosen a generator of electricity that could give the 1.6 billion people without access to an electrical grid the power they need to join this global conversation. But it does

much more. It gives them a quite new level of control over their environment and could transform the way in which they can live. It is a solar-powered lamp.

The lamp that the British Museum has acquired for its collection is in fact a little kit, consisting of a plastic light containing a rechargeable six-volt battery and a separate, small photovoltaic panel. The lamp has a handle and is about the size of a large coffee mug, and the solar panel looks like a smallish silver photo frame – the sort you see on a desk or a bedside table. When the solar panel is exposed to eight hours of bright Sun, the lamp can provide up to 100 hours of even, white light. At its strongest it can illuminate an entire room – enough to allow a family with no electricity to live in a quite new way. The whole kit sells for about 2,250 rupees ($45), although a simple lantern costs as little as 499 rupees ($10). But once paid for, it requires only Sun.

Solar photovoltaic panels convert sunlight into electricity. If we could do this more efficiently, all our power problems would be solved. The Earth receives more solar energy in one hour than the world population consumes in an entire year. Solar panels are one of the simplest and most practical ways of harnessing the limitless energy of the Sun to provide clean, reliable and cheap power.

The panels are composed of solar cells made from silicon, which are wired together and encased in plastic and glass. When exposed to sunlight, the cells generate electricity which can charge and recharge a battery. This kit uses a range of new technologies that have recently transformed our lives: it is largely made of plastic; its photovoltaic cell depends on the silicon-chip technology that made possible personal computers and mobile phones, and the rechargeable batteries are also recent innovations. This seemingly low-tech source of energy has some astoundingly high-tech elements.

At the level of our lamp, this is a cheap and cheerful solution to basic energy needs. This technology is an economical and long-lasting source of modest energy. The 'modest' is important, because although silicon is cheap and sunshine is free, solar panels big enough to generate the huge amounts of electricity devoured every hour by rich countries would be prohibitively expensive: so, paradoxically, this technology which is costly for the rich is cheap for the poor.

Many of the world's poorest people live in the sunniest latitudes,

which is why this new energy source is so important in South Asia, sub-Saharan Africa and tropical America. In a poor household a small number of volts can make a very big difference. If you live in the tropics without electricity, your day ends early. Light at night is supplied by candles or by kerosene lamps. Candles are dim and don't last. Kerosene is expensive – it consumes on average around 20 per cent of African rural income – and gives off toxic fumes. Kerosene lanterns and cooking stoves cause up to three million deaths every year, most of the dead being women, because the fumes are especially dangerous in enclosed spaces where most cooking is done. Homes are usually made of wood or other natural materials, and so are highly inflammable – at constant risk from kerosene spills.

Photovoltaic solar panels change almost every aspect of this domestic existence. Freely available light at home means that children – and adults – can study at night, improving their education and therefore their futures. Home becomes a safer place. Larger panels can provide the heat for cooking, freeing everybody from the dangers of fumes and fire. They are also able to power fridges, televisions, computers and water pumps. Many of the defining amenities of towns can now be available to villages.

Our simple lamp kit doesn't of course do all this, but as well as light it offers something of enormous significance. Next to the socket is a symbol that is universally recognized – the outline of a mobile phone. The mobile has transformed rural Africa and Asia – putting communities in touch, giving access to information about jobs and markets and providing the basis for informal and highly effective banking networks, so local businesses can start up with virtually no investment.

A recent study of sardine fishermen in the state of Kerala in India showed the kind of changes mobile-phone access can make. It gave them weather information to make fishing safer and market information that reduced waste and increased profit by an average of 8 per cent. Another study, of mobile use in South Asia, reported that day labourers, farmers, prostitutes, rickshaw drivers and shopkeepers all said that their income gets a big boost when they have access to a mobile. And solar panels are making this access more and more common in the poorest rural communities of the world.

There is surely something miraculous about this technology which

brings such benefits in terms of health and safety, education, communication and business. Solar panels circumvent the need for massively expensive infrastructure, and although they carry an initial cost, micro-credit schemes are increasingly available to allow the spread of payments so that lamps like ours can be paid for in instalments over one to two years from savings on kerosene. As this low-cost, clean, green technology is made available to greater numbers, it could bring enormous opportunities to the poorest people in the world.

It might also help stabilize our environment: solar power may one day be a part of the answer to our current dependence on fossil fuels and their contribution to climate change. This possibility was articulated nearly a hundred years ago by the man who more than any other deserves the credit, or the blame, for our electricity-dependent way of life – Thomas Edison. This man, who developed the light bulb and other electricity-consuming devices, was an unexpected visionary for renewable energy. In 1931 he observed to his friends Henry Ford and Harvey Firestone, 'I'd put my money on the Sun and solar energy. What a source of power! I hope we don't have to wait until oil and coal run out before we tackle that.'

The power of the Sun seems a good place to end this global history. Solar energy may allow humanity to share more equally in the opportunities of life, and it has the potential to enable us all to enjoy them without damaging the planet. It is a dream of the future that echoes the deepest and most universal of human myths – that of the life-giving sun. You could see our solar-powered lamp as a humble echo of this myth – the fire-stealing Prometheus reduced to the role of helper in the kitchen.

Just as we learnt to preserve or bottle summer fruits so that the warmth and nourishment of summer could see us through winter, everybody has dreamt of capturing the Sun to have its light and power available at will. In Chapter 1 of this history, the Egyptian priest Hornedjitef took with him a scarab as the magical symbol of the regenerative light of the Sun, to lighten the darkness of the afterlife. Given the opportunity, he might now take a solar-powered lamp as back-up.

This 100th object brings me to the end of this particular history of the world. Other objects would have yielded different stories and taken us

along different paths. The possibilities are infinite. But I hope that this book has demonstrated the power of things to connect us with unmatchable immediacy to people far distant in time and place and to allow all humanity to have a voice in our common story. Amartya Sen reflects:

> When we look at the history of the world, it is very important to recognize that we are not looking at the history of different civilizations truncated and separated from each other. Civilizations have a huge amount of contact, and there is a kind of inter-connectedness. I have always thought of the history of the world not as a history of civilizations but as a history of world civilizations evolving in often similar, often diverse, ways, always interacting with each other.

Above all, I hope this book has shown that the 'family of man' is not an empty metaphor, however dysfunctional that family usually is; that all humanity has the same needs and preoccupations, fears and hopes. Objects force us to the humble recognition that since our ancestors left East Africa to populate the world we have changed very little. Whether in stone or paper, gold, feathers or silicon, it is certain we will go on making objects that shape or reflect our world and that will define us to future generations.

Maps

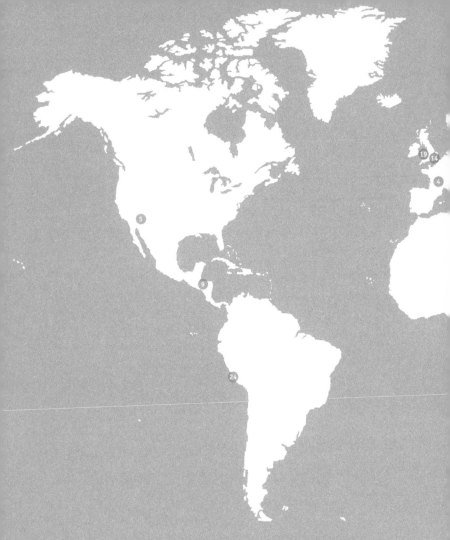

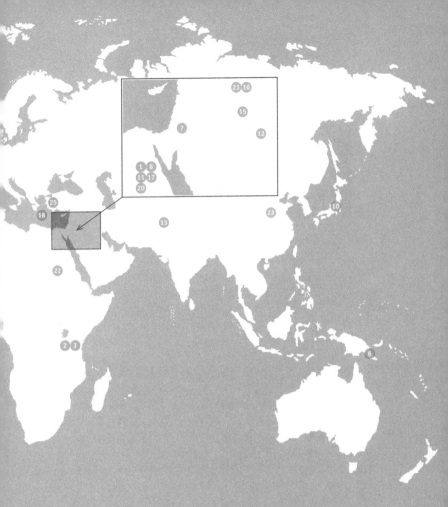

See next pages for objects *26–100* →

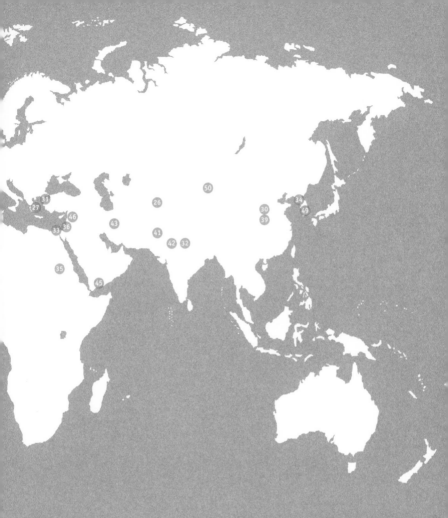

See next pages for objects *51–100* →

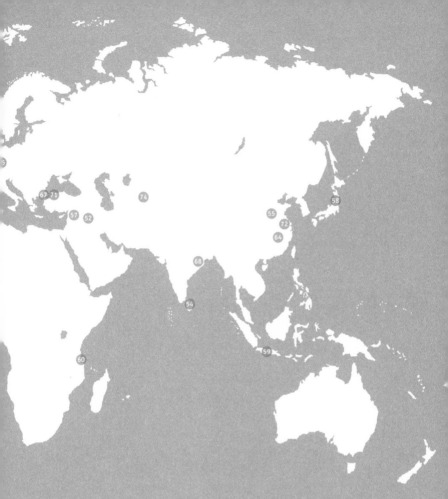

See next pages for objects 76–100 →

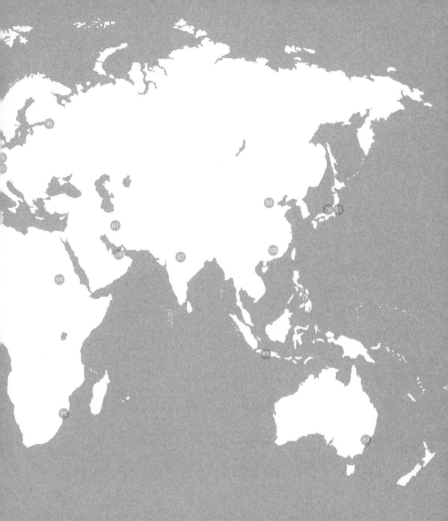

List of Objects

Object	Dimensions	Inventory No.
1 Mummy of Hornedjitef	H: 194.5 cm / W: 60 cm	.6678
2 Olduvai stone chopping tool	H: 9.3 cm / W: 8.1 cm / D: 7.2 cm	1934,1214.1
3 Olduvai handaxe	H: 23.8 cm / W: 10 cm / D: 5 cm	1934,1214.49
4 Swimming reindeer	H: 3 cm / W: 20.7 cm / D: 2.7 cm	Palart.550
5 Clovis spear point	H: 2.9 cm / W: 8.5 cm / D: 0.7 cm	1962,1206.137
6 Bird-shaped pestle	H:36.2 cm/ W:15 cm / D:15 cm	Oc1908,0423.1
7 Ain Sakhri lovers figurine	H: 10.8 cm / W: 6.2 cm / D: 3.8 cm	1958,1007.1
8 Egyptian clay model of cattle	H: 10 cm / W: 30 cm / D: 15.3 cm	1901,1012.6
9 Maya maize god statue	H: 90 cm / W: 54 cm /D: 36 cm	Am1923,Maud.8
10 Jomon pot	H: 15 cm / W: 17 cm	OA+.20
11 King Den's sandal label	H: 4.5 cm / W: 5.4 cm	1922,0728.2
12 Standard of Ur	H: 21.5 cm / W: 12 cm / D: 49.5 cm	1928,1010.3
13 Indus seal	H: 2.4 cm / W: 2.5 cm / D: 1.4 cm	1892, 1210.1
14 Jade axe	H: 21.2 cm / W: 8.12 cm / D: 1.9 cm	1901, 0206.1
15 Early writing tablet	H: 9.4 cm / W: 6.8 cm / D: 2.3 cm	1989,0130.4
16 Flood Tablet	H: 15 cm / W: 13 cm / D: 3 cm	K.3375
17 Rhind Mathematical Papyrus	H: 32 cm / W: 295.5 cm	1865,0218.2 *(large piece)*
	H: 32 cm / W: 119.5 cm	1865,0218.3 *(small piece)*
18 Minoan Bull-leaper	H: 11.1 cm / W: 4.7 cm / D: 15 cm	1966,0328.1
19 Mold gold cape	H: 23.5 cm / W: 46.5 cm / D: 28 cm	1836,0902.1
20 Statue of Ramesses II	H: 266.8 cm / W: 203.3 cm	.19
21 Lachish reliefs	H: 269.2 cm / W: 180.3 cm	1856,0909.14
22 Sphinx of Taharqo	H: 40.6 cm / W: 73 cm	1932,0611.1
23 Chinese Zhou ritual vessel	H: 23 cm / W: 42 cm / D: 26.8 cm	1977,0404.1
24 Paracas textile	H: 8 cm / W: 8 cm	Am1954,05.563 Am1954,05.565 Am1937,0213.4-5
25 Gold coin of Croesus	H: 1 cm / W: 2 cm	RPK,p146B.1sam
26 Oxus chariot model	H: 7.5 cm / D: 19.5 cm	1897,1231.7

	Object	Dimensions	Inventory No.
27	Parthenon sculpture: Centaur and Lapith	H: 134.5 cm / W: 134.5 cm / D: 41.5 cm	1816,0610.12
28	Basse-Yutz Flagons	H: 39.6 cm / W: 19.5 cm	1929,0511.1-2
29	Olmec stone mask	H: 13 cm / W: 11.3 cm / D: 5.7 cm	Am1938,1021.14
30	Chinese bronze bell	H: 55 cm / W: 39 cm / D: 31.5 cm	OA1965,0612.1
31	Coin with head of Alexander	W: 3 cm	1919,0820.1
32	Pillar of Ashoka	H: 12.2 / W: 32.6 cm / D: 7.6 cm	1880.21
33	Rosetta Stone	H: 112.3 cm / W: 75.7 cm / D: 28.4 cm	.24
34	Chinese Han lacquer cup	H: 6 cm / W: 17.6 cm / D: 12 cm	1955,1024.1
35	Head of Augustus	H: 46.2 cm / W: 26.5 cm / D: 29.4 cm	1911,0901.1
36	Warren Cup	H: 11 cm / D: 11 cm	1999,0426.1
37	North American otter pipe	H: 5.1 cm / W: 10 cm / D: 3.3 cm	Am,S.266
38	Ceremonial ballgame belt	H: 12 cm / W: 39.5cm/ D: 50 cm	Am,ST.398
39	Admonitions Scroll	H: 24.3 cm / W: 343.7 cm	1903,0408,0.1
40	Hoxne pepper pot	H: 10.3 cm / W: 5.7 cm / D: 4.2 cm	1994,0408.33
41	Seated Buddha from Gandhara	H: 95 cm / W: 53 cm / D: 24 cm	1895,1026.1
42	Gold coins of Kumaragupta I	W: 1.9 cm	1894,0506.962
43	Silver plate showing Shapur II	H: 12.8 cm / W: 11.5 cm / D: 2.6 cm	1908,1118.1
44	Hinton St Mary Mosaic	H: 810 cm / W: 520 cm	1965,0409.1
45	Arabian bronze hand	H: 18.5 cm / W: 11 cm / D :2.6 cm	1983,0626.2
46	Gold coins of Abd al-Malik	W: 1.9 cm	1874,0706.1
47	Sutton Hoo helmet	H: 31.8 cm / W: 21.5 cm	1939,1010.93
48	Moche warrior pot	H: 22.5 cm / W: 13.6 cm / D: 13.2 cm	Am,P.1
49	Korean roof tile	H: 28 cm / W: 22.5 / D: 6 cm	1992,0615.24
50	Silk Princess painting	H: 12 cm / W: 46 cm / D: 2.2 cm	1907,1111.73
51	Maya relief of royal blood-letting	H: 109 cm / W: 78 cm / D: 6 cm	Am1923,Maud.4
52	Harem wall-painting fragments	H: 14.4 cm / W: 10.2 cm / D: 3 cm H: 11 cm / W: 10.5 cm / D: 2.7 cm	OA+.10621 OA+.1062
53	Lothair Crystal	W: 18.6 cm / D: 1.3 cm	1855,1201.5
54	Statue of Tara	H: 143 cm / W: 44 cm / D:29.5 cm	1830,0612.4
55	Chinese Tang tomb figures	*Tallest* H: 107.7 cm / W: 49 cm / D 25 cm	1936,1012.220– 229 *and* 1936,1012.231 –232
56	Vale of York hoard	*cup* H: 9.2 cm / W: 12 cm	2009,4133.77– 693 2009,8023.1–76
57	Hedwig glass beaker	H: 14.3 cm / W: 13.9 cm	1959,0414.1
58	Japanese bronze mirror	W: 11 cm	1927,1014.2
59	Borobudur Buddha head	H: 33 cm / W: 26 cm / D: 29 cm	1859,1228.176
60	Kilwa pot sherds	*Largest* H: 12.5 cm / W: 14 cm / D: 2.5 cm	OA+.916
61	Lewis Chessmen	*Tallest* H: 10.3 cm	1831,1101.78- 144
62	Hebrew astrolabe	H: 11 cm / W: 9 cm / D: 2.1 cm	1893,0616.3
63	Ife head	H: 35 cm / W:12.5 cm / D: 15 cm	Af1939,34.1

	Object	Dimensions	Inventory No.
64	The David Vases	H: 63.6 cm	PDF,B.613 -4
65	Taino ritual seat	H. 22 cm / W. 14 cm / D: 44cm	1949,22.118
66	Holy Thorn Reliquary	H: 30 cm / W: 14.2 cm / D: 6.8 cm	WB.67
67	Icon of 'The Triumph of Orthodoxy'	H: 37.8 cm / W: 31.4 cm / D: 5.3 cm	1988,0411.1
68	Shiva and Parvati sculpture	H: 184.2 cm / W: 119.4 cm / D: 32 cm	1872,0701.70
69	Sculpture of Huastec goddess	H: 150 cm / W: 57 cm / D: 14 cm	Am,+.7001
70	Hoa Hakananai'a Easter Island statue	H: 242 cm/ W: 100 cm / D: 55 cm	Oc1869,1005.1
71	Tughra of Suleiman the Magnificent	H: 45.5 cm / W: 61.5 cm	1949,0409,0.86
72	Ming banknote	H: 34 cm / W: 22.2 cm	CIB,EA.260
73	Inca gold llama	H. 6.3 cm/ W. 1.5cm / D. 5.5 cm	Am1921,0721.1
74	Jade dragon cup	H: 6.4 cm / W: 19.4 cm	1959, 1120.1
75	Dürer's *Rhinoceros*	H:24.8 cm / W:31.7 cm	1895,0122.714
76	Mechanical galleon	H: 104 cm / W:78.5 cm / D: 20.3 cm	1866,1030.1
77	Benin plaque: the Oba with Europeans	H: 43.5 cm / W: 41 cm / D: 10.7 cm	Af1898,0115.23
78	Double-headed serpent	H: 20.5 cm / W: 43.5 cm / D: 5 cm	Am1894,-.634
79	Kakiemon elephants	H: 35.5 cm / H: 44 cm / D: 14.5 cm	1980,0325.1-2
80	Pieces of eight	W: 4 cm	1920,0907.382
			1950,0805.1
			1956,0604.1
			1990,0920.31,
			1991,0102.61
			1906,1103.1951
81	Shi'a religious parade standard	H: 127 cm / W: 26.7 cm / D: 4.5 cm	1888,0901.16-17
82	Miniature of a Mughal prince	H: 24.5 cm / W: 12.2 cm	1920,0917,0.4
83	Shadow puppet of Bima	H: 74.5 cm / W: 43 cm	As1859,1228.675
84	Mexican codex map	H: 50 cm / W: 77 cm	Am2006,Drg.22070
85	Reformation centenary broadsheet	H: 28.4 cm / W: 34.7 cm	1880,0710.299
86	Akan drum	H: 41 cm / D: 28 cm	Am,SLMisc.1368
87	Hawaiian feather helmet	H: 37 cm / W: 15 cm / D: 30 cm	Oc, HAW.108
88	North American buckskin map	H: 126 cm / W: 100 cm	Am2003,19.3
89	Australian bark shield	H: 97 cm / W: 29 cm	Oc1978,Q.839
90	Jade *bi*	W: 15 cm / D: 1 cm	1937,0416.140
91	Ship's chronometer from HMS *Beagle*	H: 17.6 cm / W: 20.8 cm / D: 20.8 cm	1958, 1006.1957
92	Early Victorian tea set	*Tallest* H: 14.4 cm / W: 17.5 cm / 10.7 cm	1909,1201.108
93	Hokusai's *The Great Wave*	H: 25.8 cm / W: 37.9 cm	2008,3008.1
94	Sudanese slit drum	H: 80 cm / W: 271 cm / D: 60 cm	Af1937,1108.1
95	Suffragette-defaced penny	W: 3.1 cm	1991,0733.1
96	Russian revolutionary plate	W: 24.8 cm / D: 2.87 cm	1990,0506.1
97	Hockney's *In the Dull Village*	H: 35 cm / W: 22.5 cm	1981,1212.8.8
98	Throne of Weapons	H: 101 cm / W: 61 cm	Af2002,01.1
99	Credit card	H: 4.5 cm / W: 8.5 cm	2009,4128.2
100	Solar-powered lamp and charger	H: 17 cm / W: 12.5 cm / D: 13 cm	

Bibliography

1. Mummy of Hornedjitef

Taylor, John, *Egyptian Mummies* (London, 2010)

Smith, A. S., *The Art and Architecture of Ancient Egypt* (New Haven, 1999)

2. Olduvai Stone Chopping Tool

Gamble, C., *Timewalkers: The Prehistory of Global Colonization* (London, 1995)

Schick, Kathy, and Nick Toth, 'African Origins', in C. Scarre (ed.), *The Human Past: World Prehistory and the Development of Human Societies* (London, 2009), pp. 46–83.

3. Olduvai Handaxe

Gamble, C., *Timewalkers: The Prehistory of Global Colonization* (London, 1995)

Stringer, Chris, *Homo Britannicus: The Incredible Story of Human Life in Britain* (London, 2006)

4. Swimming Reindeer

Bahn, Paul, and Jean Vertut, *Journey Through the Ice Age* (London, 1997)

Cook, Jill, *The Swimming Reindeer* (London, 2010)

5. Clovis Spear Point

Haynes, Gary, *The Early Settlement of North America: The Clovis Era* (Cambridge, 2002)

Meltzer, David, *First Peoples in a New World. Colonizing Ice Age America* (Berkeley, 2009)

6. Bird-shaped Pestle

Barker, Graeme, *The Agricultural Revolution in Prehistory: Why Did Foragers Become Farmers?* (Oxford, 2007)

Bellwood, Paul, *The First Farmers: The Origins of Agricultural Societies* (Oxford, 2005)

7. Ain Sakhri Lovers Figurine

Hodder, Ian, *The Domestication of Europe* (London, 1991)

Watkins, Trevor, 'From Foragers to Complex Societies in Southwest Asia', in C. Scarre (ed.), *The Human Past: World Prehistory and the Development of Human Societies* (London, 2009), pp. 201–33.

8. Egyptian Clay Model of Cattle

Check, Erika, 'Human Evolution: How Africa Learned to Love the Cow', *Nature*, 444 (2006), 994–6

Wengrow, David, *The Archaeology of Early Egypt: Social Transformations in North-East Africa, 10,000–2,650 BC* (Cambridge, 2006)

9. Maya Maize God Statue

Barker, Graeme, *The Agricultural Revolution in Prehistory: Why Did Foragers Become Farmers?* (Oxford, 2007)

Tetlock, Dennis, *Popol Vuh* (New York, 1996)

10. Jomon Pot

Habu, Junko, *Ancient Jomon of Japan* (Cambridge, 2004)

Kobayashi, Tatsuo, *Jomon Reflections: Forager Life and Culture in the Prehistoric Japanese Archipelago* (Oxford, 2004)

11. King Den's Sandal Label

Kemp, Barry, *Ancient Egypt: Anatomy of a Civilization* (London, 2005)

Wilkinson, T., *Early Dynastic Egypt* (London, 2001)

12. Standard of Ur

Crawford, Harriet, *Sumer and Sumerians* (Cambridge, 2004)

Zettler, Richard, and Lee Horne (eds.), *Treasures from the Royal Tomb at Ur* (Philadelphia, 1998)

13. Indus Seal

Possehl, Gregory, *The Indus Civilization: A Contemporary Perspective* (Walnut Creek, 2002)

Wright, Rita, *The Ancient Indus: Urbanism Economy and Society* (Cambridge, 2010)

14. Jade Axe

Edmonds, Mark, *Stone Tools and Society: Working Stone in Neolithic and Bronze Age Britain* (London, 1995)

Sheridan, Alison, 'Green Treasures from Magic Mountains', *British Archaeology*, 96 (2007), 22–7

15. Early Writing Tablet

Schmandt-Besserat, Denise, *When Writing Met Art: From Symbol to Story* (Austin, 2007)

Robinson, Andrew, *The Story of Writing: Alphabets, Hieroglyphs and Pictograms* (London, 2007)

16. Flood Tablet

George, Andrew, *The Epic of Gilgamesh* (London, 2003)

Mitchell, T. C., *The Bible in the British Museum: Interpreting the Evidence* (London, 2004)

17. Rhind Mathematical Papyrus

Imhausen, Annette, *Mathematics in Ancient Egypt* (Princeton, 2010)

Robins, Gay, and Charles Shute, *The Rhind Mathematical Papyrus* (London, 1987)

18. Minoan Bull-leaper

Fitton, J. Lesley, *Minoans* (London, 2002)

Rice, Michael, *The Power of the Bull* (Oxford, 1998)

19. Mold Gold Cape

Bradley, Richard, *The Prehistory of Britain and Ireland* (Cambridge, 2007)

Needham, Stuart, 'The Development of Embossed Goldwork in Bronze Age Europe', *Antiquaries Journal*, 80 (2000), 27–65

20. Statue of Ramesses II

Tyldesley, Joyce, *Ramesses: Egypt's Greatest Pharaoh* (London, 2000)

Van der Mieroop, Marc, *The Eastern Mediterranean in the Age of Ramesses II* (London, 2009)

21. Lachish Reliefs

Collins, Paul, *Assyrian Palace Sculptures* (London, 2009)

Collins, Paul, *From Egypt to Babylon: The International Age 1550–500 BC* (London, 2008)

22. Sphinx of Taharqo

Bonnet, Charles, and Dominique Valbelle, *The Nubian Pharaohs: Black Kings on the Nile* (Cairo, 2006)

Welsby, Derek, *The Kingdom of Kush: The Napatan and Meroitic Empires* (London, 2002)

23. Chinese Zhou Ritual Vessel

Von Falkenhausen, Lothar, *Chinese Society in the Age of Confucius (1000–250 BC)* (Los Angeles, 2006)

Hsu, Cho-yun, and Katheryn Linduff, *Western Chou Civilization* (New Haven, 1988)

24. Paracas Textile

Moseley, M. E., *The Incas and Their Ancestors: The Archaeology of Peru* (London, 2001)

Paul, Anne, *Paracas Ritual Attire: Symbols of Authority in Ancient Peru* (Norman, Oklahoma, 1990)

25. Gold Coin of Croesus

Seaford, Richard, *Money and the Early Greek Mind: Homer, Tragedy, and Philosophy* (Cambridge, 2004)

Schaps, David, *The Invention of Coinage and the Monetization of Ancient Greece* (Michigan, 2004)

26. Oxus Chariot Model

Briant, Pierre, *From Cyrus to Alexander: A History of the Persian Empire* (Winona Lake, 2002)

Curtis, John, *Ancient Persia* (London, 2000)

27. Parthenon Sculpture: Centaur and Lapith

Beard, Mary, *The Parthenon* (London, 2004)

Jenkins, Ian, *The Parthenon Sculptures in the British Museum* (London, 2007)

28. Basse-Yutz Flagons

James, Simon, *The World of the Celts* (London, 2005)

Megaw, Ruth and Vincent, *Celtic Art from Its Beginnings to the Book of Kells* (London, 2001)

29. Olmec Stone Mask

Diehl, Richard, *The Olmecs: America's First Civilization* (London, 2004)

Pool, Christopher, *Olmec Archaeology and Early Mesoamerica* (Cambridge, 2007)

30. Chinese Bronze Bell

von Falkenhausen, Lothar, *Chinese Society in the Age of Confucius (1000–250 BC)* (Los Angeles, 2006)

So, Jenny F., *Music in the Age of Confucius* (Washington, 2000)

31. Coin with Head of Alexander

Bosworth, A. B., *The Legacy of Alexander: Politics, Warfare, and Propaganda Under the Successors* (Oxford, 2005)

Lane Fox, Robin, *Alexander the Great* (London, 2006)

32. Pillar of Ashoka

Wood, Michael, *The Story of India* (London, 2007)

Thapar, Romila, *A'soka and the Decline of the Mauryas* (Oxford, 1998)

33. Rosetta Stone

Parkinson, Richard, *The Rosetta Stone* (London 2005)

Thompson, Dorothy J., 'Literacy and Power in Ptolemaic Egypt', in Alan K. Bowman and Greg Woolf (eds.), *Literacy and Power in the Ancient World* (Cambridge, 1994) pp. 67–83

34. Chinese Han Lacquer Cup

Barbieri Low, Anthony, *Artisans in Early Imperial China* (Washington DC, 2007)

Lewis, Mark Edward, *The Early Chinese Empires: Qin and Han* (Harvard, 2007)

35. Head of Augustus

Eck, W., *Age of Augustus* (London, 2007)

Southern, Pat, *Augustus* (New York, 1998)

36. Warren Cup

Clarke, John R., *Looking at Lovemaking: Constructions of Sexuality in Roman Art 100 BC–AD 250* (Berkeley, 1998)

Williams, Dyfri, *The Warren Cup* (London, 2006)

37. North American Otter Pipe

Milner, G., *The Moundbuilders: Ancient Peoples of Eastern North America* (London, 2004)

Rafferty, Sean, and Rob Mann, *Smoking and Culture: The Archaeology of Tobacco Pipes in Eastern North America* (Knoxville, 2004)

38. Ceremonial Ballgame Belt

Evans, Susan Toby, *Ancient Mexico and Central America: Archaeology and Culture* (London, 2004)

Whittington, E. Michael, *The Sport of Life and Death: The Mesoamerican Ballgame* (London, 2001)

39. Admonitions Scroll

Lewis, M. A., *China Between Empires: The Northern and Southern Dynasties* (Boston, 2009)

McCausland, Shane, *First Masterpiece of Chinese Painting: The Admonitions Scroll* (London, 2003)

40. Hoxne Pepper Pot

Johns, Catherine, *The Hoxne Late Roman Treasure: Gold Jewellery and Silver Plate* (London, 2010)

Tomber, Roberta, *Indo-Roman Trade: from Pots to Pepper* (London, 2008)

41. Seated Buddha from Gandhara

Berendt, Karl A., *The Art of Gandhara in the Metropolitan Museum of Art* (New York, 2007)

Zwalf, Vladimir, *Buddhism: Art and Faith* (London, 1985)

42. Gold Coins of Kumaragupta I

Thapar, Romila, *The Penguin History of Early India: From the Origins to AD 1300* (London, 2002)

Willis, Michael, *The Archaeology of Hindu Ritual* (Cambridge, 2009)

43. Silver Plate Showing Shapur II

Daryaee, Touyaj, *Sasanian Persia: The Rise and Fall of an Empire* (London, 2009)

Harper, Prudence O., *In search of a Cultural Identity: Monuments and Artefacts of the Sasanian Near East, 3rd to 7th century AD* (New York, 2006)

44. Hinton St Mary Mosaic

Petts, David, *Christianity in Roman Britain* (Stroud, 2003)

Mattingly, David, *An Imperial Possession: Britain in the Roman Empire* (London, 2007)

45. Arabian Bronze Hand

Gunter, A. C. (ed.), *Caravan Kingdoms: Yemen and the Ancient Incense Trade* (Washington, 2005)

Simpson, St John, *Queen of Sheba: Treasures from Ancient Yemen* (London, 2002)

46. Gold Coins of Abd al-Malik

Crone, P., and M. Hinds, *God's Caliph: Religious Authority in the First Centuries of Islam* (Cambridge, 2003)

Robinson, Chase F., *Abd al-Malik* (Oxford, 2005)

47. Sutton Hoo Helmet

Carver, Martin, *Sutton Hoo: Burial Ground of Kings* (London, 2000)

Campbell, James, *The Anglo Saxons* (London, 1991)

Marzinzik, Sonja, *The Sutton Hoo Helmet* (London, 2007)

48. Moche Warrior Pot

Bawden, G., *The Moche* (Cambridge, 1999)

Bourget, S., and K. L. Jones (eds.), *The Art and Archaeology of the Moche* (Austin, 2008)

49. Korean Roof Tile

Nelson, Sarah Milledge, *The Archaeology of Korea* (Cambridge, 1993)

Portal, Jane, *Korea: Art and Archaeology* (London, 2000)

Seth, Michael J., *A Concise History of Korea: From the Neolithic Period to the Nineteenth Century* (Lanham, 2006)

50. Silk Princess Painting

Baumer, Christoph, *The Southern Silk Road: In the Steps of Sir Aurel Stein and Sven Hedin* (Bangkok, 2000)

Vainker, S., *Chinese Silk: A Cultural History* (London, 2004)

51. Maya Relief of Royal Bloodletting

Grube, Nilolai, and Simon Martin, *Chronicle of the Mayan Kings and Queens: Deciphering the Dynasties of the Ancient Maya* (London, 2008)

Freidel, David, and Linda Schele, *A Forest of Kings: The Untold Story of the Ancient Maya* (London, 1990)

52. Harem Wall-painting Fragments

Irwin, Robert, *The Arabian Nights: A Companion* (London: 2009)

Robinson, C. F., *A Medieval Islamic City Reconsidered: An Interdisciplinary Approach to Samarra* (Oxford, 2001)

53. Lothair Crystal

Kornbluth, Genevra, *Engraved Gems of the Carolingian Empire* (Pennsylvania, 1995)

McKitterick, Rosamund, *The Frankish Kingdoms under the Carolingians 751–987* (London/New York, 1983)

54. Statue of Tara

Thapar, Romila, *The Penguin History of Early India: From the Origins to AD 1300* (London, 2002)

De Silva, K. M., *A History of Sri Lanka* (Berkeley, 1981)

55. Chinese Tang Tomb Figures

Michaelson, Carol, and Jane Portal, *Chinese Art in Detail* (London, 2006)

Benn, Charles, *China's Golden Age: Everyday Life in the Tang Dynasty* (Westport, 2002)

56. Vale of York Hoard

Ager, B., and G. Williams, *The Vale of York Hoard* (London, 2010)

Holman, Katherine, *The Northern Conquest: Vikings in Britain and Ireland* (Oxford, 2002)

Graham-Campbell, J., and G. Williams (ed.), *Silver Economy in the Viking Age* (California, 2007)

57. Hedwig Glass Beaker

Klaniczay, Gabor, *Holy Rulers and Blessed Princesses: Dynastic Cults in Medieval Central Europe* (Cambridge, 2002)

Riley-Smith, Jonathan, The *Oxford Illustrated History of the Crusades* (Oxford, 2001)

58. Japanese Bronze Mirror

Morris, Ivan, *World of the Shining Prince* (New York, 1994)

Shikibu, Murasaki, *et al.*, *Diaries of Court Ladies of Old Japan* (New York, 2003)

59. Borobudur Buddha Head

Grabsky, P., *The Lost Temple of Java* (London, 1999)

Lockard, C., *Southeast Asia in World History* (Oxford, 2009)

60. Kilwa Pot Sherds

Horton, M. C., and J. Middleton, *The Swahili* (Oxford, 2000)

Mitchell, P., *African Connections: Archaeological Perspectives on Africa and the Wider World* (Maryland, 2005)

61. Lewis Chessmen

Robinson, James, *The Lewis Chessmen* (London, 2004)

McDonald, Andrew R., *The Kingdom of the Isles: Scotland's Western Seaboard c.1100 – c.1336* (Edinburgh, 1997)

62. Hebrew Astrolabe

Lowney, Chris, *A Vanished World: Muslims, Christians and Jews in Medieval Spain* (Oxford, 2005)

Webster, Roderick and Marjorie, *Western Astrolabes* (Chicago, 1998)

63. Ife Head

Davidson, Basil, *West Africa before the Colonial Era* (London/New York, 1998)

Platte, Editha, *Bronze Head from Ife* (London, 2010)

64. The David Vases

Carswell, John, *Blue & White: Chinese Porcelain Around the World* (London, 2000)

Brook, Timothy, *The Confusions of Pleasure: Commerce and Culture in Ming China* (California, 1999)

65. Taino Ritual Seat

Oliver, Jose R., *Caciques and Cemi Idols* (Tuscaloosa, 2009)

Wilson, Samuel M., *The Archaeology of the Caribbean* (Cambridge, 2007)

66. Holy Thorn Reliquary

Cherry, John, *The Holy Thorn Reliquary* (London, 2010)

Benedicta Ward, *Relics and the Medieval Mind* (Malden/Oxford/Victoria, 2010)

67. Icon of the Triumph of Orthodoxy

Cormack, Robin, *Icons* (London, 2007)

Herrin, Judith, *Byzantium: The Surprising Life of a Medieval Empire* (London, 2007)

68. Shiva and Parvati Sculpture

Blurton, Richard, *Hindu Art* (London, 1992)

Elgood, Heather, *Hinduism and the Religious Arts* (London, 1999)

69. Sculpture of Huastec Goddess

Evans, Susan Toby, *Ancient Mexico and Central America* (London, 2004)

McEwan, Colin, *Ancient American Art in Detail* (London, 2009)

70. Hoa Hakananai'a Easter Island Statue

Hooper, S., *Pacific Encounters: Art and Divinity in Polynesia 1760–1860* (London, 2006)

Van Tilburg, Jo Anne, *Hoa Hakananai'a* (London, 2004)

71. Tughra of Suleiman the Magnificent

Inalcik, Halil, *The Ottoman Empire: The Classical Age 1300–1600* (Burtonsville, 2001)

Rogers, J. M., and R. M. Ward, *Süleyman the Magnificent* (London, 1988)

72. Ming Banknote

Clunas, Craig, *Empire of Great Brightness: Visual and Material Cultures of Ming China 1368–1644* (London, 2007)

Brook, Timothy, *Troubled Empire: China in the Yuan and Ming Dynasties* (Harvard, 2010)

73. Inca Gold Llama

D'Altroy, Terence N., *The Incas* (Oxford, 2002)

McEwan, Colin, *Precolumbian Gold: Technology, Style and Iconography* (London, 2000)

74. Jade Dragon Cup

Forbes Manz, Beatrice, *The Rise and Rule of Tamerlane* (Cambridge, 1989)

Forbes Manz, Beatrice, *Power, Politics and Religion in Timurid Iran* (Cambridge, 2007)

75. Dürer's *Rhinoceros*

Bartrum, Giulia, *Albrecht Dürer and his Legacy: the Graphic Work of a Renaissance Artist* (London, 2002)

Bendini, Silvio A., *The Pope's Elephant* (Austin, 1997)

76. The Mechanical Galleon

Evans, R. J. W., *Rudolf II and his World: A Study in Intellectual History 1576–1612* (Oxford, 1973)

Wolfe, Jessica, *Humanism, Machinery and Renaissance Literature* (Cambridge, 2004)

77. Benin Plaque: The Oba with Europeans

Plankensteiner, Barbara, *Benin Kings and Rituals: Court Arts from Nigeria* (Paris/Berlin, 2007)
Girshick Ben-Amos, P., *The Art of Benin* (London, 1995)

78. Double-headed Serpent

Evans, Susan Toby, *Ancient Mexico and Central America: Archaeology and Culture History* (London, 2004)
McEwan, C., *et al.*, *Turquoise Mosaics from Mexico* (London, 2006)

79. Kakiemon Elephants

Impey, Oliver, *Japanese Export Porcelain* (Amsterdam, 2002)
Cullen, A. M., *A History of Japan 1582–1941: Internal and External Worlds* (Cambridge, 2003)

80. Pieces of Eight

Stein, S. J. and B. H., *Silver, Trade and War: Spain and America in the Making of Early Modern Europe* (Baltimore, 2000)
Vilar, P., *A History of Gold and Money* (London/New York, 1991)
Elliott, John Huxtable, *Empires of the Atlantic World: Britain and Spain in America 1492–1830* (New Haven, 2007)

81. Shi'a Religious Parade Standard

Canby, Sheila R., *Shah 'Abbas: The Remaking of Iran* (London, 2009)
Axworthy, Michael, *A History of Iran: Empire of the Mind* (New York, 2010)

82. Miniature of a Mughal Prince

Canby, Sheila R., *Princes, Poets and Paladins: Islamic and Indian Paintings from the Collection of Prince and Princess Sadruddin Aga Khan* (London, 1998)

Stronge, Susan, *Painting for the Mughal Emperor: The Art of the Book 1560–1660* (London, 2002)

83. Shadow Puppet of Bima

Scott-Kemball, Juene, *Javanese Shadow Puppets* (London, 1970)
Tarling, Nicholas (ed.), *The Cambridge History of Southeast Asia, Vol. 1, Part 2* (Cambridge, 1992)

84. Mexican Codex Map

Brotherston, Gordon, *Painted Books from Mexico* (London, 1995)
Edgerton, S. Y., *Theaters of Conversion: Religious Architecture and Indian Artisans in Colonial Mexico* (Albuquerque, 2001)

85. Reformation Centenary Broadsheet

Wilson, Peter H., *Europe's Tragedy: A New History of the Thirty Years War* (London, 2010)
Pettegree, Andrew, *Reformation and the Culture of Persuasion* (Cambridge, 2005)
MacCulloch, Diarmaid, *The Reformation: A History* (London, 2003)

86. Akan Drum

Reindorf, Carl C., *History of the Gold Coast and Asante* (Accra, 2007)
McCaskie, T. C., *State and Society in Pre-colonial Asante* (Cambridge, 1995)

87. Hawaiian Feather Helmet

Lummis, Trevor, *Pacific Paradises: The Discovery of Tahiti and Hawaii* (Sutton, 2005)
Forbes, David W., *Encounters with Paradise: Views of Hawaii and its People, 1778–1941* (Honolulu, 1992)

88. North American Buckskin Map

Richter, Daniel K., *Facing East from Indian Country: A Native History of Early America* (Harvard, 2001)

Warhus, Mark, *Another America: Native American Maps and the History of Our Land* (New York, 1997)

89. Australian Bark Shield

Nugent, Maria, *Cook Was Here* (Cambridge, 2009)

Flood, Josephine, *The Original Australians* (Crows Nest, 2004)

90. Jade *Bi*

Elliott, Marc C., *The Qianlong Emperor: Son of Heaven, Man of the World* (Harlow, 2009)

Rawson, Jessica, *Chinese Jade: From the Neolithic to the Qing* (London, 1995)

81. Ship's Chronometer from HMS *Beagle*

Andrewes, W. (ed.), *The Quest for Longitude* (London, 1996)

Glennie, P., and N. Thrift, *Shaping the Day: A History of Timekeeping in England and Wales 1300–1800* (Oxford, 2009)

92. Early Victorian Tea Set

Macfarlane, A. and I., *Green Gold: The Empire of Tea* (London, 2004)

Dolan, Brian, *Josiah Wedgwood, Entrepreneur to the Enlightenment* (London, 2008)

93. Hokusai's *The Great Wave*

Huffman, James L., *Japan in World History* (Oxford, 2010)

Bouquillard, Jocelyn, *Hokusai's Mount Fuji: The Complete Views in Color* (New York, 2007)

94. Sudanese Slit Drum

Green, Dominic, *Three Empires on the Nile* (New York, 2007)

Johnson, Douglas H., *The Root Causes of Sudan's Civil Wars* (Oxford, 2002)

95. Suffragette-defaced Penny

Phillips, Melanie, *The Ascent of Woman: A History of the Suffragette Movement and the Ideas Behind It* (London, 2004)

Liddington, Jill, *Rebel Girls: How Votes for Women Changed Edwardian Lives* (London, 2006)

96. Russian Revolutionary Plate

King, David, *Red Star Over Russia: A Visual History of the Soviet Union* (London, 2010)

Rudoe, Judy, *Decorative Arts 1850–1950: The British Museum Collection* (London, 1994)

97. Hockney's *In the Dull Village*

Livingstone, Marco, *David Hockney* (World of Art Series)(London, 1993)

Cavafy, C. P., *Collected Poems*, ed. George Savvidis, trans. Edmund Keeley and Philip Sherrard (Princeton,1992)

98. Throne of Weapons

Bocola, S. (ed.), *African Seats* (London, 2002)

Nordstrom, C., *A Different Kind of War Story* (Philadelphia, 1997)

99. Credit Card

Ritzer, George F., *Explorations in the Sociology of Consumption: Fast Food, Credit Cards and Casinos* (Thousand Oaks, 2001)

Maurer, Bill, *Mutual Life Limited: Islamic Banking, Alternative Currencies, Lateral Reason* (Princeton, 2005)

100. Solar-powered Lamp and Charger

de Bruijn, Mirjam, Francis Nyamnjoh and Inge Brinkman (eds.), *Mobile Phones: The New Talking Drums of Everyday Africa* (Bamenda and Leiden, 2009)

MacKay, David J. C., *Sustainable Energy – Without the Hot Air* (Cambridge, 2008)

Boyle, Godfrey, *Renewable Energy* (2nd edn, Oxford 2004)

Grimshaw, David J., and Sian Lewis, 'Solar Power for the Poor: Facts and Figures', 24th March 2010: www.scidev.net/en/features/solar-power-for-the-poor-facts-and-figures-1.html

References

p. 43 Randall-MacIver, David, and Arthur Mace, *El Amrah and Abydos 1899–1901: Memoir of the Egypt Exploration Fund 23* (London, 1902)

p. 52 Tedlock, D., *Popul Vuh* (2nd edn; London, 1996)

p. 230 Plautus, *Curculio*, translated in Dyfri Williams, *The Warren Cup* (London, 2006)

p. 243 Fray Diego Duran, *Book of the Gods and Rites and the Ancient Calendar*, translated and edited Fernando Horcasitas and Doris Heyden (Oklahoma, 1971), p. 316

p. 268 *Romantic Legends of Sakya Buddha: A Translation of the Chinese Version of the Abhiniskramana Sutra*, Samuel Beal (original edition 1875; reprinted Kila, MT, 2003), p. 130

p. 321 Hsuan-tang, *Great Tang Records of the Western Regions*, translated in Aurel Stein, *Sand-Buried Ruins of Ancient Khotan* (London, 1904; reprinted New Delhi, 2000), p. 229

p. 324 Stein, Aurel, *Sand-Buried Ruins of Ancient Khotan* (London, 1904; reprinted New Delhi, 2000), P. 251

p. 328 Stephens, John Lloyd, *Incidents of Travel in Central America, Chiapas and Yucatan* (New York, 1841)

p. 330 Diego de Landa, *Relación De Las Cosas De Yucatán,* translated in William Gates, *Yucatan Before and After the Conquest* (New York, 1978)

p. 333 Haddawy, H. (trans.), *The Arabian Nights: Based on the Text Edited by Muhsin Mahdi* (New York, 2008), p. 153

p. 336 Al-Shābushti, Abūal-Hasan Ali b. Muhammad, *Kitāb al-Diyārāt*, ed. K. 'Awwād (Baghdad, 1986), pp. 160–61; translated in Alastair Northedge, 'The Palaces of the Abbasids at Samarra', in Chase F. Robinson (ed.), *A Medieval Islamic City Reconsidered: An Interdisciplinary Approach to Samarra*, Oxford Studies in Islamic Art XIV (Oxford, 2001), 29–67

p. 338 Ibn al-Mu'tazz, 'Abd Allah, *Dīwān* (Cairo, 1977), vol. 2, p. 217; translated in Julie Scott-Meisami, 'The Palace Complex as Emblem: Some Samarran Qaṣīdas', in Chase F. Robinson (ed.), *A Medieval Islamic City Reconsidered: An Interdisciplinary Approach to Samarra*, Oxford Studies in Islamic Art XIV (Oxford, 2001), 69–78

p. 341 *The Chronicle of Waulsort,* translated in Genevra Kornbluth, *Engraved Gems of the Carolingian Empire* (Pennsylvania, 1995), p. 33

REFERENCES

p. 344 Sedulius Scottus, *De Rectoribus Christianis*, translated in Genevra Kornbluth, *Engraved Gems of the Carolingian Empire* (Pennsylvania, 1995), p. 47

p. 364 Ibn Fadlan, Ahmad, *Kitāb ilā Mulk al-Saqāliba*, translated in J. Brønsted, *The Vikings* (London, 1960), p. 265

p. 373 *Ōkagami, the Great Mirror: Fujiwara Michinaga (966–1027) and His Times*, translated Helen Craig McCullough (Princeton, 1980), p. 86

p. 375 From the diary of Murasaki Shikidu', translated in Annie Shepley Omori and Koci Doi, *Diaries of Court Ladies of Old Japan* (Boston, 1920)

p. 380 Raffles, Thomas Stamford, *The History of Java*, vol. 2 (1817)

p. 387 Corrêa, Gaspar, *The Three Sea Voyages of Vasco de Gama* (London, 18690, pp. 291–2

p. 395 Clancy, T. O., *The Triumph Tree: Scotland's Earliest Poetry AD 550–1350* (Edinburgh, 1998), p. 288

p. 420 Bartolomé de las Casas, *Historia de las Indias,* translated in Jose R. Oliver, *Caciques and Cemi Idols* (Tuscaloosa, 2009), p. 83

p. 446 Bernardino de Sahagún, *Historia general de las cosas de Nueva España* (1550), translated as *Florentine Codex: General History of the Things of New Spain*, by C. E. Dibble and A. J. O. Andrerseon (Salt Lake City, 1950–82), vol. 1, p. 23

p. 468 Translated in Felicia J. Hecker, 'A fifteenth-century Chinese Diplomat in Herat', *Journal of the Royal Asiatic Society*, third series, 3 (1993), 85–98

p. 474 Garcilaso de la Vega ('el Inca'), *Comentarios reales de los Incas* (1609), translated as: H. V. Livermore, *Royal Commentaries of the Incas and general History of Peru* (Austin, 1966), vol. 1, pp. 360–62

p. 475 Ibid., p. 550

p. 486 Antonio Sanfelice, translated in Silvio A. Bendini, *The Pope's Elephant* (Manchester, 1997), p. 129

p. 494 Translated in J. J. Leopold, 'The Construction of Schlottheim's Nef', in J, Fritsch (ed.), *Ships of Curiosity: Three Renaissance Automata* (Paris, 2001), at pp. 68–9

pp. 499–500 Dapper, Olfert, *Description of Benin*, translated in Henry Ling Roth, *Great Benin: Its Customs, Arts and Horrors* (Halifax, 1903), p. 160

p. 501 Read, C. H., and O. M. Dalton, 'Works of Art from Benin City', *Journal of the Anthropological Institute of Great Britain and Ireland*, 27 (1898), 362–82

p. 507 (1) Bernal Díaz del Castillo, *The Discovery and Conquest of Mexico*, translated A. P. Maudslay (New York, 1956), p. 190

p. 507 (2) Fray Diego Durán, *Historia de las Indias de Nueva Espana, y Islas de la Tierra Firme*, translated in Michael E. Smith, ' The Role of Social Stratification in the Aztec Empire: A View from the Provinces', *American Anthropologist*, 88 (1986), 70–91

p. 513 Letter of Filippo Sassetti, translated in R.W. Lightbown, 'Oriental Art in Late Renaissance and Baroque Italy', *Journal of the Warburg and Courtauld Institutes*, 32 (1969), pp. 228–79

p. 518 Alvaro Alonso Barba, *El Arte de los Metales* (The Art of Metals) (1640) translated in *A Collection of Scarce and Valuable Treatises Upon Metals, Mines, and Minerals* (1738, reprinted 2008)

p. 518–19 Capoche, Luis, *Relación general de la Villa Imperiale de Potosi* (1585), translated in P. Vilar, *A History of Gold and Money* (London, 1991), p. 127

P. 522 Gonsalez de Cellorigo, *Memorial de la Politica necesaria y util a la Republica de Espana* (Valladolid, 1600) translated in Jon Cowans, *Early Modern Spain: A Documentary History* (Philadelphia, 2003), pp.133–41

p. 535 *The Tûzuk-i-Jahangiri, or Memoirs of Jahangir*, translated Alexander Rogers (London, 1909–14), vol. I, p. 37

p. 535–6 (1) *The Embassy of Sir Thomas Roe to the Court of the Great Mogul 1615–1619, as Narrated in His Journal and Correspondence*, edited by William Foster (London, 1899), vol. 2., p. 382

p. 536 (2) *The Tûzuk-i-Jahangiri, or Memoirs of Jahangir*, translated by Alexander Rogers (London, 1909–14), vol. I, p. 355

p. 548–9 Letter of Juan de Zumàrraga, translated in Martin Austin Nesvig, 'The "Indian Question" and the Case of Tlatelolco', in Martin Austin Nesvig (ed.), *Local Religion in Colonial Mexico* (Alburquerque, 2006), p. 79

p. 558 John Locke, *A Letter Concerning Toleration* (Huddersfield, 1796), pp. 9–10

p. 563–4 Chambers, Ephraim, *Cyclopaedia; or An Universal Dictionary of Arts and Sciences* (London, 1728), vol. 2, p. 623

p. 570–71 Samwell, David, *A Narrative of the Death of Captain James Cook* (London, 1786)

p. 575 Published in American State Papers, *Documents, Legislative and Executive, of the Congress of the United States from the Second Session of the Eleventh to the Third Session of the Thirteenth Congress Inclusive, Class ii: Indian Affairs* (Washington, 1834), pp. 339–40

p. 577 Diagram from Lewis, G. Malcom, 'An Early Map of Skin of the Area Later to Become Indiana and Illinois', *British Library Journal*, 22 (1996), 66-87

p. 602 Johnson, Samuel, 'Review of "A Journal of Eight Days Journey"', *The Literary Magazine*, 2, no.13 (1757)

p. 603 English translation of Geijer quoted in Alan and Iris Macfarlane, *Green Gold: The Empire of Tea* (London, 2003), pp. 71–2

p. 605 H. Evershed, 'The Farming of Surrey', *Journal of the Royal Agricultural Society of England*, 1st series, 14 (1853), pp. 402–3

p. 611 Online source: http://afe.easia.columbia.edu/japan/japanworkbook/modernhist/perry.html#document

p. 621–2 'Scrapbook for 1912: Vera Brittain Introduces Dame Ethel Smyth', *National Programme* (BBC, first broadcast 9 March 1937)

p. 623 *Female Suffrage: A Letter from the Right Hon. W. E. Gladstone, M. P. to Samuel Smith, M. P.* (London, 1892)

p. 624 (1) Transcript of a speech made by Christabel Pankhurst, 1908 (Copyright © British Library)

p. 624 (2) Mary Richardson quoted in ' *National Gallery Outrage. Suffragist Prisoner in Court. Extent of Damage*', The Times, 11 March 1914

p. 631 Letter from the State Porcelain Factory, 4 June 1920, translated in Tamara Kudryavt-seva, *Circling the Square: Avant-garde Porcelain from Revolutionary Russia* (London, 2004), p. 27

p. 637 Cavafy, Constantine, 'In the Dreary Village', translated by John Mavrogordato (London, 1974)

p. 638 Hockney, David, *Hockney by Hockney* (London, 1979), p. 23

Picture Credits and Text Acknowledgements

p. 167 (tomb of Cyrus) copyright © Robert Harding Picture Library Ltd / Alamy

p. 189 (La Venta) copyright © Danita Delimont / Alamy

p. 246 (Two ballplayers at the court of King Charles V, by Christoph Weiditz (1528)) photograph courtesy of Germanisches Nationalmuseum, Nuremberg

p. 275 (Neasden temple) copyright © David Churchill / arcaidimages.com

p. 381 (Borobudur) copyright © ImageState / Alamy

p. 383 (ship detail from Borobudur) copyright © Wolfgang Kaehler / Alamy

p. 429 (Sainte-Chapelle window) photograph Bernard Acloque copyright © Centre des monuments nationaux, Paris

p. 526 (interior of cathedral at Isfahan) copyright © Arkreligion.com / Michael Good

p. 529 (detail of mosque at Isfahan) copyright © Arkreligion.com / Tibor Bognar

p. 551 (pilgrims at Virgin of Guadalupe) copyright © Juan Barreto / AFP / Getty Images

p. 588 (the Qianlong emperor) reproduced courtesy of the Palace Museum, Beijing

p. 590 (the Qianlong emperor's white bowl) reproduced courtesy of the Palace Museum, Beijing

p. 606 'The Advantages of Floating in the Middle of the Sea' from *Pacific Overtures*, words and music by Stephen Sondheim. Copyright © 1975 (renewed) Rilting Music, Inc. All rights administered by WB Music Corp. All Rights Reserved. Used by Permission. Reprinted by permission of Hal Leonard Corporation

p. 625 (50p coin) reproduced by courtesy of the Royal Mint

p. 634 *In the Dull Village* from *Illustrations for Fourteen Poems by C. P. Cavafy*, 1966/7. Etching on paper. Edition B-366/500 copyright © David Hockney/Editions Alecto

p. 635 Extract from 'Annus Mirabilis' taken from *Collected Poems* by Philip Larkin copyright © the Estate of Philip Larkin, reproduced by permission of Faber and Faber Ltd

p.637 'In the Dreary Village' from *The Poems of C. P. Cavafy*, translated by John Mavrogordato, published by Chatto & Windus. Reprinted by permission of The Random House Group Ltd

Acknowledgements

A History of the World in 100 Objects has been created in partnership with BBC Radio 4. Without Mark Damazer's championing, this project would not have happened. I would like to extend my warmest thanks to him.

I am grateful to Jane Ellison, Commissioning Editor at Radio 4 and Joanna Mackle, Director of Public Engagement at the British Museum, for bringing the BBC and BM together to realize the full potential of this ambitious project, not just on Radio 4. My extended thanks to Rob Ketteridge and the BBC editorial and production team in the Documentaries Unit, BBC Audio & Music Production – Philip Sellars, Anthony Denselow, Paul Kobrak, Rebecca Stratford, Jane Lewis and Tamsin Barber – for bringing the programmes to life so vividly on radio.

Although I appear as the author of the series and this book, they are in fact the work of many hands. *A History of the World in 100 Objects* has been in every sense a team effort, which would not have been possible without the knowledge and skills, hard work and dedication of many colleagues. This book is the culmination of many people's work, and I would like to take this opportunity to thank those who were most closely connected with the project. For their extensive curatorial research and guidance: J. D. Hill, Barrie Cook and Ben Roberts; for working closely with me and the curatorial team in shaping the scripts for broadcast on which these chapters are based, Patricia Wheatley; for managing the *History of the World* project at the British Museum, including this book, Emma Kelly; for their support in every element of this book and the wider project, Rosalind Winton and Becky Allen; for their boundless patience, my closest colleagues – Kate Harris, Polly Miller and Lisa Shaw, and my Deputy Director Andrew Burnett.

I should also like to thank curatorial colleagues and the scientists and conservation experts whose research and knowledge underpin every chapter in this book. Thanks to the Museum Assistants who have given their time to provide ongoing and unprecedented access to these objects over the last few years and to the photography team for the images in this book.

I would like to thank the many people who have contributed to the wider project and its groundbreaking website. It is due to the energy, dedication and support of Museum professionals and BBC teams across England, Wales, Northern Ireland and Scotland that the ideas which underpin this project have reached such a wide audience.

My thanks too must be extended to CBBC, who worked in partnership with the Museum to bring thirteen of the objects from the series to life for children in a unique series of TV programmes, supported by a schools initiative.

ACKNOWLEDGEMENTS

From the British Museum, I would like to thank Hannah Boulton, Frances Carey, Sara Carroll, Katie Childs, Matthew Cock, Holly Davies, Sonia D'Orsi, Rosemary Folkes, David Francis, Lynne Harrison, Caroline Ingham, Rosanna Kwok, Susan La Niece, Ann Lumley, Sarah Marshall, Pippa Pearce, David Prudames, Susan Raikes, Olivia Rickman, Margaux Simms, Clare Tomlinson and Simon Wilson.

From the BBC, I would like to thank Seamus Boyd, Claire Burgoyne, Katherine Campbell, Andrew Caspari, Tony Crabb, Sian Davis, Craig Henderson, Susan Lovell, Christina Macaulay, Claire McArthur, Kathryn Morrison, Jamie Rea, Angela Roberts, Paul Sargeant, Gillian Scothern, Shauna Todd and Christine Woodman.

And finally, my thanks to Stuart Proffitt, Publishing Director of Allen Lane, who was able to re-imagine this series as a book, and to the team at Penguin: Andrew Barker, James Blackman, Janet Dudley, Richard Duguid, Caroline Hotblack, Claire Mason, Donna Poppy, Jim Stoddart, Shan Vahidy and especially John Gribbin, who did much of the work turning the radio scripts into book prose.

A special debt of thanks to all the outside contributors to the series and the book, whose voices have so enriched our understanding of the objects and who have given so generously of their time, knowledge and insight. It has not been possible, for reasons of space, to include all the radio contributions in the book, but that does not lessen my gratitude for them.

Index